Manchester studies in the history of art
General editor: C. R. Dodwell

Dedicated to the memory of
Dorothy Lawrence Pilkington

Edited by Ulrich Finke

French 19th century painting and literature

With special reference to the relevance of literary subject-matter to French painting

Manchester University Press

Published by
Manchester University Press
316–324 Oxford Road
Manchester M13 9NR

ISBN 0 7190 0413 6

Printed in Great Britain by
Butler & Tanner Ltd
Frome and London

Contents

List of illustrations

Foreword

I should like to express my warmest appreciation to the busy and eminent scholars who came to Manchester to make the Symposium on French 19th Century Painting and Literature such a success. I am also grateful to the University Press for making this the first in a series of publications on art history that will be published from Manchester.

C. Reginald Dodwell
Pilkington Professor of the History of Art
University of Manchester

Preface

At the invitation of the History of Art Department of the University an international Symposium was held from 26 to 29 November 1969 in the Whitworth Art Gallery in Manchester. The Manchester University Press has kindly offered to publish in the present volume, the papers which reputed international scholars gave at the Symposium, the Catalogue of French 19th century illustrated books which accompanied it and a few additional contributions on the theme of book illustration.

The main point in organizing this conference was to attempt to bring neighbouring disciplines into a dialogue with each other. Nowadays this appears the more important as individual disciplines become more and more distant from each other and a growing tendency towards isolated specialization is discernible. The theme, 'French 19th century painting and literature—with special reference to the relevance of literary subject-matter to French painting', was of interest both to literary scholars and to art historians, so that communication between these two disciplines was at once possible and justified. It was of course difficult to obtain a series of connected papers—and there were some which, though planned, failed to materialize—with so restricted a formulation of the general problem. But all contributions were finally linked by the endeavour to explore, with different perspectives and methods, the reciprocal relationship between literature and painting. For this purpose the French 19th century seemed particularly appropriate; it bears as does no other the stamp of 'literature', and saw for the first time a completely new stratum of society, the *bourgeoisie*, noted for its voracious reading habits. One need only think of the large number of illustrated books produced in the 19th century. Nor did painting remain untouched by the literary consciousness of the 19th century, even when, during the second half, there were increasing tendencies towards the painting of pictures which would be 'free' from literature. The word 'literature' should doubtless not be interpreted only in its strict sense of 'relating to literature', but also as relating

to narrative or representational art. One of the main themes of the conference was the transformation of 'literary' material in French 19th century painting; it finally led, in the work of Cézanne, to an artistic method which excluded all 'literary' associations in the sense of imitative representation.

The papers are printed in the order in which they were given. The reader will perceive a certain arrangement concerning chronology and themes. The first session was concerned with investigating the nature of the specific relationship between poets, critics and painters; the second dealt more with the reciprocal relationship between literature and painting, particularly in the works of Courbet, Manet and Degas; the third was devoted to certain transformations of and links between the literary and the pictorial in the works of Hugo, Redon, Cézanne and Proust.

At the close of each of the three sessions a discussion took place between guest speakers and other participants, at which Professors Dodwell and Sutcliffe kindly consented to take the chair. The most important questions and replies are reproduced in brief, after the notes to each paper.

On the occasion of the Symposium a small exhibition of French 19th century illustrated books was arranged in the Whitworth Art Gallery, to catch visually one aspect of the conference's theme. For technical and financial reasons many 'incunabula' of the French 19th century illustrated book had to be left out. The success of the exhibition was due in large measure to the British Museum in London, the John Rylands Library in Manchester and the university libraries of Keele, Leeds, Liverpool and Manchester: to all of them go sincere thanks for the books loaned.

My warmest thanks go to the guest speakers and the participants who made this conference possible in the first place. The French Embassy and the American Embassy in London, and the University of Manchester, all gave financial help which enabled the conference to take place. I should like further to thank the Manchester University Press, in particular Mr Jones and Mr Nettleton, and also Mr Griffiths who dealt with all the photographs for this publication. It is of course to Professor Dodwell, Head of the History of Art Department of the University of Manchester, that I wish above all to express my gratitude, for he took up my idea for this Symposium with enthusiasm and gave me all conceivable help in its organization.

Ulrich Finke

Part I

French painting and literature

Francis Haskell

1

The Sad Clown: some notes on a 19th century myth

Early in 1858 Gérôme's 'Duel après le bal masqué' [1] was exhibited in London. Such a combination of the picturesque, of gaudy colours and of slick painting was bound to be a success, and the press was able to point out that 'a finer moral lesson than this of M. Gérôme's has not been taught since Hogarth's time'.[1] For what really made the fortunes of the picture was the fact that while it was being exhibited in London, a much publicized duel—murderous assault would be a better definition—took place in Paris after a journalist had made

1 Gérôme: 'Duel après le bal masqué'

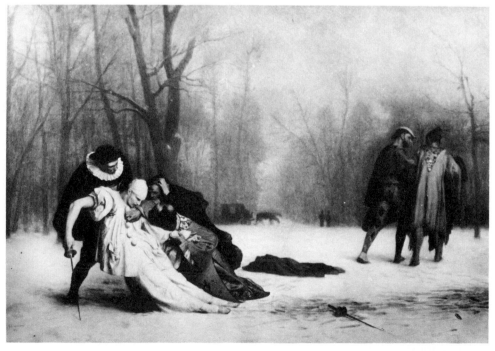

a very mild joke at the expense of the army.[2] 'Title and subject', wrote *The Times*, 'together furnish a startling comment on the late murderous duel in Paris, where for a jest as light as that which may have set these men, hot from the mad folly of the masquerade, face to face in deadly combat, Monsieur de Pène now lies at death's door.' And even when the picture had been shown in Paris a year before this, critics had suggested that Gérôme was commenting on the many frivolous duels that had been taking place among members of high society.[3] This may, indeed, have been the case; but in none of these, as far as I am aware, had the protagonists been dressed in theatrical costume,[4] and today I am interested in a different problem: the suffering clown of whom *The Times* observed that 'We have never seen a figure in every line of which death was written in characters so true and legible as that of the mortally wounded Pierrot'.

Dead clowns, sad clowns—they have played a significant role in French painting from Gérôme's dueller (is he the first?) to the tragic figures of Rouault and, above all, Picasso [2]. Why are they so sad? That, basically, is the problem that I want to consider today, and why did the theme first occur

2 Picasso: 'Death of Harlequin'

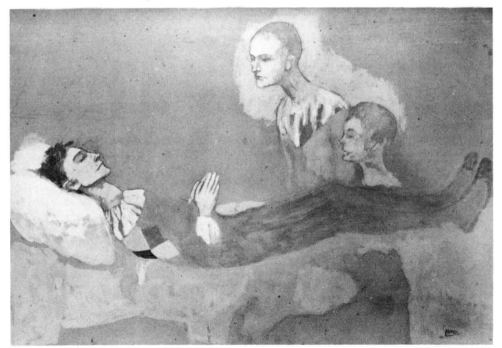

3 Couture: 'Duel after the masked ball'

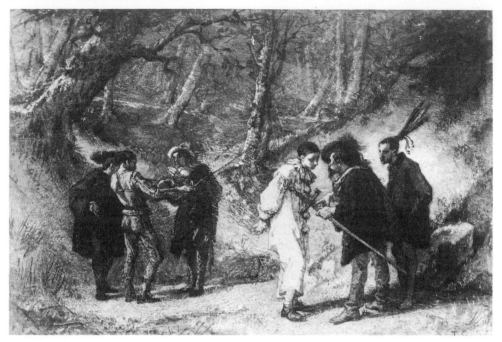

in art at this time, the middle years of the 1850s? Indeed, in the same year
that Gérôme painted his duel, a very much finer artist painted the same
subject [3], though at a slightly different stage of the story, and there were
the inevitable discussions as to who had thought of the idea first.[5] We shall
shortly see that both these pictures can probably be related to a literary text,
but first we must embark on a fairly long detour.

The very words Sad Clown necessarily conjure up for us the most beautiful
and evocative image of the theme ever painted [4]. But were Watteau's scenes
from the Commedia dell'Arte in fact intended to be looked at in this light?
There is, as far as I know, not a single trace of evidence dating from the 18th
century itself to suggest that they were.[6] On the contrary, everyone of his
early biographies, all written by men who had known him personally, point
to the contrast between the restless pessimism of his character and the 'gaiety'
of his pictures. The first person to suggest that Watteau's paintings were
implicitly melancholy seems to have been Emile Deroy, the painter friend of
Baudelaire, who drew attention to this aspect of his art in the 1840s.[7] Very
soon the idea was taken up by Gérard de Nerval, Banville and others until it

4 Watteau: 'Gilles'

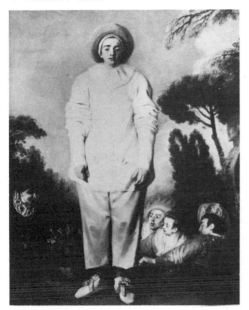

5 Porreau: 'Deburau'

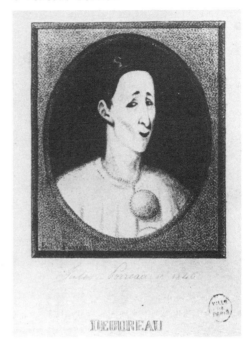

became a commonplace, but never until much later was this point made about the 'Gilles' [4], a picture which was almost totally neglected even by the Goncourts. As late as 1867, that most sensitive of critics and passionate admirer of Vermeer and Watteau, Thoré, wrote of this picture,[8] 'Regardez-le, comme il est gentil et narquois, de grandeur naturelle, tout en blanc, et si gai.' Only one man, as far as I know, saw something different in this picture. Writing in 1863,[9] four years before Thoré, Jules Michelet said of the 'Gilles', 'Au dernier triomphe, écrasé de succès, de cris et de fleurs, revenu devant le public, humble et la tête basse, le pauvre Pierrot un moment a oublié la salle; en pleine foule, il rêve (combien de choses! la vie dans un éclair), il rêve, il est comme abimé... Morituri te salutant. Salut, peuple, je vais mourir.'

In fact, as we now know thanks to the researches of Mrs Panofsky,[10] Watteau is here showing us, in very imaginative terms, a *parade*—that is to say not an actual performance by the Italian Comedians, but the free advertisement for such a performance which took place on a raised platform outside the theatre in order to attract the public, of a form which survived well into the age of Seurat and which can be occasionally seen even now in country fairs and

circuses. This particular *parade* is one of a farcical series called 'A laver la tête d'un âne on perd sa lessive'—hence the donkey. These *parades* always involved Gilles, who wore the same costume and had the same character as Pierrot—a fearful, coarse, stupid valet, who was generally pushed around and unsuccessful in everything he undertook. He was a farcical creature, not a tragic or a sensitive one, and the somewhat forlorn features that Watteau shows us bear no relation to the part he is acting, nor do they appear to represent a portrait of some particularly famous clown of the day. It is, however, hard for us to resist the conclusion that the consumptive Watteau has invested the figure of Gilles with some degree of self-identification, and Mrs Panofsky has also pointed out that on many other occasions when painting Pierrot figures Watteau not only gave them a predominance which was absolutely not justified by the nature of the parts they were called upon to act, but may even have hinted at something Christ-like in their role. So great and so original an artist was Watteau that his interpretation of Pierrot has, since the late 19th century, affected everyone who has ever thought about the nature of clowns—and everyone includes art historians. Whether such an identification of Pierrot and Christ could conceivably have occurred to Watteau on either the conscious or even the unconscious level, or whether we ourselves are not influenced by certain later artists and writers about whom I will be talking, must therefore remain an open question.

The interpretation of Watteau thus plays a decisive, but somewhat late, role in the notion of the Sad Clown, but his imagery leads us directly into the heart of our problem. That imagery centres on the strange and now vanished world of the Commedia dell'Arte, those touring companies of Italian actors with a cast of standardized characters—the Doctor, the Captain, Pantaloon, Harlequin and so on—who relied on improvisation for the effects of their farces. Appearing first in the early 16th century they soon spread all over Europe and enjoyed particular success in France a century or so later; and ever since, despite their virtual disappearance even before the Revolution, they have—as we will see—haunted the imaginations of artists and poets. For many of these, indeed, the world of the Commedia dell'Arte came to represent a sort of alternative to the long established tradition of classical mythology, whose gods and goddesses had acquired over the years different, sometimes even conflicting, layers of meaning. In just the same way, Harlequin and Pierrot and Gilles absorbed characteristics from each other and often changed their natures as they were interpreted by one great actor or another. 'Perhaps', Théophile Gautier once said,[11] 'there are as many Pierrots as there were Jupiters or Hercules's', and we urgently need a *Survivance des comédiens antiques*

to add to Professor Seznec's *Survivance des dieux antiques* on our bookshelves.[12] But fortunately for us 19th century painters were not as learned as their Renaissance predecessors, and if I am somewhat vague today in my discussion of the various characters involved, so—I can plead in my defence—were the artists whose works I am considering.

For all their crudity of plot and vulgarity of theme the farces of the Commedia dell'Arte had from the first been an aristocratic form of entertainment with leading companies being raised and maintained by kings and princes. But towards the end of the 18th century, as the aristocracy sought diversions elsewhere, the improvised pantomimes and harlequinades which French acrobats and actors took over from the Italians became an increasingly plebeian form of entertainment, despised or ignored by the regular theatre-going public, and playing as often as not on casual stages in fairgrounds or in the more proletarian areas of Paris. No doubt the world of Pierrot would have vanished altogether—and Watteau's 'Gilles' would have seemed as remote to us as one of the fantasies of Bosch or Piero di Cosimo—had there not appeared an actor of genius to interpret the role during the early years of the 19th century. The accounts that we have of Jean Gaspard Deburau [5] are by no means entirely consistent, but his greatness seems to have been recognized by all who saw him.[13] From the late twenties onwards, a few writers poets and artists began to penetrate to the squalid Théâtre des Funambules in which he appeared and in 1832 he became a celebrity thanks to a book by that most fashionable of critics, Jules Janin.[14] 'There is no longer a Théâtre-Français; only the Funambules... In the old days dramatic art was called Molé or Talma: today, it is just Deburau . . . Let us write the history of art as it is, filthy, beggarly and drunken, inspiring a filthy, beggarly and drunken audience. Since Deburau has become the king of this world, let us celebrate Deburau the king of this world . . .' Today we have become so used to writers such as Max Beerbohm glorifying the music hall of the 1890s or, more recently, music critics telling us that the Beatles are the greatest composers since Beethoven, that we are liable to forget how surprising such highbrow interest in urban, popular art once was. Janin's book is, I think, the ancestor of the whole genre and it has the same rather self-conscious 'camp' attitude to its subject, revealing the critic's self-satisfied daring in shocking conventional opinion which characterizes all later examples. It caused a furore of indignation and it turned Deburau into the idol of the fashionable avant-garde. Writers such as Charles Nodier, who had always admired him, were now joined by Gérard de Nerval, Théophile Gautier, Banville and many more. The cult of the pantomime was born.

The interesting thing for us about all this is that Deburau's own perform-
ances were not, as far as we can tell, by any means tragic in implication or
even sentimental.[15] Though Janin's book was illustrated by lithographs, one at
least of which [6] suggests that the artist had some acquaintance with Watteau's
'Gilles', Gautier tells us that, wonderful though his acting was—'he is the
greatest mime in the world'[16]—Deburau's interpretation of the part of Pierrot
was technically incorrect because 'Pierrot assumed the airs of a master and
an aplomb unsuited to the character; he no longer received kicks—he gave
them . . . Cassandra would think twice before daring to box his ears'[17] In
all this Deburau was no doubt revealing facets of his own not very attractive
character. Something of an illiterate lout,[18] he once accidentally killed a young
boy who was taunting him, and though he was acquitted at the trial—partly,
it is said, through the intervention of George Sand—it was impossible there-
after for the audience not to see an ironical link between the parts he was
called upon to play and his own personality.

Deburau's place in the history of acting is a very great one; in our story it
is essential, but also somewhat incidental. His talent attracted the intellectuals

6 Bouquet: 'Deburau'

7 Cézanne: 'Mardi-Gras'

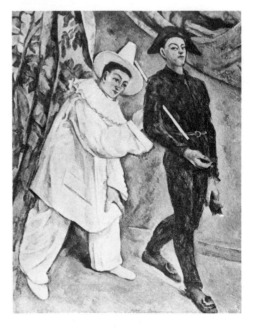

to a virtually forgotten and unexplored theatrical genre, and the intellectuals then proceeded to change the nature of that genre. As anthropology does today, so in the 1830s and 1840s the popular entertainment of the pantomime was made to support a whole philosophy of life. Gautier himself wrote panto-mimes[19] and produced casual but influential theories about them. He pro-fessed to see in the stereotyped figures of the Commedia dell'Arte a microcosm of the human condition,[20] and in so doing he almost imperceptibly softened the outlines of the very performances by Deburau which he himself had seen. For Janin, Deburau had been 'the people, in turn happy, sad, ill, well, beat-ing, being beaten, the poet, but always poor as the people . . . He is Molière's Misanthrope.' Gautier adapted this very significantly as follows: 'Pierrot, pallid, slender, dressed in sad colours, always hungry and always beaten, is the ancient slave, the modern proletarian, the pariah, the passive and dis-inherited being, who, glum and sly, witnesses the orgies and follies of his masters . . .'[21] One result of all this attention was that a new scholarly interest began to develop in the popular theatre and the Commedia dell'Arte. Rather apologetically at first historians of the Roman stage suggested that Deburau

8 Daumier: 'Charles Deburau'

9 Daumier: 'Saltimbanque jouant le tambour'

could actually throw light on the practice of antiquity,[22] and in 1860 Maurice, the son of George Sand, wrote the first serious modern study of the Commedia dell'Arte.[23]

Well before this, however, the most important step had been taken in the creation of the myth that interests us. In 1843, Jules Champfleury, then aged twenty-two and still living in the provincial town of Laon under his real name Jules Husson, made his first visit to Paris, and 'not by chance' went at once to the Funambules.[24] The acting of Deburau was a revelation to him—though he had already seen a pantomime 'in the English style', *Mother Goose*, which he classed with his 'memories of Molière, Swift and Hoffmann'. Now his experience of Deburau, of mime, of popular art influenced him far more profoundly, and as I believe far more fruitfully, than the Realism for which he is remembered today. For despite a very few years of political opposition, of 'realist novels', of championship of the brothers Le Nain and of Courbet, it is as an investigator of caricature, myth and folklore that he made his major—and still wholly neglected—contribution to French culture.

In 1846 Deburau died. How? It is from Champfleury that we have the most vivid, if not the most clinically accurate, account. [25] Deburau, he tells us, had for years been racked by asthma; the doctors forbade him to act, but—mindful only of his faithful public—he returned to the stage, where, overcome by his enthusiastic reception, 'a tear ran down the flour which covered his face. A real tear in the theatre is so rare. . . . A few days later he died.' And so, we may add in a gloss of our own, a clown has wept for the first time: the father of an innumerable progeny.

It was for Deburau's successors, his son Charles and another great mime, Paul Legrand, that Champfleury himself now began—just before 1848—to write a series of pantomimes which aimed to retain all the 'popular' ingredients of the genre, but which would also have a philosophical content. The first of these was *Pierrot, valet de la mort*, which aroused the enthusiasm of Gérard de Nerval, Gautier and Baudelaire. After a series of grotesque adventures in which Pierrot is accidentally killed by his doctor, he is released by Death on the one condition that when he returns to life he will, in his place, send Harlequin to Death as his servant. Pierrot agrees to the arrangement, and as soon as he gets back to the world he challenges Harlequin to a duel. The result is inconclusive, but eventually Pierrot breaks his pact with Death (who is himself killed by Polichinelle), and then magnanimously blesses the marriage of his rival Harlequin to Colombine, the girl whom he himself has loved. This sudden return to virtue and triumph over Death was criticized by Gautier as being too abrupt, and Champfleury himself later explained that he

had been inspired by the sentimental optimism which prevailed before 1848.[26] The details are by no means correct, but do we not find some reflection of this curious pantomime in the pictures by Gérôme and Couture with which I began this paper? One good reason for believing that this is indeed the case is that we hear from a later source that Paul Legrand, who acted the part of Pierrot in Champfleury's pantomime, kept a photograph of Gérôme's picture on the wall of one of the rooms in his house.[27] And so, just as Gautier claimed that the old pantomime was being swept away by vaudeville and comic opera, because 'the crowd has lost the meaning of these high symbols and profound mysteries which make the poet and the philosopher dream',[28] Pierrot, Harlequin and the other denizens of the Commedia dell'Arte began to take on a new lease of life in the world of high culture. Their literary appearances are familiar enough,[29] and it is not very long before we find a trickle of artists as different as Couture and Meissonier, Manet, Cézanne and many more taking an interest in themes from the Commedia dell'Arte. These are nearly always treated in a vein of melancholy, often with strongly symbolic overtones [7].[30] Many of the writers of the 1840s had at least hinted at the melancholy inherent in the parts played by Deburau, but it was, I believe, Champfleury who gave Pierrot his metaphysical content, who was— dare I make an absurd analogy? —the Marsilio Ficino of the Commedia dell'Arte, lending weight to the theme and suggesting to artists (in whose work he himself was possibly not much interested) how the crude, stock characters of a vanished world could, like Venus or Pan during the Renaissance, be made to carry meanings relevant to the second half of the 19th century. The iconography of so influential a painter as Couture would, I feel certain, repay investigation along these lines.[31]

The metaphysical sadness of the clown represents, however, only one aspect of our theme; the other is the plight of the actual performer himself. These two aspects are closely linked both in time and in artistic milieu. Champfleury's friend Daumier painted only one true portrait in his whole career, and this significantly enough was of Charles Deburau [8].[32] Thus, even if we lacked other evidence, we would know that he was an admirer of the Sad Clown, as it had been developed since the death of Jean-Gaspard Deburau by his son Charles. But Daumier scarcely touched the theme from this point of view. In the way that had perhaps inspired Watteau, and that was certainly to be taken up again by other artists at the end of the century, Daumier's wonderful drawings and watercolours of clowns, dating mainly from the 1850s and 1860s, are more 'realistic' in inspiration. I use the word with extreme reluctance because, although it is always applied to Daumier, it seems to me

10 Daumier: 'Les Saltimbanques'

11 Watteau: 'Le Départ des comédiens italiens'

that he, like Champfleury, was one of the greatest myth creators of the 19th century, one of the only artists, for instance, who was able to interpret the Bible and imaginative literature of the past in a truly successful manner. What I mean by 'realism' in this context is that Daumier's Sad Clowns are usually shown with convincing reasons for their sadness and that these derive not from any conceptions of their role, but from their failure to attract a public [9] and [10]. There is a rational explanation for the sour features of the Harlequins, which contrast so frighteningly with their garish costumes. They are old and hungry and the public is no longer interested in what they have to offer. It is impossible not to think of Baudelaire's *Vieux saltimbanque*, first published in 1861,[33] 'la misère absolue, la misère affublèe, pour comble d'horreur, de haillons comiques, où la nécessité, bien plus que l'art, avait introduit le contraste'. And much later Henry James was to be struck by Daumier's drawings of this kind:[34] '. . . the crowd doesn't come, and the battered tumblers, with their furrowed cheeks, go through their pranks in the void. The whole thing is symbolic and full of grimness, imagination and pity.'

In 'Le Déplacement des saltimbanques' [12] Daumier shows us another motif: the homelessness of the clown, forced to be always on the move from one unappreciative public to the next, driven out perhaps by the civic authorities. The Goncourts wrote about this in these same years, though in a more light-hearted spirit,[35] and the subject had been treated by Watteau (in collaboration perhaps with his master Gillot) in a picture that is now known only through an engraving 'Le Départ des comédiens italiens' [11], and that refers to the expulsion of the Italian Commedia dell'Arte from Paris in 1697 at the

behcst, apparently, of Madame de Maintenon. But a far more compelling juxtaposition and one that shows us the concept of the Sad Clown developing under our very eyes is provided by an anonymous lithograph clearly dating from a few years before Daumier's drawing [13]. Compared to this rather homely scene, Daumier's treatment of the subject gives his clowns all the legendary and tragic power of that other myth which so fascinated Champfleury, that of the Wandering Jew.[36]

Thus during the 1850s two distinct, but closely associated, contributions were made to the concept of the Tragic Clown by a number of artists and writers. When interest in the pantomime revived nearly half a century later these contributions merged and Pierrot was already a symbol of despair ripe for exploitation. The revivalists of the late 1880s, above all Felix Larcher and Paul Margueritte,[37] looked back to one of the few surviving poets of the great generation which had actually seen Deburau on the stage, Théodore de Banville. 'Rien qu'à vous parler de Deburau, qui fut le Napoléon de cet art, nous en aurions pour sept ans!' he told them, and 'L'histoire de la pantomime!!! Mais alors, mon cher monsieur, c'est l'histoire de l'humanité que

12 Daumier: 'Le Déplacement des saltimbanques'

13 Anon, French: 'Départ des saltimbanques'

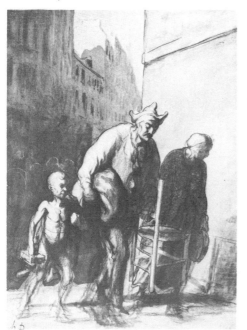

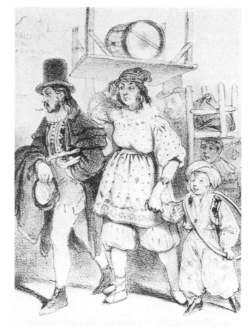

vous voulez faire...'[38] Far from it, in fact. The revival was an artificial one, just because it lacked humanity, because there was no Deburau to give it true vitality, because Pierrot was turned into an entirely symbolic character who could be shaped at will by the beliefs of a new generation of writers. To take one example among many, for the anti-Semites he could represent 'a simple Christian soul being constantly duped by the Jews';[39] and there were endless variations popularized by Adolphe Willette of the concept of Pierrot 'pessimiste et macabre'. The Tragic Clown had more substance when he was transferred from the pantomime to the more vital art of the circus and he acquired a further twist by the vogue for English spectacles, in which (as we learn from many writers, including Baudelaire and Edmond de Goncourt whose circus novel *Les Frères Zemganno* was partly set in England)[40] the clowns were particularly violent, brooding and sinister.

Thus for the greatest exponent of the theme of the Sad Clown, Picasso, a rich and varied symbolism was already traditional. He could portray the clown as the artist himself, as we know from innumerable drawings early and late in his career; the clown as metaphysical hero with overt religious analogies, which had perhaps just been hinted at by Watteau, and which was certainly emphasized in a deliberately ironical context by the painter Anatole Bazoche in the Goncourts' *Manette Salomon*;[41] and the clown as a forlorn wanderer in the spirit of Daumier.

It is easy enough to see why this theme should have appealed so much to 19th and 20th century poets, artists and, perhaps, above all art historical lecturers who were able to project on to it their own feelings about being forced to please a public which responded with indifference or even hostility, but I want to conclude by considering for one moment the wider implications of the myth. Essentially, it is concerned with the paradox that someone who ought to be laughing is in fact weeping. Now the close relationship between these two activities has been recognized ever since antiquity, but towards the end of the 18th century and the beginning of the 19th it became an intensely popular theme. Samuel Richardson, Horace Walpole, Beaumarchais and Byron are only a few of the writers who explored in different ways the paradox 'And if I laugh at any mortal thing, / 'Tis that I may not weep!'[42] This sort of paradox lies at the basis of many other 19th century mythologies, and even earlier ones, for the concept of the 'Noble Savage' itself has some of the same quality. We find it exemplified in the Prostitute with the Heart of Gold who was born in the 1830s shortly before the Tragic Clown, and in that belief, so cherished by Dostoievsky and certain *fin-de-siècle* Catholic writers, that the Greater the Sinner the Greater the Saint. It would not do, of course, to press

all these different themes into an identical mould, but they do, I believe, help to throw a little light on the continuing vitality of the subject that I have, very tentatively, been trying to explore. A clown by Rouault thus carries us beyond tired clichés, beyond the 'rational' explanation provided by countless popular novels and operas such as Leoncavallo's *Pagliacci*, beyond the private meaning it may have had for the disheartened artist, beyond even the obvious analogies with Christianity. A great actor, a forgotten pantomime by a distinctly muddled thinker, and a few poets and painters of genius have helped to make us aware of certain strange processes of the uncounscious which lie buried deep in all of us.

Notes and discussion

(1) *The Athenaeum*, 30 Jan. 1858. For this and comments from *The Times*, 27 May 1858, see 'Tragedy and Comedy: Opinions of the press on Gérome's celebrated picture of the Duel after the Masquerade, published by E. Gambart and Co.' (n.d.).

(2) For a full account, see *The Times*, Tuesday 18 May 1858, p. 12, and references in the Goncourt *Journals* and Viel Castel, *Mémoires*.

(3) See Edmond About, *Nos artistes au Salon de 1857*, pp. 70–3.

(4) Since delivering this talk in Manchester, and as I am about to send it to the printer, I have come across the very interesting and important article by Coleman O. Parsons: 'The Wintry Duel: A Victorian Import', in *Victorian Studies*, June 1959. Mr Parsons claims that the pictures by Gérôme and Couture were in fact based on a specific duel between two masqueraders, Deluns-Montaud and Symphorien-Casimir-Joseph Boittelle, which took place in the winter of 1856–7. This, of course, provides a far more satisfactory explanation of the iconography of these paintings than my own very tentative one, and I naturally accept his conclusions. Unfortunately, however, I have not had an opportunity of referring to the principal sources to which he draws attention in his Note 1, and although the Goncourt *Journals* (and recent biographical dictionaries) frequently refer to Boittelle, I can nowhere find any mention of the duel in question. In any case a full discussion of these pictures, interesting though they are, would not be relevant to the main theme of this paper, and I have therefore decided not to change the text.

(5) About, op. cit.

(6) I do not feel that the sententious verses
Ce que t'offre ici le pinceau,
Quoique pris de la Comédie,
N'est que trop souvent le tableau
De ce qui se passe en la vie

attached to the 1719 engraving of Watteau's *Arlequin, Pierrot et Scapin*, now at Waddesdon, in fact 'gives an explicit indication of the half-melancholy vein which informs all Watteau's pictures of this kind', as Ellis Waterhouse claims in his catalogue of *The James A. de Rothschild Collection at Waddesdon Manor—Paintings*, 1967, p. 286.

(7) See Théodore de Banville, *Mes souvenirs*, 1882, p. 93. Also Seymour O. Simches, *Le Romantisme et le gout esthétique du XVIII siècle*, 1964.

(8) *Paris Guide*, 1867, p 544.

(9) J. Michelet, *Histoire de France*, Tome XV (1863)—*La Régence*, Ch. XIX, quoted by Hélène Adhémar, *Watteau*, 1950, p. 156.

(10) D. Panofsky, 'Gilles or Pierrot' in *Gazette des beaux-arts*, 1952, Vol. 39, p. 319.

(11) Théophile Gautier, *Histoire de l'art dramatique en France depuis vingt-cinq ans*, Paris, 1858–9, V (Jan. 1847), p. 27.

(12) But see P. L. Duchartre, *La Comédie italienne*, Paris, 1924, and *La Commedia dell'arte et ses enfants*, Paris, 1955.

(13) For his biography see Tristan Rémy, *Jean-Gaspard Deburau*, Paris, 1954.

(14) Jules Janin, *Deburau — histoire du Théâtre à Quatre Sous*, 1832, and 1881 edition (Librairie des Bibliophiles) with preface by Arsène Houssaye.

(15) See also A. G. Lehmann, 'Pierrot and fin de siècle' in *Romantic Mythologies* edited by Ian Fletcher, 1967, which is concerned with some of the same problems as this lecture, though from a rather different angle. Also Enid Welsford, *The Fool*, London, 1935 (reprinted 1969).

(16) Gautier, op. cit., I, p. 43.

(17) Gautier, op. cit., V, p. 25—quoted also by Maurice Sand in *Masques et Bouffons*, Paris, 1860.

(18) Though George Sand in *Questions d'art et de littérature*, 1878, Ch. XV, gives a far more attractive picture of him.

(19) See Gautier, *Shakespeare aux funambules* reprinted in *L'Art moderne*, 1856.

(20) Gautier, *Histoire de l'art dramatique*, cit., V, p. 23.

(21) Gautier, op. cit.

(22) C. Magnin, *Les Origines du théâtre moderne*, Paris, 1838.

(23) Maurice Sand, *Masques et bouffons*, 1860.

(24) Champfleury, *Souvenirs et portraits de jeunesse*, 1872, Ch. XII.

(25) Champfleury, *Souvenirs des funambules*, 1859, pp. 11 ff.

(26) Ibid.

(27) Paul Hugounet, *Mimes et pierrots*, 1889. But see Note 4.

(28) Gautier, op. cit., V, p. 23.

(29) I am most grateful to Mr Andrew Calder of the University of Kent for putting at my disposal the extensive literary material he has collected round this theme. My friend M. Pierre Georgel has also kindly shown me many further references.

(30) Kirt Badt in *The Art of Cézanne*, London, 1965, gives an interesting psycho-analytic interpretation of this picture, which was painted in 1888.

(31) Professor Albert Boime, who has had access to the Couture papers, kindly tells me that they contain no reference to the origin of his many Pierrot paintings, which were apparently inspired by a dream while he was at work in Sainte-Eustache (Bertauts-Couture, *Thomas Couture*, 1932, p. 34). It would be worth analysing some of the Pierrot pictures not just with *Pierrot valet de la Mort*, but also with such pantomimes by Champfleury as *La Pantomime de l'avocat*, 1866.

(32) K. E. Maison, *Honoré Daumier*, 1967, I, 144.

(33) Baudelaire, *Oeuvres complètes*, 1966 (Pléiade), p. 247.

(34) Henry James, *Honoré Daumier*, 1893—reprinted in *The Painter's Eye*, 1956, pp. 229–43.

(35) Edmond et Jules Goncourt, 'Un Comédien nomade' in *Une Voiture de masques*, 1856.

(36) See Linda Nochlin, 'Gustave Courbet's *Meeting*: A Portrait of the Artist as a Wandering Jew' in *The Art Bulletin*, XLIX, 1967, pp. 209 ff.

(37) See Hugounet, op. cit., and Edmond Pilon, *Paul et Victor Margueritte*, 1905.

(38) Hugounet, op. cit.

(39) Ibid.

(40) Edmond de Goncourt, *Les Frères Zemganno*, 1879, especially Chs. XXVII and XXXI.

(41) I am extremely grateful to Dr Anita Brookner for bringing to my attention the episode in Chapter XXV of *Manette Salomon* (1867) in which, in the year 1846, when strongly under the influence of Deburau, Anatole Bazoche repaints his 'Christ humanitaire' as Pierrot.

(42) Byron, *Don Juan*, IV, 4. See also Walpole: 'The world is a comedy to those that think, a tragedy to those that feel' (letter to Countess of Upper Ossory, 16 Aug. 1776); Richardson, *Clarissa Harlowe*, Letter 84; and Beaumarchais, *Le Barbier de Seville*, Act I, scene 2. There are, of course, many authors who probe far more deeply into the subject.

Discussion. Prof. Haskell accepted a possible link between Daumier's representation of clowns and the motif of the Wandering Jew, although only in so far as both figures have a common intensity of feeling. This question of tragic intensity, particularly in the pictorial forms of Picasso and Rouault, where analogies with religious iconography have been shown, led in the discussion to Watteau's pictorial forms. Prof. Haskell dissociated himself from Waterhouse's attempt to interpret one 18th century print, where Watteau's death was accompanied by moralizing lines, as betraying a melancholy intention. Only with Romanticism was there a tendency to give a tragic interpretation either to pictorial forms in Watteau's manner or to Shakespeare's clowns. The question whether Couture had been inspired for his picture by an actual duel or by one of Champfleury's pantomimes remained open. In general Prof. Haskell agreed that Gérôme's and Couture's pictures were examples of a strange kind of genre painting. Prof. Haskell explained that his allusion to Cézanne's 'Mardi-gras' was to be taken only as a suggestion; this picture admittedly did not belong to the 'sad clown' cycle, but had symbolic and emotional overtones which were quite unambiguous.

Daniel Ternois

2
Baudelaire et l'ingrisme[1]

Le titre de cette communication indique suffisamment le sujet que je me propose de traiter : non pas les opinions de Baudelaire sur Ingres — l'homme et l'artiste créateur — : cet aspect de la question a déjà fait l'objet de nombreuses études ; mais ses jugements sur la doctrine d'Ingres, sur son enseignement, sur son école, sur ses différents élèves, sur le style de ceux-ci ; et d'une façon générale sur ce courant artistique, si important au milieu du dix-neuvième siècle, qu'on a appelé 'l'ingrisme' et qui ne se confond ni avec l'académisme, ni avec le romantisme, ni avec le réalisme, mais présente avec certains mouvements étrangers de curieuses affinités.

Mais il va de soi qu'on ne peut pas traiter ce sujet sans rappeler, au moins sommairement, ce que Baudelaire pensait du maître lui-même.

D'autre part les opinions de Baudelaire sur l'ingrisme découlent de son esthétique générale et illustrent un certain nombre de ses idées fondamentales. Elles ne peuvent être dissociées de celles-ci.

Il n'est donc pas question d'épuiser un sujet aussi vaste et aussi complexe. Je me bornerai à indiquer quelques directions de recherches, en m'effaçant le plus possible pour laisser parler Baudelaire.

Ajoutons encore ceci : pour suivre avec précision la pensée de Baudelaire, il faudrait pouvoir s'appuyer sur les œuvres mêmes qui étaient exposées aux différents Salons qu'il a visités, celles qu'il a vues et dont il a parlé. Malheureusement cela n'est pas toujours possible car, malgré les recherches récentes des historiens de l'art et de spécialistes de Baudelaire (notamment en vue de l'exposition Baudelaire à Paris en 1968), beaucoup de tableaux ont disparu ou sont mal identifiés :[2]

Où sont les paysages de Paul Flandrin et d'Alexandre Desgoffe ? Que sont devenus les portraits et les compositions d'Henri Lehmann (une vingtaine au seul Salon de 1855) ? Où se cache le fameux portrait d'une dame en bleu par Amaury-Duval,[3] qui agaçait tant Baudelaire ? Seuls sont en partie retrouvées et identifiées avec certitude les œuvres des élèves d'Ingres qui ont fait l'objet

de monographies et de catalogues récents : Janmot, Chenavard, Hippolyte Flandrin [14] ;[4] encore est-il difficile de s'en procurer de bonnes reproductions.

Toute l'histoire de la peinture française du dix-neuvième siècle est à refaire ; mais ce travail devient d'année en année plus difficile à réaliser, à cause du discrédit qui s'attache, depuis trois-quarts de siècle, à la peinture dite (souvent à tort) 'académique' et de la crise iconoclaste qui sévit depuis quelques années dans les églises catholiques de notre pays.

C'est pourquoi l'illustration de cette communication sera imparfaite et provisoire.

Baudelaire oppose constamment Ingres à son école : sévère pour celle-ci — sauf quand des influences étrangères se mêlent à l'action du maître — il exprime à propos d'Ingres des jugements à la fois admiratifs et réservés qui ont évolué avec le temps et qui sont extrêmement nuancés. C'est que, si Baudelaire reconnaît en Ingres un grand artiste et une forte personnalité, ce n'est pas le peintre selon son cœur :

L'œuvre d'art, écrit-il, doit être l'expression sincère d'un tempérament.[5] La critique consiste à découvrir la personnalité de l'artiste à travers son œuvre. Dans la médiocrité générale, deux grands talents émergent :

14 Hyppolyte Flandrin : Portrait de Mme Hippolyte Flandrin

15 Amaury-Duval : 'Baigneuse antique'

Delacroix et Ingres. Ingres séduit Baudelaire par son autorité et par son audace ; mais c'est Delacroix qui réalise son idéal de l'artiste.

1 L'école d'Ingres

Selon Amaury-Duval, qui fut le premier élève d'Ingres et qui nous a laissé sur l'atelier du maître des souvenirs amusants et fort instructifs,[6] c'est en 1825, au lendemain de son retour de Rome et du succès triomphal du 'Vœu de Louis XIII' au Salon de 1824, qu'Ingres ouvrit un atelier qui fut bientôt très fréquenté. Au temps de Baudelaire la plupart des anciens élèves d'Ingres exposaient régulièrement aux Salons annuels. Mais, dans les articles de critique où il a parlé d'eux — *Salons* de 1845, 1846 et 1859, *Exposition Universelle de 1855*[7] — Baudelaire n'en cite qu'un petit nombre : Amaury-Duval, Henri Lehmann, Alexandre Desgoffe, Jean-Auguste Bard, Dominique Papety, les frères Leleux ; les Lyonnais Hippolyte et Paul Flandrin, Louis Janmot et surtout Paul Chenavard auquel il a consacré une étude inachevée, *L'art philosophique*. Chassériau a déjà quitté le cercle d'Ingres pour celui de Delacroix et n'appartient donc plus à l'ingrisme. Le nom de Victor Mottez, qui a pourtant joué un rôle important dans le renouveau de la peinture murale et la connaissance des 'primitifs' italiens, n'apparaît à aucun moment.

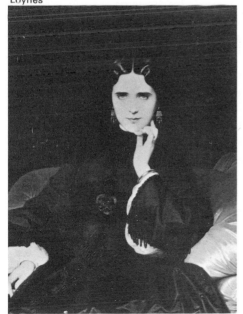

16 Amaury-Duval : Portrait de Mme de Loynes

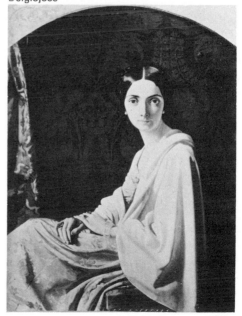

17 Lehmann : Portrait de la Princesse Belgiojoso

Baudelaire, qui avait dans *Le musée classique du Bazar Bonne-Nouvelle*[8] proclamé de façon assez inattendue la grandeur de David en face de ses détracteurs, se pose la même année, dans le *Salon de 1846*,[9] en défenseur des écoles et de la 'grande tradition'. Il compare avec nostalgie la situation présente, individualiste, anarchique et dépourvue de toute unité de style, à la cohésion des écoles dans un passé qui n'est pas si lointain :

Il y avait encore des écoles sous Louis XV, il y en avait une sous l'Empire, — une école, c'est-à-dire une foi, c'est-à-dire l'impossibilité du doute. Il y avait des élèves unis par des principes communs, obéissant à la règle d'un chef puissant, et l'aidant dans tous ses travaux (...) Tel qui rentre aujourd'hui dans la classe des singes, même des plus habiles, n'est et ne sera jamais qu'un peintre médiocre ; autrefois, il eût fait un excellent ouvrier. Il est donc perdu pour lui et pour tous. C'est pourquoi il eût mieux valu (...) que les tièdes eussent été soumis à la férule d'une foi vigoureuse ; car les forts sont rares, et il faut être aujourd'hui Delacroix ou Ingres pour surnager et paraître dans le chaos d'une liberté épuisante et stérile (...) Dans les écoles, qui ne sont autre chose que la force d'invention organisée, les individus vraiment dignes de ce nom absorbent les faibles...

Peut-on déduire de ce passage que Baudelaire considère Ingres comme un grand chef d'école ? Sa pensée sur ce point est assez nuancée. Il parle en 1846[10] de 'l'autorité fanatisante' d'Ingres sur ses élèves ; et en 1859[11] il qualifiera son enseignement de 'despotique'. Mais il souligne en même temps la 'distance immense du maître aux élèves. M. Ingres est encore seul de son école. Sa méthode est le résultat de sa nature, et, quelque bizarre et obstinée qu'elle soit, elle est franche et pour ainsi dire involontaire (...) Ces messieurs ont traduit en système, froidement, de parti pris, pédantesquement, la partie déplaisante et impopulaire de son génie'.[12] Baudelaire dénonce 'la manie de prendre à un grand artiste des qualités bizarres qui ne peuvent être qu'à lui, et d'imiter l'inimitable (...) Ce qui fut bon, ou tout au moins séduisant en lui [Ingres], eut un effet déplorable dans la foule des imitateurs...'[13] D'ailleurs tous les élèves n'ont pas strictement et humblement suivi les préceptes du maître ; tandis que M. Amaury-Duval outrait courageusement l'ascétisme de l'école, M. Lehmann essayait quelquefois de faire pardonner la genèse de ses tableaux par quelques mixtures adultères...'[14]

Cependant 'ces messieurs', comme dit Baudelaire, ont en commun un certain parti-pris dans la couleur et le dessin ; et tous (mais surtout les Lyonnais) ont un penchant marqué pour la 'peinture sérieuse' ; non pas qu'ils expriment, comme Delacroix, la profondeur de la douleur morale ; mais parce qu'ils 'ont en horreur (...) les joues allumées par la joie et la santé'.[15]

2 Le dessin et la couleur

Le métier. Parlant des tableaux des frères Leleux et de Papety exposés au Salon de 1845,[16] Baudelaire se plaint qu'ils soient trop bien faits et, dans la conclusion de son compte-rendu, il s'écrie : 'Constatons que tout le monde peint de mieux en mieux, ce qui nous paraît désolant.'[17] Sous sa forme paradoxale et provocante, la formule ne condamne en fait que la facture trop appliquée de certains peintres qui ne possèdent que de l'habileté. Baudelaire vante au contraire la prétendue 'gaucherie' de Corot, sa touche sensible et spirituelle, car 'une œuvre de génie — ou si l'on veut — une œuvre d'âme — où tout est bien vu, bien observé, bien compris, bien imaginé, est toujours très bien exécutée quand elle l'est suffisamment (...) Il y a une grande différence entre un morceau *fait* et un morceau *fini* (...) En général ce qui est *fait* n'est pas *fini* et (...) une chose très *finie* peut n'être pas *faite* du tout...'[18]

C'est pourquoi Baudelaire reproche aux élèves d'Ingres, et notamment au Lyonnais Janmot, d'être 'des ouvriers en peinture'[19] qui peignent minutieusement et laborieusement, sans imagination et sans tempérament, allant jusqu'à s'écrier avec mépris, parlant de la technique : 'cela s'apprend dans les ateliers'. Sa victime préférée est un autre Lyonnais, Saint-Jean, peintre de fleurs et de sujets pieux.[20]

En 1859 il précise et nuance un peu sa pensée : 'plus on possède d'imagination, mieux il faut posséder le métier (...) Et mieux on possède son métier, moins il faut s'en prévaloir et le montrer...'[21]

Le dessin. Pour Baudelaire il existe deux sortes de dessins : celui des dessinateurs et celui des coloristes. Delacroix, contrairement à l'opinion courante, est un admirable dessinateur qui modèle avec de la couleur.[22] Daumier dessine dans la même manière. 'M. Ingres, si amoureux du détail, dessine peut-être mieux que tous les deux, si l'on préfère les finesses laborieuses à l'harmonie de l'ensemble, et le caractère du morceau au caractère de la composition, mais... aimons-les tous les trois.'[23]

Ingres a le culte du contour ; pour Delacroix, 'la ligne n'est pas' ;[24] il n'y a que des masses colorées et mouvantes.

Pour Baudelaire, dessiner consiste à dégager le caractère individuel, en l'accentuant ou en l'exagérant s'il le faut, non à copier la nature, ni à ramener le modèle au 'beau idéal' académique : 'Chaque individu a donc son idéal.'[25]

M. Ingres est 'le représentant le plus illustre de l'école naturaliste dans le dessin' ;[26] il est audacieux et ne recule devant aucune laideur, aucune bizarrerie (le carrick de Cherubini).

Plein d'admiration pour le dessin d'Ingres en 1846, Baudelaire est plus réservé en 1855 et n'hésite pas à poser cette grave question : 'Quelle est la qualité du dessin de M. Ingres ? Est-il d'une qualité supérieure ? Est-il absolument intelligent ? (...) Le dessin de M. Ingres est le dessin d'un homme à système. Il croit que la nature doit être corrigée, amendée ; que la tricherie (...) est non seulement un droit, mais un devoir...'[27] Et il cite, en se référant à Lavater, des exemples de disparates dans les formes et dans les proportions, de bizarreries dans la construction anatomique des figures (dans les nus surtout). C'est qu'Ingres ne se contente pas d'accentuer les formes dans le sens du caractère, il leur impose un style qui est surajouté et, chose plus grave, emprunté à des formes d'art du passé.

'Remarquons aussi qu'emporté par cette préoccupation presque maladive du style, le peintre supprime souvent le modelé ou l'amoindrit jusqu'à l'invisible, espérant ainsi donner plus de valeur au contour, si bien que ses figures ont l'air de patrons d'une forme très correcte, gonflés d'une matière molle et non vivante, étrangère à l'organisme humain' ;[28] on ne saurait trouver critique plus sévère, ni plus pénétrante.

En 1846 Baudelaire opposait au dessin simple et rapide du maître celui de ses élèves, 'ces ouvriers en peinture', qui 'rendent d'abord les minuties, et c'est

18 Janmot: 'Fleur des champs'

19 Hippolyte Flandrin: Portrait de Mme de Cambourg

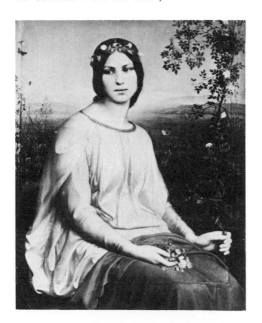

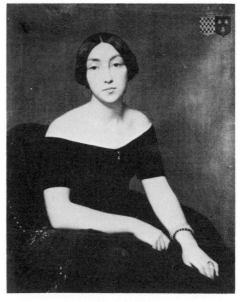

pour cela qu'ils enchantent le vulgaire, dont l'œil dans tous les genres ne s'ouvre que pour ce qui est petit.'[29] Leur modelé (surtout celui d'Hippolyte Flandrin) est 'vrai et fin',[30] mais manque de luminosité par suite de l'absence de reflets, systématiquement éteints.[31] L'imitation du maître, la manie de surajouter le 'style' au caractère du modèle, l'esprit de système enfin, engendrent chez d'autres (Lehmann ou Amaury-Duval) monotonie et affectation prétentieuse; 'leur goût immodéré pour la distinction'[32] les conduit à dessiner des mains aux doigts uniformément allongés, des visages aux yeux tous semblables: 'Depuis le portrait de la princesse Belgiojoso, M. Lehmann ne fait plus que des yeux trop grands, où la prunelle nage comme une huître dans une soupière.'[33]

La couleur. Baudelaire oppose encore Delacroix, coloriste et harmoniste, exprimant par le symbolisme des couleurs la signification du sujet traité et les sentiments humains, à Ingres, 'pur dessinateur', qui met des couleurs vives et même voyantes dans des contours, confondant ainsi coloris et coloriage: 'Un dessinateur est un coloriste manqué.'[34]

M. Ingres (...) est toujours au pourchas de la couleur. Admirable et malheureuse opiniâtreté! (...) M. Ingres adore la couleur, comme une marchande de modes. C'est peine et plaisir à la fois que de contempler les efforts qu'il fait pour choisir et accoupler ses tons. Le résultat, non pas toujours discordant, mais amer et violent, plaît toujours aux poètes corrompus...[35]

Baudelaire se considère-t-il lui-même comme l'un de ces 'poètes corrompus'? On ne serait pas éloigné de le penser: il y a chez lui, au sujet d'Ingres, un mélange d'attirance et de répulsion; tout en le critiquant avec malice ou sévérité, il est séduit par certains aspects 'bizarres' de son art.

Nulle indulgence, en revanche, pour ses élèves: il relève leur 'prétention visible à la couleur, — le grand dada de l'école! Cette malheureuse imitation de la couleur m'attriste et me désole comme un Véronèse ou un Rubens copiés par un habitant de la lune'.[36] Et Baudelaire poursuit: 'Ils recherchent les tons *distingués*, c'est-à-dire des tons qui, s'ils étaient intenses, hurleraient comme le diable et l'eau bénite (...); mais comme ils sont excessivement pâlis et pris à une dose homéopathique, l'effet en est plutôt surprenant que douloureux: c'est là le grand triomphe!'[37] Comme pour le dessin de l'école d'Ingres, c'est l'affectation et la pédanterie que Baudelaire ne peut supporter.

Cependant il s'adoucit pour Janmot; non pour le 'Portement de croix' de 1846 qu'il juge 'cru et luisant';[38] mais pour le portrait de jeune fille exposé au *Salon* de 1845 sous le titre 'Fleur des champs' (musée de Lyon) [18]: '...Il y a, dans la couleur même et l'alliance de ces tons verts, roses et rouges, un peu douloureux à l'œil, une certaine mysticité qui s'accorde avec le reste. — Il

y a harmonie naturelle entre cette couleur et ce dessin' :[39] il ne s'agit plus ici de coloriage plus ou moins agréable à l'œil, mais d'expression par la couleur, d'expressivité de la couleur—une couleur qui n'est pas celle de Delacroix, mais qui, bien que posée à la manière ingriste par un 'dessinateur', joue le même rôle que celle de Delacroix et contribue à exprimer l' 'âme' du peintre : c'est là un exemple du 'surnaturalisme' cher à Baudelaire, par lequel une certaine catégorie d'élèves d'Ingres trouve grâce à ses yeux, comme nous le verrons tout à l'heure.

Le bizarre. A plusieurs reprises, dans les jugements de Baudelaire sur Ingres, sur son dessin, sur sa couleur, reviennent les mots de 'bizarre', de 'bizarrerie' : 'L'Odalisque à l'esclave' est une 'délicieuse et bizarre fantaisie qui n'a point de précédent dans l'art ancien'.[40] 'Il a fait la redingote de M. Molé ; il a fait le carrick de Cherubini ; il a mis dans le plafond d'Homère, — œuvre qui vise à l'idéal plus qu'aucune autre, — un aveugle, un borgne, un manchot et un bossu...'[41]

C'est par ses contradictions intimes et par son étrangeté qu'Ingres, si éloigné de lui par ailleurs, attire cependant Baudelaire : '... Mélange singulier de qualités contraires (...) dont l'étrangeté n'est pas un des moindres charmes...'[42] 'L'œuvre est difficile à comprendre et à expliquer...' On se sent 'en face d'un hétéroclitisme (...) mystérieux et complexe...'[43] Beaucoup de personnes, entrant dans le 'sanctuaire' réservé à Ingres à l'Exposition Universelle, ont éprouvé une 'impression, difficile à caractériser, qui tient (...) du malaise, de l'ennui et de la peur, fait penser vaguement, involontairement, aux défaillances causées par l'air raréfié, par l'atmosphère d'un laboratoire de chimie, ou par la conscience d'un milieu fantasmatique, je dirai plutôt d'un milieu qui imite le fantasmatique...'[44]

Ingres apparait à Baudelaire comme 'révolutionnaire à sa manière'. '... Son idéal est une espèce d'idéal fait moitié de santé, moitié de calme, presque d'indifférence, quelque chose d'analogue à l'idéal antique, auquel il a ajouté les curiosités et les minuties de l'art moderne. C'est cet accouplement qui donne souvent à ses œuvres leur charme bizarre...'[45] Aussi trouve-t-il des admirateurs de différents côtés : 'Aux gens du monde M. Ingres s'imposait par un emphatique amour de l'antiquité et de la tradition. Aux excentriques, aux blasés, à mille esprits délicats toujours en quête de nouveautés, même de nou-veautés amères, il plaisait par la bizarrerie...'[46]

Ici Baudelaire introduit une distinction importante qui explique pourquoi il ne trouve pas chez les élèves d'Ingres le même attrait que chez leur maître :

'*Le beau est toujours bizarre.* — Je ne veux pas dire qu'il soit volontairement, froidement bizarre, car dans ce cas il serait un monstre sorti des rails de la vie.

Je dis qu'il contient toujours un peu de bizarrerie, de bizarrerie naïve, non voulue, inconsciente, et que c'est cette bizarrerie qui le fait être particulièrement le Beau.'[47]

La bizarrerie d'Ingres est naïve et inconsciente; celle de ses élèves est froide et sans effet parce qu'elle est trop voulue et qu'elle résulte de l'application d'un système emprunté au maître, non d'une création spontanée.

Pourtant on s'étonne de ne pas rencontrer ce mot de 'bizarre', qui sous sa plume est un éloge, à propos de tel élève d'Ingres, Janmot par exemple pour lequel il éprouve de la sympathie. Ce qu'il écrit de 'Fleur des champs' (1845) [18] est à rapprocher de ce qu'il dit de la 'Fontaine de Jouvence' de William Haussoullier [26] (qui n'est pas un élève d'Ingres): par leurs audaces naïves, notamment dans le coloris, ces deux œuvres sont étranges et attirantes.

3 Portrait, paysage et peinture religieuse

Le portrait. Pour Baudelaire le vrai portrait est 'la reconstruction idéale des individus.'[48] Il écrit en 1859: 'Le portrait, ce genre en apparence si modeste, nécessite une immense intelligence. Il faut sans doute que l'obéissance de l'artiste y soit grande, mais sa divination doit être égale (...) Rien n'est indifférent dans un portrait (...) Tout doit servir à représenter un *caractère* (...) Un bon portrait m'apparaît comme une biographie dramatisée...'[49]

Baudelaire distingue deux sortes de portraits:[50] le portrait 'historique' qui consiste à dégager le caractère du modèle en l'accentuant et même en l'exagérant par les contours et par le modelé; et le portrait 'romantique' qui est un 'poème', une 'rêverie', où le visage baigne dans l'atmosphère et dans le 'crépuscule'. David et Ingres sont les chefs de l'école historique, celle des dessinateurs; Rembrandt, Reynolds ou Lawrence représentent l'école 'romantique', celle des coloristes.

Dans toute l'œuvre d'Ingres, ce sont les portraits que Baudelaire admire le plus, car son absence d'imagination n'est pas ici un obstacle. Les portraits d'Ingres illustrent parfaitement la conception que Baudelaire se fait de l'art du portrait, 'reconstruction idéale des individus'. Ingres 'n'est point un de ces fabricants banals de portraits (...) Il choisit ses modèles (...) les plus propres à faire valoir son genre de talent. Les belles femmes, les natures riches, les santés calmes et florissantes, voilà son triomphe et sa joie!'[51]

Ce ne sont pas ces qualités de plénitude qu'ont imitées les élèves d'Ingres; et leurs portraits se ressentent trop de l'esprit de système. 'Leurs portraits ne sont pas vraiment ressemblants' parce qu'ils ajoutent quelque chose d'étranger au modèle; le style, généralement emprunté aux artistes du passé. Ils ont voulu 'restreindre les moyens' de la peinture, par impuissance ou dans

20 Amaury-Duval: 'Femme de Saint-Jean de Luz'

20 Amaury-Duval: 'Femme de Saint-Jean de Luz'

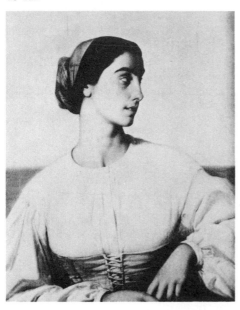

21 Lehmann: Portrait de la Comtesse d'Agoult

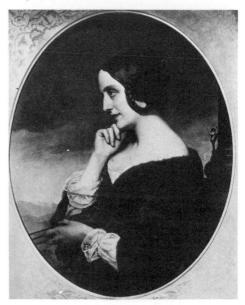

l'espoir d'obtenir une plus grande intentité d'expression, ou plus probablement les deux ensemble.[52] Ils ont simplifié les formes, supprimé les reflets, 'éteint le soleil', pour atteindre à une plus grande 'distinction' dans la couleur et dans le dessin:

Cette pédanterie dans la couleur et le dessin nuit toujours aux œuvres de ces messieurs, quelque recommandables qu'elles soient d'ailleurs. Ainsi, devant le portrait *bleu* de M. Amaury-Duval et bien d'autres portraits de femmes ingristes ou ingrisées, j'ai senti passer dans mon esprit, amenées par je ne sais quelle association d'idées, [les] sages paroles du chien Berganza [dans le conte d'Hoffmann] qui fuyait les bas-bleus aussi ardemment que ces messieurs les recherchent (...) Dulcinée du Toboso elle-même, en passant par l'atelier de ces messieurs, en sortirait diaphane et bégueule comme une élégie, et amaigrie par le thé et le beurre esthétiques. Ce n'est pourtant pas ainsi, — il faut le répéter sans cesse, — que M. Ingres comprend les choses, le grand maître![53]

En 1859, Baudelaire opposera à l'affectation de style des élèves d'Ingres, la manière simple, naturelle et cependant savante de Ricard qui, dans ses portraits, sait peindre l'âme des modèles.[54] Baudelaire le propose en exemple car il estime que le 'style' est sans valeur s'il n'est pas un moyen d'exprimer la vie intérieure, la spiritualité.

Le paysage. Baudelaire introduit, à propos du paysage, la même distinction que pour le portrait,[55] entre le paysage romantique, celui des coloristes et des naturalistes (Huet, Théodore Rousseau, Daubigny) et le paysage historique (Corot et l'école d'Ingres). Bien qu'il admire beaucoup Corot, la sympathie de Baudelaire va naturellement vers le second groupe. Et il se livre à une attaque violente contre le paysage historique :

Quant au paysage historique, dont je veux dire quelques mots en manière d'office pour les morts, il n'est ni la libre fantaisie, ni l'admirable servilisme des naturalistes : c'est la morale appliquée à la nature. Quelle contradiction et quelle monstruosité ! La nature n'a d'autre morale que le fait, parce qu'elle est la morale elle-même : et néanmoins il s'agit de la reconstruire et de l'ordonner d'après des règles plus saines et plus pures, règles qui ne se trouvent pas dans le pur enthousiasme de l'idéal, mais dans des codes bizarres que les adeptes ne montrent à personne (...) Vous comprenez maintenant ce que c'est qu'un bon paysage tragique. C'est un arrangement de patrons d'arbres, de fontaines, de tombeaux et d'urnes cinéraires (...) Tout arbre immoral qui s'est permis de pousser tout seul et à sa manière est nécessairement abattu...[56]

22 Amaury-Duval : 'Portrait de Mlle Rachel en costume de tragédie'

23 Janmot : 'L'Assomption de la Vierge'

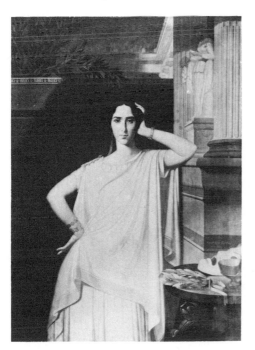

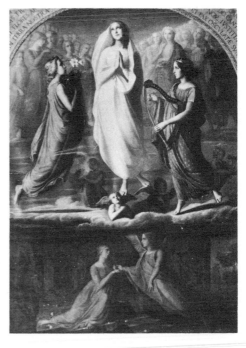

Baudelaire ne pouvait pas connaître les vues de Rome dessinées par Ingres, qui dormaient dans ses cartons et qui n'ont été révélées au public qu'il y a une quinzaine d'années, ni les trois vues de Rome peintes en *tondi* ;[57] il ne semble pas non plus avoir prêté attention aux paysages qui se trouvent parfois dans les fonds de ses portraits peints.[58] C'est donc aux paysages de ses élèves qu'il s'en prend, et plus généralement à la doctrine d'Ingres appliquée au paysage.

'En général, l'influence ingriste ne peut pas produire de résultats satisfaisants dans le paysage. La ligne et le style ne remplacent pas la lumière, l'ombre, les reflets et l'atmosphère colorante, — toutes choses qui jouent un trop grand rôle dans la poésie de la nature, pour qu'elle se soumette à cette méthode.'[59]

A propos des paysages de Paul Flandrin, Baudelaire s'écrie en 1845 : 'Qu'on éteigne les reflets dans une tête pour mieux faire voir le modelé, cela se comprend, surtout quand on s'appelle Ingres. — Mais quel est donc l'extravagant et le fanatique qui s'est avisé le premier d'ingriser la campagne ?'[60] Et en 1846 : 'MM. Paul Flandrin, Desgoffes (...) sont les hommes qui se sont imposé la gloire de lutter contre le goût d'une nation.'[61]

Baudelaire a bien senti que le paysage ingriste allait à contre-courant et que la conception 'moderne' du paysage était du côté de Corot et surtout des

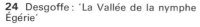

24 Desgoffe : 'La Vallée de la nymphe Égérie'

25 Paul Flandrin : 'Les Bords du Gardon'

paysagistes romantiques ou naturalistes, Huet, Rousseau ou Daubigny, qui savent exprimer la poésie de la nature, baignée par l'air et la lumière et peinte par larges touches vivantes.

Décoration monumentale et peinture religieuse. Dès 1846 Baudelaire constate l'ignorance générale dans le domaine de la décoration monumentale. Seul Delacroix montre une entente admirable de la décoration : les ensembles de la Chambre des Députés et du palais du Luxembourg montrent que pour lui la décoration consiste à enrichir l'architecture en en soulignant la structure et les valeurs plastiques, mais sans rien sacrifier de ses qualités poétiques, du mouvement, du relief, de la lumière et du coloris : 'Il trouva l'unité dans l'aspect sans nuire à son métier de coloriste.'[62] Baudelaire devait développer ces idées dans un article ultérieur, *Peintures murales d'Eugène Delacroix à Saint-Sulpice* (1861).

Il ne semble pas connaître 'L'âge d'or' d'Ingres, laissé inachevé au château de Dampierre. Il ne cite que 'l'Apothéose d'Homère', 'un beau tableau qui plafonne mal.'[63]

En revanche il examine sans grand enthousiasme, en les opposant aux peintures de Delacroix, les œuvres des élèves d'Ingres, nombreuses dans les églises parisiennes—en oubliant d'ailleurs l'importante décoration peinte en 1836 par Victor Orsel à Notre-Dame-de-Lorette et terminée après sa mort par Perrin. Le Lyonnais Orsel n'est pas un élève d'Ingres, mais il a joué, à côté de lui, un rôle important dans la formation de plusieurs peintres lyonnais et c'est par son intermédiaire que ceux-ci ont connu les 'Nazaréens' allemands.

'La plupart des chapelles exécutées dans ces derniers temps, et distribuées aux élèves de M. Ingres, sont faites dans le système des Italiens primitifs, c'est-à-dire qu'elles veulent arriver à l'unité par la suppression des effets lumineux et par un vaste système de coloriages mitigés. Ce système (...) esquive les difficultés...'[64] Baudelaire l'estime cependant 'plus raisonnable' que les 'décorations à grand fracas' du temps de Louis XIV et de Louis XV (c'est-à-dire baroques) 'qui manquaient d'unité dans la couleur et dans la composition'.

Il est peu attiré par la peinture religieuse, si ce n'est par ses aspects préraphaélite ou philosophique. C'est ainsi qu'il s'arrête un moment, en 1845, devant 'L'Assomption' de Janmot [23] (récemment retrouvée dans une église de la banlieue lyonnaise et acquise par le musée de Saint-Etienne) au sujet de laquelle, à vrai dire, il ne fait que reproduire la notice du catalogue : 'Partie supérieure : — la sainte Vierge est entourée d'anges dont les deux principaux représentent la Chasteté et l'Harmonie. Partie inférieure : Réhabilitation de la femme ; un ange brise ses chaînes.'[65]

Quant à la 'Jeanne d'Arc' d'Ingres, elle 'se dénonce par une pédanterie outrée de moyens' et une 'absence totale de sentiment et de surnaturalisme.'[66]

4 Préraphaélisme et peinture philosophique

Le préraphaélisme. Au Salon de 1845 Baudelaire fut le seul à louer avec chaleur, comme 'le morceau capital de l'exposition', le tableau d'un débutant qui suscitait les moqueries des autres critiques: 'La Fontaine de Jouvence' de William Haussoullier [26].[67]

Après cet échec, ou plutôt ce succès de scandale ('un succès à la 'Saint Symphorien.' dit Baudelaire), Haussoullier se tourna vers la gravure; il grava des peintures italiennes du Quattrocento et des tableaux d'Ingres, notamment 'Romulus vainqueur d'Acron'. Bien qu'il ne fût pas son élève, il se lia d'amitié avec Ingres.

Baudelaire parle de lui en des termes proches de ceux qu'il emploie pour les élèves d'Ingres; mais il loue ici ce qu'il accable ailleurs de ses sarcasmes; car ce qui n'est, dans l'école d'Ingres, qu'affectation de style, est ici moyen d'expression de la spiritualité:

Cette peinture a, selon nous, une qualité très importante, (...) elle est très voyante (...) La couleur est d'une crudité terrible, impitoyable, téméraire même (...) mais... elle est *distinguée*, mérite si couru par MM. de l'école d'Ingres (...) Autre qualité énorme et qui fait les hommes, les vrais hommes, cette peinture a la foi — elle a la foi de sa beauté, — c'est de la peinture absolue (...) Oserons-nous, après avoir si franchement déployé nos sympathies (...) dire que le nom de Jean Bellin et de quelques Vénitiens des premiers temps nous a traversé la mémoire, après notre douce contemplation? M. Haussoulier serait-il de ces hommes qui en savent trop long sur leur art? C'est là un fléau bien dangereux, et qui comprime dans leur naïveté bien d'excellents mouvements. Qu'il se défie de son érudition...[68]

Ici apparaissent pour la première fois deux idées qui reparaissent souvent dans la critique baudelairienne: les vertus de la 'naïveté' — c'est-à-dire le naturel, la spontanéité presque inconsciente de la création artistique, qui peut s'accompagner d'une heureuse gaucherie; et les dangers, pour cette 'naïveté', d'une trop grande connaissance des maîtres du passé, et notamment des peintres italiens ou allemands antérieurs à Raphaël.

La vraie naïveté, il la reconnaît chez Corot, chez des réalistes comme Legros et Armand Gautier;[69] Delacroix, qui réunit grande science et naïveté, lui apparaît comme 'l'homme complet'.[70]

La fausse naïveté, c'est celle des élèves d'Ingres, qui appliquent froidement un système. Seul Janmot lui paraît sincère et candide dans son portrait de 1845 intitulé 'Fleur des champs' [18], 'cette simple figure, sérieuse et mélan-

26 Haussoullier: 'La Fontaine de Jouvence'

colique, et dont le dessin fin et la couleur un peu crue rappellent les anciens maîtres allemands, ce gracieux Albert Dürer...' C'est la 'mysticité' de cette figure qui séduit Baudelaire et lui fait accepter certaines réminiscences.[71]

Sur Ingres lui-même l'opinion de Baudelaire n'est pas fixe. En 1846 il oppose son art naturel à celui de ses élèves. En 1855 dénonce son 'caractère assez éclectique, comme tous les hommes qui manquent de fatalité. Aussi le voyons-nous errer d'archaïsme en archaïsme'.[72] Et après avoir énuméré des emprunts nombreux et variés il remarque avec malice: 'C'est surtout dans ''L'Apothéose de l'Empereur Napoléon Ier'', tableau venu de l'Hôtel de Ville, que M. Ingres a laissé voir son goût pour les Étrusques, Cependant les Étrusques, grands simplificateurs, n'ont pas poussé la simplification jusqu'à ne pas atteler les chevaux aux chariots...'[73]

Ce grave défaut est érigé en système par les élèves d'Ingres: 'Ils sont allés dans le passé, loin, bien loin, copier avec une puérilité servile de déplorables erreurs, et se sont volontairement privés de tous les moyens d'exécution et de succès...'[74]

A l'exemple des primitifs, ils suppriment la lumière, juxtaposent des

couleurs crues, simplifient et 'déforment' volontairement leurs modèles pour les rapprocher de certains exemples du passé; ils croient donner du style à leurs tableaux en ajoutant artificiellement des déformations étrangères au sujet et empruntées généralement au passé.[75] Ces tendances sont visibles dans leurs portraits aussi bien que dans leurs tableaux religieux ou leurs peintures murales.

Et Baudelaire conclut: 'N'empruntez à la tradition que l'art de peindre et non les moyens de sophistiquer.'[76]

Quelques années plus tard il opposera (non sans quelque excès) à tous ces artistes tournés vers le passé 'le peintre de la vie moderne', Constantin Guys (1863).

Chez les élèves d'Ingres plus que chez le maître lui-même cette volonté d'archaïsme prend souvent la forme du préraphaélisme. La 'redécouverte' des 'primitifs' est un phénomène général en Europe, lié à certains aspects nationalistes du romantisme.

L'Exposition Universelle de 1855 permettait précisément des comparaisons entre les productions de toutes les nations. Confrontation 'inquiétante par sa variété', 'déroutante pour la pédagogie',[77] qui remettait en cause les dogmes esthétiques et faisait éclater les cadres. S'il n'y avait qu'une participation réduite et décevante des Nazaréens allemands, les envois anglais étaient importants et Baudelaire se proposait de les étudier longuement et spécialement: 'L'exposition des peintres anglais est trés belle, trés singuliérement belle...'[78] Ce projet ne fut malheureusement jamais mis à exécution; si bien que nous ne savons pas exactement ce que Baudelaire pensait des peintres anglais contemporains, et en particulier des Préraphaélites. Mais il semble bien qu'il ait éprouvé pour eux plus de sympathie que pour les Nazaréens, auxquels il reproche leur archaïsme trop voulu.

Aux emprunts archaïsants des Anglais se mêlent curieusement des éléments naturalistes; et surtout il y a chez eux une sorte de 'naïveté' et une véritable 'mysticité'. En 1859 Baudelaire regrette l'absence des Préraphaélites anglais, Hunt, Millais (exposés précédemment avenue Montaigne); il évoque chacun d'eux avec des mots justes et ne cache pas son attirance 'pour ces amis de l'imagination et de la couleur singulière, pour ces favoris de la muse bizarre':[79] le grand mot est lâché.

Il y eut aussi en France (avant l'Angleterre) un courant préraphaélite, qui trouve sa source à la fois chez Ingres et chez Victor Orsel. Il était donc naturel qu'il se développât surtout à Lyon, parmi les élèves d'Ingres comme Hippolyte Flandrin, et surtout parmi ceux qui furent aussi en contact avec Orsel: Janmot et Chenavard.

Le peinture philosophique. Baudelaire se proposait d'étudier les Nazaréens en même temps que les peintres lyonnais, dans un article auquel il fait allusion à plusieurs reprises dans sa correspondance et qu'il intitule tantôt *Peintres philosophes*, tantôt *Écoles allemande et lyonnaise*, mais qu'il ne rédigea jamais.

Lors de l'exposition de 1855 les Nazaréens avaient été soutenus surtout par la critique catholique, ce qui avait indisposé Baudelaire. Dans *L'Art philosophique* il reproche à Overbeck et à Cornelius de réduire la peinture à l'imagerie pieuse, de la mettre au service de la religion, de vouloir 'remplacer de livre' et 'rivaliser avec l'imprimerie pour enseigner l'histoire, la morale et la philosophie'.[80]

L'Allemagne est 'Le pays qui a le plus donné dans l'erreur de l'art philosophique'.[81] Seul Rethel, avec sa 'Danse des morts' moderne (une suite gravée sur bois), retient son attention. Il décrit longuement chaque pièce, notant l'imitation des anciens maîtres allemands (Dürer, Holbein), mais aussi le 'caractère byronien' de l'œuvre et ses intentions philosophiques, exprimées par des allégories et des symboles.[82]

Le principal représentant de l'art philosophique en France est le Lyonnais Paul Chenavard.[83] Baudelaire, qui avait conservé un mauvais souvenir de ses années de collège à Lyon, ne néglige aucune occasion de médire de cette ville :

Lyon est une ville philosophique. Il y a une philosophie lyonnaise, une école de poésie lyonnaise, une école de peinture lyonnaise, et enfin une école de peinture philosophique lyonnaise. Ville singulière, bigote et marchande, catholique et protestante, pleine de brumes et de charbons, les idées s'y débrouillent difficilement.

27 Chenavard : 'La Philosophie de l'histoire'

28 Chenavard : 'Le Déluge'

Tout ce qui vient de Lyon est minutieux, lentement élaboré et craintif; l'abbé Noireau, Laprade, Soulary, Chenavard, Janmot. On dirait que les cerveaux y sont enchifrenés (...) Le cerveau de Chenavard ressemble à la ville de Lyon...[84]

Et dans une *Note sur l'art philosophique* Baudelaire dresse la liste, sur deux colonnes, des peintres et des écrivains lyonnais.[85]

Il n'appréciait guère la pensée confuse et utopique de la 'Palingénésie universelle', cette suite de compositions ambitieuses retraçant les âges de l'humanité, que le Gouvernement provisoire de la République avait commandée à Chenavard au lendemain de la Révolution de 1848 pour décorer le Panthéon et dont le musée de Lyon possède les cartons. Enseigner comme un livre lui paraît une 'hérésie', une 'monstruosité'.

Chenavard est un mauvais peintre. Mais Baudelaire éprouve pour l'homme de la sympathie. Il est instruit, réfléchi, raisonneur, 'curieux de religions et doué d'un esprit encyclopédique', passionnant dans la conversation: Delacroix lui-même l'écoutait volontiers.[86]

29 Janmot: 'Le Mauvais Sentier'

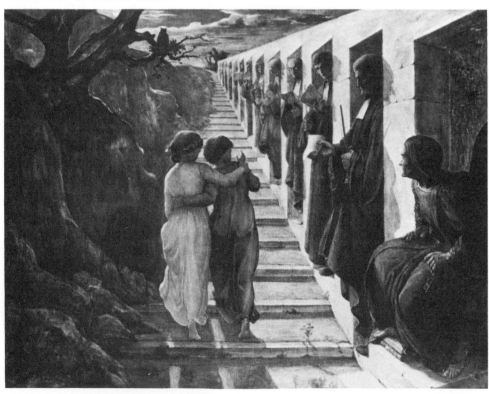

Les trente-quatre compositions du 'Poème de l'âme' [29 and 30] de Louis Janmot constituent une suite philosophique et religieuse exposant l'éveil de l'âme, de sa naissance à l'âge adulte ; puis les tentations de l'orgueil, des passions, du rationalisme et du scepticisme ; et enfin le retour de l'âme sur le chemin de la vérité.[87]

Les peintures, au nombre de dix-huit, qui occupèrent Janmot pendant de nombreuses années, furent achevées à Lyon en 1854, date de leur première exposition à Paris, passage du Saumon. Elles furent de nouveau présentées à l'Exposition Universelle de 1855 où Delacroix et Baudelaire les remarquèrent.[88] Les seize dessins qui complètent les peintures ne furent exécutés que de 1861 à 1881. L'ensemble forme un tout qui ne peut se comprendre sans la suite de poèmes destinés à l'accompagner que Janmot publia en 1881. Il y a là un cas curieux de conception simultanée sous deux formes, littéraire et picturale, dont on peut trouver un précédent plus illustre chez William Blake.

Peintures et dessins furent donnés il y a une quinzaine d'années par les

30 Janmot : 'Sur la montagne'

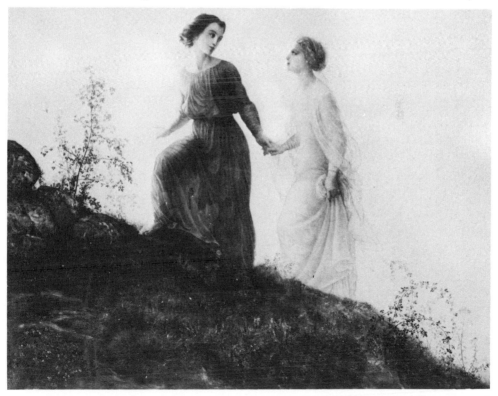

héritiers de Janmot à la Faculté des Lettres de Lyon et ont été transportés en 1968 au musée de la ville.[89]

Janmot fut successivement l'élève d'Ingres et d'Orsel. L'action de ce dernier, qui s'était lié à Rome avec Overbeck et Cornelius, fut sans doute plus forte que celle d'Ingres. Baudelaire éprouve à l'égard de Janmot à la fois de l'attirance et de l'éloignement : 'M. Janmot, lui aussi est de Lyon. C'est un esprit religieux et élégiaque, il a dû être marqué jeune par la bigoterie lyonnaise (...) 'L'Histoire d'une âme' est trouble et confuse (...) M. Janmot n'est pas un cerveau philosophiquement solide...'[90]

Mais 'il faut reconnaître qu'au point de vue de l'art pur il y avait dans la composition de ces scènes, et même dans la couleur amère dont elles étaient revêtues, un charme infini et difficile à décrire, quelque chose des douceurs de la solitude, de la sacristie, de l'église et du cloître ; une mysticité inconsciente et enfantine...'[91] Delacroix lui aussi était sensible à ce charme mystique.

Et Baudelaire se proposait d'analyser quelques sujets, 'Le Cauchemar', où brillait une remarquable entente du fantastique ; une espèce de *promenade mystique* de deux jeunes gens sur la montagne, etc...' [30].[92]

'Quoique je considère les artistes philosophes comme des hérétiques, conclut Baudelaire, je suis arrivé à admirer souvent leurs efforts par un effet de ma raison propre.'[93]

Conclusion

Baudelaire constate que 'l'imagination reine des facultés' est absente partout, sauf chez Delacroix. Ingres en est privé, ses élèves aussi : Ingres va rejoindre Courbet dans la catégorie des peintres réalistes, opposés aux imaginatifs.[94] Seuls ces derniers réussissent dans la grande peinture d'histoire (qui pour Baudelaire reste le genre supérieur) et savent traduire l'esprit épique, l'héroïsme de la vie moderne' qu'il cherche partout en vain. Les autres ne peuvent réussir que dans le portrait et dans le paysage : c'est en effet dans le portrait qu'Ingres réussit le mieux.

C'est aussi chez Delacroix que Baudelaire trouve la spiritualité et le 'surnaturalisme' dont il déplore l'absence quasi-générale. Ingres est à l'opposé du surnaturalisme. Mais ces qualités existent chez deux de ses élèves, Chenavard et Janmot ; d'où la sympathie de Baudelaire pour eux, malgré leurs médiocres qualités de peintres, car leur peinture a une 'âme'.

Il apparaît clairement que Baudelaire s'intéresse plus à l'expression, à l'âme de l'artiste, qu'aux qualités formelles de sa peinture. Sa critique reste assez littéraire. Si intuitive, si géniale qu'elle soit, elle n'est pas infaillible comme on a trop tendance à le croire.

Il a d'étranges indulgences pour des peintres littéraires, des peintres à idées. qui ne sont nullement des hommes méprisables, mais dont les intentions sont incomplètement réalisées et dont l'imagination n'est pas d'ordre plastique.

Il condamne avec mépris le métier, confondant le vrai métier avec les pratiques du dix-neuvième siècle qui ne sont que l'ignorance du métier, et justifiant ainsi par avance toutes les facilités de notre époque.

Il n'apprécie pas les 'déformations' ni les recherches de stylisation d'Ingres et de ses élèves, qui nous attirent précisément aujourd'hui et dont les artistes contemporains se réclament volontiers.

Il ne s'intéresse pas à l'archaïsme ni au primitivisme quand ils ne s'accompagnent pas de 'naïveté'.

D'une façon générale il ne prévoit nullement les développements intellectualistes ni les recherches formelles de l'art moderne, de Gauguin, du cubisme, ni la lointaine postérité de l'ingrisme.

Il se contredit en refusant de voir et d'apprécier, dans certaines œuvres des élèves d'Ingres, ces 'bizarreries' qui le charment ailleurs et qui sont pour lui l'un des signes de la beauté moderne.

Il traite avec une égale désinvolture des talents inégaux ; il se montre injuste envers Amaury-Duval, le plus intelligent et le plus doué des disciples du maître ; il dédaigne Victor Mottez, préraphaélite notoire, fresquiste et traducteur du traité de Cennino Cennini, au point de ne pas même le nommer.

Par ses partis-pris, par sa partialité affirmée comme le devoir fondamental du critique, par le prestige de sa pensée et de son style, il porte une part de responsabilité dans le discrédit et, par suite, la disparition ou même la destruction d'une grande partie de la peinture française du dix-neuvième siècle : il a rendu bien difficile la tâche de l'historien d'art.

Les *Curiosités esthétiques* nous aident à mieux comprendre Baudelaire ; il n'est pas sûr qu'elles nous aident à mieux connaître la peinture française du dix-neuvième siècle.

Mais on ne saurait reprocher à Baudelaire de ne pas avoir le don de prophétie. Il a su presque toujours distinguer les talents authentiques, les véritables créateurs, des 'singes' et des médiocres. Il a aidé ses contemporains et les générations qui ont suivi à découvrir ce qu'ils pouvaient aimer. Il a fait œuvre utile pour son époque et pour longtemps.

A nous aujourd'hui, tout en approuvant du fond du cœur beaucoup de ses jugements, d'examiner de façon plus impartiale la production artistique du siècle dernier et d'écrire, si nous le pouvons, à l'aide de connaissances

nouvelles, une nouvelle histoire de la peinture française du dix-neuvième siècle, mieux accordée aux goûts de l'homme du vingtième siècle.

Notes and discussion

(1) Je tiens à remercier ici tous ceux qui m'ont apporté leur aide: Mme Rocher-Jauneau, conservateur du Musée des Beaux-Arts de Lyon; M. Bernard Ceysson, conservateur du Musée d'Art et d'Industrie à Saint-Étienne; M. Pierre Barousse, conservateur du Musée Ingres à Montauban; M. Jean Lacambre, conservateur à l'Inspection générale des musées de province; Mme Cambas–Lanvin; M. Yves-Marie Froidevaux, architecte en chef des Monuments historiques; Mme Elisabeth Hardouin, assistante à l'Université d'Aix-en-Provence.

(2) Voir notamment: Jonathan Mayne, *Art in Paris 1845–1862. Salons and other Exhibitions reviewed by Charles Baudelaire,* Londres, Phaidon Press, 1965; — Henri Lemaître, *Curiosités esthétiques, l'art romantique et autres œuvres critiques,* Paris, éd. Garnier, 1962 (ces deux éditions — la première surtout — sont illustrées par d'assez nombreuses reproductions d'œuvres mentionnées par Baudelaire); — F. A. Trapp, *The Universal Exhibition of 1855,* dans *The Burlington Magazine,* 1965, pp. 300–5 (reproduit les photographies de l'exposition contenues dans un album publié en 1855; un exemplaire de cet album a été présenté à l'exposition Baudelaire de 1968/69, No. 260; il appartient à la Bibliothèque historique de la Ville de Paris); — Maurice Sérullaz et collaborateurs, *Baudelaire,* catalogue de l'exposition, Paris, Petit Palais, 1968/9; — Geneviève et Jean Lacambre, *Autour de l'exposition Baudelaire: peintures et sculptures du XIXe siècle retrouvées (Salons de 1845 et 1846),* communication à la Société de l'Histoire de l'Art Français, 6 décembre 1969 (à paraître); — Bruno Foucart, *A propos de l'exposition Baudelaire,* dans *L'Information d'histoire de l'art,* 1969, No. 1, pp. 35–43; — Yoshio Abe, *Baudelaire face aux artistes de son temps,* dans la *Revue de l'art,* 1969, n. 4, pp. 85–9; — P. Hahlbrock et collaborateurs, *Le Salon imaginaire. Bilder aus den grossen Kunstaustellungen der zweiten Hälfte des XIX. Jahrhunderts,* Berlin, Akademie der Künste, 1968 (le thème trop vaste de cette dernière exposition n'a pas permis d'apporter vraiment du nouveau).

(3) *Salon* de 1846, No. 15 (*Portrait de femme*). A.-H. Delaunay, rédacteur en chef du *Journal des artistes,* écrit dans le *Catalogue complet du Salon de 1846 annoté par A.-H. Delaunay:* 'Un des bons portraits du Salon, malgré les teintes gris clair du fond et bleu cru de la robe.' — Cf. Baudelaire, *Salon de 1846,* p. 160 de l'édition Lemaître.

(4) Sur Janmot: Elisabeth Hardouin, *Catalogue des peintures de Louis Janmot,* thèse de Doctorat de troisième siècle (inédite), Lyon, 1969; Mme Hardouin prépare une thèse de doctorat d'État sur Janmot. — Sur Chenavard: Joseph C. Sloane, *Paul-Marc–Joseph Chenavard, Artist of 1848,* University of North Carolina Press, 1962. — Sur les Flandrin: Mme Cambas-Lanvin, thèse pour l'École du Louvre (inédite), 1967.

(5) *Salon de 1846,* p. 101 de l'éd. Lemaître.

(6) Amaury-Duval, *L'Atelier d'Ingres,* Paris, 1878.

(7) Ces articles, réunis en volume en 1868 sous le titre de *Curiosités esthétiques,* ont fait l'objet de nombreuses éditions critiques. Nous nous référons à l'édition d'Henri Lemaître, *Curiosités esthétiques, l'art romantique,* Paris, Garnier, 1962. — Voir aussi: Baudelaire, *Oeuvres complètes,* éd. Crépet.

(8) 1846. Cette exposition comprenait surtout des œuvres de David, de ses principaux élèves (Girodet, Gérard, Ingres) et de quelques-uns des grands chefs d'ateliers du début du siècle.

(9) Pp. 191–4.

(10) *Salon de 1846,* p. 154.

(11) P. 366.

(12) *Salon de 1846,* p. 154.

(13) *Salon de 1855,* p. 230.

(14) *Salon de 1859,* p. 366.

(15) *Salon de 1846,* p. 160.

(16) *Salon de 1845,* pp. 52 et 56.

(17) *Ibid.,* p. 85.

(18) *Ibid.,* p. 61.

(19) *Salon de 1846,* pp. 152 et 155–6.

(20) *Salon de 1845,* p. 68; *Salon de 1846,* p. 186; etc.

(21) *Salon de 1859,* p. 311.

(22) *Salon de 1845,* p. 11.

(23) *Ibid.,* p. 13.

(24) *Salon de 1846,* p. 120.

(25) *Ibid.,* pp. 147–9.

(26) *Ibid.,* p. 152.

(27) *Exposition de 1855,* p. 227.

(28) *Ibid.,* pp. 227–8.

(29) *Salon de 1846,* p. 152.

(30) *Ibid.,* p. 159.

(31) *Salon de 1859,* p. 366.

(32) *Salon de 1846,* p. 159.

(33) *Ibid.* p. 155.

(34) *Ibid.,* p. 151.

(35) *Ibid.,* p. 152.

(36) *Ibid.,* p. 155.

(37) *Ibid.,* pp. 159–60.

(38) *Ibid.,* p. 155.

(39) *Salon de 1845,* p. 40.

(40) *Musée Bonne-Nouvelle,* 1846, p. 93.

(41) *Salon de 1846,* pp. 152–3.

(42) *Ibid.,* p. 153.

(43) *Exposition de 1855,* p. 224.
(44) *Ibid.,* p. 224.
(45) *Ibid.,* p. 226.
(46) *Ibid.,* p. 230.
(47) *Ibid.,* p. 215.
(48) *Musée Bonne-Nouvelle,* 1846, p. 93.
(49) *Salon de 1859,* pp. 365–6.
(50) *Salon de 1846,* pp. 158–9.
(51) *Exposition de 1855,* pp. 226–7
(52) *Salon de 1859,* p. 367.
(53) *Salon de 1846,* p. 160.
(54) *Salon de 1859,* p. 369.
(55) *Salon de 1846,* pp. 177–8.
(56) *Ibid.,* pp. 178–9.
(57) D. Ternois, *Flâneries et voyages de M. Ingres,* catalogue d'exposition, Montauban, 1952; — H. Naef, Rome vue par Ingres, Lausanne, 1960 (publication intégrale).
(58) Portraits de Granet, de Gouriev, de Cordier, de Moltedo, de Mlle Rivière.
(59) *Salon de 1846,* p. 181.
(60) *Salon de 1845,* p. 67.
(61) *Salon de 1846,* p. 179.
(62) *Ibid.,* p. 123.
(63) *Ibid.,* p. 123.
(64) *Ibid.,* p. 123.
(65) *Salon de 1845,* p. 40. — Sur l'Assomption de Janmot, cf. Elisabeth Hardouin, *Un Tableau de Louis Janmot, L'Assomption de la Vierge,* dans *La Revue du Louvre,* 1968. Cinq dessins de Janmots pour L'Assomption viennent d'être acquis par un collectionneur lyonnais.
(66) *Exposition de 1855,* p. 229.
(67) *Salon de 1845,* pp. 15–19.
(68) Ibid. pp. 18–19.
(69) *Salon de 1859*
(70) *Salon de 1846,* p. 121.
(71) *Salon de 1845,* p. 39.
(72) *Exposition de 1855,* p. 228.
(73) Ibid. pp. 228–9.
(74) *Salon de 1846,* p. 154.
(75) *Salon de 1859,* pp. 367–8.
(76) Ibid. pp. 367–8.
(77) *Exposition de 1855,* p. 216.
(78) Ibid., p. 221.
(79) *Salon de 1859,* pp. 307–8.
(80) *L'Art philosophique,* p. 503–4.
(81) Ibid., p. 505.
(82) Ibid., p. 506.
(83) Sur Chenavard, cf. Joseph C. Sloane, *Paul Marc Joseph Chenavard, Artist of 1848,* University of North Carolina Press, 1962.

(84) *L'Art philosophique,* p. 508.
(85) *Notes sur l'art philosophique,* p. 528: LYONNAIS: Chenavard, Janmot, Révoil, Bonnefonds, Orsel, Perrin, Compte-Calix, Flandrin, Saint-Jean, Jacquand, Boissieu, Laprade, Ballanche (pour la fumée), A. Pommier, Soulary, Blanc de Saint-Bonnet, Noirot, Pierre Dupont, De Gérando, J.-B. Say, Terrasson.
(86) *Journal de Delacroix,* éd. Joubin, passim (surtout t. II).
(87) Sur le *Poème de l'âme de Janmot,* cf. F. Thiollier, *Janmot et son œuvre;* — R. Jullian et M. Rocher-Jauneau, catalogue de l'exposition du *Poème de l'âme,* Lyon, Musée des Beaux-Arts, 1950; — D. Ternois, *Louis Janmot (1814–1892) et l'école mystique lyonnaise,* dans les *Cahiers d'histoire,* 1965; — Elisabeth Hardouin, *Louis Janmot,* thèse de doctorat d'état, en préparation.
(88) Delacroix, *Journal,* 17 juin 1855; éd. Joubin, t. II, pp. 341–2: '... Il y a chez Janmot un parfum dantesque remarquable... J'aime ces robes vertes comme l'herbe des prés au mois de mai, ces têtes inspirées ou rêvées qui sont comme des réminiscences d'un autre monde... On voit ses idées à travers la confusion et la naïve barbarie de ses de les rendre...'
(89) Gravement endommagés dans la Salle du Conseil de la Faculté pendant les troubles de mai 1968, ils seront néanmoins restaurés et sauvés.
(90) *L'Art philosophique,* pp. 511–12.
(91) Ibid., p. 512.
(92) *Le Mauvais Sentier* et *Sur la montagne.*
(93) *L'Art philosophique,* p. 512.
(94) *Exposition de 1855,* p. 225.

Discussion. In answer to a question about Ingres' relationship with the sect called the 'penseurs' or 'barbus' in David's workshop, Prof. Ternois expressed the opinion that Maurice Quay (1779–1804) had played a certain part, notably by influencing the 'goût de l'archaïsme' in Ingres' early work. The discussion then turned to the subject of 'naïveté', which was important both for Ingres and for Baudelaire; in this connection mention was made of Amaury-Duval, Ingres' most intelligent pupil.

Alison Fairlie

3

Aspects of expression in Baudelaire's art criticism[1]

The recent discovery of some of Baudelaire's youthful letters gives two earlier moments of insight than we yet had into his way of reacting to pictures. At the age of seventeen he describes to his stepfather a School Visit to Versailles, where an exhibition had been laid on.[2] Dutifully disclaiming expert knowledge ('Je ne sais si j'ai raison'), he at once pronounces his own judgement: 'Tous les tableaux du temps de l'Empire, qu'on dit fort beaux, paraissent souvent si réguliers, si froids!' and immediately picks an evocative verb and amusingly opposed similes to convey his reasons in visual form: 'Leurs personnages sont souvent échelonnés comme des arbres ou comme des figurants d'opéra.' Due deference to the opinions of the elderly is interwoven with a reassertion of personal taste and a provocative reference to its contributory source, namely Gautier's articles in *La Presse* of 1838:[3] 'Il est sans doute bien ridicule à moi de parler ainsi des peintres de l'Empire qu'on a tant loués; je parle peut-être à tort et à travers; mais je ne rends compte que de mes impressions: peut-être aussi est-ce là le fruit des lectures de la *Presse* qui porte aux nues Delacroix?' In deliberate provocation he quotes the pun of a journalist describing their visit in *Le Charivari*: 'après notre dîner nous étions rassasiés de croûtes'.

A few months later, he asks his stepfather to substitute, for training in fencing and horsemanship, lessons on the philosophy of religion and on 'l'esthétique ou la philosophie des arts'.[4]

Obviously Baudelaire's judgements on Empire paintings will change, but here are already signs of the qualities his criticism will so outstandingly develop. Mistrust of shibboleths; recognition of stimulus from reading; desire to relate artistic enjoyment to wide intellectual and moral problems; half-mocking modesty regarding technical competence; belief in 'une critique... amusante et poétique' (877). At the centre will remain the sense that 'je rends compte de mes impressions', with the joy of expressing physical and mental responses in words at once precise and provocative, subtle and suggestive.

Before a professional audience of art-historians, and coming after many

penetrating studies, I shall not today be directly concerned with evaluating Baudelaire's judgements, nor with tackling the charge (whether informed or anachronistic) that he is not always the infallible prophet of present-day modes. My aim is very simple. Since recent research has done the inestimable service of making available in exhibitions and reproductions a wide choice from the pictures he discussed,[5] I want to look at certain selected details which seem to have made a specially immediate or haunting impact on him, and through them to see how he verbally conveys visual sense-impressions, their relation to those of the other senses, and their wider evocative power. 'Peu d'hommes sont doués de la faculté de voir', wrote Baudelaire; 'il y en a moins encore qui possèdent la puissance d'exprimer' (1162). 'La faculté de voir.' When Baudelaire looks at a picture, he shows two special capacities: one for seizing a general impression of the effect made on him by the picture as a whole; the other for picking out the significance of particular details. Where the general impression is concerned, one might ask how far it depends on the associations of the subject, how far on formal values, on execution: as so often with Baudelaire the answer would be two-sided. His hatred of conventional moralizing leads him to attack 'l'art plastique qui a la prétention de remplacer le livre; c'est-à-dire de rivaliser avec l'imprimerie pour enseigner l'histoire, la morale ou la philosophie' (1099),[6] and to assert that, for example, torture or eroticism, 's'ils sont bien dessinés, comportent un genre de plaisir dans les éléments duquel le sujet n'entre pour rien... Une figure bien dessinée vous pénètre d'un plaisir tout à fait étranger au sujet. Voluptueuse ou terrible, cette figure ne doit son charme qu'à l'arabesque qu'elle découpe dans l'espace' (1124). A keen sense of formal delight for its own sake is evident in the famous passages on judging the harmony of a picture from a distance at which the subject cannot be discerned.[7] Yet Baudelaire will also make the open statement in 1859: 'Le sujet fait pour l'artiste une partie du génie, et pour moi, barbare malgré tout, une partie du plaisir' (1084).[8] In both sensation and subject he will discover and analyse the particular fusion of melancholy and delight, of struggle and aspiration, which combine in his definition of '*mon* Beau': 'quelque chose d'ardent et de triste... laissant carrière à la conjecture' (1255). He will look above all for the artist who can convey the solemnity and the strangeness that are inherent in the everyday and the trivial. To him, the bad artist incongruously attempts to impose these qualities from without, through inapposite conventions; the great artist finds his own fitting expression for the complex nature of things. For artists who seek this two-sided vision, even through uncertain execution, Baudelaire often makes his reservations clear, while rejoicing in the suggestions their work has offered.

'La puissance d'exprimer.' In general Baudelaire eschews technical vocabu-
lary: part modesty about his training, part consideration for the general
reader, part provocative pose of the *dandy*. Yet he inserts parentheses to show
that 'I could an' if I would',[9] and takes steps to inform himself about technical
problems.[10] His criticism is no mere impressionistic paraphrase of the plastic
in verbal terms: he speaks of himself as wishing 'non pas d'*illustrer* mais
d'expliquer le plaisir subtil' (1095). It is constantly informed by analysis and
principle, but principle that is suggestive rather than systematic. Just as he
demands of the painter not a copy of the real world, but an imaginative
illumination of it, through selection, sacrifice, suggestion and synthesis, so his
criticism rarely gives a methodical description of the left-to-right, top-to-
bottom kind; he selects both central personal impression and revealing details,
groups and constructs his effects.

Baudelaire's famous phrase 'transformer ma volupté en connaissance'
would apply to all his criticism, and raises three implications. The choice of
the strongest word for the immediate response: not just 'plaisir' or 'joie' but
'volupté'; the deliberately personal '*ma* volupté', and the enhancing of the
delight by the urge to understand causes and consequences, for 'Jouir est une
science, et l'exercice des cinq sens veut une initiation particulière' (874; cf.
814, 913). Late in life he will call himself 'un homme qui, à défaut de con-
naissances étendues, a l'amour de la peinture jusque dans les nerfs'. Sharp
sensuous response; special ability to relate this to basic problems; outstand-
ing capacity to give to both of these suggestive expression: these are the
qualities I hope to show in looking at his remarks on some individual pictures.
I shall begin and end with certain paintings to which he gives developed
discussion; in the middle I shall examine reactions to some particular
problems of perspective, of movement and of colour.

I start with a picture where Baudelaire's youthful enthusiasm has been found
puzzling: Haussoullier's 'Fontaine de Jouvence' [26]. Why did this odd and
stiffly stylized piece provoke his 'éloge violent'? First, I suggest, because the
subject itself goes to the roots of his most intense preoccupations. In a later
article he imagines a personal museum of works of art representing each shade
of eroticism or tenderness (901); in looking at the Haussoullier he at once
groups the lovers into representative types (was this the painter's intention?):
on the left the platonic, in the centre the sensuous, on the right the festive. The
central theme, to which he moves gradually, is one fundamental in Baudelaire
—that of re-birth. These are not just young lovers, but 'rajeunis', reborn
after sickness and suffering to tranquil delight: 'Dans cette composition l'on

aime et l'on boit, —aspect voluptueux—mais l'on boit et l'on aime d'une manière très sérieuse, presque mélancolique. Ce ne sont pas des jeunesses fougueuses et remuantes, mais de secondes jeunesses qui connaissent le prix de la vie et qui en jouissent avec tranquillité' (821). Baudelaire, from early life so personally haunted by apathy and disease, has responded to the theme of miraculous cleansing and renewed vigour; he sees the picture as combining melancholy and joy, and his still somewhat flat and factual evocation points forward to the many moments where he will later define the experience of 'l'âme dans ses belles heures' (1053), when out of weariness or anguish emerges the fresh ecstasy of child, convalescent or poet (349–50, 974, 1158–9. 1257, etc).[11]

He has set out here to justify his enthusiasm by an unusually systematic analysis (the young critic showing his paces). Structure is divided into 'premier plan', 'second plan', background (to which I shall come back); the division of the picture by the central standing figure is noted. On colour, he stresses in a crescendo of adverbs and adjectives the virulence of tone and violence of contrast, praised for boldness, mistrusted for crudity; 'deux femmes vaporeuse-ment, outrageusement blanches', 'la couleur d'une crudité terrible, impitoy-able, téméraire même'.[12] That the painter might later grow more subtle is indicated by a remark on 'quelques alliances de ton heureuses', without attempt to specify. The picture has an assertive self-confidence which appeals to the Baudelaire who so strongly attacked the eclectics and doubters of his day: it is no weak copy of nature. Yet on reflection he warns against the temptations of the derivative (Giovanni Bellini is mentioned) and the over-artificial. Outspoken praise and clear reservations unite in this youthful attempt at careful analysis, conducted with something of the combined bold-ness and stiffness of the picture itself.

Finally, it is the rendering of the sense-impressions which shows Baudelaire's imaginative ability, as he conveys, more delicately than the picture itself, the objective correlatives for purification and hope, whether in his image for the re-birth: 'une femme nue et à moitié couchée, semble comme une chrysalide, encore enveloppée dans la dernière vapeur de sa métamorphose', or in the evocation of the fountain (even as he admits its air of stage-property in the picture), where his words so well suggest the mobile and wavering semi-trans-parency of fringes of falling water: 'cette fontaine fabuleuse... se partage en deux nappes, et se découpe, se fond en franges vacillantes et minces comme l'air'.

I mentioned the background: here Baudelaire picks out a sense-impression whose meaning for him I shall briefly trace in a few further examples. In the

31 Corot: 'Homère et les bergers'

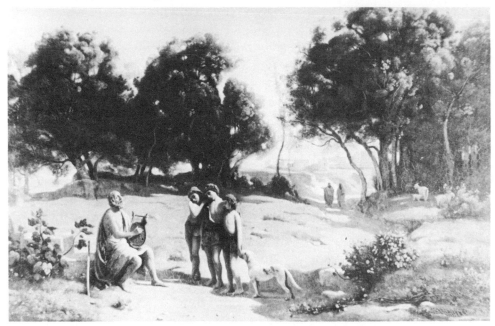

top left-hand corner, 'dans un sentier tortueux qui conduit l'œil jusqu'au fond du tableau, arrivent, courbés et barbus, d'heureux sexagénaires'. 'Un sentier tortueux qui conduit l'œil jusqu'au fond du tableau.' The physical device of perspective leading the gaze into the distance he sometimes merely briefly mentions, as with Corot's 'Homère et les bergers' [31] where he pauses to note the value of 'les deux petites figures qui s'en vont causant dans le sentier'. In other works he suggests how the recurring fascination of effects of perspective is intimately related to themes of human limitation and longing.[13] In a letter he had noted how a feeling of endless distance may best be given by framing the sky in a restricting opening; man's aspirations he likewise sees as intensified by the limits which constrain them. The sense of the hemming-in which stimulates a sense of endless expansion is explicitly expressed at the centre of his pleasure in this picture by Penguilly l'Haridon [33]: 'l'azur intense du ciel et de l'eau, deux quartiers de roche qui font une porte ouverte sur l'infini (vous savez que l'infini paraît plus profond quand il est plus resserré)...' (1070). His reservations about Penguilly's over-precise technique in general had already been indicated through telling images, 'la minutie, la patience ardente et la propreté d'un bibliomane... Sa peinture a le poli du métal et le tranchant

du rasoir'; for this picture, a crescendo of metaphor leaves us with the bold and mobile impressions of the gulls in space, 'une multitude, une avalanche, une plaie d'oiseaux blancs, et la solitude...'

He has no reservations about Delacroix's 'Prise de Constantinople par les Croisés' (970) [32] here, behind the dual central effect swiftly summed up in 'tout y est tumultueux et tranquille, comme la suite d'un grand évènement', he turns again to the suggestive perspective in that curving canyon of street leading into infinite distance: 'La ville échelonnée derrière les Croisés qui viennent de la traverser, s'allonge avec une prestigieuse vérité', and one remembers his own poetic creation of 'les plis sinueux des vieilles capitales'. In the artists who represent Paris, he picks out again effects of perspective, with the interaction of compression and space: in Meryon (to whom I shall return) he stresses 'la profondeur des perspectives augmentée par la pensée

32 Delacroix: 'L'Entrée des Croisés à Constantinople'

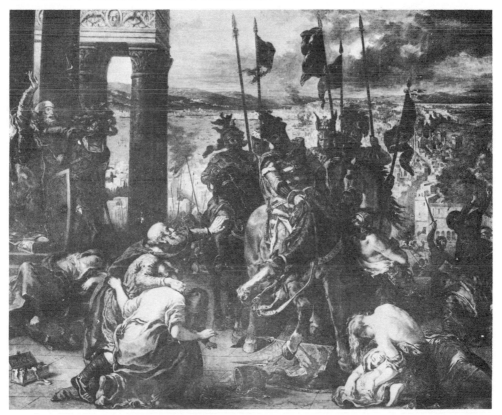

de tous les drames qui y sont contenus' (1083) [35], and he finds Constantin Guys 'épris d'espace, de perspective' (1173).[14]

One last example: a Delacroix which Baudelaire specially loved—'Ovide chez les Scythes' (1053) [36]. Here certainly the subject in itself goes to the

33 Penguilly-L'Haridon: 'Les Petites Mouettes'

35 Meryon: 'Rue des Chantres'

34 Delacroix: 'Romeo et Juliette'

roots of Baudelaire's preoccupations; just as in one of his finest poems, 'Le Cygne', he unites, around the theme of exile, Andromache from the ancient world and the negress in the mist and mud of the modern city, so here he recalls Chateaubriand's modern and musical melancholy in evoking the bitter exile of the poet of sensuous love. He gives no detailed description of the picture, simply conveying, in words that combine physical and abstract, a central effect once more of both sorrow and tranquillity: 'Je n'essaierai pas de traduire avec ma plume la volupté si triste qui s'exhale de ce verdoyant exil,' and the personal suggestion of the hypersensitive dreamer, 'couché sur des verdures sauvages, avec une mollesse et une tristesse féminines'. It is above all the sense of stretching distance which is given intense physical expression, and made to broaden into suggestive analogies: 'l'esprit s'y enfonce avec une lente et gourmande volupté, comme dans le ciel, dans des yeux pleins de pensée, dans une sentence féconde et grosse de rêverie'.[15]

These are a very few examples of how Baudelaire, without attempting technical analysis, has drawn from physical reactions to details of perspective certain widely suggestive effects. The sense of movement he thus introduces into the

36 Delacroix: 'Ovide chez les Scythes'

static—'l'esprit s'y enfonce'—brings me to another sensation that preoc-
cupies him: the effect of mobility. In discussing conventional renderings of
battle scenes, he mocks at 'l'immobilité dans la violence et l'épouvantable et
froide grimace d'une fureur stationnaire'. One odd and amusing example of
his close imaginative interpretation of the slightest gesture may be seen in
remarks in Delacroix's 'Romeo and Juliet' (897) [34]:

Dans l'étreinte violente de l'adieu, Juliette, les mains posées sur les épaules de son
amant, rejette la tête en arrière, comme pour respirer, ou par un mouvement
d'orgueil et de passion joyeuse. Cette attitude insolite, — car presque tous les peintres
collent les bouches des amoureux l'une contre l'autre, — est néanmoins fort natu-
relle: — ce mouvement vigoureux de la nuque est particulier aux chiens et aux chats
heureux d'être caressés.

To Baudelaire, 'la modernité, c'est le transitoire, le fugitif, le contingent'
(1163). In his first *Salon*, he picks out from a whole series by Decamps this
means of representing the fugitive and fleeting [37]: 'On reconnaît le génie de
Decamps tout pur dans cette ombre volante de l'homme qui enjambe plusieurs
marches, et qui reste éternellement suspendu en l'air... M. Decamps aime
prendre la nature sur le fait, par son côté fantastique et réel à la fois — dans
son aspect le plus *subit* et le plus inattendu' (823). I shall not attempt to illu-
strate the constant fascination for Baudelaire of all that is 'ondoyant' and
'miroitant' in 'le beau multiforme'. The artist who would render this shifting
complexity must, he holds, achieve extreme speed in execution; Delacroix is
a master here, and in Constantin Guys there is 'une ivresse de crayon, de
pinceau, ressemblant presque à une fureur'. The Baudelaire who saw that one
might often admire in an artist those qualities one most longs to possess is
haunted here by his own struggle to achieve adequate expression before the
moment of insight disappears: 'C'est la peur... de laisser échapper le fantôme
avant que la synthèse n'en soit extraite et saisie, c'est cette terrible peur qui
possède tous les grands artistes et qui leur fait désirer si ardemment de
s'approprier tous les moyens d'expression, pour que jamais les ordres de
l'esprit ne soient altérés par les hésitations de la main' (1168). To him, the
sharp outline, the over-finished and finical detail, suggest static self-satisfaction
rather than the aspiration he demands of Beauty; or else give a painful sense of
effort, where effort should give the illusion of ease. (Yet it is the sense of a pain-
ful and stylized effort, appealing to his own preoccupation with the struggles
of *la volonté*, which makes him find a particular stimulus in Ingres.) He
demands, however, not simply spontaneity but synthesis, realizes the dangers
of apparent ease in the technique of the 'eau-forte', and is uncompromising in

his attacks on works (e.g. some of Diaz) which provide instead of suggestive mobility, only a kaleidoscopic patchwork or the disorder of limbs that seem scattered by a railway explosion.

One of his most evocative longer passages, all the more significant in that it runs counter to his mistrust both of the 'mere' sketch and of the landscape without human focus, finds in Boudin's pastel sketches of cloudscapes a 'plénitude de jouissance': many passages from his own creative works where drifting clouds form the emblem of the shifting moods and dreams of man might obviously be set beside these works of Boudin, 'études, si rapidement et si fidèlement croquées d'après ce qu'il y a de plus inconstant, de plus insaisissable dans sa forme et dans sa couleur, d'après les vagues et les nuages' (1082).

Just as the infinite may be sensed through contrasting limitations, so mobility may be most suggestively conveyed through the impression of sharp, defined, geometrical outlines made shifting or impermanent. Masts and rigging of ships, wheels and harness of carriages, provide this challenge. Baudelaire calls up the combined precision and complexity of patterns in Whistler's Thames-side engravings, 'merveilleux fouillis d'agrès, de vergues, de cordages; chaos de brumes, de fourneaux et de fumées tirebouchonnées; poésie profonde d'une vaste capitale' (1148, 1150), and, in the article on Guys, analyses the sources of this pleasure:

une voiture, comme un vaisseau, emprunte au mouvement une grâce mystérieuse et complexe très difficile à sténographier. Le plaisir que l'œil de l'artiste en reçoit est tiré, ce semble, de la série de figures géométriques que cet objet, déjà si compliqué, navire ou carrosse, engendre successivement et rapidement dans l'espace [1191; cf. *Fusées* (1261), on man's basic need for both symmetry and complexity].

38 Meryon: 'La Tour de l'horloge' **39** David: 'Marat'

Some geometrical shapes, even when still, may fascinate by combining a complex loveliness of lines with both the physical and the mental suggestion of their impermanence. This outstanding passage on Meryon shows both the closeness of Baudelaire's contemplation of detail and the vigour and variety of his expression [**38**]. Each word first stresses the solidity and majesty of ancient buildings, then the violent and twining movement of belching smoke against the angry firmament; finally there stands out the temporary spider-web lace-work of scaffolding, the word *arachnéenne*, added in his revision of the passage, underlining its pattern and its impermanence:

Nous avons rarement vu, représentée avec plus de poésie, la solennité naturelle d'une grande capitale. Les majestés de la pierre accumulée, les clochers montrant du doigt le ciel, les obélisques de l'industrie vomissant contre le firmament leurs coalitions de fumée, les prodigieux échafaudages des monuments en réparation, appliquant sur le corps solide de l'architecture leur architecture à jour d'une beauté arachnéenne et paradoxale, le ciel brumeux, chargé de colère et de rancunes... Aucun des éléments complexes dont se compose le douloureux et glorieux décor de la civilisation n'y est oublié. [1149; cf. 1083].

The sense of flux and mobility may of course be conveyed by play of light and colour. If Baudelaire is occasionally captivated by bold contrasts or 'bitter' tones (Haussoullier or Janmot), he elsewhere sees over-rich and violent colouring as the appurtenance of the window-dresser or theatrical costumier, garish as a village scarf; he looks above all for a harmony, a system of relations involving subtle transitions and reflections, and culminating often in a muted effect whose rich subtleties emerge only on close contemplation. In Delacroix's 'Sultan du Maroc', where he hymns the 'prodigieux accord de tons nouveaux, inconnus, délicats, charmants', he stresses that 'Ce tableau est si harmonieux, malgré la splendeur des tons, qu'il en est gris — gris comme la nature — gris comme l'atmosphère de l'été, quand le soleil s'étend comme un crépuscule de poussière tremblant sur chaque objet' (818–9).[16] The *tour de force* passage on colour in the *Salon de 1846* brings out his double preoccupation: with a technical approach analysing relationships between complementaries, tones, reflections, and with an either expressive or symbolic approach, elsewhere associated with the famous term *correspondances*.[17] The second of these will clearly have richer consequences in his own work. What is important, however, is that he does not erect the potential symbolism of colour into any set of fixed, hieroglyphic equivalents. As in his poetry 'Ce qui dit à l'un: Sépulture!/Dit à l'autre: Vie et Splendeur!', so in criticism he draws attention to the infinite variables: 'Tout le monde sait que le jaune, l'orangé, le rouge inspirent des idées de joie, de richesse, de gloire et d'amour; mais il y a des milliers d'atmosphères jaunes ou rouges, et toutes les autres couleurs seront affectées logiquement et dans une quantité proportionnelle par l'atmosphère dominante' (1042).[18]

From his individual responses to colour I shall discuss only one, constantly recurring: his delight in the combination of red and green. Quite apart from technical or symbolic explanations, this was obviously an immediate reaction of his nerves: 'J'ai eu longtemps devant ma fenêtre un cabaret mi-parti de vert et de rouge crus, qui étaient pour mes yeux une douleur délicieuse.' In early criticism he flourishes the technical term: 'cette *pondération* du vert et du rouge plaît à notre âme' (816). The suggestive possibilities evoked come to centre on a preoccupation we have already seen: the fusion of violence and of peace; countless brief phrases convey the obsessive joy, in every mood from gay to sinister, 'partout, le rouge chante la gloire du vert' (881); 'L'uniforme égaye ici, avec l'ardeur du coquelicot ou du pavot, un vaste océan de verdure' (1061); 'le rouge... abondait tellement dans ce sombre musée, que c'était une ivresse; quant aux paysages... ils étaient monotonement, éternellement verts': 'le rouge, cette couleur si obscure, si épaisse, plus difficile à

pénétrer que les yeux d'un serpent, — le vert, cette couleur calme et gaie et souriante... je les retrouve chantant leur antithèse mélodique' (136); and finally 'cette sanglante et farouche désolation, à peine compensée par le vert sombre de l'espérance' (894).

If Delacroix specially fascinates him here, I want to look at a less immediately obvious example of how he is haunted by this combination, even when the meaning is implicit rather than specifically underlined: a passage on David's 'Marat' [39] (868–9). Here incidentally Baudelaire takes David not as an outmoded figure, but as an early example of what he is looking for in the Painter of Modern Life: the ability to synthesize from the trivial, the harsh or the ugly its latent solemnity. The kitchen knife, bare planks, letter, the famous ugliness of Marat himself; these might, he writes, figure in a 'realistic' novel by Balzac. A miracle of simplicity and speed has conferred outstanding and appropriate beauty and dignity, 'Cruel comme la nature, ce tableau a tout le parfum de l'idéal... Dans l'air froid de cette chambre, sur ces murs froids, autour de cette froide et funèbre baignoire, une âme voltige'. Against the

40 Daumier: 'Le Choléra' from *La Némésis médicale*

41 Guys: 'Trois femmes'

deliberate bareness, Baudelaire picks out those two colours that haunt him. The red of violent death is elaborated in each detail, 'L'eau de la baignoire est rougie de sang, le papier est sanglant : à terre gît un grand couteau de cuisine trempé de sang'. At the beginning is the simple mention of 'le pupitre vert placé devant lui', while at the end, 'tel qu'en lui-même', comes the achievement of peace : 'il repose dans le calme de sa métamorphose'.[19]

Baudelaire also noted that 'Les grands coloristes savent faire de la couleur avec un habit noir, une cravate blanche et un fond gris' (951). This interest in the art of suggestion through minimal means draws him to contemplation of engravings, woodcuts, etchings.[20] Of Daumier he writes : 'Ses lithographies et ses dessins sur bois éveillent des idées de couleur... Il fait deviner la couleur comme la pensée' (1004). His discussion of Daumier's 'Le Choléra' [40] shows the swiftness with which the black-and-white medium has suggested a whole range of sensations and reflections; it shows too how deliberately Baudelaire constructs his gradation of effects. He opens with a pervasive and violent general impression, glowing sensations beneath the burning sunlight, 'une place publique, inondée, criblée de lumière et de chaleur... le ciel... incandescent d'ardeur' (1004). After the sensation comes the bitter reflection on 'le ciel parisien, fidèle à son habitude ironique dans les grands fléaux et les grands remue-ménages politiques' (we remember the ironical sky of 'Une Charogne' or 'Le Cygne', or the ironical beauty of many fateful political days throughout the last two centuries). Neither sensation nor reflection is mere embroidery; they stem from the observation that the sun's force is conveyed by 'les ombres noires et nettes'.

Corpse and fleeing woman at the centre are indicated barely, with one sensorial detail to suggest the horror of the plague : the woman 'se bouchant le nez et la bouche'. We are brought back to the emptiness of the square, set once more against wide memories ('plus désolée qu'une place publique dont l'émeute a fait une solitude'); the deep and resonant dignity of despair, 'ce forum de la désolation', is then deliberately narrowed into the sharp delineation of grotesque nags trailing hearses in the distance ('haridelles comiques') and, as the last touch of harsh triviality, the skinny stray dog, each word intensifying its physical misery as it, 'maigre jusqu'aux os, flaire le pavé desséché, la queue serrée entre les jambes'.

In this very simple example, visual evocation is closely interwoven both with other sensorial effects and with wider reflections. I shall not attempt here any systematic examination of the extent to which Baudelaire almost imperceptibly introduces sense-impressions beyond the visual (we have already noted the pervasive cold in David's 'Marat'; in Delacroix's 'Croisés' iridescent

flags twisting in the wind convey the sound of their flapping; in Tabar's 'Guerre de Crimée' we breathe the cool scent of autumn sheaves or in Liès's 'Malheurs de la guerre' feel the jolting of conquerors' carts). Having looked rapidly at certain individual sense-impressions, I shall now take more generally certain examples of pictures, deliberately chosen to be very different from each other, which show details of Baudelaire's way of looking and expressing.

First, Legros's 'L'Angélus' (1046) [42]: Baudelaire's admiration has pained or puzzled some critics. He realizes that this is a 'modeste toile', and constructs a dialogue between himself and a conventional critic, M. C...; he also insists that good religious painting depends not on faith, but on the power to imagine and render faith. His remarks must be seen in chronological context; what worries his opponent, the conventional M.C..., is that the picture is an example not only of unfashionable religiosity, but of low and trivial 'realism', an ignoble village subject. Whatever Baudelaire's theories on relevance of subject-matter, it is clear that both subject and rendering have called up deeply rooted memories and sensations from his own sensibility, 'Comme les voilà bien revenues et retrouvées, les sensations de rafraîchissement qui habitent les voûtes de l'église catholique.' But what has centrally caught him is the artist's attempt to combine those two sides he himself wishes to see fused in 'la modernité'—a contemplation of the everyday or the grotesque so as to bring out its natural dignity with penetration and tenderness. The triviality of clothes upsets M. C... Baudelaire picks out the detail of 'coton, indienne, cotonnade, sabots et parapluies' (that most prosaic 19th century object, boldly in the foreground), and we remember his discussion elsewhere of the problem of rendering 'le tissu, le grain, le pli' of untraditional modern materials. In his description of the characters, creative physical terms evoke a theme of deep personal moment to himself: the cumulative effects of toil and suffering: 'tout voûté par le travail, tout ridé par l'âge, tout parcheminé par la brûlure du chagrin'. He concentrates on the background detail which most suggests to him the effect that may be drawn from the awkward and the ugly: 'l'enfant grotesquement habillé, qui tortille avec gaucherie sa casquette dans le temple de Dieu' (we almost glimpse Charles Bovary); and underlines his meaning by a literary allusion to a moment from the writings of Sterne which haunted him elsewhere—Sterne's loving contemplation of a donkey grotesquely devouring macaroons.[21] The central impression is summed up in 'la trivialité est ici comme un assaisonnement dans la charité et la tendresse'. Remarks on technique are brief, and introduced by 'j'oubliais de dire que', but

42 Legros: 'L'Angélus'

each relates execution to central effect: 'la couleur un peu triste et la minutie des détails s'harmonisent avec le caractère éternellement précieux de la dévotion'. As for M. C...'s objection that perspective is clumsily handled,[22] Baudelaire feels that its very awkwardness, by recalling the primitives, may suit its religious theme, 'ce défaut, je l'avoue, en me rappelant l'ardente naïveté des vieux tableaux, fut pour moi un charme de plus. Dans une œuvre moins intime et moins pénétrante, il n'eût pas été tolérable'.

Through this close contemplation of a partly unskilled work, Baudelaire suggests, whether or not the artist has fully realized them, something of the subtle possibilities of combination of tones that he himself so triumphantly creates in 'Les Petites Vieilles', as he deliberately interweaves *naïveté* and *préciosité* to draw natural dignity from the trivial or the grotesque. This particular picture has to him proved more evocative than the sentimentalities of an Ary Scheffer whom he so uncompromisingly attacks, more suggestive of his own aims than the work of a Millet whose peasants he considers too

self-consciously didactic, or a Courbet whom he sees as too unimaginatively close to brute nature. Both his reasons and his reservations are swiftly and allusively handled through the dialogue form.

Another form of suggestively using the most contemporary subjects, of endowing the trivial or the terrible with a momentary beauty or a lasting import, is what Baudelaire brilliantly evokes in Constantin Guys. That Guys has brought to a pitch certain almost mechanical tricks of stylization is recognized as Baudelaire characterizes his swift effects: 'On rencontre souvent l'Empereur des Français, dont il a su réduire la figure, sans nuire à la ressemblance, à un croquis infaillible, et qu'il exécute avec la certitude d'un paraphe... Quelquefois il est immobile sur un cheval dont les pieds sont aussi assurés que les quatre pieds d'une table...' [1174]. In keeping with the swiftness and multiplicity of Guys's sketches, Baudelaire's article draws a synthesis from many flickering effects rather than pausing in detail over individual works. It picks out as central impression the ability to convey 'le geste et l'attitude solennelle ou grotesque des êtres et leur explosion dans l'espace' (1169), and particularly notes the technique for giving swift highlights: 'M. Guys, traduisant fidèlement ses propres impressions, marque avec une énergie instinctive les points culminants ou lumineux d'un objet' (1166). That Guys's subjects go to the centre of Baudelaire's preoccupations is of course clear. For his personal expression of close reaction to detail I take this one example [41], which first evokes a general background, then moves in to a tiny notation, and finally adds its own grim reflection:

Dans un chaos brumeux et doré... s'agitent et se convulsent des nymphes macabres et des poupées vivantes dont l'œil enfantin laisse échapper une clarté sinistre; cependant que derrière un comptoir chargé de bouteilles de liqueurs se prélasse une grosse mégère dont la tête, serrée dans un sale foulard qui dessine sur le mur l'ombre de ses pointes sataniques, fait penser que tout ce qui est voué au Mal est condamné à porter des cornes [1189].

Baudelaire's own drawing of a seductive woman with the legend 'Quærens quem devoret' makes the bow around her hair give the same satanic suggestion.[24]

From Baudelaire's reflections on caricature I shall take two examples, again showing his swift personal reaction to the smallest detail, and his virulent expression of both its physical impact and its mental prolongation. Daumier's 'Le Dernier Bain' [43], which he calls a 'caricature sérieuse et lamentable', is a subject obviously near the bone. Baudelaire first forces home the startling geometrical effect, 'sur le parapet d'un quai... faisant un angle aigu avec la base d'où il se détache comme une statue qui perd son équilibre, un homme se

laisse tomber raide...' Physical details lead to the ironical reflection: the decisiveness of crossed arms and the enormity of the stone prove that 'ce n'est pas un suicide de poète qui veut être repêché et faire parler de lui'. Each detail of grotesque wretchedness is brought alive in epithets which give to objects a grim personality: 'C'est la redingote chétive et grimaçante qu'il faut voir, sous laquelle tous les os font saillie! Et la cravate maladive et tordue, et la pomme d'Adam, osseuse et pointue!'[25] Finally, an ironical footnote on a background detail: 'Dans le fond, de l'autre côté de la rivière, un bourgeois contemplatif, au ventre rondelet, se livre aux délices innocentes de la pêche.' If the provocative detachment is there in the lines of the picture, the 'ventre rondelet' is Baudclaire's own satirical touch.

Thomas Hood's 'Tell me, my heart, can this be love?' [44] is illustrated by the merest outline of a satirical Cupid; but the subject has provoked Baudelaire not only to translate a passage from *Whims and Oddities*, but to provide his own virulent verbal equivalent (1054–6). Rarely can there have been a more intense debauchery of deflating images, evoking a rich and sensuous disgust,

43 Daumier: 'Le Dernier Bain'

44 Hood: 'Tell me, my heart, can this be love?' from *Whims and Oddities*

45 Goltzius: 'Quis evadet'

46 J.-F. Baudelaire: 'La Surprise'

and leading at vertiginous speed to the stab of the climax. We are sick, says Baudelaire, of the conventional 'Cupidon des confiseurs... un poisson qui s'accommode à toutes les sauces':

ce vieux polisson, ailé comme un insecte, ou comme un canard, que Thomas Hood nous montre accroupi, et, comme un impotent, écrasant de sa molle obésité le nuage qui lui sert de coussin. De sa main gauche il tient en manière de sabre son arc appuyé contre sa cuisse; de la droite il exécute avec sa flèche la commandement: Portez armes! sa chevelure est frisée dru comme une perruque de cocher; ses joues rebondissantes oppriment ses narines et ses yeux; sa chair, ou plutôt sa viande, capitonnée, tubuleuse et soufflée, comme les graisses suspendues aux crochets des bouchers, est sans doute distendue par les soupirs de l'idylle universelle; à son dos montagneux sont accrochées deux ailes de papillon.

Behind this coruscation of satire, we are bound to remember the Goltzius engravings from which Baudelaire drew one of his subtlest, most suggestive and most serious of poems:

> L'Amour est assis sur le crâne
> De l'humanité,

47 Delacroix: 'Lutte de Jacob avec l'ange', detail

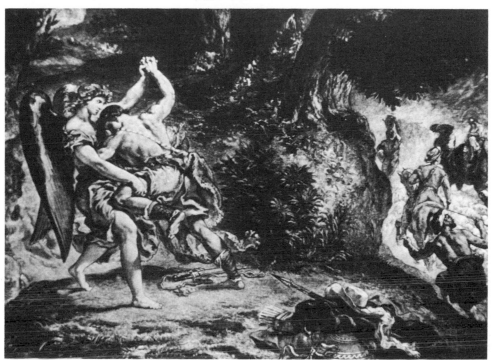

evoking the distant and lovely flight into infinity of the aspiring, frail, iridescent and transient bubbles, and concluding with his completely personal interpretation:

> Car ce que ta bouche cruelle
> Éparpille en l'air,
> Monstre assassin, c'est ma cervelle,
> Mon sang et ma chair!

I risk the suggestion that both pictures resurrect a complex memory of the picture by Baudelaire's father recently rediscovered and reproduced [46],[26] where on the pedestal of the statue can be glimpsed the opening words of the sinister Virgilian inscription: 'Frigidus, o pueri, fugite hinc, latet anguis in herba'—the threat of the sting that lurks in the delight.

Two last examples, from Baudelaire's lifelong admiration, show even in the briefest passages the combined care for detail and for breadth of suggestion. Each of these two Saint-Sulpice murals of Delacroix is given only a few lines (1109–10); from each Baudelaire has selected and concentrated those details

which lie closest both to his personal struggle and to his vision of man. First, Jacob and the Angel [47]. 'Au premier plan, gisent, sur le terrain, les vêtements et les armes dont Jacob s'est débarrassé pour lutter corps à corps.' Reproductions today sometimes rightly pick out this detail in itself as a still-life of unusual beauty.[27] Baudelaire comments only on its meaning (in the final struggle one is stripped of all adventitious aids) yet visually he puts it first. His one sentence on the two wrestlers finds vocabulary and images to stress the rendering of a being bending all his force against the abstract calm of the absolute: 'Jacob incliné en avant comme un bélier et bandant toute sa musculature, l'ange se prêtant complaisamment au combat, calme, doux comme un être qui peut vaincre sans effort des muscles et ne permettant pas à la colère d'altérer la forme divine de ses membres.' Man battling with the transcendent: and opposite it, man transcendentally condemned for guilt. In the Heliodorus mural [48] Baudelaire at the beginning evokes the richness and immensity of the background, and at the end takes the eye back to those watchers from the height of the immense staircase who gaze with those same double feelings he himself so often experiences and creates: 'avec horreur et ravissement'. Nearer the centre are the scourging angels, again suggesting the power and impassivity of transcendent justice as they 'fouettent avec vigueur mais aussi avec l'opiniâtre tranquillité qui convient', and the avenging rider whose dazzling beauty represents 'toute la solennité et le calme des cieux'. The focus of the whole is made to rest on the hoof of the horse, with a cruel and calm elegance of gesture holding the victim suspended in the endless moment of expiation.[28]

To Baudelaire, the artist rejects conventional 'poncifs', looks at the physical world and transforms it through his individual temperament. Similarly, the critic's means of expression, so constantly broadening into general insights, are rooted in the physical world. Abstract formulae, lapidary in their concision, do constantly stand out strongly: 'L'étude de la nature conduit souvent à un résultat tout différent de la nature' (883); 'Plus on possède d'imagination, mieux il faut posséder le métier pour accompagner celle-ci... Et mieux on possède son métier, moins il faut s'en prévaloir et le montrer' (1029). But, through the deliberately varied tones of leisurely conversation, sustained evocation of delight, or meditative reflections of a *moraliste*, constantly flash rich, violent or subtle images, not as mere verbal paraphrase, but as a means to provoking personal reaction. Attack is uninhibited: on the huge eyes by Lehmann 'où la prunelle nage comme une huître dans une soupière', on 'les puces de M. Meissonier', on Horace Vernet's 'masturbation agile et fréquente, une irritation de l'épiderme français', on a multitude of purveyors of pretti-

48 Delacroix: 'Hélidore chassé du temple' 49 'Baudelaire par lui-même'

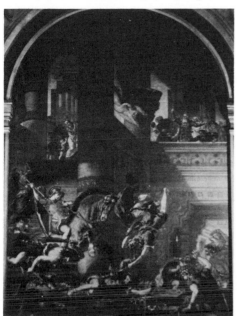 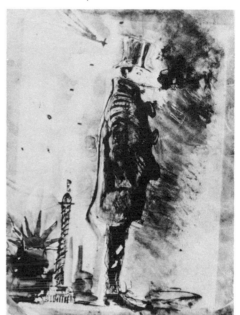

fied religiosity: 'ce capharnaüm de faux ex-voto... cette immense voie lactée de plâtreuses sottises', on the kind of artist who gives 'draperies tubulées et tortillées comme du macaroni', or would be capable of transforming the great tombs of Saint-Denis into cigar-boxes and patterns for shawls.

In this world of sensation and suggestion there are constantly recurring images taken from the art of cooking—for Baudelaire explicitly held that this was a subtle and disciplined art to be set by the side of poetry, music or mathematics—and to the art of tasting. Condiments, seasonings, sauces, pastry decorations: these and many others are used as suggestive images with their both serious and satirical place as a part of the 'correspondances' in a world of harmonious joy for both senses and intellect.

In this expression of praise, two sides of Baudelaire's own nature, as a 'paresseux nerveux', emerge specially strongly. On the one hand, there is the recurring image of explosion, whether for joy, energy, laughter, colour or light. Or flooding energy and a sense of prolonged vibration find strong and varied verbs to convey the resonance of four associated sensations: 'partout où peut resplendir la lumière, retentir la poésie, fourmiller la vie, vibrer la musique' (1162). On the other hand, he evokes the shifting and intangible

softness of drifting clouds and vapours: the 'mollesse floconneuse' of skies in Théodore Rousseau, or the Delacroix sky in the Luxembourg ceiling, 'les nuages, délayés et tirés en sens divers comme une gaze qui se déchire', or suggests the melancholy hypersensitive indolence we have seen in Delacroix's 'Ovide', or the languor of a Commodus, 'jeune, rose, mou et voluptueux, et... qui a l'air de s'ennuyer'.[29] And in Delacroix's 'Femmes d'Alger', of which he possessed a contemporary copy, beneath a surface appeal 'le plus coquet et le plus fleuri', he reads for himself 'les limbes insondés de la tristesse'.

Fully to examine such means of expression would of course demand a detailed study. I have raised only a very few suggestions. I have intentionally left aside today all that other scholars have so penetratingly discussed on the suggestive contribution of the plastic arts to *Les Fleurs du mal*. Baudelaire once desperately imagined the artist 'assailli par une émeute de détails, qui tous demandent justice avec la furie d'une foule amoureuse d'égalité absolue' (1167). Against this he set the harmony of selective creation, with its power to call miraculously to life the hidden responses of the human being: before certain pictures he hears a cry of 'Lazare, lève-toi' (1168) or feels 'un petit vent frais qui fait se hérisser le souvenir'. His writings on the visual arts select in a deliberately personal way those details which have what he called a 'resurrectionist' effect on deeply rooted responses. Many readers will find them suggestive principally as a means of insight into his own creative skill; but there remains too his way of making us re-examine the pictures he discusses. He himself paraphrased a line of verse: 'Et le tableau quitté nous tourmente et nous suit' (971). Whether or not we share Baudelaire's personal judgments or aesthetic principles, I have hoped simply to suggest that his way of freshly looking at both general impression and detail, and his gift for sharp and suggestive expression, constantly provoke and enrich our own means of both seeing and enjoying.

As a tailpiece, one example of how Baudelaire expresses himself in water-colour and not in words [49]. Certainly no mere copy of nature; an interpretation at once grotesque and solemn. Correspondences of shape are the first impression: the verticals of the self, of the Colonne Vendôme and of the factory chimneys in the distance; the brim of the hat echoing the top of the column and the huge boots its base. Real proportions are boldly reversed, not so much for perspective, as to make man uncompromisingly the towering centre. The fascination of geometrical shapes is evident again in the stylized rays of the setting sun, bisected as it is in Baudelaire's description of a plate by Rethel where it figures as an emblem of the close of life.[30] In contrast to the

stiffness of column and jaggedness of rays is set the opposite sensorial effect, that of the twining clouds of smoke; here it is man who puffs defiantly against the sullen sky those 'coalitions de fumée' echoed by a faint plume from the tiny chimney in the background. Both the stiffness and the spiralling effect of the city clothing are echoed in the column. The face might recall Baudelaire's description of a 'Hamlet' by Delacroix—'délicat et pâlot... avec un œil presque atone' (971); what comes most sinisterly alive (and we remember Baudelaire's comment on the tie twisted round the ankles in Daumier's 'Le Dernier Bain') is those springing shoe-laces. A darting winged object, mysteriously threatening (recalling Meryon or the evil Cupid?), streaks towards him through the sky. Here momentarily Baudelaire has himself schematically suggested something of what he looks for in 'le peintre de la vie moderne'.

Notes

(1) Page-references in the text will be Baudelaire's *Oeuvres complètes,* ed. Y.-G. Le Dantec, édition révisée, complétée et présentée par Claude Pichois, Paris, Gallimard (édition de la Pléiade), 1961.
In a brief article of this kind, full reference to excellent previous studies is impossible. See the index of R. T. Cargo, *Baudelaire Criticism 1950–1967,* University of Alabama Press, 1968, and the 'États présents' by Cl. Pichois (*L'Information littéraire,* 1958) and L. J. Austin (*Forum for Modern Language Studies,* III, 4, Oct. 1967). Among articles which have appeared since may be noted: L. J. Austin, 'Baudelaire et Delacroix'; W. Drost, 'De la critique d'art baudelairienne' (both in *Baudelaire: Actes du Colloque de Nice,* Paris, Minard, 1968); G. Poulet, 'Baudelaire précurseur de la critique moderne' in *Journées Baudelaire — Actes du Colloque de Namur,* Brussels, Académie royale de langue et de littérature françaises, 1968; Yoshio Abé, 'Baudelaire face aux artistes de son temps' in *Revue de l'Art,* 1969, 4; J. C. Sloane, 'Baudelaire as Art Critic' in *Bulletin baudelairien,* Nashville, Tennessee, V, 1; D. J. Kelley, 'Deux aspects du *Salon de 1846* de Baudelaire: la dédicace aux bourgeois et la couleur' in *Forum for Modern Language Studies,* V, 4, Oct. 1969.
(2) Baudelaire, *Lettres inédites aux siens,* présentées et annotées par Philippe Auserve, Paris, Grasset, p. 153. Letter of July 1838.
(3) See M. C. Spencer, *The Art Criticism of Théophile Gautier,* Geneva, Droz, 1969.
(4) *Lettres inédites aux siens,* p. 170 (Feb. 1839).
(5) See especially the following: *Les Fleurs du mal, Les Épaves, Sylves,* avec certaines images qui ont pu inspirer le poète, édition établie par Jean Pommier et Claude Pichois

(Paris, Club des Libraires de France, 1959, reprinted 1967); Jonathan Mayne, *The Mirror of Art* (London, Phaidon, Anchor, 1955); Jonathan Mayne, *Baudelaire: The Painter of Modern Life and Others Essays* (London, Phaidon, 1964); Jonathan Mayne, *Baudelaire: Art in Paris, 1845-62* (London, Phaidon, 1965); B. Gheerbrandt, *Baudelaire critique d'art* (Paris: Club des Libraires de France, 1956); J. Adhémar's edition of the *Curiosités esthétiques* (Lausanne, Éditions de l'Oeil, 1956); G. Poulet and R. Kopp, *Qui était Baudelaire?* (Geneva, Skira, 1969); the Catalogue of the Baudelaire Exhibition at the Petit Palais, 23 Nov. 1968 to 17 March 1969 (Paris, Réunion des Musées Nationaux, 1968); P.-G. Castex, *Baudelaire critique d'Art* (Sedes, 1969).
(6) Several passages object to the contamination of one art form by another. Cf. 'Je désire qu'un artiste soit lettré, mais je souffre quand je le vois cherchant à capter l'imagination par des ressources situées aux extrêmes limites, sinon au-delà, de son art' (1064); see also pp. 1008, 1031, etc. Baudelaire's views on allegory, which in the *Salon de 1845* he calls 'un des plus beaux genres dans l'art', on several occasions stress the difference between its generally suggestive function and the dangers of a fixed system of equivalents (over-ingenious, over-rigid, anachronistic) (cf. 1014). Moreover, 'même à l'esprit d'un artiste philosophique, les accessoires s'offrent, non pas avec un caractère littéral et précis, mais avec un caractère poétique, vague et confus, et souvent c'est le traducteur qui invente *les intentions*' (1101).
(7) La bonne manière de savoir si un tableau est mélodieux est de le regarder d'assez loin pour n'en comprendre ni le sujet ni les lignes' (883). 'Un tableau de Delacroix, placé à une trop grande distance pour que vous puissiez

juger de l'agrément des contours ou de la qualité plus ou moins dramatique du sujet, vous pénètre déjà d'une volupté surnaturelle... Et l'analyse du sujet, quand vous vous approchez, n'enlèvera rien et n'ajoutera rien à ce plaisir primitif' (1124).

(8) Cf. his defence of Balzac's supposed way of looking at pictures (957). W. Drost in the article quoted in note 1, discusses further aspects of Baudelaire's reaction to subject. Baudelaire is of course willing to claim the right to contradiction and to admiring an individual artist contrary to his own general principles. His treatment of Chenavard in painting might be compared with his attitude to Marceline Desbordes-Valmore in poetry.

(9) E.g., p. 957.

(10) See, quoted in H. Lemaitre's edition of the *Curiosités esthétiques* (Paris, Garnier, 1962), p. 400, Delacroix's letter of 8 Oct. 1861: 'Vous m'avez écrit, il y a deux mois, relativement au procédé que j'emploie pour peindre sur mur.'

(11) Here Baudelaire's response should be compared with his very strong reaction to the Baron picture discussed in 1859 (1062).

(12) He does not comment specifically on the combination of reds and greens; this must certainly have affected him strongly (see below). Reproductions fail to bring out the sharpness of the green in particular.

(13) In certain English painters, 'représentants enthousiastes de l'imagination', he notes the 'profondeurs fuyantes des aquarelles, grandes comme des décors, quoique si petites' (1026) Delacroix above all conveys to him 'l'infini dans le fini' (1053).

(14) Cf. also on one of his Athens pictures: 'Tous ces petits personnages... rendent plus profond l'espace qui les contient' (1173).

(15) Cf. on Lavielle: 'une lisière de bois, avec une route qui s'y enfonce... il y a une volupté élégiaque irrésistible que connaissent tous les amateurs de promenades solitaires' (1080). See also the passage on Delacroix's Luxembourg ceiling: 'Ce paysage circulaire, qui embrasse un espace énorme... un horizon à souhait *pour le plaisir des yeux*' (896).

(16) Cf. also remarks on Corot and Fromentin in particular.

(17) For wider aspects of this passage see the article by D. J. Kelley listed in note 1 above.

(18) For general remarks on 'le sens moral de la couleur, du contour, du son et du parfum' see especially the discussion on imagination and analogy (1037). Occasional remarks touch on the allusive attributes of particular colours, e.g. 'le rose révélant une idée d'extase dans la frivolité... violet (couleur affectionée des chanoinesses)' (1187). The sense of context is always important.

(19) Having opened with its cruelty, Baudelaire ends: 'il y a dans cette œuvre

quelque chose de tendre et de poignant à la fois'. I discuss below the fusion of the grotesque and tender he finds in Legros. Cf. his remark that the caricatures of Traviès contain 'quelque chose de sérieux et de tendre' (1013).

(20) That some of these are commented on more closely than are many paintings is a natural result of their easy accessibility. Baudelaire possessed many himself.

(21) Cf., p. 307, 'Les Bons Chiens' and note in R. Kopp's edition of the *Petits poèmes en prose* (Corti, 1969), p. 364.

(22) Cf. note in J. Mayne, *Art in Paris*, p. 165, on this point.

(23) Gautier's introduction to *Les Fleurs du mal* (Calmann-Lévy, s.d.) has some interesting pages on Baudelaire and Guys (noted by Gustave Geffroy, *Constantin Guys*, Crès, 1920). Gautier remarks that he gave Baudelaire several of Guys' works and analyses some of Baudelaire's reasons for enthusiasm and reservations. Some passages run closely parallel with parts of Baudelaire's article. For interesting *rapprochements* between the literary and the visual see *Au temps de Baudelaire, Guys et Nadar*, avant-propos de François Boucher, présentation d'Anne d'Eugny en collaboration avec René Coursaget (Éditions du Chêne, 1945).

(24) See *Baudelaire, Documents iconographiques,* ed. Cl. Pichois and Fr. Ruchon (Geneva, Cailler, 1960), pl. 122; also reproduced in many other works.

(25) Cf. in *Salon de 1846*, on the general problem of representing modern dress, 'les plis grimaçants, jouant comme des serpents autour d'une chair mortifiée, n'ont-ils pas leur grâce mystérieuse?' (951).

(26) Reproduced for the first time in *Documents iconographiques* (see above, note 24), pl. 60.

(27) See Lee Johnson, *Delacroix*, London, Weidenfeld and Nicolson, 1963, pl. 67.

(28) A different vision of triumphant rider and trampling hoof struck Baudelaire in the Mortimer engraving which inspired the poem 'Une Gravure fantastique'. See F. W. Leakey, 'Baudelaire and Mortimer', in *French Studies*, VII, 2, 1953.

(29) Cf. his evocation of Delacroix's *Hamlet* 'tout délicat et pâlot, aux mains blanches et féminines, une nature exquise, mais molle, légèrement indécise, avec un œil presque atone' (971) or of Guérin's Cleopatra, who "une créole aux nerfs détendus, a plus de parenté avec les premières visions de Chateaubriand qu'avec les conceptions de Virgile... son œil humide, noyé dans les vapeurs du Keepsake..." etc.

(30) See p. 1101. The Rethel plate is given in Mayne, *Painter of Modern Life*, pl. 50.

Eileen Souffrin-Le Breton

4
Banville et la poétique du décor

C'est Baudelaire qui attire notre attention sur l'importance de l'idée de décor dans la poésie de Banville, et cela dans son article intitulé 'Théodore de Banville' qui parut dans la *Revue fantaisiste* du 15 août 1861. Pratiquant une méthode qu'avait proposée Sainte-Beuve, Baudelaire recherche quels sont les mots que Banville a utilisés le plus fréquemment, ces mots traduisant les thèmes obsessionnels du poète. Baudelaire en conclut que le mot clef chez Banville est le mot 'lyre'. Baudelaire commente ainsi : 'la *Lyre* étant expressément chargée de traduire les *belles heures*, l'ardente vitalité spirituelle, l'homme hyperbolique, en un mot, le talent de Banville est essentiellement, décidément et volontairement lyrique'. Baudelaire constate ensuite que les figures de rhétorique préférées de Banville sont l'hyperbole et l'apostrophe, ces figures —que Baudelaire appelle 'des formes de langage'—lui sont, dit Baudelaire, non seulement des plus agréables, mais aussi des plus nécessaires'. Baudelaire, après avoir observé que 'l'âme lyrique fait des enjambées vastes comme des synthèses', explique : 'C'est cette considération qui sert à nous expliquer quelle commodité et quelle beauté le poëte trouve dans les mythologies et dans les allégories'. C'est alors que Baudelaire introduit la notion qui fait l'objet de notre exposé d'aujourd'hui ; ce qui est très intéressant, c'est qu'il introduit cette notion en la liant à l'hyperbole. Toujours à propos de la poésie de Banville, Baudelaire note : 'Ici, le paysage est revêtu, comme les figures, d'une magie hyperbolique ; il devient *décor*',[1] et Baudelaire met en italiques le mot 'décor'. Autrement dit, pour Baudelaire, le décor est un élément essentiel du lyrisme, d'où l'importance du décor chez Banville qu'il présente comme le poète lyrique par excellence, le lyrisme étant conçu comme un langage avant tout hyperbolique. Tel est le problème d'esthétique que pose Baudelaire et que nous allons maintenant examiner.

Le terme de 'décor' fait son apparition dès le premier recueil de Banville, c'est-à-dire dès *Les Cariatides* qui paraissent en 1842, lorsque notre poète n'a que dix-neuf ans. Dans un long poème intitulé 'La Voie lactée', et qui va

être dans la poésie de Banville l'équivalent du poème de Baudelaire sur 'Les Phares', à savoir un hommage aux grands artistes inspirateurs, Banville célèbre Victor Hugo, dont il s'affirmera toujours le disciple, et voulant souligner l'importance du thème de la nature dans la poésie de Hugo, Banville écrit :

> Ce sont des ruisseaux d'or, de larges horizons,
> Des fruits divers donnés à toutes les saisons,
> Des cascades, des fleurs, de grandes voûtes d'arbres,
> Des cailloux anguleux plus brillants que des marbres,
> Des oiseaux garrulants qui s'envolent troublés,
> De gais coquelicots qui dansent dans les blés,
> Des lacs aux flots unis où, sans cesse jetée,
> La lumière dessine une moire argentée,
> Des cieux pleins de blasons qui paradent au loin
> Et de vagues parfums qui s'exhalent du foin !
> Et sur ce beau décor, un choeur immense, un monde.[2]

Ainsi, dès 1842, la nature est devenue, aux yeux de Banville, un 'beau décor'. Remarquons que ce paysage, qui a déjà un accent hyperbolique, n'est pas tellement un paysage de Victor Hugo ; par contre, il annonce le paysage typique de Banville.

Mais ne quittons pas encore ce poème de 'La Voie lactée'. Banville rend hommage aux comédies de Shakespeare, et il représente Shakespeare en train d'imaginer ses personnages :

> Mais ce qui le ravit dans une molle ivresse
> C'est ce théâtre bleu couché dans sa paresse.[3]

Toutefois, ce théâtre n'est pas un théâtre ordinaire car Banville le représente :

> Sans quinquets enfumés, ni ciel de toile peinte,

et, aussitôt après avoir ainsi rejeté tout décor, Banville transforme tout le paysage en un décor. Le paysage ici devient non seulement plus précis, mais encore — sans vouloir faire de jeu de mots — plus précieux, et nous prenons ici ce terme dans son sens historique. Banville décrit, en effet, un paysage où :

> Des cascades d'argent dans des pays quelconques
> Versent leurs diamants aux marbres de leurs conques ;
> Des arabesques d'or se brodent sur les cieux ;
> Les arbres sont d'un vert qui ferait mal aux yeux ;
> Tout est très-surprenant sans causer de surprises.[4]

Les personnages qui errent dans ce décor ont des costumes particulièrement ambigus en ce sens que les femmes s'habillent en hommes et que d'autre part, avec un art très subtil, Banville décrit les étoffes comme s'il parlait d'objets faisant partie de la nature. Autrement dit, les personnages semblent se fondre dans le décor :

> Les femmes ont au corps les plus riches étoffes,
> Des robes de brocart, de saphirs et d'oiseaux,
> Souples comme une vague ou comme des roseaux ;
> Des mantelets aurore ou bien couleur de lune.[5]

A cet endroit, Banville ajoute une note qui, dès 1842, préfigure étonnamment les équivoques de Verlaine dans les *Fêtes galantes* :

> Elles vont très-souvent mises en cavaliers,
> Tiennent avec pudeur mille propos infâmes.

Banville mentionne alors dans son poème un personnage de *L'Astrée* d'Honoré d'Urfé, ce qui montre que notre adjectif de 'précieux' n'était pas choisi au hasard :

> Des Céladons poudrés, amants d'une Égérie,
> En habits de satin font de la bergerie.

Ce terme de 'satin', nous le retrouverons dans un poème des *Stalactites*, qui constituent le second recueil de Banville et qui paraissent en 1846, quatre ans donc après son premier recueil. Il s'agit du poème intitulé 'L'Arbre de Judée'. Après avoir parlé des fleurs de cet arbre, Banville dit :

> Quand la feuille leur met son beau satin ouvert,
> Ils sont plus doux encore aux regards de l'artiste ;
> La pourpre s'adoucit près du feuillage vert,
> Et la tendre émeraude encadre l'améthyste.[6]

Deux vers de la strophe suivante nous montrent à quel point, à cette époque là, Banville avait pris une allure précieuse — et même rococo — puisque, parlant de la nature, il emploie des métaphores empruntées au monde des objets fabriqués de main d'homme :

> Je veux, couché sur l'herbe, oubliant toutes choses,
> Dans ses vivants écrins égarer mon esprit.

Et, tout d'un coup, nous passons de cette description précieuse de l'arbre de Judée à l'évocation d'un monde imaginaire qui va se révéler comme un monde

du XVIIIe siècle, et comme un monde du théâtre. Nous nous retrouvons soudain dans un parc à la française :

> Sous ces bosquets charmants, épanouis pour eux,
> Pleins d'ombrages secrets et de faibles murmures,
> Voyez ces beaux enfants, ces couples amoureux
> Qui vont en écartant les épaisses ramures.
>
> C'est toi, belle Rosine ! Hélas ! le vert rideau
> Nous dérobe tes pieds, les plus charmants du monde.

Banville fait ici allusion, comme je l'ai montré dans mon édition critique des *Stalactites*, au *Barbier de Séville*. Nous restons dans la note XVIIIe siècle avec la strophe suivante, qui se termine par un vers très verlainien et où va reparaître l'image si banvillienne du satin :

> Quel est ce bruit de cor qui passe dans les bois ?
> C'est la chasse qui vient : salut, blanches marquises !
> Mettez les cœurs en flamme et le cerf aux abois,
> Vos paniers de satin ont des façons exquises.

Le premier vers de la dernière strophe nous donne nettement la clef de toute cette rêverie, et la date du poème fait que ce vers est un témoignage sur l'histoire du goût dans certains groupes littéraires vers le milieu du XIXe siècle :

> C'est ainsi que je rêve aux temps des Pompadours.

On retrouve la même atmosphère et le même décor, avec la même obsession du satin, dans un autre poème des *Stalactites*, 'La Symphonie de la neige' :

> En cavalcade, au long des terrasses de brique,
> Des dames, dont Zéphyr baise le front mutin,
> Avec des cavaliers au sourire lubrique,
> Passent dans leurs habits d'hermine et de satin.[7]

La strophe suivante nous introduit dans un décor nocturne qui est aussi un décor lumineux, ambiguïté de la nuit et du jour dont nous aurons encore d'autres exemples dans Banville :

> Les pages, les muguets langoureux et bravaches,
> Et les belles de cour, aux cheveux crespelés,
> Font briller dans la nuit, sous d'insolents panaches,
> Les fronts de leurs chevaux d'une flamme étoilés.

Certes, il existe des poèmes de Banville où il n'y a point d'équivoque, des poèmes où le décor est incontestablement un décor de théâtre. Il en est ainsi

dans le poème des *Stalactites* où Banville évoque les trois grandes ballerines romantiques:

> Elssler! Taglioni! Carlotta! sœurs divines
> Aux corselets de guêpe, aux regards de houri,
> Qui fouliez, en quittant le carton des collines,
> Le splendide outre-mer des ciels de Cicéri![8]

L'allusion à Cicéri est des plus précises, car Cicéri était alors le plus célèbre des peintres travaillant pour l'Opéra et il était renommé en particulier pour la qualité lumineuse de ses ciels.[9] La notation 'carton des collines' indique d'ailleurs nettement qu'il s'agit ici d'un décor pour la scène et l'on peut regretter que dans une édition ultérieure du texte Banville y ait substitué le plus banal 'gazon des collines'. Une variante dans le titre même du poème prouve que cette composition si étonnamment théâtrale s'adressait à une ballerine.[10] Un autre poème du même genre évoque Carlotta Grisi dans le fameux 'pas du songe' de *La Péri*:

> Elle va dans l'azur, laissant flotter ses voiles,
> Conduire en souriant la danse des étoiles,
> Poursuivre les oiseaux et prendre les rayons;
> Et, par les belles nuits, d'en bas nous la voyons;
> Dans les plaines du ciel d'ombre diminuées,
> Jouer, entrelacée à ses soeurs les nuées,
> Ouvrir son éventail et se mirer dans l'eau.[11]

Il s'agit là d'un décor de théâtre et nous le savons, mais, en fait, ce décor n'est pas plus artificiel que ne le sont nombre de paysages dans la poésie de Banville. En effet, ce qui frappe sans cesse chez Banville, c'est la manière dont il parvient à créer une nature mi-féerique, mi-réelle. Nous sommes dans un parc à la française où errent des personnages habillés de costumes du XVIIIe siècle. S'agit-il d'une scène de théâtre? Sommes-nous en train de contempler un paysage véritable, ou seulement un décor peint? Il se crée ainsi une atmosphère de mystère.

Il y a toutefois un poème qui éclaircit le mystère. C'est le poème intitulé 'Arlequin et Colombine' et qui reste peu connu, n'ayant pas été recueilli dans l'édition définitive des oeuvres de Banville. Le poème parut d'abord dans *L'Artiste* du 1er septembre 1853 et ensuite dans la deuxième édition des *Stalactites* en 1857. Le paysage que décrit Banville dans ce poème, que je citerai en entier, ressemble étonnamment au paysage que nous avons trouvé dans 'La Voie lactée' de 1842 avec, en plus, les statues de marbre auxquelles

Les Stalactites de 1846 nous ont habitués : le paysage est du reste animé ici par deux personnages de théâtre :

> Bosquets harmonieux, célestes paysages,
> Sérénité des eaux, profondeur des ombrages,
> Frondaison lumineuse où resplendit la nuit,
> Où l'atmosphère en feu dans l'obscurité luit,
> O forêts et jardins, retraites et fontaines,
> Horizons ruisselants de tendresses hautaines
> Sources vives, guirlande amoureuse, beaux parcs,
> Où les bambins joufflus tendent au loin leurs arcs,
> Lointains de pourpre rose où les aurores saignent,
> Flot scintillant de lune, où doucement se baignent
> Des nymphes au dos svelte, adorables lueurs,
> Grave et sombre idéal, mystères enchanteurs,
> Voix des oiseaux mêlée à l'haleine des roses,
> Solitudes des bois pures et grandioses.

50 Watteau : 'Les Champs-Elysées'

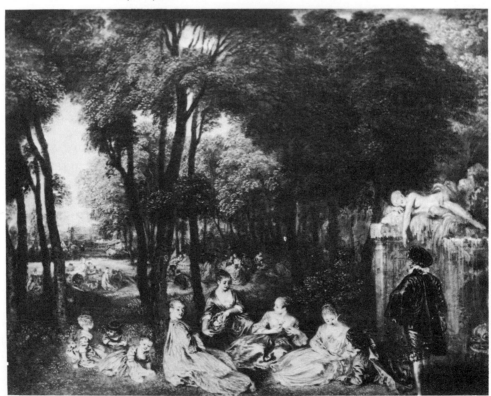

51 Watteau: 'Arlequin et Colombine' **52** Watteau: 'La Perspective'

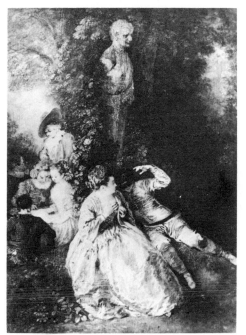

Jusqu'ici nous avons le paysage typique de Banville. Mais voici que le poète nous fournit enfin une clef :

> Oh ! que vous rayonniez, paysage endormi,
> Lorsque le grand Watteau faisait errer parmi
> Votre ombre étincelante et votre nuit divine
> Son Arlequin rêveur auprès de Colombine![12]

Oui. Le paysage qu'évoque si souvent Banville est le paysage de Watteau. C'est Watteau qui, si souvent, peint ce parc à la française, avec ses grands arbres, ses pièces d'eau, ses fontaines et ses statues, ses palais, ses personnages habillés dans la mode du XVIIIe siècle ou travestis comme des personnages de la Commedia dell'Arte. C'est Watteau qui obtient ces effets de lumière si curieux que l'on ne sait plus si l'on assiste à un spectacle de théâtre ou à une fête en plein air. C'est Watteau le peintre par excellence de l'ambiguïté.[13]

Or, les débuts de Banville ont coïncidé avec la redécouverte de Watteau en France. On sait que la gloire du peintre des *Fêtes galantes* avait connu une éclipse au moment de la Révolution et de l'Empire et qu'il faudra attendre la fin de la domination davidienne, après 1830 par conséquent, pour que

l'attitude change. Ce regain de faveur sera surtout notable après 1840 ; les prix qui seront alors atteints dans les ventes reflèteront clairement la cote grandissante de Watteau. Ainsi Georges, peintre expert près du Louvre qui en 1845 établit le Catalogue de la vente Fesch, n'hésite pas à déclarer : 'Il n'est pas de tableaux... plus recherchés aujourd'hui en France et en Angleterre que ceux de Watteau.'[14] C'est le moment du reste où le docteur Lacaze commence à former la fameuse collection qu'il devait léguer au Louvre ; le marquis de Hertford, qui collectionne des tableaux depuis 1841, achètera son premier Watteau en 1848. Si l'on compulse la presse de l'époque, l'on constate qu'au lendemain de 1830 il y a déjà nombre d'allusions à Watteau mais que c'est aux environs de 1840 seulement que les articles se multiplient ; l'année de la vente Fesch, on en compte beaucoup. La redécouverte de Watteau a été, en réalité, l'œuvre d'un petit nombre d'hommes, écrivains et peintres qui avaient fait partie de la Bohème Galante. C'étaient, pour la plupart, des collaborateurs de L'Artiste, et des amis intimes de Banville ;[15] je veux parler d'Arsène Houssaye, de Gautier, de Léon Gozlan, de Paul Hédouin, de Champfleury. Dans L'Artiste, celui-ci, par exemple, étudie les dessins de Watteau en 1845 ; le 16, 25 et 30 novembre de la même année, également dans L'Artiste, Hédouin essaie d'établir un premier catalogue de l'œuvre de Watteau et constate que Watteau est devenue déjà 'l'objet d'une espèce de fanatisme'. C'est dans son Salon de 1846 que Baudelaire fait allusion à 'L'Embarquement pour Cythère'.

A cette date, Watteau avait suffisamment pénétré dans le grand public pour qu'il fût de bon ton d'avoir un intérieur décoré à la Watteau. Nerval décrit l'appartement de Jules Janin, qui était d'ailleurs voisin de la famille de Banville : 'Les portes et les panneaux, dit Nerval, sont couverts de gracieuses peintures dans le style de Watteau, exécutées par des peintres amis de Jules Janin.'[16] L'on sait, du reste, que le peintre Wattier s'était spécialisé en quelque sorte dans l'imitation de Watteau.[17] Ce n'est pas une pure coïncidence si, dans Le Cousin Pons (qui est de 1847), il est beaucoup question de Watteau. Balzac reconnaît, par le truchement de l'un de ses personnages, que Watteau 'est fort à la mode',[18] et le cousin Pons, qui est un vrai connaisseur, estime que la plus belle pièce de sa collection est un éventail peint par Watteau.

Ce qui nous intéresse particulièrement pour notre sujet, c'est que l'influence de Watteau s'étend au théâtre. Gautier note déjà en février 1840 :

Le pas tiré du ballet de Manon Lescaut est tout ce que l'on peut imaginer de plus trumeau, de plus Watteau, de plus Pompadour ; c'est un dessus de cheminée en action, un éventail vivant : Lancret, Lépicié, Boucher, n'ont rien fait de mieux : figurez-vous ce bon et spirituel Barrez en costume de pèlerin partant pour Cythère,

avec une houlette, une musette, tout l'attirail d'un berger du Lignon... Mademoiselle Forster est une charmante bergère que Watteau eût volontiers prise pour modèle.'[19]

Pour jouer du Musset, on habille les acteurs dans des costumes à la Watteau : Antoine Benoist signale que, dans le rôle de Fortunio, Delaunay 'portait un habit gorge de pigeon et il avait l'air de sortir d'une toile de Watteau'.[20] A voir les diverses manifestations de cette vogue, on a l'impression que Théophile Gautier n'exagère pas beaucoup lorsqu'il affirme en 1852 : 'Les esprits les plus froids, les plus prosaïques, les plus sèchement utilitaires, n'ont pu se défendre de cet entraînement, tant la séduction du magicien est grande'.[21]

Gautier a surtout compris ce qui était susceptible de plaire aux poètes. 'Nous concevons très-bien, dit-il, dans ce même texte, qu'un poëte ait la fantaisie de transposer dans son art cette coquetterie si spirituelle et si profondément française sous son léger travestissement italien : c'est un caprice qui doit tenter quiconque s'est arrêté devant ces toiles si roses et si bleuâtres, si transparentes et si fines.' Il a bien marqué que ce qui attirait alors les poètes vers la peinture de Watteau, c'était la hantise du lointain inaccessible : 'Qui, demande-t-il, toujours dans ce texte de 1852, n'a pas eu, une fois dans sa vie, le désir de s'embarquer sur cette galère à poupe dorée, à voiles de soie, du *Voyage à Cythère* de Watteau ?' Le chapitre IV de la *Sylvie* de Nerval s'intitule, en hommage à Watteau, 'L'Embarquement pour Cythère' et nous y trouvons un parc à la française et la description d'une fête dont Nerval indique bien la signification : 'La traversée du lac avait été imaginée peut-être pour rappeler le 'Voyage à Cythère' de Watteau.' Et Nerval ajoute aussitôt cette phrase : 'Nos costumes modernes dérangeaient seuls l'illusion.'[22] Retenons ce terme d''illusion', car il contient toute une esthétique que nous rencontrerons également dans Banville et dans Baudelaire (Houssaye préfère le terme 'mensonge'),[23] et rappelons que l'*Aurélia* de Nerval s'appelait d'abord : *Le Rêve et la vie*. Notons encore que Watteau est ici associé à un parc, association que nous trouvons constamment dans Banville. Cette association remonte d'ailleurs à Gautier qui, dans un poème de jeunesse d'abord intitulé 'Rococo' et ensuite 'Watteau', avait écrit :

Je regardai bien longtemps par la grille,
C'était un parc dans le goût de Watteau,[24]

vers auxquels font écho ces deux vers de Banville sur une actrice :

Et d'un pas léger grimpant le coteau
Du vieux parc cher à Wateau.[25]

53 'La Filleule des fées' acte II, Ballet de
Jules Perrot avec décors de Cambon,
Despléchin et Thierry

54 De Troy: 'Le Jeu du pied de bœuf'

Banville, comme toute sa génération, salue en Watteau un homme fasciné par le théâtre. Gozlan, n'avait-il pas expliqué le génie de Watteau par un apprentissage chez un peintre de décors?[26] Banville de son côté présente Watteau travaillant pour l'Opéra; en 1849, il montre 'Watteau, le plus grand peintre de tous les temps, peignant pour lui des décors de sa main immortelle'.[27] Pour qui avait applaudi Deburau aux Furnambules, Watteau était le peintre qui avait immortalisé les personnages de la Comédie italienne, comme en témoigne le poème sur 'Arlequin et Colombine'. Prenons maintenant un autre poème, qui se trouve dans les *Odes funambulesques* et qui s'intitule 'La Ville enchantée':

> Il est de par le monde une cité bizarre,
> Où Plutus en gants blancs, drapé dans son manteau,
> Offre une cigarette à son ami Lazare,
> Et l'emmène souper dans un parc de Wateau.

Quelques vers plus loin, nous avons l'impression de nous trouver au théâtre alors que, comme nous l'apprenons à la fin du poème, c'est Paris que Banville

veut évoquer — mais un Paris vu comme un décor de théâtre et qui est, dès le début du poème, placé sous le signe de Watteau :

> C'est le pays de fange et de nacre de perle ;
> Un tréteau sur les fûts du cabaret prochain.
> Spectacle où les décors sont peints par Diéterle,
> Cambon, Thierry, Séchan, Philastre et Despléchin.[28]

Remarquons ce dernier vers uniquement composé de l'énumération des peintres de décors de théâtre les plus connus à l'époque de Banville.

Cette conception pour ainsi dire théâtrale de la peinture de Watteau (et le terme 'théâtral' ne comporte aucune nuance péjorative ici) est si forte chez Banville que lorsqu'il lui arrive de parler du théâtre de Marivaux, il ne peut s'empêcher de songer aussitôt à Watteau. Dans un colloque qui s'est tenu à l'Institut Français de Londres en février 1965, j'avais étudié l'association constante qui s'était établie chez les poètes et les critiques de la génération de Banville entre le théâtre de Marivaux, les comédies de Shakespeare, et la peinture de Watteau.[29] Les écrivains de cette génération croyaient retrouver dans les parcs de Watteau des personnages semblables à ceux des pièces de Marivaux. Pour eux, cette synthèse de la poésie de Watteau et du charme de Marivaux constituait une sorte d'équivalent français de la poésie de Shakespeare dans ses comédies. D'ailleurs l'association entre ces trois noms est si forte même qu'elle s'est conservée jusqu'à nos jours dans les manuels et qu'elle est devenue un cliché de la critique. Je ne donnerai qu'un exemple de l'association Watteau-Marivaux dans la poésie de Banville, en citant ces vers adressés à Caroline Letessier, actrice qui s'était fait une réputation comme interprète de Marivaux :

> Au temps des pastels de Latour,
> Quand l'enfant-dieu régnait au monde
> Par la grâce de Pompadour,
> Au temps des beautés sans seconde ;
>
> Au temps féerique où, sans mouchoir,
> Sur les lys que Lancret dessine
> Le collier de taffetas noir
> Lutte avec la mouche assassine ;
>
> Au temps où la Nymphe du vin
> Sourit sous la peau de panthère,
> Au temps où Wateau le divin
> Frête sa barque pour Cythère ;

En ce temps fait pour les jupons,
Les plumes, les rubans, les ganses,
Les falbalas et les pompons;
En ce beau temps des élégances,

Enfant blanche comme le lait,
Beauté mignarde, fleur exquise,
Vous aviez tout ce qu'il fallait
Pour être danseuse ou marquise.

Et nous retrouvons les amours de 'L'Embarquement pour Cythère' dans les vers suivants du même poème:

Tous les enfants porte-flambeau
Vous suivent en battant des ailes.

Tous ces petits culs-nus d'Amours,
Groupés sur vos pas, Caroline,
Ont soin d'embellir vos atours
Et d'enfler votre crinoline,

et Banville prononce le nom de Marivaux:

Et, digne d'un art sans rivaux,
Pour charmer les chancelleries,
Vous avez traduit Marivaux
En mignonnes espiègleries.[30]

Il y a un texte de Banville où se trouve réunis tous les thèmes que nous sommes en train de rassembler, le thème des comédiens italiens, le thème de la peinture de Watteau, celui aussi du théâtre de Marivaux, et le tout dans un décor de parc. Ce texte est un feuilleton de Banville daté du 6 septembre 1869 et qui concerne Arlequin: 'Arlequin, ce rêve d'agilité, de tendresse et de folie que Watteau penchait au bord de ses fontaines aux eaux murmurantes, dans ses grands parcs silencieux dont les vastes et clairs ombrages ensoleillés frissonnent comme des chevelures!' Banville s'adresse alors à Watteau lui-même dans une phrase qui montre qu'il était pleinement conscient de cette sorte de théorie du décor que nous essayons de dégager de son œuvre. Banville écrit en effet: 'Mais ô maître, qui dans ta divine féerie mêlas les masques du théâtre aux enchantements des paysages, comprenant bien que tu avais créé le seul paradis qui soit à la portée de l'homme.'[31] Voilà un texte capital sur lequel nous aurons l'occasion de revenir. Mais poursuivons notre feuilleton. Il y est question ensuite du 'langage idéal, délicieusement tendre et tout esprit de Marivaux' et aussi des Colombines 'aux longues robes de satin, simples et sévères, dans les bocages amoureux où résonnent les guitares!'

On sait que lorsque Baudelaire évoque Watteau dans 'Les Phares', il le présente, lui aussi, comme un homme fasciné par le théâtre :

> Watteau, ce carnaval où bien des coeurs illustres,
> Comme des papillons, errent en flamboyant,
> Décors frais et légers éclairés par des lustres
> Qui versent la folie à ce bal tournoyant.[32]

Banville — le fait est bien connu — attachait une importance extrême à la rime qui était pour lui le ressort poétique par excellence. Sa pensée, pourrait-on dire, s'exprimait en rimes. Or, il y a une rime extraordinairement révélatrice de la conception théâtrale que Banville se faisait de la peinture de Watteau. Cette rime, nous la rencontrons dans les vers suivants qui sont de 1854 :

> Elite du monde élégant,
> Qui fuis le boulevard de Gand,
> O troupe élue,
> Pour nous suivre sur ce tréteau
> Où plane l'esprit de Wateau,
> Je te salue ![33]

Lorsqu'en mars 1869 paraîtra le recueil des *Fêtes galantes* de Verlaine, Banville sera le premier à en faire le compte rendu. Il est aisé d'imaginer qu'il a reconnu aussitôt dans les poésies de Verlaine l'écho de sa propre nostalgie de ce paradis qu'avait su évoquer Watteau. Dans l'article qu'il écrit alors, Banville relève d'abord chez Verlaine la note 'délicieusement triste' et le caractère volontairement artificiel de la nature représentée par le poète. C'est alors que Banville fait cette remarque, toujours à propos de Verlaine, remarque si profonde et si révélatrice de ce qu'il avait lui-même cherché dans la peinture de Watteau. Banville écrit : 'Il est des esprits affolés d'art, épris de la poésie plus que de la nature, qui, pareils au nautonier de 'L'Embarquement pour Cythère', au fond même des bois tout vivants et frémissants rêvent aux magies de la peinture et des décors.'[34] Voilà un texte qui nous fait pénétrer loin dans l'esthétique de Banville. La peinture et les décors de théâtre sont associés dans l'esprit de Banville qui considère que tous deux créent une sorte de magie — cette magie qu'il définit comme 'Le seul paradis qui soit à la portée de l'homme'. Et quel singulier culte de l'artificiel nous rencontrons dans ce texte puisque c'est parmi les paysages mêmes de la nature que le poète rêve à la magie de la peinture et des décors !

Arrivés à ce moment de notre étude, nous pouvons noter déjà quelques résultats. Nous avons constaté l'importance de la notion de décor pour Banville et découvert que le décor typique de Banville est ce que l'on pourrait appeler

55 Watteau: 'Les Plaisirs du bal'

le décor à la Watteau. Nous avons trouvé aussi que l'attirance de Banville pour le peintre des *Fêtes galantes* venait de ce que Watteau est, par excellence, le peintre de l'ambiguïté. Nous voulons dire par là que, dans la peinture de Watteau, nous nous trouvons au point de rencontre du théâtre et de la nature ou, pour reprendre un titre de Nerval, au point de rencontre du rêve et de la vie. L'ambiguïté de Watteau vient de ce qu'il représente des comédiens, qu'il s'agisse de comédiens italiens ou de comédiens français, c'est-à-dire des êtres qui ne sont ni la réalité ni le rêve, d'autant plus que ces comédiens sont souvent masqués. D'autre part, ces comédiens sont représentés dans un parc à la française, c'est-à-dire dans une nature à laquelle s'est surajouté l'art du jardinier, une nature à demi-inventée. Mais l'ambiguïté ne s'arrête pas là. Dans certains tableaux de Watteau — et c'est cela qui a tellement séduit Banville, comme cela a séduit Nerval et Baudelaire, et comme cela séduira un

56 Lancret: 'Comédiens italiens au bord d'une fontaine'

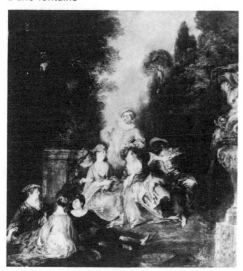

peu plus tard Verlaine — on se demande si Watteau représente une scène de théâtre ou une fête dans un parc. Le fait que, pour eux du moins, Watteau avait été peintre de décors de théâtre, intriguait fort nos poètes qui voyaient là une raison de plus pour interpréter Watteau dans un sens théâtral. 'L'Embarquement pour Cythère' les attirait tout particulièrement car s'introduisait alors la notion d'une sorte de fête paradisiaque. Baudelaire a souligné combien était caractéristique de Banville l'idée de fête. Banville parle dans son célèbre poème sur 'les bataillons futurs'[35] d''éternelles fêtes', et nous avons cité ce texte si révélateur de Banville où il emploie cette expression de 'paradis' à propos de la peinture de Watteau. Nous ne voudrions pas ici nous laisser entraîner trop loin, mais il y a une notion que l'on trouve dans Hugo, que l'on retrouve dans Banville, notion qui aboutira à la 'Prose pour Des Esseintes' de Mallarmé, et qui est la notion de 'jardin de la poésie'. On peut dire que le décor à la Watteau, qui est avant tout un parc à la Watteau, est par excellence un jardin de la poésie. Je me place évidemment toujours du point de vue de ces poètes du milieu du XIXe siècle: le Watteau qui m'intéresse est *leur* Watteau.[36] On pourrait encore entrer dans le détail à propos de cette notion d'ambiguïté. Vous avez certainement été frappés comme moi que le costume de ces personnages à la Watteau, dont parle si souvent Banville, sont des costumes faits de satin.[37] Or le satin, avec ses effets de moire qui rappellent l'eau d'un lac, est une étoffe de ce point de vue spécialement ambiguë. Il est

inutile de le souligner, car cela vous aura déjà paru clairement, que l'on voit déjà dans Banville se dessiner une esthétique de la méprise et de l'équivoque, qui sera l'esthétique même de Verlaine, dans les *Fêtes galantes* et ailleurs. Je pense à des expressions de Verlaine comme :

> Il faut aussi que tu n'ailles point
> Choisir tes mots sans quelque méprise[38]

et aussi à l'expression célèbre : 'un soir équivoque d'automne'.[39] C'est cette équivoque que la peinture de Watteau offrait avant tout à nos poètes du milieu du siècle.

Il y a une œuvre que je n'ai pas jusqu'ici mentionnée et où cette notion d'ambiguïté s'affirme de façon magistrale : je veux parler de 'La Fête chez Thérèse' de Victor Hugo. On sait que ce poème a été publié dans *Les Contemplations* en 1856 mais qu'en réalité il avait été composé dès 1840, et qu'il s'appelait à l'origine : 'Trumeau'.[40] Le professeur Barrère dans son grand travail sur *La Fantaisie de Victor Hugo*[41] a bien montré à quel point ce poème se rattachait à ce retour à Watteau dont nous parlions tout à l'heure. Ce qui nous intéresse, nous, dans ce poème de Victor Hugo, c'est la manière dont il joue sur l'équivoque du rêve et de la vie, de l'art et de la nature. C'est d'abord une fête : d'autre part, il y a dans 'La Fête chez Thérèse' un théâtre en plein air, et précisons ; un théâtre dans un jardin. Et ce qui plus est, ce théâtre est à claire-voie, il est en treillage. Regardons de plus près le texte de Hugo :

> Or, on avait bâti, comme un temple d'amour,
> Près d'un bassin dans l'ombre habité par un cygne,
> Un théâtre en treillage où grimpait une vigne.
> Un cintre à claire-voie en anse de panier,
> Cage verte où sifflait un bouvreuil prisonnier,
> Couvrait toute la scène, et sur leurs gorges blanches
> Les actrices sentaient errer l'ombre des branches.[42]

Mais je ne vais pas citer tout le poème bien qu'il offre pour notre thème des citations incomparables. Je citerai encore seulement 'le soleil tenait lieu de lustre', et nous retrouverons le décors et les lustres dont parle Baudelaire dans 'Les Phares', et ces quelques vers encore qui sont très proches de certains vers de Banville :

> Rangés des deux côtés de l'agreste théâtre,
> Les vrais arbres du parc, les sorbiers, les lilas,
> Les ébéniers qu'avril charge de falbalas,
> De leur sève embaumée exhalant les délices
> Semblaient se divertir à faire les coulisses.

Rappelons aussi que ceux qui participent à la fête chez Thérèse sont costumés

en personnages de la Commedia dell'Arte. Vraiment, nous ne sommes pas loin de ce tréteau dont parlait Banville, 'ce tréteau/Où plane l'esprit de Watteau', et de ce 'parc aérien' dont il parle encore dans le même poème.[43] Cette thématique de l'équivoque est même si puissante dans les poètes du milieu du siècle qu'on la retrouvera non seulement chez Verlaine, mais aussi chez Rimbaud, Il est inutile de rappeler tout ce que le jeune Rimbaud devait à Banville. Indiquons seulement que lorsque Rimbaud va pour la première fois à Paris, c'est dans la maison de Banville qu'il s'installe tout d'abord. Or, il y a des décors à la Watteau dans Rimbaud. Je me contenterai de citer quelques phrases des *Illuminations,* et en particulier cette phrase de 'Soir Historique': 'La comédie goutte sur les tréteaux de gazon'[44]; il est inutile maintenant de vous en souligner l'accent banvillien. Et ceci dans un texte de Rimbaud qui s'appelle justement 'Scènes': 'La féerie manœuvre au sommet d'un amphithéâtre couronné de taillis.'[45] Il y a dans cette phrase un écho de 'La Fête chez Thérèse' de Victor Hugo, mais le mot 'féerie' nous renvoie à Banville. Rimbaud joue admirablement de l'ambiguïté de la nature et de l'art, de la réalité et de l'artifice, du théâtre et du paysage dans l'Illumination à laquelle il a donné le titre de 'Fête d'hiver'. Le nom de Watteau n'est pas prononcé, mais nous n'en restons pas moins dans la tradition du peintre des *Fêtes galantes.* Je lis toute cette Illumination, très courte d'ailleurs, car, en quelques mots, tout notre sujet s'y trouve condensé. Voici Rimbaud: 'La cascade sonne derrière les huttes d'opéra-comique. Des girandoles prolongent, dans les vergers et les allées voisins du Méandre, — les verts et les rouges du couchant. Nymphes d'Horace coiffées au Premier Empire, — Rondes Sibériennes, Chinoises de Boucher.'[46] Remarquons à propos de ce poème que l'ambiguïté vient de l'éclairage puisque les lumières artificielles 'prolongent', selon le mot de Rimbaud, les couleurs contrastées du soleil couchant. C'est le décor ici qui prolonge la nature. Rimbaud n'ignore pas non plus le terme de 'décor'. Je n'en choisirai qu'un seul exemple dans *Les Illuminations.* Il s'agit du poème qui porte le titre anglais de 'Fairy', et qui se termine sur la phrase suivante: 'Et ses yeux et sa danse supérieurs encore aux éclats précieux, aux influences froides, au plaisir du décor et de l'heure uniques.'[47] Retenons cette expression du 'plaisir du décor', mais n'oublions pas de noter également que, pour Rimbaud, le plaisir du décor est maintenant une notion dépassée puisque les yeux et la danse du personnage d'Hélène, dont il est question dans cette Illumination, sont 'supérieurs' à ce décor unique. Voilà un bel exemple à la fois de la connaissance profonde que Rimbaud avait de la poésie de Banville et de la poésie de Baudelaire et, en même temps, de l'attitude essentiellement critique qu'il adoptait en face de ses prédécesseurs.

Reprenons l'article que Baudelaire a consacré à Banville. Après avoir signalé que le mot 'lyre' caractérisait le talent de Banville, après avoir expliqué que le paysage prend une allure 'hyperbolique' et devient 'décor', Baudelaire arrive à un autre mot qui reparaît souvent dans la poésie de Banville :

Tout poëte lyrique [note Baudelaire], en vertu de sa nature, opère fatalement un retour vers l'Eden perdu. Tout, hommes, paysages, palais, dans le monde lyrique, est pour ainsi dire *apothéosé*. Or [continue Baudelaire], par suite de l'infaillible logique de la nature, le mot *apothéose* est un de ceux qui se présentent irrésistiblement sous la plume du poëte quand il a à décrire (et croyez qu'il n'y prend pas un mince plaisir) un mélange de gloire et de lumière.[48]

On pourrait croire d'abord qu'il n'est pas ici question de théâtre et que Baudelaire prend le mot d''apothéose' dans son sens étymologique. Baudelaire, comme Banville, avait fait de bonnes études de latin au lycée et tous deux connaissaient certainement la *Bucolique V* de Virgile qui décrit, comme on le sait, l'apothéose de Daphnis. Mais, si nous ouvrons notre Littré, nous découvrons qu'après avoir signalé le sens étymologique de : 'mise au rang des dieux ; réception parmi les dieux', Littré donne un autre sens, qui est un sens contemporain : 'au théâtre, dans les féeries, décor final où plusieurs personnages sont représentés dans un sorte de gloire céleste'. Banville adorait les féeries, comme en témoignent les *Odes funambulesques*. Il n'est donc pas invraisemblable que Baudelaire, qui n'ignorait certainement pas ce goût de Banville, ait joué sur ces deux sens du mot 'apothéose'[49] quand il cherche à définir ce qu'il appelle un 'mélange de gloire et de lumière'. La mention même des paysages et des palais dans ce texte de Baudelaire indique assez que cette page est à situer en prolongement du texte qui la précède et qui concerne la notion de décor chez Banville.

On peut penser que nous sommes maintenant loin de Watteau. Ce serait une erreur. Watteau pour cette génération du milieu du siècle — qui n'avait pas encore vu les toiles impressionnistes — était un peintre lumineux.[50] Arsène Houssaye insiste sur ce point et cite même Banville qui avait déclaré à propos de Watteau : 'Il crée une nature immense et infinie, qu'il enveloppe d'une atmosphère lumineuse.'[51] Les Goncourt, dans leur essai sur Chardin de leur célèbre ouvrage sur *L'Art du dix-huitième siècle*, parleront encore de 'L'Embarquement pour Cythère', 'ce chef-d'œuvre des chefs-d'œuvre, cette toile enchantée' comme d'un 'poëme lumineux'.

Banville se plaisait aux effets de lumière éblouissante, aux couleurs extrêmement vives, à l'éclat des pierreries, aux satins et aux ors qui brillent. Ce goût se manifeste dès sa jeunesse. Ainsi, dans *Les Stalactites,* on trouve la description d'un nu qui est conçu de façon très picturale. Je fais allusion au

poème intitulé 'La Femme aux roses', où Banville vise à un effet singulier puisque c'est le corps de la femme qui sert de fond à des roses qui la recouvrent en partie. Banville désigne alors ce nu comme le 'fond éblouissant pour ces splendeurs écloses'.[52] En un sens, on peut dire que c'est le nu lui-même qui devient décor.

En 1874, Banville devait publier *Les Princesses*, recueil constitué d'une suite de vingt sonnets, dont chacun est consacré à une femme de la mythologie ou de l'histoire, femme toujours d'une beauté hyperbolique. Banville présente les princesses dans un sonnet liminaire où il formule nettement sa poétique:

> Les Princesses, miroir des cieux riants, trésor
> Des âges, sont pour nous au monde revenues;
> Et quand l'Artiste en pleurs, qui les a seul connues,
> Leur ordonne de naître de revivre encor,
>
> On revoit dans un riche et fabuleux décor
> Des meurtres, des amours, des lèvres ingénues.[53]

57 Watteau: 'L'Embarquement pour Cythère'

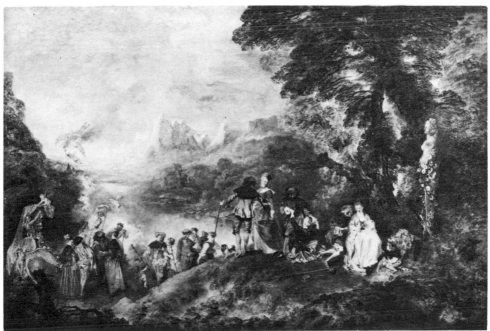

Ainsi donc, pour Banville, l'artiste — et le terme, si caractéristique d'ailleurs de l'époque, est à souligner puisqu'il désigne à la fois le peintre et le poète — l'artiste ne peut faire revivre les personnages fabuleux que s'il crée d'abord pour eux un riche décor. Il serait intéressant de comparer cette notion de riche décor à l'idée baudelairienne du luxe dans 'L'Invitation au voyage' qui est, elle aussi, l'évocation d'un décor. Il serait intéressant également de la comparer à la notion baudelairienne du cadre dans le sonnet qui porte justement le titre 'Le Cadre' dans les *Fleurs du mal* :

> Comme un beau cadre ajoute à la peinture
>
> Ainsi bijoux, meubles, métaux, dorure,
> S'adaptaient juste à sa rare beauté ;
> Rien n'offusquait sa parfaite clarté,
> Et tout semblait lui servir de bordure.[54]

Baudelaire reprend ce terme de 'cadre' dans le poème en prose de 'L'Invitation au voyage' : '... n'est-ce pas, dans ce beau pays si calme et si rêveur, qu'il faudrait aller vivre ?... Ne serais-tu pas encadrée dans ton analogie, et ne pourrais-tu pas te mirer, pour parler comme les mystiques, dans ta propre *correspondance* ?'[55] L'image du miroir est à retenir : le personnage se mire dans son décor ; ou bien, on peut dire que le décor est un reflet du personnage. En tout cas, le décor prend une grande valeur puisque le personnage ne saurait être évoqué que dans son décor, dirait Banville, et n'a d'existence qu'à l'intérieur de son cadre, dirait Baudelaire.

L'article de Baudelaire, où il est question du décor dans la poésie de Banville, date de 1861. Or, dans la troisième édition des *Stalactites*, publiée en 1873, on constate que le poème liminaire a pris le titre : 'Décor'. Le poème avait été composé en avril 1857, à la veille de la seconde édition du recueil, sans doute dans le but de mieux faire saisir la signification du titre du recueil. A cette date, le poème liminaire n'avait encore pas de titre ; c'est seulement dans l'édition de 1873 que le titre du poème a été trouvé. Ce poème nous fournit un merveilleux exemple du décor éblouissant chez Banville : tous les objets sont calculés pour nous éblouir :

> Dans les grottes sans fin brillent les Stalactites.
>
> Du cyprès gigantesque aux fleurs les plus petites,
> Un clair jardin s'accroche au rocher spongieux,
> Lys de glace, roseaux, lianes, clématites.

Des thyrses pâlissants, bouquets prestigieux,
Naissent, et leur éclat mystique divinise
Des villes de féerie au vol prodigieux.

Voici les Alhambras où Grenade éternise
Le trèfle pur; voici les palais aux plafonds
En feu, d'où pendent clairs les lustres de Venise.
..........
Dans un tendre cristal aux reflets métalliques
S'élancent, dessinant le rhythme essentiel,
Vos clochetons à jour, ô sveltes basiliques,
..........
Stalactites tombant des voûtes, stalagmites
Montant du sol, partout les orgueilleux glaçons
Argentent de splendeurs l'horizon sans limites.

Babels de diamants où courent des frissons,
Colonnes à des Dieux inconnus dédiées,
Souterrains éblouis, miraculeux buissons,

Tout frémit : cent lueurs baignent, irradiées,
Les coupoles qui sont pareilles à des cieux.
Pourtant, c'est le destin, voûtes incendiées![56]

Le poème tout entier est un décor. Or, ce qui est capital, c'est que ce poème
est, en fait, un poème sur la poésie. C'est une sorte d'art poétique. Ce décor
que décrit Banville est la grotte où vit la muse de la poésie, la muse

Que devance le chœur ailé des Métaphores,

précise Banville. Les formations de stalactites sont composées des larmes du
poète, comme le dernier vers du poème l'indique :

Ces caprices divins sont des larmes gelées !

Les formes qu'elles revêtent sont les créations de l'imagination poétique. Il
a fallu, dit encore Banville, le travail du poète :

Pour installer ce rare et flamboyant décor.

Nous aimerions maintenant établir un parallèle Banville-Baudelaire à
propos de cette notion de décor. Il est évident que si Baudelaire a souligné la
présence du mot 'décor' dans les poésies de Banville c'est que, premièrement,
la notion lui a paru importante, et même centrale, dans l'œuvre de Banville
et que, deuxièmement, cette notion de décor l'intéressait personnellement.
Il y a un poème des *Fleurs du mal* qui, pour le parallèle que nous faisons

maintenant, est d'un intérêt extrême : c'est le poème intitulé 'L'Amour du Mensonge'. Or, nous possédons le manuscrit autographe de ce poème et nous savons que Baudelaire l'avait d'abord intitulé 'Le Décor' :

> Quand je te vois passer, ô ma chère indolente,
> Au chant des instruments qui se brise au plafond
> Suspendant ton allure harmonieuse et lente,
> Et promenant l'ennui de ton regard profond ;
>
> Quand je contemple, aux feux du gaz qui le colore,
> Ton front pâle, embelli par un morbide attrait,
> Où les torches du soir allument une aurore,
> Et tes yeux attirants comme ceux d'un portrait,
>
> Je me dis : Qu'elle est belle ! et bizarrement fraîche !

Il conviendrait ici de noter encore l'ambiguïté de l'éclairage dans la seconde strophe. Reprenant au vers 17, on lit :

> Je sais qu'il est des yeux, des plus mélancoliques,
> Qui ne recèlent point de secrets précieux ;
> Beaux écrins sans joyaux, médaillons sans reliques,
> Plus vides, plus profonds que vous-mêmes, ô Cieux !
>
> Mais ne suffit-il pas que tu sois l'apparence,
> Pour réjouir un cœur qui fuit la vérité ?
> Qu'importe ta bêtise ou ton indifférence ?
> Masque ou décor, salut ! J'adore ta beauté.[57]

Claude Pichois nous apprend, dans son édition de la Pléiade, que Jacques Crépet avait pensé d'abord que la femme désignée dans le poème était Jeanne Duval, mais qu'ensuite il l'avait rapporté à Marie Daubrun. Il avait une preuve d'ailleurs car, en envoyant le manuscrit du poème à Poulet-Malassis (qui possédait une photographie de Marie Daubrun), Baudelaire avait précisé : 'Vous reconnaîtrez l'héroïne de cette fleur.'[58] Comme le fait remarquer Claude Pichois, les deux premières strophes ne deviennent compréhensibles que si elles s'adressent à une actrice. D'autre part, comme vous le savez, Marie Daubrun a été la maîtresse de Banville, comme elle a été celle de Baudelaire. L'auteur des *Fleurs du mal* écrivant un poème sur Marie Daubrun pouvait difficilement donc s'empêcher de penser à Banville. Et c'est pourquoi ce premier titre de 'Décor' paraît si étonnamment approprié, puisqu'il s'applique aussi bien à Marie Daubrun qu'à l'art de Banville. Comme Banville va donner ce titre même de 'Décor' au poème liminaire des *Stalactites*, il y a échange de titres entre les deux poètes ! Il est permis de supposer que Banville

a eu connaissance dès sa composition du titre de Baudelaire. Ce qui nous intéresse du point de vue de l'esthétique du décor, c'est que pour Baudelaire les termes de 'décor' et d''amour du mensonge' ont une valeur équivalente. On peut ajouter plus : dans le manuscrit, Baudelaire avait mis une épigraphe à son poème, épigraphe qu'il a ensuite retirée ; Baudelaire citait les vers célèbres d'*Athalie* :

> Même elle avait encor cet éclat emprunté
> Dont elle eut soin de peindre et d'orner son visage
> Pour réparer des ans l'irréparable outrage.

Ces vers de Racine sur le maquillage nous font penser immédiatement aux célèbres pages de Baudelaire appelées 'L'Éloge du maquillage' dans son essai sur 'Constantin Guys, peintre de la vie moderne', chapitre dans lequel Baudelaire défend vigoureusement la valeur de l'artifice et de l'artificiel. C'est dans 'L'Éloge du maquillage' que Baudelaire écrit : 'Qui oserait assigner à l'art la fonction stérile d'imiter la nature ? Le maquillage n'a pas à se cacher, à éviter de se laisser deviner ; il peut, au contraire, s'étaler, sinon avec affectation, au moins avec une espèce de candeur.'[59] Lorsque dans le poème 'L'Amour du mensonge', Baudelaire termine : 'Masque ou décor, salut ! J'adore ta beauté', on sent que son esthétique du décor doit être pensée en fonction de son éloge du maquillage, car il n'y a pas loin de 'masque' à 'maquillage' et, pour lui, 'décor' et 'masque' doivent être conçus comme des synonymes : c'est toujours l'éloge de l'artificiel — d'ailleurs, il s'agit d'une actrice dans 'L'Amour du mensonge'. Or, le poème des *Fleurs du mal* intitulé 'Les Sept Vieillards', dans les 'Tableaux parisiens', révèle l'idée que Baudelaire se faisait de l'âme de l'acteur :

> Et que, décor semblable à l'âme de l'acteur,
> Un brouillard sale et jaune inondait tout l'espace.[60]

L'âme de l'acteur est un décor, donc en tant qu'actrice, fardée, maquillée comme Athalie (et remarquons encore l'ambiguïté puisque Athalie est un personnage de théâtre), Marie Daubrun, l'actrice et la maîtresse de Banville, devient elle-même un décor. Et Baudelaire l'aime dans la mesure même où il aime le mensonge (puisque c'est le titre du poème) et dans la mesure où il aime le décor (puisque c'est encore un autre titre du même poème).

Baudelaire, en effet, aimait les décors de théâtre. Il le déclare sans ambages, et même avec une ferveur qui nous étonne aujourd'hui. Il y a un texte très révélateur dans le *Salon de 1859*. A propos des paysagistes, Baudelaire écrit :

Je regrette encore, et j'obéis peut-être à mon insu aux accoutumances de ma jeunesse, le paysage romantique, et même le paysage romanesque qui existait déjà au dix-huitième siècle... Je dois confesser en passant que... M. Hildebrandt, par son énorme exposition d'aquarelles, m'a causé un vif plaisir. En parcourant ces amusants albums de voyage, il me semble toujours que je *revois*, que je reconnais ce que je n'ai jamais vu. Grâce à lui, mon imagination fouettée s'est promenée à travers trente-six paysages romantiques, depuis les remparts sonores de la Scandinavie jusqu'aux pays lumineux des ibis et des cigognes, depuis le Fiord de Séraphitus jusqu'au pic de Ténériffe.

Et Baudelaire prononce alors le mot qui nous intéresse : 'La lune et le soleil ont tour à tour illuminé ces décors, l'un versant sa tapageuse lumière, l'autre ses patients enchantements.'[61] On voit donc d'après ce passage que, pour Baudelaire, 'paysages romantiques' et 'décors' étaient à peu près identiques. Mais continuons de lire Baudelaire, qui ajoute :

Vous voyez, mon cher ami, que je ne puis jamais considérer le choix du sujet comme indifférent, et que, malgré l'amour nécessaire qui doit féconder le plus humble morceau, je crois que le sujet fait pour l'artiste une partie du génie, et pour moi, barbare malgré tout, une partie du plaisir. En somme, je n'ai trouvé parmi les pay-sagistes que des talents sages ou petits, avec une très grande paresse d'imagination'.

Baudelaire termine de façon assez surprenante :

Je désire être ramené vers les dioramas dont la magie brutale et énorme sait m'im-poser une utile illusion. Je préfère contempler quelques décors de théâtre, où je trouve artistement exprimés et tragiquement concentrés mes rêves les plus chers. Ces choses, parce qu'elles sont fausses, sont infiniment plus près du vrai ; tandis que la plupart de nos paysagistes sont des menteurs, justement parce qu'ils ont négligé de mentir'.[62]

Ce texte de 1859 ne représente pas simplement une phase dans Baudelaire, car on en trouve déjà les éléments dans un texte de 1846, texte qui nous intéresse d'autant plus que Baudelaire y prononce le nom de Watteau. C'est le chapitre XV, intitulé 'Du paysage', dans son *Salon de 1846*. Baudelaire écrit :

Quant au paysage de fantaisie, qui est l'expression de la rêverie humaine, l'égoïsme humain substitué à la nature, il fut peu cultivé. Ce genre singulier, dont Rembrandt, Rubens, Watteau et quelques livres d'étrennes anglais offrent les meilleurs exemples, et qui est en petit l'analogue des belles décorations de l'Opéra, représente le besoin naturel du merveilleux. C'est l'imagination du dessin importée dans le paysage : jardins fabuleux, horizons immenses, cours d'eau plus limpides qu'il n'est naturel, et coulant en dépit des lois de la topographie, rochers gigantesques construits dans des proportions idéales, brumes flottantes comme un rêve.[63]

Ce texte de Baudelaire est intéressant en ce qui concerne notre parallèle, car le paysage qu'évoque Baudelaire est très proche du paysage de Banville. D'autre part, ce paysage est du même type que le célèbre 'Rêve parisien' des *Fleurs du mal* qui révèle, lui aussi, des réminiscences de Banville.[64] De plus, nous voyons dans ce texte Baudelaire faire un rapprochement entre les peintures de Watteau et les décorations de l'Opéra, c'est-à-dire dans le langage d'aujourd'hui, les décors de l'Opéra. Or, nous pouvons préciser à qui pense Baudelaire : il songe vraisemblablement à Cicéri, qui peignait alors les décors de l'Opéra de Paris, décors dont parle Banville ; rappelez-vous : 'Le splendide outre-mer des ciels de Cicéri.'

Notre dessein n'est pas ici d'approfondir dans tous les détails l'idée de décor dans l'œuvre de Baudelaire. D'ailleurs, la question Baudelaire vient d'être traité amplement et savamment dans ce Colloque. Mais il nous a paru utile de citer ces textes de Baudelaire car ils éclairent de façon singulière la conception de décor telle qu'on peut la trouver dans l'œuvre de Banville. On pourrait montrer que l'esthétique de Baudelaire et l'esthétique de Banville ont beaucoup de points de rencontre. C'est un tel point de rencontre que nous avons voulu étudier, et d'autre part, comme c'est un texte de Baudelaire qui a attiré notre attention sur cette question du décor, il nous a paru nécessaire de le situer dans l'œuvre même de Baudelaire. Notons encore à ce sujet que dans le 'Poème du haschisch' des *Paradis artificiels,* Baudelaire emploie par deux fois l'expression 'décor'. Parlant du drogué, il déclare : 'Ce seigneur visible de la nature visible (je parle de l'homme) a donc voulu créer le Paradis par la pharmacie, par les boissons fermentées, semblable à un maniaque qui remplacerait des meubles solides et des jardins véritables par des décors peints sur toile et montés sur châssis.'[65] Ainsi donc Baudelaire identifie l'idée de décor et l'idée de paradis artificiels. Nous avons déjà noté que, pour Banville, les décors à la Watteau constituaient une sorte de paradis — 'L'Embarquement pour Cythère' est une invitation pour le paradis. L'autre texte de Baudelaire dans le 'Poème du haschisch', au chapitre de 'L'Homme-Dieu', est particulièrement révélateur et il montre avec quel soin Baudelaire avait regardé les décors de théâtre puisque, en grand critique d'art qu'il était, il a noté que ces décors utilisaient une perspective spéciale. Il s'agit toujours du drogué et Baudelaire écrit : 'Tous les objets environnants sont autant de suggestions qui agitent en lui un monde de pensées, toutes plus colorées, plus vivantes, plus subtiles que jamais, et revêtues d'un vernis magique. "Ces villes magnifiques, se dit-il, où les bâtiments superbes sont échelonnés comme dans les décors..."'[66]

Il est un poème en prose qui présente du point de vue de notre sujet un

intérêt tout particulier : c'est le poème en prose intitulé 'Les Projets', que nous citerons dans le texte de 1857, qui est le texte original. Baudelaire imagine la bien-aimée dans une série de décors, et c'est dans le fond ce que Banville fera lui-même dans la série de vingt sonnets qu'il intitule *Les Princesses*. En effet, Banville représente toujours un peu la même femme dans une série de décors différents qui vont de la Grèce de la mythologie jusqu'à la France napoléonienne, en passant par la Renaissance et la Révolution. C'est ce que fait Baudelaire dans 'Les Projets', et il est frappant que le premier décor auquel il pense soit ce décor à la Watteau que nous avons si souvent rencontré dans la littérature de cette époque. C'est un horizon de parc à la française, mais voici le texte de Baudelaire : 'Comme tu serais belle, dans un costume de cour compliqué et fastueux, descendant à travers l'atmosphère d'un beau soir, les degrés de marbre d'un palais, en face des grandes pelouses et des bassins !' Et Baudelaire s'écrie alors : 'Mais à quoi bon de si beaux décors ? Insensé ! J'oubliais que je hais les rois et leurs palais.' Et Baudelaire de continuer un peu plus loin : 'Ah ! je sais bien où je voudrais t'aimer interminablement ! — Au bord de la mer, une belle case en bois, enveloppée d'ombrages !' et Baudelaire se reprend alors et dit : 'Mais non ! — Pourquoi cette vaste mise en scène ?'[67] Cette dernière phrase marque à quel point l'imagination de Baudelaire est influencée par l'optique théâtrale. C'est là une constation que nous avons faite bien des fois avec Banville.[68]

Je terminerai cette courte étude en citant quelques passages remarquables de Stéphane Mallarmé sur Banville. Mon objectif n'est pas du tout de traiter de la notion de décor chez Mallarmé car nous voulons nous limiter à Banville, mais l'on sait que ce problème du décor a beaucoup préoccupé l'admirable critique de *Divagations*. Je voudrais seulement attirer votre attention sur ce fait très simple qu'un des textes les plus célèbres de Mallarmé sur le vers se situe à l'intérieur d'un chapitre intitulé 'Solennité' qui a été en partie écrit à propos d'une pièce de théâtre de Banville : *Le Forgeron*. Je fais allusion à la phrase célèbre sur 'le ciel métaphorique qui se propage à l'entour de la foudre du vers... ce spirituellement et magnifiquement illuminé fond d'extase'.[69] Il est facile de voir, me semble-t-il, qu'il y a là quelque chose de plus que la formulation de l'esthétique mallarméenne : il y a aussi une interprétation géniale de la poétique de Banville. Ce 'ciel métaphorique' qui se propage autour du vers, n'est-ce pas ce 'rare et flamboyant décor' dont Banville nous a parlé dans le poème liminaire des *Stalactites* ? N'est-ce pas aussi le 'riche et fabuleux décor' du sonnet liminaire des *Princesses* ? N'est-ce pas encore le fond éblouissant' du poème de 1846 sur 'La Femme aux roses' ? Je citerai encore une expression très heureuse de Banville que nous trouvons dans un

autre poème des *Stalactites* intitulé 'La Fontaine de Jouvence'; c'est un poème directement inspiré par une peinture, très exactement par une peinture de William Haussoullier, exposée au Salon de 1845 et que Baudelaire a également admirée. Il s'agit d'ailleurs d'une scène assez proche de Watteau, d'une sorte de fête galante dans un parc. Banville dans ce poème écrit ce vers qui est l'expression d'une poétique:

Créons autour de nous des cieux intelligents.[70]

Ces 'cieux intelligents' de Banville ne sont pas si loin du 'ciel métaphorique' de Mallarmé. N'oublions pas que Mallarmé plaçait très haut Banville, dont il disait — justement dans 'Solennité' — qu'il était 'un être à part, supérieur et buvant tout seul à une source occulte et éternelle'.[71]

Dans ce volume de *Divagations,* Mallarmé a recueilli un autre hommage à Théodore de Banville dans ses 'Quelques médaillons et portraits en pied'. Il s'agit d'un texte écrit par Mallarmé pour le *National Observer* de Londres à l'occasion de l'inauguration d'un buste à la mémoire de Banville dans le jardin du Luxembourg. Dans ce texte, publié le 17 décembre 1892 et que nous allons citer dans la version originale que vient de nous restituer Norman Paxton, Mallarmé commence par souligner à quel point le jardin du Luxembourg est le lieu idéal pour une telle commémoration puisque Banville avait lui même célébré ce jardin dans son poème 'La Malédiction de Cypris', où l'on voit Vénus descendre dans ce jardin. Ajoutons que ce poème avait été très admiré de Baudelaire. 'Je me figure...' dit Mallarmé, 'que convient, pour la quotidienne apothéose, un cimetière désintéressé, profane, glorieux, comme ce Luxembourg; ouvert au ciel particulier qui demeure sur les citadines futaies, les vases décoratifs, les fleurs...' Ne laissons pas passer cette 'épithète de 'décoratif' qui n'est pas dû au hasard car l'on sait avec quel soin Mallarmé choisissait ses mots. On peut dire la même chose du mot 'apothéose'. Mallarmé, parfaitement conscient du fait que les parcs à la française faisaient partie aussi du décor préféré de notre poète, ajoute même cette précision: 'Détail cher, le triomphateur en était, voici à peine dix-huit mois, l'hôte rêveur, lui même, presque chaque jour.' Mallarmé se met à citer ensuite un hommage à Banville qu'il avait composé dans sa jeunesse et qu'il appelle une page d'écolier et même, dans un terme très XVIIIe siècle, 'le pauvre trumeau, suranné'. Cette page révèle une lecture attentive de l'article de Baudelaire d'où nous sommes partis, comme en témoigne assez cette déclaration: 'mon poëte c'est Théodore de Banville qui n'est pas quelqu'un, mais le son même de la lyre'. Puis, dans une phrase où viennent se mêler tous les différents thèmes que nous avons trop rapidement étudiés aujourd'hui — et

c'est pourquoi notre communication s'achèvera sur cette phrase de Mallarmé — le jeune Mallarmé écrit : 'Institue, ô mon rêve, la cérémonie d'un triomphe à évoquer aux heures de splendeur et de féerie, et l'appelle la Fête du Poëte : l'élu est cet homme au nom prédestiné, harmonieux comme un poème et charmant comme un décor.'[72]

Notes and discussion

(1) Baudelaire, 'Théodore de Banville', *Oeuvres complètes, texte établi et annoté par Y.-G. Le Dantec. Édition révisée, complétée et présentée par Claude Pichois*, Paris, Bibliothèque de la Pléiade, 1963, p. 736.
(2) Banville, 'La Voie lactée', *Les Cariatides*, Paris, Pilout, 1842, p. 66.
(3) Ibid., p. 57.
(4) Ibid., p. 58.
(5) Ibid., p. 58.
(6) Banville, 'L'Arbre de Judée', *Les Stalactites. Édition critique établie par E. M. Souffrin*, Paris, Didier, 1942, p. 320.
(7) Banville, 'La Symphonie de la neige', ibid., p. 354.
(8) Banville, 'Pour mademoiselle ***', ibid., pp. 280–1.
(9) Voir Antoinette Allevy, *La Mise en scène en France dans la première moitié du XIXe siècle,* Paris, Droz, 1938, pp. 51–61. La question du décor intéressait d'autant plus Gautier qu'il était lui-même l'auteur de pièces de théâtre, de pantomimes et de livrets de ballet. Aussi note-t-il avec satisfaction après la première de son ballet *Giselle* en juillet 1841 : 'Quant aux décorations, elles sont de Cicéri, qui n'a pas encore son égal pour le paysage' (*Histoire de l'art dramatique en France*, Paris, Hetzel, 1859, II, p. 142). Nous indiquerons cet ouvrage par le sigle : H.A.D. Il convient de relever ce terme 'décoration', qui pourrait prêter à confusion : dans le langage de l'époque, 'décoration' était employé comme synonyme de 'décor'. Gautier semble même préférer le mot 'décoration' car dans le livret de Giselle, on lit : 'Décoration de M. Cicéri' (*Théâtre, mystère, comédies et ballets*, Paris, Charpentier, 1877 (2e édition), p. 245). Ailleurs, Gautier annonce : 'La toile se lève... sur une fort belle décoration de Cicéri' (H.A.D., II, p. 104).
(10) En 1867, dans la deuxième édition des *Stalactites*, le poème porte le titre : 'Pour une Ballerine' (voir mon article, 'Théodore de Banville et le ballet romantique', *Revue des Sciences Humaines*, janvier-mars 1963).
(11) Banville, 'L'Académie Royale de Musique', *Odes funambulesques*, Paris, Lemerre, 1873 (3e édition), pp. 91–2.
(12) Banville, 'Arlequin et Colombine', *Les Stalactites*, p. 342. Il ne subsiste qu'une seule toile de Watteau qui porte ce titre, celle de la Wallace Collection. Voir *Wallace Collection Catalogues. Pictures and Drawings. Text with Historical Notes and Illustrations*, Londres, Hertford House, 1968 (16e édition), p. 359. Est-ce cette toile qui est à l'origine du poème de Banville ? Plutôt qu'une 'transposition poétique' d'une seule peinture, le poème semble s'inspirer de l'impression créée sur Banville par diverses œuvres de Watteau et même par diverses œuvres de l'école de Watteau. Voir la note 22. Ce qu'il convient de relever, en tout cas, c'est que ce poème de Banville fut publié avant la parution des deux textes qui devaient marquer de façon si profonde les *Fêtes galantes* de Verlaine, à savoir Charles Blanc, *Les Peintres des fêtes galantes*, 1854, et Edmond et Jules de Goncourt, 'La Philosophie de Watteau', *L'Artiste,* 7 septembre 1856, article recueilli, avec quelques légères variantes, dans *L'Art du dix-huitième siècle*, 1860.
(13) L'ambiguïté dans la peinture de Watteau frappe d'autres critiques de l'époque. Gautier écrit : 'Ce n'est pas la nature, direz-vous, ou c'est la nature vue à travers l'Opéra, éclairée au jour de la rampe, avec des magies factices, plutôt du ressort du décorateur que de celui du peintre' (H.A.D., VI, p. 316). Une remarque analogue est faite par Arsène Houssaye : 'Il faut avouer que le paysage de Watteau rappelle autant l'Opéra que la nature' (*Galerie du XVIIIe siècle*, Paris, Hachette, 1858, V, p. 57). On relève chez Delacroix la même réaction. Après avoir rendu visite à son neveu, le duc de Morny, et vu dans sa collection *Les Plaisirs du bal*, toile qui pendant longtemps encore devait être attribuée à Watteau, Delacroix note dans son carnet, le 3 avril 1847 : 'Il a un Watteau magnifique. J'ai été frappé de l'admirable artifice de cette peinture' (*Journal, nouvelle édition publiée d'après le manuscrit original avec une Introduction et des Notes par André Joubin*, Paris, Plon, 1950 (édition revue et

augmentée), I, p. 212). Le 11 janvier 1857, Delacroix notera le même phénomène et cette fois pour le critiquer: 'Watteau. Très méprisé sous David et remis en honneur. Exécution admirable. Sa fantaisie ne tient pas en opposition aux Flamands. Il n'est plus que théâtral à côté des Ostade, des Van de Velde, etc.' (Ibid., III, p. 12). Les Goncourt voient dans l'art de Watteau 'l'hymen de la Nature et de l'Opéra' (L'Art du dix-huitième siècle. Paris, Rapilly, 1873 (2e édition), I, p. 6).
(14) Cit. Chantelou, 'Un Hommage à Thoré-Burger', Le Monde, 27 décembre 1968. Sur la fortune de Watteau, voir Hélène Adhémar, Watteau, sa vie — son œuvre, Précédé de 'L'Univers de Watteau' par René Huyghe. Catalogue des peintures et illustration par Hélène Adhémar, Paris, Tisné, 1950, p. 148 et seq. ; Seymour O. Simches, Le Romantisme et le goût esthétique du XVIIIe siècle, Paris, P.U.F., 1964, Ch. I; Banville, Les Stalactites, pp. 337–43.
(15) Afin de souligner la communauté de pensée de ces 'découvreurs' de Watteau, nous nous référerons sans cesse aux écrits de tout le groupe.
(16) Nerval, La Vie des lettres. Oeuvres complémentaires, textes réunis et présentés par Jean Richer, Paris, Minard, 1959, vol. I, p. 177. Un autre exemple en est fourni par Banville qui se rappelle qu'à l'Hôtel Pimodan, 'le peintre Boissard s'enorgueillissait avec raison d'un piano peint tout entier de la main de Watteau!' (Mes souvenirs, Paris, Charpentier, 1882, p. 79). Voir aussi S. Simches, op. cit., Ch. III.
(17) 'Wattier, ce savant qui a tant aimé Watteau' dira Baudelaire dans son Salon de 1859 (Oeuvres, p. 1062). Wattier n'était pas le seul à vouloir faire du Watteau (voir S. Simches, op. cit., p. 29 et seq.) et l'on se demande à qui pense Banville lorsque, dans ses 'nouveaux souvenirs', il évoque 'un artiste, qui ne manquait ni d'originalité ni de génie, [qui] brossait pour un marchand de tableaux de la rue Laffitte de faux Watteau, payés cinq francs, qu'il peignait sur de vieux dossiers de chaises' (L'Ame de Paris, Paris, Charpentier, 1890, p. 207).
(18) Balzac, Le Cousin Pons. Introduction, notes et relevé de variantes par Maurice Allem, Paris, Garnier, 1962, p. 68. Voir également pp. 31, 34, 36 et 37. Depuis 1834, Balzac avait des velléités de collectionneur et possédait notamment un service à thé que l'on disait peint par Watteau.
(19) Gautier, H.A.D., II, p. 25. En 1838 déjà, le décor d'une féerie le fait penser à Watteau car, à propos de Peau d'Ane, acte I. il écrit: 'La jardin de la fée, où s'élève un château d'eau d'une riche architecture, se distingue par une grande fraîcheur et une délicieuse

humidité; la brume argentée de la cascade est parfaitement rendue; les arbres ont une tournure maniérée et Watteau tout à fait élégante' (ibid., 1, p. 160). L'Eucharis, ballet de Coralli avec décor dè Cicéri et dont la première eut lieu à l'Opéra en 1844, peut encore être cité en exemple. Il s'agit d'un ballet inspiré par le Télémaque de Fénelon, et d'une ballerine costumée en marinier, Gautier dit: '... ce serait un mousse délicieux pour une de ces embarcations aux cordages fleuris, à la poupe garnie de lanternes de couleurs que Watteau faisait voguer, chargées de pèlerins et de pèlerines, vers les bords d'une Cythère d'opéra' (ibid., III, p. 249). La Filleule des fées témoigne encore de l'influence de Watteau sur son école sur les décors de théâtre. La première de ce ballet eut lieu le 8 octobre 1849; notre illustration No. 53 donne une idée de la mise en scène; pour une description, voir Cyril Beaumont, Complete Book of Ballets, New York, Putnam's Sons, 1938, pp. 284–5. On constate que l'influence de Watteau pénètre également dans le ballet en Angleterre, quoique plus lentement. Après la première de L'Ile des amours, ballet au titre déjà si révélateur de Paul Taglioni, le critique du Times écrit le 24 mars 1851: '. . . a bold, novel and successful attempt to found a ballet on an entirely new principle—the reproduction of a certain school of painting', et l'historien du ballet ajoute: 'that of Watteau' (Ivor Guest, The Romantic Ballet in England, Londres, Phoenix House, 1954, p. 139).
(20) Antoine Benoist, Essais de critique dramatique, Paris, Hachette 1898, p. 127.
(21) Gautier, H.A.D., VI, p. 316.
(22) Nerval, Sylvie. Oeuvres, texte établi, annoté et présenté par Albert Béguin et Jean Richer, Paris, Bibliothèque de la Pléiade, 1952, p. 269. Si les poètes se réfèrent sans cesse à L'Embarquement pour Cythère, c'est en grande partie parce que c'était là encore la seule toile de Watteau que possédât le Louvre. Jusqu'en 1869, où le legs du docteur Lacaze y remédiera, le Louvre devait rester singulièrement pauvre en ce qui concerne l'œuvre de Watteau. Les admirateurs de l'artiste devaient compter sur les collectionneurs qui voulaient bien montrer leurs acquisitions à des visiteurs ou les prêter à des expositions. Banville se rappelle combien il était difficile dans sa jeunesse de voir l'œuvre peinte de Watteau: '...à part les gravures et L'Embarquement pour Cythère, le peintre, comme tout le monde alors, avait vu fort peu de Wateau'' (L'Ame de Paris, p. 207). Il y avait encore des toiles restées en province et il est possible que Banville, avec ses attaches bourbonnaises, en ait vues; c'était là, en tout cas, l'opinion que m'exprima un jour le regretté Max Fuchs, auteur de la première

thèse consacrée à Banville. Le poète évoque,
certes, des Watteau 'épanouis au mur' (*Les
Cariatides*, p. 312), mais on note justement
qu'il souligne en même temps : 'je rêvais…'
C'est grâce à la gravure que Watteau a été
connu et grâce en particulier au Recueil Julienne
qui contient déjà deux cents gravures environ
et qui a été complété par les 351 gravures
d'après les dessins de Watteau que com-
portent les *Figures de différents caractères*
(voir Jean Adhémar, *Graphic Art of the 18th
century*, Londres, Thames and Hudson, 1964,
p. 16 et seq.) Le XIXe siècle aimait même
tant la gravure que l'on a mis dans le
commerce des albums de gravures de l'œuvre
de Watteau (voir Hélène Adhémar, op. cit.,
p. 154) ; du reste, des revues comme *Le
Magasin pittoresque, L'Artiste*, etc., en
reproduisaient. L'attitude ici de Banville est
typique ; comme Baudelaire, il fréquentait les
marchands d'estampes et, dans un rondel, il
nous indique clairement ses préférences :

Je vais voir, quand il est Midi,
Les estampes du quai Voltaire,
Fragonard qui ne peut se taire,
Et Boucher toujours étourdi.
…
Mais Wateau, nautonier hardi,
C'est toi surtout, cœur solitaire,
C'est toi qu'en la triste Cythère
Où ton soleil a resplendi,
Je vais voir, quand il est Midi.

'Le Midi', *Poésies complètes*, Paris, Charpentier,
1899 (édition définitive), III, pp. 308–9
On sait d'ailleurs tout ce que les *Fêtes
galantes* de Verlaine devront à la gravure.
Étant donné le peu de facilités dont on
disposait pour voir les peintures de Watteau,
il n'est pas très étonnant que l'on eût tant
de mal à distinguer entre les Watteau
authentiques et les faux, comme aussi à
distinguer entre l'œuvre du maître et celle de
ses disciples, et il faut ajouter ici que les
erreurs du Recueil Julienne ont beaucoup
contribué à la confusion. Il est évident que
pendant longtemps on a englobé dans une
commune admiration Watteau et Pater,
Lancret, Fragonard, et même Boucher.
Gautier, à l'époque de la Bohème
Galante, dit avoir peint un tableau, 'imitation
d'un Watteau ou d'un Lancret quelconque'
(cit. in René Jasinski, *Les Années romantiques
de Th. Gautier*, Paris, Vuibert, 1929, p. 263) ;
cette remarque témoigne des idées encore très
approximatives de Gautier concernant l'art du
XVIIIe siècle. Il faut tenir compte
également des attributions erronées ; il y avait
un très grand nombre de toiles que l'on
attribuait encore à Watteau et qui étaient, en
fait, l'œuvre de Pater ou d'un autre. Gautier
semble avoir été la victime d'une attribution
erronée lorsqu'en 1852 il analyse la peinture
de Watteau et qu'il évoque les 'bancs de

mousse [qui] attendent des conversations
amoureuses et des concerts champêtres'
(*H.A.D.*, VI, p. 316). Il semble bien se référer
ici à ces six 'Fêtes champêtres' qui se
trouvaient au Petit Trianon et que
l'Inventaire Officiel attribuait encore à
Watteau, alors qu'en réalité elles sont de Pater
(voir Hélène Adhémar, op. cit., p. 236). Pater
avait si merveilleusement recueilli la leçon
ultime de son maître dans 'Fête dans un parc',
'Conversation galante', etc., que l'on pouvait
facilement se tromper. Banville a-t-il commis
l'erreur ? On a nettement l'impression que,
dans 'Arlequin et Colombine', ces 'nymphes
au dos svelte' qui se baignent, appartiennent
plutôt à l'univers de Pater ; elles font
songer aux 'Baigneuses' du musée
d'Edimbourg, et surtout aux 'Baigneuses dans
un parc' du musée de Stockholm.
(**23**) A. Houssaye écrit : '… tout en confondant
les idées théâtrales et champêtres [Watteau]
arrive à créer un poème qui nous séduit et
nous fait croire au mensonge' (op. cit., V, p. 57)
(**24**) Gautier, 'Watteau', *Poésies complètes,
publiées par René Jasinski*, Paris. Firmin-Didot,
1932, II, p. 75. Le poème fut publié en
décembre 1835. L'intérêt de Gautier pour
Watteau remonte, en effet, à l'époque où il
faisait partie de la Bohème Galante. Il n'est pas
fait mention de Watteau dans les *Poésies* de
1830 ; par contre, dans *Albertus*, qui est de
1832, Gautier décrit l'atelier de son
personnage, atelier où se trouvent des
tableaux représentant : 'Le beau de chaque
époque et de chaque contrée' et l'on y voit
précisément : 'Reynolds près de Hemling
Watteau près de Corrège' (ibid., I, p. 165).
D'autre part, le roman de *Mademoiselle de
Maupin*, dont la première partie fut publiée
en 1835, se déroule dans un cadre à la
Watteau (voir en particulier le chapitre XI).
Cette caractéristique fut aussitôt remarquée
par Esquiros qui, dans son compte rendu du
roman dans *La Presse* du 14 octobre 1836,
déclare : 'Le style… se prend çà et là aux
préciosités et aux mignardises de Watteau
avec un art et un bonheur inouïs' (cit. in R.
Jasinski, *Les Années romantiques de Th.
Gautier*, p. 321).
(**25**) Banville, 'Amédine Luther', *Les Exilés*,
Paris, Lemerre, 1867, p. 231. On a remarqué
déjà que Banville écrit le plus souvent avec un
seul 't' le nom de Watteau. Ce fut là
l'orthographe employée par un des premiers
biographes du peintre, le comte de Caylus, et
l'on est conduit à se demander si c'est pour
cette raison que Banville préfère une
orthographe archaïque. Le texte du comte de
Caylus fut reproduit par les Goncourt, mais
Banville aurait pu en prendre connaissance
à une date antérieure.
(**26**) Voir Hélène Adhémar, op. cit., p. 151,
note 4.

(27) Banville, *Critiques. Choix et préface de Victor Barrucand,* Paris, Charpentier, 1917, p. 231. Houssaye parle de son passage à l'Opéra : 'A l'Opéra, Watteau jeta à tort et à travers les flammes de son pinceau : montagnes, lacs, cascades, forêts, rien ne l'effrayait, pas même les Camargo qu'il prenait pour modèles... Il quitta l'Opéra avec son maître, une fois le nouveau décor fini' (op. cit., V, pp. 38–9). Cette insistance sur Watteau peintre de décors à l'Opéra pourrait être due en partie, me semble-t-il, au fait que le docteur Lacaze, qui faisait si volontiers visiter sa collection, possédait justement 'un grand fragment de décoration, peinture en détrempe fixée à l'essence, qui était attribuée à Watteau' (E. Bénézit, *Dictionnaire critique et documentaire des peintres, sculpteurs, dessinateurs et graveurs,* Paris, Librairie Gründ, 1959 (nouvelle édition), VIII, article 'Watteau'). Les Goncourt insisteront sur le caractère théâtral de la peinture de Watteau (voir op. cit., I, pp. 5–9). Par contre, ils ne se préoccupent pas de l'inspiration fournie à Watteau par *Les Trois Cousines* de Dancourt ou par telle autre pièce de théâtre.
(28) Banville, 'La Ville Enchantée', *Odes funambulesques,* p. 26. Avec Cicéri, dont il a déjà été question (voir note 9), ce sont ici les peintres de décors les plus célèbres de l'époque Très souvent, d'ailleurs, il y avait collaboration entre eux ; aussi Gautier parle-t-il du 'quadruple pinceau de MM. Feuchère, Séchan, Diéterle et Despléchin' (*H.A.D.,* II, p. 84) ; les décors de *La Péri,* par exemple, étaient l'œuvre de Séchan, Diéterle et Despléchin pour l'Acte I, et de Philastre et Cambon pour l'Acte II. Au sujet de ces peintres de décors, il convient surtout de se rappeler le rang très élevé qu'ils occupaient à cette époque : c'étaient des personnages. 'Aucune société n'aima plus le théâtre que celle du Second Empire', déclare André Bellessort (*La Société française sous Napoléon III,* Paris, Perrin, 1932, p. 237), et cela est vrai déjà pour ce qui concerne la décade précédente. Le spectateur accordait tous les honneurs aux peintres de décors et ceux-ci arrivaient au théâtre dans de magnifiques équipages afin d'accueillir personnellement, sur la scène, les applaudissements de l'auditoire. Car il faut bien dire que, plus qu'à aucune autre époque, le spectateur attachait une importance énorme à la mise en scène. Jusqu'aux premières années du romantisme, on n'avait pas cherché de rapport bien précis entre le spectacle et le décor ; la toile de fond avait été conçue pour cacher les murs du théâtre et conservait essentiellement un rôle décoratif (voir Richard Southern, *Changeable Scenery,* Londres, Faber and Faber, 1952, p. 357). Au XIXe siècle, l'attitude change. On commence à vouloir non

simplement un décor qui harmonise avec le spectacle mais qui y corresponde d'une manière évidente. On cherche, en un mot, 'ce que nous autres modernes', dit Gautier, 'nous appelons l'illusion' (*H.A.D.,* VI, p. 443). Créer l'illusion, voilà la principale préoccupation, et c'est pourquoi un historien du théâtre désigne l'époque qui nous concerne comme 'l'âge de l'illusion' au théâtre (voir Richard Southern, *The Seven Ages of the Theatre,* Londres, Faber and Faber, 1962, p. 253 et seq.). On note que Gautier admire les décors de Cicéri pour *Giselle* précisément parce que ces décors créent l'illusion : 'Le lever du soleil, qui fait le dénouement, est d'une vérité prestigieuse' (*H.A.D.,* II, p. 142). De tels effets, comme aussi les nombreux changements à vue résultant des nouvelles libertés prises par les dramaturges, n'auraient pas été possible sans la révolution qui s'était effectuée dans le domaine technique : les perfectionnements réalisés dans le chariot utilisé pour la scène à l'italienne, dans les trappillons, les châssis, dans les coulisseaux mobiles, etc. permettaient des innovations que les machinistes n'auraient jamais pu entreprendre avec les ressources traditionnelles. Le diorama, puis le cyclorama permettaient également de créer des effets scéniques nouveaux. Le succès d'un ouvrage comme le *Parallèle des principaux théâtres modernes de l'Europe et des machines théâtrales françaises, allemandes et anglaises,* avec le texte de Filippi et les dessins de Clément Constant, ancien machiniste en chef de l'Académie Royale de Musique, montre à quel point on se passionnait en France pour ces problèmes. Il s'est trouvé que la France a eu une équipe de peintres qui a su exploiter les innovations techniques ; ce sont ces peintres de décors dont le nom revient si souvent sous la plume d'un Gautier et d'un Banville. Ils étaient appréciés dans la mesure où ils parvenaient à créer l'illusion. Or, la recherche de l'illusion est caractéristique du XIXe siècle mais non du nôtre, et dans ce contexte on peut citer E. H. Gombrich qui, à propos des *Prisons* de Piranèse, fait remarquer combien il est difficile pour nous aujourd'hui de 'lire' ces gravures comme des décors de théâtre car, écrit-il, 'this is due only to the fact that twentieth century artists and stage designers have come to spurn the tricks of illusion' (*Art and Illusion. A Study in the Psychology of Pictorial Representation,* New York, Pantheon Books, Bollingen Series XXXV, 1960, p. 246). Cet essai de Gombrich est, évidemment, fondamental en tout ce qui concerne le problème si complexe de l'ambiguïté dans la représentation picturale ; d'ailleurs, ce terme même de 'représentation' est révélateur.
(29) 'Marivaux et Watteau dans la Poésie

parnassienne', Colloque Marivaux sous la présidence du professeur Frédéric Deloffre, à l'Institut Français du Royaume-Uni, du 26 au 28 février 1965 (les actes du colloque n'ont pas été publiés). 'Marivaux est le Watteau du théâtre', déclare Gautier (*H.A.D.*, V, p. 289). L'essai des Goncourt s'ouvre sur le rapprochement Watteau-Shakespeare (voir op. cit., I, p. 3) et, à propos des personnages de Watteau, les Goncourt notent: 'Sur les lèvres ouvertes voltigent des pensées, des musiques, des paroles semblables aux paroles des comédies de Shakespeare' (ibid., I, p. 11).
(**30**) Banville, 'La Voyageuse', *Odes funambulesques*, pp. 49–56.
(**31**) Banville, *Critiques*, p. 204.
(**32**) Baudelaire, 'Les Phares', *Oeuvres*, p. 13.
(**33**) Banville, 'Les Folies-Nouvelles', *Odes funambulesques*, p. 108. Le Théâtre des Folies-Nouvelles venait d'être créé dans le but de reprendre la tradition du Théâtre des Funambules où le répertoire faisait usage des personnages de la Commedia dell'Arte.
(**34**) Cit. in Jacques-Henry Bornecque, *Lumières sur les 'Fêtes galantes' de Verlaine*, Paris, Nizet, 1959, p. 8. Dans son article, Banville parle encore de Watteau comme s'il parlait d'un Marivaux génial; il évoque 'tout le monde idéal et enchanté du divin maître des comédies amoureuses, du grand et sublime Watteau'.
(**35**) Banville, 'Vous en qui je salue une nouvelle aurore...', *Le Sang de la coupe, Poésies complètes*, Paris, Poulet Malassis et De Broise, 1857, p. 368.
(**36**) On peut se demander dans quelle mesure la vision romantique de la peinture de Watteau reste valable pour un critique d'aujourd'hui. La réponse nous est donnée dans l'essai de René Huyghe sur 'L'Univers de Watteau', essai qui précède l'étude d'Hélène Adhémar, *Watteau, sa vie—son œuvre*. Il est frappant de voir que René Huyghe, comme faisant écho aux vers de Gautier et de Banville, commence son texte en écrivant: 'Sans doute avons-nous poussé la porte d'un vieux parc...' (p. 1). Huyghe note également ce jeu si subtil du rêve et de la réalité auquel se livre constamment l'art de Watteau, 'Avec lui', écrit Huyghe, 'apparaît le monde imaginé qui sait se superposer au véritable sans cesser d'y puiser ses éléments' (p. 31). Et Huyghe ajoute: 'Il lui faut un décor... que de ''souvenirs'' du Luxembourg ou de Montmorency comme, pour Corot, de ''Souvenirs'' de Mortefontaine.' Enfin, Huyghe souligne à quel point Watteau, comme il le dit, a 'subi l'envoûtement' du théâtre, et il rappelle: 'C'est un décorateur d'Opéra qu'il suit à Paris; c'est Gillot, peintre de la Commedia dell'arte qui le forme; c'est désormais à la Comédie Française ou

Italienne, au théâtre de foire, qu'il prend ses personnages et leurs situations; les modèles, que, resté chez lui, il pare de costumes de scène, sont parfois des acteurs; et les sujets auxquels il les mêle trouvent encore leur source dans un spectacle: on l'a montré pour *L'Embarquement*, inspiré d'un intermède des *Trois Cousines* de Dancourt' (p. 32).
(**37**) Les Goncourt commenteront l'emploi du satin dans la peinture de Watteau (voir op. cit., I, p. 8) et ils évoqueront 'toutes ces âmes vêtues de satin' (ibid., I, p. 11). Cet aspect avait déjà trouvé faveur auprès du comte de Caylus; 'Il faut dire encore qu'il n'a guères peint que des étoffes de soie toujours sujettes à donner des petits plis' (texte reproduit in Goncourt, op. cit., I, p. 45).
(**38**) Verlaine, 'Art poétique', *Jadis et naguère, Oeuvres poétiques*, Paris, Messein, 1901, I, p. 311.
(**39**) Verlaine, 'Les Ingénus', *Fêtes galantes*, ibid., I, p. 55.
(**40**) Voir René Journet et Guy Robert, 'Le *Manuscrit des contemplations*', *Annales littéraires de l'université de Besançon*, 1956, tome II, fascicule V, p. 29.
(**41**) Voir Jean-Bertrand Barrère, *La Fantaisie de Victor Hugo*, Paris, Corti, 1949, I, pp. 354 et 395; 1950, III, pp. 112–13.
(**42**) Hugo, 'La Fête chez Thérèse', *Les Contemplations. Texte établi avec introduction, chronologies des 'Contemplations' et de Victor Hugo, bibliographie, notes et variantes par Léon Cellier*, Paris, Garnier, 1969, p. 57.
(**43**) Banville, 'Les Folies-Nouvelles', *Odes funambulesques*, p. 109.
(**44**) Rimbaud, 'Soir historique', *Les Illuminations, Édition critique avec introduction et notes par H. de Bouillane de Lacoste*, Paris, Mercure de France, 1959, p. 123.
(**45**) Rimbaud, 'Scènes', ibid., p. 122.
(**46**) Rimbaud, 'Fête d'hiver', ibid., p. 105.
(**47**) Rimbaud, 'Fairy', ibid., p. 113.
Rappelons dans ce contexte les vers de Verlaine:
> Ce sera comme quand on rêve et qu'on s'éveille!
> Et que l'on se rendort et que l'on rêve encor
> De la même féerie et du même décor.

'Kaléidoscope', *Jadis et naguère, Oeuvres*, I, p. 302
(**48**) Baudelaire, 'Théodore de Banville', *Oeuvres*, p. 737.
(**49**) Cet autre sens du mot 'apothéose', comme aussi du mot 'gloire', est bien illustré par les chroniques de Gautier. A l'occasion d'une féerie de Dupenty et Delaporte, *Amours de Psyché*, Gautier écrit de la fin du spectacle: 'Le théâtre change et représente une gloire avec feux de Bengale, vols de génies, amours, tous les ingrédients nécessaires à une apothéose convenable, et

la toile tombe au milieu des applaudissements'
(*H.A.D.*, II, p. 158). Dans un triolet daté de
1845, et intitulé justement 'Feu de Bengale',
Banville évoque ce genre de spectacle:
 Néraut, Tassin et Grédelu
 Sont l'honneur des apothéoses,
 Odes funambulesques, p. 215
Dans un commentaire ajouté en 1873, le
poète explique que ce sont là trois acteurs
qui jouaient à la Porte Saint-Martin 'au temps
de la féerie' (ibid., pp. 366–7). Nous avons
encore le témoignage de Gautier sur l'emploi
des feux de Bengale dans ces féeries; il
décrit ainsi les *Mille et une nuits* à la Porte
Saint-Martin en janvier 1843: 'Bramah
pardonne et le sultan rentre glorieusement
dans son palais de Samarcande, éclairé de
feux verts et rouges, comme il convient à
tout palais qui comprend sa position de
décor féerique' (*H.A.D.*, II, p. 142). C'est
un tel spectacle qu'évoque encore Nerval dans
Sylvie, sauf qu'il s'agit cette fois d'une féerie
donnée au Théâtre des Funambules. A la vue
de la vieille tante de Sylvie, Nerval écrit:
'Cela me fit penser aux fées des Funambules
qui cachent, sous leur masque ridé, un visage
attrayant, qu'elles révèlent au dénoûment,
lorsqu'apparaît le temple de l'Amour et son
soleil tournant qui rayonne de feux magiques'
(*Oeuvres*, pp. 274–5).
(**50**) A. Houssaye parle de 'ces jolis chefs-
d'œuvre tout étincelants' (op. cit., V, p 35).
Les Goncourt admirent chez Watteau 'le pays
aimable et radieux! Soleils d'apothéoses,
belles lumières dormantes sur les pelouses'
(op. cit., I, pp. 5–6).
(**51**) Cit. in A. Houssaye, op. cit., V, pp. 32–
33.
(**52**) Banville, 'La Femme aux roses', *Les
Stalactites*, p. 188.
(**53**) Banville, 'Les Princesses', *Les Princesses*,
Paris Lemerre, 1874, p. 3.
(**54**) Baudelaire, 'Le Cadre', *Les Fleurs du mal,
Oeuvres*, p. 37.
(**55**) Baudelaire, 'L'Invitation au voyage',
Le Spleen de Paris, Oeuvres, pp. 254–5.
(**56**) Banville, 'Décor', *Les Stalactites*, pp.
114–16.
(**57**) Baudelaire, 'L'Amour du mensonge',
Les Fleurs du mal, Oeuvres, pp. 94–5.
(**58**) Ibid., p. 1546.
(**59**) Baudelaire, 'Éloge du maquillage',
Oeuvres, p. 1185.
(**60**) Baudelaire, 'Les Sept Vieillards', *Les
Fleurs du mal, Oeuvres*, p. 83.
(**61**) Baudelaire, *Salon de 1859, Oeuvres*,
p. 1084.
(**62**) Ibid., p. 1085.
(**63**) Baudelaire, *Salon de 1846, Oeuvres*,
pp. 936–7.
(**64**) Voir Jean Pommier, 'Banville et
Baudelaire', *Revue de l'histoire littéraire de*

la France, 1930, pp. 514–41; Banville, *Les
Stalactites*, pp. 109–10.
(**65**) Baudelaire, 'Poème du haschisch',
Paradis artificiels, Oeuvres, p. 349.
(**66**) Ibid., p. 382. Il est intéressant de voir
que Gautier également fait le rapprochement
entre le décor de théâtre et la vision de
l'opiomane. Racontant à Nerval l'impression
créé par *La Péri*, Gautier écrit; 'Si tu as
été dans les cafés des fumeurs d'opium et que
tu aies fait tomber la pâte enflammée sur le
champignon de porcelaine, je doute que,
devant tes yeux assoupis, il se soit développé
un plus brillant mirage que l'oasis féerique
exécutée par MM. Séchan, Dieterle et
Despléchin qui semblent avoir retrouvé la
vaporeuse palette du vieux Breughel, le
peintre du paradis. Ce sont des tons fabuleux,
d'une tendresse et d'une fraîcheur idéales;
un jour mystérieux, qui vient ni de la lune ni
du soleil, baigne les vallées, effleure les lacs
comme un léger brouillard d'argent, et
pénètre dans les clairières des forêts
magiques' (*H.A.D.*, III, pp. 81–2). Toute la
description fait songer à 'Décor' dans *Les
Stalactites* de Banville.
(**67**) Baudelaire, 'Les Projets', *Le Spleen de
Paris, Oeuvres*, p. 1610.
(**68**) On constate le même phénomène dans
la poésie de Gautier. Ainsi dans un poème,
publié d'abord en 1854 et ajouté aux *Emaux
et Camées* en 1858, on lit:
 Le cygne s'est pris en nageant,
 Et les arbres, comme aux féeries,
 Sont en filigrane d'argent.
'Fantaisies d'hiver' II, *Poésies*, III, p. 67
(**69**) Mallarmé, 'Solennité', *Oeuvres
complètes, texte établi et annoté par Henri
Mondor et G. Jean-Aubry*, Paris, Bibliothèque
de la Pléiade, 1945, p. 334. 'Solennité' est
composée de deux textes dont le second,
d'où est tirée notre citation, parut dans la
Revue indépendante en juin 1887. Une lettre
de Mallarmé à Dujardin, qui dirigeait la revue,
révèle que Mallarmé considérait ce texte
comme 'la moins mauvaise des études que
j'ai publiées chez vous' (*Correspondance,
recueillie, classée et annotée par Henri
Mondor et Lloyd James Austin*, Paris
Gallimard, 1969, III, p. 116. Voir aussi mes
deux articles 'Une Amitié de poètes.
Théodore Banville et Stéphane Mallarmé',
Le Goëland, juin 1943 et juillet-août 1943.
(**70**) Banville, 'La Fontaine de Jouvence',
Les Stalactites, p. 246.
(**71**) Mallarmé, 'Solennité', *Oeuvres*, p. 333.
(**72**) Mallarmé, 'Théodore de Banville', texte
original du *National Observer*, reproduit in
Norman Paxton, *The Development of
Mallarmé's Prose Style*, Genève, Droz, 1968,
pp. 118–20. Dans une lettre du 15 novembre
1886, Mallarmé remercie Henri de Régnier
de l'envoi de son recueil: *Apaisement* et, en

particulier, de la dédicace accompagnant le sonnet 'L'Ile', 'un de mes préférés', precise Mallarmé (*Correspondance*, III, p. 70). Ce sonnet contient dans son tercet final comme un dernier écho affaibli de cette poétique du décor que nous avons cherché à définir :

Surgir à l'horizon s'ouvrant comme un décor
Dans le magique éclat d'une aube virginale
L'Île des fleurs de pourpre et des feuillages d'or.

Discussion. In the course of discussion, attention was drawn to the revaluation, during the 1830s, of the idea of the 'Rococo', which for a long time had carried a pejorative meaning; in this connection Gautier's poem 'Rococo', whose title changed in 1838 to 'Watteau', was cited. The question of some connection between the revaluation of 'Rococo' and the idea of 'Décor' remained unanswered.

Michael Podro

5
The painters' analogies and their theories 1845–80

In this paper I want to examine three things which I believe to be closely con-
nected. The first is a set of distinctions between subject-matter, the exer-
cise of perception, and states of mind or attitudes. Second, I want to suggest
certain similarities between the views of Schiller and Baudelaire with regard
to the relation of these three factors, and suggest that the similarities may also
have involved a historical connection. Third, I want to indicate some ways in
which the general framework of ideas, more or less explicit in Baudelaire and
Schiller, may provide a context which illuminates critically the distinctive opera-
ations of perception in Impressionism, and say something about the theory
and practice of those operations of perception.

1

Writers on art of any seriousness, whether philosophers, critics or painters,
have set out to distinguish the difference between the interest of a work of art
which represents some subject, and the interest which that subject might have
in ordinary experience—whether the subject is a bullfight or a still-life. The
distinctions they draw can be divided broadly into three classes, and normally
a writer of any distinction has used distinctions from more than one class. First
it has been held that art presents us with something which is otherwise un-
perceived by us. The two classical forms of this way of marking off the interest
of art from the interest of its subject-matter are by holding that the artist
constructs or reveals an ideal form which ordinary nature never achieves, and
that the artist transforms his subject-matter, when it is dramatic, to reveal
only what is essential to its theme or story, subordinating character, setting,
gesture, colour and everything else, to what would amplify his central *istoria*.

Such types of demarcation remained central to critical writing in the mid-
19th century, although there were modifications on the traditional Albertian
and academic theory.[1]

When Castagnary tells the artist 'Nature and life . . . stretch out around

99

you. Go! And come back to show other men what you have found there,"[2] he is treating the artist as revealing some aspect of the world which it is assumed eludes us in ordinary experience or eludes the experience of ordinary men. And earlier, when Diderot had instructed the artist to observe the reciprocal interaction of the parts of the body in which the distinctive configuration of any one individual was revealed,[3] although rejecting an outworn conception of the ideal as the aim of the artist, he was still basing his conception of the artist's task as the revelation of something about the subject. When it came to the question of dramatic subjects, Diderot was for the most part in conformity with the traditional view of subordinating all aspects of the work to its central subject. All such views base the distinction between the interest of a work of art and its subject on the work of art being revelatory of some aspect of the subject. It may be that the art is seen as revelatory of what is thought of as being the *essence* of the subject, the ideal to which it aspires, or that which constitutes its most important characteristic or its inherent order. But even this is not necessary, for the artist may be seen as revealing something which is inessential. When Théophile Thoré invokes the beauty of the accidental and momentary as opposed to the ideal, he is still talking about the *subject* the artist may try to represent.[4]

The second class of criteria for characterizing the difference between the interest of the work of art and the subject it represents is made up of those which refer explicitly to the perceptual procedures of the spectator: for instance, seeing similarity through difference or perceiving an underlying unity or continuity through a multiplicity of features. Now, it might be argued that unity in multiplicity could as well be a question of subject-matter, of all the parts belonging to a coherent depiction, as of a special use of perception. The distinction intended here can perhaps best be brought out by saying that in some cases of coherence we can *only* talk about that coherence by making a reference to the mental procedures of the spectator. It is one thing to say that a scene or figure is coherent or complete, it is another thing to say that the spectator can, by a capacity for recognizing analogy, or by adjusting his attention in a certain way, come to see its unity or see a characteristic in the painting that could not otherwise be seen. And it is to introduce a different kind of criterion for including something in the category of art, to hold that just such demands on our perception are characteristic of something *in so far as it is a work of art.*[5]

It is on the borderline between that unity which belongs to the real or idealized subject and that which involves reference to the perceptual operation of the spectator, that a later section of this paper will focus.

The third way in which writers on art have characterized the interest that things take on when included within works of art is by reference to states of mind or feelings or attitudes which become engaged in art in a way distinct from our engagement with the same subject in reality, most frequently by insisting that, confronted by a work of art, we achieve an emotional equilibrium, a purging or poise or inward harmony, which we do not normally possess. These states are not thought of, except in some recent and intellectually eccentric literature, as an exclusive 'aesthetic state' unrelated to the overall scheme of our sensibility, not even by Roger Fry. Typically it is invoked, from Aristotle onwards, to bring out the distinction between our satisfaction in tragedy as opposed to the feeling we might expect to have in front of real human disaster or suffering.

In separating these three ways in which writers on art have set out to distinguish the interest of ordinary objects in the world from the interest they take on when included within a work of art, I am not suggesting that any one way has been held to be sufficient. Nor do I believe that any simple additive combination of such criteria would be sufficient. For we seem to be confronted by three kinds of factor—attitude or inward state, exercise of perception, and the objects of attention—and these three always seem to interact.

A crucial fact of the critical discussion of art is that, when we talk about the unity of a work of art, we *may* be invoking any one or a combination of such criteria : unity may be a matter of all the parts belonging to the subject without there being irrelevant or inexplicable or incongruous features : it may also be a matter of the spectator's procedures of *perception*, that is, by recognition of analogy or by the fusions and separations we make, or it may be thought of as some interior harmony of mind.

2

My natural historical starting point is Schiller's famous letter to Goethe of 7 August 1797 regarding Diderot :

I have in the last few days been reading Diderot's *Sur la peinture*, to refresh myself by the company of this invigorating man. It seems to me that with Diderot, as with many others, he catches the truth with feeling only to lose it again with his rationalizations. He seems to me to be far too concerned in works which are aesthetic with moral and extrinsic aims, rather than seeking aims in the object itself and its presentation. For him the work of art must always serve some further purpose. And since the truly beautiful and perfect in art must necessarily be humanly improving, he seeks this effect of art in its content and in a determinate result for the understanding or for moral sentiment.[6]

There are, I think, two preliminary things to notice about Schiller's letter here: first that Schiller makes an immediate transition from literal interest in the subject to moralizing. Second, the literal interest is the ordinary life interest, which is moral and sentimental. What would Schiller have meant and have been understood to mean by insufficient attention to 'the object itself and its presentation'.

There are three fundamental implications for this in Schiller. The first can best be brought out by reference to his conception of the necessary reciprocity of receptivity and activity in the perception of art, as he describes it in his review article on the landscape poetry of Matthisson:

If by poetry in general, one understands the art which places us in a particular frame of mind through a particular effort of our productive imagination . . . then there are always two demands which no poet worthy of the name can avoid: First he must leave the imagination free play and self determination, and secondly he must simulate a specific sensation and be certain of his effect. At first these two demands seem mutually contradictory. For according to the first, our imagination must reign and obey nothing but its own rule: according to the other it must be subservient, and obey the rule of the poet. How does the poet overcome this contradiction? By this: that he prescribes for our imagination no other path than that which it must take in its full freedom, and following its own laws. . . .[7]

And Schiller elaborated this relation between an interplay of receptivity and activity toward the end of the paper: the poet

. . . may hint at these ideas, touch on those feelings: but he must not complete them himself, he must not forestall the imagination of his reader. As definition becomes more exact it becomes felt as an oppressive limitation. For the attraction of such aesthetic ideas lies precisely in this: we gaze into the content as into an unfathomable depth. . . .[8]

For Schiller this is quite distinct from mere personal association: it is a determinate suggestiveness, being led to *find* connections, conclusions and correspondences which are there, and in this lies our freedom.

A rigidly literal and moral view fails to give an account of that interplay between object and perceiver which is characteristic of art, and that interplay is thought of by Schiller in terms of perceptual play in the making of analogies.

The second point can be made with reference to Schiller's *Letters on Aesthetic Education*: the stronger the demands of the subject, the more it is likely to impose upon the spectator, the greater the need for the artist to arrest this impact and impose his own order, one which is not that of the subject itself.

Subject-matter, then, . . . always has a limiting effect upon the spirit, and it is only from form that true aesthetic freedom can be looked for. Herein, then, resides the real secret of the master in any art: that he can make his form consume his material; and the more pretentious, the more seductive this material is in itself, the more it seeks to impose itself upon us, the more high-handedly it thrusts itself forward with effects of its own, or the more the beholder is inclined to get directly involved with it, then the more triumphant the art which forces it back and asserts its own kind of dominion over it... There does indeed exist a fine art of passion; but a fine passionate art is a contradiction in terms; for the unfailing effect of beauty is freedom from passion. No less self-contradictory is the notion of a fine art which teaches (didactic) or improves (moral); for nothing is more at variance with the concept of beauty than the notion of giving the psyche any definite bias.

(Letter XXII)[9]

Parallel to this, Schiller talks of each art, not only each kind of subject-matter, needing, within the special limits of its own nature, to modify itself by reaching to the borders of—approximating itself to—another art.

Music, at its most sublime, must become sheer form and affect us with the serene power of antiquity. The plastic arts at their most perfect, must become music and move us by the immediacy of their sensuous presence. Poetry, when most fully developed, must grip us as powerfully as music does, but at the same time, like the plastic arts, surround us with serene clarity. This precisely is the mark of perfect style in each and every art: that it is able to remove the specific limitations of the art in question without thereby sacrificing its specific advantages, and through a wise use of its individual pecularities, it is able to confer on it a more general character.

(Letter XXII)

The balancing out of the biases of particular arts would seem to have two kinds of implications: the first and more general is simply that there is a natural bias in any art of falling too much on to the side of sense or feeling, or on to the side of clarity of thought. But Schiller is here pointing to something more interesting than a vague balancing out of mental states. The demand that music should 'become sheer form', and that the plastic arts must 'move us by the immediacy of their sensuous presence', becomes a matter of liberating our minds from the bias inherent in the material or type of art, and this for Schiller is characteristically a matter of restoring or enforcing our intellectual spontaneity or sensuous receptivity in the perception of the works concerned (whichever is most likely to suffer). The insistence on the sensuous character of painting is a way of curtailing looking at the representational painting simply for what it represents.

I turn now to Baudelaire and his attack in his *Salon of 1845* on Thoré, and examine its possible rapports (historical and theoretical) with the position of

58 Delacroix: 'Last words of Marcus Aurelius'

Schiller. Baudelaire had attacked Thoré for having written the following in his account of the Delacroix 'Marcus Aurelius' [58].

In the 'Death of Marcus Aurelius' one *listens* with attention. And indeed how all the details harmonize with the principal idea. The past grows dark in the figures and drapery of the friends of Marcus Aurelius, and the future is red like the robe of Commodus. The light only strikes the figure of the young Caesar, while the philosophers of the preceding reign die away in shadow. . . .[10]

Baudelaire singles this out for ridicule:

A well-known critic has sung the painter's praise for having placed Commodus, that is the future, in the light; and the Stoics, that is to say the past, in the shade. What a brilliant thought! But in fact except for two figures in half shadow, all the characters have their share of illumination. This reminds one of the admiration of a republican man of letters who could seriously congratulate the great Rubens with having painted Henry IV with a slovenly boot and hose...to him it was a stroke of independent satire. Rubens the revolutionary, O criticism, O you critics.[11]

How far does Baudelaire's onslaught on Thoré correspond to Schiller's more mannerly criticism of Diderot. They have in common the obvious rejec-

tion of literalism and moralizing and the insistence on sensuous presence of the painting as painting. But what would make this reaction to Thoré's criticism nearer to Schiller (and not merely the ridicule of allegory as in Diderot and Heine)[12] would be to link it to the remarks in the section 'A quoi bon la critique?' in the *Salon of 1846*, where Baudelaire condemns criticism which is 'cold and algebraic, and which under the pretext of explaining everything, possesses neither hate nor love'.

There are two distinct historical points which arise here: first, is it appropriate to link Baudelaire's criticism of Thoré in his *Salon of 1845* with his discussion of criticism of the following year. I think it is. For the discussion of criticism in the *Salon of 1846* seems itself to be readable as an answer to Thoré's account of criticism in 1845 in a passage which is close to that on the 'Marcus Aurelius'. There Thoré had maintained that criticism depended upon the application of a general concept of beauty, and that it was 'exactly the same as political journalism which defends a given principle, by giving an exposition of its underlying reasons, and shows how the results make manifest the principle'.[13]

It is to his *general view* of criticism that we may hear Baudelaire replying in 1846 as he replied to a *particular application* of it in 1845.

The second problem I want to raise concerns the kind of connection we can usefully make with Schiller. One might say that if we take the passages together we get something which has a clear similarity to Schiller's attack on an over-intellectualized literalism and moralism, a literalism and moralism which inhibits the flexibility and the sensuous and emotional receptiveness of the mind. But the question remains—how fortuitous is the resemblance? Was it a matter of intuitively sensitive men facing a recurrent problem and producing a similar reaction or solution. Is it that the interest of the similarity is simply that it leads us to understand the underlying problem and the responses to it more fully? This may be so, but it seems there may also be an historical connection.

First of all the analogy with Schiller gains force in a general way in the preface of the *Salon of 1846*, which cannot be dismissed as a *jeu d'esprit*.

It was central to Schiller's outlook in the *Letters on Aesthetic Education* that art was necessary to the re-integration of human personality from the domination of the intellect and its specializations on the one side and our appetites and senses on the other. Baudelaire's preface 'Au bourgeois' is an attack on the new bourgeois ideal 'republic': '. . . the day will dawn when the property owners will be wise or the wise property owners.' It is a parody—a joke—and by being a joke making its point about freedom from the domination of the

intellect without sacrificing the intellect. It is the function of this wit to proclaim: 'Art is an infinitely precious good, a draught both refreshing and sheering, which restores the stomach and the mind to the natural equilibrium of the ideal.'

The question arises: how far were the rather difficult theories of Schiller available to Baudelaire at this point. The answer to the question of availability is interesting. In between the writing of Baudelaire's *Salon of 1845* and that of 1846, a superbly lucid account of Schiller's *Letters on Aesthetic Education* appeared in the *Revue indépendante* by a Mme de Dombasle.[14] Every point and passage I have used from Schiller's *Letters on Aesthetic Education* appears there. The same periodical was carrying a series of *Salon* revues as well as George Sand's *Isadora*, and so Baudelaire would probably have seen it and, given his critical interests at the time, would have been unlikely not to scan it. That is, I am proposing that similarity, and availability of Schiller's ideas suggest historical connection at this point.

But quite independently of this direct historical connection I want to emphasize that the broad framework of attitudes to subject-matter in painting suggested in Baudelaire and Schiller may serve a critically important function for understanding the art of the next generation.

3

What has the position which is here attributed in detail to Schiller and is at least evoked by Baudelaire to do with Manet and Impressionism? To put the answer at its simplest it is this: the demand on the flexibility of our perception and the denial of a literal or literary attitude toward subject-matter was to produce one half of a new situation, a situation in which the question arose: what was to count as the distinctive nature of the painter's role, and what was to count as relevant to his painting, and so to unifying it, once the criterion of relevance to subject or amplification of the subject was in question. One theoretical alternative was to treat the mood or 'music of colour' as the core of the painting, but within the tradition of painting at the time it offered no clear painterly procedure.

To say that there was now a problem about the artist's use of subject-matter, about what could be made relevant within a painting, is not to say that the unity of a Delacroix or Rubens or Claude was simply literary or literal. But it is to say that for those artists there was always a focus of subject within which the visual analogies and continuities, the richness of painting were absorbed as metaphors within the fabric of a traditional novel.

In saying that the literal or literary viewpoint is being called into question

by the kind of comment made by Schiller and Baudelaire, what I mean is not that literary or literal subject-matter is being dismissed, but that painting, or criticism that treats painting as of interest simply for its conveying of the subject or the '*pensée principale*', is held to be inadequate. For to treat painting in this way appears to ignore what it is that the painter has achieved in handling the subject beyond merely reproducing something which existed independently of him and his medium; it is to ignore the sensuous quality of the medium itself, and thus allow our minds to regard the work of art simply for the facts it represents or the moral it prompts, instead of leading us to suspend our practical determinate judgement in the face of what Baudelaire would call *suggestiveness* and Schiller the free play of the mind.

If you call into question the literal or literary viewpoint, you put a high premium on whatever will enable the artist to elude the literal and literary and yet have some procedure which we can understand or in which we can participate. To do this—elude both the literal and literary at the same time—could not have been easy, and the possibility of doing so appears to have depended upon new ways of controlling perceptual analogy, which was to make interest and unity through visual analogy relatively dominant and interest and unity through subject-matter relatively recessive.

59 Cézanne: 'Railway cutting'

The clearer understanding of the operations of perception is revealed in a number of factors: the use of *optical mixture* which produces a unity among discrete colour patches. Closely related to this is the use of 'homogeneous colour', where some tone but different hue, juxtaposed, seem to fuse and separate. This is used with particular effectiveness where the fusion is also a fusion between what we recognize as discrete objects.[15] There were also the 'plays of perception' upon uncertainty of scale and distance.

Brücke wrote: 'We underestimate all large distances by approximating them too small. The inexperienced believes he is close to a distant mountain . . . and is surprised when it takes a long time to reach. He takes a mountain range to be homogeneous and when he comes close he finds there are miles between the various hills.'[16]

Such observations were not new, but in the context of perceptual psychology and of the problems in the tradition of painting of the second half of the 19th century they take on a new urgency. For psychologists of perception were concerned about how we came to transform what they took to be essentially two-

60 Monet: 'Poppy field'

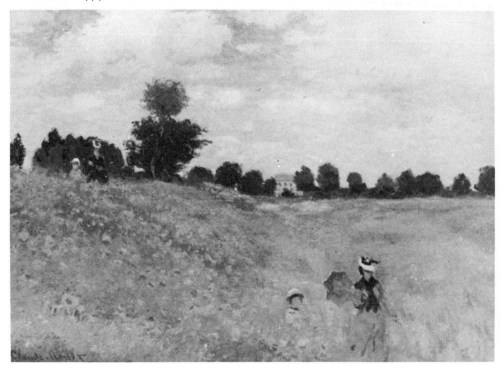

61 Renoir: 'Pathway up a grassy slope'

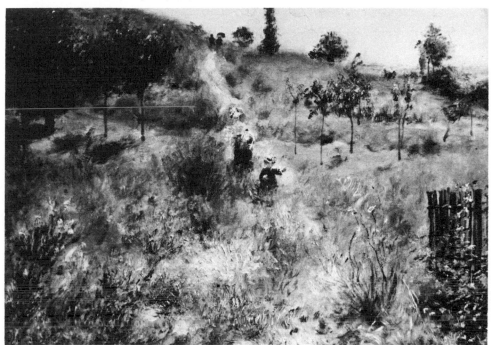

dimensional optical impressions into a grasp of the three-dimensional world, so the relation between the flat plane and the third dimension was as central to them as to the painter. One way in which this plays back upon painting is by sustained 'continuities' between foreground and background of the kind described by Brücke which is surely already present in Cézanne's 'Railway cutting' [59]. Another more elusive effect is the way our constancying mechanism works in perception. One object twice as far away as another and of the same size projects an image half the size of the nearer object, but we do not see it that way; we believe that even the 'projected' size of a distant object is nearer the size it would have when in our immediate vicinity.[17]

It is surely part of the effect of both Monet's 'Poppy field' [60] and Renoir's 'Pathway up a grassy slope' [61] that we are surprised by the distance we must project between the two groups of figures in each painting, and that as we realize the distance we find the figures further back seem to grow. That is, by virtue of analogizing between the two groups of figures we both realize the group further back is so much smaller, giving us our one clear cue in the picture as to distance, and in just so far as the discrepancy of size gives us a cue

to distance the discrepancy itself seems to diminish and we see the image of the background enlarge as our 'size constancy' mechanism is jerked into play.

How far was the painting of these two pictures dependent on a control, a self-consciousness which came from a knowledge of psychological optics? We have both a Renoir and a Monet using the same device although not painting the same scene, which makes it look rather less than accidental and in Monet's painting the forward group is almost exactly half the size of the backward group. Furthermore, all the relevant psychological information was available in a few paragraphs of Helmholtz, whose major work on optics appeared in French in 1867.[18] Talking about estimation of distance he writes:

. . . the images of distant objects appear close to each other, while the images immediately around us take on a relatively greater three-dimensionality. It is above all men and domestic animals which furnish us . . . with the most useful information (with regard to distance). Their movements easily draw our attention, and the size varies little and is familiar to us.

And he goes on to say how the inhabitant of the plane is easily mistaken about the height and distance of mountains, confusing pine trees with briars. 'It is for this reason that painters put men and animals in their landscapes . . .'

Helmholtz goes on to say that the impurity of the atmosphere makes us see

62 Monet: 'Poplars' **63** Monet: 'Beach at Trouville'

things as further away than they are, and in so far as we do this we augment their size and appearance, in proportion, as we see them as more distant. And he remarks that when we use a telescope on a piece of distant landscape it does not look as if it were something larger but something nearer.

If we look back now at the Renoir and the Monet we see, I think, that we are given no firm depth cues except the figures: indeed, we are led to sustain a sense of the homogeneous plane partly because the figures are on a slope, partly because of the fragmented surfaces and atmospheric effects. Clearly the text book never anticipated an art in which our constancying mechanism was brought into play by an analogy between groups of figures and which then led us to see both their discrepency in size and to approximate the one to the other. This clearly is no mere application of a rule; it must depend on controlling the level of obviousness of the analogy and the level of dominance of the overall atmospheric effect. But it is hard to imagine this level of control without the armature of psychological knowledge.

It is perhaps worth pointing back to Cézanne's 'Railway cutting' [59] at this point and to Helmholtz: 'the summits of distant mountains, particularly when they are covered in snow and illuminated by the sun's glare, appear to the traveller with a clarity which he is used to experiencing only in objects which close . . .'[19] When Cézanne links the background mountain to the middle-ground hill of the railway cutting by a continuity of line, he seems to obtain a continuity of the two which we then realize must be a mistake, and in dissoci-ating them we have a sense of instability of the mountain's size in the picture.

Whereas in their *Salons* in 1859 both Baudelaire[20] and Dumesnil[21] warn the painter that he cannot dispense with 'composition' and show just any view which happens to be caught in the frame of a window, this is surely what Pissarro or Renoir deliberately appear to do, and they can do it and produce unity, a resolvable picture, because unification or resolution now depends not upon the unity of the subject, literary or literal coherence, but upon dis-coveries of similarity through difference, be it the similarity of flickering paint marks and the carriage behind the girl's head in Renoir's 'Place Clichy', or between the sense of a single homogenous plane and the suggestion of distances within the painting, or between the multiplicity of directions which we attribute to a line of poplars by Monet [62], or between the sharp striations of paint in Monet's 'Beach at Trouville' [63] and the sense of flickering sun-light (Boudin describes the transition when he talks of Monet's hard 'husk' of paint which you have to lift in order to catch the vision).[22] Here again the satisfaction or resolution of the painting involves, crucially, a process of adjustment, a play of perception on our part.

What I am saying, putting it briefly, is that the challenge to the idea that the interest of a painting or its unity was established by reference to the subject, its literal coherence and the availability of systematic thought on perceptual ambiguity and analogy, created two related conditions of the development of Impressionism.

4

In what way can we trace equivocality toward subject-matter other than in the shift of emphasis from literal and literary interest of the subject itself to the operations of perception? It is characteristic of Impressionism that it does not have subjects which are emotionally overpowering, but it does have subjects. Its 'plein air' is as much a matter of subject and our emotional attitude to it as of technique, and our perceptual flexibility can become involved with our attitude in various ways. In Manet's 'Femme aux seins nus' [64] we have a sense of volume completely dovetailed with a sense of shallow relief, and a sensuousness toward paint inextricably linked with that toward the girl. In Renoir's 'Torse de femme au soleil' [65] the patches of paint which mark the shadows

64 Manet: 'Femme aux seins nus'

65 Renoir: 'Torse de femme au soleil'

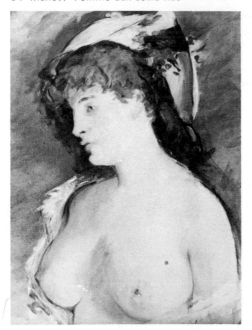

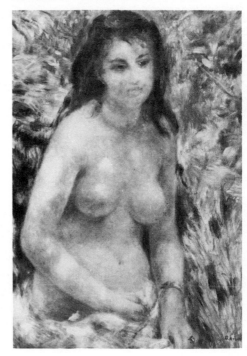

are inseparable from our sense of the girl's torso, as though we have to adjust to the unusual illumination and to the transition from paint to flesh in co-incident ways. The point here is that the interest of the subject does not break free from the sense of painting procedure, that the eroticism is extended into a pleasure in the handling of the medium. It does not cease to have the sensuality of its subject-matter, it ceases to have it as an isolated or isolable thing. (The point here, it should perhaps be underlined, is not that attention to brushwork or pattern is a distraction from the interest of the subject-matter but that they interplay and modify each other.)[23] Considered in this way, from the point of view of attitude or emotional involvement, Impressionism and the art of Manet are not particularly different from earlier painting. If one does want to find distinctive attitudes it is perhaps in the insistance on underplaying the ordinary dramatic explicitness and circumstantial interest, as in Manet's 'Suicide' or 'Funeral'. Manet's 'Bar at the Folies Bergère' [66] might be thought of as a counter example, and one that I want to end by considering.

Flaubert writes back to George Sand on how he has to resist just those sub-jects which emotionally engage him too much and on another occasion

66 Manet: 'Bar at the Folies Bergère'

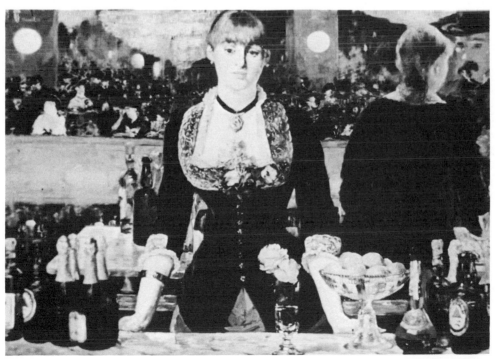

insists that 'one always falsifies reality when one wants to lead [the reader] to a conclusion'.[24] In *Sentimental Education* the way of employing ambiguity, or analogy and flexibility of viewpoint can be brought out by two brief allusions: the flat that was prepared by Frédérick for the ideal mistress, Madame Arnoux, is eventually where he is to become Rosanette's lover, and the Rosanette relation takes on an emotional reality compared to what later becomes a fay romanticism in his relation to Madame Arnoux. During the one serious and idyllic period of the affair with Rosanette she tells him how she was seduced as a girl, and at the end of the book, when Frédérick has deserted Rosanette, it is an old protector who marries and looks after her. There is no viewpoint from which the relationships are unqualifiedly endorsed or rejected by Flaubert. No point at which the reader is driven to a conclusion. In Manet's 'Bar at the Folies Bergère' where the girl confronts us so openly, and yet we have to see whether we correspond to the man in the perspectivally curious mirror, can we catch a similar refusal to allow us our unequivocal attitude?

Notes and discussion

(1) This concept of decorous exposition, and its continuation into 19th and 20th century criticism, is considered in an earlier paper which I gave in 1964, 'Modern Criticism and Decorum', *Stil und Ueberlieferung in der Kunst des Abendlandes, 21 Internationaler Kongress fuer Kunstgeschichte*, Bonn, 1964, VIII, pp. 230 ff. This paper is to some extent a development of ideas first suggested there.
(2) Cited by Linda Nochlin, *Realism and Tradition in Art, 1848–1900,* New Jersey, 1966, p. 68, From Castagnary, 'Salon de 1868', *Salons (1857–70)*, Paris, 1892, I. p. 298 f.
(3) Diderot, 'Essai sur la peinture', Chap 1, *Oeuvres complètes,* Paris, 1872, X, pp. 46 ff.
(4) T. Thoré, *Salon de 1845*, Paris, 1845, p. 61.
(5) It is the kind of factor involved in ambiguity and the mind's play with analogy. the fullest and theoretically most elegant analysis of such plays of perception, although involving certain logical difficulties, is that of Johann Friedrich Herbart, who considered this in terms of the fusion and separation of discrete features in perception, the perception of one feature as the transformation of another, and the conflict of different 'contexts' or interpretations which we try to project on to the same feature. See particularly 'Einleitung in der Philosophie', *Sämtliche Werke*, ed. Kehrbach, Langensalza, 1883–, IV, pp. 126 ff., and 'Psychologie als Wissenschaft', ibid., VI, pp. 68, 82, 106 ff.
(6) *Briefwechsel zwischen Schiller und Goethe*, Stuttgart, 1881, p. 281.
(7) Schiller, *Sämtliche Werke,* Säkular Ausgabe, XVI, p. 252 f.
(8) Ibid., p. 260.
(9) The translations here are from that of Wilkinson and Willoughby of Schiller's *Aesthetic Education of Man*, Oxford, 1967.
(10) T. Thoré, *Salon de 1845*, Paris, 1845, p. 65.
(11] Baudelaire, *Curiosités esthétiques et l'Art romantiques,* ed. H. Lemaitre, Paris, 1962, p. 10. The translation of the Baudelaire passage from the Delacroix section of the *Salon de 1845* is that of J. Mayne, in Baudelaire, *Art in Paris*, London, 1965, p. 4.
(12) Diderot, 'Salon de 1767' *Oeuvres complètes*, Paris, 1872, XI, p. 51, and Heine, 'Französische Maler Gemäldeausstellung in Paris, 1831', *Sämtliche Werke*, Leipzig, n.d., VII, p. 17.
(13) T. Thoré, op. cit., p. 58.
(14) *Revue indépendant*, 25 Oct. and 10 Nov. 1845. The reference is cited in E. Eggli, *Schiller et le romantisme français*, Paris, 1927, II, p. 568, but not there related to Baudelaire.
(15) For a summary and recent discussion of these factors see W. I. Homer, *Seurat and the Science of Painting*, Cambridge, Mass., 1964.
(16) E. Brücke, *Principes scientifiques des beaux-arts*, Paris, 1878, p. 53.
(17) Ibid., p. 52.

(18) H. Helmholtz, *Optique Physiologique*, Paris, 1867, pp. 787 ff. But earlier in France one finds discussion of size constancy, e.g. J. M. Séguin, *Comptes rendus* (de l'Académie des Sciences), Paris, XLVII, p. 198.

(19) H. Helmholtz, op. cit., p. 789.

(20) Baudelaire, *Salon de 1859*, op. cit., p. 371 (Section VIII on Landscape.)

(21) M. H. Dumesnil, *Salon de 1859*, Paris, 1859, p. 15. The Baudelaire and Dumesnil passages are strikingly close.

(22) Boudin letter of 19 June 1886, cited in G. Jean-Aubry, *Eugene Boudin*, London, 1969, p. 107.

(23) The relation between eroticism and perceptual difficulty is discussed, with reference in passing to this Renoir, by E. H. Gombrich in 'Psycho-Analysis and the History of Art': in *Meditations on a Hobby Horse*, London, 1963.

(24) Passages cited by A. Cassagne in *L'Art pour l'art en France*, Paris, 1906, pp. 293 and 263 ff.

Discussion. Baudelaire's possible knowledge of Schiller's aesthetic writings, in particular his *Über die ästhetischen Erziehung des Menschen*, was extensively discussed. On this point Prof. Austin and Dr Fairlie gave some clarification: Baudelaire had no first-hand knowledge of Schiller's writings. Other possibilities were considered, for example that Schiller's writings might have reached Baudelaire via Mme de Staël, Heinrich Heine, Gautier, Nerval or Delacroix, but this remained hypothetical. Dr Podro stressed once again the conditions which led to a change in artistic perception and had their origin in several sources, including ideas like those of Schiller, as well as in the work of artists learning 'to control the perceptual mechanisms of ambiguity and analogy within what was, at first sight, a highly fragmented object'. Artists were in a position to convert a multiplicity of features into a unity, by means of 'visual analogy', and hence no longer needed to revert to the traditional unities in the dramatic or narrative sense.

Alan Bowness

6

Courbet's early subject-matter[1]

When Courbet arrived in Paris in November 1840, aged twenty-one, he was a young painter in search of a subject as well as a style. It took him eight years before he was able to produce what is universally agreed to be his first major picture, 'Une Après-dinée à Ornans', painted at his native Ornans in the summer and autumn of 1848, and exhibited at the *Salon* of 1849. In 1849 and 1850 Courbet painted three more large pictures which were all shown at the delayed 1850 *Salon*, which opened on 30 December of that year. They were 'L'Enterrement à Ornans' [69], 'Les Casseurs de pierres' and 'Les Paysans de Flagey revenant de la foire'. These four paintings established a new manner of painting, manifestly neither Romantic nor Classical, which was soon labelled Realist. The purpose of this paper is to investigate as precisely as possible the circumstances in which these paintings were produced.

Now the way in which Courbet's *style* was formed in the eight years from 1840 to 1848 is clear enough, and this is not my concern here. It is enough to say that it was a compound on the one hand of contemporary and on the other hand of 16th and 17th century sources. Courbet drew from current Romantic painting—which we should not associate too closely with Delacroix, though he did copy 'La Barque de Dante'—and from the rival Classical school—which again we should not associate too exclusively with Ingres. More important, he made copies of works by Van Dyck, Hals, Rembrandt and Velasquez, painted pastiches of Florentine and Venetian painting, and generally displays the extent of his debt, in particular, to Spanish and Dutch painting. By 1848, Courbet had succeeded in drawing all these influences together to forge an unmistakable personal style. The paintings executed between 1840 and 1848 are often stylistically inconsistent with one another, but this is largely because each picture tends to reflect its model. Courbet was deliberately learning from others—in his statement of 1855, he says that he was 'extracting from the entire body of tradition the rational and independent concepts appropriate to my own personality'.

These words reflect an egocentric approach to art, to which I shall return later, because it is fundamental to Courbet. There are, for example, at least twelve self-portraits painted between 1840 and 1848 alone, and in both quality and quantity they dominate the early work. They are markedly more Romantic in style than, for example, the portraits of his family—it is as if Courbet had deliberately used the Classical style when he wanted to please his father, whereas his more personal work is frankly Romantic. Of course this demonstrates how closely subject and style are connected, but so far as possible I want to concentrate on subject-matter. Let us survey all the work up to 1848 from this point of view.

Courbet's earliest oil paintings, most of which have disappeared and are known only by title, are landscapes with local associations: 'La Vallée de la Loue', 'L'Entrée d'Ornans', 'La Maison de grand-père Oudot', all dating from 1839–40. This represents a constant stream in Courbet's work, though in fact landscape is not much in evidence from about 1842 until 1847, when he painted at Ornans the three pictures shown at the 1848 *Salon* under the titles 'Matin', 'Midi' and 'Soir'. Some of the earliest landscapes evidently had Romantic connections—'Ruines le long d'un lac' (1839), 'Moine dans un cloître' (1840)—and there is also no doubt that as a young painter Courbet attempted compositions based on Romantic literature. Again, many are lost. There was certainly an 'Odalisque' after Victor Hugo's poem beginning: 'Si je n'étais captive / J'aimerais ce pays', and a painting after George Sand's *Lélia*, which was published in 1833. The connection with George Sand is an important one, to which I will return. There is also, in 1841, according to Georges Riat, Courbet's biographer, a 'Nuit de Walpurgis', which he describes as 'un alchimiste poursuivant une jeune femme'. Other young painters, besides Courbet, were choosing such literary subjects in the 1840s, as one can see from *Salon* catalogues. Delacroix of course is the prime example of this direction, and a lost Courbet picture, 'Le Prisonnier du Bey d'Alger', may even have displayed his direct influence.

Otherwise, most of Courbet's work up to 1848 was in portraiture—either straightforward portraits of family and friends, or, more interesting, the self-portraits, done in a variety of disguises and dramatic postures. These were in fact the pictures with which Courbet made his début at the *Salon*—in 1844 with 'Courbet au Chien Noir', and then in 1845 with the 'Guittarero', or 'Jeune homme à la campagne'. In this year, 1845, four of his five pictures had been rejected. Writing home, Courbet lists them: they were 'Le Hamac, un rêve de jeune fille', a portrait of Juliette, the one in the wicker-backed chair which Courbet had entitled 'Baronne de M....'; 'Des

joueurs de dames', a small genre painting; and finally a male portrait, life size.

Apart from the latter, none of these pictures was very large, and as Courbet says in his letter: 'Les petits tableaux ne font pas la réputation. Il faut que j'exécute pour l'an qui vient un grand tableau qui me fasse décidément connaître sous mon vrai jour. Car je veux tout ou rien. Les petits tableaux ne sont pas seulement ce que je peux faire. J'entends les choses plus largement.'

So Courbet tried to paint a large picture during the summer of 1845; it was still beyond his capacities and had to be abandoned. Nevertheless, in 1846 he did send no less than eight pictures to the *Salon*: all were rejected, except for one, the small 'Portrait de M.', which is probably a self-portrait, now in Besançon, closely related to 'L'Homme à la pipe'. This caught the eye of a young Dutch dealer, Van Wisselingh, who invited Courbet to Holland in August 1847, when he saw the big paintings of Rembrandt and Van der Helst.

In 1847, Courbet's three entries for the *Salon* were all turned down: they were 'L'Homme à la pipe'; a portrait of his friend, Urbain Cuénot; and the self-portrait, 'Le Violoncelliste', a rather larger picture than usual. In the summer of this year, Courbet painted what is certainly the largest and the most surprising of his early works, 'St Nicholas ressuscitant les petits enfants'. This was painted for the parish church of the village of Saules, near Ornans: it is Courbet's only religious picture. Why did he do it? Perhaps to please his mother? Or for the money—900 francs? Or at the request of his friend, the architect Victor Baille, who was engaged in restoring the church? Another friend, Urbain Cuénot, was the model for the saint. The picture is plain evidence of Courbet's admiration for Zurbaran, of his interest in popular imagery, and perhaps of his willingness at this date, 1847, to paint a religious work at all. It is hard to believe that at this point he had any very strong ideas about pictorial subject-matter.

The severity of the jury in 1847 led to protests on the part of the rejected artists and their sympathizers, and plans were made for an exhibition independent of the *Salon*. The revolution of February 1848, however, brought about a general liberalization of the *Salon*, and all works submitted in 1848 seem to have been shown. Thus instead of the 2000 works exhibited in 1847, over 5000 were shown in 1848.

Although he complained about the numbers, Courbet did at last have the opportunity of showing a substantial group of his works, and for the first time attracted critical attention. He exhibited seven paintings and three drawings. The drawings were 'Jeune fille rêvant' (La Guitariste) and two portraits, 'M. A. D.' and 'M. C. S.' The paintings were the three Ornans landscapes of the times of day; the portrait of Cuénot and the self-portrait, 'Le Violon-

celliste', which had both been rejected in 1847; a 'Jeune fille dormant', and finally the 'Nuit classique de Walpurgis', after Goethe's *Faust*. This, listed as a drawing, was a large picture which has disappeared[2]—Riat says that 'Les Lutteurs', shown at the 1863 *Salon*, was painted over it.

There is a reference to this picture in an article on Courbet by the Besançon painter Jean Gigoux, which appeared in the *Revue franc-comtoise* in October 1884. Gigoux, born in 1828, was a Fourierist who may well have influenced Courbet, as we shall see. In 1848 Courbet had invited him to visit his studio and look at a large picture, 4 by 3 metres, which he had just finished. Gigoux recollects: 'Je vis sur la toile énorme une Nymphe poursuivie par un Apollon quelconque, les bras étendus, courant au pas de gymnastique, et pour comble, portant une queue de morue — un frac — dont les pans flottants accompagnaient le mouvement de la jambe, et un large feutre sur l'oreille à la mode du temps! Tout d'abord, je compris que je devais m'abstenir de remarquer les étrangetés de mon jeune homme; je n'étais pas venu après tout pour lui faire un cours en mythologie.'

Gigoux goes on to say that the picture, though at first refused, was in fact exhibited at the 1848 Salon. If this is correct, it can only be a description of the 'Nuit classique de Walpurgis'. It would probably not be wrong to see here in the incongruous introduction of a figure in a dress coat a direct reaction to Baudelaire's demands in the *Salon of 1846*: 'Note too that the dress coat and the frock coat not only possesses their political beauty, which is an expression of universal equality, but also their poetic beauty, which is an expression of the public soul. . . .' But whether these remarks are being taken seriously or satirically by Courbet would seem an open question. I shall return to the Baudelaire/Courbet relationship and to the 'Nuit classique de Walpurgis' later.

I have discussed this early work in some detail, because there is, in Courbet's *painting* at least, nothing whatever to prepare us for the sudden appearance of 'Une Après-dinée à Ornans' at the *Salon* of 1849. To understand why Courbet painted it, one must therefore go back and investigate Courbet's early years in a wider context, and consider the political and literary milieu in which he lived.

This is not easy, because there is remarkably little information about Courbet's friends and contacts during the first six or seven years in Paris. He appears to have remained in a circle largely restricted to Ornans friends like Cuénot and Promayet, both of whom he painted. His only painter friend of consequence was François Bonvin, born in 1817, whom he met at the Atelier Suisse; Bonvin took Courbet to copy in the Louvre. Though there is in Bonvin's earliest surviving work nothing of the scale of the 'Après-dinée', a small study

of 1844 does seem to anticipate the farmhouse setting. Bonvin could paint only in his spare time: he had a job first as a compositor, and then he was employed in the *Préfecture de Police*. Bonvin made his *Salon* début in 1847 with a portrait, in 1848 he showed a small genre scene. It is unlikely that he had any real influence on Courbet. But I shall return later to Bonvin's major work at the 1849 *Salon*, 'La Cuisinière'. This won him a third-class medal, on the strength of which he resigned his job, and turned to painting full-time.

If one can find out little about his artist-contacts, what do we know about his other friends? There is an important document here, for Courbet wrote a short autobiographical note in 1866 for Victor Frond, which was first published by Pierre Courthion. He writes of himself in the third person:

Cet homme, d'une indépendance entière, des montagnes du Doubs et du Jura, républicain de naissance par son grand père maternel, continua l'idée revolutionnaire par son père liberal de 1830, sentimentaliste, et sa mère rationaliste et républicaine catholique. Il oublia les idées et l'instruction de son jeune âge pour suivre, en 1840, les socialistes de toutes sectes. Arrivé à Paris, il était fourieriste.[3] Il suit les élèves de Cabet et de Pierre Leroux. Il continua en même temps que la peinture ses études philosophiques. Il étudia les philosophes français et allemands, et fut pendant dix ans, avec des rédacteurs de la *Réforme* et du *National,* [the two leading left-wing newspapers] de la révolution active, jusqu'en 1848. Alors ses idées pacifiques echouèrent devant l'action réactionnaire des libéraux de 1830, des jacobinistes, et des restaurateurs de l'histoire sans génie.

The implications of this account is that Courbet was more deeply involved politically between 1840 and 1848 than is generally realized, and that after 1848 he was less interested in republican politics. Fourier had died in 1837, but his ideas were still very influential, and one of his followers, the 'apostle' Jean Journet, was known to Courbet. Fourier wanted to abolish the state, and divide society up into *phalanges*, profit-sharing associations, each inhabiting a *phalanstère*. Fourier thought that a *phalange* should have at least 1620 members, because he counted up to 810 different kinds of human temperament, and he wanted one of each sex. His followers were less dogmatic, and many attempts at co-operative living were made among the disciples of Fourier, and of the other pioneer French socialist, the Comte de Saint-Simon. Of the two men whose disciples Courbet said he followed, the older was Étienne Cabet (1788–1856). He was famous in the 1840s for his *Voyage en Icarie, roman philosophique et social* (first published 1839—five more editions, 1840–8). Icarie was a dream city in America, but in 1848 Cabet and his followers set out to make it a reality, and Icarian settlements existed in the United States until the end of the century. Cabet was one of the first to use the term communist—in an article of 1840

entitled 'Le Démocrate devenu communiste malgré lui'. Of course his concep-
tion of communist communities existing isolated from the rest of society was to
be regarded by Marx as escapism, and a refusal to accept and join in the class
struggle.

Pierre Leroux (1797–1871) for his part is sometimes said to be the inventor
of the word socialism, though he was in some ways closer to Marx's ideas than
Cabet. He was a democrat and an idealist. A printer by profession, he had
many friends in the world of letters. In 1835 Sainte-Beuve introduced him to
George Sand, and the two collaborated to write several novels—*Spiridon*
(1839), *Consuelo* (1842–3) and *La Comtesse de Rudolstadt* (1843–5). Such works
preach an egalitarian, pacifist philosophy, and would certainly have appealed
to the young Courbet.

Courbet did in fact get to know George Sand (1804–76), perhaps through
her daughter Solange Dudevant who married Courbet's friend, the Besançon
sculptor, Jean-Baptiste Clésinger. There exists a miniature by Courbet of
George Sand and her daughter, which one could guess was painted well before
1848, unless done later from a photograph. The Chopin portrait, which
Courbet probably painted in 1847, or alternatively in 1849, the year of the
composer's death, came about through the Clésinger-Sand connection. So,
given Courbet's probable interest in the Leroux-inspired social novels of the
early 1840s, he must surely have known and read *La Mare au Diable* when it was
published in 1846. This was the direct consequence of George Sand's semi-
retirement in Berry in 1839, to become 'La dame de Nohant'; and with *La
Mare au Diable* begin the rural novels in which the author expresses her love
for her native land and her profound sympathy for the peasants who farm it.

Now although George Sand's humanitarian and egalitarian views are cer-
tainly not disguised in the rural novels, they are not their *raison d'être*. As the
author makes clear in a preface to the 1851 edition: 'Quand j'ai commencé,
par *La Mare au Diable*, une série de romans champêtres... je n'ai eu aucun
système, aucune prétention révolutionnaire en littérature'. She wants to do
something very touching and very simple—to show country people just as they
are. 'Voyez donc la simplicité, vous autres, voyez le ciel et les champs, et les
arbres, et les paysans surtout dans ce qu'ils ont de bon et de vrai...'

George Sand's influence in her own time was of course considerable, and
this is immediately reflected in painting. If we look at the catalogue of the 1846
Salon, for example, we find that three pictures were exhibited with specific
references to her. This is a significant number: the complete list of 19th
century authors referred to in the *Salon livret* is Goethe four, (but three are
by Ary Scheffer), George Sand and Walter Scott three, Byron, Lamartine and

Eugène Suë two each, and one each for Chateaubriand, Hugo, Gautier (a bullfight picture), Schiller and Shelley.

Unfortunately the three George Sand pictures have disappeared, and their authors are forgotten. But, for the record, they were: no. 1265, 'Consuelo' by Mlle Alexandrine Martin, after the novel of 1842–3 written in collaboration with Leroux; no. 1068, 'La Dribe' by Mme Adèle Langrand, exhibited with a quotation from 'Le Péché de M. Antoine', not published in book form until 1847 (?); and no. 861, 'Femme du peuple' by Guermann-Bohn, exhibited with an unidentified sentence from George Sand, which I quote: 'Compte-t-on pour rien toutes ces âmes aimantes qui la possèdent (la poésie), et qui souffrent; qui se taisent devant les hommes, et qui pleurent devant Dieu.' The 'Femme du peuple' may have been a life-size painting, as Guermann-Bohn's 'La Mendiante', also at the 1846 Salon, seems to have been.

In the catalogue of the 1847 Salon there are altogether fewer literary references, and I can find only one with a specific reference to George Sand— no. 670, Henri Gambard's 'La Fille aux oiseaux', taken from Téverino. But my impression in this Salon is that there were more pictures with country subjects that parallel her novels, directly so perhaps in works like Just Veillat's 'Pacages de Berry' (1576), 'Fermière du Berry' (1578) and 'Intérieur Berrichon' (1580).

Veillat also painted 'Une Fileuse' (1577), which inevitably suggests Courbet's 'Fileuse endormie' of 1853. And with Courbet's subject-matter in mind, one immediately notices the following titles of work exhibited in 1847: Jules de Bonnemaison's 'Repas de chasse' (178), Michel Bouquet's 'Halte de chasse, dans le forêt de Fontainebleau' (196) and several more hunting pictures; at least six 'Intérieurs d'atelier', some with a portrait of the artist included; Hippolyte Coté's 'Intérieur de ferme en Basse-Bretagne' (385), and several more 'intérieurs de ferme'; Nicolas Prévost's landscape, 'La Source de la Loue, vallée d'Ornans (Doubs)' (1331)—not yet painted by Courbet, so far as I know; and perhaps most striking of all, because the subject is an unusual one, the vicomte de Becdelièvre's 'La Toilette de la mariée, au bourg de Batz (Loire-Inférieure)' (103), exhibited with a passage that begins 'les parentes et les amies de la mariée sont groupées autour d'elle, occupées à la parer pour aller à l'autel…'

Now I have as yet found no trace of these pictures, and would not suggest for a minute that they were necessarily the inspiration for Courbet's paintings of similar titles. Works of art survive for aesthetic, abstract reasons, and it would be most unwise to imagine that one can discuss 19th century subject-matter with as much confidence as one talks about 19th century style. Most of

the evidence is lost for ever, and probably nobody will ever know whether, for example, Auguste Testé's 'L'Après-dîner' (1669) at the 1846 *Salon* put an idea into Courbet's head, or whether his 'Toilette de la mariée' derives from the vicomte de Becdelièvre's picture.

What is evident, however, is that there was a general tendency in 1846–7 to turn to a straightforward depiction of country (not *peasant*) subjects. This tendency runs parallel with and to some extent is inspired by the rustic tales of George Sand, with their strong feeling for her native land, and sympathy for the people who inhabit it. Of course the scale of Courbet's pictures, and their quality, completely outclass all his contemporaries, with one possible exception—that of Millet; but he too was affected by the same tendency, and was converted to a comparable subject-matter in even more dramatic fashion. When Millet showed 'La Vanneur' at the 1848 *Salon*, Courbet must have been deeply impressed: the echo of the figure's pose is so strong in his 'Casseurs de pierres' that I personally feel that the chief reason why Courbet stopped to watch the men breaking stones was because the pose of one of them reminded him so strongly of Millet's picture. This kind of subject-matter was common enough, especially in the popular imagery of the time.

There is another area of evidence which must be considered in any discussion of the emergence of Courbet's subject-matter, that is, the nature of his relationships with Baudelaire and with Champfleury, born in 1821 and 1820 respectively, and thus of exactly the same generation as Courbet.[4]

I am inclined to believe that Baudelaire had comparatively little influence on Courbet, but that another member of the group, Champfleury, was decisive for the development of his ideas, and for the emergence of the new subject-matter. I realize that this is a highly controversial point of view, but let us consider the weight of the contemporary evidence. We are so mesmerized by the personality of Baudelaire and the quality of his writing that we cannot always see him as he must have appeared to his contemporaries. Not all of them could see he was a giant.

Baudelaire's early career is comparatively familiar, but Champfleury's is not, so I will summarize briefly. He was born Jules Fleury at Laôn in 1821, the son of a printer and local publisher. Determined to make a name for himself in the literary world, he arrived in Paris in 1843. He immediately met Henri Murger, and together they began writing vaudevilles. From the very beginning, his fundamental interest was in the popular arts. At this early date he also began his researches into the then forgotten 17th century Laôn painters, the Le Nain brothers. Their revival was due to Champfleury, not to the 1848 Revolution.

Champfleury's technique of promoting himself was exceedingly simple. He went to people whom he thought could help him, like Eugène Suë, the popular novelist, and author of the Fourierist *Les Mystères de Paris* (1842), the first French novel published in parts, or Arsène Houssaye, editor of the highly influential magazine *L'Artiste*. He asked them if he could write an article on them for publication in his father's magazine, knowing that one such flattering favour would deserve another. Champfleury always remained a great one for dedications, inscribing later books to Manet and Daumier.

By December 1844 he was contributing to *Le Corsaire Satan* as well as to *L'Artiste*, and in the early months of 1845 Baudelaire asked him if he would review his *Salon of 1845* in the *Corsaire Satan*. So far as I know he did not do so, but Baudelaire, Champfleury and his friend Murger all wrote booklets on the *Salon* of 1846, and Murger recommends Baudelaire's text at the end of his own. All these young men belonged to the impoverished literary Bohemia of the day, which Murger was to depict, at Champfleury's instigation, in the *Scènes de la vie de Bohème*, which he began to write in 1846; these were first published in the *Corsaire Satan*, then in a single volume in 1851. Murger's book is of course an account of life as it actually was, it is realist in intention, and, in subject and form, dependent on the sketches that Champfleury was writing for periodical publication. The most celebrated of these was *Chien-Caillou*, written in 1845, and published with other pieces in book form in January 1847. The book is dedicated to Victor Hugo, who had already noticed *Chien-Caillou* on its periodical appearance, and praised it as a masterpiece. *Chien-Caillou* is not a realist novel, as is sometimes imagined—Champfleury subtitles the book in which it appears, *fantaisies d'hiver*—but it does show a much more down to earth, obviously post-Romantic attitude: witness for example the section printed in two columns, on one side *les mansardes des poëtes*, with a romanticized picture of the Bohemian life of a young writer; and on the other *les mansardes réelles*, with an account giving the harsh and sordid truth.

For all his involvement in the literary Bohemia of the day, Champfleury was evidently an ambitious, hard-working young writer, determined to succeed, and with Hugo's help he was in 1847 well on the way to fame. Courbet, who seems only to have come into the orbit of both Baudelaire and Champfleury in 1847, or at the earliest in 1846, could well have been forgiven had he felt that it would be better to follow Champfleury's star rather than Baudelaire's. The conjunction of the three young men is firmly fixed by the revolutionary paper, *Le Salut public*, which was edited by Baudelaire, Champfleury and their mutual friend the medical student Toubin. Two numbers only appeared in February 1848, and for the second one Courbet provided a vignette. This is very

evidently a reference to Delacroix's painting of the 1830 revolution, 'Liberty guiding the people', greatly admired by both Baudelaire and Champfleury. It is also a further indication of Courbet's eclecticism of style and subject at this date.

The reason for saying that Courbet was closer to Champfleury's ideas than to Baudelaire's can be found in a comparative examination of their art criticism of this period. Baudelaire, for all his plea for a painter who should find *la beauté moderne* in Parisian life, was still indissolubly attached to the Romantic painting of Delacroix, and can never in fact shake himself free of Romanticism. This is why I believe he could bring himself only to pass a few commendatory words about Courbet, but otherwise preferred to leave the promised article unwritten. In any case, after the 1846 *Salon*, Baudelaire stopped writing art criticism for a time: indeed in 1848 Courbet might well have thought he had stopped writing for ever.

Champfleury, on the other hand, was still very active, and that much more useful to Courbet, who was in February 1848 a painter completely unknown outside the very small circle of his personal friends. Remember he had had little success at the *Salon*, and so far as I know, no critical notice whatever. He badly needed to make the breakthrough every young artist needs.

It was Champfleury who first wrote about his painting, and this was in connection with his showing at the unrestricted revolutionary *Salon* of 1848:

On n'a pas assez remarquée cette année au Salon, une œuvre grande et forte, 'La Nuit Classique de Walpurgis', peinture provoquée par l'idée générale du Faust.

Je le dis ici, qu'en s'en souvienne! Celui-là, l'inconnu qui a peint cette 'Nuit', sera un grand peintre. La critique, dont le devoir est de décourir les talents naissants, l'a oublié.

Le peintre s'appelle Courbet. Il est parti dans les montagnes, allant courir après la nature qu'il ne voyait plus depuis la république.

Courbet débutait avec dix toiles: une immense tableau, des portraits, des paysages, des dessins. Signe de force que cette fécondité et que cette abondance de moyens divers.

Courbet envoyait à la faveur de la révolution, car le jury académique aurait tous réfusé, des peintures très remarquables et qui ont été peu remarquées. C'est la condamnation du jury et de la critique.

Obviously any young painter would be grateful to a critic who wrote as enthusiastically as that, and this was, after all, the first critical notice that Courbet had ever received. I am convinced that he was now, up in the mountains, set upon painting the kind of picture of which he knew Champfleury would approve—the 'Après-dinée à Ornans'.

We have a good idea of Champfleury's artistic preferences, from his *Salon of 1846* and other writings. First he liked the Le Nains, because they came from Lâon, and nobody yet realized that they were great painters. Courbet now did, and we can see this in his own work. Perhaps they gave him this new ambition to be the painter of his native town. Secondly, Champfleury had written at length about Ary Scheffer's Faust paintings at the 1846 *Salon*: he didn't like them much—'cette peinture pâle et maladive, où les personnages semblent des ombres plutôt que des vivants'—but this interest in the subject may be the reason for Courbet's choice of a Faust subject, seen in up-to-date dress, at the 1848 *Salon*, and for Champfleury's commendation of it. Thirdly, he praised Chenavard's 'Enfer' at the same *Salon*, and the Lyonnais Chenavard was a friend of Courbet's. In fact Champfleury tells us later that Courbet began Proudhon's artistic education, presumably soon after they met some time in 1848 (at the latest), by taking him to Chenavard's studio. Fourthly, although Champfleury admits that there is no great contemporary French painting apart from Ingres and Delacroix, he does find some young genre painters at the 1846 *Salon* highly commendable—these are 'les frères Leleux et M. Hédouin, les chefs de l'école Bretonne picturale'. Their painting rises above the ordinary level because it is: 'solide et nullement entachée de

67 Armand Leleux: 'Travellers on a mountain pass'

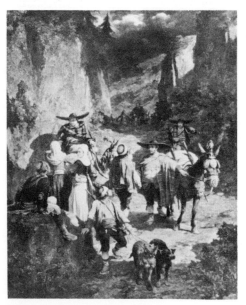

68 Adolphe Leleux: Landscape with figures

69 Courbet: 'L'Enterrement à Ornans'

cet odieux chic si déplorable'. Champfleury singles out these now forgotten
painters once again in an article in *L'Artiste* of 4 October 1846, reviewing an
exhibition at the Odéon: 'Les honneurs sont pour MM. Corot, Hédouin et
les frères Leleux. J'ai retrouvé là de vieilles connaissances du Salon, et j'ai
été tenté de serrer la main aux montagnards de M. Hédouin, de braves gens
des Basses-Pyrenées qui n'ont pas riche, mais qui ont une tournure très
pittoresques dans leurs guenilles éclatantes.' In this same short article he also
finds a good word for Maurice Sand, the young painter son of George Sand,
and it should be obvious that the brothers Leleux and Hédouin represented
that same tendency of Sandian country painting which I have already dis-
cussed in connection with Courbet. It is difficult to find examples of their
work, but the landscape with figures of 1849 [68] by Adolphe Leleux (1812–
91) shows the continued pastoral rococo flavour of the older painter's work,
whereas 'Travellers on a mountain pass' [67] of 1846 by Armand Leleux
(1818/20–85) is typical of the more straightforward approach of the younger
brother. Much of our evidence of the work of these painters still comes only
from *Salon* titles: for example, at the 1847 *Salon*, Armand Leleux exhibited
no. 1041, 'Retour du marché (Basse-Bretagne)'. I am not claiming that
Courbet's 'Paysans de Flagey revenant de la foire' is directly related to
Leleux's picture—it was a common enough subject—though it might be.
What is incontestable is that Leleux's was the kind of new painting which
Champfleury particularly admired in 1846, and that Courbet does sub-
sequently adopt something very similar indeed.

To return now to the earliest of the four pictures, 'L'Après-dinée à Ornans'. It was the centrepiece of Courbet's contribution to the 1849 *Salon*, along with four Ornans landscapes, the self-portrait with leather belt, and 'M. N. T. examinant un livre d'estampes'—the picture of Trapadoux, another of the Bohemians, and a friend of Baudelaire's. Champfleury again gives Courbet his most enthusiastic notice:

> Courbet force les portes du Salon avec neuf tableaux. Personne hier ne savait son nom: aujourd'hui il est dans toutes les bouches. Depuis longtemps on n'a vu succès si brusque.
> Seul, l'an passé, j'avais dis son nom et ses qualités; seul j'ai parlé avec enthousiasmes de quelques tableaux enfouies au dernier Salon...
> Je ne me suis trompé, j'avais raison. Aussi m'est-il permis de fouetter l'indolence des critiques qui si'inquiètent plus des hommes acceptées que de la jeunesse forte et courageuse... Courbet à osé peindre un tableau de genre de grandeur naturelle. C'est à la campagne, un soir; après la chasse on a dîné gaiement... Ce tableau peut être mis hardiment dans les musées flamands, au milieu des grandes assemblées de bourgemestres de Van der Helst... Courbet, avant peu d'années, sera un de nos plus grands artistes.

The other young painter at this *Salon* that Champfleury praised highly was Courbet's friend, François Bonvin: he showed three pictures, and Champfleury writes about no. 210, 'La Cuisinière': 'la femme qui taille la soupe est un tableau qui indique toute une école de jeunes peintre, toute une génération nouvelle qui part de principes opposés à ceux des peintres romantiques de 1830. La femme qui taille la soupe est un tableu *historique*... [This is the puzzling phrase which Courbet uses as subtitle to the "Enterrement" [69]] Pour lui [Bonvin] un pot, une cruche, un vase, une tasse sont des sujets aussi compliqués et aussi mysterieux qu'un homme, aussi aimable, aussi étranger qu'une femme...' Courbet's painting of 'Trapadoux', shown in this same *Salon*, helps explain why Champfleury could talk about a school of young artists. There are many points of similarity, as with an unknown and unfinished Courbet, 'The Tinker', probably of exactly the same period. The Chardin revival at that time is a major contributory factor, of course. The exact relationship between Courbet and Bonvin in 1848–50 warrants discussion in greater detail than is possible here.

One significant fact about Champfleury's attitude to this new subject-matter, at which that last sentence quoted may already have hinted, is that it is not a political one. Apart from a very brief involvement at the time of the February revolution, I can find no evidence for any direct political interest on Champfleury's part. Indeed in a letter of 9 February 1849 he says specifically: 'Nous sommes dans un singulier temps plein d'insurrections et plus

comique que méchant. Aussi suis-je plutôt rouge que réactionnaire ; tu sais que je n'aime guère les bourgeois. Ils sont encore les maîtres sous la République, mais ils ne peuvant pas durer. Malgré tout, je ne m'occupe nullement de politique, et je suis plein d'indulgence pour les uns et les autres.'

What we have here is surely that disenchantment with political action that we find in Baudelaire at the same time, and there is no reason to feel that Courbet felt any differently. I speak with some caution, but so far as I can see there is no evidence whatever for presuming that Courbet had the slightest political intent when he painted 'L'Enterrement', 'Les Paysans de Flagey' and 'Les Casseurs de pierres' in the autumn and winter of 1849. Of course we know of his republican and Fourrierist background, already discussed, which certainly predisposed him to the new subject-matter, introduced primarily, I believe, by George Sand's rustic novels, which were certainly mildly political. But times were changing rapidly, and the fact remains that Courbet went home in 1849 to paint some country subjects, as he had done the year before ; and none of his comments on the work in progress in letters to Champfleury or to the writer Francis Wey, a friend of Bonvin's as well as of Courbet's, with whom he stayed in the summer of 1849, give the slightest indication that he thought there was any political message in his three pictures, not even the 'Casseurs'. That Courbet's friends interpreted these pictures to suit their own political viewpoints, and that Courbet to some extent accepted their interpretations after the fact, does not affect the issue, and is beyond the scope of this paper.

A further point of extreme importance is the autobiographical nature of at least three of Courbet's four large pictures. 'L'Après-dinée' showed Courbet sitting with his father and friends in the kitchen of the Courbet home. As far as subject-matter is concerned, it is not so much a large genre picture, as Champfleury calls it, as an enlarged and extended version of the self-portraits Courbet had been regularly painting in the preceding six years. 'L'Enterrement' was for Courbet, I believe, primarily a homage to his maternal grandfather, Jean Antoine Oudot, who had died aged eighty-one in 1848, and who is depicted on the extreme left of the picture. We know the closeness of Courbet's attachment to his grandfather. 'Revenant de la foire' is a picture of Courbet's father, Régis, riding home with his three farmworkers. And the figure on the right seems to be a man seen by Courbet on the roadside, just as he saw the old man and the boy breaking stones : 'Je n'ai rien inventé, cher ami ; chaque jour allant m'y promener je voyais les personnages si misérables. Dans cet état, c'est ainsi qu'on commence, c'est ainsi qu'on finit. Les vigner-

ons, les cultivateurs, que ce tableau séduit beaucoup, prétendent que j'en ferais un cent que je n'en ferais pas un plus vrai.'

Admittedly 'Les Casseurs de pierres' does not appear to have that autobiographical element which the other pictures possess, so far as we can tell. But when one considers that Courbet's next big picture was 'Les Demoiselles de village faisant l'aumône à une gardeuse de vaches', painted in 1851 for the 1852 *Salon*, and that this shows Courbet's three sisters giving something to a little cowgirl, it is surely clear that this group of early works is more autobiographical than socio-political in intention. Apart from this autobiographical aspect, which is both permanent and very important, there is (it seems to me) little evidence to show that Courbet was interested in the subject-matter of his pictures. He was more the pure painter, concerned to record the things that he could see; and I don't believe that it mattered greatly to him what he painted.

Of course there is a period in his work—from 1848 to 1855—when the subject-matter of his paintings is of real importance. But this is largely due to the influence on Courbet of certain of his friends, notably Champfleury, Proudhon and Bruyas. The four pictures I have been discussing in this lecture are, I believe, explicable only in terms of Champfleury's influence on the impressionable Courbet. The label 'realism' was attached to Champfleury's writings as well as to Courbet's paintings, and Champfleury was happy to associate himself with Courbet's paintings, and to further Courbet's use of the term. The little-known story of the break between painter and critic bears this out. After Balzac's death in 1850, Champfleury hoped to persuade the novelist's heir, Madame Hanska, to allow him to complete the unfinished work. Suddenly, the idea was dropped. Champfleury sought the reason and discovered that Courbet, whom he had introduced to Mme Hanska, had been talking to her behind his back, belittling him, and claiming that he had nourished him—'il se vante de m'avoir nourri', said the incredulous Champfleury, writing to Max Buchon on 12 October 1854. The reverse situation was true. Relations between Courbet and Champfleury were henceforward polite but cool.

Nevertheless, Courbet gave Champfleury an important place in 'L'Atelier', where he is depicted as the most prominent of his freinds and supporters during the decisive seven-year period of Courbet's artistic life. Better than anything, the picture shows Courbet's gratitude to the man who had done so much to launch him.

As Courbet's intimate friend, Champfleury seems to have been succeeded around 1850 by the anarchist philosopher Proudhon. In a later study, I hope

70 Courbet: 'L'Atelier'

to show how Proudhon's ideas find an echo in Courbet, and in particular how Proudhon helped formulate Courbet's demand for the absolute freedom of the artist, who should be able to create exactly what he wants to create. How, with the support of another close friend, Alfred Bruyas, Courbet demonstrated this position in 'L'Atelier' [70], I tried to show in the 1967 Charlton lecture.[5] For the 'Atelier' is 'the modern artist's declaration of independence . . . a work in which the artist and the activity of creating art becomes the subject'.

I hope I have been able to show how the four early paintings should be seen as contributing to this general development, rather than as socio-political statements standing independently of Courbet's art. For the whole issue of realism has for too long dominated any understanding of Courbet's art, and should be allowed to recede into the background, where it belongs.

Notes and discussion
(1) This paper is here printed exactly as given at Manchester. It is still under revision, and will be re-published later in extended form with footnotes, references, etc.
(2) See page 125 for Champfleury's comment on it.
(3) Max Buchon is said to have been introduced to Fourier's ideas when he visited Paris in 1842—perhaps by Courbet.

(4) It is of course obvious that Baudelaire's call in the *Salons* of 1845 and 1846 for a painter who would show the beauty and grandeur of modern dress did not go unheeded by Courbet. And yet it is equally clear that Baudelaire expected such a painter to treat *La Vie parisienne*—the urban life, with which he associated the dress. Apart from the picture of 1848 described by Jean Gigoux, with the man in tails chasing

a nymph—and this can only have been a false beginning, soon destroyed—this Courbet did not attempt to do until he painted the 'Pompiers courant à une incendie' in 1851. The 'Pompiers', however, was done on Proudhon's suggestion, and introduces another relationship which I cannot discuss in this paper. Other demands of Baudelaire—for *solennité* for example—may have been heeded by Courbet, but it is still not clear to me how far Baudelaire's ideas in the *Salons* of 1845 and 1846 were original, and how far they reflect what many other young men also thought and felt. The question of modern dress is certainly not Baudelaire's invention. (5) Published by the University of Newcastle, 1971.

Discussion. Mr. Bowness again demanded that a clear separation be drawn between the politico-social element, which had been brought into Courbet's work since Proudhon, and the artist's own intention. In the course of the discussion attention was drawn to the fact that notions like 'solidarité' and 'socialisme' had been borrowed from the legal language of the eighteenth century. In connection with Courbet's 'Stonebreakers', the expression 'personnages si miserables', which Courbet had used in a letter referring to his painting, was pointed out; a politico-social intention in the artist could not, after all, be denied off hand.

Anne Coffin Hanson

7

Popular imagery and the work of Édouard Manet[1]

The sources for Manet's imagery have been under discussion for slightly over one hundred years. Despite Zola's insistence that Manet worked directly from nature[2] and despite Baudelaire's assurances that the similarity of Manet's 'Le Torero mort' to a painting in the Pourtalès Collection was a 'mysterious coincidence',[3] by 1864 critics had already pointed out Manet's dependence on works by Courbet, Goya, Vclasquez, El Greco, Rubens, the Caracci and a Raimondi engraving after Raphael.[4] Subsequent writers have vastly enlarged this list,[5] some demonstrating more about their knowledge of the history of art than of Manet's painting. The fact that further similarities seem always to be found makes it reasonable to conclude that Manet's art is based on art as much as it is based on nature. A continued search for sources may yield little more than a longer list of names, but it still seems profitable to ask what kinds of sources Manet used and why. To date, the primary aim of source-hunting has been to find motifs borrowed from the masters. Certainly, like his great predecessor Ingres or his great follower Picasso, Manet quoted directly from the works of major artists. Like his colleagues of his own day, his vision was conditioned by the photograph and the Japanese print. In addition to these sources, Manet's special commitment to modernism led him to find in ordinary French illustrative material suggestions for his subjects and his style.

It is easy to propose intellectual explanations for artistic borrowing, but these are sometimes completely at odds with the nature of artistic perception. Certainly many artists use motifs from other works of art because of their specific meanings: both visual and verbal wit is obvious in much of Picasso's borrowing, and, at times, in Manet's. More often, however, the artist is interested in the visual image itself, and, preoccupied with it, he literally sees in terms of the image he holds in his mind. When such an image dominates his thought, he sees it everywhere. If the artist works from a pattern book, copying out an image from a standard guide, one image may suffice, but 19th and 20th century artists, largely freed from shop methods and even from academic

training, are more liable to collect and combine similar images from a variety of sources, including sketches from nature. Therefore it is usually futile to search for the one 'correct' source for a given motif in Manet's work. Since numerous equally convincing sources present themselves, and we know he worked from models as well, we can conclude that he practised a kind of image-collecting which many contemporary artists have experienced in creating their own works. This is not to say that such images are devoid of content for Manet. In fact, we can demonstrate in many cases that the appeal of the subject or content may well have drawn Manet to certain images in the first place. It *is* to say, however, that we must usually accept a probable 'source' in the most general terms.

A second point to be made about artistic borrowing is that one can never assume that one artist copies another artist because he emulates his work. It has been demonstrated again and again that artists are often influenced by works which, in quality, are inferior to their own. Images can be attractive as raw material quite regardless of their quality or even their expressive force if they offer formal or associative elements relevant to the artist's aim. It is not surprising, therefore, to find Manet turning to the masters on one hand as admirable examples of artistic expression, and on the other hand to the ordinary illustrative material of his day as a reflection of his own world—the subject of his greatest preoccupation.

As an artist Manet was not alone in his interest in popular imagery. In his review of the *Salon des refusées* Théophile Thoré stated that with that exhibition French art had been reborn. The subjects were not those to be found in the official halls; there was little mythology and history, but instead, 'la vie présente, et sourtout les types populaires'.[6] Because of an unusually severe jury in 1863 the paintings in 'the official halls' included more mythology and history than had been shown in the immediately preceding years. Even the official *Salons*, however, had included in increasing numbers examples of popular types—the typical widow, the typical doctor, the Bretan peasant, the nun, the orphan, to name only a few.[7] When, at the prize-giving ceremony of the *Salon* of 1857, the minister of state warned young artists to resist public tastes, it was in part because the danger was already apparent among the works accepted by the official jury.[8] By this date a marked rise in the number of genre works was manifest, and the question of the new directions for French art was a subject for critics and philosophers, both liberal and conservative.

First, there seemed to be general agreement that French painting had fallen below previous standards and that changes were in order, if not inevitable.[9] Edmond About described the *Salon* of 1857:

Quand vous entrez dans une de nos expositions, ce n'est pas la nature qui vous saute aux yeux, mais le conflit des idées, le tiraillement des écoles, la variété des esprits qui s'escriment sur la création pour la déformer... Une petite minorité se groupe autour de M. Ingres en admirant du coin de l'œil le génie de M. Delacroix, qui n'est pas loin. Le reste est tumulte et confusion.[10]

Ingres himself had characterized the *Salon* as a vast picture shop with business rules instead of art.[11] An entry in Delacroix's *Journal* for 1857 expresses his despair with the taste of his day.[12] Gautier, writing in 1856, described historical landscapes as being like the wallpapers in the dining rooms of provincial inns.[13]

Such objections certainly reached the average intelligent reader. The *Chronique universelle illustrée* of 1860 includes more than one complaint about the quality of contemporary art. Théophile Silvestre, art critic of that elegant magazine, bemoaned the fact that French art seemed to have renounced the privilege of exercising any influence over the epoch.[14] Not everyone saw the picture in quite such negative terms. Castagnary felt that the *Salon* of 1855 was confusing,[15] but he found a new unified tendency in the *Salon* of 1857:

La peinture religieuse a disparu du salon... La peinture historique occupe bien quelque place; mais il appert, à la voir ainsi produire des œuvres trop directement inspirées par les événements politique de notre temps... La majorité, et une majorité compacte, appartient aux tableaux de genre... C'est le côté humain de l'art qui se substitue au côté héroïque et divin, et qui affirme à la fois avec la puissance du nombre et l'autorité du talent.[16] Une nouvelle période de l'art commence avec un objet nouveau, l'homme.[17]

This is similar, of course, to Thoré's well-known statement, 'Jadis on faisait de l'art pour les dieux et pour les princes. Peut-être que le temps est venu de faire "L'ART POUR L'HOMME".'[18] Neither Castagnary nor Thoré thought that the new art had arrived, only that the new need was obvious, and that a new direction toward meeting that need had begun.[19]

Such feelings were in part reflections of the positivism of the period—an optimism about a better world to come which would need still another revolution to dampen its force. Taine believed that since art was a product of the environment a new art would take its form naturally from the new milieu. 'We have only to open our eyes to see a change going on in the condition of men, and consequently in their minds, so profound, so universal, and so rapid, that no other country has witnessed the like of it. . . . What its forms will be and which of the five great arts will provide the vehicle of expression of future sentiment, we are not called upon to decide.[20] Théophile Gautier had expressed optimism about man's changing condition in his *Fusains et eaux-fortes*.

Not only did he see the railroad as a sign of progress,[21] but he believed that the balloon, once its flight could be directed, would make communications so easy that there would be a new reign of liberty, all men would be brothers, and there would be no more war.[22] Gautier saw the machine as a means of freeing mankind from repugnant work. 'Le républicain, grâce à ses ilotes de vapeur aura le temps de cultiver son champ et son esprit.'[23]

Such encouraging hopes passed quickly into popular imagery, both visual and verbal. Pierre Dupont's collection of songs echoed public sentiment, and Dupont's own preface, written in 1851, almost uses Gautier's words. Dupont predicts that there will not be one helot left in the new modern republic. 'Il faut rompre avec les traditions menteuses, et inaugurer dans le monde, par le travail, la science, et l'amour, le règne de la verité.'[24] Gautier's ideas are

71 'Le Voyageur à pied' from *Chants et chansons*

72 Manet: 'Le Ballon'

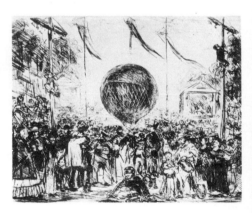

reflected not only in the preface, but in the songs themselves. 'Le Voyageur à pied' [71] is closer to Courbet's imagery than to Manet's,[25] but serves to illustrate the new optimism about the new world.

> Au roulier il tient compagnie,
> Riant de scepticisme amer
> De ce vieux mécréant qui nie
> Le succès du chemin de fer.
> Il lui repond; mais que sera-ce,
> Quand les ballons vont se frayer
> Un nouveau chemin dans l'espace,
> Emportant charette et roulier?

Balloon ascents, often only an afternoon's amusement, were nevertheless clear symbols for a universally better future. They were common subjects for illustrations of contemporary life,[26] and it is not surprising to find Manet making a lithograph of a captive balloon hovering over a crowded public park [72].[27]

Manet's teacher, Thomas Couture, has suggested that the artist of the future might find as appropriate themes, workers, scaffolding for building construction, and the railroad.[28] The idea was certainly a current one, if Flaubert, in L'Education sentimentale, can have his artist, Pellerin, produce a painting entitled 'La République, ou le Progrès, ou la Civilization,' depicting Jesus Christ driving a locomotive through a virgin forest.[29]

The year 1859 saw the publication of one of those ephemeral magazines of the periode, La Vie moderne. The first issue included the following comment on modern progress:

> Oui, le temps a doublé son cours,
> L'humanité se précipite.
> Tous les chemins deviennent courts.
> L'ocean n'a plus de limites!
>
> La vie était longue autrefois;
> Sur la pente elle est entrainée;
> Nous vivons plus en un seul mois
> Que nos aïeux dans une année![30]

Twenty years later a second periodical appeared with the name La Vie moderne, a fashionable publication devoted to the arts, travel, literature and Parisian life. A long poem by Théodore de Banville inaugurated the first issue. In it, Banville indicated that he saw a new reign of truth in the modern world and urged the artist to portray it.

Artiste, désormais tu veux peindre la vie
Moderne frémissante, avide, inassouvie,
Belle de douleur, calme, et de sévérité
Car ton esprit sincère a soif de vérité.[31]

But who was this artist to be? As late as 1879 when this poem was published no one seems to have been appointed to the role, yet the critics had been announcing his coming as if awaiting a messiah. Taine could hardly have suggested the nature of the new artist when he felt unable to predict what forms the new art would take. Champfleury, although he admired Courbet, apparently did not feel that he was the messiah, only a sort of prophet. 'Le maître, avec sa réhabilitation du moderne et les excellents procédés dont il recouvre la représentation du moderne, facilitera peut-être l'arrivée d'un Velasquez noble et grand, d'un Goya railleur et satyrique.'[32] Champfleury and

73 Manet: 'Buveur d'absinthe'

74 Traviès: 'Le Chiffonnier' from *Les français peints par eux-mêmes*

75 'Le Chiffonnier' from *Les Rues de Paris ou Paris chez soi*

Le Chiffonnier.

Manet knew each other well, and Champfleury's admiration for the Spanish masters and his important works on the Le Nain brothers undoubtedly helped direct Manet's interest to these artists. But Champfleury had another forceful influence on Manet. The writer was fascinated with popular illustrations and popular customs. He published a book on popular songs in the provinces in 1850, and was at work on his great book in a closely related field, the history of caricature, from 1865 to 1880. In 1869 he produced *L'Histoire de l'imagerie populaire*, and, in the same year, *Les Chats*, for which Manet made an illustration and a poster.[33] This book is almost a parody of the popular literature on human types, describing in detail the characteristics of different cats, not only as breeds, but as social types like the country cat and the city cat.

The friendship between Baudelaire and Manet has been frequently discussed, and Baudelaire's influence on Manet's paintings such as the 'Buveur d'absinthe' and the 'Olympia' has repeatedly been suggested. Although poems

76 Manet: 'Le Vieux Musicien'

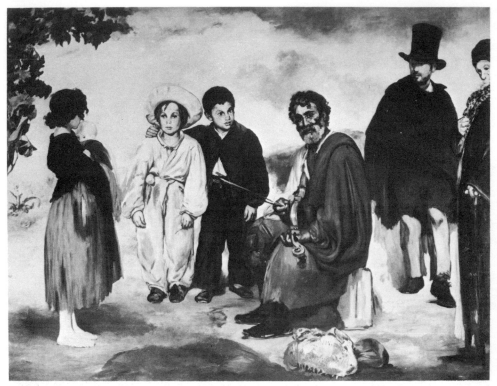

in *Les Fleurs du mal* may have suggested some of Manet's images,[34] Baudelaire's critical views on art perhaps exerted an even greater influence on the artist. Baudelaire accepted the marginal and popular art of caricature as a valid expression of the age and showed extraordinary perception and judgement in recognizing some caricaturists as merely superficial and others as major figures worthy of consideration with the masters.[35] As early as 1845 Baudelaire had called for a painter who could 'snatch its epic quality from the life of today and make us see and understand, with brush and with pencil, how great and poetic we are in our cravats and our patent-leather boots'.[36] In 1863 he indicated his choice for the *peintre de la vie moderne* with a description of Constantin Guys. It is reasonable to believe that had he waited for Manet's mature work he would have found him a better choice.[37]

In view of the strong plea for a modern art on the part of the critics of all persuasions and the personal interests of his literary friends, Manet's desire to

succeed in the *Salons* and to paint modern life are hardly as incompatible as many of his biographers would have them seem.

His subjects—ragpickers, beggars, gypsies, actors, the inhabitants of the streets of Paris—were the 'types populaires' commonly seen in the *Salons* and are to be found in much of the literature of the period. Songs, magazine articles and chapters of books often bear the same titles as paintings in the *Salons* of the 1850s and 1860s. Essays on typical people and typical places frequently appeared in magazines such as *Paris-comique*, *L'Image*, *La Vie parisienne*, *Diogène*, *La Chronique universelle*, and *Magasin pittoresque*. Well-known examples of this kind of descriptive writing are Victor Fournel's book of 1858, *Ce qu'on voit dans les rues de Paris*, and Émile de Labedollière's *Les Industriels Métiers et professions en France* of 1842. The latter was illustrated by Henry Monnier, who himself produced numerous plays and illustrations for his *Scènes populaires* which appeared during the 1830s and 1840s. Books like Zaccone's *Rues de Paris* (1859) and *Le Tiroir du diable : Paris et les Parisiens* (1850)

77 Schlesinger: 'L'Enfant volé' from *Magasin pittoresque*

by Balzac, Sand and others are almost like guidebooks to the sights of Paris with illustrations of various quarters and their inhabitants. A series of little books called *Les Physiologies* published in the 1840s, and a large work entitled *Les Français peints par eux-mêmes* which appeared in several editions between 1839 and 1876, comprised illustrated essays on French types by a variety of artists and authors. The number of analogies which can be found in *Les Français peints par eux-mêmes* and in Manet's work suggest that he knew these volumes well.[38]

It has often been said that Manet's 'Buveur d'absinthe' here illustrated by the etching made after the painting [73], was rejected from the *Salon* of 1859 because of its subject. The interpretation of the subject may well have seemed offensive, especially since to many it suggested parallels with poems by Baudelaire. The subject itself, a ragpicker, however, had already appeared more than once in illustrated essays, and two pictures of ragpickers were accepted in the

78 Pauquet: 'La Béarnaise' from *Les français peints par eux-mêmes*

La Béarnaise. Dessin de Pauquet.

79 'Famille caraïbe de Saint-Vincent' from *Voyages aux îles de l'Amérique*

PLANCHE XIV, *Famille caraïbe de Saint-Vincent. Gravure du XVIIIᵉ siècle.*

80 Engraving from *Voyages aux îles de l'Amérique*

very *Salon* from which Manet's painting was rejected.[39] The absinthe-drinker's top hat has sometimes been considered a sign that the poor man had fallen from a higher estate. However, the pages of *Les Français peints par eux-mêmes* demonstrate the fact that beggars and ragpickers, drunk or sober, often wore top hats [74].[40] Bertrand, the author of the chapter on ragpickers in these volumes, explains that ragpickers differ from beggars in several important way. Ragpickers do not beg; they collect and sell unwanted materials. He lists the equipment a ragpicker must have and then describes at length a ragpicker named Christophe who, while typical, can be regarded as the best of his type. He is proud, honest, drinks little and talks a great deal. He preserves probity in misery, and it is not easy to obey the law when you are hungry.[41] The author then explains that ragpickers have a special café at the Barrière de Fontainbleau where the best room is called the *Chambre des pairs*, the next best the *Chambre des députés*, and the least attractive the *Réunion des vrais prolétaires*.[42]

It is interesting to turn to a much later book, Zaccone's *Les Rues de Paris*,

81 Gavarni: from *Physiologie de la grisette*

which also has a section on ragpickers and similar illustrations by other artists
[75]. The author, Louis Berger, states that the ragpicker is a practical philoso-
pher of the streets, that he drinks little, talks a lot, is both proud and humble,
and is to be admired for his probity. If these similarities are not enough, we
can read further and find that the ragpickers have a rendezvous at the *barrière*
called the *Chambre des députés*.[43] This repetition is one of many examples of
the persistence of specific details in the descriptions of popular types.

Manet's absinthe-drinking-ragpicker appears again in 'Le Vieux musicien'
of 1862 [76]. This larger painting is a composite of types from the fringes
of French society, beggar children, a wandering musician, perhaps a little
player from the popular Commedia dell'Arte, and, to the far right, the

Wandering Jew, subject of many popular prints, Eugène Süe's book, and a song by Béranger with the catching refrain, 'Toujours, toujours, toujours, toujours / tourne la terre ou moi je cours.'[44] A full study of the meaning of this assembly of characters has yet to be published.

'Le Vieux musicien' has been the centre of much discussion about Manet's borrowings, most recently in articles by Michael Fried and Theodore Reff in the pages of *Artforum*.[45] Fried suggests no less than four paintings by Louis Le Nain as sources for this work.[46] Reff offers still another by Antoine Le Nain.[47] While Manet could have seen these paintings or engravings after them in many ways, it is interesting to note that an engraving after 'La forge' by Louis Le Nain was used to illustrate the chapter on workers in *Les Français peints par eux-mêmes*,[48] and that 'Les Moissonneurs' by Louis Le Nain and 'Le Vieux joueur de fifre' by Antoine Le Nain were illustrated in the *Gazette des beaux-arts* during 1860, just before Manet began work on 'Le Vieux musicien'. Watteau's 'Gilles', which has frequently been cited as the source for the little

82 'Le Sauvage' from *Chants et chansons*

83 de Lemud: 'Ma nacelle' from *Oeuvres complètes de P .I. Béranger*

Pierrot figure in white, also appeared in the same volume.[49] These facts again suggest that Manet collected images from a variety of sources. The reappearance of major paintings in the magazines which Manet read may have served to confirm his interest in these images. Fried proposes 'Les Moissonneurs' as the source for the little girl at the left in 'Le Vieux musicien';[50] Reff offers a more convincing suggestion in the little girl at the far left of 'Le Vieux joueur de fifre'. A still closer source can be found in a painting by Henri-Guillaume Schlesinger which was exhibited in the *Salon* of 1861 and which appeared in the *Magasin pittoresque* during the show [77].[51] Schlesinger's painting, like Manet's, depicts traditional wanderers, popular in the literature of the day. That the little girls in both paintings follow the traditions for the depiction of popular types can be shown in still another illustration from *Les Français peints par eux-mêmes* [78].[52]

The interest in popular types which Manet shared with so many artists and

84 Manet: 'Déjeuner sur l'herbe'

85 Manet: 'La Musique aux Tuileries'

writers of his day has a long history. It derives in part from the simple arts of
the people, but as much from the kind of observation and recording practised
in travel literature. Descriptions of the natives of foreign lands, both in words
and pictures, usually depend on European standards of beauty and European
desires to organize the unfamiliar into clear concepts as classes or types. Plants,
animals and people alike are described, not according to their particular
features, but with the features common to them as a class. Thus the Audubon
bird has perfect colouring and all its feathers are in place.

 This 'scientific' approach for the description of the natives of foreign parts
was practised as well for illustrations of Europeans of different regions,
nationalities, professions and classes. With a growing concern about man's
role in society in 19th century France, descriptions of the Frenchman in his
own habitat became of great interest to the Parisian, and narrative elements
in illustration and literature often gave way to a deft combination of acute
observation and preconceptions about the typical—a combination common
in travel literature. Even a periodical like the *Gazette des beaux-arts* encouraged
this interest. In 1859 it published a review of a new book describing sections of
Paris, *Paris qui s'en va*. The reviewer praises the author and chides another

86 Parent: 'Les Enfants et les oiseaux au jardin des Tuileries', from *Les français peints par eux-mêmes*

author who has published notes on a trip to Venice but, in Paris, has not even gone as far as the *Barrière d'Italie.*[53]

Since the aim of travel-book illustration is to provide information, views or scenes are usually directly descriptive, often including human figures involved in typical tasks. Even more common is the single standing figure set against the slightest indication of low-lying landscape. Such figures wear typical dress and often hold tools or weapons which offer further information about their lives. Two plates, chosen at random from an 18th century travel book, depict a descriptive scene [79] and typical standing figures [80].[54] The similarity of these figures to illustrations of French types is obvious [78, 95, 97].

The illustration for Pierre Dupont's song, *Le Sauvage* [82], illustrates a continuation of this mode. We see a single standing figure in front of a minimal indication of landscape, but here he is framed by a series of scenes, not of his own habitat, but of modern France. This combination reflects the content

87 Manet: 'Au café'

of the song, an appeal for the brotherhood of all mankind,[55] and the decorative arrangement of tools and weapons above the native's head further carries out this theme. The lower portion of the illustration, showing an assembly of partially clothed river gods on a modern French river bank, is a happy suggestion that the enjoyment of nature is not incompatible with the progress of the modern world. The escape from the pressures and activities of the modern city is a common subject for illustrations of the modern Frenchman. Real people rather than gods, can be seen relaxing in the countryside in a little drawing for *Physiologie de la grisette* [81].[56] Manet and the Impressionists were exposed to many such pictures in the popular press which suggest not only the subjects they chose to paint, but also the direct and casual approach to the subject. A related image is to be found in an illustration to a song by Béranger, 'Ma Nacelle' [83].[57] Here we see the muse of song in the boat and some rather attractive graces on the river bank together with three up-to-date Frenchmen

88 'Les Joueurs de l'hôtel d'Angleterre' from *Les Rues de Paris ou Paris chez soi*

Les Joueurs de l'hôtel d'Angleterre.

(Baudelaire's 'modern heroes'?) who have brought along their picnic with the product of the grape which grows along the border of the illustration securely packaged in modern French wine bottles. One finds oneself thinking of Manet's pastoral picnic, the shocking 'Déjeuner sur l'herbe' [84]. The removal of the last veil of classical reference, and the direct confrontation with the spectator, separate Manet's painting from its numerous, easily accepted popular sources. Without the influence of such sources, however, Manet might never have painted his far more provocative and interesting record of contemporary life.

Manet's 'La Musique aux Tuileries' [85] may lack the power of the 'Déjeuner sur l'herbe' both to captivate and offend, but it is equally a reflection of the numerous illustrations of the period. While the *Physiologies* and *Les Français peints par eux-mêmes* are divided by human types, *Le Tiroir du diable* and *Le Nouveau Paris* are divided by sections of the city. Series of articles in *La Chronique universelle illustrée* and other magazines and newspapers are similarly

devoted to descriptions of places. In discussing 'La Musique aux Tuileries', Sandblad compares it with a military concert in the Tuileries from *L'Illustration*.[58] Another possible source can be found in *Les Français peints par eux-mêmes* [86].[59] It is no better and no worse than Sandblad's choice and simply serves to demonstrate the ubiquitous nature of such descriptive views. It is true, of course, that Manet's painting is more than an illustration of a section of Paris, since he includes portraits of himself and many of his friends in the picture. But unlike Courbet who, in his 'Allégorie réelle', made his position central while surrounding himself with his friends and his subjects, Manet has preserved the descriptive nature of the scene as a record of his own way of life, leaving as subtle inferences the ideas to be drawn from so casual an assembly of such distinguished figures.

We have already mentioned the critics' plea for a new artist for the new age.

89 'Le Café-concert' from *Le Nouveau Paris*

Le Café Concert.

90 Manet: 'Coin de café-concert'

91 Anon. French: 'Pauline Duvernay'

Such a plea is repeated in Jules Janin's introduction to *Les Français peints par eux-mêmes*:

...ce que vous faites aujourd'hui, ce que vous dites aujourd'hui, ce sera de l'histoire un jour. On parlera dans cent ans comme d'une chose extraordinaire, de vos places en bitume, de vos petits bateaux à vapeur, de vos chemins de fer si mal faits, de votre gaz si peu brillant, de vos salles de spectacle si étroites, de votre drame moderne si moderé, de votre vaudeville si réservé et si chaste.[60]

The volumes are to be a magic lantern of the period[61] for which 'l'artiste n'est même pas nommé'.[62] Manet probably read Janin's essay; he may also have read Gautier's words in *Fusain et eaux-fortes*, 'Les bonnes manières, l'élégance et l'art s'accordent très bien avec la liberté. L'absence d'une cour a-t-elle pour résultat de supprimer le luxe, l'éclat, la beauté?' He speaks of the 'grands édifices publics nécessités par la nouvelle vie sociale', and says, 'Nous croyons fermement que les artistes trouveront d'aussi nobles formes pour ces Versailles populaires qu'ils en ont inventé autrefois pour les fantaisies de Louis XIV.[63] Manet may also have taken to heart Castagnary's later admonishment, 'La beauté est sous les yeux, non dans la cervelle; dans le présent, non dans le passé; dans la verité, non dans le rêve, dans la vie, non dans la mort... Hâtez-vous, ne tardez pas une heure; formes et aspects seront changés demain.

Peindre ce qui est, au moment où vous le percevez... c'est encore écrire de l'histoire pour la posterité à venir.' [64]

Is it any wonder that Manet, in 1879, wrote a letter to the prefect of the Seine offering to decorate the conference room of the new Hôtel de Ville with a series of compositions representing the Paris of his own day—'Paris-Halles, Paris-Chemins de fer, Paris-Port, Paris-Souterrains, Paris-Course et jardins.' [65] Manet's pictures of French life, the racetrack, the railroad, the Tuileries gardens, the Folkestone boat, give us some idea of the possibilities of such a grandiose venture. Perhaps his 'Paris-Souterrains' would have resembled the descriptions and illustrations of the catacombs such as Labedollière's essay in *Le Nouveau Paris* which refers to an underground tour as 'une promenade à la mode'. [66]

The cafés of Paris, like the parks and streets, are depicted again and again in the French press. As in the case of *La Musique aux Tuileries*, any 'source' we might suggest for one of Manet's café pictures can be matched by other 'sources' among the vast numbers of similar illustrations. Manet made several

92 Anon. French: 'Camarga'

93 'Mr Kime' from 'L'Art au theâtre', *Gazette des beaux-arts*, 1859

drawings of café interiors where men relax, drink, chat and play games [87], free derivations of such illustrations as 'Le Jouers de l'hôtel d'Angleterre' from *Les Rues de Paris* [88].[67] The café-concert interested him as much as the café. His 'Coin de café-concert' in the Walters Art Gallery, Baltimore [90], depicts several café-goers and a waitress, all apparently disinterested in the singer on the lighted stage at the upper left. The same peripheral treatment of the evening's event can be found in a picture of a café-concert in *Le Nouveau Paris* [89].[68]

Manet focused his interest in performers in his enticing painting of Lola de Valence, the *prima ballerina* of the troup of Spanish dancers who performed at the Hippodrome in the summer of 1862. More than a portrait, it is a reflection of popular theatre images common for posters or handbills [91] and [92][69] and for descriptions of theatrical life. The same conventions of pose and format can be seen in an illustration of one of the actors in a bourgeois drama playing at the Odéon which was reviewed in the *Gazette des beaux-arts* in 1859 [93].[70] In the painting of Lola de Valence, the dancer stands in front of the

94 Manet: 'Lola de Valence'

95 Émy: 'La Basquaise' from *Les français peints par eux-mêmes*

back of some stage scenery. The derivation of this motif from popular imagery has been discussed elsewhere.[71] Lola is illustrated here in an etching which Manet made after his painting [94].[72] The stage scenery has been removed, and the figure is treated in the conventional manner for theatrical advertising. Although Lola's precise pose certainly demonstrates her role as a dancer, it was not confined to illustrations for the theatre and the ballet. Instead, it seems to have been a standard convention for typical figures of any kind. An illustration for a chapter on peasants in *Les Français peints par eux-mêmes* can attest to this tradition [95].[73] Manet's final illustration of Lola, a lithograph for the cover of a song by Zacharie Astruc, again turns this conventional image to a popular use.

Spaniards, Italians and gypsies were among the most popular of popular types. Gypsies were seen in all the *Salons* from 1857 onwards; numerous books and articles appeared describing in travel-book style the gypsies' language, dress and customs. Prosper Mérimée's *Carmen* of 1847 was largely based on George Borrow's standard work on gypsies. There were plays, pantomimes

96 Manet: 'Les Gitanos'

97 Jeanron: 'La Limoisine' from *Les français peints par eux-mêmes*

98 Blake: 'Family of negroes from Laongo' from *Narrative of a Five Years Expedition against the Revolted Negroes of Surinam*

99 Pauquet: 'L'Ouvrier de Paris' from *Les Français peints par eux-mêmes*

100 Manet: 'Chapeau et guitare'

101 Vignette from 'L'Art au théâtre'

102 Vignette from *Le Nouveau Paris*

and ballets and Bizet's *Carmen* was produced at the Opéra Comique in 1875. Franz Liszt's *Des bohémiens et de leur musique en Hongrie* of 1859 brought serious interest to the study of gypsy music. It is not surprising that Manet, so receptive to the interests of his day, decided to paint a large picture of gypsies. It was shown in Martinet's gallery in 1863[74] and in Manet's large exhibition near the Pont de l'Alma in 1867.[75] After that, Manet cut the painting into several fragments, and today we know the original composition through the etching he made after the painting [96].[76] The standing male gypsy, placed almost centrally, again repeats the convention for the description of regional types [97] [77] and is like a modern version of a travel-book record of the appearance of an exotic figure. The male gypsy dominates the composition, while the figures of the boy and the female gypsy with her baby seem to be squeezed into the picture almost as attributes to the typical male. This compositional curiosity, in fact, may lie behind Manet's decision to cut up the painting, and to create of its fragments more typical single figures. On the other hand, Manet's original plan to paint a family group also has its roots in popular illustrations and travel-books, where a male figure stands in front of a slight indication of landscape dominant over the other members of his family [98 and 99].[78]

In 'Les Gitanos' a basket lies on the ground in front of the female gypsy. (I have reason to believe that this section of the painting was preserved when Manet cut the canvas apart.[79]) The use of still-life elements at the feet of standing figures is a device used by Velasquez, and one which Manet followed in works like his portrait of Duret, 'Le Buveur d'absinthe' and 'La Femme au perroquet', to name only a few. Manet's still-life in the 'Déjeuner sur l'herbe' has long been recognized as both a beautiful passage of painting and an important adjunct to the meaning of the picture. When Manet was faced with the task of designing a cover for a portfolio of his prints, he turned to still-life as an appropriate motif. His etching for the folio frontispiece shows at the bottom of the page a group of objects which Manet had in his studio during his period of intense interest in Spanish motifs, a basket of Spanish costumes, a guitar and a sombrero [100].[80] An early state of the etching includes a list of the contents of the portfolio above the still-life (this list is removed in the final state).[81] All but one of the works listed and all but one of the works included in the portfolio ('La Toilette') are either of Spanish subjects or are directly influenced by Spanish art.

The meaning behind Manet's frontispiece etchings and the order in which they were made are fully discussed in two articles by Theodore Reff and by Jean Collins Harris in her recent catalogue of Manet's graphic works.[82] The

observation can be added, however, that in using a still-life vignette below the list of the contents of the folio, Manet was again following a popular practice. Still-life vignettes comprising suitable objects were frequently used to close the chapter of a book or end an article. Common in the descriptions of popular types, they served to add further information about the subjects discussed. Like Manet's vignette, a hat and a musical instrument are included in a vignette at the end of an article on the theatre in the *Gazette des beaux-arts* [101].[83] A very different kind of hat is included in another similar illustration which follows a description of a section of Paris in *Le Nouveau Paris* [102].[84] Manet not only used this form of popular imagery in an expected place, to follow the lists of related titles on his portfolio cover, but also in a large painting of the same motif, now in the Musée Calvet, Avignon. Again he has taken a minor, almost trivial, comment on everyday life as subject for a painting of major size and importance.

103 Manet: 'Pertuiset, chasseur de lions'

104 'Le Tueur de lions' from *Chants et chansons*

Manet's interest in most of the subjects discussed here could have been aroused by any number of similar images. There is, however, a curious instance where a specific song and its illustration may have been a single and direct source for a strange portrait painted near the end of Manet's life. In 1881 he sent to the *Salon* a picture of his friend Pertuiset, a painter, collector and explorer [103]. We do not know whether Manet or Pertuiset chose for the portrait his occasional role as lion hunter, but it seems reasonable to believe that the choice was suggested by the popularity of one of Béranger's songs 'Le Tueur de lions', and an illustration for it [104].[85] While the similarities are striking, the differences are important as well. The song illustration shows the hunter in an exotic landscape at the dramatic moment before the kill. By contrast, Pertuiset's exploit appears to have taken place in a French landscape where we would not be surprised to find the picnickers of the 'Déjeuner sur l'herbe' behind the trees. They would be safe enough, for the danger is past, and the hunter poses before the dead lion with the iconic frontality of a modern Hercules. Manet has again taken an illustrative image and re-formed it into a curiously provocative work of art.

Manet's *œuvre* had an enormous effect on the art which was to follow. He has always been an artists' artist, admired for his facile handling of paint and the sheer beauty of the surfaces he created. However, much of the fascination which his works hold for us today is also due to his commitment to modern life with all its seductions and perversions. Artists of today, struggling with the popular imagery of the 20th century, can admire him all the more for his direct forceful and eternal record of the life of his own time.

Notes and discussion
(1) In the discussion at the Symposium a question was raised from the floor as to the appropriateness of the term 'popular imagery' for the type of material discussed in this paper. It was suggested that it might better have been called the 'imagery of the French press'. I must agree that 'popular' in such a context as this more often refers to simple rural people and their culture than to the reading material of the average Parisian. However, *types populaires,* the stereotypes for portraying simple people, their costumes, songs and customs, had gradually gained the interest of serious artists and writers. Thus it seems of questionable value to discard the use of the word 'popular' in discussing French imagery at mid-century which derived from and appealed to the people, rural and urban, simply because this

imagery had gained the interest of all classes and was to be found in all kinds of books and periodicals.
I wish to express my gratitude to the National Endowment for the Humanities and to Bryn Mawr College for making possible a year of leisure during which much of the work for this article was accomplished.
(2) Émile Zola, 'Mon salon', *L'Événement*, 20 May 1866, reprinted in *Mes haines*, Paris, Bernouard, 1928, p. 221. See also *Édouard Manet: étude biographique et critique*, Paris, Dentu, 1867, pp. 253, 258, and *Exposition des œuvres d'Édouard Manet*, Paris, Quantin, 1884, Preface.
(3) Charles Baudelaire, letter to Théophile Thoré in answer to statements in Thoré's article in *L'Indépendance belge*, 15 June 1864, reprinted in Étienne Moreau-Nélaton, *Manet raconté par lui-même* (2 vols.), Paris,

Laurens, 1926, I, pp. 58—9. Thoré answered Baudelaire's letter in *L'Indépendance belge*, 26 June 1864.
(4) Théophile Thoré [W. Bürger, pseudonym], *Salons* (2 vols.), Paris, 1870, I, pp. 424, II, pp. 98—9. Ernest Chesneau, *L'Art et les artistes modernes en France et en Angleterre*, Paris, 1864, pp. 190, 279.
(5) Casual references to Manet's sources are to be found throughout the literature and are far too numerous to mention. The following are some of the more useful works on Manet's sources: Nils Gösta Sandblad, *Manet: Three Studies in Artistic Conception*, Lund, CWK Gleerup, 1954; Paul Jamot, 'Études sur Manet', *Gazette des beaux-arts*, XV (1927), pp. 27—50, 381—90; Alain de Leiris, 'Manet's *Christ Scourged* and the Problems of his Religious Paintings', *Art Bulletin*, XLI (1959), pp. 198—201; Alain de Leiris, 'Manet, Guéroult and Chrysippos', *Art Bulletin*, XLVI (1964), pp. 401—4; E. Lambert, 'Manet et l'Espagne', *Gazette des beaux-arts*, IX (1933), pp. 368—82; Léon Rosenthal, 'Manet et l'Espagne', *Gazette des beaux-arts*, XII (1925), pp. 203—14; Charles Sterling, 'Manet and Rubens', *L'Amour de l'art*, XIII (1932), p. 290; Theodore Reff, '"Manet's Sources": A Critical Evaluation', *Artforum*, VIII, No. 1 (September 1969), pp. 40—48; Michael Fried, 'Manet's Sources: Aspects of his Art, 1859—1865', *Artforum*, VII, No. 7 (March 1969), pp. 28—82. Fried discusses Manet's sources at great length, summarizing many of those suggested in earlier literature, adding a few examples, and proposing a thesis to explain Manet's choice of sources. He thinks that Manet was deeply concerned with the Frenchness of French art and that he had 'access' to the works of non-French schools through the mediation of French artists. While I disagree with this thesis and strongly object to the arbitrary way Fried twists both visual and verbal evidence to support it, I believe that he is to be congratulated for recognizing the futility of compiling lists and for attempting the more important task of analysing the nature of Manet's sources and discovering his reasons for choosing them.
(6) Thoré, *Salons*, op. cit., I, pp. 414.
(7) Anne Coffin Hanson, 'Manet's Subject Matter and a Source of Popular Imagery', The Art Institute of Chicago, *Museum Studies*, III (1968), pp. 64—6.
(8) *Explication des ouvrages de peinture, sculpture, gravure, lithographie, et architecture, des artistes vivants exposés au Palais de Champs-Elysées le 15 avril 1859*, Paris, Charles de Morgues Frères, 1859, pp. viii—x.
(9) For a general discussion of these changes in the attitudes of critics, see Léon Rosenthal, *Du romanticisme au réalisme*, Paris, Renouard, 1914, pp. 345—7, and

Joseph C. Sloane, 'The Tradition of Figure Painting and Concepts of Modern Art in France from 1845 to 1870', *Journal of Aesthetics and Art Criticism*, VII (1948), pp 1—29.
(10) Edmond About, *Nos Artistes au Salon de 1857*, Paris, Hachette, 1858, p. 37.
(11) John Rewald, *The History of Impressionism*, New York, Museum of Modern Art, 1961, p. 20.
(12) Eugène Delacroix, *Journal de Eugène Delacroix* (3 vols.), ed. André Joubin, Paris, Plon, 1932, III, pp. 60—2, entry for 4 Feb. 1857.
(13) Théophile Gautier, *L'Art moderne*, Paris, Michel Lévy Frères, 1856, p. 286.
(14) Théophile Silvestre, 'La Critique de l'art et l'école française', and Henry de Riancy, 'Beaux-arts', *La Chronique universelle illustrée*, I (1860), p. 219 and pp. 111—12.
(15) Jules Antoine Castagnary, *Salons, 1857— 1879*, Paris, Charpentier, 1892, p. 2.
(16) Ibid., p. 3.
(17) Ibid., p. 15.
(18) Théophile Thoré [W. Bürger], *Salons de T. Thoré*, Paris, Librairie International, 1868, p. ix.
(19) Thoré, 'Nouvelles tendences de l'art', Brussels, 1857, reprinted in *Salons*, 1868, pp. xiii—xliv, and Castagnary, op. cit., p. 13.
(20) Hippolyte Taine, 'The Ideal in Art', *Lectures on Art*, trans. John Durand, New York, 1875, I, pp. 162—4, here quoted from Sloane, op. cit., p. 14.
(21) Théophile Gautier, *Fusains et eaux-fortes*, Paris, Charpentier, 1880, 'Les Chemins de fer' (1837), pp. 187—95.
(22) Gautier, *Fusains*, op. cit., 'A propos de Ballons' (1848), pp. 255—64.
(23) Ibid., 'La République de l'avenir' (1848), pp. 237—8.
(24) Pierre Dupont, *Chants et chansons* (4 vols.) Paris, 1855, Preface, July 1851, p. 24.
(25) Dupont, op. cit., IV, 25—8. Linda Nochlin in Gustave Courbet's *Meeting: A Portrait of the Artist as a Wandering Jew'*, *Art Bulletin*, XLIX (1967), p. 216, suggests that Courbet and Dupont were friends, and discusses the ideas in this song in relation to Courbet's painting 'Meeting'.
(26) For example, balloon ascents and descents are depicted in the *Almanach du Magasin pittoresque*, Paris, 1852, p. 23; 1865, p. 39.
(27) 'Le Ballon', lithograph, 1862, No. 68 in Marcel Guérin, *L'Oeuvre gravé de Manet*, Paris, Floury, 1944.
(28) Thomas Couture, *Méthode et entretiens d'atelier*, Paris, 1867, pp. 254—6.
(29) Gustave Flaubert, *L'Education sentimentale*, Paris, 1922, p. 360.
(30) I have not been able to find this periodical in the United States. The excerpt quoted here is taken from Eugène Hatin, *Bibliographie*

historique et critique de la press périodique
française, Paris, Firmin Didot, 1866, p. 540.
(31) Théodore de Banville, 'La Vie
moderne', La Vie moderne, I (1879), p. 6.
(32) Jules Husson [Champfleury], Grandes
figures d'hier et d'aujourd'hui, Paris, Poulet-
Malassis, 1861, pp. 252–3. Champfleury's
meaning is further clarified a few lines below:
'Les physionomies des gens d'Ornans sont
elles plus effrayantes et plus grotesques que
celles de Goya, d'Hogarth et de Daumier?'
(33) 'Le Chat et les fleurs' (1869, etching,
Guérin No. 53) was used as an illustration in
the 1870 edition of Les Chats. 'Le Rendez-
vous des chats' (1868, lithograph, Guérin
No. 74) was used to advertise the 1870
edition and as an illustration to an article on
cats in La Chronique illustrée, 25 Oct. 1869.
(34) See George Heard Hamilton, Manet and
his Critics, New Haven, Yale University Press,
1954, pp. 30, 79, 80, 94; Jens Thiis, 'Manet
and Baudelaire', Études d'Art, I (Algiers,
1945), pp. 9–23; and Hanson, Museum
Studies, p. 73.
(35) Charles Baudelaire, 'De la caricature',
Le Présent, 1 Oct. 1857.
(36) Baudelaire, Salon de 1845, here quoted
from The Mirror of Art: Critical Studies by
Charles Baudelaire, trans. and ed. Jonathen
Mayne, New York, 1956, p. 37.
(37) Le Peintre de la vie moderne, Paris,
1863.
(38) I have discussed Les Français peints par
eux-mêmes as a source for Manet with
particular reference to his paintings of
philosophers in Museum Studies, cited above.
This paper will add a few observations about
that source which were not included in that
article. For full bibliographical information
about Les Français peints par eux-mêmes,
see Museum Studies, p. 78, n. 7.
(39) Explication... le 15 avril 1859: 'Un
Chiffonnier', No. 2024, and 'Ragpicker,
chiffonière de New York', No. 2680. Manet,
'Buveur d'absinthe', Guérin No. 9, State II.
(40) Traviès, 'Le Chiffonnier', in Les Français
peints par eux-mêmes (8 vols.), Paris,
Curmer, 1841, III, p. 333. Also see Pauquet,
'Pauvre', ibid., 1842, IV, p. 97.
(41) Les Français peints par eux-même, 1876,
IV, pp. 22-3.
(42) Ibid., p. 32.
(43) Pierre Zaccone, Les Rues de Paris ou
Paris chez soi, Paris, [1859], pp. 205–8.
(44) Oeuvres complètes de P.-J de Béranger
(2 vols.), Paris, Perrotin, 1856, II, pp. 214–
215. Champfleury devoted a large portion
of his L'Histoire de l'imagerie populaire of
1869 to the legend of the Wandering Jew. It
was, however, published after Manet's picture
was painted.
(45) Fried, op. cit., pp. 29–33; Reff, op. cit.,
p. 43.

(46) Fried, op. cit., pp. 30–1, 44–6.
(47) Reff, op. cit., p. 43.
(48) Les Français peints par eux-mêmes,
1876, IV, p. 37.
(49) As Fried (op. cit., p. 30) points out, the
Gilles in the Louvre was first noted as a
source for Manet by Michel Florisoone,
Manet, Monaco, 1947, pp. xvi–xvii.
(50) Fried, op. cit., p. 46.
(51) 'L'Enfant volé', engraving after the
painting published in Magasin pittoresque,
XXVIII (1861), p. 293.
(52) Pauquet, La Béarnaise, in Les Français
peints par eux-mêmes, 1842, III, p. 111.
(53) 'Livres d'art et publications d'éstampes',
Gazette des beaux-arts, I (1859). Anonymous
review of Paris qui s'en va, Paris, Cadart,
1859, with illustrations by Flemeng.
(54) The edition of R. P. Labat, Voyages
aux îles de l'Amérique, ed. t'Serstevens,
Paris, 1931, includes as Plate I an illustration
from the 1724 edition [80] and an anonymous
18th century travel illustration as Plate XIV
[79]. In citing such examples we do not
mean to overlook earlier French interests in
types as demonstrated in the work of artists
such as Callot, nor the evolution of the
'typical' standing figure in 18th century
Italian and Spanish genre painting.
(55) Dupont, op. cit., I, pp. 101–3.
(56) Untitled illustration by Gavarni, in Paul
Huart, Physiologie de la grisette, ed. Aubert,
Paris, Lavigne, [1841], p. 86.
(57) A. de Lemud, Ma nacelle, in Oeuvres de
Béranger, I, p. 250.
(58) Nils Gösta Sandblad, Manet: Three
Studies in Artistic Conception, Lund, CWK
Gleerup, 1954, Plate 1, 'Concert militaires
dans le jardin du Palais des tuileries',
xylograph in L'Illustration, 17 July 1858.
(59) Ulysse Parent, 'Les Enfants et les oiseaux
au jardin des Tuileries', in Les Français peints
par eux-mêmes, 1876, IV, p. 173.
(60) Les Français peints par eux-mêmes,
1876, I, p. v.
(61) Ibid., p. xvi.
(62) Ibid., p. vi.
(63) Gautier, Fusains, op. cit., p. 235.
(64) Castagnary, Salon de 1867, op. cit.,
pp. 241–2.
(65) Letter, April 1879, from Edouard Manet,
artiste peintre, né à Paris, 77 rue
d'Amsterdam' offering to paint 'Le Ventre de
Paris', reprinted in Moreau-Nélaton, II, 97.
(66) Émile de Labédollière, Le Nouveau Paris,
Paris, Barbu, [1860], p. 220.
(67) 'Les Joueurs de l'hôtel d'Angleterre', in
Zaccone, op. cit., p. 216
(68) 'Le Café-concert', in Labédollière, op. cit,
p. 113
(69) Anonymous French print, 1839 of the
dancer, Pauline Duvernay, and anonymous
French print, c. 1850, of the dancer,

Camarga, both in the New York Public Library. These prints, and others like them, were found by Miss Mollie Faries, a former student of mine, and presented by her in a talk, 'Some Sources for Manet in Popular Imagery', at *A Symposium on the History of Art*, 16 April 1966, Institute of Fine Arts, New York University. I owe her the warmest thanks for sharing many of her ideas with me.

(70) 'Mr Kime', in Louis Ulbach, 'L'Art au théâtre', *Gazette des beaux-arts*, I (1859), p. 169.

(71) John Richardson, *Manet*, London/New York, 1958, p. 14, and Hanson, *Museum Studies*, p. 66, suggest sources in Daumier and Gavarni. Similar illustrations can be found in *Physiologie de l'homme á bonnes fortunes*, Paris, Aubert, [1841], p. 28, and Labédollière, op. cit., p. 129.

(72) 'Lola de Valence', 1862, etching after oil painting, Guérin No. 23, State II.

(73) Émy, 'La Basquaise', in *Les Français peints par eux-mêmes*, 1841, II, p. 93.

(74) March 1863, Louis Martinet Gallery. More than fourteen works exhibited. No known catalogue. See Moreau-Nélaton, op. cit., I, p. 43.

(75) *Catalogue des tableaux de M. Édouard Manet exposés Avenue de l'Alma en 1867*, Paris, Imprimerie Poupart-Davyl, 1867, No. 9.

(76) 'Les Gitanos', 1861, etching, Guérin No. 21. For a complete discussion of the fate of the painting, see Anne Coffin Hanson, 'Edouard Manet, *Les Gitanos*, and the Cut Canvas', *Burlington Magazine*, CXII (1970), p. 158–166.

(77) Jeanron, 'La Limoisine', in *Les Français peints par eux-mêmes*, 1841, II, p. 249.

(78) 'Family of Negroes from Laongo', 1792, engraved by William Blake, in John Gabriel Stedman, *Narrative of a Five Years Expedition against the Revolted Negroes of Surinam* (2 vols.), London, Johnson, 1813, II, p. 290; Pauguet, 'L'Ouvrier de Paris', in *Les français peints par eux-mêmes*, 1842, V, p. 361.

(79) A photograph of a painting resembling this basket was published without comment in an article by Charles Perrusaux, 'Manet: coupeur des toiles', *Lettres françaises*, 18 Sept. 1955. I have been unable to see this painting, which is now in a private collection in Paris.

(80) 'Chapeau et guitare: frontispice pour un cahier', etching Guérin No. 62, State III. While the second state of this etching is dated 1874 and served for the frontispiece of a portfolio of etchings at that date, the still-life had already appeared in an etching intended for a frontispiece of a portfolio published in 1862 (Guérin No. 29).

(81) For the list of works on the first state of this etching and the lists of the contents of the portfolios of 1862 and 1874, see Guérin, op. cit., pp. 12–13.

(82) Theodore Reff, 'Manet's Frontispiece Etchings', *Bulletin of the New York Public Library*, LXVI (1962), pp. 142–8, and 'The Symbolism of Manet's Frontispiece Etching', *Burlington Magazine*, CIV (1962), pp. 182–6. Jean Harris, *Edouard Manet: Graphic Works*, New York, Collectors' Editions, 1970, pp. 115–21.

(83) Vignette in Louis Ulbach, 'L'Art au théâtre', *Gazette des beaux-arts*, I (1859), p. 174.

(84) Vignette at the end of the chapter, 'La Bourse', in Labédollière, op. cit., p. 32.

(85) 'Le Tueur de lions', in Dupont, op. cit., IV, p. 125.

Discussion. Prof. Hanson stressed again the significance of the pictorial subject-matter which Manet had derived from modern life. Although Manet's choice of material had something in common with pictures exhibited at the *Salon*, the specific artistic form he gave to such commonplace scenes was new in French art. In connection with Manet's 'Absinthe drinker', Prof. Hanson drew attention to Couture's related genre pictures. The notion of 'popular images' was to be understood in terms of the wide circulation and repetition of certain typical images in both high and low art; Prof. Hanson was aware of the ambiguities involved. See above, note 1. It was nevertheless interesting that such themes— the Wandering Jew, for example— preoccupied both intellectuals and great artists.

Lilian R Furst[1]

8
Zola's art criticism

Zola's art criticism spans more than thirty years—from the early 1860s to 1896 —and during that period his views underwent a number of changes. It would, I think, be misleading to speak of a 'development' in so far as that word implies a continuous, and to some degree logical, line of evolution. Zola's judgements were not particularly consistent either within any given phase or in their sequence; indeed, at two points his art criticism veers in astonishing fashion. Yet whatever his opinions, his critical approach remains fundamentally the same, and it is his method rather than his ideas which give his art criticism a certain unity. What I propose to do is to review the main lines of Zola's thought and then to analyse his critical method, drawing my examples from all the various phases of his art criticism.

Zola's earliest pronouncements on art are frankly surprising from the author of the monograph on Manet and *Les Rougon-Macquart*. For his preference in about 1860–5 was for artists such as Greuze, Gustave Doré and Ary Scheffer [105]. Of Scheffer's 'Françoise de Rimini' Zola wrote most enthusiastically to Cézanne in March 1860: Scheffer 'était poète dans tout l'acception du mot, ne peignant presque pas le réel, abordant les sujets les plus sublimes, les plus délirants. Veux-tu rien de plus poétique, d'une poésie étrange et navrante, que sa Françoise de Rimini?'[2] It is well to bear in mind that Zola was barely twenty at the time and was soon to outgrow this adolescent sentimentality. The change occurred simultaneously in his creative writing and his art criticism: after the pseudo-Romantic *Contes à Ninon* of 1864 and *La Confession de Claude* of 1865, there came in 1866 *Thérèse Raquin*, a cornerstone of the Naturalist movement. Similarly, the admiration for Scheffer and for Gustave Doré (in two articles of 1863[3]) gives way by 1866 to an attack on 'l'idéaliste Gustave Doré'[4] with his 'rêves'[5] and his whole 'monde menteur'.[6] In this professed 'jugement d'un réaliste'[7] the direction of Zola's thought becomes abundantly clear as he repeatedly criticizes Doré for having no 'souci de la réalité'[8] and for spurning 'l'étude de la nature vraie et puissante'.[9]

105 Scheffer: 'Françoise de Rimini'

106 Cézanne: 'Portrait of Zola'

107 Manet: 'Zola'

108 Bazille: 'Mon atelier'

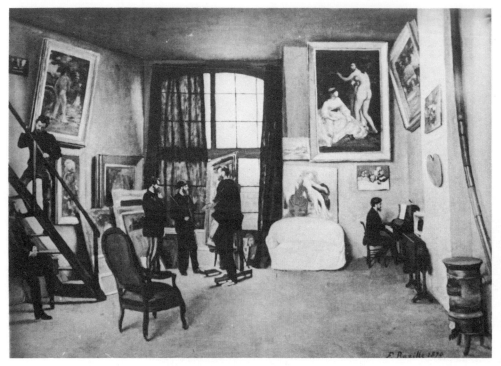

Whether this change of attitude came about through a natural process of maturing or whether it should be attributed to the influence of his friends it is hard to say. Between 1863 and 1866, through the intermediacy of Cézanne, who had been his school-fellow in Aix, Zola had met most of the leading Impressionists: Pissarro, Monet, Degas, Renoir, Fantin-Latour, Bazille, Guillemet, Guillaumin, Béliard and the critic Duranty who introduced him to Manet. Zola became a habitué of the Café Guerbois, the Impressionists' meeting-place in the Batignolles *quartier* of Paris which was portrayed by Manet. Zola features on many of the canvases of this period: Cézanne's and Manet's portraits of Zola [106 and 107], Cézanne's 'Une lecture chez Zola' and 'Zola reading to Paul Alexis' as well as in 'Mon atelier' by Bazille [108] and 'Atelier aux Batignolles' by Fantin-Latour [109]. Zola associated almost exclusively with painters at this time and soon came to be regarded as the spokesman—indeed the champion—of the Batignolles group.

What was it that now drew this erstwhile follower of Greuze and Scheffer to the Impressionist cause? Partly, at least, the very fact that it was a cause and

as such appealed to the fighting spirit that formed so salient a streak of Zola's character throughout his life. He envisaged the Impressionists as 'des lutteurs'[10] engaged in a twofold struggle: against a sterile academicism and for 'une nouvelle manière en peinture', as he subtitled his essay on Manet. Zola, who had been head of publicity at Hachette for a time, espoused this cause with fervour. In the art criticism of 1866–8—and this includes the *Salons* of those years, the essays on Manet and on the *Exposition Universelle* of 1867—he adopts a strongly aggressive posture marked by a predominance of words that have bellicose overtones: *combat, audace, lutte, drapeau, terres ennemies, défendre* and so forth. The same war-like terms recur, incidentally, in those parts of his novel *L'Oeuvre* which describe the official *Salon* and the *Salon des Refusés* of 1863.[11] Moreover, the whole tone and structure particularly of the *Salon* of 1866 show its propagandist momentum: the short, sharp sentences, the combination of passion and irony, the vigour of the imagery and of the presentation, about which I shall say more later—all these reveal the belligerency that inspired Zola's art criticism at this stage. His outraged sense of justice at the treatment accorded to the young painters is given full vent in his biting attacks

109 Fantin-Latour: 'Atelier aux Batignolles'

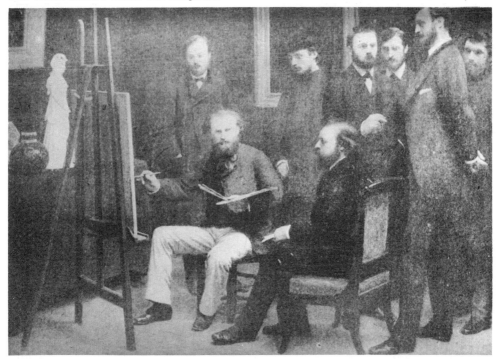

on the jury. It has been suggested—with good reason, I believe—that Zola was attracted more by the Impressionists' audacity than by their actual aims. As a man of independent spirit as well as a born fighter, Zola was bound to sympathize with the Impressionists' revolt against the dictatorship of established authority. His underlying motive in taking up the cudgels on their behalf stemmed much more from an instinctive urge to champion the underdog (as in the case of Dreyfus) than from a sensitive appreciation of their artistic ideology.

But Zola's joy in the fray would not alone have sufficed to attach him to the Impressionist cause. There was another, deeper reason for his allegiance, namely his conviction that the Impressionist painters were endeavouring to do in the visual arts what the Naturalist writers sought to do in literature. Again and again in his art criticism he emphasizes this affinity: 'l'évolution est la même en peinture que dans les lettres',[12] 'les maîtres de demain—seront nos frères, accompliront en peinture le mouvement qui a amené dans les lettres l'analyse exacte et l'étude curieuse du présent'.[13] For this reason Zola used the terms *Impressionniste*, *Naturaliste* and *Actualiste* interchangeably as though they were completely synonymous, as indeed they were in his mind. Thus in his pleas for the Impressionists Zola was continuing and extending the campaign he was waging on the literary front for a new realism in the arts. His

110 Degas: 'Les Blanchisseuses'

111 Manet: 'Nana'

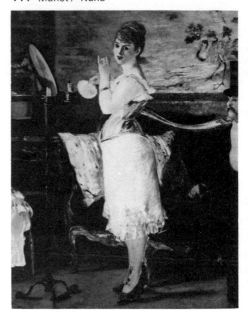

112 Monet: 'Gare St Lazare'

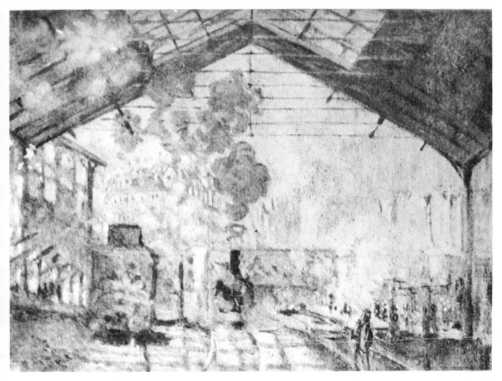

approach to painting was thereby given a special bias, so that he was led to stress certain aspects at the expense of others.

This lopsidedness is particularly evident in his constant insistence on the modernity of the Impressionists' subject matter, to which he attached the greatest importance. His highest praise is to say, as he does of Bazille: 'On voit que le peintre aime son temps',[14] or of Monet: 'Celui-là a sucé le lait de notre âge',[15] in the same way as he eulogized Balzac because 'il a peint admirablement son temps'.[16] It is of course true, as Venturi has so nicely put it, that the Impressionists' 'preference was for the humble motif, for cabbages and huts rather than for roses and palaces'.[17] They painted what was before their eyes: the beaches, the races, the theatres, the cafés, the everyday domestic scenes around them in town and country. And in several instances the subjects of their canvases do coincide with those of Zola's novels: Degas portrayed 'Les Blanchisseuses' [110] and Zola wrote about them in *L'Assommoir*; Manet's 'Nana' [111] is clearly related to Zola's novel of that name; Monet's 'Gare St

Lazare' [112] came thirteen years before Zola's railway novel, *La Bête humaine*. But modernity of subject-matter was by no means the crux of the Impressionist programme, as Zola would have us believe from his *Salons* of 1866 and 1868. Indeed the Impressionists were neither specially concerned with modernity nor even strikingly original in this respect. For many years already Courbet had been painting peasants and stone-breakers and had thus moved away from the classical, mythological and historical scenes favoured by the Academy. Zola proclaims with great satisfaction that

Chaque année, je constate que les femmes nues, les Vénus, les Eves et les Aurores, tout le bric-à-brac de l'histoire et de la mythologie, les sujets classiques de tous genres, deviennent plus rares, paraissent se fondre, pour faire place à des tableaux de la vie contemporaine, où l'on trouve nos femmes, nos bourgeois, nos ouvriers, nos demeures et nos rues, nos usines et nos campagnes, toutes chaudes de notre vie. C'est la victoire prochaine du naturalisme dans notre école de peinture.[18]

He is here in fact revealing his ignorance of the essence of Impressionism. For the Impressionists painted contemporary scenes not for their modernity but in order to be able to observe the play of colour and of light. This was their primary concern and herein lay their true innovations. Subjects close to hand were chosen because of the opportunity they afforded for constant observation of the changes in colour and shape at different times of day, under differing light. 'Traiter un sujet pour les tons et non pour le sujet lui-même, voilà ce qui distingue les impressionnistes des autres peintres',[19] according to Renoir's friend, Georges Rivière. This Zola failed to grasp; missing the point completely, taking the effect for the cause, he in fact distorted Impressionism.

Zola's entire art criticism of the years 1866–8 turns on this crooked axle of modernity, which is set up as the criterion of judgement between the old and the new. The old—'les œuvres de genre, les scènes militaires, les intérieurs alsaciennes... les petites indiscrétions grecques ou romaines, les épisodes historiques taillés en menus morceaux',[20] 'les paysages, des cieux de roc et des prairies de coton, avec des arbres en sucre'[21]—all this is rejected with scorn because it is conventional, stylized, academic, artificially pretty, in other words out of touch with the reality of the present. It is the dream-world of Gustave Doré which Zola had once liked and which he now castigates without mercy. In contrast to this inane 'fabrique du beau'[22] stands the new school of Naturalism, truthfully depicting contemporary subjects from a faithful observation of reality. Manet, Monet and Pissarro are all lavishly praised for doing just this. Of Pissarro, for instance, Zola writes:

L'artiste n'a souci que de vérité, que de conscience; il se place devant un pan de nature, se donnant pour tâche d'interpréter les horizons dans leur largeur sévère, sans chercher à y mettre le moindre régal de son invention; il n'est ni poète ni philosophe, mais simplement naturaliste, faiseur de cieux et de terrains. Rêvez si vous voulez, voilà ce qu'il a vu.[23]

When 'poète' becomes a term of abuse, as it does here, the artist—visual or literary—is inevitably reduced to the rank of a mere recorder. Even in the phrase so often reiterated in both Zola's art and his literary criticism: 'Une œuvre d'art est un coin de la création vu à travers un tempérament', the emphasis seems to lie, in theory at least, more on the actual seeing of reality than on the 'tempérament'. This is a fundamental flaw in Zola's aesthetic, as evident in his art criticism as in his literary theory. For these two sides of Zola's critical activity run parallel: just as the admiration for Greuze and Scheffer corresponds to the *Contes à Ninon* and *La Confession de Claude*, so the *Salons* of 1866 and 1868 partner the early stages of Naturalist doctrine in literature. Modernity, *réalité*, *vérité* and *observation de la nature* are the leitmotifs common to both. Zola, as I have tried to show, was convinced of the affinity between the Naturalists in literature and the Impressionists in painting. His interpretation of the Impressionists in the *Salons* of 1866 and 1868 certainly turned them into Naturalists in the literary sense of that term—not without loss of their true character.

I have devoted so much time to these early *Salons* because they form the kernel of Zola's art criticism. These remarkably productive years were followed by a period of apparent silence in this field, a silence that seemed to last until 1880 and that aroused much speculation among Zola critics. The puzzle was finally solved quite recently; in an article on 'Zola, Manet and the Impressionists' in *PMLA* of 1958 (vol. lxxiii, pp. 407–17) Professor F. W. J. Hemmings has shown that Zola did not abandon art criticism between 1868 and 1880, but he did not—could not in fact—publish in France.[24] Even in 1866 the editor of *L'Événement* had been forced by the protests of indignant readers to replace Zola in mid-stream by a more anodyne critic. Before long Zola had acquired so inflammatory a reputation as to make his art criticism suspect to any French journal. He was, however, invited to contribute to a Russian journal in St Petersburg and this he did between 1875 and 1879. These Russian articles are included in the 1959 collected edition of Zola's *Salons*. Since the original French, from which they were translated into Russian, has been lost, this text is a translation of a translation, and as such I beg to question its reliability. It has been reported that the Russian editor toned down certain potentially controversial passages, for instance replacing the term 'Naturalism' by the

more innocuous 'Realism'. Of this we are in no position to judge as we do not know what Zola actually wrote, although it is true that the whole tone of the Russian *Salons* is far more conciliatory than that of his other art criticism. Further doubt is cast on the trustworthiness of this double translation by the notorious confusion of Manet and Monet, which gave rise to the rumour that Zola had turned against Manet. Zola's defence, namely that 'la traduction du passage cité n'est pas exacte', applies, in my opinion, to all the Russian articles, and for this reason I propose largely to discount them.[25]

The last phase of Zola's activity as an art critic comprises the *Salon of 1880*, the preface to the catalogue of the 1884 *Exposition Manet* and the *Salon of 1896*. It is somewhat invidious to group these together because the *Exposition Manet*, a retrospective exhibition following Manet's death, is a kind of obituary-tribute, paying homage to Manet in much the same terms, though rather more sedately than before: 'il s'est mis simplement en face de la nature, et, pour tout idéal, il s'est efforcé de la rendre dans sa vérité et sa force'.[26] Zola has thus not changed his fundamental criteria in judging an artist's work; what has changed is his opinion of the Impressionists. Whereas in 1866–8 he saw them as the rising generation with the promise of a great future that was to transform French art, by 1880 his disappointment is already beginning to crystallize. He still condemns 'cette misère', the academic canvases of Cabanel, Bouguereau and Signol,[27] and he still continues to welcome 'les progrès croissants du naturalisme',[28] but at the same time he is critical, maintaining that 'le grand malheur, c'est que pas un artiste de ce groupe n'a réalisé puissamment et définitivement la formule qu'ils apportent tous, éparse dans leurs œuvres'.[26] In pronouncing this judgement, Zola adopts rather a patronizing attitude—that of the successful Naturalist towards the failed. On the other hand, I cannot accept the suggestion made by George Hamilton[30] among others that by 1880 Zola, with his growing reputation, was not anxious to jeopardize his position by associating himself with the as yet unrecognized Impressionists. This does an injustice to a man who risked much for the far more unpopular cause of Dreyfus. Zola's criticisms of the Impressionists were made, I believe, sincerely and on artistic grounds, and such cooling off as there was occurred, if truth be told, on both sides. Renoir said that Zola 'painted with bitumen'; Cézanne's dry little thank-you notes on receiving Zola's successive novels reveal a lack of enthusiasm and comprehension for his friend's writing that parallels Zola's failure to appreciate Cézanne's paintings; even the amiable Pissarro was complaining by 1883 that Zola was 'a bit too photographic', and later accused him of running with the hare and hunting with the hounds. Nor were matters helped by the appearance in 1886 of Zola's

novel *L'Oeuvre* which portrays an Impressionist painter driven to suicide by his inability to realize the ideals of his vision. Whether Claude Lantier was modelled on Manet or on Cézanne is, in the present context, beside the point. As a piece of fiction, *L'Oeuvre* is in any case marginal to Zola's art criticism, and I mention it here only because it reiterates Zola's view of the Impressionists as artistic failures.

The disappointment has become wholesale disillusionment in the *Salon of 1896*, which has fittingly been called 'une sorte de fanfare de victoire joué en marche funèbre'.[31] It is a fanfare of victory in so far as it celebrates the triumph of Impressionist techniques, particularly the pale colouration of that year's paintings. But these wishy-washy canvases evoke in Zola the response 'c'est affreux, affreux, affreux!'[32] so much so that 'j'en viens presque à regretter le Salon noir, bitumineux d'autrefois'.[33] It is indeed a funeral march when he asks himself, 'c'est pour ça que je me suis battu?'[34] The wheel has come full circle, perhaps inevitably; none the less it is a sad ending to Zola's career as an art critic. The disillusionment stems partly from Zola's conviction that the Impressionists had fallen short of their aims, partly from the exploitation of their techniques by lesser, modish painters, and partly also from a change in Zola's tastes attributable as much to a physical cause as to anything else. For as Adhémar[35] has rightly hinted, Zola's preference for Impressionism in painting may well have been determined by his short-sightedness.

A report on Zola's sight by a M. Sauvineau is contained in Dr Edouard Toulouse's *Enquête medico-psychologique*.[36] In the right eye Zola had 'une myopie assez forte' of − 10 together with 'un léger astigmatisme' (− 1.50 on the vertical axis) while in his left eye there was very slight astigmatism (−0.75 on an axis of 120 degrees) with a myopia of − 8. Sauvineau added that 'le reflexe accommodateur est faible. Il n'existe pas de mouvement de convergence, ce qui est en rapport avec la myopie', as was 'une contracture de l'orbiculaire'. In practical terms, this amounts to pretty poor sight, defective particularly in discerning depth and outline. The perception of colour is less affected by short-sightedness than that of contour, and this in itself predisposes the myopic to a bias towards Impressionist painting. What is more, lenses were far less well ground a hundred years ago than today. In any case it was not until about 1877 that Zola began to use a *lorgnon* in public. He must have been able to see relatively little when he wrote his first *Salons*. The editor of *L'Événement*, Villemessant, was apparently not unaware of this, for he is reputed to have said 'Je me paye un critique d'art myope — myope comme une taupe'.[37] By 1896 when Zola was in his mid-fifties his shortsightedness was considerably attenuated, amounting to − 8 in one eye and − 3 in the other.

His better vision coincides with his increasing dissatisfaction with the blurred effect of the Impressionist style.

Zola's short-sightedness is also of some importance to his critical method. The fact that he was probably unable to see very distinctly may account for the vagueness of his approach. His comments on pictures tend to be rather general, lacking in sharpness of focus; of Manet's 'Joueur de fifre', for example, after briefly describing its content, he says: 'J'ai dit plus haut que le talent de M. Manet était fait de justesse et de simplicité, me souvenant sur-tout de l'impression que m'a laissée cette toile. Je ne crois pas qu'il soit pos-sible d'obtenir un effet plus puissant avec des moyens moins compliqués.'[38] This remark illustrates Zola's choice of non-committal words; the recurrent vocabulary of his art criticism consists of *charme, grâce, harmonie, énergie, justesse, exactitude, vérité, puissance, vigueur, force, fraîcheur, simplicité, douceur, franchise, délicatesse, ampleur, gravité* and so forth. These are less terms of precise descrip-tion than of imaginative evocation and as such they are characteristic of Zola's essentially poetic manner. There are many instances when he waxes lyrical: Monet's seascapes inspire the phrase 'l'eau dort, chante dans ses tableaux',[39] while in Pissarro's landscapes, 'on y entend les voix profondes de la terre, on y devine la vie puissante des arbres'.[40]

This poetic streak is very evident in the wealth and originality of Zola's imagery, which endows the *Salons* with an element of constant surprise. The academic painters 'peignent mal, pensent trop, drapés en gentilshommes dans le manteau troué de l'idéal';[41] the art critics 'assez consciencieux pour dresser un catalogue exacte, me semblent étiqueter les toiles comme les apothicaires étiquetant les drogues';[42] the realists are 'gens qui sont accusés de ne pas se laver les mains',[43] whereas the excessively pale canvases that finally horrify him are 'des linges décolorés par de longues lessives'.[44] A great many of the most striking images are, as in Zola's novels, connected with food; these are applied with little mercy and great effect to pictures concocted 'd'après la recette sacrée de l'École'.[45] 'des friandises',[46] 'de pâte d'amande blanche et rose',[47] 'des pots de confiture, transparents, gélatineux, avec des reflets de gelée de groseille ou de coing',[48] in short 'les douceurs des confiseurs artistiques à la mode, les arbres en sucre candi et les maisons en croûte de pâté, les bons-hommes en pain d'épices et les bonnes femmes faites de crème à la vanille'.[49] There is no denying the wonderful vividness of Zola's art criticism, whatever its intrinsic worth. In the skill of his presentation, notably in the grand cres-cendo of the ironic 'Adieux d'un critique d'art' at the end of the *Salon of 1866*, his journalistic flair comes very much to the fore. As a man of letters, Zola certainly knew know to make the most of his material.

But this predominantly literary slant also had grave drawbacks for his art criticism. 'Je parle en poète', Zola confessed, 'et les peintres, je le sais, n'aiment pas cela.'[50] In spite of his presence at the discussions at the Café Guerbois, Zola's knowledge and understanding of the visual arts seem to have been superficial, as is conceded even by critics favourable to him. His own collection, with the exception of a few pictures given to him, has been dismissed as 'a deplorable hodge-podge of commonplace canvases'.[51] Moreover, he lacked technical expertise; in L'Oeuvre he even made mistakes in describing the preparation of a canvas.[52] Hence Zola—like many of his predecessors—looked in paintings chiefly at the 'theme'. A picture was to him not so much a record of the artist's vision as an expression of his ideas. It is perhaps worth recalling that his earliest art criticism was on Doré's Bible illustrations, that about 1860 he cherished the idea of a sublime book with a text by himself and engravings by Cézanne and that in 1867 plans were afoot, which came to nothing, for Manet to illustrate the Contes à Ninon. Evidently Zola envisaged painting as illustrated thought, and not in terms of colour and contour, light and shadow, pattern and form. Throughout his art criticism, from beginning to end, he invariably dwells first and foremost on the actual subject-matter. There are examples on virtually every page, so that there is no point in quoting chapter and verse. Suffice it to say that this approach is identical whether Zola is condemning Cabanel's 'Naissance de Vénus'[53] or extolling Manet's 'Joueur de fifre'.[54] The main emphasis falls on the description of the content of the picture; if Zola disapproves of the painting, the description is ironically phrased and interspersed with kitchen imagery; if, on the other hand, he approves of it, he praises its simplicity, charm, energy and so forth. This overriding concentration on subject-matter stems from another fundamental misconception of Zola's art criticism, namely his worship of modernity as tantamount to realism. Only a critic who looked primarily at the subject-matter could have fallen into the error of judging paintings by this criterion.

Zola's literary bias is betrayed again by the way he writes about painters and paintings, by his predominantly literary rather than pictorial range of words. He calls pictures 'poèmes';[55] he speaks umpteen times of the artists' 'langage',[56] of 'mots',[57] of 'parler',[58] 'bégayer',[59] 'balbutier',[60] épeler,[61] etc. These are, of course, the phrases which come naturally to the literary critic; their very frequent occurrence in Zola's art criticism suggests that he made no distinction in principle between the poet and the painter. He failed to grasp and to examine many of the essentials of the visual arts: shape, perspective, solidity, composition, volume, tonal effects, perception of planes, drawing and modelling. These are largely absent from his art criticism for the simple

113 Monet: 'Camille' 114 Pissarro: 'Côte du Jallais à Pontoise'

reason that they were outside his range of interest in pictures as an expression of ideas.

Zola's method can best be characterized by a comparison with that of a 'professional' art critic. I should like to attempt this with reference to two pictures: Monet's 'Camille' [113] (alternatively called 'Le Femme à la robe verte') and Pissarro's 'Côte du Jallais à Pontoise' [114]. This is what Venturi has to say about the Monet:

It was really inspired by Courbet, both in colour and in the position of the image, which recalls the woman in the group of society amateurs in the *Studio*. Nevertheless it reveals Monet's personality: his indifference to the plastic allows him to make convincing the movement of the image and the vibrancy of light in the skirt, thus giving the whole an effect of rapidity and immediacy that is lacking in Courbet.[62]

And here now is Zola's much longer comment on the same picture:

J'avoue que la toile qui m'a le plus longtemps arrêté est la *Camille*, de M. Monet. C'est là une peinture énergique et vivante. Je venais de parcourir ces salles si froides

et si vides, las de ne rencontrer aucun talent nouveau, lorsque j'ai aperçu cette jeune femme, traînant sa longue robe en s'enfonçant dans le mur, comme s'il y avait eu un trou. Vous ne sauriez croire combien il est bon d'admirer un peu, lorsqu'on est fatigué de rire et de hausser les épaules.

Je ne connais pas M. Monet, je crois même que jamais auparavant je n'avais vu une de ses toiles. Il me semble cependant que je suis un de ses vieux amis. Et cela parçe que son tableau me conte tout une histoire d'énergie et de vérité.

Eh oui! voilà un tempérament, voilà un homme dans la foule de ces eunuques. Regardez les toiles voisines, et voyez quelle piteuse mine elles font à côté de cette fenêtre ouverte sur la nature. Ici, il y a plus qu'un réaliste, il y a un interprète délicat et fort qui a su rendre chaque détail sans tomber dans la secheresse.

Voyez la robe. Elle est souple et solide. Elle traîne mollement, elle vit, elle dit tout haut qui est cette femme. Ce n'est pas là une robe de poupée, un de ces chiffons de mousseline dont on habille les rêves ; c'est de la bonne soie, point usée du tout et qui serait trop lourde sur les crèmes fouettées de M. Dubufe.[63]

It is surely superfluous to comment on the difference between Venturi's technical appreciation of the visual and Zola's concentration on the subject-matter which arouses his enthusiasm for the energy, truth and realism he discerns in Monet's painting. The contrast is perhaps even greater in relation to the Pissarro. Again taking Venturi first:

> This picture contains none of those relations of light and colour which will later constitute Pissarro's greatness, but the other qualities of the painter are all there. Despite the large dimensions of the picture (it is two metres wide), the total effect is obtained by subordination of details; there is thus a homogeneity of form and colour which reveals a fully conscious art. The volume of the hill, even though it is inspired by Courbet, is realized in pictorial style with a certain atmospheric distance, and it is therefore not ponderous. The wall surfaces of the houses are firmly represented in the manner of Corot, by means of contrasts of colour: they emphasize the precision of the areas of the hill. In the foreground the lightness and variety of the brush strokes suggest the immersion of the masses in the atmosphere. The colours are dark and precious, conventional and perfectly harmonious.

Once more it is the technical and visual which form the substance of Venturi's criticism. Not so with Zola:

> Un vallon, quelques maisons dont on aperçoit les toits au ras d'un sentier qui monte ; puis, de l'autre côté, au fond, un coteau coupé par les cultures en bandes vertes et brunes. C'est là la campagne moderne. On sent que l'homme a passé, fouillant le sol, le découpant, attristant les horizons. Et ce vallon, ce coteau sont d'une simplicité, d'une franchise héroique. Rien ne serait plus banal si rien n'était plus grand. Le tempérament du peintre a tiré de la vérité ordinaire un rare poème de vie et de force.[65]

All attention is focused here on the content, which is interpreted as a typically modern scene and praised, in accordance with Zola's beliefs, for its simplicity,

truthfulness and lyrical power. There could be no better example of the way in which Zola saw pictures not as independent works of art but as an expression of ideas, as fodder to his own theories.

How effective then was Zola as an art critic? Opinion is divided, although negative evaluations tend to predominate: Zola was not 'un critique d'art vraiment inspiré';[66] he was 'incapable de présenter une doctrine cohérente';[67] he 'lacked sensitivity of observation and taste';[68] his enthusiasm was 'unselective',[69] his culture too narrow,[70] so that he was a 'témoin partial et peu compréhensif'[71] of the Impressionist period. Few—if any—of these contentions could be seriously challenged. On the other hand, the points in Zola's favour have been enumerated all too rarely, and some have been completely overlooked. He did show great courage in so plainly speaking his mind against the dictates of convention and fashion. He was a superb publicist and he undoubtedly succeeded in drawing attention to the Impressionists. His enthusiasm gave his art criticism a vigour and freshness of expression that makes it still readable today—more so, to my mind, than much of his literary criticism. Last, but by no means least, his judgements, even though they were strangely motivated, have by and large stood the test of time; to put it crudely, Zola was 'right' in valuing Manet more highly than Cabanel, and for this he deserves due credit.

None the less, the debit side weighs heavy, and it amounts to more than a mere lack of taste, sensitivity, consistency or even inspiration. Zola's art criticism has two quite fundamental flaws, both of which point to his failure to understand the nature of the visual arts. Firstly, as I have tried to show, his approach is entirely literary: he writes about Scheffer, Manet, Pissarro as though they were poets expressing ideas in a medium no different from that of the artist in words. His concentration on subject-matter stems from the presupposition that painting is illustrated thought, not patterns of colour and light. This misconception is, of course, particularly damaging in dealing with the Impressionists, all of whom would have subscribed to Monet's avowed aim: 'c'est justement cet éclat, cette lumière féerique que je m'attache à rendre'.[72] This brings me to the second major flaw in Zola's art criticism, which I have so far implied rather than stated. Zola is so bound by the narrow confines of his own artistic theory that he cannot do full justice to any painter, or indeed writer, for the same limitation mars his literary criticism. He is able to see only through the spectacles of *réalité*, *vérité* and *nature*, and he tries to adjust the Impressionists, too, to these sights. He defines his role in the *Salons* as that of 'un historien consciencieux expliquant le mécanisme humain'.[73] Hence he 'explains' the Impressionists by wrongly grafting on to them his own favourite

ideas, forcing them into the straitjacket of modernity and realism. That they in fact looked at reality only to see colour, air and light; that the very word 'Impression', the subtitle given to Monet's paintings 'Soleil levant' and 'Soleil couchant', implies an essentially subjective vision; that the whole tendency of the movement was away from the object, the precision of the delineated detail towards blurred contours, colours flowing into each other to evoke the sensation of light; that Impressionism in the last resort was more akin to Symbolism than to Naturalism in literature: all this apparently Zola did not perceive. His short-sightedness was as much intellectual as physical.

Yet the great irony of it is that in his own creative writing Zola transcended reality in much the same way as the Impressionists. He did not remain a captive of *réalité*, *vérité* and *nature*; there was, fortunately, a great dichotomy between his theory and his practice, so that he was 'not the mechanical monster he set out to be in his *obiter dicta*',[74] to quote Harry Levin's apt phrase. He did indeed maintain long and loud that the artist's function was, like that of the scientist, to observe dispassionately and to record the mechanism of human existence determined, as he believed it to be, by heredity, environment and instinct. He may even have thought that he was doing just this and no more in his novels. But he rose far above these self-imposed limits, for his works contain as much poetry as fact. We need only recall those still-life descriptions in *Le Ventre de Paris* of the market-stalls laden with fruits, vegetables, sausages, fishes and cheeses to see how marvellously and subtly Zola was able to evince the lyrical quality out of everyday reality. The self-acclaimed cold observer proves to have been a neglected lyricist, just as the systematic analyst emerges also as a myth-maker. Nana, as Flaubert realized, turns into a myth without ceasing to be real, and so does the railway-engine, La Lison, personified throughout *La Bête humaine* and the soil, one of the chief protagonists in *La Terre*. Thus even in these most extreme of Zola's naturalistic novels the supra-real plays a vital part. When Zola is called in Proust's vivid words, 'the Homer of the cesspool', it is always the cesspool aspect which is stressed to the detriment of the powerful poetic colouring which gives his novels their lasting literary worth.

Once Zola's own creative work is seen in this light, his lack of true understanding for the Impressionist painters becomes all the more puzzling. Surely there is a parallelism between their path and his in the delicate balance of observation and transfiguration. Perhaps Zola had a deeper sympathy with the Impressionists than the *Salons* show? Perhaps his poetic phraseology at certain points signifies that he saw more than *réalité* portrayed with *exactitude* in these brilliant pictures? These questions I must leave unanswered.

Notes and discussion

(1) I wish to express my sincere gratitude to Dr Finke, without whose encouragement and advice I should hardly have had the audacity to attempt this paper.

(2) É. Zola, *Lettres de jeunesse*, Paris, 1907, p. 203.

(3) *Le Journal populaire de Lille*, 20 and 23 Dec. 1863.

(4) *Mes haines*, Paris, 1880, p. 96.

(5) Ibid., p. 86.

(6) Ibid., p. 95.

(7) Ibid., p. 96.

(8) Ibid., p. 86.

(9) Ibid., p. 95.

(10) *Salons*, edited by F. W. J. Hemmings and R. J. Niess, Paris, 1959, p. 122.

(11) *Les Rougon-Macquart*, Édition Pléiade, Paris, 1966, IV, p. 124: 'On se sentait là dans une bataille, et une bataille gaie, livrée de verve, quand le petit jour naît, que les clairons sonnent, que l'on marche à l'ennemi avec la certitude de le battre avant le coucher du soleil.'

(12) *Salons*, op. cit., p. 241.

(13) Ibid., p. 129.

(14) Ibid., p. 132.

(15) Ibid., p. 130.

(16) *Les Romanciers naturalistes*, Paris, 1890, p. 57.

(17) L. Venturi, *Impressionists and Symbolists*, London, 1950, p. 68.

(18) *Salons*, op. cit., p. 243.

(19) *L'Impressionniste*, (6 April 1877), reprinted in L. Venturi, *Archives de l'Impressionnisme*, Paris, 1939, II, p. 309.

(20) *Salons*, op. cit., p. 119.

(21) Ibid., p. 120.

(22) *Corsaire*, 3 Dec. 1872.

(23) *Salons*, op. cit., p. 127.

(24) I am indebted to Prof. T. Reff for drawing my attention to Zola's review of the third Impressionist exhibition of April 1877, reprinted in *Les Nouvelles littéraires*, 2 Feb. 1967, p. 9. This article was originally published in *Le Sémaphore de Marseille* of 19 April 1877, and will appear in the new edition of Zola's *Oeuvres complètes* (tome XII, p. 973) in preparation for the Cercle du livre précieux under the editorship of Professor H. Mitterand, to whom I am most grateful for help on this point. Professor Mitterand has told me that Zola's contributions to the *Sémaphore de Marseille* (1871–7) were unsigned, i.e. he did not publish art criticism in France at this time under his own name.

(25) In his article 'The Enigma of Zola's *Madame Sourdis*' (*Nottingham French Studies*, V. No. 1, 1966, p. 7) John Christie gives convincing evidence of the poor quality of the Russian translations of Zola's writings at that time, adding that the translator of

Madame Sourdis was particularly weak on the technical terms of painting.

(26) *Salons*, op. cit., p. 260.

(27) Ibid., p. 249.

(28) Ibid., p. 253.

(29) Ibid., p. 242.

(30) G. Hamilton, *Manet and his Critics*, New Haven, 1954, p. 220.

(31) Gustave Goffrey, quoted by J. Rewald in *Cézanne, sa vie, son œuvre, son amitié pour Zola*, Paris, 1939, p. 361.

(32) *Salons*, op. cit., p. 267.

(33) Ibid., p. 266.

(34) Ibid., p. 269.

(35) J. Adhémar, 'La Myopie d'Émile Zola', *Aescalupe*, XXXIII (Nov. 1952).

(36) Paris, 1896, pp. 158–9.

(37) A. Lanoux, *Bonjour Monsieur Zola*, Paris, 1954, p. 106.

(38) *Salons*, op. cit., p. 68.

(39) Ibid., p. 245.

(40) Ibid., p. 127.

(41) Ibid., p. 122.

(42) Ibid., p. 107.

(43) Ibid., p. 60.

(44) Ibid., p. 266.

(45) Ibid., p. 119.

(46) Ibid., p. 137.

(47) Ibid., p. 111.

(48) Ibid., p. 120.

(49) Ibid., p. 68.

(50) Ibid., p. 76.

(51) G. Mack, *Cézanne*, London, n.d., p. 288.

(52) See *Les Rougon-Macquart*, op. cit., IV, p. 231, and note, p. 1459.

(53) *Salons*, op. cit., p. 111.

(54) Ibid., p. 68.

(55) Ibid., pp. 89, 129.

(56) Ibid., pp. 62, 76, 87, 90, 92, 93, 94 98, 102, 134, 135: *Mes haines*, p. 96.

(57) *Salons*, op. cit., pp. 87, 243.

(58) Ibid., pp. 62, 87; *Mes haines*, p. 96.

(59) Ibid., pp. 268, 243, 248.

(60) Ibid., pp. 244, 254.

(61) Ibid., pp. 62.

(62) Venturi, op. cit., pp. 53–4.

(63) *Salons*, op. cit., pp. 70–1.

(64) Venturi, op. cit., pp. 69–70.

(65) Zola, op. cit., pp. 128–9.

(66) A. Lanoux, preface to *Les Rougon-Macquart*, I, p. xv.

(67) L. Hautecœur, *Littérature et peinture en France du XVIIIe au XXe siècle*, Paris, 1963, p. 133.

(68) J. Rewald, *The Ordeal of Paul Cézanne*, London, 1950, p. 31.

(69) Hamilton, op. cit., p. 147.

(70) F. W. J. Hemmings, 'Zola, Manet and the Impressionists', *PMLA*, (1958) p. 416.

(71) F. W. J. Hemmings, preface to *Salons*, op. cit., p. 10.

(72) In a letter to Durand-Ruel from Bordighera, 11 March 1884, reprinted in

L. Venturi, *Les Archives de l'Impressionnisme*, I, p. 273.
(73) *Salons,* op. cit., p. 240.
(74) H. Levin, *Gates of Horn*, N.Y., 1966, p. 311.
Discussion. Zola's art criticism of the 1860s was discussed, particularly with respect to criteria for pictorial form and subject-matter; Manet's 'Déjeuner sur l'herbe' was cited as an example. To the question why Zola wrote no articles in the 1870s, with the exception of those published in Russia, Dr Furst was of the opinion that Zola was then taking less interest in the Impressionists, in order to devote himself more exclusively to his own literary work.

Theodore Reff

9

Degas and the literature of his time[1]

1

No other artist's career illustrates more vividly than Degas's the history of that troubled yet fruitful marriage of painting and literature in the second half of the 19th century which, despite the partners' frequent avowals of independence and occasional liaisons with other arts, seems in retrospect to have been one of the essential features of the period.[2] For he was both a painter dedicated to purely formal variations on a restricted group of subjects and an illustrator responsive to many types of fiction, drama and poetry; an outspoken, even violent critic of writers who meddled in painting and a close friend of many leading novelists and poets of his day; a parochial thinker of whom Redon remarked, 'Il n'a rien lu, sauf je ne sais quel livre de 1830, propos d'atelier où il est parlé de Ingres ou de Delacroix',[3] and a catholic reader of whom his niece recalled, 'La littérature [l']avait toujours vivement intéressé... Parfois, pour son seul plaisir, [il] lisait un de ses auteurs favoris à haute voix.'[4] In short, he is an ideal figure in which to study those intimacies and tensions in the union of the two arts that have troubled the Modernist tradition from Courbet's and Baudelaire's time down to our own.

As is often the case, Degas's vehement rejection of the literary profession barely concealed an equally powerful attraction to it. According to Valéry, who was a rather shrewd judge in such matters, there was in him, in addition to the artist, a potential writer, 'un homme de lettres qui se manifestait assez par les *mots* qu'il faisait, et par les citations de Racine ou de Saint-Simon qui lui venaient assez souvent'.[5] This literary potential was also evident in his sonnets, whose quality and originality Valéry admired: 'Je ne doute pas que cet amateur qui a su peiner sur son ouvrage... n'eût fait, s'il s'y fût tout donné, un poète des plus remarquables, du type 1860–1890.'[6] For us, it is even evident in his correspondence, where he often alludes to works of literature, or parodies the styles of other writers, or contrives highly expressive forms of his own, such as the letter, obviously composed in a bleak and lonely mood, which con-

sists entirely of short, unconnected sentences, accented by ironic puns: 'Ne pas finir au salon, une vie passée ailleurs — à la cuisine. Il y a les pires moments où il faut employer sa raison. De la Croix a le nom d'un peintre... Il y a des voyageurs plus heureux que moi. Est-ce que je voyage moi, disait un chef de gare?'[7]

In retrospect, the 'man of letters' in Degas seems to have been particularly fortunate in the circumstances of his birth and later career, which enabled him both to cultivate a taste for the French and Latin classics and to become intimately acquainted with the leading movements of his own day. Having been born into a well-connected bourgeois family with an interest in the arts, and having received a solid classical education at the Lycée Louis-le-Grand, he acquired early the varied interests which those who were familiar with the contents of his library still remarked at the end of his life.[8] Moreover, he was in his middle years an active member of the avant-garde literary and artistic circles at the Café Guerbois and the Café de la Nouvelle-Athènes, and in his later years a participant in the *salons* of prominent figures like Madame Straus and Jacques-Émile Blanche, where he met many of the writers of the next generation. Even the decade of his birth seems to have been propitious, for it permitted him to witness a series of extraordinarily vital developments in French literature—in his youth, Romanticism and Realism; in his maturity, Naturalism and Aestheticism; in his old age, Symbolism and Idealism—developments which were, in addition, all closely involved with parallel movements in the visual arts.[9]

Like these developments themselves, but with some significant time lags, Degas's contacts with them can be schematized as beginning with a Romantic phase from about 1850 to 1865, shifting to a Naturalistic phase from about 1865 to 1885, and ending with a Symbolist phase from about 1885 to 1900. Needless to say, the three periods were of unequal importance for him, the Naturalistic one easily dominating the other two; and there were, as we shall see, certain continuities of taste. Nevertheless the schema is sufficiently valid to serve as an outline for the following discussion, whose subject, strictly speaking, is Degas's taste in, affinities with and illustrations of 19th century French literature and the appearance of his person and pictures within it.

2

In the first phase of his career, driven by his ambition to rival the masters of Renaissance and Romantic art whom he admired, Degas projected in his notebooks, studied in countless drawings, and occasionally realized in monumental paintings a remarkably large number of illustrations based on his

reading in biblical, classical and Renaissance literature.[10] Although their discussion cannot be undertaken here, their mere number and variety are worth noting, for they reveal both the breadth of Degas's literary culture and the strength of its hold on his imagination in these formative years around 1860. But despite the unusual subjects among those he selected from the Bible and the Lives of the Saints, from Homer, Herodotus and Plutarch, from Dante, Brantôme and Tasso, the historical and literary interests that inform them are on the whole typical of the Romantic period; whereas the texts he chose to transcribe or illustrate and the figures he chose to portray among the Romantic writers themselves are more revealing of a personal taste which emerged in the same years. It centres on four figures—Vigny, George Sand, Musset and Barbey d'Aurevilly—who were all a generation older than Degas and, except for Barbey, unknown to him personally, although all were still extremely popular when he turned to them in the 1850s and 1860s.

There were, of course, other Romantic writers in whom Degas was perhaps equally interested. His niece reports that he placed among the greatest poets not only Vigny and Musset, but Leconte de Lisle, Hugo and Gautier, that he was fascinated by the latter's 'Egyptian' novel *Le Roman de la momie*, and that

115 Degas: 'La Fille de Jephté'

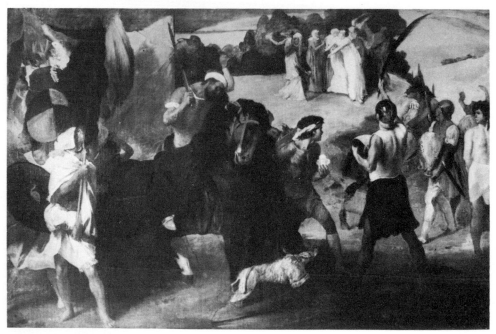

he read repeatedly Flaubert's novels as well as his correspondence: 'Il connaissait par cœur certains passages des lettres du solitaire de Croisset à Louise Colet',[11] no doubt discovering in them a solace for his own unhappy loneliness. And according to Daniel Halévy, Degas enjoyed having the historical novels of Alexandre Dumas read to him in his later years, and even spoke 'with a certain admiration' of the Socialist philosopher Proudhon, whose revolutionary books *De la justice* and *Du principe de l'art* he much admired.[12] Surprisingly, however, one of the greatest Romantic writers, Baudelaire, is nowhere mentioned in Degas's correspondence or in the memoirs of his friends; and were it not for an unpublished letter of 1869, in which Manet asks him to return 'les deux volumes de Baudelaire'—undoubtedly *L'Art romantique* and *Les Curiosités esthétiques*, both published the year before—his acquaintance with these essential texts would remain unknown.[13] But if Vigny, George Sand, Musset and Barbey d'Aurevilly are not the only writers of this period whom Degas appreciated, they are nevertheless those who either directly inspired his art or appeared in it themselves.

The influence of Vigny is evident in the largest and most ambitious of Degas's historical compositions, 'La Fille de Jephté' [115] (L.94),[14] and in

116 Degas: Study for 'La Fille de Jephté'

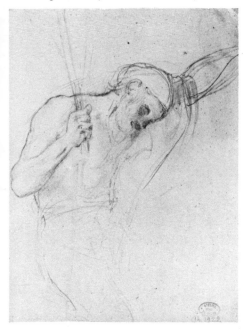

fact helps to explain some of its unusual features. For contrary both to the account in the Book of Judges and to earlier pictorial representations, Degas sets the scene in an open, somewhat desolate country, rather than near the walls or city gates of Mizpeh; shows Jephthah's daughter surrounded by a group of her companions, rather than coming forth alone to greet him; and has Jephthah himself almost collapsing at the sight of her, his head bowed and his eyes closed, rather than looking heavenward or gesticulating dramatically.[15] Even more clearly than in the final painting, this last feature is evident in a preparatory drawing for the figure of Jephthah [116].[16] Now precisely these unusual elements are found in Vigny's dramatic poem 'La Fille de Jephté' (1820), one of a series on biblical and classical themes which were extremely popular at the time and were reportedly among Degas's favourites in Romantic poetry.[17] Describing the moment when Jephthah recognizes his daughter in the distance, Vigny writes:

> Le peuple tout entier tressaille de la fête.
> Mais le sombre vainqueur marche en baissant la tête;
> Sourd à ce bruit de gloire, et seul, silencieux.
> Tout à coup il s'arrête, il a fermé ses yeux.
> Il a fermé ses yeux, car au loin, de la ville,
> Les vierges, en chantant, d'un pas lent et tranquille,
> Venaient; il entrevoit le choeur religieux.
> C'est pourquoi, plein de crainte, il a fermé ses yeux.

Like Degas, then, Vigny isolates and emphasizes the two protagonists visually—the father, who alone is aware of his fate, closing his eyes in dread, and the daughter, unaware but already part of a religious chorus, moving toward him from the city far away. In a later passage, Vigny develops further this theme of religious resignation, making the daughter's fate a central element in his interpretation, whereas traditionally it had merely been the occasion of the father's grief;[18] and Degas too shows the daughter swooning and her companions despairing, as if already aware of her destiny. A similar emphasis on her lamentation also occurs in other Romantic treatments of the subject, such as those in Byron's 'Hebrew Melodies', Tennyson's 'Dream of Fair Women' and Chateaubriand's 'Mélodies romantiques'; but none of them opposes it so dramatically to a corresponding emphasis on the father's despair, and none describes the scene in such graphic terms. Indeed, the biblical account itself is far more abstract and colourless, so that Vigny, while following its outlines closely, had also to supplement it with descriptive details gleaned from other passages in the Bible and from the commentaries of Calmet, Fleury and other scholars in order to paint his vivid and dramatic

tableaux.[19] It was no doubt this essentially pictorial aspect of his version of the tragedy that made it so congenial a model for Degas.

An attraction to the pictorial element in Romantic literature—in this case, the rendering of a picturesque type, rather than a dramatic action—is also apparent in Degas's transcription of a long passage in one of George Sand's rustic novels describing a peasant girl's wedding costume. It occurs in the essay 'Les Noces de campagne', published as an appendix to *La Mare au Diable* (1846), and it dwells nostalgically not only on the charming, old-fashioned form of the costume, which had once been traditional in her native region of Berry, but on the innocence and purity of manners it had expressed so well. 'Aujourd'hui elles étalent leur fichu avec plus d'orgueil', she writes of the peasant girls of her own day, 'mais il n'y a plus dans leur toilette cette fine fleur d'antique pudicité qui les faisait ressembler à des vierges d'Holbein.'[20] A familiar theme in George Sand's pastoral novels, this nostalgia for the modesty and dignity of an earlier age was also characteristic of Degas, who in later years was often outspoken in regretting the disappearance from contemporary life of the sober bourgeois morality he had known in his youth.

However, this was probably not his only reason for choosing to transcribe

117 Degas: Copy of Roger van der Weyden's 'Head of the Madonna'

118 Van der Weyden: 'Head of the Madonna'

the passage in a notebook that he used in the early 1860's [117].[21] Since he obviously did so after having drawn the woman's head and the meandering lines which are seen above it, its content must somehow have been suggested by that of the drawing. And since the latter reproduces a Renaissance drawing in the Louvre—a 'Head of the Virgin' by Roger van der Weyden [118][22]— Degas must have recalled the appropriate passage in *La Mare au Diable* after having copied this drawing, the text thus 'illustrating' the image, rather than the reverse. Moreover, this text, although based on George Sand's memories of her native region, is in turn inspired by an image, the 'vierges d'Holbein', to which she refers in the passage just quoted. In fact, Holbein's art played an important role in the very genesis of the novel, as she indicates in a prefatory statement acknowledging her debt to one of the woodcuts in his famous series *The Dance of Death*.[23] And in her earlier novel *Jeanne* (1844), the heroine is partly based on one of Holbein's pictures of the Virgin, which she characteristically describes as 'une fille des champs rêveuse, sévère et simple'.[24] The works to which she refers, both there and in *La Mare au Diable*, are presumably the Darmstadt and Solothurn Madonnas, Holbein's most familiar paintings of this subject.[25] And since the Darmstadt Madonna in particular shows a type of the Virgin strikingly similar to that in the drawing Degas copied, which in his day was attributed to Dürer, a contemporary of Holbein, we have returned, by a rather curious path, to a point quite close to the one where we began.

Alfred de Musset, the third Romantic writer in whom Degas was interested,

119 Degas: 'Danseurs et musiciens espagnols'

was of course one in whom George Sand herself had shown a certain interest. That Degas was aware of their liaison, and of the many others in the poet's life which had become public knowledge by this time, is evident in an amusing composition that he painted around 1869 to decorate a woman's fan [119] (L.173). In it Musset appears at the left, as a reveller who has temporarily joined a troupe of Spanish dancers and musicians performing outdoors and is serenading one of the dancers with a guitar.[26] This, at least, was the traditional identification of the figure in the family of Berthe Morisot, to whom Degas offered the fan shortly after he painted it; and it is supported by comparison with the most widely reproduced portraits of Musset, one of which must have served as Degas's model.[27] In this case, of course, the poet's amorous adventure is a purely imaginary one, perhaps inspired by those he describes so vividly in the *Contes d'Espagne et d'Italie* (1830).

Yet the fact that Degas conceived it as part of the decoration for a fan, which he then offered to Berthe Morisot, suggests that he was practising a playful, appropriately artistic form of courtship himself. Indeed, she intimates as much in a letter of 1869 describing a recent gathering of Manet's circle: 'M. Degas... est venu s'asseoir auprès de moi, prétendant qu'il allait me faire la cour, mais cette cour s'est bornée à un long commentaire du proverbe de Salomon: "La femme est la désolation du Juste".'[28] Despite this unusual tactic, Degas must have been persuasive, at least artistically, for Berthe Morisot not only copied this fan in several watercolours, but reproduced it prominently in the background of a double portrait she painted in that year.[29] In ironically assuming the role of a suitor, Degas may well have been competing with Manet, through whom he had met Berthe Morisot only a year earlier. For Manet too had shown a particular interest in her and had even portrayed her in a Spanish guise in 'Le Balcon', a composition obviously based on one by Goya; moreover he had already depicted a company of Spanish dancers and musicians in 'Le Ballet espagnol' of 1862, and in the same year had decorated a fan with motifs from the bullfight.[30]

Already fascinated a decade earlier by the legends surrounding Musset, Degas tried to envisage an 'epic portrait' of him that would combine the grandeur of Renaissance art with a sentiment of modernity. In a notebook of about 1859, he sketched a seated figure of the Romantic poet, his head turned meditatively downward to the right [120], and opposite it he remarked: 'Comment faire un portrait épique de Musset? L'Arioste de Mr Beaucousin le dit beaucoup, mais [il] reste à trouver une composition qui peigne notre temps.'[31] The 'Arioste', a 16th century Venetian portrait formerly in the collection of Edmond Beaucousin, a friend of Degas's family, is

now attributed to Palma Vecchio rather than Titian, but its subject is still identified as the great Renaissance poet; he is in fact shown with laurel leaves behind him and with an expression of reverie that might well be called poetic.[32] In using this portrait of Titian's famous contemporary as a model, Degas

120 Degas: Study for a projected 'Portrait of Alfred de Musset'

121 Degas: 'Barbey d'Aurevilly in the salon of Mme Hayem

obviously hoped to endow his own portrait of a nearly contemporary figure with something of its nobility. Musset had died only two years earlier, and was in 1859 the subject of a literary controversy sparked by the publication of George Sand's autobiographical novel *Elle et lui*, in which, by the way, the protagonists are both artists.[33] Degas may also have connected the 'Ariosto', a work attributed to Titian, with Musset's popular story *Le Fils du Titien* (1838), whose hero is endowed with his father's talent but is so overwhelmed by love that he renounces art.[34] Unable to find the specifically modern form he was seeking, Degas abandoned the project; but it remains a document of his fascination with Musset's personality.

In Barbey d'Aurevilly too it was not the writer but the man, not the author of the sadistic and licentious stories in *Les Diaboliques*, but the dandy who cut an extravagantly modish, yet curiously outmoded, figure in the literary *salons* of Paris, that intrigued Degas. Thus he portrays Barbey, in a notebook sketch of about 1877 [121], as the dominant personality in one of the most brilliant of these *salons*, that of Madame Hayem, where he was accustomed to playing the lion.[35] Seated before him are the philosopher Adolphe Franck, a distinguished professor at the Collège de France, and his hostess, a talented sculptor who later modelled a portrait bust of Barbey; but it is clearly the latter's figure that attracts Degas, who repeats its elegant silhouette in a second sketch in the margin. That this was indeed a characteristic pose, both physical and social, is evident from a contemporary drawing by Régamey of another literary *salon*, where Barbey's imposing figure dominates an even more distinguished company.[36] Unlike Régamey, however, Degas seems to have taken the metaphor of the lion seriously, for in another sketch, drawn a few years later, he depicts the writer's frowning, rather shaggy head in those very terms.[37]

The element of cultivated fierceness in Barbey's personality undoubtedly struck a responsive chord in Degas as he grew older and outwardly fiercer himself; a hint of his admiration for it appears beneath his indignation even when he is reporting to the Halévys a particularly unpleasant story of the writer's rudeness to Louise Read, his devoted companion.[38] Moreover, Barbey's reactionary political and religious views, which were based on those of De Maistre and the Catholic restoration generally, must have also appealed to Degas, for whom 'le Mémorial était, avec de Maistre, une de ses lectures favorites'.[39] On the other hand, the one passage in Barbey's innumerable publications that Degas actually transcribed, an aphorism he found in the newspaper *Le Nain Jaune* (1867), expresses a typically dandyish ideal of elegance as nonchalant and even as enhanced by a touch of awkwardness: 'Il y a

parfois une certaine aisance dans la maladresse, qui, si je ne me trompe, est plus gracieuse que la grace même.'[40] Clearly, it was the youthful Barbey, the apologist of Beau Brummel and author of *Le Dandysme*, who appealed here to the youthful Degas.

3

If Degas's quotation from Barbey, like his sketches of the latter a decade later, and like the enthusiasm he showed for *Don Quixote* and *The Arabian Nights* two and even three decades later,[41] are signs of a lingering Romantic taste in

122 Degas: 'Louis-Émile Duranty

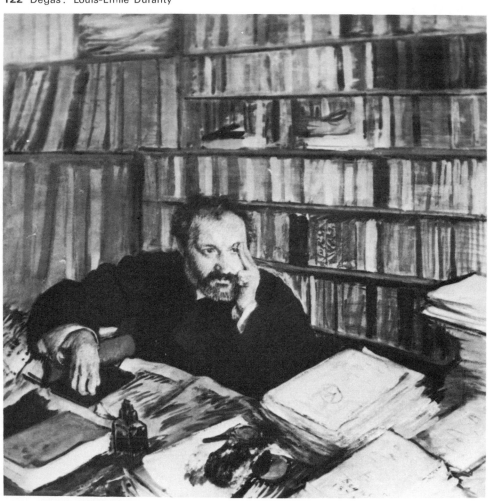

literature, that quotation was, nevertheless, something of an anachronism by 1867 both in his own development and in that of art generally. By this time he had already been introduced, through Manet and Duranty, into the circle of artists and writers at the Café Guerbois who were creating Naturalism and Impressionism, and he himself had largely turned away from historical subjects of a Romantic inspiration toward the contemporary urban subjects that would occupy him henceforth. For at least twenty years now his principal literary contacts and affinities would be with the Naturalist writers, especially Duranty, Zola, Edmond de Goncourt and Huysmans, all of whom, except Huysmans, were of his own generation. In this period too he would collaborate on various projects with the librettist and playwright Ludovic Halévy, who was also an exact contemporary and in fact a former schoolmate.

Surprisingly, however, there is little evidence of Degas's interest in the work of two major Naturalist writers, Daudet and Maupassant, although he was acquainted with both of them.[42] Evidently he and Maupassant did admire

123 Degas: 'Bouderie' or 'Le Banquier'

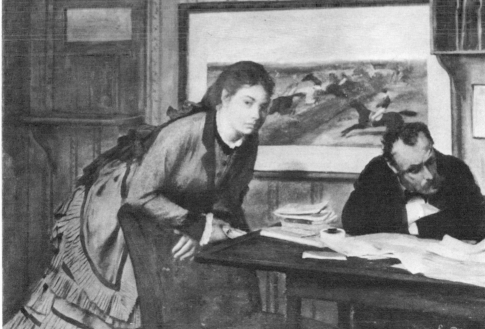

the graphic power of each other's art; for according to his niece, Degas considered the writer 'un styliste absolument remarquable qui pouvait donner de la vie et des hommes des images vivantes et colorées', and Maupassant, despite a predilection for the fashionable artists of the *Salon*—characteristic-ally, the works of art in his novels are based on the *Baigneuses* of Gervex and the *Danseuses* of Falguière, rather than those of Degas—did send the latter a copy of *Pierre et Jean* (1888) inscribed 'A Edgar Degas, qui peint la vie comme j'aurais voulu pouvoir la peindre'.[43] Yet when Degas, who had already devoted a powerful series of monotypes to the brothel, was commissioned to illustrate *La Maison Tellier*, he began (and never completed) a drawing of a ballet dancer.[44]

The first and probably the most important of Degas's contacts with the Naturalist writers was with Duranty, whom he met about 1865.[45] At this critical moment in his development toward realism Duranty, who had been one of its leading advocates for over a decade, must have been of particular importance to him. In fact, Duranty's conception of realism as the depiction of contemporary subjects in a dryly impersonal style, devoid of virtuosity, was precisely the one which he himself began to cherish, in contrast to that of Manet and the emerging Impressionists. Degas may also have been moved by the writer's personal aloofness, growing disillusionment and frequently mordant irony, qualities which he was beginning to experience in himself.[46] Hence it is not surprising that, of all the literary figures in this circle, Duranty alone appears in his portraiture, and more than once. In addition to the well-known likeness of him painted in 1879 [122] (L.517) which shows him seated in his book-lined study, his hand supporting his head in a characteristic gesture, there is another one, painted a decade earlier, which was not recog-nized until recently because it occurs in a genre scene.[47] Generally called 'Bouderie', but occasionally also 'Le Banquier' [123] (L.335), it represents the office of a small, privately owned bank of the Second Empire, perhaps the one directed by Degas's father, and the banker himself is modelled on Duranty. This becomes evident when his contracted features and receding blond hair are compared with those in known portraits of him, including the later one by Degas.

What makes Duranty's presence in 'Le Banquier' so fitting is the extent to which this work illustrates theories of expression and description that he had already developed and that Degas was coming into contact with at just this time. The former theory is stated both in Duranty's essay 'Sur la physiognomie' (1867)[48] and in Degas's contemporaneous programme, 'Faire de la tête d'expression (style d'Académie) une étude du sentiment moderne', by which

he meant to transform the schematized and exaggerated physiognomies typical of academic art into portrayals of the more subtle and complex emotions characteristic of modern sensibility, such as the sullen withdrawal of Duranty himself in 'Le Banquier'.[49] The theory of description, an important one in Naturalist aesthetics to which we shall return presently, is also well illustrated by 'Le Banquier', whose furnishings and décor Degas represents in scrupulous detail, basing the window counter fitted with opaque glass, the table piled with papers, and the rack filled with ledgers on studies he had made in his notebook, again perhaps in his father's bank.[50] Although Duranty did not comment publicly on this work, he did remark of Degas's portrait of Madame Gaujelin (L.165), shown at the *Salon* of 1869, 'On sent bien qu'elle a été peinte pour un certain endroit avec lequel elle s'accorde bien.'[51]

Just as Duranty appears in a fictional guise in 'Le Banquier', a realistic genre scene with narrative implications, so Degas appears in his own guise in *Le Peintre Louis Martin*, a fictional story with real characters and situations. First published serially in 1872, but largely based on Duranty's souvenirs of the years around 1863, this curious blend of fact and fiction brings together invented characters such as Louis Martin, the young protagonist of Realism, and contemporary celebrities such as Courbet, Manet and Degas himself.[52] When Martin arrives at the Louvre to begin copying a Poussin, he discovers that 'à côté de lui, s'escrimant aussi sur le Poussin, était installé Degas', and in fact such a copy by Degas after Poussin is not only known—it is of the 'Rape of the Sabines' (L.273)—but is datable *c*. 1862 precisely on the evidence provided by Duranty's story.[53] When Martin, expressing a typically Realist position, criticizes the gesture and attitudes in the Poussin for being 'd'une banalité et d'une insignifiance ridicules', the astonished Degas, still very much a disciple of Ingres, praises its 'pureté de dessin, largeur de modelé, grandeur de disposition'.[54] This essentially intellectual approach, which was evident not only in Degas's copies but in his art generally, must have impressed Duranty, for he goes on to characterize him as an 'artiste d'une rare intelligence, préoccupé d'*idées*, ce qui semblait étrange à la plupart de ses confrères', and refers to 'son cerveau actif, toujours en ébullition'.[55]

What this active, effervescent mind was thinking, Duranty does not say; but in his well-known pamphlet *La Nouvelle Peinture* (1876), written in defence of the second Impressionist group exhibition, he discusses Degas's contribution to contemporary art in detail. Without naming him—paradoxically, none of the figures in this factual account is named, whereas the fictional one in *Le Peintre Louis Martin* identifies them explicitly—but alluding unmistakably to him, Duranty asserts that 'la série des idées nouvelles s'est-elle formée

surtout dans le cerveau d'un dessinateur, un des nôtres... un homme du plus rare talent et du plus rare esprit'.[56] These new ideas consist above all in establishing an intimate rapport between the figure in a work of art and its setting, which must be characterized as carefully as the figure itself: 'Autour de lui et derrière lui sont des meubles, des cheminées, des tentures de murailles, un paroi qui exprime sa fortune, sa classe, son métier.'[57] And just as this statement is perfectly illustrated by a picture such as 'Le Banquier', so the illustrations which Duranty goes on to give obviously allude to other works by Degas: 'Il examinera son échantillon de coton dans son bureau commercial, il attendra derrière le décor le moment d'entrée en scène, ou il appliquera le fer à repasser sur la table à tréteaux', and so forth.[58]

This does not mean, however, that the radical ideas in La Nouvelle Peinture were dictated by Degas, as some writers have maintained. Although many of these ideas clearly reflect recent developments in his art, the latter were in turn inspired by a theory of description which had already been formulated by Duranty and others in the Realist movement two decades earlier. In 1857, for example, when the backgrounds of Degas's portraits were still conventionally neutral, Duranty had written in the journal Réalisme: 'En décrivant un intérieur, on raconte souvent la vie privée d'un individu ou d'une famille.'[59] Yet in his own fiction he wavered between detailed, inventory-like descriptions, to which he sacrificed the psychological development of his characters, and very summary ones inspired by Champfleury's conviction that literature cannot compete with painting and should employ its own techniques, which are in fact superior to those of painting.[60] In this uncertainty, Duranty expressed a dilemma that pervades Naturalist aesthetics as a whole. Even Zola, a far more assertive personality, acknowledged that a concern with the pictorial aspects of description would lead writers into competition with painters. In Le Roman expérimental, and again in Les Romanciers naturalistes, he argues that 'l'indication nette et précise des milieux et l'étude de leur influence sur les personnages [sont] des nécessités scientifiques du roman contemporain'.[61] But he is also aware that 'il peut y avoir abus, dans la description surtout... On lutte avec les peintres, pour montrer la souplesse et l'éclat de sa phrase.'[62]

Nowhere were the lines of this 'struggle' more sharply drawn than in Zola's frequent exchanges with Degas—and not surprisingly, for of all the Impressionists Degas was not only the most literate and articulate, but also the most deeply involved in the representation of modern urban life, hence the one who could pose the greatest threat of competition. In reviewing the 1876 Impressionist exhibition, about which Duranty had written enthusiastically, Zola acknowledges that Degas 'est épris de modernité, de la vie intérieur et de ses

types de tous les jours', but feels obliged to add that 'l'ennui, c'est qu'il gâte tout lorsqu'il s'agit de mettre la dernière main à une œuvre. Ses meilleurs tableaux sont des esquisses.'[63] And in discussing the Impressionists' reasons for exhibiting together in 1880, he observes rather maliciously that in Degas's case, 'il pouvait exposer des esquisses, des bouts d'étude, de simples traits où il excelle, et qu'on ne lui aurait pas reçus au Salon'.[64] Only in 1877, in the course of a brief and generally very favourable review, does he admit that Degas is 'un dessinateur d'un précision admirable, et ses moindres figures prennent un relief saisissant'.[65] More indicative of his real opinion is the letter he wrote to Huysmans in 1883 in receipt of the latter's book *L'Art moderne*: 'Plus je me détache des coins d'observation simplement curieux, plus j'ai l'amour des grands créateurs abondants qui apportent un monde. Je connais beaucoup Degas, et depuis longtemps. Ce n'est qu'un constipé du plus joli talent.'[66]

Equally disdainful in his turn of the limitations of Zola's encyclopaedic conception of art, Degas remarked, 'Il me fait l'effet d'un géant qui travaille le Bottin.'[67] And the epigrammatic conciseness of this remark, like that of his other 'mots', is itself the expression of an aesthetic of which he was perfectly conscious: 'En un trait', he observed, 'nous [peintres] en disons plus long qu'un littérateur en un volume.'[68] Appropriately, this was said in a conversation about Zola. When questioned further about him, Degas recalled that he had known the writer well, 'avec Manet, Moore, à la Nouvelle-Athènes; nous discutions à n'en plus finir', but that fundamentally they had disagreed about the nature of realism: 'Cette conception de l'art de Zola, fourrer tout sur un sujet en un volume, et passer à un autre sujet, me paraît puéril.'[69] Berthe Morisot records several other examples of Degas's insistence on the limitations of Zola's method, and precisely where it touched on painting. On one occasion, he suggested to Zola's publisher Charpentier the idea of bringing out a New Year edition of *Au Bonheur des dames* (1883), whose setting is a department store, with illustrations consisting of actual samples of fabric and lace—a suggestion which today might seem like a brilliant anticipation of Pop Art, but which at the time must surely have seemed malicious.[70]

Perhaps the most striking evidence of the great distance between Degas and Zola is in their comments on *L'Oeuvre* (1886), the latter's novel about the failure of a modern artist. According to Berthe Morisot, Degas insisted that it had been written 'pour prouver la grande supériorité de l'homme de lettres sur l'artiste',[71] and this in fact is what Zola himself, in an interesting conversation reported by George Moore, maintained was 'the theory of his book— namely, that no painter working in the modern movement had achieved a

result proportionate to that which had been achieved by at least three or four writers working in the same movement'.[72] When Degas was proposed as an exception to this rule, Zola replied: 'I cannot accept a man who shuts himself up all his life to draw a ballet-girl as ranking co-equal in dignity and power with Flaubert, Daudet and Goncourt.' It is not difficult to guess whom he meant by the 'fourth writer'. Ironically, however, it was Zola who here expressed a narrowly Naturalist conception of art, one that was rejected both by his Impressionist friends and by the Symbolist poets of the following generation, who were already able to admire the aesthetic rather than the realistic aspects of Impressionism. 'Très enthousiastes de notre art, les jeunes', Pissarro observed in 1886. 'Ils tombent, par exemple, joliment sur *l'Oeuvre* de Zola. Il paraît que c'est absolument mauvais — ils sont sévères.'[73]

In view of their competitive attitudes, it would be surprising to discover that one of Degas's most impressive pictures, the so-called 'Intérieur' or 'Le Viol' [124] (L.348), was inspired by one of Zola's novels. Yet several writers have observed its close relation to the climactic scene in *Madeleine Férat* (1868),

124 Degas: 'Intérieur' or 'Le Viol

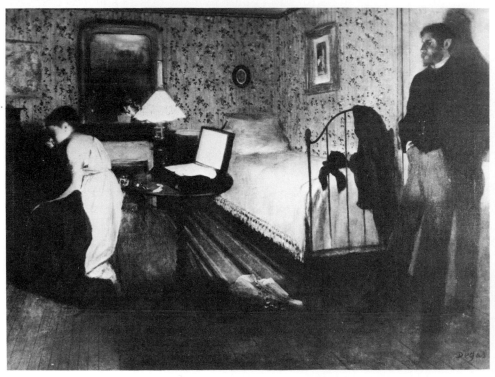

125 Degas: Study for 'Intérieur' or 'Le Viol'

where 'the quiet despair of the woman, the tense exasperation of the man are true to Zola's meaning, while the round table and the narrow virginal bed are actually mentioned in the text'.[74] Moreover, the latter was published serially in *L'Événement*, a newspaper well known in Degas's circle, toward the end of 1868, and his first sketch for 'Intérieur' is on the verso of a business document dated only months earlier.[75] But 'if Degas did have *Madeleine Férat* in mind, then, certainly, he has taken extensive liberties with his text . . . [since] Zola describes the bedroom in the Auberge du Grand Cerf with great care and at every stage in the action indicates the situation of his characters, [whereas] Degas disregards this detailed scenario at almost every point'.[76] Hence the relation of picture to text, although suggestive, remains ambiguous. It may seem less so when we consider the scene immediately preceding this one, where Madeleine's long-lost lover, who is by strange coincidence

spending the night in this very hotel, steals in during her husband's temporary absence and, remaining near the door ready to depart, while she cringes before him helpless and ashamed, unconsciously torments her with memories of their former loves, which had by even stranger coincidence taken place in this very room.[77] Yet even here there are too many discrepancies for the painting simply to be taken as an illustration of the novel, and the solution to this problem may still be missing.[77a]

In any event, the comparison makes clear the extent to which Degas and Zola, at least at this point in their respective developments, shared a profound feeling for the vividly realistic settings in which their imaginary dramas were enacted. Thus the bed, which Degas studies separately in an exquisitely shaded drawing [125],[78] half in precise detail, half in mysterious shadow, and which Zola describes ironically as 'un lit singulièrement étroit pour deux personnes... [une] couche étroite, bombée au milieu comme une pierre blanche de tombe', is obviously for both of them an object whose symbolic significance is inseparable from its powerful physical reality.[79]

Intersections such as this of art and literature are even more frequent in the work of Degas and the Goncourt brothers, and even more revealing, since he shared with them a broader range of social, psychological and stylistic affinities. This was already observed by Huysmans, who wrote in 1880: 'Ils auront été, les uns et les autres, les artistes les plus raffinés et les plus exquis du siècle',[80] and by another contemporary, Georges Rivière, who later wrote: 'Degas avait plus d'inclination pour les Goncourt que pour Émile Zola: leur réalisme élégant convenait à l'esprit de ce bourgeois bien né... Le peintre professe le même dédain que les romanciers à l'égard des gens d'une autre catégorie sociale que la sienne.'[81] As Huysmans remarked, this essentially aristocratic conception of realism resulted in both cases in an emphasis on the subtle observation of manners and incisive definition of forms, and on ingenious innovations in the use of language or pictorial technique. It also resulted in a fascination with those aspects of modern life in which the artificial seems to dominate the natural, especially in such subjects as the ballet, the brothel and the circus.

It was in fact the brilliant artificiality of a circus performance that enabled Degas to contrast his own art most clearly with that of the Impressionist landscape painters, declaring to one of them: 'À vous il faut la vie naturelle, à moi la vie factice.'[82] It also enabled him to create one of his most remarkable images, that of the acrobat Miss La La dramatically silhouetted against the rafters of the Cirque Fernando, literally hanging on by her teeth high above the unseen audience (L.522). That was early in 1879; and when, a few months

126 Degas: Illustration of *La Fille Elisa*

later, Edmond de Goncourt published *Les Frères Zemganno*, which depicts the courage and skill of two circus acrobats, Degas responded enthusiastically. 'Il passa sur tout ce qu'avait d'artificiel le soi-disant réalisme du roman,'

127 Degas: Illustration of *La Fille Elisa*

Rivière recalled. 'Il en parlait à tous ses amis.' [83]. One of these friends, by the way, was Barbey d'Aurevilly, who in turn reviewed *Les Frères Zemganno*, developing a parallel between the grace and strength of the acrobat and those of the writer that would surely also have appealed to the painter: 'Je suis convaincu que, pour qui a le sentiment des analogies et la puissance des mystérieuses assimilations, les regarder, c'est apprendre à écrire.' [84]

Aesthetically, if not morally, the brothel, too, was an exemplary subject for both Edmond de Goncourt and Degas, one in which the natural and the artificial, the naked truth and the cynical disguise, mingled with a special poignancy. Between 1877 and 1880, each of them treated this subject in an impressive form, the artist in a series of monotypes we shall discuss presently, the writer in a novel about prostitution which the other then illustrated. He did so in his own manner, however, for the rapid sketches that he drew in an after-dinner album while visiting the Halévys in 1877 [126 and 127], although

128 Degas: 'Le Ballet'

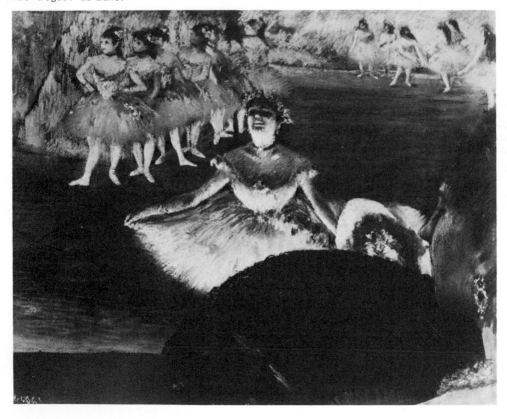

identified as illustrations of the recently published work *La Fille Elisa*, are as much Degas's own inventions.[85] Whereas for Goncourt the novel's significance lay in its realistic depiction of the inhuman conditions in contemporary prisons — 'la prostitution et la prostituée, ce n'est qu'un épisode,' he explains in the preface, 'la prison et la prisonnière, voilà l'intérêt de mon livre'[86] — for Degas this 'episode' was the sole source of interest. Concentrating on the one scene set in a brothel near the École Militaire, and proceeding with a sense of humour altogether foreign to the text, he caricatures the sly rather than the sordid aspects of the soldiers and their companions, picturing them soberly playing cards or quietly conversing, as if in a bourgeois *salon*.

Nevertheless, the general conception, as well as specific details of the milieu, the physical types, the costumes they wear, are clearly inspired by Goncourt's text. This is all the more interesting in that the latter, although based on direct observation, was also based on works of visual art; as Gustave Geffroy already observed at the time, much of its pictorial form and tonality derive from drawings of soldiers and prostitutes by Constantin Guys.[87] He was in fact an acquaintance of the Goncourts, and one whom Edmond characterized in their journal as 'le peintre de la basse putain'.[88] As in the case of Degas's relation to George Sand, then, but with a rather different type of subject, his images illustrate a text which in turn 'illustrates' an older artist's images.

Given this mutual contamination of art and literature, it was almost inevitable that Degas and Edmond de Goncourt should consider themselves rivals, and that each should resent the other's mastery of his medium or discovery of novel subjects. Thus Degas, whose frequently self-conscious letters betray his own unfulfilled literary ambitions, parodies the excesses of Edmond's 'écriture artiste' in several letters of the 1880s. In describing a bust he is making in a friend's home, for example, he writes: 'Vous ne m'y croyez donc pas *acharné après, avec sur mon talent* (style Goncourt) *un famille penchée?*'[89] And the latter, in recording his first visit to Degas's studio in 1874, admits that he is 'l'homme que j'ai vu le mieux attraper, dans la copie de la vie moderne, l'âme de cette vie', but like Zola he feels obliged to add: 'Maintenant, réalisera-t-il jamais quelque chose de complet? J'en doute. C'est un esprit trop inquiet.'[90] Indeed, in revising this account later Edmond retained the passage, 'Il s'est énamouré du moderne, et dans le moderne, il a jeté son dévolu sur les blanchisseuses et les danseuses', but added, 'Je ne puis trouver son choix mauvais, moi qui, dans *Manette Salomon* [1867], ai chanté ces deux professions, comme fournissant les plus picturaux modèles de femmes de ce temps, pour un artiste moderne.'[91]

Edmond was in fact deceiving himself, for if his novel of artistic life was an

important statement of the new aesthetic, and if Degas, who later acknowledged it 'als unmittelbare Quelle seiner neuen Erkenntnis',[92] was undoubtedly encouraged by the example of its hero Coriolis to take up modern subjects in general, he could hardly have been led by it to laundresses and dancers in particular. For it does not mention the latter, and its only reference to the former—Coriolis's notation of 'le hanchement d'une blanchisseuse au panier lourd'—although apparently a description 'avant la lettre' of Degas's 'Blanchisseuses portant du linge' (L.410), is in fact based on earlier representations of the same subject by Daumier and Gavarni.[93] It was probably, as Rothenstein reports, because 'Degas had told him that modern writers got their inspiration from painters', that Edmond was compelled to assert his own priority retrospectively.[94]

With much more justification, Edmond might have cited those passages in their journal where, already in the early 1860s, he and his brother had described precisely the types of theatre and ballet subjects that Degas was to paint a decade later. With an artist's eye for the novel effects of perspective and illumination characteristic of the stage, indeed with repeated references to similar effects in Rembrandt and Goya, the Goncourts had created in their own medium vivid pictures of dancers rehearsing with the ballet master behind the scenes, or mounting the spiral staircase in the practice room, or moving as luminous shapes against the sombre stage sets, very much as in Degas's later canvases and pastels.[95] In one such passage, written in 1862, the very structure of the vision seems to anticipate that of a work like 'Le Ballet' [128] (L.476) of some eighteen years later. In both cases, the artist views the stage from a *loge*, seated beside a young woman: 'Nous sommes à l'Opéra, dans la loge du directeur, sur le théâtre. A côté de nous, Peyrat et Mlle Peyrat, une jeune fille...' In both, he looks past the young woman to observe the glittering star on stage: 'Et tout en causant, j'ai les yeux sur une coulisse qui me fait face... La Mercier, toute blonde, chargée de fanfreluches dorées... se modèle en lumière, absolument comme la petite fille au poulet de la *Ronde* de Rembrandt...' And in both, he glimpses behind the star the vague shapes of other performers in the distance: 'Puis derrière la figure lumineuse de la danseuse... un fond merveilleux de ténèbres et de lueurs, de nuit et de réveillons. Des formes qui se perdent...'[96] Even the allusion to Rembrandt is relevant to Degas, who often remarked, apropos his use of dramatic chiaroscuro, 'Si Rembrandt avait connu la lithographie, Dieu sait ce qu'il en aurait fait', and, as is obvious in 'Le Ballet' itself, often fell under its influence.[97]

The resemblances between Degas's image and the Goncourts' are not, however, signs of a mysterious affinity, but rather the result of their mutual

reliance on the conventional method of representing space by means of three contrasting planes, a method he had absorbed while copying in the Louvre and they while preparing to write *L'Art du XVIIIᵉ siècle* (1859–70); the influence of their art-historical studies on their imaginative writing has already been observed.[98] But the extent to which both he and they stress the subjective quality of vision, by placing the observer himself in the foreground of their images and allowing his eccentric position to determine the structure of the whole, indicates the extent to which Degas and the Goncourts were able to modify the conventional method in order to express the greater subjectivity of modern experience.[98a]

Like the Goncourt brothers, Huysmans often exhibits in his work of the 1880s striking similarities in subject and style to the work of Degas; and not surprisingly, since he was both a disciple of the Goncourts in literature and an enthusiastic champion of Degas in art. If, as Pissarro remarked about his exhibition reviews in *L'Art moderne*, 'Comme tous les critiques, sous prétexte de *naturalisme*, il juge en littérateur, et ne voit la plupart du temps que le sujet',[99] the impact of Impressionism, and especially of Degas's novel version of it, was so great on Huysman's own vision around 1880 that, in addition to being 'sometimes an extension of his experience of life, at others a parallel to his own work',[100] Degas's pictures must also have played an important role in shaping that experience and work. From the beginning of his career, which was as an art critic, Huysmans had been concerned with the most minute description of pictures, and their influence on his fiction has been noted more than once.

Significantly, the clearest examples of his debt to Degas are in his scenes of brilliantly contrived entertainment: the descriptions of ballet and circus performances in his prose sketches of modern life, the *Croquis Parisiens* (1880). Thus, he sees the dancers at the Folies-Bergère exactly as Degas's ballet pictures, about which he had already written perceptively in 1876,[101] had taught him to see them. It is, however, a different vision from that which some of Degas's pictures share with those in the Goncourts' journal, a vision that focuses more on the physical dynamism of the dancers' movements than on their logical positions in space, more on the dazzling effects of artificial illumination than on a mysterious half-light evocative of Rembrandt. In Huysmans's image, precisely as in a Degas pastel such as *Danseuses basculant* [129] (L.572) of about 1878, 'C'est, à un moment, sous les jets de lumière électrique qui inondent la scène, un turbillon de tulle blanc, éclaboussé de feux bleus, avec du nu de chair sautant au centre; puis, la première danseuse... remue ses faux sequins qui l'enveloppent comme d'une ronde de points d'or,

bondit et s'affaisse dans ses jupes, simulant la fleur tombée, les pétales en bas et la tige en l'air.'[102]

Huysmans was familiar with Degas's ballet pictures more intimately than as a critic who saw them in occasional exhibitions; for according to his friends, he had installed one of them in a place of honour in his apartment.[103] And as is often the case in his work, the same picture appears in his description of a fictional setting, that of the writer André Jayant in *En ménage* (1881). A 'vue de coulisses avec des danseuses en gaze rose, au repos, devant des portants bar-bouillés de verdures, des petites voyoutes exquises lutinant de grands dadais empesés dans leur tenue de bal',[104] it is obviously a work such as the pastel 'Dans les coulisses, deux danseuses en rose' (L.544) or the small oil 'Les Danseuses roses avant le ballet' (L.783). It is true that Degas's disciple Forain, a close friend of Huysmans and an artist whom he praised highly in *L'Art*

129 Degas: 'Danseuses basculant'

130 Degas: 'Miss La La au Cirque Fernando'

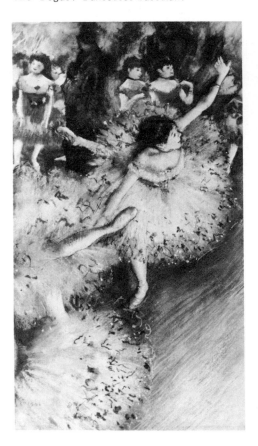

moderne, also treated this subject in the late 1870s, but the extant samples do not resemble as closely the picture described in *En ménage*.[105]

Even more evidently indebted to Degas—in this case, to 'Miss La La au Cirque Fernando' [130] (L.522), which Huysmans had admired when it was exhibited in 1879—is his description of an acrobatic performance at the Folies-Bergère. Again insisting on the purely phenomenological aspect, and again in contrast to Goncourt, who in *Les Frères Zemganno* (1879) had kept the personal and pathetic aspects in view, Huysmans paints a verbal picture closely resembling Degas's: 'La femme monte à son tour jusqu'au filet qui plie sous elle... [et] posée en face de l'homme, séparée de lui par toute la salle, elle attend... Les deux jets de lumière électrique dardés sur son dos du fond des Folies l'enve-lopent, si brisant au tournant de ses hanches, l'éclaboussant de la nuque aux pieds, la gouachant pour ainsi dire d'un contour d'argent.'[106] The last phrase, especially the word 'gouachant', points unmistakably to a pictorial influence, and precisely that of Degas, who was almost alone among the Impressionists at this time in exploiting the brilliant, matte quality of gouache. Here too the one exception is Forain who, in imitation of Degas himself, not only worked in pastel and gouache, but used them in depicting scenes of popular entertain-ment; moreover, he was closely enough acquainted with Huysmans to be asked to illustrate the first edition of *Croquis parisiens*. But like his paintings of this period, Forain's etched illustrations, even of the Folies-Bergère section of the *Croquis*, focus entirely on intimacies and encounters witnessed behind the scenes or in the theatre's bar,[107] and hence do not correspond as closely as Degas's picture does to the performance described by Huysmans.

Nothing reveals more clearly the latter's fascination with the technical aspects of Degas's art than his observation that in 'Miss La La au Cirque Fernando' the artist, 'pour donner l'exacte sensation de l'œil qui suit Miss La La... [a fait] pencher tout d'un côté le plafond du cirque',[108] an observation whose equivalent in Degas's practice is the scrupulously detailed perspective study of the ceiling itself, on which he actually noted that 'les fermes sont plus penchées'.[109]

More than the ballet and the circus, the brothel had a special fascination for both Degas and Huysmans as a subject imbued with that melancholy spirit of isolation and disillusionment which each of them identified with a modern sensibility. Drawn by nature to the closed nocturnal world of urban entertain-ment and distraction, rather than the sunlit one chosen by their Impressionist colleagues, they found in the brothel an ideal source of imagery. Of course, others in the Naturalist movement also took up this theme around 1880—not only Edmond de Goncourt, but Maupassant, Forain, Rops and several lesser

figures—but in treating it none of them expressed so profoundly cynical an attitude toward women as that which informs Huysmans's novel *Marthe, histoire d'une fille,* and Degas's monotypes of 'maisons closes', an attitude of which there is further evidence elsewhere in their work.[110] The two treatments are nearly contemporary, the novel having appeared in 1876 and again in 1879, the monotypes having been executed about 1879–80; yet the one seems definitely to have influenced the others. Not simply because it singles out the same details in describing either the setting or the women's costumes,[111] since these are more or less standard in images of the brothel in that period; but rather because it depicts the women themselves in the same positions of total physical abandon, in contrast to which their attitudes in other works, such as *La Fille Elisa* and the drawings of Guys, seem restrained, almost conventional.

Thus Huysmans, viewing the brothel through Martha's eyes, writes: 'Elle regardait avec hébétement les poses étranges de ses camarades, des beautés falotes et vulgaires, des caillettes agaçantes, des homasses et des maigriottes,

131 Degas: 'Au salon'

132 Degas: 'Repos'

133 Degas: 'Ludovic Halévy et Albert Boulanger-Cavé'

étendues sur le ventre, la tête dans les mains, accroupies comme des chiennes, sur un tabouret, accrochées comme des oripeaux, sur des coins de divans...'[112] And Degas, in a monotype such as 'Au salon' [131] strews the room in a similar manner with bodies of vulgar proportions and depraved postures, including one shown crouching like a dog, as in the text.[113] Indeed, in another monotype, ironically entitled 'Repos' [132], he juxtaposes three bizarrely placed nudes—one lying on the floor with her back to us, another reclining on a sofa with her legs in the air, and a third scratching herself with her legs widespread —whose grotesque appearance illustrates perfectly Huysmans's text and may well have been meant to do so.[114] In contrast to Degas's images, those of Forain, which were actually conceived to illustrate the second edition of *Marthe,* are more conventionally lewd and lack their psychologically disturbing character.[115]

After Huysmans, the Goncourts and Zola, it is a relief to turn at last to Ludovic Halévy, who was neither a bitter competitor of Degas nor a source of pessimistic subject-matter for his work. Both in his personal relations with Degas—as a former schoolmate who became one of his few really intimate friends—and in his professional achievement—as a highly successful author

134 Degas: Illustration of *La Famille Cardinal*

135 Degas: Illustration of *La Famille Cardinal*

of light comedies and libretti who satisfied his taste for worldliness—Halévy stands in contrast to these other figures. Of all the Naturalist writers, only Duranty was as close to Degas personally and, like Halévy, was the subject of one of his portraits. But if that of Duranty, the studious novelist and art critic, shows him seated amidst his papers and books, that of Halévy [133] (L.526), which was also painted in 1879, shows him standing in the wings of the Opéra, conversing with the dilettante and 'animateur' Albert Boulanger-Cavé. Like Degas himself, he was thoroughly at home there, having begun to frequent the Opéra as a young man, when his uncle Fromental Halévy was its choral director.[116] But despite his fashionable attire and nonchalant pose, Halévy appears curiously sombre and thoughtful; as he himself observed rather wistfully, 'Moi, sérieux dans un endroit frivole: c'est ce que Degas a voulu faire.'[117] Nothing sums up better the sophisticated detachment that Degas admired in him than this image of Halévy and his own wry comment on it; yet he, at least, rejected the role as too shallow, and when, a few years later, Degas criticized his recent novel *L'Abbé Constantin* (1882) for its supposed sentimentality, he lamented: 'Il m'a dit ce matin des injures. Je dois faire toujours

des Madame Cardinal, des petites choses sèches, satiriques, sceptiques, iron-
iques, sans cœur, sans émotion.'[118]

Consequently, it was not *L'Abbé Constantin,* but *La Famille Cardinal,* that 'chef-
d'œuvre d'impassibilité gouailleuse... [et] de décence dans la maniement de
choses malodorantes',[119] which Degas chose to illustrate in a series of mono-
types about 1880. And appropriately, one of the first that he executed [134]
shows Halévy and Madame Cardinal standing backstage at the Opéra in posi-
tions very much like those of himself and Cavé in Degas's portrait.[120] It repre-
sents the first episode narrated by Halévy, his meeting with the mother of two
young dancers whose fortunes at the Opéra and in marriage, as recounted to
him in several such meetings, constitute most of the book. Here Degas follows
the text rather closely, both in the description of Madame Cardinal, 'une
grosse dame, d'une mise négligée, un vieux tartan à carreaux sur les épaules et
de vastes lunettes d'argent sur le nez', and in the placement of the figures
'dans le petit coin à gauche.'[121] And elsewhere, too, he is content to illustrate its

136 Degas: Illustration of *La Famille Cardinal*

more vividly rendered incidents faithfully; for example, the amusing one in which Halévy and three companions—one of them, 'un peintre', is perhaps Degas himself—accost the Cardinal girls in a passage of the Opéra in order to persuade them to accept a dinner invitation [136].[122] 'Elles en grillaient d'envie, les deux petites Cardinal: "Mais, jamais, disient-elles, jamais maman ne consentira..." Et, tout d'un coup, elle apparut au bout du couloir, cette mère redoutable', exactly as in Degas's image.[123]

In other monotypes, however, he ignores specific indications in the text and instead represents simple, if ingeniously varied, groups of dancers and their admirers conversing in the wings and dressing rooms of the Opéra, very much as in his other works of these years. So absorbing is his interest in this milieu, that he avoids most of the incidents not set within it, including such highly entertaining ones as Monsieur Cardinal's career as a local politician, one daughter's marriage to a marquis and affair with an Italian tenor, and the other daughter's romance with a soldier. In contrast, the etchings made by Charles Léandre for the 1893 edition of La Famille Cardinal single out precisely these picturesque and dramatic aspects of the story. However, Degas does represent a few scenes of domestic drama, notably Monsieur Cardinal almost coming to blows with his son-in-law the marquis during the famous Good Friday dinner [135], which he renders in a remarkably expressive manner, seizing on the climactic moment when, in Madame Cardinal's words, 'Voilà que le marquis m'appelle coquine; Monsieur Cardinal se lève et veut jeter une carafe à la tête du marquis, Pauline se sauve en pleurant, et Virginie, à moitié pâmée, s'écrie: Papa! Maman! Édouard!'[124] But on the whole, Degas's illustrations are more a re-creation of the spirit and ambience of Halévy's novel than authentic illustrations of its scenes, and this is probably why the latter refused to accept them for publication, despite his friendship with the artist.[125]

Several years earlier, the two friends had collaborated fruitfully on another project, the stage production of La Cigale (1877), a satirical comedy about contemporary artistic life written by Halévy and Henri Meilhac in the wake of the first Impressionist exhibitions and the violent reactions they had elicited. Some of its satire is of a type traditionally dear to critics of modern art, one painter, for example, lamenting that a canvas which he began ten minutes ago is not yet finished, another exclaiming that a canvas which has accidentally fallen on his palette is actually improved; but most of it is directed specifically against the Impressionists. In fact, although the stage directions for the third act merely mention 'tableaux étranges... peintures bizarres', Zola's review refers explicitly to 'le décor de l'atelier, avec ses charges des

137 Degas: Illustration of *La Cigale*

toiles célèbres de MM. Manet, Claude Monet, Degas, Cézanne, Renoir, Sisley, Pissarro, etc.',[126] and we may well wonder whether Degas was responsible for this set. He himself implies as much in a letter to Halévy, written while the play was in rehearsal, offering his services 'pour l'atelier de Dupuis', the one shown in this act: 'J'ai beau mal y voir, la chose me plaît beaucoup et je la ferai.'[127]

He may indeed have played an even larger role in the creation of *La Cigale*, for according to Rivière, who was present with Renoir at the opening, 'Personne n'eût aucun doute sur la complicité de Degas dans l'élaboration de la pièce.'[128] When Marignan, the painter protagonist, admires the modernity of La Cigale's nose—'Il n'est pas grec celui-là, il n'est pas vieux jeu... Est-il assez parisien! est-il assez moderne!'—he is merely repeating a sentiment already expressed by Degas in a letter to Duranty, which the latter had published in *La Nouvelle Peinture* the year before.[129] And when Marignan alludes mockingly to Impressionist theories of colour and light—'Je suis luministe... je comprends la lumière d'une certain façon... et je fais [les choses] comme

138 Degas: 'Au bord de la mer'

je les vois', even if that means painting a face violet or green—he is simply echoing Degas's low opinion of those theories.[130] Yet he himself is not spared a few satirical thrusts, notably when Marignan has a model pose as a laundress washing linen, in allusion to Degas's well-known interest in this subject. It was evidently a topic of discussion at the Halévys' too, for in the after-dinner album kept for him there he sketched this incident twice, once with Marignan at his easel [137], thus illustrating a theatrical conception he had originally inspired.[131]

More revealing of Degas's influence, however, is a later scene in which Marignan, declaring that 'nous ne sommes plus impressionnistes maintenant, nous sommes intentionnistes, nous avons des intentions', displays an abstract composition consisting of two equal areas, one blue, the other red, and describes it as a landscape, or rather as two landscapes: with the blue area below, 'C'est la mer, la mer immense... illuminée par un magnifique coucher de soleil', but with the red area below, 'C'est le désert... les sables brûlants du désert... et au-dessus, un ciel d'azur.'[132] For if its general design, with the

horizon cleanly bisecting the surface, is that of a Courbet or a Barbizon School seascape[133]—the first act of *La Cigale* is in fact set in an inn at Barbizon—its closest equivalents are in a series of works executed about 1869 by Degas himself, among them 'Au bord de la mer' [138] (L.245), a pastel whose surface is divided into two roughly equal areas of colour so uninterrupted in their sweep that it almost could be inverted to produce an image of the opposite situation in nature.[134] Thus Degas's remarkably extensive contacts and affinities with Naturalist literature, which were largely centred on themes of urban labour and pleasure, could also include a landscape subject almost devoid of content, one that is conceived—in a manner which today seems prophetic of the art of Mark Rothko—primarily as a field of luminous areas of colour.

4

If in the 1870s the anti-Naturalist character of Marignan's 'intentionist' landscape and, by implication, of Degas's 'abstract-impressionist' seascape seemed so exceptional as to provoke laughter, it became in the following decades a major direction both in his own art and in advanced art and literature generally. And just as his own work became increasingly abstract in form, brilliant in colour and subjective in expression after about 1885, so that of the Naturalist writers with whom he had been associated also evolved toward a more spiritualized form with affinities to Symbolism. In that year, Edmond de Goncourt himself admitted: 'Je demeure fidèle à la réalité, mais en la présentant quelquefois sous une certaine projection de jour, qui la modifie, la poétise, la teinte de fantastique.'[135] Many of the younger writers with whom Degas now came in contact were Symbolists who rejected the positivism of the preceding period. Among them were Mallarmé, Valéry, Mirbeau, Mauclair and Proust: and except for Mallarmé, who however became prominent only at this time, all of them were a generation younger than Degas and on the whole less intimately acquainted with him than the Naturalists had been. Moreover, their relations with him were largely one-sided: while they admired his boldly original art and intransigent personality, he professed not to understand or appreciate their writings, clinging instead to his Romantic tastes and Naturalist theories.

Surprisingly, he did respond to Édouard Dujardin's Symbolist play, *Antonia* when it was performed in 1891, but this was probably for its romantic setting and theme of melancholy love, rather than for its highly contrived rhythmic prose.[136] Nor is there any evidence of his interest in the writings of Gide, a far more important figure in this movement and one with whom he was

already acquainted in the 1890s, although Gide in his turn repeatedly expressed his admiration for Degas's art and even found his reactionary ideas congenial.[137] He seems in fact to have had more affinities with the Parnassian poets of the preceding generation, turning at once to Banville's *Traité de versification* when he began to compose sonnets in the winter of 1888–9, dedicating the first of them to Heredia, whose mastery of that form was one of his sources of inspiration, and receiving in his turn the dedication of one of Charles Cros's lapidary poems in 1879.[138]

Nothing reveals more clearly the fundamental differences between Degas and the Symbolist writers than his problematic relationship with Mallarmé, the one who was perhaps most sympathetic to him personally, sharing his deep interest in painting and his friendship with the other Impressionists, particularly those in the circle of Berthe Morisot. He had written perceptively about Degas's art, and in terms that suggest they were already acquainted, as early as 1876: 'A master of a strange new beauty, if I dare employ towards his works an abstract term, which he himself will never employ in his daily conversation.'[139] And Degas, who was evidently attracted to the poet's gentle, thoughtful manner, created an image of him which Valéry considered 'le plus beau portrait de Mallarmé que j'ai vu'; it is a photograph, taken in 1895 [139], which shows him leaning against a wall beside a mirror, with Renoir sitting on a sofa opposite him and his wife and daughter, as well as Degas himself at the camera, appearing as ghostly reflections in the mirror.[140]

Yet when Mallarmé read his moving tribute to Villiers de l'Isle-Adam in the studio of Berthe Morisot, Degas, alone among the distinguished company, claimed not to understand a word and left abruptly before the reading had ended. Henri de Régnier, who tells the story, adds that 'l'auteur favori de Degas était Brillat-Savarin, il se faisait lire la *Physiologie du goût*'.[141] Several incidents of Degas's stubborn refusal to comprehend the poet's work, even when a sympathetic reading would have penetrated many of its admitted obscurities, are also reported by Valéry.[142] Moreover, on two occasions— once in 1888–9, when Mallarmé planned an illustrated edition of his prose poems, and again a decade later, when his daughter planned a posthumous edition of his poetry—Degas agreed to provide a drawing and then declined.[143] For the earlier publication, the drawing was presumably to represent a ballet dancer, to illustrate the prose poem *Ballets*; yet despite their similarity of subject, the two works would have inevitably differed in conception, and in a way that illuminates a basic difference between the painter and the poet. In contrast to the powerful realism of Degas's forms which, even in this relatively subjective phase of his art, were ultimately based on physical sensations,

Mallarmé's subtle meditation on the meaning of the dance, with its para-
doxical thesis that 'la danseuse n'est pas une femme qui danse, pour ces
motifs juxtaposés qu'elle n'est pas une femme... et qu'elle ne danse pas', was
bound to seem arbitrary and obscure.[144]

Nevertheless, Degas must have realized the importance of Mallarmé's
achievement, for when he became temporarily obsessed with writing poetry
himself, it was to him that he turned for advice. And the poet, although
fearful that this new interest would further delay delivery of the promised
drawing, was sympathetic and encouraging: 'Au fond, il ne vit plus,' he con-
fided to Berthe Morisot. 'On reste troublé devant cette injonction d'un art
nouveau dont il se tire, ma foi, très joliment.'[145] Yet there was a profound
difference between the two men here too, as is evident from their exchange on
one of the occasions when Degas sought Mallarmé's advice. Lamenting his

139 Degas: Photograph of Renoir and
Mallarmé

140 Degas: 'Walter Sickert, Daniel
Halévy, Ludovic Halévy, Jacques Blanche,
Gervex et Boulanger-Cavé'

inability to complete a certain sonnet, he remarked, 'Et cependant, ce ne sont pas les idées qui me manquent... J'en suis plein... J'en ai trop', to which the other replied, 'Mais, Degas, ce n'est point avec des idées que l'on fait des vers... C'est avec des mots.'[146] It seems ironic, yet also characteristic of Degas's relation to Symbolist literature, that he failed to grasp the significance of this doctrine in composing his poems or in judging those of Mallarmé and other poets, although it coincided with the one he himself often stated in affirming the essentially subjective nature of his art, which in fact had become increasingly evident in this final period. As Valéry observes, 'Degas disant du dessin qu'il était *la manière de voir la forme,* Mallarmé enseignant que *les vers sont faits de mots,* [se] résumaient, chacun dans son art.'[147]

In the development of Valéry's own ideas on art, Mallarmé and Degas were, for all their differences, clearly the two greatest influences, the latter as much through the force of his personality as through his pictures themselves. What Valéry admired above all was his intellectual rigour and moral probity, his relentless search for perfection and indifference to material success, his ideal of art as a series of difficult problems and of the artist's life as a dedicated effort to solve them—qualities which Valéry had already begun to cherish before he met Degas in the winter of 1893–4 in the home of Ernest Rouart.[148] 'La connaissance de Degas [m'est] très précieuse,' he wrote to Gide a few years later. 'Cet homme me plaît infiniment, autant que sa peinture. Il a l'air si intelligent!'[149] Even before they became acquainted, Valéry had formed an image of Degas from the pictures he had seen and the anecdotes he had heard. 'Je m'étais fait de Degas,' he later recalled, 'l'idée d'un personnage réduit à la rigeur d'un dur dessin... Une sorte de brutalité d'origine intellectuelle en était le trait essentiel.'[150]

This image, its outlines partly strengthened by contact with the real Degas, was evidently in Valéry's mind when, in the summer of 1894, he wrote *La Soirée avec Monsieur Teste,* the first of several puzzling and difficult pieces—he himself described them variously as portraits, stories, or episodes in a novel—in which the personality and thought of this extraordinary character constitute the sole interest. Monsieur Teste, it is true, resembles Degas neither physically nor psychologically, and is at least as much inspired by Mallarmé and, oddly enough, by the detective Auguste Dupin in Poe's *Tales of Mystery and Imagination*; but he reflects nevertheless that notion of Degas's intellectual discipline and moral righteousness which Valéry had already formed.[151] Indeed, he later admitted that *La Soirée* 'n'est pas sans avoir été plus ou moins *influencé* (comme l'on dit) par *un certain Degas que je me figurais*'.[152]

Consequently, we may also wonder whether Degas's art, which he knew

through the great examples in Rouart's collection, through exhibitions at Durand-Ruel's gallery, and even through photographs he purchased, played a role in the creation of this work.[153] Its central section, the most concrete and 'visual' of the three, is after all set at the Opéra, and although it does not describe a performance in any detail—on the contrary, Monsieur Teste deliberately turns his back on the stage in order to enjoy the spectacle of the audience—it does portray him in a manner reminiscent of certain portraits by Degas. Behind the description of Teste, 'debout avec la colonne d'or de l'Opéra, ensemble... son être noir mordoré par les lumières, la forme de tout son bloc vêtu, étayé par la grosse colonne',[154] there may well lie a portrait like the one discussed earlier of Halévy and Cavé standing in the wings of the Opéra [133], where the figure is likewise seen as a strikingly dark silhouette, its surface enlivened by reflected lights, its form deliberately compared with a vertical architectural form behind it.

Hence it seemed altogether appropriate for Valéry to think of dedicating *La Soirée avec Monsieur Teste* to Degas; but when, too timid to ask for permission, he asked one of the Rouarts to do so, the almost predictable answer was a brusque No: 'Je ne tiens pas à ce que l'on me dédie des choses que je ne comprendrai pas. J'ai soupé des poètes...'[155] In retrospect, Degas's refusal seems all the more ironic in that Valéry later wrote a most charming and perceptive memoir, entitled *Degas danse dessin*, which is in effect dedicated to him. A meditation on the nature of art and artists, it is inspired by the very qualities of Degas's thought and personality that had originally inspired the invention of Monsieur Teste. Its conception is actually contemporary with the latter, Valéry having informed Gide as early as 1898, 'J'écrirai (sur Degas non désigné plus clairement); *Monsieur D. ou la Peinture*.'[156] Like *La Soirée* itself, however, *Degas danse dessin* owes much to the parallel example of Mallarmé and is also a vehicle for the expression of Valéry's own aesthetic doctrine, to which that of Degas is sometimes adapted.

Although, as Valéry and a few other intimate friends realized, there was in Degas 'a humanity beneath the inhuman face he insisted on presenting to the world',[157] it was the latter alone that most of his acquaintances saw and that the writers among them seized on in their fictional portraits of him. A decade before Valéry subtly transformed it into a purely intellectual image of Monsieur Teste, it had already appeared in a more exaggerated form in another character, the artist Lirat in Octave Mirbeau's novel *Le Calvaire* (1886). An influential critic as well as a novelist, Mirbeau knew many of the leading artists of his day, including Monet, Gauguin and Rodin, whose work he championed in his widely read newspaper columns. According to Vollard,

who tells a curious story of an encounter between Mirbeau and Degas, he was also well acquainted with the latter, although he seems to have written very little about him.[158] In *Le Calvaire*, however, the violent pessimism of Mirbeau's vision distorts his characterization of Lirat to the point where it becomes as much a caricature of the misanthropic traits in Degas's personality as a tribute to the independence and originality of his art. For if Mirbeau was as a critic responsive both to the Impressionism of Monet and the Symbolism of Gauguin, he was as a novelist far closer to the Decadents in his obsession with the perversity and cruelty of modern life, as is evident in that supremely decadent work *Le Jardin des supplices* (1899).

Hence it was above all the legend of Degas's anti-social behaviour that he seized on, using it as a model for the alienated and embittered artist he wanted to portray in *Le Calvaire*.[159] Like Degas, at least according to this legend, Joseph Lirat 'eut la réputation d'être misanthrope, insociable et méchant... Il était si dur, si impitoyable à tout le monde, il savait si bien... découvrir le ridicule, et le fixer par un trait juste, inoubliable et féroce'—an obvious allusion to Degas's malicious sayings—that even young Mintié, who admired him, trembled in his presence.[160] And like Degas, he had an equally austere artistic ideal, so that ultimately 'il avait pris le parti de ne plus exposer, disant: On travaille pour soi, pour deux ou trois amis vivants, et pour d'autres qu'on n'a pas connus et qui sont morts',[161] a notion of himself in relation to past and present art which corresponds closely to that of Degas.

Also inspired by stories that had circulated in the art world of Paris about Degas's artistic genius and irascible behaviour is the portrait of him as Hubert Feuillery, 'le pastelliste des danseuses, le grand misanthrope, admiré par son art et redouté pour ses boutades cruelles', in Camille Mauclair's novel *La Ville lumière* (1903).[162] Like Lirat, Feuillery is a rather bizarre and hostile figure, 'un être d'aspect étrange, petit, nerveux, crispé... [qui] avait des mots féroces et tragiques, des saillies subites, de démoniaques ironies...'[163] But unlike Mirbeau's essentially Decadent artist, he is capable of noble sentiments and actions, revealing 'au fond une âme exquise, toujours froissée, une immense contention de soi-même, une pitié révoltée et le dégoût de son époque'.[164] The last point is significant, for Feuillery is clearly conceived as a symbol of uncompromising integrity, in contrast to the materialism and self-seeking which motivate the painters, dealers and critics whose machinations in the so-called 'ville lumière' Mauclair depicts in detail.

A Symbolist poet in the circle of Mallarmé and an art critic for the Symbolist magazine *Mercure de France*, he quite naturally adopted an idealist position in condemning the cynicism of the contemporary art world and in exalting a

selfless dedication to art, even when it was accompanied by personal eccentricities, as in the case of Degas.[165] Whereas his colleagues actively seek publicity, Feuillery goes so far as to bribe one critic with a drawing, 'pour obtenir en échange que vous ne publiiez rien sur moi'.[166] In his art-historical essays, too, Mauclair admired in Degas 'l'homme digne de toute estime pour la noble intégrité de sa vie, son insouci de la gloire, son labeur et sa discrète fierté...'[167] Ironically, however, he was hostile to almost all the other original artists of his day, sarcastically rejecting Pissarro and Guillaumin as well as Cézanne, Gauguin and Toulouse-Lautrec, so that the idealism of *La Ville lumière* now seems rather false.[168]

So vivid was the impression Degas made on his contemporaries toward the end of his life, that its influence is still felt in two novels published after his death: *Aymeris,* a fictional autobiography of the painter and writer Jacques-Émile Blanche, and *Sodome et Gomorrhe,* the fourth volume of Proust's great work *A la recherche du temps perdu.* By coincidence, both novels appeared in 1922, although they were largely written before the war and were prepared even earlier, in that 'fin-de-siècle' Parisian society where their authors were acquainted with each other as well as Degas. In fact, when Blanche published the first volume of his essays on art, one of which is a valuable memoir of Degas, Proust contributed a long preface evoking their youthful friendship and mutual interest in painting.[169]

In *Aymeris*, Degas appears in his own guise, but his behaviour is as eccentric and anti-social as it is in *Le Calvaire* and *La Ville lumière*, where he appears in a fictional guise. Like Blanche himself, Georges Aymeris is a young art student in the early 1880s who hears about 'les curieux tableaux de théâtre d'un certain Degas' and determines to make his acquaintance.[170] Unfortunately, the latter 'ne veut voir personne, surtout les jeunes gens, qu'il déteste et trouve stupides', and instead Georges visits Bouguereau, who, he discovers, has 'l'air aussi furieux que M. Degas'.[171] When he finally gains access to the artist's studio, he is shown 'mille dessins, pastels, de chevaux de courses, de danseuses', and more surprisingly 'toutes ses œuvres anciennes, son *Jeu de Jeunes Spartiates, La Sémiramis*'.[172] But when he returns another day, he is brusquely rebuffed: 'Encore vous? Veuillez bien me f... la paix, je travaille.'[173] The extent to which this portrait of Degas differs from the more attractive one in Blanche's memoirs indicates the extent to which he had already become identified as the type of misanthropic artist around 1885. For as Blanche recalled, he was in fact 'avec nous dans l'intimité la plus complète... Il avait été comme un oncle vénéré, chéri, pour ma femme et ses sœurs, le dieu Terme de notre foyer.'[174] Moreover, it was precisely in 1885, during a summer

holiday in Dieppe, that Degas, far from 'detesting' his younger colleagues, portrayed three of them—Gervex, Sickert and Blanche himself—together with their friends and neighbours—Ludovic and Daniel Halévy and Boulanger-Cavé—in a remarkable composition [140] (L.824) whose brilliant design does not conceal his sympathetic understanding of their diverse personalities.[175]

In *Sodome et Gomorrhe*, too, Degas appears under his own name, but some traits of the fictional painter Elstir may also have been inspired by Proust's acquaintance with him and his work. A classmate of Daniel Halévy and an intimate friend of Madame Straus as well as Blanche, all of whom were well known to Degas, Proust would have had many opportunities to meet him in the early 1890s, and would surely have appreciated his penetrating observations of French society. How well he knew Degas's art is more difficult to determine: his own statement, in a letter to Blanche of 1919, that 'Cézanne, Degas, Renoir [sont des] peintres que je devine à peine et dont j'eusse été passionné de connaître des œuvres',[176] cannot be taken literally, since he had undoubtedly seen many of those works in the exhibitions organized by Durand-Ruel, in the publications which already proliferated before 1914, and in the collections of such friends as the Prince de Wagram and Blanche himself.[177] Some writers have therefore maintained that formally 'Proust a dû méditer Degas, ses artifices de mise en page et son goût des perspectives imprévues; c'est bien à quoi fait penser l'art d'Elstir',[178] and that iconographically too, 'Elstir's pictures giving intimate glimpses of women at their daily tasks bring definitely to mind the work of Degas'.[179] But the general opinion is that Elstir, a composite figure representing the type of the modern painter, is based primarily on Manet, Monet, Whistler and Turner, with whose art Proust was better acquainted, and above all on Helleu, whose life and work resemble Elstir's in many respects and whom Proust himself reportedly addressed as such.[180]

More rewarding are the explicit references to Degas in *Sodome et Gomorrhe*. Two of them are almost identical in form and seemingly conventional in content: a ballet dancer kept by a wealthy man is described as 'une figurante celle-là d'un genre fortement caracterisé, et qui attend encore son Degas', and again, a little further on, as 'un rat d'opéra d'une autre sorte, à laquelle il manque encore un Degas'.[181] But the curious repetition of the formula, and its real function as a simile for a kept boy rather than a girl, a simile whose very structure is ambivalent, make us wonder how much Proust had guessed or heard rumoured about Degas's fascination with sexually ambiguous subjects. The third reference to him occurs in a debate on the merits of Poussin and is of another order entirely. When Mme de Cambremer, a lady of rather

precious taste, affects to find Poussin 'un vieux poncif sans talent... le plus barbifiant des raseurs', Swann cleverly replies: 'M. Degas assure qu'il ne connaît rien de plus beau que les Poussin de Chantilly', and Mme de Cambremer, 'qui ne voulait pas être d'un autre avis que Degas', begins at once to revise her opinion.[182] Although published much later, this incident undoubtedly reflects the legend of Degas's cult of Poussin that had been current in the 1890s, when Proust would have known him. Both Meier-Graefe and George Moore comment on the fame of his copy after the 'Rape of the Sabines', the latter pretending it is 'as fine as the original',[183] and a friend of Gide indicates the reactionary basis of this cult in writing to Degas: 'Ce qui me plaît, c'est que vous n'aimez pas les Juifs et que vous lisez Libre Parole, et que vous trouvez comme moi que Poussin est un grand peintre français.'[184]

Clearly the situation had changed in the twenty-five years since Duranty's story Le Peintre Louis Martin was published and the fact that Degas was an 'artiste d'une rare intelligence, préoccupé d'idées... semblait étrange à la plupart de ses confrères'.[185] By the time Proust knew him, and even more by the time Sodome et Gomorrhe appeared, Degas's essentially intellectual approach to art, like his cult of Poussin, had become the basis for another, much narrower cult. Indeed, Degas himself had entered history by now, and the discussion of his complex relations to the literature of his time is necessarily concluded.

Appendix I. *La Cigale* in England

In December 1877, a few months after the opening in Paris of *La Cigale*, the comedy by Meilhac and Halévy on which Degas collaborated, an English version of it was produced on which his friend Whistler evidently also collaborated. In adapting it for the London stage, the producer John Hollingshead substituted for Impressionism, which was not yet widely known there, the work of Whistler, the most notorious local symbol of modernism and at that moment the subject of a controversy with Ruskin. Thus Marignan, the hero of *La Cigale*, becomes Pygmalion Flippit, 'an Artist of the future', who declares that he is a 'Harmonist in colours—in black and white, for example', and that he and his colleagues 'now call ourselves Harmonists, and our work harmonies or symphonies, according to colour'.[186] Once he even refers to 'my great master, Whistler', and in his memoirs Hollingshead adds that for this production 'a caricature of "Jim" Whistler was painted by Pellegrini, with the celebrated artist's consent'.[187] This is all the more intriguing in that Pellegrini, the popular cartoonist for *Vanity Fair*, was also a friend of Degas, who portrayed him, in an equally caricatural manner, in this very year (L.407); moreover, there is evidence in two of Degas's notebooks that in the same year he visited Pellegrini in London, and thus may even have witnessed a performance of *The Grasshopper*.[188]

In any event, when the caricature of Whistler was criticized in the press, Hollingshead insisted that 'Mr Whistler's consent was asked before he was painted', and

added that 'he attended the last rehearsal and approved of the dialogue', which is hardly surprising in view of his love of wit and satire.[189] The painting itself was later described by the Pennells, his devoted friends and biographers, in a rather deprecating tone: '[It] shows Whistler in evening dress, no necktie, and a gold chain to his monocle; and in a scene parodying the studios and artists of the day, it was pushed in on an easel, some say by Pellegrini, with the announcement, 'here is the inventor of black-and-white!'' It was a failure, and no wonder. It was impossible to see the point.'[190] Yet Whistler's printer Thomas Way, an equally loyal friend, recalled that 'the caricature in the "Grasshopper" was not a cause of offence to him, at least I have never heard any protest from him'.[191] What may in fact have offended him much more, at least in retrospect, was the scene in which Flippit's 'dual harmony in red and blue' was presented to a prospective buyer both right side up and upside down, since it was in the latter state that his own 'Nocturne in Black and Gold: The Falling Rocket' was shown to the court—apparently by accident, but with unfortunate consequences—during his suit against Ruskin the following year.[192] Ironically, the event thus illustrated perfectly what his protégé Oscar Wilde would later call life imitating art.

Appendix II. Degas's pictures in Moore's novels

In three novels published by George Moore in the 1880s, the decade when he was closest to the Impressionists and especially to Degas, there are allusions to specific pictures by the latter which parallel those in contemporary French literature and are therefore worth noting.[193]

In *A Modern Lover* (1883) three such pictures are described, in addition to the more or less easily recognized 'bar girls, railway trains and tennis players' of his colleagues and an unidentifiable 'flight of ballet girls' by himself. The first is 'a racecourse, . . . with some racers walking down to the post, the principal horse's head being cut in two by a long, white post, which divides the picture into equal halves'; this is obviously 'Jockeys avant la course' (L.649) of *c.* 1881.[194] The second is 'two washerwomen, one ironing and the other yawning', which is probably 'Les Repasseuses' (L.686) of *c.* 1882, since this is the only version that corresponds to Moore's description of it in a later essay as having 'sharp outlines upon a dark background'.[195] The third is 'neither more nor less than a group of peasant women bathing', and although this sounds at first like 'Petites paysannes se lavant à la mer, vers le soir' (L.377) of *c.* 1876, it is more likely—to judge again from the description in Moore's article of 'three large peasant women plunging into a river, not to bathe, but to wash or cool themselves (one drags a dog in after her)'—either 'Deux femmes au bain' (L.1075) or 'Femmes au bain' (L.1076), although the former shows only two women and the latter no dog, and both are generally dated *c.* 1890–5.[196]

In *A Mere Accident* (1887) there is, in addition to several fairly specific allusions to works by Manet, Monet and Renoir, a long description of one entitled '"The Drop Curtain" by Degas', which sheds an interesting light on the way such a composition was seen: 'The drop curtain is fast descending; only a yard of space remains. What a yardful of curious comment, what a satirical note on the preposterousness of human existence! . . . Look at the two principal dancers! They are down on their knees,

arms raised, bosoms advanced, skirts extended, a hundred coryphées are clustered about them. Leaning hands, uplifted necks, painted eyes, scarlet mouths, a piece of thigh, arched insteps, and all is blurred; vanity, animalism, indecency, absurdity, and all to be whelmed into oblivion in a moment.'[197] The picture is, of course, 'Le Baisser du rideau' (L.575), which had been exhibited in London in 1882.

Finally, in *Mike Fletcher* (1889) the hero's allusion to one of Degas's toilette scenes —'I know of no more degrading spectacle than that of a woman washing herself over a basin; Degas painted it once'—is specific enough for it to be identified as 'La Toilette' (L.787), which had appeared in the Impressionist exhibition of 1886.[198]

Notes and discussion

(1) This paper was first published in the *Burlington Magazine*, CXII, 1970, pp. 575–89, 674–88. I am grateful to the organizers of the Symposium for permitting its prior publication there.

(2) Among the most useful studies are: P. Dorbec, *Les Lettres françaises dans leurs rapports avec l'atelier de l'artiste*, Paris, 1929; L. Hautecœur, *Littérature et peinture en France du XVIIᵉ au XXᵉ siècle*, Paris, 1942; T. R. Bowie, *The Painter in French Fiction*, Chapel Hill, 1950; and J. Seznec, *Literature and the Visual Arts in Nineteenth Century France*, University of Hull, 1963.

(3) O. Redon, *Lettres, 1878–1916*, Paris, 1923, pp. 22–3, to Fabre, 1895.

(4) J. Fevre, *Mon Oncle Degas*, ed. P. Borel, Geneva, 1949, pp. 72–3; this is, however, a somewhat biased, unreliable source.

(5) P. Valéry, *Oeuvres*, ed. J. Hytier, Paris, 1966, II, p. 1208, from *Degas danse dessin*, 1936.

(6) Ibid., p. 1209. On Degas's poetry and its relation to his painting, cf. also J. Nepveu-Degas, 'Préface', *Huit sonnets d'Edgar Degas*, Paris, 1946, especially pp. 6–7, 14–22.

(7) E. Degas, *Lettres*, ed. M. Guérin, Paris, 1945, p. 69, to Bartholomé, 9 Sept. 1882. On their literary quality, cf. also the letter from George Moore to Daniel Halévy, ibid., pp. 259–61.

(8) Fevre, *Mon Oncle Degas*, pp. 50–1, 71–3; Nepveu-Degas, 'Préface', p. 11.

(9) Cf. Hautecœur, *Littérature et peinture en France*, Chs. IV, V, VI, where however there is little on Degas's own contacts with particular writers or texts.

(10) The standard account, in P. A. Lemoisne, *Degas et son oeuvre*, Paris, 1946–9, I, pp. 41–5, and that in P. Pool, 'The History Pictures of Edgar Degas and their Historical Background', *Apollo*, LXXX, 1964, pp. 306–11, focus on a few major works, ignoring a score of others in small canvases, drawings and notebooks. I plan to discuss all this material and its literary sources on another occasion.

(11) Fevre, *Mon Oncle Degas*, pp. 117, 50, 72, Flaubert's correspondence was first published in 1887–93.

(12) D. Halévy, *My Friend Degas*, trans. M. Curtiss, Middletown, Conn., 1964, pp. 97, 41–3. Perhaps an illustration of one of Dumas's *Mousquetaire* novels, although difficult to identify explicitly as such, is the small panel 'Le Duel' of c. 1865 (not in Lemoisne; cf. sale, Succession G. Viau, Hôtel Drouot, 11 Dec. 1942, lot 86).

(13) Manet's letter, formerly Collection of Jean Nepveu-Degas, Paris, reads as follows: 'Mardi. Mon cher Degas. Je viens vous demander de me renvoyer les deux volumes de Baudelaire que je vous ai prêtés. Hyppolite [sic] Babou me les demande pour faire une réponse à l'article de Scherer. Vous les aurez aussitôt qu'il en aura fini et ce ne sera pas long. Cordialités. E. Manet.' It must have been written in July 1869, shortly after Scherer's attack on Baudelaire was published; cf. E. Scherer, *Études sur la littérature contemporaine*, Paris, 1882–9, IV, pp. 281–91. Nepveu-Degas, 'Préface', pp. 11–12, refers to this letter, but assumes that it concerns *Les Fleurs du mal*.

(14) Lemoisne, *Degas et son œuvre*, II, No. 94; cited hereafter as L.94, etc.

(15) Cf. Judges 11 : 29–40, and W. O. Sypherd, *Jephthah and His Daughter*, Newark, Del., 1949, pp. 227–34, on earlier pictorial representations.

(16) E. Mitchell, 'La Fille de Jephté par Degas', *Gazette des beaux-arts*, XVIII, 1937, pp. 183–4 and Fig. 15; cf. also Figs. 11, 16.

(17) A. de Vigny, *Poèmes*, ed. F. Baldensperger, Paris, 1914, pp. 57–60, from *Poésies*, 1822; cf. pp. 383–403 on the many later editions. Fevre, *Mon Oncle Degas*, p. 117, lists Vigny first among Degas's favourite poets.

(18) Cf. Sypherd, *Jephthah and His Daughter*, pp. 129–80, for literary treatments before c. 1860.

(19) J. G. Clemenceau le Clercq, *L'Inspiration biblique dans l'œuvre poétique d'Alfred de Vigny*, Annemasse, 1937, pp. 46–58. On his

interest in the visual arts, cf. M. Citoleux, 'Vigny et les beaux-arts', *Revue universitaire*, XXXI, 1922, pp. 194–208, 276–92.
(20) G. Sand, *La Mare au Diable*, ed. P. Salomon and J. Mallion, Paris, 1956, pp. 161–2; first ed. 1846. Degas transcribed the entire passage from 'Sa cornette de mousseline claire' to 'plus profond et plus idéal', but without identifying it. I am indebted to Professor Seznec for doing that.
(21) Bibliothèque Nationale, Dc. 327d. réserve, Carnet I, p. 209; the text continues on to p. 212. Cf. J. S. Boggs, 'Degas Notebooks at the Bibliothèque Nationale', *Burlington Magazine*, C, 1958, pp. 201–5.
(22) Louvre, Cabinet des Dessins, Inv. No. 20. 644. Cf. A. E. Popham, *Drawings of the Early Flemish School*, New York, 1926, p. 23 and pl. 13.
(23) Sand, *La Mare au Diable*, pp. 4–5, 6–7.
(24) Ibid., editors' introduction, p. v. On her interest in the visual arts, cf. M. L.Hôpital, *La Notion d'artiste chez George Sand*, Paris, 1946, pp. 49–51, 162–70.
(25) P. Ganz, *The Paintings of Hans Holbein*, London, 1956, pls. 55, 47. A study for the Solothurn Virgin's head is in the Louvre; cf. P. Ganz, *Les Dessins de Hans Holbein le Jeune*, Geneva, n.d., I, pl. III, No. 5.
(26) For this identification, cf. Orangerie des Tuileries, *Degas*, Paris, 1937, No. 185.
(27) M. Allem, *Alfred de Musset*, Paris, 1911, pp. 165, 173, 181, 187. Cf. also M. Clouard, *Documents inédits sur Alfred de Musset*, Paris, 1900, pp. 13–19, on Charles Landelle's well-known portrait.
(28) B. Morisot, *Correspondance*, ed. D. Rouart, Paris, 1950, p. 23, to Edma Morisot, 18 March 1869.
(29) M.-L. Bataille and G. Wildenstein, *Berthe Morisot*, Paris, 1961, No. 19 and p. 15.
(30) P. Jamot and G. Wildenstein, *Manet*, Paris, 1932, no. 150 ('Le Balcon'), No. 48 ('Ballet espagnol'). A. de Leiris, *The Drawings of Edouard Manet*, Berkeley and Los Angeles, 1969, No. 175 ('Course de taureaux').
(31) Bibliothèque Nationale, Dc.327d. réserve, Carnet 27, pp. 6–7. Cf. Boggs, 'Degas Notebooks', pp. 200–1 and n. 45.
(32) C. Gould, *National Gallery Catalogues, The Sixteenth-Century Venetian School*, London, 1959, pp. 59–61.
(33) Clouard, *Documents inédits sur Alfred de Musset*, pp. 91–7, 106–9.
(34) A. de Musset, *Oeuvres complètes en prose*, ed. M. Allem and P. Courant, Paris, 1960, pp. 412–53, first published in 1838. On his own interest in the visual arts, cf. R. Bouyer, 'Musset, critique d'art', *Revue bleue*, XLVIII, 1910, pp. 789–92.
(35) Paris, formerly Collection of Ludovic Halévy, Carnet I, pp. 46–7. Cf. E. Degas, *Album de dessins*, Paris, 1949, unpaginated,

and the preface by D. Halévy; also J. Canu, *Barbey d'Aurevilly*, Paris, 1965, pp. 379–80.
(36) J.-P. Seguin, *Iconographie de Barbey d'Aurevilly*, Geneva, 1961, pl. 84 and caption. Cf. also the description of Barbey by Octave Uzanne, quoted in ibid., pl. 89, caption.
(37) Paris, formerly Collection of Ludovic Halévy, Carnet 2, p. 33. Reproduced in Degas, *Album de dessins*, unpaginated. The man shown exercising in another sketch on this page also appears to be Barbey, but on comparison with a sketch of him on p. 29, identified in Halévy's preface as William Busnach, the playwright who dramatized several of Zola's novels in the 1880s, he can be recognized as the latter.
(38) Halévy, *My Friend Degas*, pp. 61–2.
(39) J.-E. Blanche, *Propos de peintre, de David à Degas*, Paris, 1919, p. 303.
(40) Bibliothèque Nationale, Dc.327d. réserve, Carnet 8, p. 6. Cf. Boggs, 'Degas Notebooks', p. 243, where however the source is not identified. Barbey's aphorism appeared in *Le Nain jaune*, 7 April 1867, as 'Quelques bouts d'idées', No. CXXIX; I am indebted to Professor Julius Kaplan for this information.
(41) Degas, *Lettres*, p. 79, to Bartholomé, 16 Aug. 1884; ibid., p. 133, to the same, 9 Sept. 1889. According to D. Halévy, *Pays parisiens*, Paris, 1929, p. 52, Degas illustrated one episode in *The Arabian Nights*.
(42) W. Rothenstein, *Men and Memories*, New York, 1931, I, p. 159; also n. 43, below.
(43) Fevre, *Mon Oncle Degas*, p. 73 and n. 1 On Maupassant and the visual arts, cf. A. Vial, *Guy de Maupassant et l'art du roman*, Paris, 1954, pp. 335–8, and G. de Lacaze-Duthiers, 'Guy de Maupassant critique d'art', *La Revue mondiale*, CLXVI, 1925, pp. 169–72.
(44) F. Steegmuller, *Maupassant, A lion in the Path*, New York, 1949, pp. 402–3. Degas's monotypes, although used by Vollard to 'illustrate' a later edition of *La Maison Tellier*, were of course not conceived as such.
(45) M. Crouzet, *Un Méconnu du réalisme, Duranty*, Paris, 1964, p. 335. However, according to Lemoisne, *Degas et son œuvre*, I, pp. 49–50, they had met as early as 1861–3.
(46) Crouzet, *Un Méconnu du réalisme*, pp. 335–6.
(47) The following discussion is based on T. Reff, 'The Pictures within Degas's Pictures', *Metropolitan Museum Journal*, I, 1968, pp. 143–7.
(48) L.-E. Duranty, 'Sur la physiognomie', *La Revue libérale*, II, 1867, pp. 499–523. Like Degas, he argues for a more precise and nuanced theory than Lavater's, and adds: 'A l'heure qu'il est, on est plus habile que Lavater et il ne lutterait pas contre un

romancier de ce temps ci' (ibid., p. 510).
(**49**) Bibliothèque Nationale, Dc.327d. réserve, Carnet 21, pp. 44–7. Cf. Boggs, 'Degas Notebooks', pp. 243-4. The quotation continues : 'C'est du Lavater, mais du Lavater plus relatif, en quelque sorte.'
(**50**) Bibliothèque Nationale, Dc.327d. réserve, Carnet 24, pp. 36, 37, 39. Cf. Boggs, 'Degas Notebooks', p. 244 and fig. 39 (reproducing p. 37, not p. 39).
(**51**) Crouzet, *Un Méconnu du réalisme*, p. 337, from 'le Salon de 1869', *Paris*, 14 May 1869. On his art criticism, cf. R. Baschet, 'La Critique d'art de Duranty', *Revue des sciences humaines*, No. 125, 1967, pp. 125–135.
(**52**) Crouzet, *Un Méconnu du réalisme*, pp. 315–16. Published in *Le Siècle*, 13–16 Nov. 1872, it was reprinted in L.-E. Duranty, *Le Pays des arts*, Paris, 1881, pp. 315–50.
(**53**) T. Reff, 'New Light on Degas's Copies', *Burlington Magazine*, CVI, 1964, p. 255. Cf. Duranty, *Le Pays des arts*, pp. 335–6.
(**54**) Ibid., p. 337.
(**55**) Ibid., p. 335. Duranty was, however, also critical of Degas's work at this time ; cf. Crouzet, *Un Méconnu du réalisme*, p. 335.
(**56**) L.-E. Duranty, *La Nouvelle Peinture*, ed. M. Guérin, Paris, 1946, p. 43. On this work cf. Guérin's preface, and O. Reuterswürd, 'An Unintentional Exegete of Impressionism', *Konsthistorisk Tijdskrift*, IV, 1949, pp. 111–115.
(**57**) Duranty, *La Nouvelle Peinture*, p. 45.
(**58**) Ibid. The works alluded to are 'Portraits dans un Bureau, Nouvelle-Orléans' (L.320), 'Danseuses se préparant au ballet' (L.512) and 'Repasseuse à contre-jour' (L.356), all of which were exhibited in 1876.
(**59**) Crouzet, *Un Méconnu du réalisme*, p. 653, from an untitled article in *Réalisme*, 15 Jan. 1857.
(**60**) Ibid., pp. 652–60. Precisely its lack of descriptive detail is in fact what makes Duranty's novel *Les Combats de Françoise du Quesnoy* (1873, but serialized earlier) an unlikely source for Degas's picture 'Le Viol' (L.348), despite the statement of an acquaintance that he had planned to illustrate it ; cf. G. Rivière, *Mr. Degas, Bourgeois de Paris*, Paris, 1935, pp. 97–8. On the literary source of 'Le Viol', cf. Crouzet, *Un Méconnu du réalisme*, p. 335, n. 106, and the discussion below.
(**61**) É. Zola, *Oeuvres complètes*, ed. H. Mitterand, Paris, 1966–8, XI, pp. 74–6, from *Les Romanciers naturalistes* (1881).
(**62**) Ibid., Cf. also Zola's definition of description as 'la peinture nécessaire du milieu', in his *Oeuvres complètes*, X, p. 1301, from *Le Roman expérimental* (1880).
(**63**) É. Zola, *Salons*, ed. F. W. J. Hemmings

and R. J. Niess, Geneva, 1959, p. 195, from 'Deux expositions d'art au mois de mai', *le Messager de l'Europe*, June 1876.
(**64**) Ibid., pp. 239–40, from 'Le Naturalisme au Salon', *Le Voltaire*, 18–22 June 1880.
(**65**) 'Zola juge l'Impressionisme', *Les Nouvelles littéraires*, 2 Feb. 1967, p. 9, from *Le Sémaphore de Marseille*, c. 16 April 1877. On his little-known exhibition reviews for this newspaper, cf. R. J. Niess, 'Émile Zola and Impressionism in Painting', *The American Society Legion of Honor Magazine*, XXXIX, 1968, pp. 89–90.
(**66**) É. Zola, *Correspondance (1872–1902)*, ed. M. Le Blond, Paris, 1929, pp. 594–5, to Huysmans, 10 May 1883. Edmond de Goncourt described Degas in precisely the same terms ; cf. F. W. J. Hemmings, 'Émile Zola critique d'art', in Zola, *Salons*, p. 38, n. 69.
(**67**) G. Moore, *Impressions and Opinions*, London, 1891, p. 319.
(**68**) D. Halévy, *Degas parle...*, Paris and Geneva, 1960, p. 48.
(**69**) Ibid., p. 47. Cf. also Rivière, *Mr. Degas*, p. 142, on his rejection of 'l'exagération du naturalisme tourné au crapulisme' in Zola's novels.
(**70**) Valéry, *Oeuvres*, II, p. 1226, from 'Souvenirs de Berthe Morisot sur Degas', *Degas danse dessin*, 1936.
(**71**) Ibid. Cf. also the story told here of Degas's sarcastic remarks to Daudet.
(**72**) Moore, *Impressions and Opinions*, pp. 298–9. On his contacts with French writers, cf. G.-P. Collet, *George Moore et la France*, Geneva and Paris, 1957, especially pp. 19–21, 122–47 on Zola.
(**73**) C. Pissaro, *Lettres à son fils Lucien*, ed. J. Rewald, Paris, 1950, p. 93, dated 5 Feb. 1886 ; cf. also pp. 99–100, dated March 1886.
(**74**) Q. Bell, *Degas, Le Viol*, Newcastle upon Tyne, 1965, unpaginated. This observation was first made by J. Adhémar in Bibliothèque Nationale, *Émile Zola*, Paris, 1952, No. 114, but with reference to the dramatic version *La Madeleine*, which was written in 1865 but not produced until 1889 (ibid., No. 111).
(**75**) Illustrated and described in *Huit sonnets d'Edgar Degas*, pp. 13, 45. On the publication of 'Madeleine Férat' in *L'Événement* and the latter's popularity, cf. H. and J. Adhémar, 'Zola et la peinture', *Arts*, No. 389, 12–18 Dec. 1952.
(**76**) Bell, *Degas, Le Viol*, unpaginated. For the text cf. Zola, *Oeuvres complètes*, I, pp. 819–20, 845–6. Appropriately, Zola dedicated the novel to a painter and, in sending a copy to a colleague, referred to his 'grand talent d'observateur et de peintre' ; cf. Bibliothèque Nationale, *Émile Zola*, Nos. 112, 113.
(**77**) Zola, *Oeuvres complètes*, I, pp. 831–4.

(77a) After submitting this essay for publication, I discovered a more likely literary source in the dramatic wedding-night scene in Zola's previous novel *Thérèse Raquin* (1867). I plan to discuss this and other aspects of 'Le Viol' on another occasion.

(78) Sale, Atelier Edgar Degas, Galerie Georges Petit, 2–4 July 1919, lot 266b. Another study for the setting of 'Le Viol' is in Bibliothèque Nationale, Dc.327d. réserve, Carnet 8, p. 98.

(79) For other aspects of the symbolism of this scene, cf. J. C. Lapp, *Zola before the Rougon-Macquart,* Toronto, 1964, pp. 124–5.

(80) J.-K. Huysmans, *Oeuvres completes,* Paris, 1928–9, VI, pp. 136–7, from *L'Art moderne,* 1883.

(81) Rivière, *Mr Degas,* pp. 104–7. Cf. also K. V. Maur, 'Edmond de Goncourt et les artistes de la fin du XIXᵉ siécle', *Gazette des beaux-arts,* LXXII, 1968, pp. 214–17.

(82) Moore, *Impressions and Opinions,* p. 308, reporting a conversation that took place at the Cirque Fernando.

(83) Rivière, *Mr. Degas,* pp. 104–7.

(84) J. Barbey d'Aurevilly, 'Les Frères Zemganno', *Le Constitutionnel,* 12 May 1879, quoted in H. Trudgian, *L'Évolution des idées esthétiques de J.-K. Huysmans,* Paris, 1934, pp. 120–1.

(85) Paris, formerly Collection of Ludovic Halévy, Carnet I, pp. 13v–14, 15, 16, 17, 18, 23, 33. Cf. Degas, *Album de dessins,* unpaginated, and E. de Goncourt, *La Fille Elisa,* Paris, 1877, pp. 113–21.

(86) Ibid., pp. iii–v. By contrast, when Toulouse-Lautrec began to illustrate the novel a decade later—supposedly on the urging of Degas, among others—he depicted all its aspects and characters; cf. the facsimile edition with his watercolours, Paris, 1931.

(87) G. Geffroy, *Constantin Guys, l'historien du Second Empire,* Paris, 1904, pp. 144–8. Cf. the detailed discussion in R. Ricatte, *La Genèse de 'La Fille Elisa',* Paris, 1960, pp. 140–54.

(88) E. and J. de Goncourt, *Journal, mémoires de la vie littéraire,* ed. R. Ricatte, Monaco, 1956, XXI, p. 41, dated 22 April 1895. Cf. also J. Adhémar, 'Lettres adressées aux Goncourt, concernant les beaux-arts, conservées à la Bibliothèque Nationale', *Gazette des beaux-art,* LXXII, 1968, p. 235.

(89) Degas, *Lettres,* p. 86, to Ludovic Halévy, undated (1884). Cf. also p. 63, to Henri Rouart, 2 May 1882, and p. 107, to Bartholomé, undated (*c.* 1885).

(90) Goncourt, *Journal,* X, pp. 163–5, dated 13 Feb. 1874. Cf. also XV, p. 86, dated 26 Feb. 1888, a pointed attack on Degas, Raffaëlli and others.

(91) Ibid., X, p. 164, n. 1, an addendum of 1891.

(92) J. Elias, 'Degas', *Die Neue Rundschau,* XXVIII, 1917, p. 1566. On the significance of *Manette Salomon* for Degas, cf. Lemoisne, *Degas et son œuvre,* I, pp. 98–9.

(93) R. Ricatte, *La Création romanesque chez les Goncourt, 1851–1870,* Paris, 1953, p. 370, n. 189, and pp. 365–6.

(94) Rothenstein, *Men and Memories,* I, p. 159. Cf. also Edmond's bitter remarks, in Goncourt, *Journal,* XV, pp. 109–10, dated 8 May 1888.

(95) These parallels were first drawn by F. Fosca [Traz], *Edmond et Jules de Goncourt,* Paris, 1941, pp. 357–9, but with little attempt to analyse their significance.

(96) Goncourt, *Journal,* V. pp. 72–3, dated 12 March 1862. For other relevant passages, cf. IV, pp. 162–3, dated 6 March 1861, and VI, pp. 70–1, dated 22 May 1863.

(97) Valéry, *Oeuvres,* II, p. 1236, from the memoir by Ernest Rouart, transcribed in *Degas danse dessin,* 1936. On Degas's early interest in Rembrandt, cf. Reff, 'New Light on Degas's Copies', p. 251.

(98) Ricatte, *La Création romanesque chez les Goncourt,* p. 59.

(98a) After submitting this essay for publication, I discovered a caricature of Edmond de Goncourt in a notebook used by Degas in 1878–9, with Edmond's address written above it in his own hand. Cf. Bibliothèque Nationale, Dc.327d. réserve, Carnet 23, p. 85, and the photographs in L. Deffoux, *Chronique de l'Académie Goncourt,* Paris, 1909, opposite pp. 40 and 112.

(99) Pissarro, *Lettres à son fils Lucien,* pp. 44–5, dated 13 May 1883.

(100) P. Ward-Jackson, 'Art Historians and Art Critics VIII: Huysmans', *Burlington Magazine,* CIX, 1967, p. 618. For a more positive view, cf. H. Jouvin, 'Huysmans critique d'art', *Cahiers J.-K. Huysmans,* No. 20, 1947, pp. 356–75.

(101) Huysmans, *Oeuvres complètes,* VI, pp. 130–1, from a review in *La Gazette des amateurs,* 1876, reprinted in *L'Art moderne,* 1883.

(102) Ibid., VIII, pp. 19–20, from *Croquis parisiens,* 1880. The relation of such a passage to Degas's ballet pictures is suggested in G. Cevasco, 'J.-K. Huysmans and the Impressionists', *Journal of Aesthetics and Art Criticism,* XVII, 1958, p. 203.

(103) M. Harry, *Trois ombres,* Paris, 1932, pp. 26–7. Cf. also R. Baldick, *The Life of J.-K. Huysmans,* Oxford, 1955, p. 60.

(104) Huysmans, *Oeuvres complètes,* IV, pp. 119–20, from *En ménage,* 1881.

(105) E.g. *'Les Coulisses de l'Opéra en 1880'* (sale, Hôtel Drouot, 10 June 1937, lot 36), 'Dans les coulisses' (sale, Sotheby's, 3 July

1968, lot 1), and 'Protecteur et danseuses dans les coulisses' (sale, Sotheby's, 30 April 1969, lot 248). On their friendship, cf. J. Jacquinot, 'Deux amis: Huysmans et Forain', *Cahiers J.-K. Huysmans*, No. 38, 1959, pp. 440–9.

(**106**) Huysmans, *Oeuvres complètes*, VIII, pp. 15–17, from *Croquis parisiens*, 1880. On its relation to *Les Frères Zemganno*, cf. Trudgian, *L'Évolution des idées esthétiques de J.-K. Huysmans*, pp. 120–1.

(**107**) M. Guérin, *J.-L. Forain, aquafortiste*, Paris, 1912, I, Nos. 17, 20; cf. also No. 8 bis, 'Le Bar des Folies-Bergère' (1878–80), and Huysmans's own comments on Forain's painted versions of the same subjects, in *L'Art moderne*, his *Oeuvres complètes*, VI, pp. 122–3.

(**108**) Ibid., p. 137.

(**109**) J. S. Boggs, *Drawings by Degas*, St Louis, 1967, No. 84.

(**110**) Interesting in this respect is Degas's conviction, 'L'art c'est le vice. On ne l'épouse pas, on le viole. Qui dit art, dit artifice. L'art est malhonnête et cruel.' J.-M. Lhôte, *Les Mots de Degas*, Paris, 1967, p. 41.

(**111**) Cf., for example, E. P. Janis, *Degas Monotypes*, Cambridge, Mass., 1967, No. 83. For the comparable text, cf. Huysmans, *Oeuvres complètes*, II, pp. 34–5, from *Marthe, histoire d'une fille*, 1876.

(**112**) Ibid., p. 35. For the history of its publication, cf. ibid., pp. 141–8.

(**113**) Janis, *Degas Monotypes*, No. 82.

(**114**) Ibid., No. 73. On the series of brothel monotypes, cf. ibid., pp. xix–xxi, where however a specific relation to Huysmans's novel is denied.

(**115**) Guérin, *J.-L. Forain, aquafortiste*, I, Nos. 12, 13. However, in *L'Art moderne* Huysmans does express admiration for Forain's brothel scenes, especially a large one entitled 'Le Client'; cf. his *Oeuvres complètes*, VI, pp. 125–6, and sale, Nicolas Rauch S.A. (Geneva), 13–15 June 1960, lot 477.

(**116**) E. Brieux, *Discours de réception à l'Académie française*, Paris, 1910, pp. 11–13.

(**117**) L. Halévy, 'Carnets', *Revue des deux mondes*, XLII, 1937, p. 823, dated 15 April 1879.

(**118**) Ibid., XLIII, 1938, p. 399, dated 1 Jan. 1882.

(**119**) H. Roujon, 'En Souvenir de Ludovic Halévy', *Revue de Paris*, XI, No. 4, 1908, pp. 50–1.

(**120**) Janis, *Degas Monotypes*, No. 198; cf. the related images, Nos. 195–7.

(**121**) L. Halévy, *La Famille Cardinal*, Paris, 1883, pp. 1–5. The first edition, with illustrations by Henri Maigrot, or Henriot, had

appeared in 1880; cf. Janis, *Degas Monotypes*, p. xxi.

(**122**) Ibid., No. 220; cf. also Nos. 218, 219.

(**123**) Halévy, *La Famille Cardinal*, pp. 68–70.

(**124**) Ibid., pp. 23–8. Cf. Janis, *Degas Monotypes*, No. 205 (illustrated here) and No. 204.

(**125**) Ibid., pp. xxi–xxii, based on information from Mrs Mina Curtiss, who had access to the Halévy archives.

(**126**) É. Zola, *Oeuvres complètes*, ed. H. Mitterand, Paris, 1966–8, XI, p. 716, from a review in *Le Bien public*, 15 Oct. 1877, reprinted in *Nos auteurs dramatiques*, 1881. For the stage directions, cf. H. Meilhac and L. Halévy, *Théâtre*, Paris, 1900–2, III, p. 107, from *La Cigale*, first produced on 6 Oct. 1877.

(**127**) Degas, *Lettres*, pp. 41–2, to Ludovic Halévy, Sep. 1877. Cf. also his letter to Halévy, of Sept. 1891, ibid., p. 190, concerning a new production of *La Cigale*. On the earlier collaboration, cf. L. Tannenbaum 'La Cigale, by Henri Meilhac and Ludovic Halévy—and Edgar Degas', *Art News*, LXV, No. 9, Jan. 1967, pp. 55, 71.

(**128**) Rivière, *Mr. Degas*, pp. 88, 91.

(**129**) Duranty, *La Nouvelle Peinture*, pp. 28–29, Cf. Meilhac and Halévy, *Théâtre*, III, p. 17.

(**130**) Ibid., pp. 88–9.

(**131**) Paris, formerly Collection of Ludovic Halévy, Carnet 2, pp. 11, 12. Cf. Degas, *Album de dessins*, unpaginated, and Meilhac and Halévy, *Théâtre*, III, p. 120. Since none of Degas's laundress pictures actually shows this subject, the allusion may instead be to the famous scene of Gervaise washing linen in Zola's novel *L'Assommoir*, which had appeared early in 1877.

(**132**) Meilhac and Halévy, *Théâtre*, III, pp. 124–5.

(**133**) E.g. Courbet's 'Mer orageuse', 1870, and Jules Dupré's 'Coucher de soleil sur la mer', c. 1871; cf. C. Sterling and H. Adhémar, *Musée du Louvre, peintures, École française, XIXᵉ siècle*, Paris, 1958–61, I, No. 484, and II, No. 817.

(**134**) Cf. also the other pastels in this series (L.217–53), especially 'Cavaliers et promeneurs au bord de la mer' (L.218), which has a narrow vertical format like Marignan's composition.

(**135**) Goncourt, *Journal*, XIV, p. 23, dated 24 July 1885. Cf. Maur, 'Edmond de Goncourt et les artistes de la fin du XIXᵉ siècle', pp. 223–4.

(**136**) Halévy, *My Friend Degas*, pp. 56–7. Cf. E. Dujardin, *Antonia, tragédie moderne*, Paris, 1891, first produced on 20 April 1891.

(**137**) A. Gide, *Oeuvres complètes*, ed. L. Martin-Chauffier, Paris, 1932–8, II, p. 486 letter to Ernest Rouart, 24 Jan. 1898; IV,

pp. 423–31, from 'Promenade au salon d'automne', 1905; V, pp. 285–7, from 'Witold Wojtkiewicz', 1907. Cf. also A. Gide, *Journal, 1889–1939*, Paris, 1951, pp. 127–8, dated 6 Feb. 1902, and pp. 274–5, dated 4 July 1909.
(**138**) Cf. respectively E. Degas, *Letters*, trans. M. Kay, Oxford, 1947, p. 64, to Christian Cherfils, *c.* 1889; Halévy, *My Friend Degas,* pp. 76–7; and C. Cros, *Oeuvres complètes,* ed. L. Forestier and P. Pia, Paris, 1964, p. 88, from *Le Coffret de Santal,* 2nd ed., 1879.
(**139**) S. Mallarmé, 'The Impressionists and Édouard Manet', *Art Monthly Review*, I, 1876, p. 121. Cf. J. C. Harris, 'A Little-Known Essay on Manet by Stéphane Mallarmé', *Art Bulletin*, XLVI, 1964, pp. 559–563.
(**140**) Valéry, *Oeuvres*, II, p. 1191, from *Degas danse dessin*, 1936. For the date of this photograph, usually given incorrectly as *c.* 1890, cf. Halévy, *My Friend Degas*, p. 73.
(**141**) H. de Régnier, *Nos rencontres*, Paris, 1931, pp. 201–3, from 'Mallarmé et les peintres', pp. 195–214. On this subject, cf. also W. Fowlie, 'Mallarmé and the Painters of His Age', *Southern Review,* II, 1966, pp. 542–58.
(**142**) Valéry, *Oeuvres*, II, pp. 1181–4, from *Degas danse dessin*, 1936.
(**143**) S. Mallarmé, *Oeuvres complètes*, ed. H. Mondor and G. Jean–Aubry, Paris, 1956, pp. 1523, 1536 on the earlier project, pp. 1403–4 on the later one. On the former, cf. also S. Mallarmé, *Correspondance*, ed. H. Mondor and L. J. Austin, Paris, 1959–, III, p. 162, to Emile Verhaeren, 15 Jan. 1888, and p. 254, n. 2, unpublished letter from Degas to Mallarmé, 30 Aug. 1888. I am indebted to Professor Austin for this information.
(**144**) Mallarmé, *Oeuvres complètes*, pp. 303–7, from 'Ballets', 1886. Cf. also ibid., pp. 307–9, from 'Autre étude de danse', 1893.
(**145**) Morisot, *Correspondance*, p. 145, from Mallarmé to Morisot, 17 Feb. 1889. Cf. Degas, *Lettres*, p. 87, to Mallarmé (?), *c.* 1889: 'Je vous admire, vous pouvez jouer avec des pareils poids…'
(**146**) Valéry, *Oeuvres*, II, p. 1208, from *Degas danse dessin*, 1936.
(**147**) Ibid., pp. 1208–9. On the significance of this doctrine for Valéry's own aesthetic, cf. R. A. Pelmont, *Paul Valéry et les beaux-arts*, Cambridge, Mass., 1949, pp. 79–83.
(**148**) Ibid., pp. 30–2, 105–7. For a more negative view, cf. A. Lhote, 'Degas et Valéry', *Nouvelle revue française,* LII, 1939, pp. 133–42.
(**149**) A. Gide and P. Valéry, *Correspondance, 1890–1942*, ed. R. Mallet, Paris, 1955, p. 260, to Gide, 7 Feb. 1896.

(**150**) Valéry, *Oeuvres*, II, p. 1168, from *Degas danse dessin*, 1936.
(**151**) C. A. Hackett, 'Teste and *La Soirée avec Monsieur Teste*', *French Studies*, XXI, 1967, pp. 112–13. Cf. also Valéry, *Oeuvres*, II, pp. 1383–4, from a memoir by Edmond Jaloux, and p. 1379 on the date of *La Soirée*.
(**152**) Ibid., p. 1168, from *Degas danse dessin*, 1936.
(**153**) Cf. his letters to Gide, 5 Oct. 1896 and 11 March 1898, on recent Degas exhibitions, also 14 Feb. 1898 on photographs; Gide and Valéry, *Correspondance*, pp. 281, 314, 312 respectively.
(**154**) Valéry, *Oeuvres*, II, pp. 20–1, from *La Soirée avec Monsieur Teste*, 1896.
(**155**) Ibid., p. 1386, letter from Eugène Rouart to Valéry, 27 Sept. 1896. On the proposed dedication, cf. also Gide and Valéry, *Correspondance*, p. 261, from Gide to Valéry, 25 March 1896, and pp. 277–8, from Valéry to Rouart, 19 Sept. 1896.
(**156**) Ibid., p. 316, from Valéry to Gide, 28 March 1898.
(**157**) B. Nicolson, 'Degas as a Human Being', *Burlington Magazine*, CV, 1963, p. 240.
(**158**) A. Vollard, *Degas, An Intimate Portrait*, trans. R. T. Weaver, New York, 1927, pp. 32–4. On Mirbeau's art criticism, cf. F. Cachin, 'Un Défenseur oublié de l'art moderne'', *L'Oeil*, No. 90, June 1962, pp. 50–5, 75.
(**159**) M. Schwarz, *Octave Mirbeau, vie et œuvre*, The Hague, 1966, pp. 47–57, where however the relation to Degas is overlooked. For that, cf. J. Rewald, *The History of Impressionism*, New York, 1961, p. 627.
(**160**) O. Mirbeau, *Le Calvaire*, Paris, 1925, pp. 78–80; written in 1886, first ed. 1887.
(**161**) Ibid., pp. 81–3. Cf. the comments on Degas in O. Mirbeau, *Des artistes, deuxième série*, Paris, 1924, p. 66, from *Le Journal*, 13 Nov. 1898.
(**162**) C. Mauclair, *La Ville lumière*, Paris, 1903, p. 15. On its topical significance, cf. Bowie, *The Painter in French Fiction*, pp. 10, 14–15, 19, etc. I am indebted to Professor Bowie for help in locating a copy of this rare novel.
(**163**) Mauclair, *La Ville lumière*, pp. 39–41.
(**164**) Ibid., p. 40.
(**165**) Cf. G. Jean-Aubry, *Camille Mauclair*, Paris, 1905, especially pp. 28–9.
(**166**) Mauclair, *La Ville lumière*, pp. 183–5.
(**167**) C. Mauclair, *L'Impressionnisme, son histoire, son esthétique, ses maîtres*, Paris, 1904, p. 86. He later published several monographs on Degas and Impressionism.
(**168**) Pissarro, *Lettres à son fils Lucien*, p. 344, dated 29 May 1894; cf. Rewald's remarks on Mauclair in ibid., n. 1.
(**169**) J.-E. Blanche, *Propos de peintre, de David à Degas*, Paris, 1919, pp. i–xxxv. Cf.

ibid., pp. 286–308 on Degas, part of an article from the *Revue de Paris,* XX, 1913, pp. 377–92.
(**170**) J.-E. Blanche, *Aymeris,* Paris, 1922, p. 106; largely written 1911–14. On its autobiographical elements, cf. J.-E. Blanche, *La Pêche aux souvenirs,* Paris, 1949, pp. 91–2.
(**171**) Blanche, *Aymeris,* pp. 111–12, 116.
(**172**) Ibid., p. 117. The references are of course to 'Petites filles spartiates provoquant des garçons' (L.70) and 'Sémiramis construisant une ville' (L.82).
(**173**) Ibid., p. 119. Cf. also p. 204, where Aymeris quotes one of Degas's sayings.
(**174**) S. Barazzetti, 'Jacques-Emile Blanche, portraitiste de Degas', *Beaux-Arts,* 19 March 1937, p. 3; based on an interview with him.
(**175**) Cf. Blanche, *Propos de peintre,* p. 296, and J. S. Boggs, *Portraits by Degas,* Berkeley and Los Angeles, 1962, pp. 70–2.
(**176**) M. Proust, *Correspondance générale,* ed. R. Proust and P. Brach, Paris, 1930–6, III, p. 156, to Blanche, 25 Jan. 1919.
(**177**) J. Monnin-Hornung, *Proust et la peinture,* Geneva, 1951, p. 19. For works owned by Blanche, cf. L.430, 444, 824, 1118; for those owned by the Prince de Wagram, L. 362, 476, 530, 1297.
(**178**) R. Allard, 'Les Arts plastiques dans l'œuvre de Marcel Proust', *Nouvelle revue française,* XX, 1923, pp. 228–9.
(**179**) M. E. Chernowitz, *Proust and Painting,* New York, 1944, pp. 115–16.
(**180**) P. Howard-Johnston, 'Bonjour M. Elstir', *Gazette de beaux arts,* LXIX, 1967, pp. 247–50. Cf. also Monnin-Hornung, *Proust et la peinture,* pp. 72–101, especially pp. 95–100.
(**181**) M. Proust, *A la recherche du temps perdu,* ed. P. Clarac and A. Ferré, Paris, 1964–5, II, pp. 844–5, from *Sodome et Gomorrhe,* 1922.
(**182**) Ibid., pp. 811–13. In another passage (ibid., p. 811) the same lady declares: 'Monet, Degas, Manet, oui, voilà des peintres.'
(**183**) Moore, *Impressions and Opinions,* p. 321; the date that he gives, 1840, is presumably a misprint. Cf. J. Meier-Graefe, *Degas,* trans. J. Holroyd-Reece, New York, 1923, pp. 22–3, referring to the 1890s.
(**184**) Gide, *Journal,* p. 77, quoting a letter from Athman ben Sala to Degas, 1896. On the reactionary neo-classicism of *c.* 1900, cf. T. Reff, 'Cezanne and Poussin', *Journal of the Warburg and Courtauld Institutes,* XXIII, 1960, pp. 164–9.
(**185**) Duranty, *Le Pays des arts,* p. 335, from 'Le Peintre Louis Martin', 1872.

(**186**) J. Hollingshead, *The Grasshopper, A Drama in Three Acts, Adapted from 'La Cigale' by MM. Meilhac and Halévy,* London, 1877, p. 27; first produced at the Gaiety Theatre, 10 Dec. 1877.
(**187**) J. Hollingshead, *My Lifetime,* London, 1895, II, pp. 120–1.
(**188**) Bibliothèque Nationale, Dc.327d. réserve, Carnet 3, pp. 8, 18, 28, 34, 98, and Carnet 7, pp. 4, 50, 78, 98, the addresses of Pellegrini and others in London. On Degas's portrait of him, cf. Boggs, *Portraits by Degas,* p. 53.
(**189**) Hollingshead, *My Lifetime,* II, pp. 154–5, from an article in the *Daily News,* 14 Dec. 1877.
(**190**) E. R. and J. Pennell, *The Life of James McNeill Whistler,* Philadelphia, 1911, p. 157. The painting was formerly in the collection of John W. Simpson, New York.
(**191**) T. R. Way, *Memories of James McNeill Whistler,* London, 1912, pp. 21–2.
(**192**) Pennell, *The Life of James McNeill Whistler,* p. 170. There is evidently no connection between Whistler's part in *The Grasshopper* and his later painting of a nude entitled 'La Cigale', illustrated in D. Sutton, *Nocturne: The Art of James McNeill Whistler,* London, 1964, pl. 116.
(**193**) On their relationship, cf. R. Pickvance, 'A Newly Discovered Drawing by Degas of George Moore', *Burlington Magazine,* CV, 1963, pp. 276–80, on which the following discussion is largely based; however, the drawing in question is probably not by Degas.
(**194**) G. Moore, *A Modern Lover,* London, 1883, II, pp. 89–90.
(**195**) Ibid., III, p. 98. Cf. Moore, *Impressions and Opinions,* p. 316.
(**196**) Moore, *A Modern Lover,* III, p. 98. Cf. Moore, *Impressions and Opinions,* p. 318.
(**197**) G. Moore, *A Mere Accident,* London, 1887, pp. 72–4.
(**198**) G. Moore, *Mike Fletcher,* London, 1889, p. 178.

The discussion showed that the problem of a possible literary source for Degas's 'Semiramis' has so far remained unsolved, although mention was made in this connection of 18th and 19th century popular theatre. Degas's 'Semiramis' was known to have preoccupied Paul Valéry. Prof. Reff found that literary sources hitherto proposed for Degas's picture 'Le Viol' unsatisfactory and was not prepared to exclude the possibility that the picture only gave the appearance of having a literary source. (But cf. now note 77a, above).

Lloyd James Austin

10
Mallarmé and the visual arts

Among the many English and American books received by Mallarmé and still piously preserved at his little house at Valvins,[1] near Fontainebleau, overlooking the Seine and the forest on the farther bank, there is one of particular interest for us. It is called *Lazy Tours in Spain and Elsewhere,* and it contains this inscription, written on the flyleaf: 'To / Stéphane Mallarmé / with the affectionate / greetings of— / Louise Chandler Moulton / Christmas 1896.' Within it is a slip of paper, on which the same hand has written: 'See page 171.' If we do so, what we find is this passage:

It was M. Stéphane Mallarmé, the poet,—one of the best art critics I know,—who took me to see the impressionist pictures at the gallery of Boussod, Valadon, & Co., on the Boulevard Montmartre, and at both the gallery and the house of M. Durand-Ruel, who is said to have the finest collection of impressionist pictures owned by any one man. M. Mallarmé wrote me a list of the living impressionist masters in, approximately, the order of their importance. It reads thus: Claude Monet, Renoir, Degas, Sisley, Pissarro, Mme Berthe Manet [Morisot], and Raffaëlli. Having handed me this list, he took it back again, and added the name of an American lady, Miss Mary Cassatt, who was of too much consequence, so he said, to be ignored in selecting his chosen few.

Louise Chandler Moulton need not detain us here.[2] What matters is Mallarmé's selection and classification of 'living impressionist painters'. A comprehensive list of his artist friends would also include Manet (who had died in 1883), Whistler, Odilon Redon, Gauguin, Vuillard, Jacques-Émile Blanche, Auguste Rodin and many others.[3]

Mallarmé's personal acquaintance or friendship with the leading artists of his time is well known in general terms, and certain aspects have been studied in some detail. With most of them he exchanged letters. Those he received have been for the most part preserved at Valvins. Many of those he wrote have been lost, destroyed or dispersed in sales; but many have been discovered and many have been published. All that are found will eventually figure in the edition of

Mallarmé's *Correspondance* now in progress, the third volume of which has just appeared.[4] But, despite the work already done on detailed points or broader issues,[5] the whole question of Mallarmé's relations with the visual arts remains to be treated comprehensively. All I hope to do here is to indicate the kind of question that needs to be asked, the kind of problem that calls for solution, and the kind of approach that may be fruitful.

Various levels and various kinds of relationships have to be differentiated. Poets and painters may live side by side and watch each other at work, exchanging ideas to their mutual enrichment, but without revealing in their respective creations any specific traces of a cross-fertilization which may be sensed but not defined. Even here, it may be relevant and rewarding to establish the actual biographical data concerning such personal relations; and this is where letters and memoirs come in. In this respect, it is also interesting to see how far each artist may be able to venture into the medium of a fellow-artist: how gifted a painter may be in verbal expression, or a poet in visual expression. Even without abandoning the painter's studio for the writer's desk, as Gautier did, many writers, in France and elsewhere, have had considerable artistic talent: Hugo, Baudelaire, Valéry spring to mind. Valéry in particular, as anyone who has looked through his *Cahiers* knows, handled both pen-drawing and water-colours with taste and skill; his self-portrait, formerly in the late Henri Mondor's collection, and recently bequeathed to the Musée de Sète, is powerful in conception and impressive in execution; and in the same museum a small bronze head of Mallarmé shows Valéry's potentialities as a sculptor. Mallarmé himself was less gifted in this way. But he had a minor talent for humorous sketching, particularly in his correspondence with Méry Laurent, whom he liked to portray as a peacock: a typical example of these unpretentious little drawings has been published.[6]

Conversely, some painters have written well or excellently. Delacroix is of course the supreme example in France: he would be remembered for his great *Journal* if he had never painted a picture.[7] Degas wrote (with extreme difficulty) some remarkable sonnets.

But on the whole, writers are more at home with words, and painters with forms and colours. Each may try to transform into his own medium the impressions received from the personalities or the works of the exponents of a different art from his own. Painters may be inspired by the personality or appearance of writers of genius, and try to capture these by the art of portraiture. Painters may be inspired by the literary works they read, and feel moved to recreate them in their own medium. Or they may be asked to provide illustrations for literary works. Conversely, the writer may try to portray

in words the appearance and personality of the painter, or express in literary terms his response to a painting. He too may be asked to provide a text for paintings, etchings or drawings. It is probably important to distinguish here between the spontaneous response and the command performance. Not that the second is necessarily less likely to produce good results than the former. The romantic myth of spontaneity overlooks the positive challenge that may come from an outside, and at first sometimes unwanted, stimulus.

All these forms of reciprocal suggestion and stimulation could be illustrated from the relations between Mallarmé and the artists of his time. He inspired a number of portraits in varying media and of varying merit, from the portrait in oils by Manet to the woodcut by Félix Vallotton, for Rémy de Gourmont's *Livre des masques*.[8] Manet illustrated Mallarmé's translation of Poe's *Raven* and his poem *L'Aprés-midi d'un faune*.[9] He worked spasmodically, and with some discouragement, on additional illustrations of other poems by Poe, to illustrate a projected volume of Mallarmé's collected translations of Poe's work.

141 Manet: 'Portrait de Mallarmé'

142 Ingres: 'Portrait de Cherubini'

143 Gauguin: 'Portrait de Mallarmé'

Mallarmé constantly sought to elicit illustrations of his own works from his artist friends, with comparatively little success, for reasons we shall shortly examine. After his death, several artists, notably Raoul Dufy and Matisse, illustrated his poetry, Dufy his madrigals or occasional verse, Matisse his serious poetry.[10]

Mallarmé on his side wrote in defence and illustration of Manet, Whistler and Berthe Morisot,[11] stimulated the more influential pen of Octave Mirbeau to write in favour of Gauguin,[12] and maintained, as we saw, an extensive correspondence with many artists. He freely used his influence, as a friend of Henry Roujon, Directeur des Beaux-Arts, to achieve the purchase by the State of Whistler's famous 'Portrait of his Mother', now in the Louvre, and to ensure that Whistler should be awarded the Cross of the Légion d'Honneur.[13] All this is well known, apart from much of the correspondence which remains to be published. I do not propose to discuss Mallarmé's art criticism as such, interesting though this would be. What I should like to do is to look for a moment at three of the more striking portraits of Mallarmé, relate briefly the story of his sustained and unsuccessful attempt to have his poems in prose illustrated, and finally consider Mallarmé's use of visual sources in his poetry, with special attention to one privileged and well-documented example.

The precise date of Manet's famous portrait of Mallarmé [141], long in doubt, can now be fixed with certainty.[14] Writing to Arthur O'Shaughnessy on Thursday, 19 October 1876, Mallarmé states, 'Manet fait un petit portrait de moi en ce moment; je le ferai photographier en cartes à votre intention.'[15] Seven years later, when Verlaine was preparing his essay on Mallarmé for the series *Les Poètes maudits*, which did so much to arouse public interest in Mallarmé's work (and in that of Rimbaud), he wrote to Mallarmé asking for his authorization and for a photograph. Mallarmé replied saying that he had no photograph, as he had vowed not to face the camera until later, when he emerged safe and sound from his present literary undertaking (a hint at the *Grand Oeuvre* of which he dreamt throughout his life). He went on, however, to say: 'il y a, à la maison, un curieux tableautin de Manet qui me représente à une époque déjà ancienne'.[16] Mallarmé promised to have this photographed and to send Verlaine a print. The little book appeared in April 1884, with Mallarmé's portrait, engraved by Blanchet.[17] Verlaine's comment on it is perceptive, and reveals an aptitude for art criticism, and indeed orthodox art history, not surprising in the author of the *Fêtes galantes*, with their sensitive response to Watteau:[18] 'Manet a peint Mallarmé dans une attitude et à un âge immémoriaux en dépit des cigare et veston qu'affectionnait pour ses portraits d'hommes le grand artiste moderniste, si intuitif et fin sous le dandysme de sa bonhomie. Ici le poète est en quelque sorte apothéosé, *immortalisé*.' Then Verlaine makes a somewhat unexpected comparison: 'Serait -ce aller trop loin que de se souvenir du Cherubini d'Ingres [142]? La Muse n'est pas visible bénissant le génie, mais elle est là tout de même et c'est une bien autre muse pour un bien autre génie! Et si Mallarmé avait posé pour Ingres, Ingres eût-il mieux fait que Manet? Non!'[19] The reference to Mallarmé's *veston* recalls the shock Ingres had caused by painting Cherubini in a *carrick* or box-coat (Baudelaire had noted this detail as a particularly daring feature of Ingres's art).[20] The similarity otherwise observed lies in the general attitude. The hands are differently placed, and the expression quite different. Manet has admirably brought out the inner gaze of the meditative poet, whose face forms a triangle with the sensitive, expressive hands, one slipped into the pocket of his jacket, the other holding the smoking cigar, the indispensable adjunct to meditation. The face itself is curiously different from that in the better-known Nadar photographs. Here in Manet's portrait, the straw-coloured moustache spreads out its generous handlebars, the shock of black hair, while swept back from the high forehead, luxuriates freely but not untidily over the crown, and the face is thin and almost ascetic with its hollow cheeks.

It is not surprising that, ten years later, Henri de Régnier, who knew

Mallarmé's features from the Manet portrait as reproduced in Verlaine's volume, should not have recognized Mallarmé when he finally met him. [21] The Mallarmé whom Régnier knew is to be seen, not only in the Nadar photographs, but in the striking etching by Gauguin [143], made in 1891, the first and last etching he was to do. Gauguin had been introduced to Mallarmé by Charles Morice, and Mallarmé joined in the general publicity campaign skilfully and ruthlessly organized by Gauguin to prepare for the sale of his works on 23 February 1891. Thanks largely to Mallarmé's intervention, Octave Mirbeau wrote a resounding article on Gauguin, which appeared in the *Écho de Paris* a week before the sale.[22] It was during this period that Gauguin produced two portraits of Mallarmé: one, a pen and pencil drawing, the other, the etching, which bears the date 'Jer [Janvier] 1891'.[23] The etching, for which Gauguin used his own drawing, is expressive and impressive. Rotonchamp has described how, after borrowing the necessary equipment, he set to work: 'Gauguin [...] attaqua le cuivre avec audace. Pointe, plume, burin, grattoir, tous les moyens lui sont bons. Dans la fièvre du travail, il renverse l'eau-forte et l'éponge avec les étoffes les plus proches qui lui tombent sous la main.'[24] With his taste for symbolism, Gauguin placed in the penumbra above the poet's head the profile of the head of the raven [215], which Manet had drawn in Indian ink to illustrate Mallarmé's translation of Poe's poem (Gauguin himself was later to use the haunting knell of the refrain 'Nevermore' as the title of one of the best known of his pictures from Tahiti). The features of the poet are chiselled, with the firm bold line of the nose, the short-clipped hair, the moustache still full, and the beard thick but well-trimmed. The large faun-like ears are emphasized. The eyes are less clearly expressive than in Manet's portrait, but the gaze is directed outwards rather than inwards. All in all, if this really was Gauguin's *coup d'essai* in this medium it was also a *coup de maître*.

But probably the finest of all the portraits of Mallarmé is the lithograph after a drawing by Whistler [144] which figured as the frontispiece of Mallarmé's anthology, or *florilegium* as he liked to call it, of his *Vers et prose*, published by Perrin in November 1892. Mallarmé had intended to have a portrait of himself by Marcellin Desboutin as the frontispiece, but at the last moment it was Whistler who in October 1892 provided the portrait. The story has often been told, and there is no need to repeat the details of what has been said. Théodore Duret concentrated on the technical problem, relating how Whistler had sketched at great speed a number of drawings he at once rejected, until at last the final version provided the perfect synthesis of all the previous efforts.[25] Henri de Régnier gave an amusing sidelight on the physical discomfort suffered by the poet while posing. Mallarmé was standing in front of a

stove, and whenever he tried to move away, Whistler imperiously beckoned to
him to stay still. Mallarmé went away with his calves roasted. When he later
told Whistler of his fiery ordeal, the painter merely burst out into his proverb-
ial and diabolical laughter.[26] Rodenbach's account is that of a poet evoking
another poet . . .[27] All those who knew Mallarmé are agreed that this is a most
'speaking' likeness of him, not only in his features and attitude, but in his
gestures and indeed his speech. This is how the *Mardistes* remembered him.
And Mallarmé himself said, when thanking Whistler: 'Ce portrait est une
merveille, la seule chose qui ait été jamais faite d'après moi, et je m'y souris.[28]
Whistler gave a print of his portrait on *papier Hollande* to the poet, with a
pencilled inscription: 'à mon Mallarmé!' which is kept at Valvins still.
Whistler also drew a similar portrait of the poet's daughter Geneviève, where
he sensitively brings out the close resemblance between father and daughter.[29]

144 Whistler: 'Portrait de Mallarmé' **145** Renoir: 'Le Phénomène futur'

If portrait-painting is the most significant response a painter can have to a poet's presence, the transposition into visual terms of the impact of the poet's writings may be no less interesting. Baudelaire said the best account of a picture might be a sonnet or an elegy: a painter might say his best response to his reading might be a picture. Mallarmé's position on this point is complex. When asked in January 1898 what he thought of book illustrations, he produced a richly ironical reply: first, the writer's almost inevitable rejection of a rival art (Flaubert said the same): 'Je suis pour — aucune illustration, tout ce qu'évoque un livre devant se passer dans l'esprit du lecteur'; then the sardonic but prophetic comment that what many books were trying to do could be better done by the cinematograph: 'mais, si vous remplacez la photographie, que n'allez-vous droit au cinématographe, dont le déroulement remplacera, images et textes, maint volume, avantageusement.[30] The date of this comment is significant in two ways. First, the cinema had been invented by the Lumière brothers only three years before: here, as so often, the author of *La Dernière Mode* showed an acute 'sense of his time': it is intriguing to think of Mallarmé as a potential *cinéaste*. Secondly, Mallarmé, now nearing the end of his life, may have felt some not unjustified disillusionment about co-operation with artists in the illustration of his works.

For difficulties arose, even with Manet. Mallarmé enormously appreciated Manet's illustrations to the *Raven* and the *Faun*: he described the latter as: 'son illustration si curieuse: mêlant dans un sentiment moderne très vrai à la fois le japonais et l'antique'.[31] (Mallarmé, following Baudelaire, always sought the *modern* note.) But Manet was the first and not the last of the painters who delighted in Mallarmé the man yet were baffled by Mallarmé the poet. When Mallarmé asked him in 1881 for further illustrations to his Poe translations, Manet (already ill) replied with some ill-temper: 'Vous autres poètes, vous êtes terribles et il est souvent impossible de figurer vos fantaisies.'[32]

Mallarmé met with similar incomprehension when in 1888 he planned to publish his collected prose-writings in a volume that was to bear the sumptuous title, reflecting the taste for Japanese art that he shared with Manet and his whole age: *Le Tiroir de laque*. The book as he described it was to be a volume of poems in prose, 200 pages with four illustrations in colours and an etching.[33] The artists he had chosen were John Lewis-Brown, Degas, Renoir, Berthe Morisot and Monet. John Lewis-Brown was to do the cover, for which 'une des plus belles personnes de Paris' (no doubt Méry Laurent) was to pose.[34] Berthe Morisot was to illustrate the prose-poem 'Le Nénuphar blanc' and Monet, 'La Gloire'. It is not known what Degas was to do: perhaps a dancer, to illustrate Mallarmé's articles on the ballet. Renoir was to evoke the radiantly

beautiful woman of 'Le Phénomène futur'. The team was admirably chosen. But with one exception, all finally gave up, after some more or less half-hearted attempts. It is saddening to follow through the poet's correspondence the story of his indefatigable efforts to encourage his friends, who were baffled by his writings, even in the most accessible part of his work, the prose-poems. Berthe Morisot said from the start that she and Renoir were 'très ahuris': 'nous avons besoin d'explications pour les illustrations', she said, inviting Mallarmé to dinner.[35] It is not clear exactly how far each artist went before giving up. Berthe Morisot did a dry-point sketch for her illustration; John Lewis-Brown seems to have done something for his. But it is hard to be sure. Mallarmé adroitly suggests to each member of his team that the others have finished or are getting on. The problem seems to have been partly a technical one. Mallarmé wanted the drawings to be done 'aux trois crayons', and Monet was not happy with this medium. It is a great pity, for otherwise he had an ideal subject in 'La Gloire', which depicts the autumnal splendour of the forest of Fontainebleau: who better than Monet could have evoked that? In compensation for his withdrawal, Monet presented to Mallarmé one of his paintings,[36] which gave Mallarmé special joy: he used to say of this landscape, with a river winding through meadows: 'C'est aussi expressif que le sourire de la Joconde.'[37]

The one artist who did complete his illustration and give it to Mallarmé for his book was Renoir. The subject was congenial. 'Le Phénomène futur' imagines the world's future decrepitude, when a showman might display something rare and strange:

J'apporte, vivante (et préservée à travers les ans par la science souveraine) une Femme d'autrefois. Quelque folie, originelle et naïve, une extase d'or, je ne sais quoi! par elle nommée sa chevelure, se ploie avec la grâce des étoffes autour d'un visage qu'éclaire la nudité sanglante de ses lèvres. A la place du vêtement vain, elle a un corps; et les yeux, semblables aux pierres rares, ne valent pas ce regard qui sort de sa chair heureuse: des seins levés comme s'ils étaient pleins d'un lait éternel, la pointe vers le ciel, aux jambes lisses qui gardent le sel de la mer première.[38]

Renoir's charming but slight etching [145] can hardly match this vision. The austerity of the medium is partly to blame. What might not the painter of the radiant 'Baigneuses' have made of this theme in texture and colour! And who knows? They may some day bring their own challenge to the poets of a future age which, but for them, has outlived beauty.

Right up to the end of his life Mallarmé continued to solicit the collaboration of artists to illustrate his works, even the most esoteric. The lithographs prepared by Odilon Redon to illustrate the experimental poem *Un Coup de*

Dés, which the 'marchand de tableaux' Ambroise Vollard proposed to publish, have recently been revealed.[39] But I do not wish to encroach on Professor Seznec's domain . . . I would simply say that only one of the lithographs can be easily related to the text: the half-Hamlet, half-mermaid figure [184]. Ambroise Vollard also sought to have *Hérodiade* illustrated by Vuillard; and in May 1898 Mallarmé encouraged Vollard to ensure Vuillard's consent, saying that he was pleased with the way his work on the final stages of the poem was going.[40] But Mallarmé died without completing it; and this project too came to nothing. This was a pity, as there were close affinities between Vuillard and Mallarmé, which André Chastel has admirably brought out.[41] Nevertheless one may wonder if *Hérodiade* was the right poem for him to illustrate: it is rather the sonnets evoking the 'fulgurante console' or glimmers of light in the penumbra of mysterious interior scenes that call to mind Vuillard's masterly treatment of similar themes.

I come now to Mallarmé's use of visual sources in his poetry. This is probably not extensive (certainly less than that of Gautier or Baudelaire), but much detailed work remains to be done before one can be sure of its scope. I propose to discuss here three examples, which may show something of the problems of method involved and the need for caution and rigour. The first illustrates the dangers of over-hasty affirmation; the second, the double dangers of both over-hasty affirmation *and* negation; the third, the complexities of even a certain and well-documented source.

Here, first, is an example of over-confident identification of a supposed visual source. In 1954, in a book bearing the promising and catch-franc title *Les Clefs de Mallarmé*, the late Charles Chassé, who did excellent pioneer work on Mallarmé before and after the first World War, and some misguided and misleading work on him after the second, affirmed that Mallarmé owed the central idea of his poem 'Cantique de saint Jean', to a famous water-colour by Gustave Moreau, 'Apparition' [147].[42] This very striking picture had been first exhibited at the *Salon* of 1876, and had been described in great detail by Huysmans in 1884 in his novel *A rebours* (in which, incidentally, Mallarmé himself was brought to the notice of a wide public).[43] The 'Cantique de saint Jean' is one of the finest of Mallarmé's poems.[44] It belongs to the planned continuation of his *Hérodiade* on which he was working when he died, although the poem as a whole, probably including the Song of the Baptist, was conceived at an early stage, some ten years before Gustave Moreau painted his picture. Chassé, who rightly says that the 'Cantique' probably belongs to this early period, fails to see that Moreau could not have inspired a poem already

conceived and probably written. This does not deter him from making this comment on the poem:

L'idée ici exprimée par Mallarmé d'un bout à l'autre du poème lui a été certainement dictée par *Apparition,* le tableau de Gustave Moreau [...] Le poème en effet est une description du tableau de Moreau où, pendant que Salomé danse, la tête coupée du Baptiste s'élève rayonnante devant les yeux fixes de la fille d'Hérode [*sic*]. A l'arrière-plan de la toile du peintre, on voit l'exécuteur de saint Jean, son sabre à la main, ce sabre devenu 'une faux' dans le poème parce que Mallarmé songea sans doute à la courbure du cimeterre.[45]

There is no need to give a detailed exegesis of the poem in order to demonstrate that it is not a description of this picture. Chassé sees, in what is manifestly a long, straight, two-handed executioner's sword, the suggestion of a curved sabre or scimitar. Again, he says later that the pronoun 'Elle' in the poem refers to Salomé, when grammatically it must go with 'tête', the head of the Saint; and that the Saint's head is bowed in the picture when in fact it is bolt upright. Chassé is of course right in saying that Mallarmé shared with

146 Boucher: 'Pan et Syrinx'

147 Moreau: 'L'Apparition'

148 Raffaëlli: 'Le Carreleur de souliers'

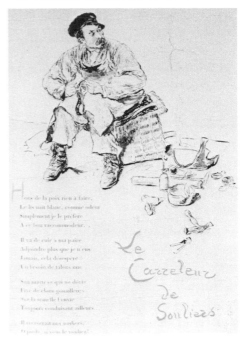

Gustave Moreau an interest in the solar theory of the origins of mythology; but Mallarmé did not owe this interest to Moreau: he was acquainted with this theory as early as 1871, when he first planned his translation of G. W. Cox's little manual of mythology which he published in 1880 as *Les Dieux antiques*.[46] It would be interesting to go further into this question. What is clear is that the valid comparison would be between Gustave Moreau's painting and Huysmans's prose—not Mallarmé's poetry.

 The second example is two-edged. In 1912, in a note to the first edition of his important and still indispensable book, *La Poésie de Stéphane Mallarmé*, Albert Thibaudet wrote:

En rappelant, à propos de *L'Après-midi d'un faune*, le XVIIIᵉ siècle de Fragonard, je ne savais pas ce que j'ai constaté depuis à Londres: c'est que le poème a été en effet inspiré par un tableau de Boucher qui se trouve à la *National Gallery* sous le nom de *Pan et Syrinx* [**146**]: deux nymphes nues, roses et blanches, brune et blonde, qui (surprises par l'apparition du Faune surgi près d'elles des roseaux [...]) se désenlacent. C'est donc durant son séjour à Londres, et à l'occasion de ce tableau, que l'idée de *L'Après-midi* fut conçue.[47]

This categorical assertion was toned down in the revised edition of 1926 to a mere probability: 'Le motif de l'*Après-midi* a été très probablement fourni à Mallarmé par un tableau de Boucher à la *National Gallery*.'[48]

 Thibaudet's assertion remained largely unchallenged until the late Henri Mondor, in 1948, raised what he thought was a decisive objection. After describing the picture in detail, in terms which deliberately emphasize the difference between Boucher's picture and Mallarmé's poem, Mondor concluded:

Quel dommage pour l'amusante hypothèse de Thibaudet et l'affirmation de moins en moins indécise de ses imitateurs que les conservateurs du musée anglais indiquent, ces jours-ci encore, comme date d'entrée, à la National Gallery, de ce voluptueux tableau, susceptible, certes, d'intéresser un poète, même de l'inspirer, l'année 1880; c'est-à-dire dix-sept ans après le séjour londonien du jeunne rêveur et quinze ans après le choix de son sujet![49]

Mondor's chapter is headed 'Une source fictive'; and it is evident that he felt the matter was settled. But he was not unaware that Mallarmé need not have seen the picture in London, or indeed the original picture itself anywhere, in order to know something of it. It would be worth while going into the history of the painting before it came into the National Gallery and, above all, investigating the albums of reproductions of Boucher's work that Mallarmé might have seen. Boucher is mentioned more than once in Mallarmé's early poems, notably 'Placet futile' in its first version, and 'A une petite laveuse blonde'. The latter in particular contains this stanza:

> Boucher jusqu'aux seins t'eût noyée
> Dans l'argent du cygne onduleux,
> Cachant sous l'aile déployée
> Ton ris de pourpre et tes yeux bleus.[50]

Boucher's painting of Leda and the Swan is, I believe, in the Stockholm Museum, and Mallarmé never went to Stockholm. Mondor himself asked the relevant question, which still awaits an answer: 'Quelque image existait-elle qui eût pu, entre les mains de Mallarmé étudiant, l'instruire de la composition du peintre?'[51] I believe that the 'inspiration' of *L'Après-midi d'un faune* is complex, involving literary no less than visual sources.[52] But I also believe that the partial relevance of Boucher's 'Pan et Syrinx' may yet be vindicated.

 Thibaudet, then, was wrong to say that Mallarmé was inspired by a picture he could not have seen where and when Thibaudet thought he saw it; but Mondor was wrong in not allowing enough weight to the likelihood of

Mallarmé's having seen a reproduction of the picture. The lack of conclusive evidence here invited rash conjecture on both sides.

The final example I wish to consider rests on firm, but still tantalizingly incomplete, documentary evidence. The poems concerned are the eight little pieces called *Chansons bas*, two sonnets and six quatrains, which were first published in March 1889, as part of the seventh instalment of an album entitled *Les Types de Paris*.[53] This is composed of sketches in prose by twenty leading writers of the day, including Edmond de Goncourt, Zola, Maupassant and Huysmans, evoking different aspects of Parisian life and work, and illustrated by numerous drawings by Jean-François Raffaëlli. It will be recalled that Raffaëlli figured at the end of the list of the 'French living impressionist painters' that Mallarmé gave to Louise Chandler Moulton and which I quoted at the beginning of this paper. Posterity has not endorsed this verdict; but posterity is not infallible. Huysmans praised Raffaëlli in 1879: 'Un autre peintre, vraiment moderne celui-là, et qui est de plus un artiste puissant, c'est M. Raffaëlli.'[54] Degas long protected him (to the displeasure of the other Impressionists); and Henri Focillon gave him honourable mention in his history of painting in the 19th and 20th centuries. Raffaëlli painted portraits, notably of Clemenceau and of Edmond de Goncourt. His paintings of Parisian streets and suburban scenes are often excellent. But it is with his work as an illustrator that we are concerned here.

Raffaëlli was on friendly terms with Mallarmé, and they exchanged a number of cordial letters and cards. These are coming gradually to light, particularly those written by Raffaëlli. I can already amplify and rectify what I said in vol. III of Mallarmé's *Correspondance* about the collaboration between Mallarmé and Raffaëlli for *Les Types de Paris*.[55] It then seemed apparent that Mallarmé had written several of the little poems called *Chansons bas* with Raffaëlli's pictures before him. It is now evident that only one of the full-scale pictures was in Mallarmé's hands when he wrote the corresponding poem. But Raffaëlli sent Mallarmé a letter with tiny rough sketches illustrating five others, and detailed comments on them; Mallarmé on his side sent Raffaëlli a sonnet and a quatrain which Raffaëlli then illustrated by sketches The whole episode offers a fascinating sidelight on a rare example of close collaboration and reciprocal action between a poet and a painter.

The story begins with a letter sent by Raffaëlli to Mallarmé on 23 August 1888, when the poet was having a short holiday at Royat in the Massif Central, as the guest of Méry Laurent and Dr Evans. Raffaëlli said how glad he was that he could count on Mallarmé, and that if Mallarmé had anything ready of the kind he wanted, Raffaëlli would be delighted to take it as it was; if not,

he promised to send Mallarmé in a week's time little engravings of the following types:

Le peintre d'enseigne
Le vitrier
Le carreleur de souliers
Le M^d [Marchand] d'ail et d'échalottes
Le cantonnier
Le crieur d'imprimés
Le petit bourgeois au soleil

He asked Mallarmé to write *two to fourteen* lines of verse beside each type, so as to make one full page for each type and its accompanying verse. He then continues: 'Ce serait, je crois, joli. — L'article s'appellerait "Petites gens de La Rue" ou quelque chose d'approchant — Si vous pouviez choisir pour ces quelques vers la délicieuse petite tournure que vous avez employée dans tant d'invitations, adresses, etc., cela ferait un petit bijou.' (Raffaëlli is referring to Mallarmé's occasional verse, notably the octosyllabic quatrains he used in addressing letters: their clarity no less than their wit delighted his friends, who constantly begged him always to write like that.)

Raffaëlli then makes it clear that Mallarmé is not obliged to write *about* the drawings, but simply *alongside* them, so that Mallarmé's verse will be framed by the drawings. He concludes by saying that he is to receive 100 francs for each section and that he will send this 'grosse somme' to Mallarmé. In a postscript he adds that he has just bought the Vanier edition of Mallarmé's *Après-midi d'un faune*, which he greatly admires.[56]

Raffaëlli's first list contains two types which at once disappear from the scene: the first and the last: there is no sign-painter and, alas, no 'petit bourgeois au soleil' in the book. On the other hand, three types were subsequently added, making eight poems in all. A further complication is that, although Raffaëlli drew a picture of the glazier, and Mallarmé wrote a quatrain on this subject, neither picture nor poem appeared in *Les Types de Paris*. But this is to anticipate.

Five days after the first letter, Raffaëlli wrote again (on 28 August 1888) in reply to a letter from Mallarmé which has not been found. In it, Mallarmé had evidently announced that he had written a sonnet on 'La Marchande de lavande'. Raffaëlli said in his reply that Mallarmé should send this sonnet with the other pieces, and that he would do a drawing to illustrate the sonnet. Meanwhile Raffaëlli could send only one of the promised engravings: it would give an idea of the rest. This was for information only: Mallarmé was not to bother about Raffaëlli and his drawings; these drawings, he repeated, would

frame Mallarmé's verse in each full page. Raffaëlli further said he entirely agreed with Mallarmé that a quatrain on each of the types would be excellent. The specimen drawing he sent was 'Le Carreleur de souliers', with this comment: 'vous voyez l'épreuve que je vous envoie dans la page et votre quatrain figuré au bas, — c'est ainsi dans le journal; le quatrain peut être *régulier* et court comme nombre de pieds.' Mallarmé, however, provided, not a quatrain, but a sonnet; and this does seem to make the lay-out a trifle unbalanced, as we shall see in a moment.

Then comes the fascinating part of this letter. Raffaëlli enumerates the seven drawings he had in mind, and (apart from 'Le Carreleur de souliers') he gives tiny sketches (reminiscent of those that Gabriel de Saint-Aubin drew on the 18th century *Salon* catalogues and which are familiar to us from Professor Seznec's magnificent edition of Diderot's *Salons*). Raffaëlli accompanies the little drawings with descriptive notes. It is interesting to compare them, both with Mallarmé's texts and with Raffaëlli's finished drawings.

But first, let us look at 'Le Carreleur de souliers' [148]. I suspect that Raffaëlli may have originally placed the title on the left: a quatrain would have fitted comfortably beneath the cobbler's accessories: the sonnet Mallarmé sent called for more space. The sonnet, moreover, is not very closely related to the drawing. Mallarmé followed, however, Raffaëlli's suggestion that short lines would be appropriate: he uses in this sonnet, and throughout the series of little poems, the unusual seven-syllable line, which emphasizes the swift, laconic effect. The title means an itinerant cobbler: in the definitive version, Mallarmé replaced it by the better-known term 'Le Savetier'. The sonnet is of a modified 'Shakespearean' type, with three stanzas followed by a clinching rhyming couplet, and is built up on five rhymes, which are often comically far-fetched, and 'rich' as millionaires. The first stanza evokes the smell and colour of pitch, an essential element of the cobbler's craft (there is a pot of it in the picture). 'You can't get along without pitch' sets the keynote. Mallarmé then expresses with ironical naïveté a natural preference for lilies in colour and fragrance (the comic rhyme of 'comme odeur / raccommodeur' is what matters here). The second stanza expresses the fear that the cobbler will put thick soles and heels on the poet's shoes, thus frustrating his desire to go barefoot (this facetious aspiration of the poet to a god-like state recurs in the final poem). The third stanza evokes the deft accuracy of the hammer driving the nails into the soles as if they were pinning down the poet's natural wanderlust: the nails mock at this desire ('gouailleurs'). The final couplet suggests that the cobbler would recreate shoes if only the poet's feet would accept this servitude. With virtuosity and suggestive

brevity, Mallarmé gives a graceful and charming expression of admiration, amusement and mild resentment in these tiny lines, suggesting both the endless restlessness of the poet and the creative possibilities of the cobbler.

Then follows Raffaëlli's series of little sketches and comments [149]. First, 'Le Vitrier', of which Raffaëlli says: 'il passe dans la rue, dans mon dessin, en criant et regardant en haut'. The drawing for this, as we saw, did not appear in *Les Types de Paris*, nor did Mallarmé's quatrain. But he did write it; and it appeared posthumously in the 1913 (NRF) edition of his *Poésies*:

Le pur soleil qui remise
Trop d'éclat pour l'y trier
Ôte ébloui sa chemise
Sur le dos du vitrier.

Mallarmé's treatment of the subject differs from that of Baudelaire, who in his *Petit poème en prose* meditated on the mysteries of human motives, or of Proust, who dwelt on the musical modulations of the glazier's cry.[57] Mallarmé evokes the dazzling reflection of the glass panes carried on the glazier's

149 Raffaëlli: 'Lettre à Mallarmé'

150 Raffaëlli 'Le Marchand d'ail et d'échalottes'

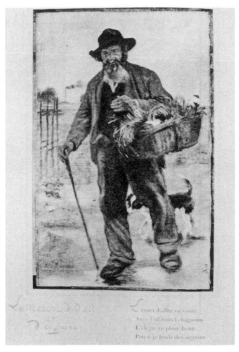

back. The sunlight concentrates so much dazzling brilliance on the glazier that it is impossible to distinguish the shirt from his back and therefore it, as it were, removes the shirt. Again we have in 'l'y trier / vitrier' the virtuosity of a quadruply rich rhyme. Mallarmé packs into less than twenty words a complex of sensations and ideas. (Other readings are of course possible!)

Next, 'Le Marchand d'ail et d'échalottes' [150], with this commentary by Raffaëlli: 'un vieux, un peu paralysé, avec son chien bâtard noir et blanc dans les jambes;—il a un panier d'osier au bras et dedans de l'ail, des échalottes; du thim (?) [sic] et du *laurier* [;] paysage de banlieue, effet de pluie'. Mallarmé ignores these picturesque details and concentrates on the most insubstantial aspect of the vendor's wares, their aroma. He comically extols the anti-sociable virtues of garlic and the lachrymatory effects of peeling onions, useful for elegiac poets. Here again there is a gloriously rich and unexpected rhyme: 'éloignons / oignons'.

Then 'Le Cantonnier' [151] in Raffaëlli's description: 'assis sur une borne kilométrique sur laquelle se lit "Paris 4 k.1"; effet de pluie; attitude primitive

151 Raffaëlli: 'Le Cantonnier' 152 Raffaëlli: 'Lettre à Mallarmó'

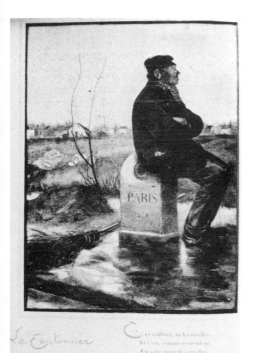

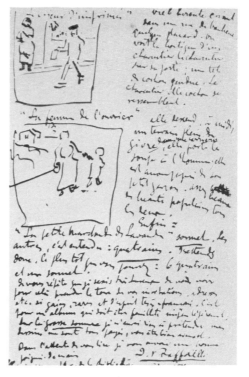

et rêveuse; bord de grande route de banlieue; son balai par terre'. Apart from the broom (and what may be a heap of stones in the background), there is little in Raffaëlli's picture to identify precisely the roadmender's work. Once again Mallarmé thinks himself into the roadman, in the harsh task of breaking and levelling stones (perhaps remembering Courbet's famous picture, or the popular song 'Sur la route de Louviers', where

> Il y avait un cantonnier (*bis*)
> Et qui cassait (*ter*)
> Des tas d'cailloux
> Pour les mettre sur la route).

Mallarmé evokes the desperate assault on recalcitrant material, whether it be the public so impenetrable to poetry, or pupils resistant to all efforts of the teacher: the heads of public or pupil are compared to stones that need to be broken, so 'cabochards' they are. Paul Valéry, in a more serious vein, but with the same startling switch from abstraction to the violently concrete image, evoked the analogy between bursting pomegranates and 'des fronts souverains / Éclatés de leurs découvertes' ('Les Grenades').

The roadman is followed by 'Le Crieur d'imprimés' [152], described by Raffaëlli as: 'vieil hirsute criant dans une rue de banlieue quelque placard. On voit la boutique d'un charcutier, le charcutier sur sa porte; une tête de cochon pendue. Le charcutier et le cochon se ressemblent [153]'. Again Mallarmé proceeds independently, and facetiously, with another acrobatic rhyme ('S'enrh*umer au* / n*uméro*') and a comical coinage ('siffle-litres': say, 'pint-swigger') for the bibulous newsvendor who, whatever the title or the weather, not even catching cold at the thaw, gaily hawks first issues of the papers.

The next type, the last of the tiny sketches in the letter, is a different case. It is 'La Femme de l'ouvrier' [154], of whom Raffaëlli writes: 'elle descend (à midi) un terrain plein de givre dans une carrière, elle porte la soupe à l'homme; elle est accompagnée de son petit garçon. Assez beaux beauté populaire tous les deux.' Here for once Mallarmé does comment directly on the subject-matter of the picture, and his words echo Raffaëlli's words. A woman is carrying soup (a generic term for the meal as a whole) to a quarry-man: Mallarmé ironically comments that this shows he is to be congratulated on having adopted the custom of getting married. Mallarmé savours the slang expression 'coupe / Dans' meaning 'accepts', 'believes in', 'goes in for', juxtaposed with the archaic legal term 'l'us' (now current only in the plural and in the compound expression: 'les us et coutumes').

Such, then, were the drawings in Raffaëlli's letter, and the full sketches and

poems arising from them. Raffaëlli concluded this letter with a recapitulation: 'En fin: "La petite Marchande de Lavandes" *sonnet*. Les autres, c'est entendu; quatrains. J'attends donc, le plus tôt que vous pourrez: 6 quatrains et un sonnet.' He also renewed his suggestion that Mallarmé adopt the familiar style of his rhyming postal addresses: 'Je vous répète que je serais très heureux de vous voir pour cela prendre le ton de vos invitations, adresses, etc. si gaies, rares et d'esprit très-français. C'est pour un album qui doit être feuilleté un peu légèrement.'

A third letter from Raffaëlli (undated, but perhaps written about 5 September 1888) shows that Mallarmé had sent some of his little poems, including the sonnet about the cobbler. Raffaëlli was delighted with them, and anxious to have the others: 'Faites donc tout votre possible, cher Monsieur Mallarmé, pour m'envoyer vos derniers vers avant Dimanche? Ceux que vous m'avez adressés déjà sont délicieux, pleins d'allure. La coupe du sonnet est fort gouailleuse [this word, as we saw, appears in the sonnet] c'est tout-à-fait parfait!'

Finally, in his fourth and last letter, also undated, but probably written a

153 Raffaëlli: 'Le Crieur d'imprimés' **154** Raffaëlli: 'La Femme de l'ouvrier'

few days later (perhaps about Sunday, 9 September 1888), Raffaëlli acknowledged the receipt of Mallarmé's last batch of poems, and sent him the promised 100 francs. He confesses only here what could be previously read between the lines: he had had some difficulty in having Mallarmé accepted among his authors, because of Mallarmé's reputation for obscurity. Raffaëlli had clearly gone out of his way to do the always impecunious poet a good turn:

Cher Monsieur Mallarmé,

Je reçois vos très-curieux vers, ils m'enchantent. Le sonnet de la 'Marchande de lavande' est un bijou, et le quatrain du 'crieur d'imprimés' très-amusant. J'aurai bien un peu de mal avec mon éditeur, *peut-être*, car il avait peur de votre nom; mais il suffit que la chose me semble délicieuse, je pense, pour qu'il arrive à penser de même.

Je vous envoie sous ce pli ce que je reçois de Plon, Nourrit & Co pour chacune des monographies. (100 fr.)

Croyez à mes meilleurs sentiments et soyez assuré que je reste votre très-obligé et dévoué

J. F. Raffaëlli

155 Raffaëlli: 'La Petite Marchande de lavandes'

156 Raffaëlli: 'La Marchande d'habits'

An apologetic postcript follows: 'Je voudrais vous écrire plus au long ce que je pense de vos vers, mais, hélas! dans quel gâchis je suis avec ce gros livre à mettre sur ses pieds! — Pardonnez-moi? — et à bientôt?'

Among these last poems received by Raffaëlli were two for which Mallarmé had had no drawing or sketch before him. Here it was the poems which preceded and perhaps inspired the pictures. These are 'La Petite Marchande de lavandes' and 'La Marchande d'habits'. They are probably the finest of all, and Raffaëlli placed one at the beginning, the other at the end of his series.

'La Petite Marchande de lavandes' [155] (called in the definitive version, with a revised second stanza, 'La Marchande d'herbes aromatiques') is a sonnet, similar in structure to 'Le Carreleur de souliers'. It is one of those that best show the amused observation Mallarmé brought to bear on *Les Types de la rue*. French open-air markets are enlivened by the quick wit and ready tongue of uninhibited vendors of all kinds of wares. Mallarmé imagines a slightly slatternly girl selling fragrant herbs, including lavender stalks, their appearance evocatively suggested by 'Ta paille azur de lavandes'. There is a special challenge to the art of suggestion, expressed in a minor key, half satirical, half *précieux*; lavender was bought to give fragrance to lavatories, and this knowledge of its delicate and ironical function would be implicit in the attitude of seller and buyer. Mallarmé conveys the whole situation with very few words: 'avec ce cil / Osé' is a witty litotes where the single eyelash conveys the whole rather brazen look of connivance, the placing of 'Osé' after the *enjambement* giving the word its full force. Similarly 'Comme à l'hypocrite' suggests the rather unsuccessful effort of the client to ignore the Jamesian situation where she knew that he knew that she knew. The poet rejects the offer, and instead tells the girl to put the lavender sprig in her untidy shock of hair ('envahissante'), which needs the 'brin salubre' to perfume it, or even to counteract those vermin in it, of which her future spouse will have the first-fruits. The poetic and musical proper names 'Zéphirine, Paméla' (both suggesting a comic kind of innocence—zephyr, Richardson . . .), form an ironical poetic counterpoint to the lively stylized satire of these light-hearted lines. Raffaëlli's charming little drawing could hardly bring out all this; but it does suggest a pert and pretty girl who might well have sustained her part in this imagined exchange.

The last drawing of the series, 'La Marchande d'habits' [156] is perhaps the best of all, with the contrasting red of the shawl, the blues of the skirt, the sheen of the topper. In Mallarmé's witty little quatrain, the old-clothes woman mentally undresses the poet, not in erotic but in commercial reverie, and

leaves him naked as a god: this echoes the discreet allusion to the quasi-divine character of the poet already given in the poem on the cobbler. The series is rounded off by the elegant calligraphy of Mallarmé's familiar signature, followed by his characteristic little flourish. The whole episode is a minor, but happy chapter in the history of the interrelations between poetry and painting in 19th century France.

Notes

(1) I wish to express my deep gratitude to the late Madame E. Bonniot for generously opening to me the Mallarmé archives at Valvins and making this study possible.

(2) Louise Chandler Moulton (1835–1908), born in Connecticut, divided her time between Boston and Europe, and wrote tales for children, novels, essays and melancholy poems. The 'music-maker and dreamer of dreams' Arthur O'Shaughnessy introduced her to Mallarmé in 1876. She spent the winter of 1876–7 in Paris: perhaps it was then that the list was drawn up, but if so Manet should have appeared on it. She translated Mallarmé's sonnet 'Le Tombeau d'Edgar Poe' into English verse, using a prose translation he had sent her for the purpose (see S. Mallarmé, *Correspondance*, II, 1871–85, ed. H. Mondor and L. J. Austin, Paris, Gallimard, 1965 [referred to below as *Corr.* II], pp. 129 and n. 2, 136 and n. 2, 155, n. 1, and S. Mallarmé, *Oeuvres complètes*, ed. H. Mondor and G. Jean-Aubry, Paris, Gallimard, Bibliothèque de la Pléiade [referred to below as *OC*], p. 225). Mallarmé's letters to Louise Chandler Moulton are now in the Library of Congress; they were recently published by Thomas A. Williams, Jr., in *Romance Notes*, autumn 1966, pp. 29–37, with numerous errors and omissions ('Lazy Tours', for example, figures as 'Lazy Bones'!).

(3) Of those mentioned in Mallarmé's list, neither Sisley nor Pissarro seems to have corresponded with the poet, although he was certainly acquainted with both. His daughter Geneviève, in company with Julie Manet (the daughter of Berthe Morisot and ward of Mallarmé) and Paule and Jeannie Gobillard (later Mme Paul Valéry), visited Pissarro in Rouen in 1896 and saw and admired some of the scenes of Rouen he was then painting from the window of his room. She also admired the cathedral of Rouen beneath the setting sun, adding by her description a variation on Monet's famous series which evokes the manifold metamorphoses of the cathedral beneath the changing light of hours and days (letters of Geneviève Mallarmé to her father, 28 and 29 Sept. 1896).

(4) S. Mallarmé, *Correspondance*, III, 1886–9, ed. H. Mondor and L. J. Austin, Paris, Gallimard, 1969 (referred to below as *Corr.* III).

(5) H. Mondor, *Vie de Mallarmé*, Paris, Gallimard, 1941 (referred to below as *VM*), contains many documents concerning Mallarmé's relations with the artists of his time; Kurt Wais, *Mallarmé*, Munich, Beck, 2nd ed., 1951, pp. 296–310, gives a useful synthesis of what was then known; more recently, Jean-Pierre Richard, *L'Univers imaginaire de Mallarmé*, Paris, Seuil, 1961, provides both some illuminating pages on Mallarmé and Impressionist painting and valuable bibliographical details (p. 509). Mallarmé's correspondence with Berthe Morisot was published in 1950 by Denis Rouart *(Correspondance de Berthe Morisot*, Paris, Quatre Chemins-Editart), and that with Whistler in 1964 by Carl P. Barbier *(Correspondance Mallarmé-Whistler*, Paris, Nizet [referred to below as *CMW*]), while Mallarmé's letters to Odilon Redon (but not Redon's letters to Mallarmé) were published in 1960 by Ari Redon and Roseline Bacou *(Lettres [...] à Odilon Redon*, Paris, Corti). Roseline Bacou had already devoted some penetrating pages to the relations between Mallarmé and Redon in her excellent book *Odilon Redon* (Geneva, P. Cailler, 1956, 2 vols.).

(6) *Mallarmé. Documents iconographiques*, ed. H. Mondor, Geneva, P. Cailler, 1947 (Collection *Visages d'Hommes Célèbres*), No. LXXX (referred to below as *DI*).

(7) Cf. L. J. Austin, 'Baudelaire et Delacroix', in *Baudelaire, actes du Colloque de Nice (Annales de la faculté des lettres et sciences humaines de Nice*, No. 4, June 1968), Paris, Minard, 1968, pp. 13–23.

(8) Most of these are reproduced in *DI*. The Renoir portrait is reproduced in colour as the frontispiece of the review *Le Point*, XXIX–XXX, Feb.–April 1944 (Lanzac, par Souillac, Lot): Mallarmé himself felt that this portrait made him look like a 'financier cossu' (*OC*, p.

1375). Edvard Munch's lithograph forms the frontispiece of Kurt Wais's *Mallarmé*; his correspondence with Mallarmé was published in *Documents Stéphane Mallarmé*, I, présentés par C. P. Barbier, Paris, Nizet, 1968, pp. 113–24 (referred to below as *DSM*, I), with facsimiles of two versions of Munch's portrait of Mallarmé.

(9) LE / CORBEAU / THE RAVEN / *poëme* / par / EDGAR POE / Traduction française de STÉPHANE MALLARMÉ / *Avec illustrations* / par / ÉDOUARD MANET / Paris / Richard Lesclide, Editeur, 61, rue de Lafayette / 1875.—The illustrations include the frontispiece (the Raven's head), and ex-libris (the Raven with outspread wings), and four drawings in black and white wash reproduced by lithography, depicting the poet at his table with his lamp and books, the poet flinging open the shutter and the Raven flying in through the window, the Raven perched upon a bust of Pallas, and the shadow that lies floating on the floor (this last particularly suggestive in its bold economy of means).—L'APRÈS-MIDI / D'VN / FAVNE / Églogve / par / STÉPHANE MALLARMÉ / avec frontispice, flevrons & cvl-de-lampe / Paris / Alphonse Derenne, Editeur / 52, boulevard Saint-Michel, 52 / M DCCC LXXVI. The diminutive illustrations are the well-known wood-cuts hand-tinted by Manet himself, representing the faun in the reeds playing his pipes, three nymphs bathing amid the reeds, a bunch of grapes and a leaf and grass motif as an ex-libris.—These editions, with their illustrations, have recently been reproduced in a reduced format in a volume of the series 'Les Peintres du livre', Paris, Le Livre-Club du Libraire, 1969; the volume also includes Manet's illustrations for Charles Cros's *Le Fleuve*.—Excellent copies of the *Raven* and the *Faun* illustrations were on display at the Manchester Symposium.

(10) STÉPHANE MALLARME / *MADRIGAUX* / Images de / Raoul Dufy / Editions de la Sirène / 12, rue La Boétie, Paris / MCMXX. Illustrated by twenty-five full-page drawings by Raoul Dufy [B.N.: Rés.m. Ye.208]. A new edition was published in 1960 by the Cercle du Livre Précieux in the series 'Le Musée du bibliophile'.—I have not seen the edition of Mallarmé's *Poésies* with 126 etchings by Matisse (Lausanne, A. Skira, 1932, folio, 161 pages), but copies of the etchings are to be seen in various places, such as the Art Institute, Chicago, the Cone Collection at the Baltimore Museum of Art, etc. Ten are reproduced in Wallace Fowlie, *Mallarmé*, Chicago, University of Chicago Press; London, Dennis Dobson, 1953.

(11) See *OC*, pp. 531 (Whistler), 532–3, 695–700, 1618–20 (Manet), 533–7, 1591–2

(Berthe Morisot). See also *DSM*, I, pp. 66–86, the full text in English of Mallarmé's article 'The Impressionists and Édouard Manet', published in *The Art Monthly Review* in Sept. 1876. The French original has not been found, but an abridged retranslation into French by Marilyn Barthelme was published in *La Nouvelle Nouvelle Revue Française*, Aug. 1959, pp. 375–84.

(12) See *VM*, pp. 589–90, 596–7, 604. Further details will be given in S. Mallarmé, *Correspondance*, IV (in preparation).

(13) See *CMW*, passim.

(14) See A. Tabarant, *Manet et ses œuvres*, Paris, Gallimard, 1947, p. 296.

(15) *Corr.* II, p. 130.

(16) Ibid., p. 245.

(17) Both the portrait and Verlaine's description of it had been published on 29 March 1884 in the *avant-garde* periodical *Lutèce*, which was widely read in young literary circles.

(18) See J.-H. Bornecque, *Lumières sur les fêtes galantes de Paul Verlaine*, Paris, Nizet, 1959

(19) Paul Verlaine, *Oeuvres complètes*, Paris, Le Club du Meilleur Livre, (Collection 'Le Nombre d'or'), 1959, t. I, p. 446.

(20) Ch. Baudelaire, *Oeuvres complètes*, Paris, Gallimard (Bibliothèque de la Pléiade), pp. 860, 916–17, 921.

(21) Henri de Régnier, *Nos rencontres* (referred to below as *NR*), Paris, Mercure de France, 1931, p. 100.

(22) The article was refused by the *Figaro*, but appeared in the *Echo de Paris* on 16 Feb. 1891. It incorporated textually several passages from Mallarmé's letter (see *VM*, p. -96). Françoise Cachin, *Gauguin*, Paris, Le Livre de poche, 1968, p. 203, affirms that Mallarmé refused to write an article himself ('Il va voir Mallarmé qui se récuse...') but recommended Mirbeau instead. Mallarmé, of course, rightly believed that Mirbeau commanded a far wider audience than himself. The sale was a success, but not a resounding one.

(23) See H. de Régnier's evocation of Gauguin's presence at the Mardis (*NR*, p. 208). Of Gauguin's portrait of Mallarmé, Paul Claudel wrote: 'Ce portrait est un chef-d'œuvre. Gauguin a tout remarqué: l'oreille pointue, l'arc aigu des sourcils, ces cheveux raides et hérissés du professeur. Mallarmé nous faisait la classe tous les mardis' (Paul Claudel, *Journal*, II (1933–55), Paris, Gallimard (Bibliothèque de la Pléiade), 1969, p. 389).

(24) Jean de Rotonchamp, *Paul Gauguin 1848–1903*, Paris, Crès, 1925, p. 83.

(25) Théodore Duret, *Histoire de James McN. Whistler et de son œuvre*, Paris, Floury, 1904, p. 124. Duret also writes of this portrait: 'Mallarmé est d'une étonnante ressemblance, le bras en mouvement et la tête inclinée selon

son habitude, lorsqu'il conversait avec ses amis. Ceux qui l'ont connu peuvent croire qu'ils l'entendent parler' (ibid.).
(26) *NR,* pp. 213–14.
(27) *L'Amitié de Stéphane Mallarmé et de Georges Rodenbach,* Préface de Henri Mondor, introduction et notes par François Ruchon, Geneva, p. Cailler, 1949, pp. 137–8.
(28) *CMW,* p. 188.
(29) See *DI,* No. LXIX, *Mallarmé (Le Point),* p. 27. Whistler also did a portrait in oils of Geneviève (reproduced in *CMW*) and planned to begin one of Mallarmé in the winter of 1898: but the poet died on 9 Sept. of that year.
(30) *OC,* p. 878.
(31) *Corr.* II, p. 119.
(32) *OC,* p. 1521.
(33) *Corr.* III, pp. 162–3.
(34) Ibid., p. 227.
(35) Ibid., p. 151, n. 1 and n. 2.—See *OC,* p. 1404, for mention of Berthe Morisot's sketch for 'Le Nénuphar blanc'.
(36) Ibid., p. 363, n. 1.
(37) See Gustave Geffroy, *Claude Monet,* Paris, Crès, 1924, t. II, p. 95. Henri de Régnier was mistaken in attributing to Mallarmé exclusively modern tastes in painting: 'Mallarmé aimait beaucoup la peinture, mais j'ai le sentiment que la peinture datait pour lui de Manet […]. Je me demande même si la Joconde lui avait jamais souri, car jamais il ne laissa supposer qu'il lui eût rendu visite et qu'il eût franchi les portes du Musée du Louvre.' (*NR,* pp. 195–6.)' But the 'Gioconda smile' was for Mallarmé symbolical of the second phase of his triadic theory of the development of Beauty—between the Vénus de Milo and his own *Hérodiade* (see Mallarmé, *Correspondance,* I, 1862–71, ed. H. Mondor and J.-P. Richard, Paris, Gallimard, 1959, p. 246; and cf. L. J. Austin, 'Mallarmé et le rêve du "Livre"', *Mercure de France,* Jan. 1953, pp. 96–7 and n. 19). Régnier is thus exaggerating when he affirms: 'Ce manque complet d'intérêt et de curiosite pour l'art de peindre, tel qu'il existait avant l'impressionnisme, venait sans doute de ce que cet art, en ses manifestations antérieures et en ses œuvres les plus renommées, n'apportait aucun appui et aucun aliment à ses méditations esthétiques. La Peinture était pour lui muette, tandis qu'il était infiniment sensible aux voix révélatrices de la Musique qui provoquaient et nourrissaient sa rêverie et stimulaient son activité spirituelle' (*NR,* p. 196). It could be argued that Mallarmé had a better grasp of the principles of the visual arts than he had of music, fascinated though he was by this art. It is significant that he writes of his musical impressions mainly in visual terms (light and darkness, etc.). See L. J. Austin,

'Mallarmé on Music and Letters', *Bulletin of the John Rylands Library* (Manchester), Vol. 42, No. 1, Sept. 1959, p. 33.
(38) *OC,* p. 269. Cf. Baudelaire's sardonic comment when 'Le Phénomène futur' was sent to him in Belgium: 'Un jeune écrivain a eu récemment une conception ingénieuse, mais non absolument juste. Le monde va finir. L'humanité est décrépite. Un Barnum de l'avenir montre aux hommes dégradés de son temps une belle femme des anciens âges artficiellement conservée. "Eh! quoi! disent-ils, l'humanité a-t-elle pu être aussi belle que cela?" Je dis que cela n'est pas vrai. L'homme dégradé s'admirerait et appelerait [sic] la beauté laideur' (Baudelaire, *Oeuvres. complètes,* p. 1329: the passage comes from *Pauvre Belgique.* Cf., for the circumstances, J. Crépet, *Propos sur Baudelaire,* Paris, Mercure de France, 1957, pp. 66–7).
(39) See Robert G. Cohn, *Mallarmé's Masterwork,* The Hague: Paris, Mouton, 1966, pp. 75.–111, with reproductions of Redon's three lithographs and of Mallarmé's corrected proofs for the proposed Lahure edition. Those present at the Manchester Symposium could see each day a fine copy, from the Print Room of the British Museum, of Redon's illustration for p. 8 of the poem (the 'half-Hamlet, half-mermaid figure'). I share Professor Seznec's reservations about the success of this illustration: it limits rather than liberates the reader's imagination, and all the background of night and stars and ocean and mystery disappears.
(40) See Ambroise Vollard, *Souvenirs d'un marchand de tableaux,* Paris, Club des Libraires de France, 1957, p. 196. See also *VM,* p. 791, where the letter is not dated.—After Mallarmé's death, Geneviève, with Édouard Dujardin's help, planned an illustrated edition of Mallarmé's *Poésies.* But this too fell through (*OC,* pp. 1403–4).
(41) André Chastel, 'Vuillard et Mallarmé', *La Nef.* Jan. 1947, pp. 13-25.
(42) Charles Chassé, *Les Clets de Mallarmé,* Paris, Aubier, 1954, p. 185.
(43) J.-K. Huysmans, *A rebours,* Paris, Charpentier, s.d. (trente-huitième mille), Ch. V, pp. 70–80. (The passage on Mallarmé is on pp. 259-66.) Huysmans describes the two versions of Moreau's picture shown at the *Salon* of 1876, first the oil painting 'Salomé dansant devant Hérode', now in the Huntington Collection, Hartford, New York (No. 22, Plate 11 of the catalogue of the Gustave Moreau exhibition at the Louvre in June 1961), then the watercolour 'L'Apparition', now in the Cabinet des Dessins, Louvre (RF, 2130) (No. 90, Plate 30, Louvre exhibition, 1961). In addition, the catalogue of the Musée Gustave Moreau

lists nineteen pictures (oils and water-colours) and thirteen studies or compositions on the theme of Salomé.

(44) See L. J. Austin, 'Le "Cantique de saint Jean" de Stéphane Mallarmé', *AUMLA*, No. 10, May 1959 (special number in honour of A. R. Chisholm), pp. 46–59.

(45) Op. cit., pp. 185–6.—Mallarmé was of course fusing the executioner's sword with the emblematic scythe of Death.

(46) See *Corr.* II, p. 22, n. 1.

(47) Quoted by H. Mondor, *Histoire d'un faune*, Paris, Gallimard, 1948, p. 19.

(48) A. Thibaudet, *La Poésie de Stéphane Mallarmé*, Paris, Gallimard, 1926, p. 394.

(49) *Histoire d'un faune*, p. 20.

(50) *OC*, p. 18.

(51) *Histoire d'un faune*, p. 21.

(52) See L. J. Austin 'L'*Après-midi d'un faune*: essai d'explication', *Synthèses*, 258/9, Dec./Jan. 1968, pp. 24–35. The central image of the Faun holding up the grapes to the light probably derives from some classical plastic source. But Mallarmé enriches it beyond measure by his subtle image of the luminous skins, emptied of their substance (which itself imparts a sensation of light) and filled again with the immaterial breath of the poet's inspiration—a splendid evocation of 'la divine transposition [qui] va du fait à l'idéal'.

(53) *Les Types de Paris* appeared in ten weekly instalments from 1 Feb. 1889, published by Plon, Nourrit et Cie for the newspaper *Le Figaro*. Mallarmé shared the seventh instalment with Paul Bourget. The text of his poems in their definitive version is in *OC*, pp. 62–4. Mallarmé, who retained only the two sonnets, 'Le Savetier' and 'La Marchande d'herbes aromatiques' for the Deman edition of his *Poésies*, which appeared posthumously in 1899, described them in his 'Bibliographie' in these terms: '*Chansons bas* I et II commentent, avec divers quatrains, dans le recueil les *Types de Paris,* les illustrations du maître-peintre Raffaëlli, qui les inspira et les accepta' (*OC*, p. 78).

(54) See J.-K. Huysmans, *L'Art moderne*, Paris, Charpentier, 1883, p. 41.

(55) *Corr.* III, pp. 11, 250–1 and notes, 286, n. 2, 296, n. 2. The Raffaëlli letters are of course in the Mallarmé archives at Valvins. But Mallarmé's letters to Raffaëlli have been dispersed and many have not been recovered.

(56) Ibid., p. 250, n. 2.

(57) Baudelaire, 'Le Mauvais Vitrier', *Oeuvres complètes,* pp. 238–40; Proust, *l a Prisonnière*, in the Pléiade edition of *A la recherche...*, t. III, p. 127 (ed. A. Ferré and P. Clarac, Paris, Gallimard, 1954).

Jean-Bertrand Barrère

11

Victor Hugo's interest in the grotesque in his poetry and drawings

It is worth noting for my purpose that the word *grotesque* had its origin in painting. *Grottesca* in Italian was used of 'arabesques' or drawings of an imaginative nature discovered on cave walls. Montaigne spoke of 'grotesques qui sont peintures fantasques n'ayant grâce qu'en la variété et étrangeté'[1] and quoted Horace's famous line:

> Desinit in piscem mulier formosa superne.[2]

In the grotesque there is an element of fanciful diversity that can become, at its limit, sheer monstrosity, that is to say a combination of two forms of beings which will give birth to a new creature that bears no resemblance to reality.[3] This limit was not usually reached in Callot's famous grotesques [157], which were comic or picturesque exaggerations of faces, figures and costumes. However, Hugo, who used both Callot and Shakespeare as examples, was quick to profit from this hybrid nature in his literary theory of the grotesque expounded in his *Préface de Cromwell* (1827) when he was twenty-five years old. Here the grotesque appeared as an element essentially designed to break the uniformity of a drawing, of a play, or of life itself, and to revive the spectator's interest by the introduction of a sudden discord or a break in the 'pattern'. He described the effect in the theatre in these words: 'C'est donc une des suprêmes beautés du drame que le grotesque (...) Grâce à lui *point d'impressions monotones*.' In more general terms he praised its role in the works of modern times: 'Il y est partout: d'une part il crée le difforme et l'horrible; de l'autre, le comique et le bouffon.'

Victor Hugo took the characters of the Commedia dell'Arte as examples of embodiments of the grotesque, 'ces Scaramouches, ces Crispins, ces Arlequins, grimaçantes silhouettes de l'homme'. To the grotesque, in his view, are ascribed in the human comedy 'tous les ridicules, toutes les infirmités, toutes les laideurs (...) les passions, les vices, les crimes': 'c'est lui qui sera tour à tour Iago, Tartufe, Basile; Polonius, Harpagon, Bartholo; Falstaff,

Scapin, Figaro.' As can be seen, the species is enormous: he summarized it in one image, 'la bête humaine', referring to composite creatures from 'la folie païenne', such as fauns, centaurs and tritons, which seem to evade the laws of nature and yet, however, derive from nature an abnormal physical or mental power.

Apparently Victor Hugo's taste for the grotesque first manifested itself in writing. As early as his first novels *Han d'Islande* and *Bug-Jargal*, Hugo introduced half-comic, half-terrifying figures, notably Spiagudry, guardian of the Spladgest or the Drontheim mortuary, and Habibrah, a fierce and jealous dwarf: their descriptions are complementary. Spiagudry is tall and cadaverous, a Don Quixote figure: 'on voit sur son dos une bosse, formée sans doute par une besace que cache un grand manteau noir dont les bords profondément *dentelés* annoncent les bons et loyaux services'. I record the use of the cloak and the jagged pattern of its edge: we shall see these again. Habibrah is a small, portly figure, shaped more like a Sancho Panza: 'ce nain hideux

157 Callot: 'Balli'

XXIII. — Les Balli : Fracischina. — Gian Farina (1621)

XXIV. — Les Balli : Cap Bonbardon. — Cap Grillo (1621)

était gros, court, ventru et se mouvait avec une rapidité singulière, sur deux jambes grêles et fluettes'. His head, under a jester's cap, was enormous, 'enfoncée entre ses deux épaules', 'hérissée d'une laine rousse et crêpue' and decorated with 'deux oreilles si larges' that he was able to use them for wiping his eyes. We shall see more of these traits in the drawings. Moreover, this figure is the precursor by forty years of 'le Roi des Auxcriniers', the malignant fiend of 'Les Travailleurs de la mer'; and the grinning face foretells 'L'Homme qui rit'.

If we now return to *Han d'Islande*, we see that this novel appeared in an English translation in 1825 'avec d'admirables gravures à l'eau-forte de Cruikshank': as Hugo said, 'l'effet n'en est pas agréable, mais elles sont terribles'. Later Baudelaire was to praise the work of this artist for 'une abondance inépuisable dans le grotesque'; I find it rather surprising that young Hugo retained only the terrifying effect. This ambiguity was always fairly characteristic of Hugo. There are, he said, 'des êtres dont la conformation physique est si étrange qu'ils paraîtraient des monstres, s'ils ne faisaient rire'. The grotesque, emphasized on the one side or the other, flowed from his pen like *rimes riches*: we can, indeed, speak thus of Hugo as Baudelaire did of Cruikshank.[4] Moreover, even though it was expressed in words, it contained an element of visual characterization.

The *Préface de Cromwell* spoke of 'les orgies de Callot'. Perhaps Hugo was thinking of 'Le Festin des Bohémiens'? Their procession, and in particular 'L'Arrière-garde', was to inspire Baudelaire. Hugo must have noticed the 'Balli' [157], weird comedians wearing extravagant hats who twisted themselves into demoniac or acrobatic contortions. Fraceschina may have inspired the portrait of Esmeralda. However, such characters correspond to the grotesques in the plays Hugo wrote between the ages of thirty and forty. At the head of the procession came a professional player, the 'Gracioso', 'petit et bossu', a member of the troup of actors in *Marion de Lorme*. He draws this caricature of Laffemas, the 'lieutenant-criminel':

> Humph! costume d'alcade et figure de sbire!
> Un petit œil orné d'un immense sourcil...

Then he imagines him as a monster:

> Monseigneur! si ton dos portait—bien en son centre—
> Une bosse en grosseur égale à ton gros ventre...

Callot's 'capitan' Bonbardon displayed some of these convexities. We notice in these drawings, for future reference, the prominent noses, aggressive eye-

brows, cloaks, hats with feathers which droop or turn up, contortions of body which bring these human beings' faces, bodies and postures nearer to animals.

I shall leave out Quasimodo, *The Hunchback of Notre-Dame,* and Triboulet, the tragic clown of *Le Roi s'amuse,* who appeared in a manuscript drawing completely bristling with points (hose, crown and hair), accompanied by the caption 'le dernier bouffon songeant au dernier roi'. We shall join Don César de Bazan and his circle of Spanish ruffians in *Ruy Blas,* which dates from 1838. There are three drawings, dating from 1838 to 1840, which show the obsessive figure of a friend of Don César, Goulatromba, a grotesque who will reappear in *Le Théâtre en liberté.* The first of these drawings [158] bears as a caption three lines of Hugo's play, which are less suited, in my opinion, than the following (IV, 3):

> A côté, tu verras un gros diable au nez rouge,
> Coiffé jusqu'aux sourcils d'un vieux feutre fané
> Où pend tragiquement un plumeau consterné,
> La rapière à l'échine et la loque à l'épaule.

158 Hugo: Sketch of Goulatromba

We can also compare the brilliant verbal sketch of Zafari, alias Don César (1, 2):

> Quel est donc ce brigand qui, là-bas, nez au vent,
> Se carre, l'œil au guet et la hanche en avant,...
> Et qui, froissant du poing sous sa manche en haillons
> L'épée à lourd pommeau qui lui bat les talons,
> Promène, d'une mine altière et magistrale,
> Sa *cape en dents de scie* et ses *bas en spirale*.

We notice the use of a caption, in the style of newspaper cartoonists, for a drawing which is almost an illustration: it is a contemporary translation into art-form of what is already a drawing in words. The diagram is in the shape of a cross: the length of the sword is the same as the character's height. His cloak is striped and torn. His mouth is huge and voracious, his nose is flattened and spreading, he has animal ears, a feather hangs from his dented hat through which a pipe has been inserted. We shall see these ingredients again: hat and jagged cloak, furry ears and carnivorous maw, which add up

159 Hugo: Sketch of Goulatromba

the amalgamation man-animal or 'bête humaine', in Hugo's words, to this type of picturesque 'capitan'. We can say that the grotesque in 1840 has reached in Hugo's drawings and paintings its fullest representation, in which the monstrous remains, nevertheless, picturesque. It is amusing rather than disquieting. It belongs to the world of the picaresque novel that has been revised by an original imagination, and we can apply to this type of Spanish grotesque the words of the author of *Promontorium Somnii*: 'Toute la comédie italienne est un cauchemar qui éclate de rire.'

It is worth remembering that one of the drawings, the final one [159], shows signs of simplification and comes from a sketch-book that he took on his journey to Germany, in 1840. Besides models and incidents provided by caricaturists or by Goya, whose *Caprices*, according to Adhémar, must have been known to Hugo from the year 1827, there was, indeed, the reality of the picturesque journey. I have pointed out elsewhere some of these originals, which Hugo had met on his journeys, a replica in life of Callot's figures:[5] itinerent musicians, bringing to mind later drawings of animal instrumentalists; a girl wearing a hat crowned with a wreath of flowers; travelling actors,

160 Hugo: 'Mask'

161 Hugo: 'Scarecrow'

'l'un (...) bronzé comme Ptha, coiffé comme Osiris', 'l'autre (...) une espèce de Sbrigani pansu, barbu, velu et chevelu, l'air féroce et vêtu en hongrois de mélodrame'; elsewhere 'ce philosophe conduisait un troupeau de cochons', this is in the style of the later captions; the same remark applies to a 'pauvre diable arrangé par le haut pour le bal et par le bas pour le voyage'. Finally, a drawing made during a journey dated 1849 [161] shows us a man lost to sight beneath his cloak and hat, as indicated by the caption in Spanish.[6] Humanity disappears, disguised by the jagged shape of his patchwork cloak stretched over his invisible sword, and by the shape of his plumed hat which resembles a windmill.

The verbal distinction *'par le haut... par le bas'*, the double nature, composite and abstract, of this latter drawing, which could be summed up as a 'scare-crow', bring us to the practice of monstrosity announced in the *Préface de Cromwell,* and released in or by the drawings of Hugo's exile. Meanwhile, in 1843, had appeared Théophile Gautier's book *Les Grotesques,* devoted not to artists, but to poets, mainly from the 17th century, who were neglected at that time, in spite of their originality and colourful style: these were Villon, Racan, Théophile, etc., claimed by the Romantics as their precursors. This book was reviewed in a long article by a talented historian, a friend of Sainte-Beuve, Charles Labitte. This article, entitled 'Le Grotesque en littérature',[7] offers us a contemporary interpretation of the hugolian grotesque.

Indeed, this brilliant study was concentrated on Hugo, and was directed at his 'goût d'innovation à tout prix'. Labitte criticized 'cette langue *bariolée et métaphysique* dont les termes font saillie sur l'idée et l'enveloppent si bien que la forme prédomine sur l'idée'. He was no enemy, but a supporter of good taste. He did not deny the success of Hugo's innovation in poetry, but he recorded the failure of the grotesque in the theatre and blamed 'la mise en pratique de la trop célèbre *Préface de Cromwell*', a preface written in vigorous prose, he granted, 'mais trop tatouée et blasonnée d'images, (...) où se retrouve quelquefois la couleur effrénée de Rubens'. This analogy will be of interest to lovers of comparisons. The result of this theory of the grotesque, where the critic saw 'le côté le plus saillant de la *Préface de Cromwell*', was to have transformed art into 'une sorte de mascarade à paillettes et à oripeaux écarlates, comme au temps de ces grotesques de Louis XIII...' He explained this by two features of Victor Hugo's genius, 'son goût de la réalité matérielle et (...) sa passion si marquée pour l'antithèse': thus the grotesque reproduced nature's flaws and gave a contrast to beauty by means of ugliness. Hence 'ces personnages monstrueux, rachitiques, bossus, *contournés*, repoussants', who are lifeless. They lack 'l'aisance' of Shakespeare, the creator of Falstaff and Caliban:

'Ses grotesques me font l'effet de quelque silhouette mal venue de Callot qu'on collerait au beau milieu d'une toile de Rembrandt.' This *'fantaisie'*, as he called it, in the fashion of the period, contained something both false and over-laboured. In short, it was artificial and, far from sharing the poet's opinions about the Christian origin of this trend, he ascribed it to a survival of pagan ideas: 'Ces figurines bizarres qui grimacent sous les porches des églises, la fête de l'âne, la danse macabre, toutes les folles et cyniques gausseries du moyen âge ne sont pas autre chose.' Hugo was to profit from this comment in *Promontorium Somnii* (1863), at a time when his essay on *William Shakespeare* prompted him to similar reflections. So he was to join together 'le chimérisme antique' and 'le chimérisme gothique' into his hallucinatory vision of nature. Here is one example: 'Faites votre promenade (...) Ah! les hamadryades sont à considérer. Préoccupez-vous de Lucus, dieu des branchages; c'est une personne obscure et bizarre.' This makes me think of several drawings, and, in particular, of one dating from 1856 with the title 'Perruque parle, Feuillage écoute' [162].

In his conclusion, Labitte's main objection was directed at Hugo's style, where he saw the influence of painting:

... l'art de la plume est devenu un art d'atelier. On a écrit, comme on a peint, avec la couleur. Beaucoup de verve sans doute et de talent a été dépensé dans ces arabesques multipliées de la métaphore, dans les bigarrures diaprées de la période, dans cette prodigalité d'images enluminées, dans cette complication toute byzantine de ciselures. Toutefois un sensualisme si raffiné du style peut-il, je le demande, être accepté comme méthode?

As Labitte died shortly afterwards, he never knew Symbolist prose. But, according to him, Gautier had, by that time, already used the method to excess. Witness this opinion to add to Professor Seznec's collection:[8]

Avec lui, il faut s'attendre à mille témérités et à mille boutades, aux plus cyclopéennes énormités comme aux mignardises les plus raffinées. Ne diriez-vous pas les bergères attifées de Boucher, assises avec leur minois rose et leur nez retroussé au beau milieu du monstrueux festin de Balthazar peint par la brosse titanesque de Martinn [sic]?

This comparison suits the disciple but is even more apt for the master, for the future poet of *Les Contemplations* and *Les Chansons*.

Must we reduce Hugo's interest in the grotesque to an observation of reality joined to a taste for antithesis? Is this enough? I do not think so. For this poet said earlier, in the Preface to *Odes* (1822): 'Sous le monde réel, il y a un monde idéal', and in a line from *Les Orientales* ('Extase'):

Mes yeux plongeaient plus loin que le monde réel.[9]

162 Hugo: 'Perruque parle, Feuillage écoute' **163** Hugo: 'Profil à long nez, œil noir'

This made Gide say that Hugo was able to see the real world well enough when he wanted to. But it is true to say that, beyond the real world that he observed and contemplated, Hugo expanded by his imagination the traits and *linéaments* that he acknowledged. He reminded us of Lamennais' words: 'On ne voit guère, il est vrai, quand on ne voit qu'avec les yeux, ils ne sont guère bons que pour faire des cartes de géographie; l'imagination, l'esprit saisissent le reste.' There is no inconsistency, but rather a deepening, an orientation of vision. In the same way Hugo enjoyed putting direct opposites together side by side in order to contrast them, and also in order to unite them, as he was to do with two halves, one of an animal, one of a man, that is to say in order to create a hybrid being of his own.

In the preface of *Les Orientales*, the poet called himself 'homme de caprice et de fantaisie' and maintained that the idea for these poems had come to him

164 Hugo: 'Poète de Bergerac' **165** Hugo: 'Cavalier à mufle accoudé'

'en allant voir coucher le soleil'. There was no question of imitating nature, but he sought only an excitation from nature. Indeed, he drew from it his studies for *Soleils couchants*, in the style of painters of skyscapes, like Bonington, Constable, or later Boudin, interpreting as Hamlet did the animalistic shapes of the clouds:

> Puis voilà qu'on croit voir, dans le ciel balayé,
> Pendre un gros crocodile au dos large et rayé.[10]

But already Ordener, in *Han d'Islande*, was watching from a tower for the shapes of the 'grandes ombres', their 'sombres contours': 'son imagination eût volontiers animé toutes les formes gigantesques, toutes les apparences fantastiques, que le clair de lune prête aux monts et aux brouillards'. And later, to trees or rocks. A passage from a letter of 1825 tells of a strange

experience when he sketched for his correspondent the shadows cast by ivy leaves on his paper:

Je suis pour le moment dans une salle de verdure attenante à la Miltière; le lierre qui en garnit les parois jette sur mon papier des ombres découpées dont je t'envoie le dessin, puisque tu désires que ma lettre contienne quelque chose de pittoresque. Ne va pas rire de ces lignes bizarres jetées comme au hasard sur l'autre côté de la feuille. Aie un peu d'imagination. Suppose tout ce dessin tracé par le soleil et l'ombre et tu verras quelque chose de charmant. Voilà comment procèdent les fous qu'on appelle les poètes.

Thirty years later we find these words under a drawing: 'ce que je vois sur un mur'. This phrase brings to mind the advice given by Leonardo da Vinci to his pupils 'de considérer attentivement la lèpre des vieux murs pour en faire surgir des figures extraordinaires'.[11] These were 'dartres', marks standing out in relief on walls, and which evoked strange faces and weird shapes to his eyes. He sought them both in foliage and in the outlines of rocks.

The main point is that a tangle of broken lines provoked the poet's imagination and created in the draughtsman the desire to put down on paper this bizarre and fleeting impression. The ivy was instrumental in the process. It is remarkable that we come across it again quite often as a decorative motif, and also across other types of foliage, during Hugo's years of exile as, for example, in the rough sketch of a faun and a flautist.[12] The salient parts of the face, nose, chin, ears and, as the case may be, horns and pipe, etc., all contribute to feed this pattern of broken lines. So on one side there was discontinuity, which amused his imagination. This applies to his drawings as well as to his writings. On the other side, in the drawings, the composite (or the monstrous) stirred his imagination in a way that suggests a judgement or a problem, thus we are led to a meaning that can sometimes be defined, or that often remains an open question.

Caricature, which is the exaggeration of a trait in order to obtain a comic effect, appropriates a nose to make it prominent, a mouth to make it gape [163, 164]. The result is an expression of ridiculous arrogance or total stupidity. The painter Le Brun studied the effects of emotion upon a face, that is to say a face with diversely deformed lineaments. In the same manner, but perhaps in the other direction, Hugo watched for the inner meaning of those faces pulled in all directions. So, said Lhote, 'Goya et Daumier (...), d'un coup de baguette magique, suscitent mille tares et difformités sur les visages les plus banals.'[13] In a similar way, equivalents can be found in Hugo's satirical lines in Les Châtiments. From there, these traits are widely disseminated in Hugo's

poetry, for example in *La Légende des siècles,* before manifesting themselves freely in the fragments of comedy showing Maglia and other 'gueux'. I shall only give a few examples. I have spoken of exaggerated noses (like that of Cyrano). For Hugo the absence of a nose seems to evoke cowardice or cruelty, which often go together. So he attacks church people:

> Marguilliers aux regards vitreux, curés *camus*
> Hurlant à vos lutrins...
> Vieux bonshommes *crochus*, hiboux hommes d'état...
> > (*Chat.*, III, 4)

Was it pure coincidence, due to the limits of human physiognomy, that made him characterize one of the robber kings assembled to kill the 'petit roi de Galice' as:

> Pancho, fauve au dedans, est difforme au dehors.
> Il est *camard*, son nez étant de cartilages,
> Et si méchant qu'on dit que les gens des villages
> Ramassent du poil d'ours où cet homme a passé.

We notice in this quotation *dedans* and *dehors*, symbols of the difference between the appearance and the reality that is beyond our vision. We shall meet them again with reference to one particular case.

The hat is one of the clown's essential properties. Thrust down over the eyes, it makes the wearer look foolish; perched on top, it gives a shallow appearance. In Sorel's *Francion* we read: 'Avec cela, il avait un chapeau pointu à petit bord, tellement qu'il avait une façon bien grotesque.' In *Les Châtiments* (IV, 7) there is a description of Veuillot, a contemporary Catholic writer, sketched among church people, who are his usual target:

> Tout jeune, il contemplait, sans gîte et sans valise,
> Les sous-diacres coiffés d'un *feutre en lampion,*
> Vidocq le rencontra priant dans une église,
> Et, l'ayant vu *loucher*, en fit un espion.

Elsewhere, the maréchal de Saint-Arnaud, one of Napoléon III's followers, is characterized by the hat he is wearing in front of a conflagration (IV, 5):

> ... Ton chef branlant, couvert d'un *feutre cahoté,*
> Tu t'es fait broder d'or par l'empereur bohème.
> Ta vie est une farce...

There is no hat for this Emperor, 'césar moustachu', or 'chacal à sang froid', who 's'accoude sur la nappe' [165], 'noir pirate' and (IV, 11)

> Mâche son cure-dent taché de sang humain

The Turk, a pirate or janissary, in one of the drawings, is wearing a turban, above the 'X' formed by his moustache and eyebrows.[14] When *Les Orientales* was written this turban was used in a similar but inverse analogy, it was worn by a black rock:

> ... ce roc
> A sur sa tête un fort, ceint de blanches murailles,
> Roulé comme un turban autour de son front noir.

166 Hugo : 'Le Vieil Oiseau de proie'

167 Hugo : 'Être bizarre'

This purely picturesque image of something round becomes, in the order of epics, pointed and threatening. In *Le Petit Roi de Galice*:

La montera de fer montre ses crocs pointus.

It concerned, it seems, a sort of cap which Hugo changed into a morion. And, in *Eviradnus* (V, 481):

Le casque semble un crâne et, de squames couverts,
Les doigts des gantelets luisent comme des vers.

These 'squames' or scales, these 'crocs', demonstrating an exchange of characteristics between species, evoke the jagged outlines with which Hugo liked to surround his figures and faces *c.* 1856–8, and which have been

168 Hugo: 'Philosophe regardait l'ombre' **169** Hugo: 'Soudard à trompe'

compared to drawings of coastlines in maps. We shall see grotesques of this sort looking sometimes comic and sometimes fantastic, often pitiable and disturbing at the same time.

Perhaps this type of fantasy is not alien to the formation of an image that is picturesque, but totally lyrical, like that in a famous poem from *Les Contemplations*, where dusk crowns a cliff on the seashore with clouds, according to a strictly idiomatic metaphor:

> Et là-bas, devant moi, le vieux gardien pensif
> De l'écume du flot, de l'algue du récif,...
> Le pâtre promontoire au chapeau de nuées,
> S'accoude et rêve au bruit de tous les infinis...[15]

On the other hand, this 'overhang' motif draws our attention, in a sketch

170 Hugo: 'Vieux chauffeur'

171 Hugo: 'Désespoir de la matière'

172 Hugo: 'Caricature au crayon'

173 Hugo: 'Caricature à la plume'

from *Les Misérables*, which has not been kept, to a modern vagrant, just as, so it is said, some of Mozart's musical themes would fit equally well into an opera or an oratorio: 'C'était un bandit à casquette vivant *sous une visière* de cuir, l'œil *louche*, qui haïssait le genre humain parce qu'il avait le visage couvert de verrues — gaillard féroce.'[16]

In the drawings, a hat crowned with leaves combined with a nose in the shape of a promontory, and a weird mixture of facial lines, give an air of bucolic peace to a philosopher of nature smoking his pipe, entitled 'le vieil oiseau de proie songeait' [**166**]. In a style that is half epic and half grotesque a faun's legs are fixed into the gaudy doublet and breeches of a playing-card king [**167**]. The faun, with its goat's legs and horns, is one of the favourite types of picturesque monster from Hugo's drawings made during his years of exile. It often appears as a flautist and alternates a voyeur's attention with the knowledge of some secret of the world [**168**]. Or sometimes a human being is transformed into a monster by means of his head, as when a mercenary standing on a staircase grows a trunk [**169**], or a 'chauffeur' [**170**] wearing a jagged sort of cap sketches a dance-step.

With graphic variations, the process remains either a composition of forms, or a collection of broken lines which at times become jagged. If Hugo started out from Callot, or Goya, he must have passed, in his evolution, beyond the conditions required for making a pure drawing, for better or worse. Yet Callot was still enough of a term of reference at the time of *Les Châtiments* to evoke the figures on a sinister fairground stage:

> Debout sur le tréteau qu'assiège une cohue
> Qui vit, bâille, applaudit, tempête, siffle, hue,
> Entouré de pasquins agitant leur grelot,
> — Commencer par Homère et finir par Callot —
> Toi, spectre imperial, tu bas la grosse caisse.

The final line makes me think, on the one hand, of the drummer-monkey of *La Fête chez Thérèse*, and on the other of that monster, either a dog or a monkey, who beats the big drum in one of the sketches of animal musicians, similar to those which Journet and Robert found in *Punch* during these same years, 1855–6.[17] But there, as also in Granville's work, the drawing is much more carefully done, too much so to evoke those sketches that were at the same time bolder and less truly artistic. This kind of drawing had an experimental value for Hugo. I am not thinking here of the medium which Focillon admired for its completely modern variety.[18] I am thinking of the drawing itself, of the subject, might I say also, which is a question.

174 Hugo: 'Figure de noyé'

175 Hugo: 'Déchue'

Sometimes the drawing is an attempt to express a human attitude and in this case the idea often exists before its graphic treatment, or else it coincides with it. The satirical sketches, or caricatures, seem to search how it is that the expression of stupidity, melancholy, or indeed any other expression of emotion, could be associated with an open mouth beneath a turned-up nose, or with an eye looking upwards above a moustache. These drawings have a relationship with the caricatures of the period.[19] We might say that through these caricatures Hugo goes some way towards the style of Daumier, through the movement of some of his faces, and the simplification of their lineaments. In *Les Châtiments* (III, 8) I find this fairly accurate testimony:

176 Hugo: 'Tristitia rerum'

177 Hugo: 'Nature domptée'

O valets solennels, ô majestueux fourbes,
Travaillant votre échine à produire des courbes,
Bas hautains, ravissant *les Daumiers enchantés*
Par vos convexités et vos concavités.

But the most interesting type of drawing, although not always the best one, seems to be in search of a meaning. It starts from pure chance, from a tangle of lines. This is not always so clear-cut. The 'vieil oiseau de proie' [166], as it finally appears, seems to me to be the effect of a combination of intention and performance, as, in the same way, the old woman called simply 'déchue' [175], whose lack of forehead and ragged degradation demote her to bestial-

ity, or rather to human misery and, if I may say, to vacuous nothingness. This drawing dates from 1858 and unites, in a striking manner, with those sketches of 'larves' where Hugo experimented graphically—perhaps in order to rid himself of the idea—with a certain inevitable pessimism. It is strange to notice that beside the brilliant beggars of *Le Théâtre en liberté*, it was *La Légende des siècles*, which is the heroic collection *par excellence*, that presents an analogous and very suggestive picture of human destitution. It is in *Le Jour des rois*, dated February 1859 and probably begun in December 1858, that appears 'le mendiant du pont de Crassus', a Spanish image of a beggar suggested rather than inspired by Goya and Murillo:

> La *larve* qui n'est plus ou qui n'est pas encore
> Ressemble à ce vieillard, spectre aux funèbres yeux,
> Grelottant dans l'horreur d'un haillon monstrueux.
> C'est le squelette ayant faim et soif dans la tombe.
> Dans ce siècle où sur tous l'esclavage *surplombe*,
> Où tout être, perdu dans la nuit, quel qu'il soit...
> Offre toujours assez de place pour un maître...
> Ce pauvre homme est chétif au point qu'il est absous...
> Il est comme un cheval attendant qu'on dételle...
> Cet être obscur, infect, pétrifié, dormant,
> Ne valant pas l'effort de son écrasement;
> Celui qui le voit dit: 'C'est l'idiot', et passe;
> Son regard fixe semble effaré par l'espace;...
> C'est un de ces vivants lugubres, *engloutis*
> Dans cette extrémité où l'ombre se termine
> La maladie en *lèpre* et l'ordure en vermine.

In this long evocation of the unhappy grotesque, limit and symbol of the *condition humaine* which was already so akin to Beckett's beggar (Lucky), permanently enslaved to some Pozzo, I italicize words like '*surplombe... engloutis... lèpre*' (and his '*loque* au vent flottante'). Indeed, words and traits give the answer to each other. But Hugo does not limit a life of perplexity to men: his animism extends it to include nature and things. The drawings offer us, in the sense indicated by *La Bouche d'ombre*, some original examples of 'grotesques' among things, plants and animals. This is 'Tristitia rerum' [176] where the sadness of things is represented by the profile of a head that is perforated by a black carbuncle and whose cheek is eaten away by a dartre, as can be seen on leprous walls.[21] Or it is this feline head with dripping outlines which represents matter, or nature, though subdued, it is true, by the philosopher[22] [177]. From bestialized or humanized beings rises a cry, a moaning against existence. From this stem those curious, almost abstract, drawings,

178 Hugo: 'Dedans d'une bête'

179 Hugo: 'Dedans d'un arbre'

characterized by a gesture upwards, which are called *dedans*, the interior of a rock, an animal or a tree [178, 179]. True, this cry is also an elevation towards the Almighty. In Hugo's world, everything prays, but man alone prays with difficulty and lack of spontaneity.

There is no conclusion to a simple token of research, except this: that there is an obvious relationship between the graphic and poetic expression of an evidently original genius. Hugo said: 'Je crois des choses qui n'ont pas de contours. Cela me fatigue.' Might I suggest that in designing forms that sometimes appear quite strange, at first he experimented, as I have proposed, but finally he gave form to the formless, that is to say he made a practical effort to circumscribe nightmares, in the widest sense. One drawing seems to bear witness to this in the strict sense: it is of an emaciated old succuba, greeted with the words: 'Point du jour. — Alleluia.'

Notes and discussion

(1) *Essais,* I, 28.
(2) *Art Poétique,* 4.
(3) Cf. *Orientales,* I:
 Des colosses debout, regardant autour
 d'eux
 Ramper *des monstres nés d'accouplements*
 hideux.
(4) *Caricaturistes étrangers:* 'Le grotesque
coule inépuisablement de la pointe de
Cruikshank, comme les rimes riches de la
plume des poètes naturels.'
(5) *La Fantaisie de V. Hugo,* Paris, Corti,
1949, I, p. 232, sq.
(6) *Maison de Victor Hugo,* p. 281, cl. Buloz,
in *Dessins et lavis,* I, No. 143, Club Français
de Livre, 1967.
(7) *Revue des Deux Mondes,* VIII, 1844,
pp. 495–516.
(8) J. Seznec, *John Martin en France,* All
Souls Studies, Faber and Faber, 1964.
(9) This aspect has recently been studied by
Jean Gaudon in his book *Le Temps de la*
contemplation, Paris, Flammarion, 1969.
(10) *Feuilles d'automne,* XXXV.
(11) A. Lhote, *La Peinture, le cœur et l'esprit,*
Denoel, 1951, p. 177.
(12) *Dessins et lavis,* I, No. 357 (*Carnet, mai*
avril 1856, p.p. Journet et Robert, Belles
Lettres, 1959, No. 6).
(13) Op. cit. p. 146.
(14) *Dessins et lavis,* I, No. 138; 'gros nez
camus' mentioned in caption.
(15) *Contemplations,* V, p. 23. 'Promontoire
avec un P majuscule', remarks L. Cellier, who
quotes in a note (ed. Garnier, p. 687): 'Il est
très difficile quand on vit dans la familiarité

de la mer, de ne point regarder le vent comme
quelqu'un et les rochers comme des
personnages' (*Travailleurs de la mer,* II, I, 8).
(16) *Carnet des 'Misérables',* Minard, 1965,
p. 266 (f° 177).
(17) Notebook quoted, pl. 21 and p. 10. In
Dessins, No. 386.
(18) See *Dessins,* p. xii.
(19) Among the 'musées grotesques', I notice
in *Les Métiers grotesques,* one of Guillot's
albums (1823), an attempt at experiment:
he draws the face of a man out of his working
tools, for example of the painter with his
easel, palette and brushes. *Cabinet des*
estampes, T F 43 in–4°.
(20) Compare with the passage of *William*
Shakespeare (Reliquat) quoted in my *Victor*
Hugo à l'œuvre, p. 261, which associates
grimace with Goya and *pou* with Murillo, the
last line of the poem: 'Toi, les poux dans les
trous...'
(21) Cf. *Châtiments,* I, 10: 'L'opprobre est
une lèpre et le crime une dartre.'
(22) Cf. *Châtiments,* VII, 12, *Force des*
choses:
 O figure terrible, on te croirait aveugle!...
 La matière, aujourd'hui vivante, jadis
 morte,
 Hier écrasait l'homme et maintenant
 l'emporte.
Discussion centred around the resemblance
between the grotesque in Hugo's poetry and
in his drawings. The spiral motif which
recurs frequently in the poetry, and is
doubtless inspired by Piranesi, is not to be
found in Hugo's graphic work, although
there are some *lignes serpentines.*

Jean Seznec

12
Odilon Redon and literature

In the context of our discussions, Odilon Redon presents us with an intriguing case.

On the one hand, he seems to be the *littérateurs'* painter *par excellence*; on the other, he always appears anxious to deny any literary influences, or intentions; he is forever afraid that we should detect in his words, as he puts it, any literary smell.

The causes for the misunderstanding are obvious enough. In the first place, Redon had a confessed passion for reading. 'If I had been born in easy circumstances and without the continuous fascination of painting,' he writes to Bonger in October 1907, 'I would have done nothing but read . . . It is the best exercise of the mind.'[1] He also had a declared admiration for literature: 'Writing', he said, 'is the greatest art'; and he had thought, at one point, of making a series of medallions to serve as a kind of Pantheon of his favourite writers. He himself was very articulate; he had a gift for literary expression, as we know not only from his letters, but from his diary, *A soi-même*.

Furthermore, Redon had many friends among French, and Belgian, writers —particularly in the symbolist group—and they, quite naturally, claimed him as an ally ('un allié d'art', to use his own expression);[2] his work seemed to be, in the graphic sphere, the perfect counterpart of theirs: he was, in short, the master of *pictorial* symbolism—'our Mallarmé', as Maurice Denis described him. Nor was the parallelism gratuitous. Mallarmé and Redon resembled each other in their personalities, their quiet wisdom, their benevolence towards the younger generation; but, above all, they held some common aesthetic tenets. It would not be difficult to extract from Redon's writings an *Art poétique*. He shared the Mallarméan ambition: 'reprendre à la musique son bien'. His aim was 'to exercise upon the spectator all the evocative power, all the charm of the vague that lies at the extreme limit of thought . . . This suggestive art', he continues, 'is to be found entire . . . in music, where it is at its freest and most radiant; but it is also present in my work . . . My drawings inspire, they

do not define . . . They place the spectator, just as music does, in the world of the indeterminate.'[3] It is significant that Redon should have given a frontispiece to the *Revue Wagnérienne*, and that Mallarmé should have sent him the text of his Oxford lecture of 1894: 'La musique et les lettres'. Had not Redon himself proclaimed: 'La musique ne tardera pas à porter aux arts plastiques une atteinte suprême'?[4]

Again, to produce an effect of mystery, to impart to the work of art the quality of the unexpected, Redon advocates a device which echoes, curiously, Verlaine's *Art poétique*: it is to mix the precise with the undefined. This is a secret, Redon said, which the Impressionists have ignored, but Corot knew it; it was Corot, in fact, who had told Redon—still a young artist at the time, in 1868: 'Next to an uncertainty, place a certainty.'[5]

Yet, close and sympathetic as he was to literary symbolism, Redon always exhibited a reluctance to admit any influence from that—or indeed from any—literary quarter: he discouraged all enquiries about the non-pictorial elements entering into the genesis of his works. He himself tells the story of a young and naïve Englishman who had crossed the Channel to question him about his sources; the poor boy went away frustrated, for Redon's only answer had been a smile.[6] Mellerio, too, tried in vain to extract any revelation from the painter. 'Why should I reveal', he said with some irritation, 'anything but the *result* of my work? As for my sources, I can't even say what they have been . . . What kind of link could there be between my work, and my reading?'[7]

This is precisely what I will now try to find out; I hope to be a little less unlucky than the young Englishman.

Redon was bound to get involved with literature, since an important part of his work consists in illustrations. It is as an illustrator (much as he disliked the name) that he should be considered first. From 1886 onwards, Belgian writers such as Verhaeren and Gilkin sought frontispieces from him; and he made several *hors-texte* lithographs for Edmond Picard's play, *Le Juré*, before tackling (among others) Flaubert and Mallarmé.

Now these illustrations are of very uneven quality—and this seems to me revealing. The most successful are perhaps those which he made for Flaubert's *Temptation of St Anthony*;[8] they are certainly the most numerous, since he executed no less than three series of them. His reaction after reading the book which had been brought to him by Hennequin, was: 'It is a literary marvel, *and a mine for me.*'[9] And indeed, for anyone familiar with the general spirit of Redon's art, and his favourite themes, the case is one of pre-established harmony: the writer was providing the artist with elements which were already

180 Redon: 'Eyes in the forest' (illustration for Flaubert, *La Tentation de Saint Antoine*)

181 Redon: Illustration for Bulwer-Lytton, *The Haunted and the Haunters*

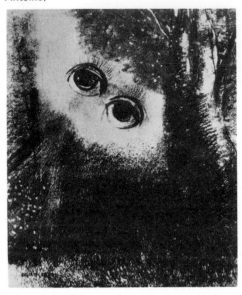

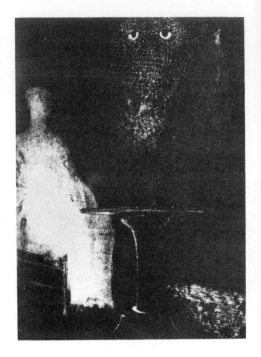

part of his mental world. In the first place, the whole text, as a hallucination, and a museum of teratology, was to appeal to Redon's nightmarish imagination; more specifically, some of the primeval monsters which fascinate St Anthony, the infusoria and the zoophytes, were bound to fascinate also the disciple of the naturalist Clavaud; it was Clavaud who had taught Redon to look, at the border of the imperceptible world, for that life which is intermediary between the animal and the plant,[10] for these ambiguous creatures which the artist was to depict in *Les Origines*: and when the horrified saint sees eyes without a head floating like molluscs [180], what he sees is, in fact, an Odilon Redon *avant la lettre*. There are other themes, which recur like obsessions through Redon's work, such as a quadriga falling from the sky: this catastrophic scene owes something to Delacroix and Gustave Moreau, but its precise description is given in Flaubert's *Götterdämmerung*. No wonder, then, that Redon seized eagerly upon a text which acted almost like an agent of self-revelation. It is all the more ironical that Flaubert should have condemned, in advance, any attempt to give a graphic interpretation of his work when he wrote: 'O illustration! modern invention designed to disgrace any literature!'

Again, in the case of Bulwer-Lytton's horror story, *The Haunted and the Haunters* (*La Maison hantée,* in Philipon's translation), it is clear that Redon is dealing with a congenial subject [181]. He follows the text very closely, as you will see:

> . . . It was a darkness shaping itself forth from the air in very undefined form. I cannot say it was of a human form, and yet it had more resemblance to a human form, or rather shadow, than to anything else . . . As it stood, its dimensions seemed gigantic, the summit nearly touching the ceiling . . . As I continued to gaze, I thought . . . that I distinguished two eyes looking down . . . from the height . . . My eyes now rested on the table . . . an old mahogany round table, without cloth or cover . . . A chair . . . was placed at the side of the table. Suddenly, as forth from the chair, there grew a shape—a woman's shape. The shadow of the shade in the background grew darker; and again I thought I beheld the eyes gleaming out from the summit of the shadow . . .[11]

Obviously, Redon was just the man to illustrate ghost stories. Elsewhere, however, he is not so successful. He once started to illustrate Pascal's *Pensées,*

182 Redon: 'Le silence éternel...

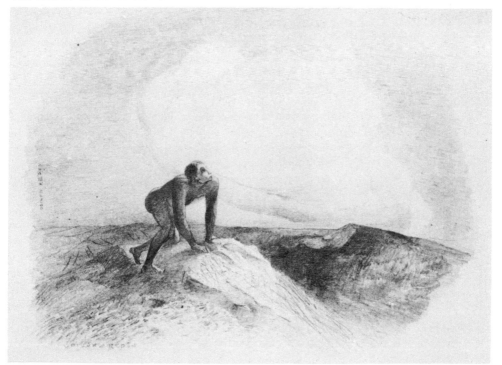

a book which was ever since his childhood, a favourite reading of his; but he had to confess his inability to meet such a challenge: 'A thought,' he said, 'cannot become a work of art, except in literature . . .'[12] and 'Pascal's text is too abstract, even for me, to generate a black and white equivalent'.[13] He never went beyond this early drawing; it is significant, however, that he should have selected 'Le silence éternel de ces espaces infinis m'effraie...'[14] and placed the emphasis on the fright. *Effroi, effrayant, affroyable!* You remember Valéry's scandalized remarks on that strange Christian who finds nothing in Heaven but terror; who pictures himself as some forsaken man, brought in his sleep to a deserted and awesome island. Redon's creature, crouching in abject fear, in a desolate landscape [182], is that man who has just woken up: he looks indeed, in Valéry's words, like a cornered animal, or some miserable dog barking at the moon.[15] We find a very similar type in an equally disquieting lithograph: this maniac lost in the forest is Don Quixote [183]. As long as there is an element of fear, or insanity, to be exploited, Redon finds himself more or less at home. He did nine drawings for Baudelaire's *Fleurs du mal*; one of them illustrates the lines:

183 Redon: 'Don Quixote'

184 Redon: Illustration for Mallarmé, *Un Coup de dés*

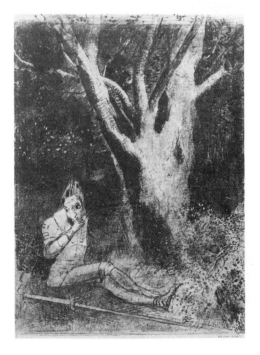

Sur le fond de mes nuits Dieu, de son doigt savant
Dessine un cauchemar multiforme et sans trêve.

A perfect programme for Redon's own production.

But let us now take Redon as an illustrator of Mallarmé [143], his friend
Mallarmé, who once called him *my ideal reader,* 'le lecteur rêvé'; and who
found, to express the rustling quality of Redon's genius, the famous sentence:
'Vous agitez dans nos silences le plumage du rêve et de la nuit.'

During the winter of 1897–8, Redon and Mallarmé worked together on an
edition of *Un Coup de dés* which Vollard wanted to publish with four litho-
graphs. Vollard had suggested, as an example of what he had in mind, a plate
from Redon's *Apocalypse* (another congenial subject), 'the plate where there is
a seated figure holding a book, with animals at its feet'. Mallarmé, however,
objected to a white background, because, he explained, 'the illustrations
would then duplicate the effect of my text whose pattern is black and white'.[16]

Mallarmé died in September 1898. The edition never appeared, but three
lithographs survive.[17] Two of them bear only a very remote relation to the
text, but the third one strives to follow it closely. Here is the relevant passage;
the arrangement of the words on the page is intended, as you know, to repro-
duce 'the prismatic subdivisions of the idea':

La lucide et seigneuriale aigrette
 au front invisible de vertige
scintille puis ombrage
 une stature mignonne ténébreuse
 en sa torsion de sirène debout
 le temps de souffleter
par d'impatientes squames ultimes bifurquées
 un roc
faux manoir
 tout de suite évaporé en brumes.

Here is Redon's picture, which Professor Austin has very aptly defined:
'half-Hamlet, half-mermaid' [184]. It seems very weak, perhaps because it
tries to be a literal rendering of a symbolic image, and leaves out all the sug-
gestions and the overtones of the text: the night, the shipwreck, the foaming
sea. And you will notice that the background has been left white.

Redon, in fact, had been reluctant to attempt such important illustrations
for such an enigmatic text. After Mallarmé's death, his daughter asked him
(in February 1899) to draw a frontispiece for a posthumous edition of the
poems. He never did it. Mallarmé had proved even more intractable than
Pascal.

Redon played with the idea of illustrating other famous texts, such as de Quincey's *Confessions*;[18] and after reading Claudel's *Tête d'or*, he wrote to Frizeau, in November 1904 : 'Each line contains a vision to be painted'; but he did not paint any of these visions.

Let us now consider Redon on his own, I mean dealing with subjects of his own choice. The preliminary question is: should a picture have a subject at all? Yes, in the sense that it should have a human content. There lies the error of the Impressionists: they have sacrificed man, and man's thought, to pure workmanship and picturesque effects. As a result, their approach to reality is superficial, and their canvases are empty—since human action and feeling are absent. Should the painter, then, take his subjects from history, from the Scripture, from the Fable? Redon does not exclude historical painting; he even supports the right of Corot and Fromentin to use the resources of mythology.[19] But he insists that the historical subject, the *anecdote*, as he puts it, should always remain accessory, almost superfluous, in the overall effect; otherwise the picture becomes *literary* in the pejorative sense. The core of a great picture is never the narrative, or dramatic, element; it is the impression, the all-pervasive feeling which it radiates. Conversely, if the *anecdote* is allowed to predominate, the picture, as picture, ceases to exist; it will be entirely reducible to words. It would have been better, then, to write the story, than to paint it.[20]

How is Redon himself going to solve this problem? How will he manage to keep the *literary idea*, as he calls it, within safe limits? How is he going to avoid *la senteur littéraire*?

He starts with shunning, personally (on the whole, for there are exceptions, as we shall see), historical and mythological subjects precisely because, in his view, they are too explicitly literary. Dreams will be the stuff of his pictures; and his best work will be, in Mallarmé's words, 'issu de ses seuls songes'.

This formula, however, needs qualification. Redon's declared ambition is to make other people dream, and even think. 'An artist', he says, 'should be a painter in front of nature, a thinker in his studio.' This does not mean, of course, that his art should be didactic or *engagé* (Redon condemns both Puvis de Chavannes and Maurice Denis on that count) but that it should contain an intellectual ferment. Redon's imagery, therefore, is not the simple transcription of his dreams; it is an ambiguous creation, deliberately ambiguous, for it is intended to puzzle and to disturb the spectator, thereby forcing him to brood, or to meditate.[21]

Mystery can be manufactured; there are, as we have already seen, devices, or recipes, to produce perplexity. Redon's captions, to start with, are inten-

tionally deceptive. Mallarmé admired them; he even confessed that he envied them: 'Vous le savez, Redon, je jalouse vos légendes.' And well he might. They are beautifully enigmatic. Even the titles of some albums, for instance *A Edgar Poe*, were, as Redon admits, equivocal, chosen to put the public, and the critics, off the track: a perfectly legitimate deception—'équivoque bien permise, très légitime'. Yet he came to regret that he had mentioned a literary figure at all . . . 'J'ai perdu mon innocence,' he said. His favourite albums were *Dans le rêve* and *Songes*, which were pure of any literary mixture or association; their captions, needless to say, were appropriately obscure. Here are two examples. The profile suspended in a lantern over a desolate landscape, with the dark bulk of a mountain in the distance, is called: 'Lueur précaire, une tête à l'infini suspendue...' which is hardly an elucidation. Another one is called: 'Sous l'aile d'ombre, l'être noir appliquait une secrète morsure' [185]. Which is the black being? Is the bite the sting of death or is it a satanic scene? We are left wondering.[22] Mellerio, however, tried to read too much in this kind of caption, to Redon's annoyance: 'All I wanted to do was to create a sort of diffuse, but imperious, attraction towards the dark world of the indeterminate, as a way of predisposing the spectator to think.'[23] Finally, he decided to give up captions altogether.

185 Redon: 'Sous l'aïle d'ombre'

186 Redon: 'Smiling spider'

187 Redon: 'Cactus man'

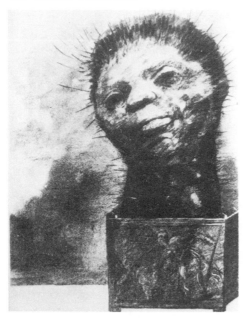

188 Dürer: 'Melancholia'

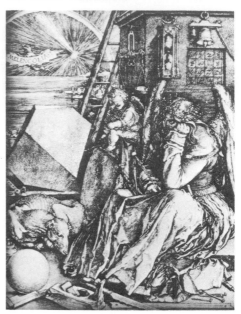

189 Redon: 'The angel with black wings'

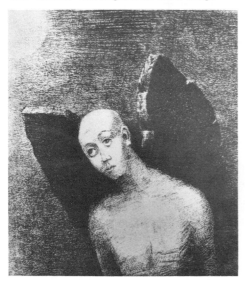

190 Redon: 'Man with a ball'

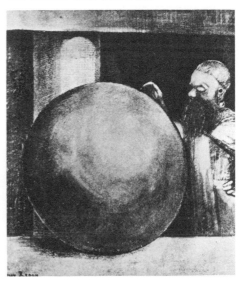

It is the figures themselves, of course, that should embody the enigma. Here again Redon applies devices. A familiar one is to detach a human expression and to place it in an animal (such as the smiling spider [186]—there is also a weeping one) or in a plant (such as the melancholy swamp flower). Conversely, a human head can be presented as a vegetal, such as this Cactus man [187]. One could draw up a whole list of these recipes.

The important thing is to maintain the ambiguity—*être tout le temps dans l'équivoque*;[24] one should, above all, avoid conventional symbols, easily intelligible allegories.

Redon once declared: 'I have not said anything that had not been fore-shadowed by Dürer in his print, "Melancholia"'[25] [188]. Here, to be sure, is a mysterious allegory, if ever there was one. It has exercised the ingenuity of countless *littérateurs*, all the way from the Romantics—Hugo, Michelet, etc., down to Huysmans and Elémir Bourges, whose verbal interpretation (an absurd one) is quoted by Redon himself.[26] Only in recent years has the combined erudition of Saxl and Panofsky been able to decipher it.

Now one element of this print, and perhaps two, have in fact been taken up by Redon. The first is the dejected figure itself; we find two such creatures in his work. One (as he pointed out himself) is the old angel, 'l'ange vieillot';[27] the other, the angel with black wings [189]; both create a mournful, uneasy feeling, but it is easy to explain. What Redon has done is simply to divest his angels of their traditional attributes: youth, whiteness, radiant beauty, aerial lightness; the result is disconcerting.

Another possible borrowing from Dürer's print is the ball. It has become prominent in an intriguing composition, a favourite of Des Esseintes. Huysmans describes it as follows: 'A bearded man, half-way between a Buddhist monk and a public square orator, touches with his finger a colossal cannon ball . . .'[28] [190].

The great difference, however, is that there are keys to Dürer's 'Melancholia', which is a profound and complex allegory, made up of two traditional figures—a temperament (the saturnine one) and a liberal art (geometry). Every single detail rests on a definite text: the wreath, the little ships, the comet, the child, the dog and the bat, the purse and the tools, the ball, the hammer and the ladder, the compass, the polyhedron and the square of number 4. Redon achieves mystery at far less expense: simply through the unexpected.

Be that as it may, mystery, for him, remains an essential ingredient in the work of art; not only does it endow the work with a spiritual value by leading the mind beyond reality, by putting, as he says, 'the visible at the service

of the invisible'; but it becomes the condition of the work's lasting interest. Redon quotes Suarès: 'The only works of art to defy time are the mysterious ones . . .'[29] Their secret unfolds gradually; and because of their very indetermination, they hold different answers to the anxious questions, and desires, of men. In the future, every man will find in them what he is looking for; he will recognize what he has seen in his dreams.

Here, however, is the reverse of the medal. Precisely because his works lend themselves to an infinite range of interpretations, Redon falls a victim to the very danger he wanted to escape. In his eagerness to avoid being called a *literary* painter he produced just the kind of art which was to make him a prey to the *littérateurs*: an art which offers itself as a factitious dream is bound to invite inexhaustible commentaries.

Redon complains: 'What did I put in my works to suggest to young writers so many subtleties? Just a little door, opening on mystery . . . It is for them now to go further.'[30] That is the trouble; they went further—in the fathoming of Redon's mysteries.

Literary glosses proliferate. Mind you, not all of them are favourable. Octave Mirbeau, who later became an admirer of Redon, started with sarcastic remarks on his ambiguity. He took as an example a flower bearing a human eye on its stem. 'What does it mean?' he asked. 'Does it mean consciousness? or unconsciousness? or uncertainty? or universal suffering? or is it just, maybe, a pin for a necktie?'[31]

Even well-meaning *littérateurs* are apt to miss the point, and to let their imagination wander. Take Huysmans and Mallarmé, discussing Redon's illustrations for Flaubert's *Tentation*. Both single out two lithographs, neither of which is, properly speaking, a creation of Redon, nor indeed of Flaubert himself.

This is how Huysmans describes the first one; 'On a short column, the artist has set the body of a thin larva, whose feminine head is leaning on the place where the capital should be . . . and that face, emaciated, pale, heart-breaking to look at, with her closed eyes, her doleful and pensive mouth, seems to hope in vain—as a victim on the headsman's block—for the liberating blow of an invisible axe.'[32]

Mallarmé sums up the same impression in a few, but pathetic, words: 'la pauvre joue triste endormie au billot'.[33] Now, Flaubert's text refers to 'a long, blood-coloured chrysalis with a human head surrounded by rays, and the word *Knouphis* inscribed around it in Greek characters'. What he describes is, in fact, an amulet, from an engraving in Matter's book on gnosticism. Redon, of course, was unaware of this; so were Huysmans and Mallarmé.

The second illustration [192] is, according to Huysmans, 'one of the most frightful lithographs ever composed . . . Against a deep, impermeable black, velvety as the back of a bat, the monster glitters in white, curved like a capital C. The skull, with its enlarged grin, its eyes filled with darkness, falls back against the bust of a mummy.' Mallarmé, in turn, declares: 'Me voici stupéfié encore par cette mort, squelette en haut, en bas enroulement puissant, tel qu'on le devine ne finir; je ne crois pas qu'artiste en eût fait, ou poète rêvé, image aussi absolue...' [34]

Where does that Death actually come from? At the time when Flaubert was working on the episode of the Monsters, Maurice Sand had sent him, as a joke, a number of grotesque little sketches [191]. Flaubert retained one of Maurice's pen drawings, 'a skull fitted on an intestinal worm', and, starting from it, he conjured up the following vision: 'It is a skull, crowned with roses . . . dominating the torso of a woman nacreously white; below, a shroud forms something like a tail; and the whole body undulates, after the fashion of a gigantic worm, erect on end.' Thus Redon—again unwittingly—was re-working another drawing; in this case, as in the preceding one, he added to it, of course, a gruesome quality which was absent from the original. Flaubert had already started distorting a graphic datum into a nightmare; Redon completed the process. Huysmans' and Mallarmé's ecstatic comments are, therefore, somewhat off the mark.

More generally, literary paraphrases have been detrimental to Redon because, by diverting attention from the plastic merits of his work, they made him appear as a *littérateur* strayed in the field of painting. In fact, all literary schools tried to annex him, or at least to claim him as a fellow-traveller: not the Symbolists only, but the Decadents, the Wagnerians, the Rosicrucians. [35] In spite of his protests, he was rigged out according to the prevailing literary fashion.

The truth is that any literary—moral or sentimental—description or comment can be fatal to a work of art; its ultimate effect can be to supersede it, indeed to cancel it altogether, for the simple reason that the comment sometimes is more expressive than the work itself. Redon's art, unfortunately, encourages this kind of parasitic verbiage; whereas Degas's art silences it. Yet, Degas's works are not devoid of literary, and even philosophical, content; but that content is totally digested, so to speak, and transcribed in pictorial terms. As a result, words become superfluous: as Fénéon remarked, no commentary, however eloquent, will ever be a substitute for the least of Degas's pastels. [36]

I should like to deal briefly with two categories which remain, or seem to

191 Sand: Drawings for Flaubert, *La Tentation de Saint Antoine*

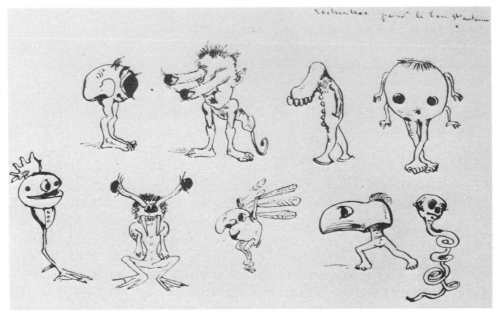

remain, apart from the usual Redonian pattern, and outside the realm of mystery: the mythologies and the flowers.

Redon was scornful of traditional myths—'à quoi bon,' he wrote, 'toutes ces légendes ?'[37] But he discovered that Gustave Moreau, in exploiting the Fable, had succeeded in renovating antiquity and modernizing the gods.[38] Is it not, in fact, what Delacroix himself had done? He had shown, in the words of Baudelaire, that 'you can make even the Romans and the Greeks into Romantics, if you are one yourself'. Redon, in turn, realized that he could use the classical figures to express contemporary moods and his own philosophy. One of his obsessive ideas is the distance between the crawling beast and man's higher destiny; the gradual, heroic liberation of mankind, painfully emerging from the embryonic larvae, through vegetal and animal metamorphosis.[39] This kind of Darwinian epic is illustrated in *Les Origines*; but it can also be clothed in mythological imagery: the centaur, the mermaid, the cyclops, the winged horse—all these hybrid creatures tell a tale of frustrated aspirations; they try in vain to disengage themselves from their animal shape, or to rise above the earth. 'L'aile impuissante n'éleva point la bête en ces noirs espaces' [193]. Wings are powerless to lift the rearing horse. Pegasus remains captive in darkness, with his gloomy captor [194]; Phateon's adventure ends in

192 Redon: 'Death'

193 Redon: 'The powerless wings'

194 Redon: 'Pegasus'

195 Redon: 'Anemone'

catastrophe. This flaming scene, however, looks like an apotheosis. In the latter part of Redon's career, at the turn of the century, these themes are taken up in colour. 'Where are my blacks now?' he writes; 'I have married colour.'[40]

This is not simply a change of medium—pastel and oil in place of charcoal and lithography; it suggests, as Roseline Bacou observes, *un éclaircissement moral*, a more optimistic outlook. Quadrigae now soar happily through blue skies (in the fresco at Fontfroide, for instance). In a letter to Claudel, in 1925, Frizeau expressed the wish that the powerful genius of the poet should carry up with him the young generations—and he compared that genius to one of Redon's latter-day quadrigae, 'ce char d'Apollon qui s'élance, quitte la terre rouge et se cabre dans les éthers lumineux'.[41] Redon now paints a white Pegasus; and even the amorphous beings of the past blossom into beautiful shapes. From among the larvae creeping at the bottom of the sea, another marine creature emerges—and Venus comes out of her shell. For these new and radiant visions still link up with the former nightmares: in the Cyclops, for instance, we recognize that lonely eye which floated about in so many earlier compositions; but here, in the figure of Polyphemus watching Gala-tea, this lonely eye is, so to speak, legitimated; at the same time, the lugubri-ous world of shadows has receded before a dazzling dawn, a paradise of colour.

The winged horse is now that of Ruggiero, flying to Angelica's rescue, across a stormy sea; but the figures (by contrast with Ingre's famous composition) are almost imperceptible, lost in a fabulous landscape, in some kind of sumptu-ous and magic garden.

Flowers indeed are now everywhere; they invade every subject, even por-traits and profiles. And this is also the time of the bouquets—the plain bouquets which at first look so innocent; but are they? Maurice Denis asked the question. 'How is it', he wrote, 'that these poppies, these field flowers, so simple, so fresh, retain that same strange charm which used to fascinate us in Redon's nocturnal lithographs?'[42] One answer would be that in Redon's early style, flowers represented a hybrid form of life, a stage in biological evo-lution. Look at this human face showing through the petals of an anemone [195]; the caption reads: 'There was, perhaps, a primary type of vision attempted by nature in the flower . . .' It seems that for Redon flowers and vision, singly and combined, had complex meanings: the eye turned to light as a flower.[43] This, however, looks like a rather feeble drawing; whereas a seemingly naïve, ingenuous bunch of anemones, such as this one, leaves you with a feeling of wonder; but mystery, this time, is produced by pure colours; and one thinks of the Mallarméan mystery, produced *avec des mots de clarté*.[44] It is 'le mystère en pleine lumière'.

Now these flowers were the occasion of a memorable misunderstanding between the painter and a literary friend, Francis Jammes. In January 1907, Jammes sent a telegram to Redon: 'I am working on an article on you. It will be marvellous.'

The article, *Odilon Redon botaniste*, appeared the following month.[45] It was overflowing with praise; but at the end, Jammes tried to account for the almost disturbing charm which he experienced in front of these geraniums, these cornflowers, these larkspurs . . . arranged with a childlike simplicity. He felt an urge to question them; but before he had time to formulate his interrogation, a rose opened its lips. 'Are you seeking the secret of this genius?' it said. 'I ignore that secret, and he himself ignores it.'

Redon was much displeased; the echoes of his irritation are to be found in several letters to his friends; he expressed it directly to Jammes; he even thought of writing a reply to the article, under the title: 'What my rose is actually saying'.[46] This ill-humour is all the more remarkable since, a little later, he welcomed another article on his flowers, signed by Marius and Ary Leblond and published in *La Revue illustrée*: a pretentious piece of writing in which, however, Redon discovered 'une rare fraîcheur littéraire'.[47]

Why, then, this anger? Because Jammes had implied that Redon's art was no more than a product of the unconscious. Three years before, Redon had already protested against a similar suggestion made by his fellow painter, Émile Bernard.[48] 'Perfect clearsightedness', he insisted, 'is indispensable to me . . . and my deliberate will is always present.' Yet it is the same Redon who had also written to Mellerio: 'Fantasy is the messenger of the unconscious; that is why it is so difficult to answer your *whys* and your *hows*, since everything is subordinated to the whim of the unknown. Nothing is made by will alone; everything is made through docile submission to the prompting of the unconscious.'[49] These two statements can be reconciled; they have been, in fact, reconciled by Redon himself, when he said: 'I suffered the torments of the imagination and the surprises which it gave me under the pencil; but I guided and controlled these surprises . . .'

There is, however, another power that plays a vital part in the genesis of the work of art; and Redon came to recognize it. The artist, he says, has to submit to the exacting demands of the medium which he uses. Ultimately, what creates the expression is that medium itself. He summed this up in a felicitous formula: *La matière a son génie.*[50]

This may be the most pertinent answer both to Francis Jammes, who thinks that pictures emanate from some obscure region of the mind, and to those *littérateurs* who ratiocinate for ever about the artist's intentions. 'La matière

a son génie.' This reminds the commentators that after all what counts in a picture is the plastic values; it reminds them of the artist's dependence on the material means of his creation; but it also reminds them that in the last analysis magic and mystery derive from his handling of these means.

It might be appropriate, by way of conclusion, to quote the comments which Redon·himself made of two pictures: a Rembrandt and a Delacroix.

Rembrandt, Redon observes, uses the chiaroscuro in such a way that he endows the shadow with moral life[51]—this is what he, Redon, was after in the first part of his career; he considered darkness as 'an agent of the mind'. Now let us look at 'The Angel leaving the family of Tobias', in the Louvre. This composition admittedly contains historical, literary and even philosophical elements—the ages of man, human reactions to the supernatural, etc. Yet one feels that these elements are peripheral, and indeed they are perceived only afterwards, through analysis, whereas most of the spectators in front of this wonderful picture are swayed by an impression born from an entirely different source. The unique accent of this sublime scene is the light which illuminates the heavenly messenger; there, in the quality of tone and shade of the chiaro-scuro, lies the secret of the whole work—an essentially *pictorial* invention.[52]

What is true for Rembrandt's chiaroscuro is true for Delacroix's colour; it appeals—according to Delacroix himself—to the most intimate part of the spectator's soul; it is from colour that a picture receives its power of suggestion and evocation.

The later Redon, the colourist, shared this conviction. As early as 1878, he had written a commentary on the famous ceiling in the Louvre, 'Apollo over-coming the serpent Python'. The real subject, he explained (using Delacroix's own words), is 'the triumph of light over darkness'; it is the joy of day, after the terrors and the anguish of night. Every single colour is expressive of that feeling, for instance the tender, exquisite blue and grey surrounding Venus . . . the golden glow of Ceres, the crimson of Mercury's mantle; . . . and in fact, the attributes which identify the Olympian gods become unnecessary, since colour tells everything. As for the expiring dragon and the marshy creatures wallowing in the primeval slime at the bottom of the composition, they are painted in sickly, venomous colours, which suffice to bespeak death.[53]

The detailed explanatory programme which Delacroix wrote about his ceiling—even the remnants of traditional iconography which he kept for the sake of clarity—all this is ultimately superfluous. Colour conveys the meaning, spiritual and moral; not only does it speak for itself but, in Baudelaire's bold expression, it thinks for itself: *la couleur pense par elle-même*. Delacroix, of course,

was well aware of it; at the very time when he was seeking in his palette a triumphant white, a triumphant red for Apollo's horses, he was making notes in his diary about the mysterious effect of colour.

Thus, although Delacroix borrowed from classical mythology, although Rembrandt borrowed from the Bible, their pictures are signal examples of non-literary art.

This is what Redon wanted to be said about his own works. Jean Cocteau once wrote him; 'Vous êtes le moins littéraire des génies, et le plus poétique.'[54] I am not sure that I would agree with that compliment; but I am sure that Redon was delighted with it.

Notes and discussion

(1) *Lettres de Gauguin, Gide, Huysmans, Jammes, Mallarmé, Verhaeren... à Odilon Redon*, ed. by A. Redon and R. Bacou, Paris, 1960, pp. 239, 254.
(2) *Lettres d'Odilon Redon (1878–1916) publiées par sa famille*, Paris, 1923. (To Mellerio, 2 Oct. 1898 (after Mallarmé's death).
(3) *A soi-même, Journal* (1867–1915), Paris, 1922 and 1961. I quote from the 1961 edition, pp. 26–7.
(4) Ibid., p. 177.
(5) Ibid., p. 36.
(6) The young Englishman was Arthur Symons, who had been introduced to Redon by Charles Morice (see *Lettres... à Odilon Redon*, op. cit., p. 198). He published an article in *Art Review*, July 1890, 'A French Blake: Odilon Redon', and another, in French (revised by Rémy de Gourmont, see Gourmont's letter to Redon, 18 Feb. 1891), in *La Revue indépendante*, March 1891, pp. 390–6.
(7) *Lettres d'Odilon Redon*, op. cit., 21 July and 16 Aug. 1898.
(8) Cf. J. Seznec, *Nouvelles études sur la Tentation de Saint Antoine*, London, 1949, pp. 88–9.
(9) *Lettres d'Odilon Redon*, op. cit., 31 March 1882.
(10) *A soi-même*, op. cit. p. 18.
(11) Bulwer-Lytton, *The Haunted and the Haunters*, London, 1864, pp. 334–6.
(12) *A soi-même*, op. cit. p. 94.
(13) *Lettres d'Odilon Redon*, op. cit. To Mellerio, 21 July 1898.
(14) On the theme of silence in Redon's work, see T. Reff, 'Redon's *Le Silence*, Iconographic Interpretation', *Gazette des beaux-arts*, 1967, pp. 354–68.
(15) 'Variations sur une pensée' in *Oeuvres*, Pléiade edition, I, pp. 461–3.

(16) *Lettres... à Odilon Redon*, op. cit., pp. 143–5.
(17) Reproduced in R. G. Cohn, *Mallarmé's Masterwork*, The Hague/Paris, 1966
(18) Sandström, *L'Univers imaginaire d'Odilon Redon, étude iconologique*, Lund, 1955.
(19) R. Bacou, *Odilon Redon*, Geneva, 1956, p. 46.
(20) *A soi-même*, op. cit., pp. 81–2.
(21) See A. G. Lehmann, 'Un aspect de la critique symboliste. Signification et ambiguité dans les beaux-arts', *12e Cahier de l'Association des Études françaises*, Paris, 1960, pp. 161–74.
(22) F. H. Dickinson, 'Some Lithographs by Redon in the Print Room', *Victoria and Albert Museum Yearbook*, 1969.
(23) *Lettres d'Odilon Redon*, op. cit. To Mellerio, 21 July 1898.
(24) *A soi-même*, op. cit., p. 100.
(25) Ibid., p. 26.
(26) Ibid., p. 109: 'Cet être n'est-il pas l'image de la certitude?'
(27) Ibid., p. 109: 'Je me souviens que j'ai fait autrefois, ainsi que Dürer, un ange des certitudes.'
(28) Huysmans, *A rebours* (1884,) ed. 1965, pp. 95–6.
(29) Letter to Fayet quoted by R. Bacou, op. cit., p. 218.
(30) *A soi-même*, op. cit., p. 92.
(31) O. Mirbeau, 'L'Art et la Nature', *Le Gaulois*, 26 April 1886.
(32) Huysmans, *Certains* (1889), p. 153. Cf. *Stéphane Mallarmé: Correspondance*, ed. by H. Mondor and L. J. Austin, III (1886–9), Paris, 1956. Letter to Redon, 9 Dec. 1888: 'Soyez encensé pour les chrysalides et les larves...'
(33) Ibid. To Redon, 19 Dec. 1888.
(34) Ibid.
(35) Cf. J. Lethève, 'Les Salons de la Rose-Croix', *Gazette des beaux-arts*, 1960, pp.

363–73. Redon did not exhibit, but his participation was announced.

(36) Fénéon, *Art et critique*, 14 Dec. 1889.

(37) *Lettres d'Odilon Redon*, op. cit. To Bonger, 7 Feb. 1904 (a propos of. Chausson's *Le Roi Arthus*).

(38) *A soi-même*, op. cit., pp. 64–5.

(39) See J. Viola, 'Redon, Darwin and the Ascent of Man', *Marsyas*, XI, New York, 1962–4, pp. 42–7.

(40) *Lettres d'Odilon Redon*, op. cit. To Bonger, 17 Jan. 1901, and to Fabre, 21 July 1902.

(41) Paul Claudel, Francis Jammes, Gabriel Frizeau, *Correspondance*, Paris, 1952, p. 311.

(42) M. Denis, *L'Occident*, April 1903: reprinted in *Théories*, pp. 136ff.

(43) Cf. Viola, op. cit.

(44) F. Fénéon, 'Les Peintres graveurs', *Le Chat noir*, 25 April 1891.

(45) In *Vers et prose*: reprinted in *Feuilles dans le vent*, 4th ed., 1923, pp. 193–202.

(46) *Lettres d'Odilon Redon*, op. cit. To Frizeau, 31 March 1907.

(47) Ibid. Letter to M. and A. Leblond, 27 March 1907.

(48) See J. Rewald, 'Odilon Redon et Émile Bernard', *Gazette des beaux-arts*, 1956, pp. 81–124.

(49) *Lettres d'Odilon Redon*, op. cit. Letter of 16 Aug. 1898.

(50) Ibid. Letter to Frizeau, 12 Oct. 1911.

(51) *A soi-même*, op. cit., p. 35.

(52) Ibid., p. 82.

(53) Ibid., pp. 175–6.

(54) *Lettres... à Odilon Redon*, op. cit., p. 256 (1913).

Further references: Stèphane Mallarmé; Correspondance, op. cit., II (1871–85), Paris, 1956; *Odilon Redon, Gustave Moreau, Rodolphe Bresdin* Exhibition Catalogue, Museum of Modern Art, New York, 1961, with a study on Redon by J. Rewald).

The discussion drew attention to a parallel between Redon and Fromentin, in connection with Fromentin's observations (*Salon de 1876*) on Redon's art as containing a 'balance of the precise and the suggestive'. To a question on the relationship between Redon and the Bordeaux school, Prof. Seznec replied that this school had indeed played an important role in Redon's development, but was not relevant to the topic Redon and Literature.

Max Imdahl

13
Cézannes Malerei als Systembildung und das Unliterarische

Die hier thesenförmig vorgetragenen Überlegungen sind das Ergebnis wiederholter ausführlicher Diskussionen mit Dr. D. Gerhardus (Universität Konstanz) und im wesentlichen gestützt auf die Cézanne-Interpretationen von R. Fry und K. Badt. Beiden Autoren war es unter anderem darum zu tun, die besondere Gegenstandsdarstellung bei Cézanne als Verfahren zu erklären. Nach Fry handelt es sich in den Bildern Cézannes um einen vollkommenen Abstraktionsprozess vom Gegenständlichen mit der Konsequenz einer Re-Konkretisierung des Gegenständlichen auf der Grundlage dieser Abstraktivität. Das heißt: Im Hinblick auf die so zu konstituierende Gegenständlichkeit vereinigen sich ununterscheidbar Abstraktivität und Produktivität. Badt hat auf die Bedeutung der Flecken (sensations colorantes) verwiesen, und zwar seien die Flecken solche Werte, ,,mittels derer Cézanne seine Körper ,entwickelt' (An — und Ausführungen von mir) und sie in ihrer Verbundenheit darstellt''. In diesem Verständnis sind die Flecken verfahrensrelevant im Sinne von Elementen mit dem Index Operationalität. Nach den Worten Badts empfing Cézanne ,,vor der Natur und von der Natur je und je seine Ideen, die aber gerade noch keine Einzelformen enthielten, sondern nur das allgemeine Darstellungsprinzip des Zusammenbestehenden und des sich gegenseitig Verdinglichenden und Tragenden''.

Wie von Gasquet mitgeteilt, hat sich Cézanne selbst über sein Malverfahren geäußert:

Eh! oui... (Il refait son geste, écarte ses mains, les dix diogts ouverts, les rapproche lentement, lentement, puis les joint, les serre, les crispe, les fait pénétrer l'une dans l'autre.) Voilà ce qu'il faut atteindre... Si je passe trop haut ou trop bas, tout est flambé. Il ne faut pas qu'il y ait une seule maille trop lâche, un trou par où l'émotion, la lumière, la vérité s'échappe. Je mène, comprenez un peu, toute ma toile, à la fois, d'ensemble. Je rapproche dans le même élan, la même foi, tout ce qui s'éparpille... Tout ce que nous voyons, n'est-ce pas, se disperse, s'en va. La nature est toujours la même, mais rien ne demeure d'elle, de ce qui nous apparaît. Notre art doit, lui,

donner le frisson de sa durée avec les éléments, l'apparence de tous ses changements. Il doit nous la faire goûter éternelle. Qu'est-ce qu'il y a sous elle? Rien peut-étre. Peut-être tout. Tout, comprenez-vous? Alors je joins ses mains errantes... Je prends, à droite, à gauche, ici, là, partout, ses tons, ses couleurs, ses nuances, je les fixe, je les rapproche... Ils font des lignes. Ils deviennent des objets, des rochers, des arbres, sans que j'y songe. Ils prennent un volume. Ils ont une valeur. Si ces volumes, si ces valeurs correspondent sur ma toilc, dans ma sensibilité, aux plans, aux taches que j'ai, qui sont là sous nos yeux, eh bien! ma toile joint les mains. Elle ne vacille pas. Elle ne passe ni trop haut, ni trop bas. Elle est vraie, elle est dense, elle est pleine... Mais si j'ai la moindre distraction, la moindre défaillance, surtout si j'interprète trop un jour, si une théorie aujourd'hui m'emporte qui contrarie celle de la veille, si je pense en peignant, si j'interviens, patatras! tout fout le camp.

Es erscheint naheliegend, weitere Überlegungen über das malerische Verfahren Cézannes im Hinblick auf diese Selbstäußerung des Malers anzustellen, und zwar zweckmäßigerweise mit einer einleitenden Bemerkung über Cézannes Einstellung zu Monet.

1

Cézanne hat von Monet gesagt, dieser sei nur ein Auge — aber, weiß Gott, was für ein Auge! Das Verhältnis Monets zur Natur läßt sich nach diesem Ausspruch verstehen als *einfach bedingt*, insofern nämlich, als das Hauptinteresse Monets auf die optisch vorbegriffliche Äußerlichkeit oder Oberflächenhaftigkeit der Naturerscheinung gerichtet ist. Hieraus ergibt sich die besondere Vorliebe Monets für die oberflächenhaft-flüchtige Erscheinungsweise der Natur. Vor allem aber ist Monets Verhältnis zur Natur charakterisiert dadurch, daß diese Natur in ihren optisch-flüchtigen Erscheinungen als problemlose Gegebenheit kritiklos anerkannt wird: Thematisiert ist die Wiedergabe der sichtbaren Naturerscheinung bzw. die Wiedergabe der Erscheinungsweisen der Natur. In einer solchen als problemlos und damit als unkritisch vorausgesetzten vorbegrifflichen Optizität der Natur beruht der Positivismus der Monetschen Malerei. Eben diese positivistische Struktur ist identisch mit denen des Realismus oder auch des Impressionismus im allgemeinen: Auch der kühne malerische Abbreviationsstil Edouard Manets setzt die fraglos anerkannte Gegenstandsintegrität des zu malenden Motivs voraus und wird an dieser gemessen. Die malerisch abkürzenden Mittel stehen im Verhältnis zur Illusion von unproblematischer Wirklichkeit.

Aufgrund seiner positivistischen Einstellung zur Natur und ihrer vorbegrifflichen Optizität schafft Monet Farbenbilder, deren Kontext gewährleistet ist durch die vorausgesetzte Integrität des im Bild erscheinenden Gegenständlichen.

2

Aufgrund ihres besonderen Naturbezugs läßt sich die Malerei Cézannes dagegen als *komplex bedingt* bezeichnen. Selbstverständlich bezieht sich auch der Malprozeß Cézannes auf die vorbegriffliche Optizität der Natur — es sind nur „plans" und „taches, qui sont là sous nos yeux" —, jedoch ist der Bezug auf die bloße Optizität von vornherein bestimmt durch die Möglichkeit, im Kontakt mit der Natur und der Natur gegenüber malerische Systeme kritisch auszubilden. Das malerische System, zu dem die Natur die Veranlassung bietet, konstituiert sich gerade nicht als ein Medium für eine problemlose und unkritisch gesehene Naturerscheinung, sondern nur mittels eines von sich aus kontextstiftenden Malverfahrens.

Im Hinblick auf die Erscheinung der Natur als auf seine Veranlassung kann das kontextstiftende Malverfahren Cézannes unterschiedlich zu den positivistischen Richtungen der Malerei (Realismus, Impressionismus) konstitutiv-kritisch genannt werden.

Es ist möglich, nunmehr einen der wesentlichen Unterschiede zwischen den Malverfahren von Monet und Cézanne zu formulieren: In seiner Malerei akzeptiert Monet eine fraglos gegebene, vorbegrifflich-optische Naturerscheinung außerhalb seines Malverfahrens — metaphorisch gesprochen: Monet malt „Erlebnisse" *der* Natur —, während für Cézanne die vorbegrifflich-optische Naturerscheinung eine Veranlassung für malerisch-systembildende Operationen ist — metaphorisch (mit Rilke) gesprochen: Cézanne malt „Erlebnisse" *an der* Natur. Eben dies bedeutet eine Wende in der Naturauffassung der Malerei. An die Stelle des Naturpositivismus oder auch, was im Prinzip dasselbe bedeutet, Naturidealismus tritt ein Naturbild, das nicht mehr im herkömmlichen Sinne mimetisch ist, sondern die Natur nur unter den Aspekten der durch sie ermöglichten und an ihr vollzogenen Operation vorstellt.

„Je prends, à droite, à gauche, ici, là, partout, ses tons, ses couleurs, ses nuances, je les fixe, je les rapproche... Ils font des lignes. Ils deviennent des objets, des roches, des arbres, sans que j'y songe." Während in den Bildern Monets die Farbpartikel (als Flecken oder virgules) einen herkömmlich gegenständlichen, perspektivischen Bildaufbau beleben oder frei vor einem solchen Bildaufbau agieren, welcher selbst von ihnen unabhängig existiert und erst recht nicht aus ihnen hervorgeht, ist angesichts der Bilder Cézannes zu sprechen geradezu von einem Leistungscharakter der Farbgebung als systemstiftendem Verfahren. Die Elemente dieses Verfahrens sind als bloße „sensations colorantes", das heißt als reine „Sichtbarkeitswerte" (dieser

Begriff von A. v. Hildebrand) allseitig anschließbare Elemente, die erst innerhalb eines durch sie selbst realisierten Malsystems Bestimmtheit, „Endgestaltstönung" (dieser Begriff von K. Koffka) erreichen hinsichtlich ihrer sowohl syntaktischen als auch semantischen Stellenwerte. Indem die durch die Naturerscheinung veranlaßte, jedoch mit reinen Sichtbarkeitswerten operierende malerische Systembildung erst in ihrer Vollendung das sie leitende Prinzip verdeutlicht, aber auch erst in ihrer Vollendung wieder Naturerscheinung resultieren läßt, enthüllt sich diese selbst als von demselben Prinzip bestimmt. Es ist angemessen, in diesem der malerischen Systembildung und der Naturerscheinung gemeinsamen Prinzip das Prinzip des Zusammenbestandes (Badt) oder einer dichten Allverbundenheit zu erkennen, in der jedes Element jedem anderen gleichgeordnet sowie mit gleichem Anteil und gleicher Bedeutung am Ganzen beteiligt ist: „Je rapproche dans le même élan, la même fois, tout ce qui s'éparpille."

3

Cézannes Bilder sind jeweils Zeugnisse dafür, wie aus Anlaß und in Kontakt mit den jeweils verschiedenen, rein optisch aufgefaßten Naturmotiven entsprechend individualisierte und das Motiv selbst individualisierende Systembildungen geschehen. Hieraus folgt, daß die Malerei Cézannes nicht nur mit Bezug auf die vorbegriffliche Optizität gegenstandskritisch sondern zugleich auch mit Bezug auf ihre eigene Systembildung verfahrenskritisch vorgeht. Deshalb auch bietet die Malerei Cézannes keine ablösbar generative, von Entscheidungen entbindende oder vor Risiken schützende Methode, die von anderen Malern übernommen und gehandhabt werden könnte (wie zum Beispiel das Malverfahren des Pointillismus). Jedes Bild Cézannes ist ein jedesmal an einem Motiv neu erkanntes und neu verwirklichtes System. Für Cézanne ist weder das Motiv ohne seine malerische Systematisierung noch die malerische Systematisierung ohne Veranlassung an einem Motiv relevant. Kategorial liegt demnach nicht ein normativer sondern ein offener Systembegriff zugrunde mit jeweils individueller Konkretisierung.

4

Bei Cézanne heißt es: „Si je passe trop haut ou trop bas, tout est flambé. Il ne faut pas qu'il y ait une seule maille trop lâche, un trou par où l'émotion, la lumière, la vérité s'échappe. Je mène, comprenez un peu, toute ma toile, à la fois, d'ensemble." Mit diesen Sätzen sind drei Aussagen gemacht.

Die erste Aussage legt den Versuch nahe, Strukturgesetze der Bilder

Cézannes zu formulieren. Entscheidend ist vor allem der schon (in Ziffer 2) angedeutete Sachverhalt, daß im jeweiligen Bild nichts an den Elementen und nichts mit ihnen geschehen kann, was nicht mit gleicher Bedeutung am ganzen System geschieht. Es ist irrelevant, angesichts der Bilder Cézannes zwischen Mikrostruktur und Makrostruktur zu unterscheiden. Jeder verfahrenstechnische Akt bestimmt sich nicht als selbständiger und einzelner, sondern bleibt immer bezogen auf das System und erhält nur von diesem seinen jeweiligen Funktionswert.

Die zweite Aussage betrifft das Risiko einer solchen malerischen Operation. Das besondere Risiko des Cézannschen Verfahrens besteht darin, mit vorbegrifflichen Elementen, das heißt mit reinen Sichtbarkeitswerten (Farbflecken) intentional auf ein System hin zu malen, das der Maler noch nicht kennt und noch nicht kennen kann. Es muß also ein System vorausgesetzt werden, von dem noch unbekannt ist, ob es sich bewährt als Rechtfertigung der Teilschritte in der Syntaktik der einzelnen Elemente sowie als Sinngebung dieser Elemente auch in semantischer Hinsicht. Das Risiko besteht also darin, die verschiedenen kleinen Schritte unwiderruflich zu tun nach Maßgabe eines Systemziels, das erst aus sämtlichen kleinen Schritten resultiert, vorher als solches aber nicht gewußt werden kann. Der Maler kann also bei der Anwendung dieses Malverfahrens scheitern. Scheitern heißt hier, die systembildende Funktion der Flecken verfehlen. In diesem Fall offenbaren die Flecken ihre Nichtigkeit.

Die dritte Aussage betrifft das Totale der Bilder Cézannes, nämlich die Tatsache, daß sie ihren Sinn nur repräsentieren im Systemzusammenhang als Gesamterscheinung. Cézannes Bilder widersetzen sich weitgehend der Möglichkeit, in ihnen Ausschnitte anzugeben und diese als anschaulich sinnvoll zu betrachten. Der Ausschnitt offenbart prinzipiell dasselbe wie das gescheiterte Malverfahren, nämlich die Nichtigkeit der malerischen Elemente. Der Ausschnitt ist als sinnvolles optisches Angebot ausgeschlossen in eben dem Maße, in welchem angesichts der Bilder Cézannes zwischen Mikro- und Makrostrukturen nicht zu unterscheiden ist. Die Bilder von Cézanne erfüllen genau den Tatbestand, der innerhalb der Gestalttheorie von W. Köhler folgendermaßen erklärt worden ist: ,,Man hat vor allem zu prüfen, ob bei konstant bedingender Form oder Topographie die stetig ausgebreiteten Gebilde in Ruhe und im stationären Zustand eine beliebige lokale Veränderung zulassen, ohne daß das Gesamtsystem darauf mit einer Verschiebung durchweg reagiert. Tritt eine solche Verschiebung auf den Eingriff hin mit größerer oder geringerer Heftigkeit ein, so bestand zuvor eine Struktur, deren Momente einander durch das ganze Gebilde trugen, also keine

selbständigen ‚Teile' in dem Ganzen waren." (Köhler, *Die physischen Gestalten in Ruhe und im stationären Zustand*, Erlangen, 1924, S. 123.)

Cézannes als kritisch-konstitutiv bezeichnetes Malverfahren hat jeden positivistischen Naturbegriff in der Kunst überwunden und damit zugleich jede diesem Naturbegriff zugeordnete mimetische Darstellungsweise. Die Natur wird verstanden unter den Aspekten der an ihr veranlaßten Möglichkeiten malerischer Systembildungen, die sich sowohl nur mit reinen Sichtbarkeitswerten vollziehen als auch nur gelingen unter Ausschluß jeglichen außeroptischen Engagements: „,... si je pense en peignant, si j'interviens, patratas! tout fout le camp." Es ist kaum denkbar, daß eine Malerei mit dieser außerordentlichen Problemstellung zugleich auf Visualisierung literarischer Stoffe zielen könnte.

John Cocking

14
Proust and painting

There is a good deal of evidence about Proust's general interests, taste and preferences in painting and he often mentions particular works in his text. But about the origins of Elstir's paintings we know less than we do about the inspiration for Vinteuil's music. I hope I shall make it clear when my ideas are based on facts and when I am guessing. I shall be choosing among suggestions already made by Chernowitz, Monnin-Hornung, Autret and Jaquillard, and adding a few of my own. Some of these suggestions are very probable. But guesses, in this kind of speculation, can be all the more subjective because of the Rorschach ink-blot component; we guess what paintings Proust had in mind, then we guess how he had them in mind—what his imagination projected into them in addition to what the painter intended him to project.

Let me illustrate what I mean. Chernowitz and Monnin-Hornung connected Elstir's 'Botte d'asperges' with Manet's canvas of that name. Fernandez analysed Proust's description of asparagus in the Combray kitchen as an Impressionist still-life. It occurred to me that Manet's asparagus might have played some part in Proust's description. Manet painted the bundle of asparagus for Proust's friend Ephrussi, who paid him so generously for it that Manet painted another single stick of asparagus as a surprise present. It looks as if Proust may have adapted this incident by turning a positive into a negative; Ephrussi the generous patron becoming Guermantes the parsimonious philistine. 'Nothing in it but a bundle of asparagus exactly like the ones you're now swallowing,' the Duc de Guermantes tells Marcel: 'but I wouldn't swallow Elstir's. Three hundred francs he wanted. Three hundred francs for a bundle of asparagus! A louis would be enough, even out of season.' But what about Proust's own still-life?

The asparagus and the pregnant kitchen-maid known to Swann as 'La Charité de Giotto' are linked together not only by the necessities of the kitchen but through being both described with reference to Giotto's fresco [196].

196 Giotto : 'Charity'

Autret pointed out that the portrait of the maid refers to so many details in the fresco that it reconstructs it. One could even say that what is ostensibly a portrait of a real person is in fact no more than a burlesque description of the fresco itself seen by an observant but irreverent spectator—a Proust who does not naïvely fail to see the symbolism and the artistry as the young Marcel did, but deliberately sets aside understanding and insight so as to exploit with broad humour the same incongruity which had struck the young Marcel and prevented his understanding before Swann told him what the fresco meant and how to look at it.

When we come to the description of the asparagus sticks they, too, are linked with Giotto's fresco. '... Les légères couronnes d'azur qui ceignaient les asperges au-dessus de leurs tuniques de rose étaient finement dessinées, étoile par étoile, comme le sont dans la fresque les fleurs bandées autour du front ou piquées dans la corbeille de la Vertu de Padoue.'

Now in Manet's pictures [197] the asparagus tips are certainly not finely drawn with their separate little stars, and this comparison with Giotto's chaplet and the flowers in Charity's basket is made from observation of what asparagus really looks like. As Autret points out, the central flowers protruding

from the basket could well be sticks of asparagus. But Manet's pictures might have suggested to Proust the idea of incorporating this literary still-life into his Combray and stirred some memories of the real Illiers. For the garden at Illiers, the Pré Catelan, had a magnificent asparagus bed, the shape of which can still be seen. In *Jean Santeuil* it is among the first things mentioned in the description of the 'Jardin des Oublis', and a little later it has a description all to itself.

This is, in fact, another example of a sense of supernatural beauty rooted in sensual pleasure like the description of the hawthorns. 'La première conviction chaleureuse', wrote Gaston Bachelard, 'est un bien-être corporel.' Some of Proust's poetry is sublimated gastronomy.

But the sublimated version of the asparagus, the literary still-life, takes us, as Fernandez pointed out, from reality into two unreal worlds—impressionism and fairyland. Impressionism resolves hard substance and clear outlines

197 Manet: 'Asperge'

into colour, light and texture. Manet's later paintings do this; so does Proust's description.

Je m'arrêtais à voir sur la table, où la fille de cuisine venait de les écosser, les petits pois alignés et nombrés comme des billes vertes dans un jeu; mais mon ravissement était devant les asperges, trempées d'outre-mer et de rose et dont l'épi, finement pignoché de mauve et d'azur, se dégrade insensiblement jusqu'au pied — encore souillé pourtant du sol de leur plant — par des irisations qui ne sont pas de la terre.

But if the paintings suggested to Proust the idea of making a description that can be called 'impressionist', Proust is not just describing the painting. His colours are Manet's colours, but they are distributed with more attention to reality. Manet's stalks are not 'finely stippled with mauve and azure'. In the picture of the single stick reality is transfigured, metamorphosed. It becomes a subtle kind of Rorschach pattern, into which we can read other things—for instance, a figure with a face that has something of the owl and something of the witch. And Proust, too, transforms his asparagus with a fantasy that gently mocks itself:

Il me semblait que ces nuances célestes trahissaient les délicieuses créatures qui s'étaient amusées à se métamorphoser en légumes et qui, à travers le déguisement de leur chair comestible et ferme, laissaient apercevoir en ces couleurs naissantes d'aurore, en ces ébauches d'arc-en-ciel, en cette extinction de soirs bleus, cette essence précieuse que je reconnaissais encore quand, toute la nuit qui suivait un dîner où j'en avais mangé, elles jouaient, dans leurs farces poétiques et grossières comme une féerie de Shakespeare, à changer mon pot de chambre en un vase de parfum.

Comparison of this passage with the corresponding part of *Jean Santeuil* suggests something further. In the earlier novel the kitchen-maid is not pregnant and Ernestine's cruelty towards her arises from fear of rivalry— Ernestine is equally cruel to a succession of kitchen-maids. The pregnancy seems to have come from Proust's spontaneous and irreverent amusement at Giotto's fresco. It is as if he reacted to paintings in much the same way as Anatole France's Madame Marmet, reading everyday reality into the painting; but *then* reversing the process, recreating everyday reality in terms borrowed from the painting—making a new reality in which the familiar is transformed.

Philip Kolb spotted a probable connection between a literary text and a letter which seems to confirm that Proust used pictures to stimulate and support his own descriptions. Among the texts published as *Contre Sainte-Beuve* is a collection of childhood memories based on Illiers and called 'Retour à Guermantes'. This includes a long description of a little brother's distress at

leaving the holiday haunt for Paris and home, because he had to abandon the pet kid he had been given and the little cart that went with it. The little boy wears a frock and a lace-trimmed skirt; his hair has been curled the day before for a farewell photograph and is tied in butterfly bows and frizzed out like a helmet; he carries his lunch, his toilet requisites and mirrors in little satin bags. A period piece in himself, his hair-do is compared to one of Velasquez's Infantas and the whole passage is marked by the kind of humorously elaborated visual detail which distinguishes so many of the descriptions of *A la recherche du temps perdu* from earlier writings. The child kisses the kid on the nose—'son nez pur et un peu rouge de bellâtre couperosé, insignifiant et cornu'. And this, says Proust, was only a little reminiscent of those many English pictures of children caressing animals; only a little, because if the child's luxurious get-up recalled the children in the English paintings, the wretchedness of his expression did not. It was Philip Kolb who spotted the connection between this description and Proust's request in a letter written early in 1908 for some English prints showing an animal with one or more human figures. The date is about right, and it suggests that Proust had found a useful way to supplement faded memories and stimulate creative imagination. This was a time when he was revisiting old haunts and former acquaintances, re-galvanizing his past; and also, I think, consciously working out ways of embellishing it.

Let us look at one of the ways in which paintings helped to transform the sad and lifeless memories of *Jean Santeuil* or the melancholy fictions of *Les Plaisirs et les jours* into the live impressions of *A la recherche du temps perdu*. In 1961 the Proust *Bulletin* published two abandoned drafts of part of Swann's love-story—impressions of *la Mondanité* personified as a god which transforms its subjects into automata. These are curious pieces of writing—rather like sequences from Robbe-Grillet's *Marienbad* or a film of Jean-Luc Goddard; familiar human gestures dehumanized, entirely divested of purpose, movements frozen even as they move by sheer meaninglessness. And this impression of spiritual congealment centres on the flunkeys, motionless as statues.

When they became the flunkeys in *A la recherche du temps perdu* they changed from unparticularized statues to very particularized figures in paintings. They still belong to the world of the imagination, of dream fusions; but a great deal more circumstantial detail from familiar imaginative worlds is fused into them. Proust is projecting another kind of oneirism; using painting and literature to re-invest his own imagination with detail and to put life even into impressions designed to show that what he calls *real* life is absent. We

198 Mantegna: 'Sentencing of St James to death'

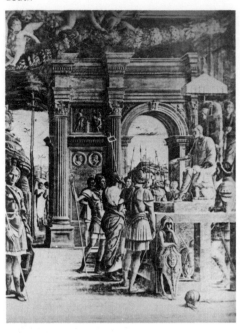

199 Mantegna: 'St James on the way to the execution'

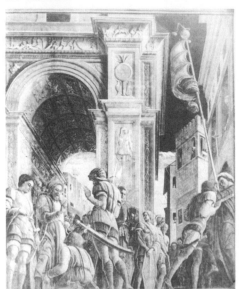

are not made to feel what it is like to be spiritually dead; we are looking at emptiness through a full, intense and vital consciousness. In the account of Swann's arrival at the reception, which has become one of the great set-pieces of the novel, the flunkeys are dehumanized not by being subordinated to a rather sinister deified abstraction, but by being grotesquely depressed or elevated away from their everyday selves—compared to animal life, or to paintings in which nature has been overwhelmed by a formalism comparable to that of *la Mondanité*; so that the humour spills over on to the paintings themselves. And though the humour is that of the waking mind, the fusion of a real situation, of contemporary reality, with the unreal and comparatively remote is the fusion of a dream; a dream which the waking mind distances and burlesques. The paintings do not merely conjure up the footmen for us—they take over and transform them. Marcel, moving through initiations corresponding to Proust's initiations by Ruskin, Emile Mâle and others, learns to see beyond superficial incongruities to the beauty behind them. Proust himself, who has been through it all and come out at the other side, can afford to use the incongruities for his own immediate purposes, disregarding for

200 Mantegna: 'The execution of St James' **201** 'The Belvedere Apollo'

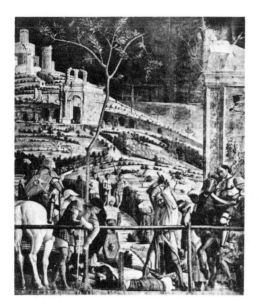

the time the idealist aesthetic which provides the novel with its philosophy.

So he chooses here Mantegna as his foil—'gauche, elaborately angular and static', as Wilenski puts it; 'posture in the figures . . . festival trappings on the architectural settings'. Wilenski also notes the real qualities of Mantegna, but these have no part in Proust's present purpose.

When Swann arrives at the reception, 'l'un [des valets de pied], d'aspect particulièrement féroce et assez semblable à l'exécuteur dans certains tableaux de la Renaissance qui figurent des supplices, s'avança vers lui d'un air implacable pour lui prendre ses affaires'.

'A quelques pas, un grand gaillard en livrée rêvait, immobile, sculptural, inutile, comme ce guerrier purement décoratif qu'on voit dans les tableaux les plus tumultueux de Mantegna, songer, appuyé sur son bouclier, tandis qu'on se précipite et s'égorge à côté de lui.' Look at the figure on the left of the 'Sentencing of St James to death' [198], or the soldier leaning on his shield near the central column in 'St James on the way to the place of execution' [199]. And here is the 'Execution of St James' [200], with the executioner we saw just now, and, on the left, another careless spectator.

Proust turns even a scrap of art-history into burlesque; remembering that Mantegna's figures are part Greek sculpture [201], in their poses, and part real people, in their faces; that the same is true of Dürer, who comes to mind because he was influenced by Mantegna, he writes of the footman: 'Il semblait précisément appartenir à cette race disparue... issue de la fécondation d'une statue antique par quelque modèle padouan du Maître ou quelque Saxon d'Albert Dürer.' What Proust is doing—as he no doubt realizes and intends—is to carry Mantegna's fusion of classical and contemporary one stage further, fusing Mantegna's fusion with his own contemporaries.

This same footman has 'glaucous, cruel eyes' which might be those of the soldier in the picture of the trial.

Proust goes on to describe the footmen's hair: was he perhaps thinking of this same soldier? He mentions Mantegna again in connection with Greek sculpture:

Et les mèches de ses cheveux roux crespelés par la nature, mais collés par la brillantine, étaient largement traitées comme elles sont dans la sculpture grecque qu'étudiait sans cesse le peintre de Mantone, et qui, si dans la création elle ne figure que l'homme, sait du moins tirer de ses simples formes des richesses si variées et comme empruntées à toute la nature vivante, qu'une chevelure, par l'enroulement lisse et les becs aigus de ses boucles, ou dans la superposition du triple et fleurissant diadème de ses tresses, a l'air à la fois d'un paquet d'algues, d'une nichée de colombes, d'un bandeau de jacinthes et d'une torsade de serpents.

Does this same warrior supply the 'enroulement lisse et les becs aigus'? And this other figure from the same composition the 'triple et fleurissant diadème de ses tresses'? As for the rest, we are fancy-free to wander among classical sculptures [201].

'D'autres encore, colossaux aussi, se tenaient sur les degrés d'un escalier monumental que leur présence décorative et leur immobilité marmoréenne auraient pu faire nommer comme celui du Palais Ducal: "L'Escalier des Géants".'

Other footmen, hired for the occasion and a little uneasy in their temporary livery, are said to stand 'sous l'areature de leur portail avec un éclat pompeux tempéré de bonhomie populaire, comme des saints dans leur niche'. These, perhaps, from Amiens [202]?

When we turn from the footmen to the guests, Proust goes on thickening the substance of his evocations with allusions to pictures.

There is the Marquis de Palancy 'qui, avec sa grosse tête de carpe aux yeux ronds, se déplaçait lentement au milieu des fêtes en desserrant d'instant en instant ses mandibules comme pour chercher son orientation'. With his monocle

202 'Prophet and saints' (Amiens)

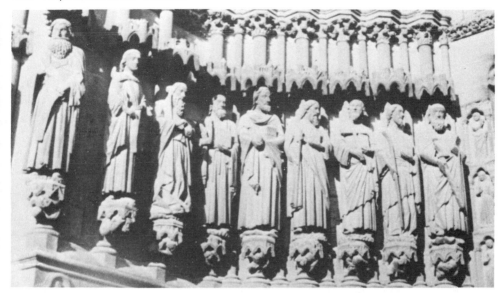

203 Giotto: 'Injustice'

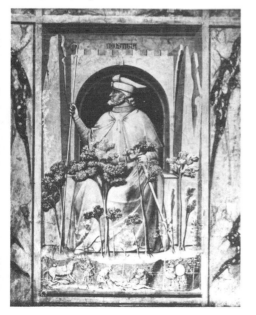

204 Giotto: 'Idolatry'

in his eye he seemed to 'transporter seulement avec lui un fragment accidentel, et peut-être purement symbolique, du vitrage de son aquarium, partie destiné à figurer le tout qui rappela à Swann, grand admirateur des Vices et des Vertus de Giotto à Padoue, cet Injuste à côté duquel un rameau feuillu évoque les forêts où se cache son repaire' [203]. As Autret points out, with a stretch of the imagination one can turn the lower strip into the floor of an aquarium, the vegetation into water-plants, and the face into a carp's head.

Another of the Vices and Virtues is referred to in *A l'ombre des jeunes filles en fleurs* when Albertine playing diabolo is compared to Infidelity [204]. Proust calls it idolatry; and Basil de Selincourt's description of it brings out that it is an emblem of Swann's shortcomings as a failed artist which could have suggested to Proust the whole theme of *Un amour de Swann*.

According to Ruskin and Lord Lindsay he totters upon his feet, an idea reasonable enough in itself, and repeated by later writers: but surely not the idea Giotto intended to convey. Infidelity, like Injustice, is regarded by Giotto as a peculiarly masculine vice, with sordid self-satisfaction for its essence. He presents to the world a miniature idol of his own making, who holding in her right hand the bough of a tree (idolatry being connected with the groves) secures her worshipper with the other by a noose about his neck. His features are gross and lifeless, and his bulky earthbound figure is set in a swaggering attitude, the left hand upon the hip. The fire, which he dedicates to sacrifice, blazes before his feet.

(Other interpreters see the fire as the flames of hell, to which Infidelity is destined as the penalty of his idolatry.)

His half closed eyes are rendered blind to heavenly things by a broad-brimmed helmet, whose lappets allow no sound to reach his ears. From above bends in vain the figure of an Evangelist or Prophet, with a scroll.

Transpose these details from religion to art, and you have Swann's spiritual destiny.

Odette de Crécy has some of the characteristics of real women like Laure Hayman, but she exists mostly as outward appearance; and that, like the kitchen-maid's, was made out of paintings. If Swann suddenly sees Botticelli's Zipporah in her, it is because Proust made her out of Botticelli's Zipporah [205]. Botticelli was promoted in the 'sixties by D. G. Rossetti, Swinburne, Walter Pater and Ruskin. If Botticelli's contemporaries and our own note chiefly the virile energy of his pagan paintings, whether we ascribe it to naturally springlike feelings or to a neo-Platonic sense of pneumatic transcendence, the Pre-Raphaelites projected the angelism of his faces into all his work.

205 Botticelli: 'Zipporah,' detail from
'Life of Moses'

Pater wrote of 'the peculiar sentiment with which he infuses his profane and sacred persons, comely, and in a certain sense like angels, but with a sense of displacement or loss about them—the wistfulness of exiles, conscious of a passion and energy greater than any known issue of them explains, which runs through all his varied work with a sentiment of ineffable melancholy'. If we chop up his paintings we can forget their rhythms and their dancing movements and isolate either the energy or the languor; and we can see the languor through Romantic minds as the nostalgia of an exiled angel. In Ruskin's reproductions, Zipporah is isolated from the Bible story in the painting and made available for a description in which Proust concentrates the kind of feeling expressed by Pater.

The fresco in which she figures shows seven scenes from the life of Moses. Proust has nothing to say about all this, but seems to be re-interpreting the figure of Zipporah isolated from the rest, as she is in Ruskin. For Ruskin's letters show that he was half in love with Zipporah himself.

Elstir's canvases, like Odette de Crécy's appearance, were created from memories or observations of real paintings.

The main passage about Elstir's art was a late addition, and is not one of the most lyrically evocative parts of the novel. Not, as Feuillerat maintained before *Jean Santeuil* and *Contre Sainte-Beuve* complicated the evidence, because the poetic parts were early and the cerebral parts late; but because the most poetic passages are the most elaborate, and some of the later additions were written more hurriedly and without much regard to their contribution to the poetic aura, already well established and generated mainly by the great set-pieces planted in strategic positions and drawn on by overt cross-reference or subtler reminders. It is when Proust is most abstractly theoretical about painting that he tends to fall back on Ruskin. Many of his general pronouncements about art and artists can be traced, in unequivocal detail, in Ruskin's writings. So can many of his remarks about the paintings and buildings Ruskin wrote about. But he wanted also to marry painting with literature, to translate Turner's and Ruskin's ideas into literary terms and reconcile these with his own creative tendencies.

Moreover, he wanted to show how Elstir taught Marcel to experience life with his eyes. On the one hand, he relates Elstir's canvases very closely to Balbec, and in reading the descriptions of them we are at least as aware of their content and its correspondences with Marcel's present surroundings as of their qualities as paintings. On the other hand, their qualities as paintings are often abstractly conveyed—a demonstration of ideas. Here and elsewhere, Proust refers very little to the colour of his fictitious paintings. But the whole passage is executed with *brio* and fits admirably into place in the book. And there are some passages where Proust's lyrical prose is at its best—notably in the description of the cathedral-like cliffs which was reworked from the earlier version of the visit to the studio and transferred to Marcel's later visit. Perhaps the presence here of Monet rather than Turner helped to make this water-colour less didactic and more immediately poetic. When Proust writes of the rocks 'peints par un jour torride... réduits en poussière, volatilisés par la chaleur' he seems to be echoing Camille Mauclair on Monet: 'Il y a des midis de Claude Monet où toute silhouette matérielle, arbre, meule ou rocher, est annihilé, volatilisée dans l'ardente vibration des poussières lumineuses.' But only Proust could turn the play of the shadows into the play of dolphins. And perhaps Proust's descriptions of Elstir's work are most poetic of all—certainly most characteristic—when, if we look for models, we find not one picture or a series of clearly definable details but vague impressions of many pictures; when Proust is adding most of his own creation. The 'Fête au bord de l'eau', one of the Elstirs in the Guermantes collection, is an example of this. In Proust's own word-pictures, colour comes into its own.

Proust's intuitions of transcendence come from works of art and from involuntary memories. These involuntary memories are perceptual illusions. Turner painted what he saw, not what he knew was there. Ruskin, in spite of his other requirement for exact observation of detail, claimed that if what the artist sees is an illusion, a perceptual error, this impression is what the artist must convey: 'If . . . we see something quite different from what is there, then we are to paint that, whether we will or not; it being for us, the only reality we can get at.' Ruskin approves of Turner: 'He always painted, not the place itself, but his impression of it . . . he was right in this.' A justification, then, of illusion. On to this Proust grafts the notion of metaphor as insight. Involuntary memory is labelled metaphor. Elstir's optical illusions are metaphor. In the earlier version of the visit to Elstir's studio the paintings are described as uniformly 'equivocal', in the later version as 'metaphorical'. And Proust then tries to reconcile impression and true observation, real observation: Elstir paints so truly that he makes us realize that, from his vantage point, the objects in his picture would *naturally* be related in what, at first, is an unfamiliar and seems a peculiar way. He teaches us the laws of perspective. An unconvincing notion when applied to some Impressionist and post-Impressionist paintings and to the phantasmagoric architecture of Turner's mythical subjects; but Proust was, by the time he wrote this, more concerned with justifying the cerebral side of his writing than the poetic side—he was a Romantic idealist a little puzzled and bothered by his own intelligence. So, while the passages on Vinteuil's music affect our feelings, this main passage on Elstir's painting is much more an attempt to demonstrate.

When, to show what he means about poetry arising out of perceptual error, the Narrator describes his own impressions of sea-view, mistaking a dark area of sea for land, or enjoying patches of blue which could be either sea or sky, there are plenty of canvases of Turner that he might have had in mind.

But when Proust came to construct Elstir's picture of Carquethuit harbour he was thinking primarily of optical illusions due to odd perspectives. He piled so many examples of this into one canvas that it is hard to see in imagination. I think Juliette Monnin-Hornung was right when she said he probably listed aspects of a great many canvases, chiefly from Turner's *Harbours of England* but probably others as well.

The other canvases seen in Elstir's studio also suggest Turner in their peculiar effects of perspective. The river which seems to make a lake closed in on all sides reminds us of 'The mouth of the Avon'. The picture painted near Balbec with its inlet of the sea trapped between cliffs of pink granite and

apparently quite cut off, though the seagulls show what it is, and the 'Lilliput-
ian grace of the white sails on their blue mirror like sleeping butterflies' at
the foot of immensely high cliffs could almost be 'Lulworth Cove', though
the pink granite is not Turner but Monet—or a personal memory of Brittany.
Monet's 'Les Falaises de Pourville' also shows tiny sailing-boats dwarfed by
high cliffs. The river which is so dislocated that it is sometimes like a lake,
sometimes a mere thread, with its bridge and wooded hill seems to be the
'Crook of the Lune'; but the town in the same picture seems to be 'Lausanne
seen from *Le Signal*':

... le rythme même de cette ville bouleversée n'était assuré que par la verticale in-
flexible des clochers qui ne montaient pas, mais plutôt, selon le fil à plomb de la
pesanteur marquant la cadence comme dans une marche triomphale, semblaient
tenir en suspens au-dessous d'eux toute la masse plus confuse des maisons étagées
dans la brume, le long du fleuve écrasé et décousu.

Juliette Monnin-Hornung hunted in vain for a model for Elstir's portrait of
Odette de Crécy as 'Miss Sacripant', disturbingly dressed as a man for a part
in a revue; I think it was probably not a painting at all, but a photograph
Proust possessed of Réjane playing the part of the Prince de Sagan in a revue.
Proust seems to have found transvestism in pictures as spicy as Baudelaire
did.

When we come to Monet we run into an interestingly complicated network
of associations. There is first the link between Turner and Monet; the rivers
of France and especially the Seine, including Vernon and its surroundings
in the case of Turner, focused on these in the case of Monet; Venice, too,
with a host of further associations in painting. Proust had also in common
with Monet the special interest in Brittany, Normandy and Holland.

When Proust wrote to Anna de Noailles about her *Visage émerveillé* in 1904
his main theme was his notion of style as a quality of vision, and vision he
thought of in terms of painting: principally Monet's painting. It was under
Monet's influence that Proust learned that not only childhood impressions
like the hawthorns but contemporary impressions of everyday life could be
seen as beautiful and transformed into poetry; that if we project the vestiges
of our past perceptions into the present instead of allowing them to pull us
back into nostalgia for the past we can find sensuous beauty all around us.
We can trace this discovery in Proust's successive writings about Monet by
name in *Jean Santeuil*, Monet as the typical Impressionist painter in the writ-
ings to and about Anna de Noailles, Monet again by name in *Contre Sainte-*

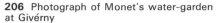

206 Photograph of Monet's water-garden
at Givérny

Beuve. In this last essay Proust says that love of Monet's paintings makes us go off to see the places Monet painted. When Proust set off for Cabourg in 1907 for the first of a long series of summer visits, he told Mme Catusse that he was led there by the memory of his mother. No doubt he was already looking for his past. But not only that. A good deal of his real past was already on paper in the rejected *Jean Santeuil.* Cabourg was also a *voyage d'art,* a pilgrimage guided by Ruskin and Mâle, Turner and Monet.

Monet had settled at Giverny and begun to make his garden in 1883 [206]. By the time Proust wrote of it in 1907 it was already a legend. Proust put it among his six gardens of Paradise before he saw it; he probably did see it in 1908 and, if so, it must have stirred memories of his first paradise-garden, the Pré Catelan at Illiers, described with such love and in such detail in the Étreuilles section of *Jean Santeuil* as 'le jardin des Oublis'. But Giverny, as Proust had expected, was a garden in which natural beauty was already heightened and concentrated, a *transposition d'art*; and, in the house, Monet's canvases, poeticizing reality without transforming it, as Fernandez wrote of Proust's impressions. Next year was marked by another concentration of

207 Monet: 'Bassin aux nymphéas'

Monet's kind of beauty; in 1909 he exhibited, in Paris, forty-eight paintings of the Giverny water-garden [207], now dispersed all over the world.

I cannot help associating all this with the creation of the *Côté de Guermantes* and the dreamlike beauty of its river and water-lilies. The Étreuilles of Jean Santeuil's holidays, so close to the real Illiers of Proust's childhood, is one-sided—no question of the symbolic geography of the two ways, no water-lilies. The river, given its real name, the Loir, is comparatively prosy. In 1903 Proust's father, when he gave away the prizes at the local school, complained about the unhygienic state of the river, slowed and muddied by water-plants.

208 Monet: 'Les Nymphéas'

209 Huijsum: 'Vase of flowers'

It is supposed that Proust helped him to write his speech, and contributed the sentences in which the mind's disquiet is balanced by the eye's appreciation.

But in the earliest text we have in which the two ways begin to exist separately and to take on a premeditated symbolism, there is still no poem of river and water-lilies. It seems likely that the transformation of the Loir into the Vivonne owed a good deal to the combined stirring of memory and stimulus of imagination which Proust referred to in his piece on Monet and perhaps experienced in visiting Monet's garden and the 1909 exhibition of Giverny paintings.

In *A la recherche*, Proust made the water-lilies into a symbol of his own creative life, wresting a calm and confident beauty out of his neurotic obsessions and repetitive submissions, his anxieties and bewilderments. First we see a few isolated water-lilies tortured by the currents, swung round, tugged, stretched, flung back—explicitly compared to people caught in the toils of their neuroses. Then the current slackens as we move into the water-garden in a private property along the Vivonne, and water and flowers turn into sheer poetry [208]. The real proprietor of that garden was no doubt Monet. The shape, colour and poetry of the water-lilies are in Monet's canvases—as

indeed are the notations of currents and disturbances, the energy of forces which the painting transmutes into vibrancy.

In summing up the importance of Monet for Proust one tends to talk rather vaguely about 'transformation of sensibility' and 'stimulus to imagination' and 'seeing with the vision of other artists'. It is difficult to be more specific in talking of the influence of one kind of art on another. Proust himself uses terms of this sort, though borrowing them need not imply acceptance of his kind of idealist aesthetic. Literature has different means at its disposal from painting. Literature uses words which, if they are not *only* concepts, are concepts primarily. Painting, as Gautier enviously observed, can produce sensations directly. When we hunt for detailed correspondences between what Monet put on canvas and Proust in words, however convinced we may be that the resulting impressions which are our responses correspond, that they make us see and feel aspects of the world around us in similar ways—'la nature telle qu'elle est, poétiquement', as Proust put it, and with a similar kind of poetry—we are as likely to be aware of differences as of likenesses. The impressions of Turner, of Monet, of Proust all tend, like Symbolist poetry, to *noyer l'objet dans ses déterminations*, to resolve entities into sensations. But whatever Proust says in his theoretical pronouncements about essential impressions depending on metaphors which are errors from the point of view of perception but revealers of inner experience, his own effects depend on the fine observation of entities as well as the sensitive rendering of sensuous and emotional response and the metaphorical superimposing of one kind of reality on another. When he describes hawthorns, he distinguishes and conceptualizes the components of the flowers with a precision like that of a Flemish or Dutch painter, and is faithful in this to one set of the precepts of Ruskin. For Ruskin also praised Turner for being true *not* to the objective reality of what he painted but to his subjective impression of it. Proust reconciles the two sets of precepts, and gives us the best of both worlds. If we look for this sort of detail and precision of form among the Impressionists, we may light on Fantin-Latour rather than Manet or Monet or Renoir or Degas; Fantin-Latour of whom it has been said that he is half-way between the Dutch *petits-maîtres* and Chardin. Already in *Jean Santeuil* we find fragments of description which are like little *trompe l'œil* details; for instance this notation of the shrub in a florist's shop: 'Une mince déchirure de la membrane verte trahissait la fatigue d'une branche, et à la base d'un calice il y avait dans le gonflement d'un pétale une goutte de rosée' [209]. But if Proust was helped by paintings, he had recourse also to Gaston Bonnier's flora. In *Le Temps retrouvé* he considers a kind of literary impressionism in which objective truth,

210 Monet: 'Waterlilies'

common-sense observation, would be entirely sacrificed to subjective impressions and rejects it as impossible. Both Turner and Monet, towards the end of their lives, tended towards such a pictorial impressionism, visual sensation abstracted from experience and made autonomous. When René Gimpel visited Monet in 1919 and found himself surrounded by the late water-lily sequence spread out on the floor, he used the same image as Proust used of part of Vinteuil's sonata [210]: 'In that infinitude, water and sky have neither beginning nor end. We seem to be present at one of the first hours in the birth of the world. It is mysterious, poetic, delightfully unreal.' Proust, for all his aesthetic of the separation of art and life, never takes us out of the real world, but transforms it in all its solid reality. And this, no doubt, is what the earlier Monet and other Impressionist painters helped to do for him.

More important to the novel than the overt or occult references to real paintings are the landscapes and seascapes Proust paints in the windows through which the Narrator looks. 'Every pane of your window', wrote Ruskin, 'may

be considered, if you choose, as a glass picture, and what you see through it, as painted on its surface.' Inversely he wrote that by hanging Turners on our walls we can open as many windows on to the charm and richness of the Turneresque. Proust worked out that idea in his own way and painted his own window-pictures. In *Le Côté de Guermantes* he sees the interiors viewed through the windows across the courtyard as a collection of Dutch genre pictures. When Marcel looks at the hawthorns he turns them into a picture by framing the view with his hands. Proust grasped the notion of painting pictures in frames, and then pictures without frames. As well as making *transpositions d'art* he created his own *équivalences d'art*. He realized Gautier's thwarted ambition as well as others; a great part of his genius lay in his ability to learn from the intensely and accurately imagined experience of others.

Discussion

Questions were asked about Proust's relationships with Dutch painting and in particular Vermeer. Prof. Cocking distinguished several phases in Proust's creation: at first the work of Meissonier and others had influenced him; he later owed to Fromentin's *Les Maîtres d'autrefois* the discovery of *das Gemütliche* in Dutch painting and finally saw this *Gemütliche* transformed into a specifically pictorial value in the works of Chardin and Vermeer. Prof.

Cocking saw Proust as one of the first to respond to painting as a kind of 'humanisme pictural' (Malraux). Ruskin's role as a mediator was explained in some detail. Discussion then centred around the problem of the 'yellow spot on the wall' in Vermeer's 'View of Delft'; the inexactitude of Proust's description—the spot in the picture is not on a wall but on the roof—was stressed by Prof. Barrère as an example of the constant misunderstanding between painters and writers.

Part II
French illustrated books

George Cambridge Johnson

15

English wood engravers and French illustrated books

1 Wood engraving

The question of wood engraving is particularly relevant to the study of 19th century illustrated books, since this technique was not only by far the most widely used but also made the real illustrated book possible. This essay attempts to outline the rise of wood engraving in England and France to the period of its full development and to indicate the connection between the practitioners of the art in the two countries.

The influence of wood engraving on the history of illustrated books and its place in the wider history of art have always tended to be obscured by loose terminology and by a lack of information on its general history, not to mention an almost complete absence of any record of the work of the men who practised it.

The ordinary person, who is aware that designs were printed from wood before the invention of printed books and will certainly be familiar with those done on wood after Dürer, may be pardoned for enquiring why this process should suddenly have assumed such importance in the 19th century, especially when he finds that almost all the historians of the art begin their accounts in the middle ages, unless they have taken the trouble to push their boundaries as far back as Greece and Babylon. Some of these historians are even wood engravers who, in their desire to shew the antiquity of their art, have understandably but quite wrongly included the altogether different process of wood-cutting.

This impression that wood-cutting and wood engraving are really the same, or that one is merely a development of the other, has also been fostered by the regular habit of the English wood engravers of calling their work *cuts* and of French writers of using the word *gravure* to refer to wood-cutting; so that it was even possible for a *Traité de la gravure en bois*[1] to be published before the art can fairly be proved to have existed.

Wood engraving is distinct both in the material used and in the method of

326

working it. Wood-cutters worked on the plank of a variety of woods, harder or softer according to the fineness or otherwise of the design, while wood engravers used the end-grain of box-wood only. Wood-cutters used the knife, while wood engravers used a graver similar to the one used by engravers on metal; in which difference it should be noticed that the characteristic means of expression of the wood-cutter is the black line, never so fine as the finest of the metal engraver, left standing when the wood is cut away from either side: that of the wood engraver the white line, often of exquisite fineness, cut by a single stroke of the graver.

There are good reasons for our ignorance of the work of the wood engravers. The most important is doubtless the sheer mass of it together with the fact that it is scattered through hundreds, nay, thousands of books, not to mention periodicals, broadsheets, bills, separate engravings and other small items; so that he who would record their work in English books alone must not look to see his findings published in his lifetime. Another reason is a kind of snobbery on two levels, which on the one hand rates a man's work in book illustration below his work in painting and on the other rates the engraver below the designer. Craftsmanship degrades a man from the rank of artist. Without opening an endless controversy, I will merely point out that interest centres on the designer rather than on the engraver, although it is the work of the latter which finally appears in the book. So much is this so that we regularly hear of books with *wood engravings by Grandville* or *Foster* when there is really, particularly in England, more of the engraver in the final illustration than is usually imagined.

2 Wood engraving in England

In the present state of knowledge it is impossible to say when wood engraving began, and this uncertainty must remain until the engravings of the time are found and recorded. Bewick began engraving on wood about 1770, which is a certain date: but what about earlier work? Since this kind of engraving was given to him by his master, Beilby, it is reasonable to suppose that Beilby was already accepting such work. Moreover, when Bewick went to London in 1776 he worked for the engraver Hodgson, who must also have been accepting it. Many earlier examples of what may be wood engraving exist, though it is not impossible that they were done in some other medium such as brass or type-metal; particularly, Croxall's *Fables* of 1722,[2] which has given rise to a perennial argument, although Linton thought that its engravings were most probably metal.

Since the remoter origins cannot be resolved, we will concern ourselves only

with the more immediate question of how the art reached the stage of develop-
ment which enabled it to change the face of illustrated books. Bewick, as I said,
began engraving on wood about 1770; but his first efforts were merely dia-
grams,[3] and it was not until 1784[4] that any considerable work was published
and not until 1790 that he became widely known through his own book, the
Quadrupeds. By that time more and more work was being done in London,
both by the older men such as Lee and by John Bewick, who went there about
1782 at the end of his apprenticeship to his brother and began turning out
small illustrations for children's books.

Thomas Bewick was a specialist in natural history and the northern country
scene; but now London was becoming the centre of wood engraving for the
illustration of works of literature, which tended not to chime with Bewick's
genius. The engravings in Somerville's *Chase*, 1796, and contributions to *Poems
of Goldsmith and Parnell,* 1795, form the best of his work for this kind of book.
London rapidly became the centre: many of Bewick's better apprentices went
there—Nesbit was working there in 1799[5] and Clennell followed about 1804—
and other engravers of unknown origin, or self-taught like Branston, arose.
This development continued through the first two decades of the 19th century
as the apprentices of the London engravers made their appearance and the
younger apprentices of Bewick followed their elders southward—Bewick's
real influence on illustrated books was through his pupils.

A difficulty during these early days was the lack of artists familiar with the
specialized art of drawing upon the wood. John Bewick had largely done his
own drawing; but he died in 1795, and by the turn of the century publishers
were willing to include engravings in a wider range of books. Somehow or
other, a copper-plate engraver, John Thurston, contrived to master this art
in a way which suited the wood engravers admirably, and during the first
twenty years of the century a variety of books with charming little vignettes
appeared, with the occasional one with larger engravings inserted in the
manner of plates. About this time also came noticeable improvements in
paper manufacture which helped, along with the growing experience of the
printers, to produce finer impressions of the engravings.

The full development of any art usually takes place at a conjunction of
favourable circumstances: there must occur simultaneously the demand, the
ability to satisfy the demand and the ability to compete in quality with other
forms. Previously the demand for illustrated books was small and came from
the wealthy. It was satisfied by the various forms of copper engraving, and
if editions were small and the process expensive it was of no consequence. By
this time, however, literacy and prosperity were spreading; so that there was a

growing market for illustrated books which were good but less expensive than the books with plates, if only they could be produced in sufficient numbers. Wood engraving reduced the expense of plates by removing the necessity for separate inking and impression, and in place of the limited life of the copper plate it offered almost unlimited wear.[6] The introduction of steel during this period did something to remedy the perishable nature of the plate, but could not give it the longevity of wood: moreover, the plate could never shed its drawback of separate inking and impression. Now also, wood equalled the plate in quality and refinement, and if it was not so suitable for very large illustrations, this was of no consequence in any but the largest books, which in any case were few. But, most of all, it produced the real illustrated book: not merely a book with plates inserted, as formerly when books and plates were often sold separately, but a book whose illustrations were part of the page and could be combined with the type in many different ways. The texture of the good white-line engraving also consorted with letterpress in a way which made plate and type seem complete strangers.

By the 1820s the conditions for full development were there, since the demand existed and the perfected art was in the hands of a sufficient body of skilled practitioners: the only hindrance was the shortage of experienced designers on wood, Thurston dying in 1821. I am inclined therefore to date the full development of illustration on wood from 1824, when one of the youngest of Bewick's apprentices arrived in London. William Harvey's arrival is significant in several ways: he was not only one of the best of the wood engravers, but the greatest of the artists on wood; he had done many of the drawings for Bewick's *Fables* of 1818 and had also engraved many of the blocks, so that he was perfectly qualified to provide the kind of drawing on wood which enabled the engravers to produce their best work; and he admirably filled the one remaining gap in the chain of circumstances necessary for the success of wood engraving in illustrated books. He quickly abandoned engraving in order to supply the demand for drawings; but one of his last achievements as an engraver was the training of Orrin Smith, who holds such a remarkable position in the history of the French illustrated book.

In Northcote's *Fables*, 1828,[7] all the elements of the illustrated book— vignettes, tail-pieces, pictorial and ornamental initials—are there, while the ornamental border had already appeared in *The Club*[8] and the *Metrical Index*;[9] so that the scene is set for the great flowering of illustrated books in the 1830s and 1840s which represents the climax of the art.

3 Wood engraving in France

Having traced wood engraving to its full development in England, I turn now
to the question of its introduction into France, this being the logical order if,
as is generally assumed, France had its wood engraving from England.

The influence of English wood engraving on French illustrated books may
be considered to have operated in various ways: by the direct employment of
English engravers on the engravings for French books, by the French engravers
learning their technique and naturally, therefore, their style of working, from
the English, or by the more nebulous process of their familiarity with the style
of English illustrated books.

I take first the most difficult question: that of whether and how the French
engravers learned the art from the English. Here we are at once acutely aware
of the difficulties mentioned at the beginning of this essay. If we had complete
information on the lives and works of all the engravers, both English and
French, it would be possible to reconstruct the course of events and to describe
exactly what took place; but our knowledge of the English engravers and their
work is sparse and that of the French engravers even thinner. I can therefore
make no pretence of answering this question fully, but propose only to draw
attention to such indications as appear at the moment.

If the French learned the technique from the English, they may have sought
it in England or it may have been taken to them in France. The first proposi-
tion is very difficult to prove, needing reliable records of known French en-
gravers who worked in England and afterwards returned to their own country
to practise the art. But here we are immediately faced with another difficulty
arising from the customs of the time. The normal way of learning was by
apprenticeship; so that we must assume that any Frenchman who carried his
quest as far as England came with the intention of apprenticing himself to an
English engraver. In this case it is unlikely that his work would have appeared
under his own name, unless he had continued to work in England for some
time after the expiration of his apprenticeship, since the custom was for the
work to appear under the name of the master, and though some exceptions
to this rule may be quoted, it was none the less a rule. Bewick, especially, was
very particular not to allow any other signature on work done for him and
would even lay claim to productions outside the normal line of work. It is not
surprising, therefore, that no evidence exists at the moment to support this
theory of French engraving learned in England.

As regards the migration of English wood engravers to France, the informa-
tion is rather less negative, although here again only extensive research into
the engravings of the time will give anything like a complete picture of the

process. We will leave on one side the almost mythical John Baptist Jackson, who spent a few years in Paris about 1726 to 1730, where he is reputed to have introduced the use of the graver, since proven work by him in pure wood engraving is not to be found and since he had no influence.

The English biographies agree that Charles Thompson went to Paris about 1816 and stayed there until his death in 1843, and Linton is quite definite as to the date of 1816 and goes so far as to say that the graver was not used in France before his arrival.[10] Linton knew the Thompsons and even worked under John Thompson for more than a year; so that he had ample opportunity to learn this from the elder brother himself. On the French side, Blumer says that Brevière 'pratiqua la gravure sur bois à partir de 1815 et fut à l'origine des essais pour l'utilisation du bois de bout dans la gravure d'illustration'.[11] This, not being restricted to France, is rather a generalization; but, since Blumer had his information from Adeline, we need only transfer our attention to the latter.

Adeline's statements,[12] though somewhat incoherent, may be summarized as follows: 'Brevière eut l'idée de remplacer le canif par le burin et le bois de fil par le bois debout' and in 1815 he engraved a vignette which was 'la première gravure en bois qui ait été exécutée en France'; Charles Thompson did not, therefore, introduce wood engraving into France, and in any case did not arrive there until 1817. Adeline is too dogmatic, for he would be a bold man who, even in our present state of knowledge, would assert that no wood engraving was done in France before 1815, any more than he would venture to say that none was done in England before 1760. That an ambitious and enterprising young engraver like Brevière should have been ignorant of the work done in England during the previous forty years seems incredible, and until further information is available the probabilities are, either that Brevière was taught by someone unknown, or that he taught himself, using, if he were wise, the innumerable existing English engravings to help him. In any case, according to Adeline, Brevière ended his apprenticeship and set up for himself at the age of nineteen, which probably means, since he was born on 15 December 1797, that he was not in a position to exert any influence until 1817.

Altogether, Adeline does not inspire confidence. His knowledge of the English engravers is of the slightest and of Charles Thompson in particular erroneous, since Charles was not a pupil of Thomas Bewick, but of Robert Branston the elder and his own brother, John. He appears to confuse the brothers John and Charles as do other French books, and understandably, because I have found more engravings in French books by John than by Charles, although John never worked in France. Moreover, Adeline did not

meet Brevière until 1865 and only knew him for the last four years of his life.

Only a thorough search for and proper attribution of French engravings of the time will enable us to decide the parts played by Brevière and Charles Thompson. In the meantime, if we confine ourselves to the known facts, we can only say that Brevière was setting up as a young engraver of nineteen in Rouen in 1817, in which year Charles Thompson was already established in Paris at the age of twenty-six with several years of experience in England behind him. Also we may say that Charles Thompson's part in French illustration seems to have been considerable. He lived to do work for many of the French books of the 1830s, such as the *Béranger*, 1837, the *Molière*, 1835–6, and the *Gil Blas*, 1836. It is interesting to note that his presence in Paris means that a number of engravings in English books were done there, as, for instance, those for Northcote's *Fables* of 1833.[13]

For other English emigrants no biographical details exist, so that again the question awaits solution by the recording of signed work in both countries. However, even at the present early stage of the work one cannot fail to remark the number of British names which occur amongst the French engravers: Beneworth, Laing, Thorn, Wade, Brown, Gowland, Elwall, etc. We also know that about this time John Quartley was a member of the French firm of *J. Quartley et Gowland*, while the Whitehead of *Whitehead et Sheeres* is probably the one who worked for the *Abbotsford* Waverley Novels.

Although the study of the work of the wood engravers is only just beginning, more has been done on the English engravers than on the French; consequently, as soon as we turn to the question of English work in French books we can form a much clearer idea of the situation. Thirty names of English engravers employed in this way can easily be mustered and their share in the production of French illustrated books can be shown to be great. All this work was, of course, done in London and represents a good proportion of the engravings in the important books of the 1830s and early 1840s, such as the *Molière*, 1835–6 (designs by Tony Johannot), *Gil Blas*, 1836 (designs by Jean Gigoux), *Don Quichotte*, 1836–7 (designs by Johannot), *Fables de La Fontaine*, 1838 (designs by Grandville), *Béranger*, 1837 (designs by Grandville and Raffet), *Histoire de l'Empereur Napoléon*, 1839 (designs by Vernet), *Voyages de Gulliver*, 1838 (designs by Grandville), *Robinson Crusoe*, 1840 (designs by Grandville),[14] and *Paul et Virginie*, 1838 (designs by various artists).

This first great flowering of French books illustrated on wood came almost simultaneously with those in England, showing that by now the art was at home in both countries. The English engravers whose work was most in request in France were John Thompson, Sears, R. Hart, Wright & Folkard and

Orrin Smith; but it is interesting also to notice the presence in our list of the ladies Elizabeth and Mary Clint, Eliza Thompson and Mary Ann Williams. At this time much of the business of Sears was with the Paris publishers, for he has work in most of the books mentioned above and more than 70 engravings in the *Histoire de l'Empereur Napoléon* alone, while John Thompson was largely employed on work of special quality, of which his engravings for *L'Art moderne en Allemagne*, 1836–41,[15] offer very good examples; but the most notable figure of this period is Orrin Smith.

Smith did work for many books, including the *La Fontaine* and *Molière* mentioned above; but his greatest contribution was to the one which is almost certainly the greatest of them all: the *Paul et Virginie*, 1838. This magnificent book is remarkable in every way, design, typography and illustration all being of a high standard. Apart from a very few steel plates, the whole of the illustrations are on wood and include vignettes, head- and tail-pieces, initial letters and pictorial borders as well as a considerable number of large wood engravings printed on India paper. In all, there are 452 wood engravings, of which 384 are by known English engravers and five by engravers with English names though not yet known to have worked in England. Of these, 111, including a large proportion of the more important ones, are by Orrin Smith, whose work so impressed the publishers that at their request his portrait appears as tail-piece to the list of engravers. It is very fitting that the pupil of William Harvey should occupy this place in the history of French illustrated books.

Before we leave the question of the work of English engravers in French books, we ought to notice the history of many of the engravings they contributed. Many were familiar to their own countrymen, since they often returned to illustrate English books, bringing with them their French fellows; so that, although French engravers seem rarely to have done work for original English books, their work was well known in this country. A few examples of this process will serve to show what happened. The *Don Quichotte*, 1836–7, provided the engravings for the *Don Quixote*, 1837–1839;[16] the engravings for the *Gil Blas*, 1836, went to England for the English edition of 1838–9[17] and then returned for the French edition of 1838, although, a certain number having apparently been lost in the meantime, the Paris 1838 has several new ones, again designed by Gigoux. A proportion of the illustrations for *Fables de La Fontaine*, 1838, were used in a quite different work, *Fables, Original and Selected*, 1839;[18] and the blocks for the *Paul et Virginie*, 1838, were sent to London for the *Paul and Virginia*, 1839,[19] and afterwards travelled to Pforzheim, where *Paul und Virginie* was issued in 1842.[20] The *Histoire de l'Empereur Napoléon,* 1839, is a peculiar case: an English version with the same engravings was published

in London in 1840–1 ;[21] but at the same time (1840–1) Tyas of London issued another text[22] with many designs by Raffet, to which he added some designs by John Gilbert and a great many new engravings after the same Vernet designs which appear in the Paris edition of 1839, all this re-engraving having been done in London.

This exchange of engravings was a regular traffic in both directions, the English engravers' contributions to French books being increased by the transfer of illustrations which had originally appeared in England, such as those for Christopher Wordsworth's *Greece*, 1839,[23] issued in Paris in *La Grèce*, 1839–40.[24]

4 Wood engraving in France and England

When we take a general view of French and English wood engraving with the intention of making comparisons, our survey can only be concerned with the art in the stage of full development which it reached in both countries in the 1830s and 1840s. In France, this form of illustration reached its maturity with great rapidity—in little more than a decade—under the influence of the English engravers, and has nothing to compare with the steady growth over forty or fifty years which took place in England, nor can it show anything to compare with the first vigorous productions of the English school. There are no Bewicks, Austins, Clennells or Nesbits, and the whole range of illustrations after Thurston have no counterpart in France.

On the other hand, when we reach the 1830s and 1840s and the material for a comparison exists, it will seem strange that any noticeable differences should occur after what we have already said of the close connections between the engravers and their products in the two countries. The conditions appear to have been the same, the productions of both were so mutually acceptable as to make the art appear international, and in many cases the very engravers employed were the same. But still there is a difference.

This difference can only be explained by considering the whole history of printing from surfaces engraved in relief. If we begin with the wood-cuts of the 15th century, we shall find that the custom of that time was to make a drawing in lines upon the wood. The wood-cutter would then cut away the white parts so as to leave the black lines of the drawing standing. The work was laborious but mechanical, and the resulting impression a very close reproduction of the original—in reality a *facsimile* of a pen drawing, with the characteristics of this form of art, including the tendency to build up depth of tone by the use of crossed lines in black, natural to the artist, but less natural to the cutter, who was required to remove the tiny spaces between the crossing

lines. The cutter's work was always unnatural, however, since, because he was working with the knife, at least four cuts, or two cuts followed by routing, were needed to produce a single line. We will call this process *facsimile*. Its modern counterpart is the line block, and between the two extends a long and persistent tradition of the representation of black-and-white drawings by cutting or etching in relief.

Wood engraving placed the natural means of expression in the hands of the engraver. The drawing, as finally appearing, was done no longer in black by the pen, but in the white line traced by a single movement of the engraver's hand, which created depth by the reduction of a black surface by white lines to give a subtle rendering in tone harmonizing much better with letterpress than the *facsimile* pen drawing.

But it was also possible to execute *facsimile* with the materials and tools of the wood engraver; so that this old tradition tended to continue alongside the style of rendering proper to the new art.

If we return to our comparison of French and English books with this situation in mind, we shall see that in the French books of the period *facsimile* is much more in evidence. It is especially noticeable in the *Gil Blas*, *Voyages de Gulliver*, *Robinson Crusoe* and *Don Quichotte*, but there is also a great deal in the *Molière* and a fair amount in the *La Fontaine*, *Béranger* and many other books.

It would be natural enough to attribute this difference to the methods of working of the French engravers and to assume that, being more recently emancipated from the use of the knife, they found *facsimile* more congenial and were not so well trained in the proper style of wood engraving. For various reasons this theory cannot be supported. In the first place, it is not to be supposed that, having so many examples before them, the French engravers could be ignorant of English methods of working. Secondly, there exist examples of their work in the true wood-engraving style which compare in every way with similar work by the English, for instance: in the *Saints Evangiles*, 1836,[25] there are India proofs of engravings in the true wood-engraving style by Brevière, S. and T. Williams, Gray and Orrin Smith in which no difference in manner of working is discernible between the French and English engravers, and the engravings for *Corinne*, done about 1840,[26] show the same similarities. Finally, in the work done for French books by the English engravers themselves this tendency is more apparent than it is in their work for English books.

The reason is to be sought, not in the different methods of working of the engravers, but in the manner in which their work was presented to them. The main feature of the growth of wood engraving in England was the very close

relationship between designer and engraver. Many, beside Bewick, engraved from their own designs, as, for instance, Samuel Williams, who undertook the complete illustration of many books, both the drawing and the engraving; and other instances of wood engravers engraving their own designs or those of other wood engravers are too numerous to quote here. The greatest provider of drawings for English wood engravers, William Harvey, was himself one of the best of them. Thurston, though not himself a wood engraver, succeeded in adopting the methods of drawing on the wood which were practised by Clennell, Nesbit and the other engravers with whom he worked. Thus there grew up in England a method of drawing on the wood which favoured the production of the true white-line engraving. The drawings were made in washes of Indian ink or sepia, which were adjusted to the depth of the tones, the details being indicated in pencil, or entirely in pencil with the tones shaded in. The resulting engraving was therefore a true drawing with the graver, in which the white lines were those of the engraver, who, as a real artist, was able to exploit his medium to the full in the rendering of tone, texture and perspective.

So long as the engraver was furnished with this kind of drawing the standard of engraving was high; but even in the England of this time there were artists who, because of their unfamiliarity with the method of drawing on wood or because their genius lay in another direction, presented the engraver with the traditional drawing in black line which reduced him to the mechanical production of *facsimile*: Leech, Cruikshank and Seymour are good examples.

I am therefore inclined to attribute the much larger proportion of *facsimile* in France not to any difference in technique or ability in the engravers, but to the unfamiliarity of most of the French designers with the methods of drawing on wood which produced such good work in England. The designs of Johannot, Gigoux, Grandville, Raffet and Vernet all tend to produce indifferent work with a marked proportion of *facsimile*. The engravings of Brevière after his own designs are quite English in character, as one would expect, and exception should be made for Français and Huet, who also appear to have understood the art of drawing on wood and were employed on English books. It is instructive to compare the engravings after Johannot in the *Don Quichotte* with those after the same artist in *Paul et Virginie,* for which latter book they were drawn on the wood by Français and Huet. Français also drew on the wood Grandville's frontispiece for La Fontaine's *Fables*.

This lack of understanding on the part of many of the artists of the medium for which they drew, with the consequent cramping of the art of the engraver, is the answer to the differences in the finished engravings. To the Englishman

many of them seem to be ahead of their time and to have more in common with the work turned out in the 1860s by the Dalziel Brothers, whose fame was built on the employment of designers well known in the ranks of the painters, but with no knowledge of drawing on wood or sympathy with the art of the wood engraver. It will also account for the scarcity amongst French books of those charming little vignettes engraved by wood engravers from their own designs, or from those of others intimately connected with their art, such as appear in the *Mabinogion*,[27] *The Rural Life of England*,[28] Thomson's *Seasons*[29] and many other books.

If we would form an impression of the resemblances between the wood engravings in French and English books, we should compare the *Paul et Virginie* with *Greece*: if we would see the differences, we should compare the *Don Quichotte* with Northcote's *Fables* of 1833.

Notes

(Details of books described in the Catalogue not given here)

(1) *Traité historique et pratique de la gravure en bois*. By J. B. M. Papillon. 3 tom. Paris, 1766.

(2) *Fables of Aesop and Others. Newly done into English. With an application to each fable*. By S. Croxall. London, J. Tonson & J. Watts, 1722.

(3) *A Treatise on Mensuration, both in Theory and in Practice*. By Charles Hutton. London, 1770.

(4) The *Select Fables*.

(5) His engravings for Grey's edition of *Hudibras* appeared in 1799.

(6) It should be unnecessary to do more than mention the long life of wood engravings; but since there are people who do not seem to realize it, it ought to be insisted upon. Speaking of numbers of impressions, Jackson said: 'Twenty thousand can be obtained from a lowered block printed by a steam-press, or by a common press with a blanket and without overlays' (*Treatise on Wood Engraving*, 1839, p. 730). Innumerable instances might be cited of blocks used over and over again, from Bewick's used in repeated editions of the *Quadrupeds* and *Birds* to Clennell's for Rogers' *Pleasures of Memory*, 1810, used in numerous editions of the *Poems* and *Italy* down to 1850, and from those for Yarrell's *British Birds*, 1843, still being used in the edition of 1871–85 to those for Birket Foster's *Pictures of English Landscape*, printed in 1862, printed again in a de luxe India edition in 1881 and printed again in 1896. And, if we consider extreme examples, there is Bewick's statement: 'I then turned to the date in my ledger, when he calculated exactly, and found it had printed above 900,000. This cut was continued in the newspaper several years afterwards.' (*Memoir*, 1862, p. 243).

(7) *One Hundred Fables, original and selected*. By James Northcote, R.A. London, G. Lawford, 1828.

(8) *The Club; in a Dialogue between Father and Son*. By James Puckle. London, printed by J. Johnson, 1817.

(9) *Metrical Index to the Bible*. By Josiah Chorley. [London,] J. Johnson, 1818.

(10) *Masters of Wood Engraving*, 1889, p. 202.

(11) *Dictionnaire de biographie française*.

(12) *L.-H. Brevière, dessinateur et graveur, rénovateur de la gravure sur bois en France, 1797–1869. Notes sur la vie et les œuvres d'un artiste normand*. By Jules Adeline. Rouen, E. Augé, 1876. Edition of 125 copies.

(13) *Fables, Original and Selected. By the late James Northcote, R.A. Second Series. Illustrated by two hundred and eighty engravings on wood*. London, John Murray, 1833.

(14) *Aventures de Robinson Crusoe par Daniel Defoe. Traduction nouvelle. Edition illustrée par Grandville*. Paris, H. Fournier ainé, 1840.

(15) *Histoire de l'art moderne en Allemagne. Par le comte Athanase Raczynski*. 4 tom. Paris, Jules Renouard, 1836–41.

(16) *Don Quixote de la Mancha. Translated from the Spanish of Miguel Cervantes de Saavedra, by Charles Jarvis, Esq. Carefully revised and corrected. Illustrated by Tony Johannot*. 3 vols. London, J. J. Dubochet, 1837–9.

(**17**) *Gil Blas. Translated by Smollett. Illustrated by Gigoux.* 2 vols. London, Dubochet, 1838–9.

(**18**) *Fables, Original and Selected; by the most esteemed European and Oriental Authors: with an introductory dissertation . . . by G. Moir Bussey.* London, Charles Tilt, 1839.

(**19**) *Paul and Virginia . . . With an original life of the author by St. Beuve.* London, Wm. S. Orr, 1839.

(**20**) *Paul und Virginie und Die indische Hütte... Neue Uebertragung durch G. Fink.* Pforzheim, Dennig Finck, [1842].

(**21**) *History of Napoleon . . . With . . . illustrations, after designs by Horace Vernet.* 2 vols. London, W. Strange, 1840–1.

(**22**) *The History of Napoleon. Edited by R. H. Horne. Illustrated with many hundred engravings on wood, from designs by Raffet and Horace Vernet.* 2 vols. London, Robert Tyas, 1840–1.

(**23**) *Greece: Pictorial, Descriptive and Historical. By Christopher Wordsworth, D.D.* London, William S. Orr, 1839.

(**24**) *La Grèce pittoresque et historique.* *Traduit de l'anglais par E. Regnault.* Paris, Curmer, 1839–40.

(**25**) Les Saints Evangiles. Traduits de la *Vulgate par M. l'abbè Dassance, vicaire-général de Montpellier.* 2 tom. Paris, L. Curmer, 1836.

(**26**) I have only been able to find the 1853 edition of this, which is: *Corinne ou l'Italie, Par madame la baronne de Staël.* Paris, Victor Lecou.

(**27**) *The Mabinogion, from the Llyfr Coch o Hergest, and other ancient Welsh manuscripts, with an English translation and notes; by Lady Charlotte Guest.* 3 vols. London, Longman, Brown, Green and Longmans, 1849. Issued in parts from 1838.

(**28**) *The Rural Life of England. By William Howitt.* 2 vols. London, Longman, Orme, Brown, Green and Longmans, 1838.

(**29**) *The Seasons and The Castle of Indolence . . . With a biographical and critical introduction by Allan Cunningham; and forty-eight illustrations, drawn and engraved by Samuel Williams.* London, Tilt and Bogue, 1841.

Ulrich Finke

16

French painters as book illustrators
—from Delacroix to Bonnard

1 Introduction

Painters as book illustrators—that is the theme which we would like to discuss here. When one attempts to give a definition of book illustration in the traditional sense, one can say that its task is to translate into visual form a situation given in the text, in which the illustration, either as a vignette or as a full-page picture, follows the text as closely as possible. It is possible to the extent that the text to be illustrated is descriptive and contains indications for the book illustrator. This direct or literal transcription of the written text into its visual equivalent characterized the illustrated books of Romanticism. The illustration directly depended on the text and was controlled by it. Nevertheless, as the intention in literary works of art turned away from exclusive description towards a dimension which contained non-descriptive elements of the word, that naturally had direct consequences for book illustration as well.

The painters too turned away increasingly from the literal transcription of the text. Thus Cézanne said in his conversations with Gasquet:

I don't like literary painting. When one writes underneath a figure what it thinks and what it does, this is an admission that its thoughts or its actions had not been translated into line and colour. And if one exaggerates the expression of nature and makes trees twist around, and rocks pull faces, like Gustave Doré, or excessively refines the expression like Leonardo, that too is still literature . . . Painting is first and foremost a matter of the visual. The content of our art is what our eyes think.[1]

If one replaces the word literary painting in Cézanne's quotation by literary illustration, that is literal translation of the word into its visible form, one can thus sum up the opposition of painters to traditional methods of book illustration in the second half of the 19th century. Although Delacroix, Manet, Redon or Bonnard were not book artists in the traditional sense, it was nevertheless possible for them by these very circumstances to make book illustration into book interpretation.

Delacroix expressed precisely the difference between the book and the plastic arts.

L'ouvrage du peintre et du sculpteur est tout d'une pièce comme les ouvrages de la nature... Si la lecture d'un bon livre éveille nos idées, et c'est une des premières conditions d'une semblable lecture, nous les mêlons involontairement à celles de l'auteur; ses images ne peuvent être si frappantes que nous de fassions nous-mêmes un tableau à notre manière à côté de celui qu'il nous présente. Rien ne le prouve mieux que le peu de penchant qui nous entraine vers les ouvrages de longue haleine. Une ode, une fable présentera les mérites d'un tableau qu'on embrasse tout d'un coup.[2]

In these sentences it is clear that painters felt themselves attracted principally by poetic matter; the choice of the material to be illustrated characterizes the difference between the painter illustrators and the book illustrators who did it for a living, like Gustave Doré, who said of himself: 'J'illustrerai tout!'

It is among the apparently paradoxical manifestations of the 19th century, that painters freed themselves from the doctrine of *ut pictura poesis* to the same degree as they turned back to the literary element in their book illustrations, which allowed them to satisfy their evidently literary ambitions. This appears at first sight a paradox, but it can be easily explained by the extremely close co-operation of painters and poets in the 19th century. In so far as literature contains 'pictures', it aroused a response in the artist's imagination; however, after the means of artistic expression in literature and also in painting had taken on a relative autonomy from the function of reproducing reality, Mallarmé's artistic principle of the 'suggestion of the limitless nuance' was also used by the painters who were occupied with the translation of language into visual forms. Baudelaire already saw the new conception of painting as an 'évocation, une opération magique', 'les formules évocatoires du sorcier'[3] and finally its aim was 'c'est créer une magie suggestive contenant à la fois l'objet et le sujet, le monde extérieur à l'artiste et l'artiste lui-même'.[4] Delacroix, Manet, Redon or Bonnard followed the literary text, in so far as it inspired them to artistic interpretations. In their extremely personal interpretation of literary models, in that 'suggestion of the limitless nuance'—and thereby in departing from literal translation of the text—they left the domain of traditional typographical layout of illustrated books in the 19th century and at the same time gained new artistic forms of interpretation. Bonnard's illustrations to Verlaine's *Parallèlement* (1900) are like a concretization of that which Verlaine expressed in his poem *Art poétique*:

> Car nous voulons la nuance encore,
> Pas la couleur, rien que la nuance!
> ...
> Et tout le reste est littérature.

2 Eugène Delacroix's illustrations to Goethe's *Faust*

Delacroix's illustrations to Goethe's *Faust* (Cat. No. 12) are among the best examples of Romantic book illustration, and were much appreciated by Goethe. At first, it is true, the poet had not thought of having his work illustrated, as can be seen from his letter of 25 November 1805, to his publisher Cotta: 'I think that we'll publish *Faust* without woodcuts and illustrations. It is so difficult for anything to be achieved which in general sense and tone suits a poem. Engraving and poetry usually parody each other.'[5]

One is only justified in treating Delacroix as a book illustrator with regard to his illustrations to *Faust*, and even here only to a certain extent. Although the lithographs in the translation by Stapfer (Cat. No. 12) appear in conjunction with the text as full-page illustrations with captions, one has reservations about speaking of an integration of text and pictures. However, what is new is the lithographic technique, which manages to reproduce the artistic expression so directly that it is very close to the sensitivity of the Romantics, and the artistic interpretation of the text. The tendency of the illustration to be for the most part separated from the text can also be seen in Delacroix's other series of illustrations: the lithographs to Shakespeare's *Hamlet* are published as a folio, as were the illustrations to Goethe's *Götz von Berlichingen,* for which the artist was unable to find a publisher in 1843. This relative independence of the pictures looks forward to the second half of the 19th century, to the works of Manet, Redon and Bonnard.

Delacroix set the tragedy back in the days of the old *Faust*-play, and avoided any kind of melodramatic exaggeration, as can be seen, for instance, in the Faust illustrations of Tony Johannot (1847, Cat. No. 41). The material had also inspired the German Romantics to produce illustrations; Peter Cornelius' outline drawings, published as etchings in 1816, had been seen by Delacroix in February 1824 at the house of his friend Pierret. 'Toutes les fois que je revois les gravures du *Faust*, je me sens saisi de l'envie de faire une toute nouvelle peinture, qui consisterait à calquer pour ainsi dire la nature.'[6] When Delacroix saw a free adaptation of Goethe's *Faust* on the stage in London in June 1825, he was particularly fascinated by the figure of Mephistopheles. 'J'ai vu ici une pièce de *Faust* qui est la plus diabolique qu'on puisse imaginer. Le Mephistophélès est un chef-d'œuvre de caractère et d'intelligence. C'est le *Faust* de Goethe, mais arrangé.'[7]

It is therefore obvious that in his pictures Delacroix was interested in the dramatic development of the character of Mephistopheles. In this he was not just in line with the poet's intentions, but in fact surpassed him in much, as can be seen from a remark by the poet to Eckermann on seeing the proofs for the

Faust edition. 'Herr Delacroix surpassed my own imagination in some scenes, and the readers will therefore find everything so much more animated, making them use their imagination.'[8] And in his commentary on the illustrations in the periodical *Über Kunst und Alterthum*, Goethe praised the artist: 'One thing is particularly noticeable, that an artist acquaints himself with this production in its basic meaning to such a degree that he has picked up all the echoes of primitive darkness, and presented a restlessly striving hero in similarly restless strokes of the stylus. In this singular production which hovers between Heaven and Earth, the possible and the impossible, the most harsh and the most delicate, and between whatever further polarities the pendulum of audacious fantasy may swing, Herr Delacroix seems to have really felt himself at home and adapted it as his own. Furthermore, the spectacular nature of the scene is played down, the mind is led from superficial clarity into a world of darkness and the primeval emotions of a fabulous tale are stirred up again.'[9]

Delacroix's choice of scenes to illustrate is important in understanding the manner in which he interprets the material. The compilation of the accompanying texts which act as captions or mottoes is also important; not infrequently they bring together several verses from different places in Goethe's text and make them into a dialogue or epigram. This dramatic condensation is appropriate to the way the scenes in question are depicted, as can be seen from a few examples. The first picture, which depicts Mephistopheles descending to Earth as a winged Satan, contains the whole range of the *Faust* material [211]. The lines quoted underneath are:

De temps en temps j'aime à voir le vieux Père,
Et je me garde bien de lui rompre en visière.

Von Zeit zu Zeit seh' ich den Alten gern,
und hüte mich, mit ihm zu brechen.

The hovering motif, which makes visual Goethe's words 'Zwischen Himmel und Erde' (Between Heaven and Earth), seems—if perhaps not consciously intended by Delacroix—to symbolize the main theme of *Faust*, as also when, in the Prologue in Heaven, God admonishes the archangels: 'Und was in schwankender Erscheinung schwebt, / Befestigt mit dauernden Gedanken.' Only intellect, however, can make the link between unstable phenomena and an idea: mere sensual comprehension—and therefore Mephistopheles—is incapable of making this step. Thus the first picture is both illustration and metaphor.

211 Delacroix: 'Mephistopheles descending to Earth' (illustration for Goethe, *Faust*)

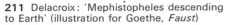

212 Delacroix: 'Faust in his study'

The second picture shows Mephistopheles' counterpart, the learned Doctor Faustus who is turning to a skull which is lying in front of him on the table [212]: 'Pauvre crâne vide que me veux lu dire avec ton grincement hideux?'

> Was grinsest du mir, hohler Schädel, her,
> Als daß dein Hirn wie meines einst verwirret
> Den leichten Tag gesucht und in der Dämmrung schwer,
> Mit Lust nach Wahrheit, jämmerlich geirret.

Here Delacroix chose a single verse which includes these thoughts of death in the form of a provocative question, and he leaves out the vital verse about human error, only to take it up again in the third picture. In this composition Goethe saw the formulation of a pictorial idea, which could exist independently from the *Faust* material: 'Thus for example the plate where Faust stands sunk in thought in his study, surrounded by all sorts of strange objects, gazing at a skull lying on the table in front of him, is in itself, even without further reference to the poem, a picture well endowed with meaning and technically well constructed.'[10] In fact Delacroix exhibited a picture on a similar

theme in the *Salon* of 1828. The illustration is also related thematically to the numerous compositions which Delacroix produced on the theme 'Hamlet looking at Yorick's skull'.

Finally in the third picture [213], Delacroix continued the theme of the second picture. On the morning of Easter Sunday, Faust and Wagner have gone out of the town, and whilst the people are joyfully celebrating the re-birth of Spring, Faust's thoughts run:

Faust—Heureux qui peut conserver l'espérance de surnager sur cet ocean d'erreurs!... /... l'esprit a beau déployer de ailes, le corps, hélas! n'en a point à y ajouter.

> O glücklich, wer noch hoffen kann
> Aus diesem Meer des Irrtums aufzutauchen!

and then says resignedly:

> Ach! zu des Geistes Flügeln wird so leicht
> Kein körperlicher Flügel sich gesellen.

213 Delacroix: 'Faust and Wagner on an Easter Sunday stroll'

214 Delacroix: 'Gretchen in the church'

The verse which comes between these two verses:

O daß kein Flügel mich vom Boden hebt,
Ihr nach und immer nach zu streben!

was left out by Delacroix, doubtless in order to increase the tension between hope and resignation. A similar poetization can also be seen in the illustration showing Faust sunk in thought with his head resting on his hand giving way to feelings of melancholy, which derives from Dürer's famous engraving 'Melancholia' (1514), and also recurs in Delacroix's paintings 'Tasso in the madhouse' and 'Michelangelo in the studio', if in slightly different form. One should also at least mention that in the collection *Sonnets et eaux-fortes* (1869, Cat. No. 52) the poem 'Promenade hors des murs' by Théophile Gautier is accompanied by an etching by Leys, which is plainly based on Delacroix's illustration.

These few examples should suffice to characterize Delacroix's subtle interpretation of Goethe's *Faust*: Delacroix emphasized the darkly realistic and grotesquely sarcastic traits in Mephistopheles, who even appears in pictures like 'Faust and Margarete in the street' and 'Faust with Gretchen in the

dungeon', although in each case he does not in fact enter until later. Delacroix's interest in the *Faust* material was not confined to this publication; in the 1840s when he painted the 'Rape of Rebecca', 'Othello' and 'The death of Lara', he produced several compositions in oils like 'Gretchen in the church' [214] (1846 and sketch of 1847), in which he repressed the earlier narrative elements in favour of Mephistopheles' great gesture of pathos and a greater effect of spatial depth; and also the 'Death of Valentine' (1848). And on the first of March 1862, he wrote to Burty that he regretted having got to know the second part of *Faust* only later on; although he found it for the most part unpoetic, it contained many incidents which could inspire a painter.

It was no doubt the poetic element in Goethe's *Faust* which aroused the artist's imagination and led him to follow up the lithographs with paintings. The 'romantic' Goethe, whose play, *Götz von Berlichingen* also stimulated the artist to produce lithographs and pictures, was extremely well interpreted by Delacroix, who also took ideas for later paintings from the illustrations. Thus book illustration and painting merge into one another, in contrast to the romantic vignette—painters like Johannot, Gigoux and Nanteuil, who always chose decorative or narrative elements related only to the particular situation as the material for their small-scale vignettes. Where they turned their hand to painting, they could not break free from the vignette-like decorative style of their miniatures. Delacroix, on the other hand, was first and foremost a painter, and found in literature characters whom he closely resembled and whose life had an exemplary meaning for him. Thus Delacroix was able to rise above mere illustration and achieve an artistic truth which found its justification in the artist's imaginative powers. The captions which Delacroix took from Goethe's text are—as already shown—in themselves an interpretation of the given literary text and thus serve as a key to the interpretation of the picture. Text and picture complement each other. In this interdependent relationship, the lithographs are still just illustrations, whereas in the paintings on the same subjects, like 'Faust in the study' or 'Gretchen in the church', the legends disappear—along with the reduction of the narrative accessories—and the illustrative element gives way to Delacroix's personal formula of pathos.

3 The *peintres-graveurs:* etching, the cult of the Japanese, and hermetic poetry

'Eaux-fortes de peintres! Lithographies de peintres! appellations prestigieuses, mais qui ne doivent pas cependant faire accepter les yeux fermés

n'importe quelle pièce, sous le seul prétexte qu'elle est de la main d'un peintre connu', Beraldi said with reference to Courbet's etchings.[11]

The rediscovery of etching in the middle of the 19th century followed the revaluation by the Romantics of the graphic works of Dürer, Rembrandt and Goya. Along with the commercial illustrators, Bracquemond, Buhot and Bresdin, it was principally the painters Millet and Daubigny of the school from Barbizon, and Whistler, Legros and Manet, who made etching the medium of expression of the new art. Publishers and printers like Cadart and Delâtre had successfully popularized this medium, and the 'Société des aquafortistes' founded by Alphonse Cadart in 1861 followed the English model of the London 'Etching Club'. Every year Cadart published folios under the title of *Eaux-fortes modernes*, to which Gautier, Janin and Thoré wrote the texts.

The credit is due to Bracquemond for being one of the first to make etching popular again with the younger artists. In 1852 Delâtre published Bracquemond's series *Huit sujets tirés des fables de La Fontaine,* from 1859 appeared the work of art history *L'art du dix-huitième siècle* by the brothers Goncourt, for which Jules Goncourt himself produced the reproduction engravings after the masterpieces of the 18th century, and Jules Jacquemart etched the plates for the *Histoire de la porcelaine* published by Albert Jacquemart and Edmond le Blant in 1862.

Etching was already beginning to be reintroduced, when Baudelaire, on the instigation of Legros or Bracquemond, published his article 'L'Eau-forte est à la mode' in *La Revue anecdotique*, 2 April 1862, under a pseudonym, and later, under his own name, in the periodical *Boulevard*, 14 September 1862. Along with Gautier, Baudelaire was one of the most passionate supporters of this form of art. 'Parmi les différentes expressions de l'art plastique, l'eau-forte est celle qui se rapproche le plus de l'expression littéraire et qui est la mieux faite pour trahir l'homme spontané.'[12] In his revised article Baudelaire praised Legros' works extensively: 'On connaît les audacieuses et vastes eaux-fortes de M. Legros, qu'il vient de rassembler en un album: cérémonies de l'Église, magnifiques comme des rêves ou plutôt comme la réalité; processions, offices nocturnes, grandeur sacerdotales, austérités du cloître; et ces quelques pages où Edgar Poe se trouve traduit avec une âpre et simple majesté',[13] where it is a question of the edition of Poe's works planned by Baudelaire, for which Legros had drawn vignettes, which however only appeared in 1861 as an incomplete series under the title *Huit vignettes sur des sujets tirés des Histoires Extraordinaires d'Edgar Poe*. In Whistler's etchings from London, which the author compared with the Paris Album of Meryon, he

admired what one could describe as his ideal of 'La vie moderne'. Baudelaire
also mentioned Manet's etching, the 'Guitarist', if only in passing.

'Pour dire le vrai, ce genre, si subtil et si superbe, si naif et si profond, si
gai et si sévère, qui peut réunir paradoxalement les qualités les plus
diverses, et qui exprime si bien le caractère personnel de l'artiste, n'a jamais
joui d'une bien grande popularité parmi le vulgaire.'[14] — 'Non seulement
l'eau-forte sert à glorifier l'individualité de l'artiste, mais il serait même
difficile à l'artiste de ne pas décrire sur la planche sa personnalité la plus
intime.'[15] What did Baudelaire mean by 'L'Eau-forte est celle qui se rap-
proche le plus de l'expression littéraire'? On the occasion of the universal
exhibition of 1855, Baudelaire had spoken of Delacroix's works in a similar
way. 'C'est qu'il est essentiellement littéraire. Non seulement sa peinture a
parcouru toujours avec succès, le champ des hautes littératures, non seule-
ment elle a traduit, elle a fréquenté Arioste, Byron, Dante, Walter Scott,
Shakespeare, mais elle sait révéler les idées d'un ordre plus élevé, plus fine,
plus profonde que la plupart des peintures modernes.'[16]

An excellent example of this interplay of etching and literature to which
Baudelaire was referring, indeed the fullest document of the *peintres-graveurs*
working together with the poets, is the de-luxe edition of *Sonnets et eaux-
fortes* (Cat. No. 52), published by Philippe Burty in 1868 (1869), in which in
every case there is a sonnet on one page, and a full-page etching on the facing
page. Amongst others, the writers Banville, Anatole France, Gautier, Sainte-
Beuve, Sully Prudhomme, Verlaine, and the artists Jérome, Doré, Seymour
Haden, Corot, Jongkind, Daubigny, Victor Hugo (!), Jacquemart, Millet
and Manet collaborated in the production of this edition. Etching and poetry
are in fact only externally related, but they are brought into an inner har-
mony by the choice of similar themes, although each etching does not
illustrate the sonnet with which it appears. For example, Manet's etching
'Fleur exotique' is only related by its title to the sonnet of the same name by
Armand Renaud: Renaud's poem seems rather to be inspired by a picture
by Ingres, possibly one of his numerous 'Odalisques', whereas Manet's etch-
ing follows Goya's 'Bellos consejos' from the *Caprichos*. It may well be that
Burty was not looking for real illustrations, for an analysis of the book shows
that only a very few of the etchings are related to the accompanying texts.
Rather there arises from the confrontation of these two different means of
expression, which have a common title, something like an analogy. This
tendency to look for the common elements seems to be important; it is the
strong point of the work, but also its weakness with regard to the illustrative
element.

The Japanese wood-cut had a not unimportant influence on the works of the *peintres-graveurs*. But it is important to note that it was the wood-cut which was the basis, stylistically and formally, of the etching. In 1856 Bracquemond saw at his publisher Delâtre an edition of Japanese wood-cuts, Hokusai's *Mangwa,* and in the following year managed to get a copy in an exchange. In place of the Chinoiserie of the 18th century, there now began a cult of the Japanese, which had rather more affinity with folk tradition and with ordinary life. When Whistler came to Paris at the end of 1855, Bracquemond introduced him to Japanese art, and when he moved to London in 1859, he persuaded Dante Gabriel Rossetti to collect Asiatic works of art. In the 1870s the graphic artists James Tissot, Felix Buhot and Bresdin made use of Japanese elements in their etchings. One also thinks of Mallarmé's poem 'Las d'aimer repos', which runs:

Imiter le Chinois au cœur limpide et fin,
De qui l'extase pure est de peindre la fin,
Sur les tasses de neige à la lune ravie,
D'une bizarre fleur qui parfume sa vie,
Transparente, la fleur qu'il a senti, enfant.

In his pictures, like 'Portrait of Zacharie Astruc' (1864) and 'Child in flowers' (1875), which in its elongated compositional form is reminiscent of the Japanese oblique style, the Makimono, Manet had come close to the decorative-surface compositional technique of Japanese art; and he had also utilized this element in his book illustrations, as for example in his illustrations to Champfleury's book *Les Chats,* in the eight etchings to Charles Cros' *Le Fleuve* (1874, Cat. No. 54) and finally in the four small wood-cuts to Mallarmé's *L'Après-midi d'un faune* (1876, Cat. No. 56). Here, the wood-cuts have a parallel effect to the poetic language, which depicts the illusory aspects of an imaginary event in a dreamlike manner, but they never directly illustrate the text. They create a similar mood, which Mallarmé characterized as, 'A candy bag, but made of dreams . . . somewhat oriental with its Japanese felt, title in gold and tie knots of black and Chinese pink.'[17] The poetry is hermetic and so Manet's accompanying pictures are in the form of dreamlike arabesques.

In his etching 'Au Louvre' (c. 1876), in which Mary Cassat is depicted, Degas took over the Japanese Naga-e; in 1891 Mary Cassat produced a series of ten etchings in colour, after she had seen the exhibition of Japanese wood-cuts in the École des Beaux-Arts, which also strongly influenced the painters Maurice Denis, Vuillard and Bonnard. Bonnard's colour lithographs at the

beginning of the 1890s are already close to abstract art in their beautiful rhythm and in the delicate coloration of their decorative surfaces.

4 Manet's illustrations to Edgar Poe's *The Raven*

In the writings of the German E. Th. A. Hoffman and the American E. A. Poe, the French poets and painters came upon a source of experience which extended beyond the world of everyday things and opened the door to the realms of magic and irrationality. Baudelaire had translated and published Poe's *Histoires extraordinaires*, and Mallarmé's translation of Poe's *The Raven* appeared in 1875, illustrated by Manet (Cat. No. 55). Like Baudelaire and Mallarmé, Manet and Redon had also fallen under the spell of the American. Delacroix too, who read Poe's *Histoires extraordinaires* in 1856, was extremely fascinated by these stories. On 6 April 1856, he noted in his diary: 'Je lis avec beaucoup d'intérêt depuis quelques jours la traduction d'Edgar Poe de Baudelaire. Il y a dans ces conceptions vraiment extraordinaires, c'est-à-dire extra-humaines, un attrait de fantastique qui est attribué à quelques natures du Nord.'[18] On 30 May 1856, Delacroix added to his observations: 'Cette

215 Manet: Illustration for Poe, *The Raven*
(frontispiece)

216 Manet: for *The Raven,* 'Once upon a midnight dreary . . .'

lecture réveille en moi ce sens du mystérieux qui me préoccupait davantage autrefois dans ma peinture, et qui a été, je crois, détourné par mes travaux sur place, sujets allégoriques, etc., etc.'[19] It must have been much the same for Manet, when he read *The Raven* with Mallarmé, and was faced with the task of illustrating the poem. The fact that his very spontaneous pen and brush illustrations, which were printed as lithographs, each occupy a full page in the text, shows the extraordinary importance which the publisher, as well as Manet and Mallarmé, placed on the illustrations.

In interpreting these illustrations, one should not forget that Poe's text contains a magical and symbolic dimension which had a great influence on Mallarmé and Manet. Just as in mythology birds are a reincarnation of dead people, the raven is a personification of the hero's lost love for his Lenora and also the bringer of bad luck who, in reply to the hero's questions about his love which become more and more despairing throughout the poem, always answers 'Nevermore'. Thus the raven is the spirit who pursues the hero, who is himself the cause of his own visions and torments; like Goya's *Caprichos*, where in the first plate of the series the author's sleeping mind

gives birth to monsters which then haunt him. 'El sueño de la razón produce monstrous.' Poe's hero was studying books—'Vainly I had sought to borrow / From my books surcease of sorrow'—which he described as 'Many a quaint and curious volume of forgotten lore', when the ominous raven appeared.

Manet at first based his four illustrations, to which were added a title vignette [215] and an ex-libris [220], directly on the text. But his modifications of the text are important and show his interpretation and extension of the poem.

The first picture [216] relates to the beginning of the poem:

> Once upon a midnight dreary, while I pondered, weak and weary,
> Over many a quaint and curious volume of forgotten lore,
> While I nodded, nearly napping, suddenly there came a tapping,
> As of someone gently rapping—rapping at my chamber door.

The hero is sitting in the lamplight over his books, whose magic power is indicated by the bright light which streams out from them; his features are like those of Mallarmé, as can be seen from the portrait of Mallarmé by Manet in the Louvre (1876); the identification of Poe's hero with Mallarmé,

217 Manet: for *The Raven*, 'Open here I flung the shutter . . .'

218 Manet: for *The Raven*, 'Perched upon a bust of Pallas . . .'

who had also dabbled in caballistic literature, is reinforced by the fact that Poe, Baudelaire and Mallarmé all saw themselves as embodying the myth of the 'poet damned by society'. Whilst the first illustration is in horizontal format, the remaining three are in vertical format, which emphasizes the dramatic nature of the way the poem continues.

In the second picture [217] the hero has stepped to the window:

> Open here I flung the shutter, when, with many a flirt and flutter,
> In there stepped a stately raven of the saintly days of yore.

Gripped by the sight of the raven the hero stands at the window, his head and his left hand are outlined against the darkness, and the outspread fingers betray his tension, as the raven flies into the room. Whereas Poe's poem runs 'In there stepped a stately raven', Mallarmé translated this concrete verb by the more general 'entra', which allowed Manet the opportunity of showing the raven in flight. The raven seems to be seen from a distance and yet appears simultaneously to be already in the room, because the tip of his right wing cuts the window frame. This ambiguity of content arising from the form intensifies the dramatic situation: for the movement of the raven creates a similar feeling of insecurity in the observer—if only in optical terms—to that experienced by the hero in the poem.

The third picture [218] shows the raven:

> Perched upon a bust of Pallas just above my chamber door—,
> Perched, and sat, and nothing more
> . . . But the raven still beguiling all my sad soul into smiling,
> Straight I wheeled a cushioned seat in front of bird and bust and door.

Harris referred to the 'unspecific character of this illustration',[20] but this does not seem to be the case. For the ambiguity of content already mentioned in the second picture recurs here. We have the shadow of the raven, whose contours indicate something like an imaginary movement of the raven towards the hero. The interplay of light and shade is purely objective, but the symbolic way the raven is about to swoop down on his victim, the hero of the poem, is metaphorical. 'And the lamplight o'er him streaming throws his shadow on the floor.' Manet follows in his illustration the contrast in the text between the 'ebony bird' and the 'pallid bust of Pallas', and also takes up the symbolic dimension, since the black raven embodies evil and the goddess Pallas Athene symbolizes wisdom. Rossall pointed out the similarity between this illustration and the plate 'Que pico de oro' from Goya's *Caprichos*,[21] in which mad monks listen delightedly to a bird which is sitting on a

soap dish. The mass of grey diagonal hatching between the raven and the hero reflects Poe's description:

> Then, methought, the air grew denser, perfumed from an unseen censer
> Swung by Seraphim whose foot-falls tinkled on the tufted floor.

The ambiguity of the raven and its shadow, the contrast between present reality and imagined future movement, makes visible the metaphorical dimension which can also be described as the magic which lies behind the world of everyday things and perceptions.

In the fourth picture [219] we have a different view of the room,; for whereas in the previous picture the door was parallel to the edge of the picture and the hero's head appeared on the bottom edge, in order to create an effect of distance, the door is now placed diagonally to the picture, facing the empty chair and the shadow. The room therefore now appears as an enlarged section, and the observer has the choice either of believing it to be empty or of seeing it from the perspective of the imaginary hero. The last verse of Poe's poem is:

> And my soul from out that shadow lies floating on the floor
> Shall be lifted—nevermore!

219 Manet: for *The Raven,* 'And my soul from out that shadow . . .'

220 Manet: for *The Raven* (ex-libris)

Now there remains only the shadow of the raven—but the bird is still sitting on the bust of Pallas, as can be clearly seen from the shadow—the loneliness which the hero feels with regard to his loved one is now transferred also to the observer, because the hero has vanished from sight, and thus the observer is left confronted by the dialectic of the real and the unreal: the presence of the raven can only be recognized from its shadow—like the poem, the illustrations, too, end, as far as the hero is concerned, in an unresolved tension, which is now further heightened by Manet by the collaborative effect of the title vignette and the ex-libris. In the title vignette the raven is seen in profile: its powerful beak is an augury of the ominous fate of the hero: 'Take thy beak from out my heart,' and its black colour represents his lament for his lost love and also death. In the ex-libris [220] Manet shows the raven hovering, able in this specific pose—like a bird of prey—to swoop down on its prey at any moment. After the unresolved tension at the end of the poem, the hero's request 'Take thy beak from out my heart' seems to be made visual in the ex-libris in a double sense: as destruction and as release.

Manet's illustrations brilliantly interpret the text in pictorial and symbolic terms, using subtleties of nuance which reflect the balance between the real and the unreal, the concrete and the visionary, damnation and salvation, to achieve a feeling of great spontaneity. Manet managed to depict the unseen aspects lying behind the world of everyday things and perceptions. Behind the concrete lurks magic and myth, not just in Poe's poem, but also in Manet's illustrations. Harris questions this, however, when he says: 'If we turn now to the scenes which are direct illustrations of the incidents of the poem, we are struck by the fact that they illustrate only those aspects of the text which could successfully be rendered in *concrete* visual terms'[22] (my italics).

5 Redon, Cézanne and Flaubert

Odilon Redon refused to regard his lithographs, in so far as they were related to literature, as illustrations. 'Je n'ai jamais employé le mot défectueux d' "Illustration", vous ne le trouverez pas en mes catalogues. C'est un mot à trouver: je ne vois que ceux de transmission, d'interprétation.'[23] We will take two concrete examples of the way Redon and Cézanne reacted to the work of Flaubert, who himself categorically refused to allow his works to be illustrated: in both cases, in Redon's series of six lithographs *Gustave Flaubert, Tentation de saint Antoine* (1889, Cat. Nos. 58 and 59) and in Cézanne's picture 'Old woman with rosary', it is not, however, a question of textual illustration in the strict sense of the word, but of a particular personal interpretation of emotional and visual elements which stimulated the artists' imagination. As

will be shown, they combine and contrast form and subject-matter in different ways.

In 1882 when Redon's series *À Edgar Poe* appeared, Hennequin had sent the artist Flaubert's *Tentation de saint Antoine* to read, with the hint that he would be able to find 'des monstres nouveaux' in this work. On 31 March 1882, Redon replied: 'Je vous remercie de m'avoir fait lire *La Tentation de saint Antoine*, une merveille littéraire et une mine pour moi.' Later Redon admitted to Mellerio: 'J'ai été vite séduit par la partie descriptive de cet ouvrage, par le relief et la couleur de toutes ces résurrections d'un passé.'[24] J. Seznec has revealed how Flaubert for his part was inspired to his literary work by a similarly entitled picture by the elder Breughel, and later by an engraving of Callot.[25] One can therefore understand that these images of a dream world could exert a reciprocal influence on an artist like Redon. In contrast to his albums *À Edgar Poe* (1882) and *Hommage à Goya* (1885), for which Redon produced the legends himself, which brought him the highest praise from Mallarmé—'J'adore aussi votre légende d'un mot ou deux...'[26]— the legends in the series *Tentation de saint Antoine* are taken from Flaubert's

221 Redon: Illustration for Flaubert, *La Tentation de Saint Antoine*

222 Redon: for *La Tentation de Saint Antoine*

work, and indicate the central points which stimulated Redon's pictorial imagination. Of the six plates three will be discussed here: (1) '... Une longue chrysalide couleur de sang...' (a male head, encircled by a radiant aureole and with a larva-like body, lies on an upside-down broken-off capital of a pillar in a vast entrance hall) [221]; (2) 'Saint Antoine: ... à travers ses longs cheveux qui lui couvraient la figure, j'ai cru reconnaître Ammonaria...' (the scene shows the flagellation of a naked woman, who is bound to a pillar) [222]; and (3) 'Le sphinx:... Mon regard, que rien ne peut dévier, demeure tendu à travers les choses sur un horizon inaccessible la chimère: moi je suis légère et joyeuse!' (in the left foreground is a white sphinx in profile; opposite it hovers a black chimera) [223].

In these three plates, fragments from Flaubert's text have been combined with additional pictorial ideas. In all three examples it can be seen that each picture contains at least one element which appears in the appropriate legend. Redon himself spoke of the relationship between text and picture: 'Le titre n'y est justifié que lorsqu'il est vague, indéterminé, et visant même confusément à l'équivoque.'[27] What Redon, 'the Mallarmé of painting', as Maurice

223 Redon: for *La Tentation de Saint Antoine*

Denis called him, takes from the text is the descriptive element. All three pictures start from depictions of the literary symbols (i.e.: (1) Longue chrysalide; (2) La figure... Ammonaria; (3) Le sphinx... La chimère...), and related visual concepts (i.e.: (1) head with body; capital of pillar, entrance hall; (2) woman, pillar, flagellator; (3) the sitting of the sphinx and the hovering of the chimera) reinforce their position in the pictures. By linking formally these symbols from the text with other symbols, they are translated into visual symbolic language (i.e.: (1) the description 'Couleur de sang' can be associated with the head on the pillar or with the image of John the Baptist = Martyr; (2) reminds one of the type of picture depicting the flagellation of Christ, etc.) and permit what is not visible to play its part in the visible world. As we have seen, the legends, and hence a knowledge of the meaning of the text, is indispensable in interpreting the picture. Since, however, the 'poetic arguments' in the picture, which require the accompanying text, do not aim to define the subject, but rather to postulate a number of possible inspirations about possible interpretations, the subjectivity of the observer is both the prerequisite and the aim of these pictures. The eclectic element in the works of the symbolists Redon, Moreau, Carnère and Puvis is the conscious assumption of inherited forms from classical figure painting, which they invest subjectively (i.e. poetically, symbolically, etc.) with new content matter or associate with well-known content matter.

In Redon's pictures, in so far as they, as in the above example, are at variance with literature, the metaphors they always contain are of prime importance as much in the textual extracts chosen as in the pictures; and this indicates that what is being attempted is the translation of symbolic language into visual form.

Cézanne, too, was concerned in his art to transform perceptual elements into pictorial elements. Whereas, however, with Redon the pictorial elements can also be put in linguistic form, Cézanne wanted to make phenomena visual, to the exclusion of the linguistic dimension. This is clearly in contrast to Redon. 'My [method] is, you see, hatred for the fantastic picture, I have never had any other. I would like to be really stupid. My method, my book of rules is Realism. But a Realism, understand me correctly, full of greatness, unconscious. The heroism of Reality. Courbet, Flaubert.'[28] Against the 'fantastic picture', that means against subjectivity in Redon's sense. In his conversations with Gasquet, Cézanne quoted an incident from Balzac's *La Peau de chagrin* to illustrate the essential difference which existed for him between painting and literature. Balzac speaks of a table cloth, 'White as a covering of freshly fallen snow, on it the covers rose up symmetrically crowned

with little blond rolls.' 'During my whole youth I wanted to paint that, that snow-white cloth—now I know, that one may attempt to paint "The covers rose up symmetrically" and "With little blond rolls". If I paint "Crowned", then I am done for.'[29] Perception must limit itself to values which can be translated into objective pictorial elements, for 'Nothing is more dangerous for a painter, you know, than to meddle with literature'.[30] 'You know, when Flaubert was writing *Salammbô*, he said he could see purplish-red. Now when I was painting my 'Old woman with rosary', I saw a Flaubert tone, an atmosphere, an indefinable something, a blueish and reddish-yellow colour which, so it seems to me, is also exuded by *Madame Bovary* . . . it was not until later that I realized that the face was reddish-yellow, the apron blueish; after the picture was finished, when I recalled the description of the old servant in the agricultural club' (in *Madame Bovary*).[31] The feeling which Flaubert's novel aroused in Cézanne had been objectified into pictorial elements—the colours; form reveals itself externally and objectively as becoming real ('Réalisation'— 'Dingwerdung' as Rilke translated the term), whereas for Redon the object, the poetic argument appeals to the *subjective* side of one's nature as idea or dream.

6 Perspectives

In contrast to England, an aesthetic of the illustrated book, the 'livre de luxe', developed in France which took no account of the traditional typographical alternation of picture and text—as was practised since the days of the printed illustrated books of the early Renaissance, and was reintroduced by William Morris—in order to give the painter-illustrator greater freedom in his artistic interpretation of the text. The one was a prerequisite and a consequence of the other: by the external disintegration of text and picture, the picture was able in fact to become more intimately linked to the text. Although Delacroix, Manet, Redon and Bonnard made little use of the usual typographical arrangement of the illustrated book, particularly as developed under Romanticism, their illustrations display a degree of acquaintanceship with the text that is seldom to be found in the works of the professional graphic book illustrators. This freedom from traditional lay-out meant a freedom which allowed a highly personal and creative contact with literature.

Ambroise Vollard is one of the best-known French publishers of the 20th century, though he began his work at the end of the 19th century. 'I was hardly settled in the Rue Laffitte when I began to dream of publishing engravings, but I felt they must be done by "painters-engravers". My idea was to obtain engravings from the artists who were not engravers by profession.'[32]

At first Vollard published albums, like *Quelques aspects de la vie de Paris* (1895) with twelve lithographs in colour by Bonnard, and albums of the *Peintres-graveurs*, which contained contributions by Bonnard, Denis, Fantin-Latour, Munch, Redon, Renoir, Valadon, Vuillard and others. For his planned illustrated books too, he turned almost exclusively to artists who had also contributed to his albums.

The first book that Bonnard illustrated for Vollard was Verlaine's *Parallèlement* (1900) [224], in which the artist treated text and pictures in a completely free manner, and also produced some free arabesques, so that sometimes the text was wound around the picture and thus subordinated to it; the bibliograph might, however, find this over-free interplay between the *grandjeu* type and the illustrations rather irritating.[33] But the constant alternation of rhythm between text and picture, the fusion of form and movement, seems to be an echo of Verlaine's maxim: 'Car nous voulons la nuance encore—pas la couleur, rien que la nuance' ('Art poétique'), which subscribes to the aesthetic of fragility, at a time when painting was going in the direction of the expressive. In such books, the impressionistic painting of the artists of the 1840s, which had undergone certain changes in the meantime, had been translated into graphic terms: the forms are soft and flowing, order is merely hinted at, colour is just nuance.

Vollard had thought first of Lucien Pissarro to illustrate Verlaine's *Parallèlement*—'Vollard also asked me whether you would do a book by Verlaine for him', wrote Camille Pissarro to his son on 1 July 1896,[34]—and later, on 3 March 1900, C. Pissarro told his son of his impressions on seeing Bonnard's illustrations.

Here they don't look at a book as a totality, even the young artists who try to do good work haven't learned this. Thus, yesterday Vollard showed me a galley for a volume of Verlaine with a 16th–17th century type. It was illustrated by Bonnard (a young artist), the drawings are rendered very freely by the [lithographic] process . . . to my objections Vollard replied: "But this is 17th century typography." I saw a book done by William Morris, which I found repellent . . . that's the situation here. Denis (the painter) is going to do *Daphnis and Chloë* with wood-cuts. He will certainly make some pretty cuts but the ensemble will undoubtedly be poor.[35]

Camille Pissarro had himself drafted some illustrations to *Daphnis and Chloë* in 1895, which L. Pissarro had cut in wood. L. Pissarro's own works, which he published partly in the periodical *L'Image*, are reminiscent of the style of the school of William Morris.

One of the most beautiful books published by Vollard—perhaps along with Verlaine's *Parallèlement* the most beautiful of all—is the *Pastorale de*

224 Bonnard: Illustration for Verlaine, *Parallèlement*

225 Bonnard: Illustration for *Pastorale de Longus ou Daphnis et Chloë*

Longus ou Daphnis et Chloë (1902) **[225]** with 151 original lithographs by Bonnard, printed by Auguste Clot, for whom Toulouse-Lautrec also worked. As far as the typography goes this book is more unified, because the illustrations are always in rectangular form, and the text, in *grandjeu* type as in *Parallèlement*, always appears as five lines underneath the picture. One thinks that of the numerous illustrators who have dealt with this subject—like Prud'hon and Gerard in Didot's de-luxe edition, and later Maillol, René Sintenis and Chagall—Bonnard managed to recreate the classical arcadian dimension in the modelling of the graceful female nude, the bucolic humour of the satyr scenes and the suspended sense of depth. Later, in his painting 'The rape of Europa' (1919), Bonnard, as it were, extracted the quintessence of his illustrations, which were the final flowering of the 19th century de-luxe edition. The delicate interplay of text and picture reflects the author's mood in his Foreword, when he says that while hunting in Lesbos in a grove consecrated to the nymphs, he found the most beautiful object that he had ever seen: a work of painting, a love story, and this picture which was clearly to be found in a temple inspired him to his novel, in order to 'Try to rival this depiction with his own'.

Bonnard may also have experienced and tried to express in his pictures what Goethe felt on reading *Daphnis and Chloë*: 'The poem is so beautiful, that in the unhappy circumstances one lives in, one cannot keep to oneself

the impression one gets from it, and one is always amazed afresh when one rereads it. There it is bright day, and one believes one can see Herculean pictures, just as these paintings too have their effect on the book and come to the aid of our imagination as we read it.'[36]

Notes

(1) Paul Cézanne, *Über die Kunst. Gespräche mit Gasquet und Briefe*. Mit einem Essay von Walter Hess. Hamburg, 1957, p. 20.
(2) *Journal de Eugène Delacroix*, ed. P. Flat and R. Piot, Paris, 1926, II, pp. 463–4.
(3) Charles Baudelaire, *Curiosités esthétiques*, Edition intégrale illustrée. Introduction et notes de Jean Adhémar, Lausanne, 1956, p. 202.
(4) Ibid., p. 294.
(5) *Goethes Briefe*, Hamburger Ausgabe, Hamburg, 1965, III, p. 16.—See further: Richard Benz, *Goethe und die romantische Kunst*, Munich, n.d. (1940), and Paul Jamot, Goethe et Delacroix, *Gazette des beaux-arts*, 1932, 2e série, etc.
(6) *Journal de Eugène Delacroix*, op. cit., I, p. 63.
(7) *Eugène Delacroix, Correspondance Générale*, André Joubin, Paris, 1935–8, I, p. 160.
(8) *Gespräche mit Goethe, in den letzen Jahren seines Leben von Johann Peter Eckermann*, 4th ed., Leipzig, 1876, I, pp. 178–80.
(9) Goethe, *Kunst und Alterthum*, II, pp. 387 ff.
(10) Ibid.
(11) Beraldi, *Les Graveurs du XIXe siècle* Paris, 1885–92, 12 vols., V. p. 59 (note).
(12) Charles Baudelaire, op. cit., p. 398.
(13) Ibid., p. 393.
(14) Ibid., p. 391.
(15) Ibid., p. 394.
(16) Ibid., p. 221.
(17) G. Michaud, *Mallarmé* trans. M. Collins and B. Humez, New York University Press, 1965, p. 89.
(18) *Journal de Eugène Delacroix*, op. cit., III, pp. 137–8.
(19) Ibid., III, p. 150.
(20) Jean C. Harris, 'Edouard Manet as an Illustrator', *Bulletin*, Philadelphia Museum of

Art, April-June 1967, LXII, No. 293, p. 232.
(21) Michael Rossall, 'The Preoccupation with Symbolic Magic—as found in Goya's *Caprichos* and Edgar Allen Poe's *The Raven* in the works of Baudelaire, Mallarmé and Manet; Unpublished B.A. Thesis, Manchester, 1969.
(22) Jean C. Harris, op. cit., p. 231.
(23) André Mellerio, *Odilon Redon*, Paris, 1923, pp. 114–15.
(24) Ibid.
(25) Jean Seznec, 'Nouvelles études sur la *Tentation de Saint Antoine* (by Gustave Flaubert),' *Studies of the Warburg Institute*, 18, London, 1949.
(26) *Lettres de Gauguin, Gide, Huysmans, Jannes, Mallarmé, Verhaeren... à Odilon Redon*, presentees par Arï Redon... textes et notes par R. Bacou, Paris, 1960, p. 133.
(27) André Mellerio op. cit. p. 110.
(28) Paul Cézanne, op. cit., p. 29.
(29) Ibid., p. 68.
(30) Ibid., p. 32.
(31) Ibid., p. 11.
(32) U. E. Johnson, *Ambroise Vollard, Éditeur, 1867–1939*, Paris, 1944, p. 13.
(33) Ibid., pp. 20–1. Johnson tells of Beraldi's reaction when the latter saw the illustrations by H. Seguin to Bertrand's 'Gaspard de la nuit'. At first he admired them tremendously and then he realized that Vollard had published the book he threw his arms up and cried: 'The man who published *Parallèlement* and *Daphnis et Chloë*?—Ah, no! that would be to let the devil into my library!'
(34) *Camille Pissarro, Letters to his Son Lucien*. Edited with the assistance of Lucien Pissarro by J. Rewald, London, 1943, p. 291.
(35) Ibid., p. 339.
(36) *Gespräche mit Goethe*, op. cit. II, pp. 211–17. Pierre Bonnard *Daphnis und Chloe*, 48 Lithographien, Nachwort von Günter Busch, Munich, 1961, p. 65.

Catalogue

1 Introduction

The de-luxe edition of Jean Racine's *Oeuvres* (1801, Cat. No. 1), for which Pierre Didot was responsible as publisher, contains a series of copper-plate engravings made from paintings by well-known painters of the school of J. L. David. That is typical of the situation of the illustrated book at the beginning of the 19th century, that it became a book with additional tabloid pictures. As for the history painting of Classicism, book illustration also followed the climatic point of the text, in order to bring alive the incident to the observer in his imagination. The works of Ch. Monnet (1810, Cat. No. 2), J. M. Moreau le jeune and P. P. Prud'hon (1817, Cat. No. 3), Fragonard, Horace Vernet and A. Devéria (1819–25, Cat. No. 4) were still close to the Rococo.

The *Histoire du roi de Bohême* (1830, Cat. No. 15) was one of the first books with vignettes and opened the series of Romantic illustrated books of the 1830s. In England Bewick had already introduced the wood engraving in place of the traditional wood-cut and thus paved the way to a popular technique and style, which influenced the subsequent development of the illustrated book in France. The wood engraving had gradually replaced the copper plate. Tony Johannot and Celestin Nanteuil were among the first to turn to the wood engraving and to fit the illustrations as vignettes to the type face. Among the Romantic masterpieces stand out Jean Gigoux's illustrations for *Gil Blas* (first edition 1835, Cat. No. 18), Tony Johannot's illustrations for Molière's *Oeuvres* (1835–6, Cat. No. 17) and for Cervantes' *Don Quichotte* (1836–7, Cat. No. 19), Grandville's and Raffet's illustrations to Béranger's *Oeuvres complètes* (1837, Càt. No. 20) and finally Bernardin de Saint-Pierre's *Paul et Virginie* (1838, Cat. No. 24), on the illustrations and vignettes to which Johannot, Meissonier, E. Isabey, P. Huet and others collaborated. These books in the 1830s belong to the earliest recorded Romantic book illustrations, and were followed by many others, among them *Notre-Dame de Paris* (1844,

Cat. No. 36), by Victor Hugo, who himself left a surprising large production of graphic works (Cat. No. 47). Hugo saw in the illustration a sensually perceptible pictorial expansion of his written word. Alongside such typical examples of Romantic illustrated books the Keepsakes were above all in the popular style, and the publishers Curmer, Hetzel or Paulin saw to it that they found a wide public in France. Great authors of the age, like Balzac, G. Sand, Ch. Nodier, Th. Gautier and others, collaborated in the publications of *Les français peints par eux-mêmes* (1840–2, Cat. No. 29), *Scènes de la vie privée et publique des animaux* (1842, Cat. No. 31) or *Le Diable à Paris* (1845, Cat. No. 38).

For Balzac the illustration was indispensable to his work in order to 'populariser le livre' as he admitted on the occasion of Gavarni's lithograph to *La Peau de chagrin* in 1831. But nevertheless it had to remain very close to the text. In a letter of October 1841 to his publisher Hetzel who was bringing out his *Comédie humaine* Balzac complained: 'Mais il est indispensable que les dessinateurs lisent le livre.' In so far as his texts contain a specifically narrative prose, it was not difficult for the artists to translate his types into popular figures. The *Oeuvres illustrées de Balzac* (1851–5) with illustrations by Johannot, Daumier, Monnier, Staal and others appear to aim at popularizing his works widely, and they were published at popular prices and in convenient sized editions. His numerous contributions to popular physiology like his *Physiologie de l'employé* (1841, Cat. No. 30) were much appreciated by the public. It was Hetzel's merit, too, as G. Sand put it: 'Si l'artiste avait une invention à émettre, une fantaisie à réaliser, il se chargeait d'en fournir le texte, d'en faire accepter l'originalité, et réciproquement, il courait de l'écrivain au dessinateur pour que l'on sut ou voulut élever son imagination au niveau de celle de l'autre. C'est ainsi qu'il a su marier le génie de Balzac à celui de Meissonier et de Grandville, celui d'Alfred de Musset à celui de Tony Johannot, et ainsi de beaucoup d'autres.'

Gil Blas (1835, Cat. No. 18) and *Paul et Virginie* (1838, Cat. No. 24) were models for their time in their typographical treatment of text and illustration. The illustrated book had plenty of artists willing to subscribe to it in the numerous first-class commercial artists like Johannot, Nanteuil, Grandville, Gigoux and Gavarni to name but a few. The vignette, however freely it may have appeared to adapt itself to the page and however much it rivalled the arabesque in its playful character, was nevertheless in its specifically narrative content exactly related to the text.

Gustave Doré linked up with the tradition of Grandville, as can be particularly well seen in his illustrations to Balzac's *Les Contes drôlatiques* (1855, Cat. No. 46). The extent of his pictorial imagination appeared inexhaustible,

stretching from witty pieces and humorous and sarcastic stories, as *Folies gauloises* (1852, Cat. No. 44) or *Histoire pittoresque, dramatique et caricaturale de la Sainte Russie* (1854, Cat. No. 45), right up to Dante's *L'Enfer* (1861, Cat. No. 48) or Cervantes' *Don Quichotte* (1863, Cat. No. 50). His preference for the universal was very typical for the spirit of his age, and he produced magnificent works on an enormous scale, which unfortunately all too easily became 'tabloids' with the text appended. In his full-page wood engravings he aimed at effects similar to paintings, and thus failed to relate picture and text formally to each other. Doré, in particular, was the target of Ruskin's criticism at a time when the illustrated book, in the taste of the early Venetian books, was beginning to experience a new lease of life in England with William Morris and his Kelmscott Press. In Doré's case it was not merely the misguided desire to make the full-page picture into a painting in its own right, but also his wood-engraving technique, which precipitated the decline of the illustrated book in the second half of the 19th century. At first Doré had chosen the facsimile technique for his vignettes, and transferred the sketch directly on to the block; the full-page plates, on the other hand, were treated as tinted prints or in a technique somewhere between black and white lines, and the artist only transferred ink or pencil sketches on to the wood and later on to paper. It was then the engraver's job to translate these tonal differences into a form suitable for wood engraving by means of parallel or intersecting layers. Thus printing was no longer facsimile printing but rather 'gravure d'interprétation'. The fact that not just the artist but also the engraver was responsible for the interpretation of the artist's personal stamp, and that finally photographic transcription of the model on to the wooden block was practised, brought Doré's book art into disrepute. If one remembers Doré's exclusively stylized sensational illustrations which led away from the text to look like proper paintings, one can understand Flaubert's attitude, calling the book illustration 'une chose anti-littéraire'. 'O illustration! invention moderne fait pour déshonorer toute littérature!' (1880).

In contrast to wood engraving, lithography and etching became the nearly exclusive forms of book illustrations used by French painters. Precisely because in these two media the artist could be sure that his intentions were reproduced. Baudelaire called the etching in his article 'L'Eau-forte est la mode' (1862): 'Parmi les differentes expressions de l'art plastique, l'eau-forte est celle qui se rapproche le plus de l'expression littéraire...' Lithography was used relatively early in France, as for instance by J. B. Isabey in his *Voyage en Italie* (1823, Cat. No. 5), E. Lami in *Vues pittoresques de l'Écosse* (1826, Cat. No. 9), H. Monnier in *Chansons de P. J. de Béranger* (1828, Cat. No. 10), E. Delacroix in

Goethe's *Faust* (1828, Cat. No. 12) and J. J. Grandville in *Métamorphoses du jour* (1829, Cat. No. 13). Whilst Gavarni and Daumier used the wood engraving for their book illustrations, they chose the lithograph for their caricatures. Daumier's *Histoire ancienne* (1841–3, Cat. No. 21) stands out amongst his work as a magnificent, completely serious division of opinion with the false ideals of Classicism. Baudelaire, who was rather less enthusiastic about plans to illustrate his work, praised Daumier's *Histoire ancienne* as 'une chose importante, parce que c'est pour ainsi dire la meilleure paraphrase du vers célèbre: QUI NOUS DÉLIVRERA DES GRECS ET DES ROMAINS? Daumier s'est abattu brutalement sur l'antiquité, sur la fausse antiquité, — car nul ne sent mieux que lui les grandeurs anciennes' (1857). In Gavarni's lithographs (cf. Cat. Nos. 22, 23, 42) the legends were written by himself. They produce a kind of antithesis between the title and the figure in the picture; Beraldi was the only one to express a few ideas on the relation between text and image, a problem which has received little attention in research.

In the second half of the 19th century especially the painters Fantin-Latour (Cat. No. 53), Manet (Cat. Nos. 54, 55, 56), Redon (Cat. Nos. 58. 59, 61), Toulouse-Lautrec (Cat. No. 62) and Bonnard used the techniques of lithography and etching, which allowed them to transcribe their pictorial ideas directly. One of the most famous illustrated books was *Sonnets et eaux-fortes* (1869, Cat. No. 52), in which poets and painters worked together. The painters were aiming to create precisely the opposite tendency in book illustration, by leaving room for every kind of nuance of interpretation, which Verlaine had favoured as opposed to mere literature, the balance between the precise and the imaginative. Mallarmé had translated Poe's *The Raven* into French, and his friendship with Manet, who had provided the work with full-page lithographs (1875, Cat. No. 55), is one more indication that he did not merely agree to such illustrations, but probably also discussed them with Manet. Mallarmé was thinking of publishing his works in an illustrated edition, and he had spoken on this subject to Degas, Renoir, Monet, B. Morisot and others, but unfortunately his project came to nothing. Earlier Manet had illustrated Mallarmé's *L'Après-midi d'un faune* (1876, Cat. No. 56), Renoir made an etching as a title page for *Pages* in 1891 and Redon produced a lithograph to *Un Coup de dés jamais n'abolira le hasard* (1898, Cat. No. 61).

At the same time when the traditional book illustration fell into decline, especially in regard to the later works by Doré and his circle, the 'livre de luxe' received an enormous revival. Vollard was one of the first at the end of the 19th century to turn for his illustrated books not to the specialists who were well versed in book design, but to the painters, which caused the bibliophiles

like Beraldi to be extremely annoyed with him. But he found a new interpretation of the illustrated book. Bonnard's lithographs to Verlaine's *Parallèlement* or to Longus' *Daphnis et Chloë* are the fulfilment of the development of the illustrated book in the 19th century and are at the same time the watershed of the departure into the 20th century art of book illustration. When seeing Bonnard's lithographs Cézanne had asked Vollard: 'De qui est-ce? C'est dessiné dans la forme.'

2 General bibliography

Beraldi (H.), *Les Graveurs du XIXe siècle*. Paris, 1885–92, 12 vol.

Bouchot (H.), *Les Livres à vignettes*. Paris, 1891.

Carteret (L.), *Le Trésor du bibliophile. Livres illustrés modernes 1875 à 1945 et souvenirs d'un demi-siècle de bibliophilie de 1887 à 1945*. Paris, 1946–8, 5 vol.

Champfleury, *Les Vignettes romantiques*. Paris, 1883.

Damase (J.), *Révolution typographique depuis Stephane Mallarmé*. Genève, 1966.

Didot (A. F.), *Essai typographique et bibliographique sur l'histoire de la gravure sur bois*. Paris, 1863.

Monglond (A.), *La France révolutionnaire et impériale Annales de bibliographie méthodique et description des livres illustrés*. Grénoble, 1930.

Rümann (A.), *Das illustrierte Buch des XIX. Jahrhunderts in England, Frankreich und Deutschland, 1790–1860*. Leipzig, 1930.

Sander (M.), *Die illustrierten französischen Bücher des 19. Jahrhunderts*. Stuttgart, n.d. [1924].

Uzanne (O.), *Les Zigzags d'un curieux causeries sur l'art des livres et la littérature d'art*. Paris, 1888.

Vicaire (G.), *Manuel de l'amateur de livres du XIXe siècle 1801–1893*. Préface de Maurice Tourneux. Paris, 1894–1920, 8 vol.

3 Catalogue

(1) 1801. *Oeuvres de Jean Racine…* À Paris, de l'imprim. de Pierre Didot l'aîné, au Palais National des sciences et arts. An IX— MDCCCI–MDCCCV
3 tom. 489×343 mm. No. 33 of 250 copies.
Copper plates by various engravers after Prud'hon Moitte, F. Gerard, A. L. Girodet, Taunai, Chaudet, Serangeli and Peyron.
(Rylands Library. F. 842.45)
Plate: Bajazet, Acte V, sc. XI. F. Gérard inv. Fischer sculp. p. 205. 'XIPHARES à MONIME Qu'avons-nous fait? MONIME Adieu, prince. Quelle nouvelle!'
Refs.: Monglond, t. 5, 584–92; Vicaire, t. 6, 936–7.

(2) 1810. *Les Aventures de Télémaque,* par
François Salignac de la Mothe-Fénélon;
nouvelle éd., enrichie d'une notice abregée
de la vie de l'auteur, de réflexions sur
Télémaque, d'une carte nouvelle de ses
voyages, des principales variantes tirées des
manuscrits et des éditions précédentes, et
de LXXII estampes gravées, d'après les
dessins de Ch. Monnet, par J.–B. Tilliard...
A Paris, de l'impr. de J. M. Eberhart, rue du
Foin-Saint-Jacques. MDCCCX.
2 tom. 261×208 mm.
(British Museum. 162.b.2)
Plate: pl. III, p. 12. 'Télémaque et Mentor
prest d'être sacrifiés aux manes d'Anchises.'
Ref.: Monglond, t. 8, 899–903.

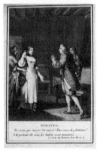

(3) 1817. *Oeuvres de P. et de Th. Corneille*,
avec les commentaires de Voltaire... A Paris,
chez Antoine–Augustin Renouard.
MDCCCXVII.
12 tom. 212×129 mm.
*Twenty-six copper plates by A. St. Aubin,
J. B. Simonet, J. Bosq, B. Roger, J. F.
Ribault and L. Petit after Caffiery, J. M.
Moreau le jeune and P. P. Prud'hon.*
(Liverpool University. H.77.1)
Plate: t. V, p. 15, La Suite du menteur.
J. M. Moreau del. J. F. Ribault sculp. 1816.
'DORANTE. Mes yeux. Que vois-je? Ou
suis-je? Êtes-vous des flatteurs? Si le
portrait dit vrai, les habits sont menteurs...'
Ref.: Vicaire, t. 2, 1013–14.

(4) 1819 (−25). *Oeuvres de Molière*, avec
un commentaire, un discours préliminaire,
et une vie de Molière, par M. Auger, de
l'Académie française... A Paris, chez Th.
Desoer, libraire, rue Christine, no. 2.
1819–25.
9 tom. 198×126 mm
*Copper plates ex text by various engravers
after Fragonard, Horace Vernet and
A. Devéria.*
(Keele University. 431)
Plate: Pourceaugnac, Act I, sc. XVI. Horace
Vernet pinxt. H. C. Muller sculp.
'L'APPOTHICAIRE. Prenez le, Monsieur,
Prenez le... POURCEAUGNAC. Allez vous
en au Diable.'
Ref.: Vicaire, t. 5, 914–15.

(5) 1823. Isabey (Jean-Baptiste). *Voyage en Italie,* par J. Isabey en 1822. Trente lithogr. num. Chez Villain.
(British Museum 1295. k.15)
Plate: 'Arcade du Colissé, 1er Étage.'
Ref.: Sander, p. 134, item 350.

(6) 1823 *Oeuvres de Rabelais,* édition variorum, augmentées de piéces inédites, des Songes drolatiques de Pantagruel, ouvrage posthume avec l'explication en regard ; des remarques de Le Duchat, de Bernier, de le Motteux, de l'abbé de Marsy, de Voltaire, de Guinguerie, etc. ; et d'un nouveau commentaire historique et philologique, par Esmangart et Éloi Johanneau, membres de la Société royale des Antiquaires. A Paris, chez Dalibon, Libraire, Palais-Royal, galerie de Nemours. MDCCCXXIII.
9 tom. 203 × 127 mm.
Twelve copper plates by various engravers after Devéria. Tome 9 contains many reproductions of early wood-cuts.
(Manchester University. Christie. 45.d. 18–26, 45.e.1)
Plate: (a) t.II, pp. 270–1. Devéria delt. Jehotte sculpt. 'Comment Grandgousier traicta humainement Toucquedillon prisonnier.' Liv. I, chap. XLVI. (b) t. IX, pp. 346–7. Reproduction of 16th century wood-cut.
Ref.: Vicaire, t. 6, 923–4.

(7) 1824. Nouvelles odes, par Victor M. Hugo. A Paris, chex L-advocat, libraire éditeur des œuvres complètes de Shakespeare, Schiller, Byron, Milleroye, et des chefs d'œuvre des théâtres étrangers. MDCCCXXIV.
146 × 94 mm. Pp. xxviii, 232.
Steel frontispiece by Adrien Godefroy after Devéria.
(Manchester University. 841. 79–G948–93)
Plate: Devéria delt. An. Godefroy sc. 'Le Sylphe'.
Refs.: Vicaire, t. 4, 231 ; Carteret, t. 1, 390.

(8) 1825. *Anacréon*, recueil de compositions dessinées par Girodet, et gravées par M. Chatillon, son élève, avec la traduction en prose des odes de ce poète, faite également par Girodet; publié par son héritier et par les soins de MM. Becquerel et P.–A. Coupin. À Paris, chez Chaillou-Potrelle, rue Saint-Honoré, No. 140. MDCCCXXV. Imprimerie de Firmin Didot, rue Jacob, No. 24.
352×261 mm. Ff.[56]
Fifty-four plates.
(British Museum. 162. c.1)
Plate: Ode XXVI, 'Effets du vin'. Girodet invt. H. G. Chatillon sculpt.
Ref.: Vicaire, t. 1, 53.

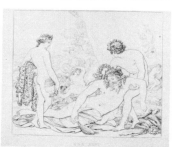

(9) 1826. Lami (Eugène). Three lithographs for the following book (British Museum. 1861.8.10. 201, 203, 210): *Vues pittoresques de l'Écosse*, dessinées d'après nature par F. A. Pernot; lithographiées par Bonington, David, Deroi, Enfantin, Francia, Goblain, Harding, Joli, Sabatier, Villeneuve, etc.; ornée de douze vignettes d'après les dessins de Delaroche jeune et Eugène Lami; avec un texte explicatif extrait en grande partie des ouvrages de sir Walter Scott par Am. Pichot. Paris, Charles Gosselin, et Lami-Denozan, éditeurs, MDCCCXXVI. pet. in-fol.
Ref.: Vicaire, t. 6, 653.

Le Sénateur.

(10) 1828. *Chansons de P. J. de Béranger*, anciennes, nouvelles et inédites, avec des vignettes de Devéria et des dessins coloriés d'Henri Monnier, suivies des procès intentés a l'auteur... Paris, Baudouin frères, éditeurs, rue de Vaugirard, No. 17. MDCCCXXVIII.
2 tom. 206×129 mm.
Thirty-two hand-coloured lithographs ex text. Small wood tail-pieces by A. Devéria.
(British Museum. 161.a.21–22)
Plate: t. 1, pp. 18–19. Henry Monnier. Lith. rue N. D. des Victoires, 16, Le Sénateur'.
Ref.: Vicaire, t. 1, 402–3.

(11) 1828. Monnier (Henry Bonaventure). Hand-coloured lithograph to illustrate the poem *Bon Vin et Fillette*, by Béranger. (British Museum. 1861. 10.10.12.771) *From an album of twenty-four plates in-4°, lithographed (in ink:) and hand-coloured after drawings by Monnier, published c. 1828 (Brivois, p. 23).* *Plate :* Pl. 3, 'Bon Vin et Fillette'. *Ref. :* Jules Brivois, Bibliographie de l'œuvre de P.-J. de Béranger, Paris, 1876, pp. 23–4 (No. 3).

(12) 1828. *Faust*, tragédie de M. de Goethe, traduite en français par M. Albert Stapfer. Ornée d'un portrait de l'auteur, et de dix-sept dessins composés d'après les principales scènes de l'ouvrage et exécutés sur pierre par M. Eugène Delacroix. A Paris, chez Ch. Motte éditeur, imprimeur-lithographe de LL.AA.RR Mgr le Duc d'Orléans et Mgr le Duc de Chartres, rue des Marais, No. 13 ; et chez Sautelet, librarie, place de la Bourse. MDCCCXXVIII (1828). 423 × 283 mm. Pp. 148. (British Museum. 1875. b.9) *Ditto. two separate lithographs.* (British Museum. 1918. 6.29.11–12) *Plates :* (a) Frontispiece. (b) Faust in his Study (between pp. 24–5). *Refs. :* Vicaire, t. 3, 1013–14 ; Carteret, t. 3, 270–2.

(13) 1829 Grandville (J. J.) Two hand-coloured lithographs (Nos. 17, 43) from the following publication (British Museum. 1856. 7.12.594–5): *Métamorphoses du Jour*, par I. Adolphe Grandville. 1829. A Paris, chez Bulla, éditeur, rue St Jacques, no. 38. Impr. Lith. de Langlumé rue de l'Abbaye, no. 4. In–4° oblong. *Plate :* No. 17. J. Granville [sic] Lith. de Langlumé. Académie de dessins / Drawing School. Chez Bulla rue St Jacques 38 et chez Martinet rue du Coq. *Ref. :* Vicaire, t. 5, 775–80 (Vicaire says that the edition with legends in French and in English does not appear to have been completed).

(**14**) Grandville (J. J.). Two drawings in pen, ink and pencil.
(British Museum. 1878. 7.13.11,13)

(**15**) 1830. *Histoire du roi de Bohême et de ses sept chateaux.* [By Charles Nodier] Paris, Delangle frères, éditeurs-libraires, place de la Bourse. MDCCCXXX.
223×138 mm. Pp. iv, 398.
Fifty wood engravings by Porret after Tony Johannot in the text.
(British Museum. 837.f.11)
Refs.: Vicaire, t. 6, 107–8; Carteret, t. 3, 430.

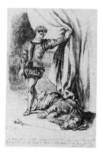

(**16**) (1834). Delacroix (Ferdinand Victor Eugène). 'Death of Polonius'. One of the original drawings for the following series of lithographs
(British Museum. 1908. 6.16.48):
Hamlet. Treize sujets dessinés par Eug. Delacroix... A Paris, chez Gihaut frères, s.d. [1843] gr. in-folio.
Lithograph: 'Ah! je meurs Horatie!' An illustration to *Hamlet:* Dated 1843.
(British Museum. 1918. 6.29.9)
Ref.: Carteret, t. 3, 191.

(**17**) 1835 (–36). *Oeuvres de Molière,* précédées d'une notice sur sa vie et ses ouvrages par M. Sainte-Beuve. Vignettes par Tony Johannot... Paris, chez Paulin, libraire-éditeur, 33, rue de Seine. MDCCCXXXV–MDCCCXXXVI.
2 tom. 256×172 mm.
Wood engravings by various French and English engravers after Tony Johannot.
(Manchester University. 842.42–A18–Q)
Ditto. India proof of the title to tome II.
(British Museum. 1914. 2.28.2918)
Refs.: Vicaire, t. 5, 919–21; Carteret, t. 3, 410–12.

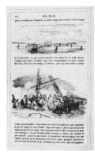

(18) 1835. *Histoire de Gil Blas de Santillane,* par Le Sage. Vignettes par Jean Gigoux. Paris, chex Paulin, Libraire-Éditeur, 33, rue de Seine. 1836 [the first edition was dated 1835].
262 × 173 mm. Pp. 972.
Wood engravings by various French and English engravers after J. Gigoux.
(Dr U. Finke)
Refs.: Vicaire, t. 5, 239–41; Carteret, t. 3, 386.

(19) 1836 (–37). *L'ingénieux hidalgo Don Quichotte de la Manche,* par Miguel de Cervantès Saavedra, traduit et annoté par Louis Viardot, vignettes de Tony Johannot... Paris. J.–J. Dubochet et Cie, éditeurs, Librairie Paulin, rue de Seine, 33. MDCCCXXXVI–MDCCCXXXVII.
2 tom. 254 × 161 mm.
Wood engravings by various French and English engravers after Tony Johannot.
(Liverpool University. P357.3.9)
Ditto. Separate proof of the frontispiece to tome I.
(British Museum. 1878. 7–13–2434)
Ref.: Vicaire, t. 2, 155–6; Carteret, t. 3, 136.

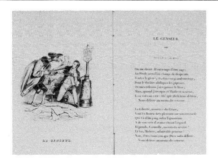

(20) 1837. *Oeuvres complètes de P. J. de Béranger.* Édition illustrée par Grandville et Raffet... Paris, H. Fournier ainé, éditeur, rue de Seine, No.16; Perrotin, libraire, place de la Bourse. MDCCCXXXVII.
3 tom. 223 × 146 mm.
One hundred and twenty wood engravings by French and English engravers after Grandville (100) and Raffet (20).
(Manchester University. 841.71–A6)
Plate: t. II, pp. 182–3. Le Censeur. Wood engraving after Grandville.
Refs.: Vicaire, t. 1, 411–12; Carteret, t. 3, [The first edition was dated 1836, and Raffet's name did not appear on the title]

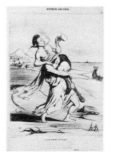

(21) 1841–3. Daumier. *Histoire ancienne.* (1re–2e série.) En vente au bureau du Charivari, 16, rue du Croissant, 16; et chez Martinet, 172 rue Rivoli et 41, rue Vivienne. Paris. n.d. [1st edition: 1841–3.]
328 × 246 mm. Ff. 50. Wrappers.
Fifty lithographs.
(British Museum. 162.c.9)
Ditto. Four separate lithographs, being numbers 15, 22, 26, 49.
(British Museum. 1918. 5.11.163, 165–7)
Ref.: Sander, 94, item 207.

(22) 1837–43. Gavarni. The original drawing for *'Fourberies de Femmes, 2e Série. 35'*. (British Museum. 1963. 12.14.11) *Lithograph, 'Fourberies de Femmes, 2e Série. 35.' From the Charivari.* 198 × 159 mm. (British Museum. 1963. 12.14.12.) *Ref.:* Sander, 119, No. 295.

(23) 1837–43. Gavarni. Five lithographs: *Les Lorettes,* Nos. 69, 71, 73, 76, 78. *From the Charivari.* (British Museum. 1861. 12.14.123–5, 128–9)

(24) 1838. *Paul et Virginie, Suivi de La Chaumière indienne,* par J.–H. Bernardin de Saint-Pierre. Paris, L. Curmer, 49, rue Richelieu. 1838. 251 × 163 mm. Pp. LVI, 458, xiii. This copy lacking the printed tissues to the large engravings and without the tail-piece to the list of designers and engravers. *Wood engravings, including twenty-nine text, mainly by John Orrin Smith and other English engravers, after Baptiste, Belaife, Brascassat, Delaberge, Français, Paul Huet, Eugène Isabey, Jacque, Tony Johannot, C. Marville, E. Meissonier and Steinheil. Seven steel engravings by various engravers after Laffitte, Johannot and Meissonier.* (Keele University) *Refs.:* Vicaire, t. 7, 42–67; Carteret, t. 3, 532–47. [Both Vicaire and Carteret give Curmer's address as 25, rue Saint-Anne. Carteret (p. 536) explains that publication began in March 1836 and ended in December 1837. Several thousand copies were sold immediately, and then in 1845 Curmer, who had changed his address, sold the remaining copies (about 4000) with his new address on the title. These copies are nevertheless of the first impression.]

(25) 1838. *Voyages de Gulliver dans les contrées lointaines*, par Swift. Edition illustrée par Grandville. Traduction nouvelle... Paris, H. Fournier aîné, éditeur, rue de Seine, 16. Furne et Cie, libraires éditeurs, rue Saint-André-des-Arts, 55. MDCCCXXXVIII. 2 tom. 200 × 123 mm.
Wood engravings by French and English engravers after J. J. Grandville.
(Leeds University. J–24.3)
Refs.: Vicaire, t. 7, 717–18; Carteret, t. 3, 578–80.

(26) 1838. *Fables de la Fontaine,* illustrées par J. J. Grandville, Nouvelle édition... Paris, H. Fournier aîné, éditeur, rue de Seine, 16. MDCCCXXXVIII.
2 tom. 223 × 148 mm. This copy wanting the half-titles to both volumes.
One hundred and twenty-one wood engravings ex text by French and English engravers after Grandville.
(Manchester University. Christie. 44.g.25)
Refs.: Vicaire, t. 4, 899–900; Carteret, t. 3, 359.

(27) 1838. *Fables de Florian,* illustrées par Victor Adam. Précédées d'une notice par Charles Nodier de l'Académie française et d'un essai sur la fable, et suivies des poèmes de Ruth et de Tobie. Paris, Delloye, Desmé et Cie, éditeurs, rue Neuve-Vivienne, 49. 1838.
227 × 148 mm. Pp. xxviii, 288. [2nd impression.]
One hundred and ten steel plates by Beyer and E. de Laplante. Wood engravings after Victor Adam in the text.
(Dr U. Finke)
Refs.: Vicaire, t. 3, 743–5; Carteret, t. 3, 237.
[The title containing 'et suivies des poèmes de Ruth et de Tobie' is not mentioned by Carteret; Vicaire describes the second impression of this book after the Dépot Légal copy, which also does not contain the phrase, but mentions (p. 745) having seen a copy corresponding to the present one.]

(28) 1839. *Histoire de l'Empereur Napoléon*, par P.–M. Laurent de l'Ardèche; illustrée par Horace Vernet. Paris, J.–J. Dubochet et Cie, éditeurs, rue de Seine- Saint-Germain, 33. 1839.
256×166 mm. Pp. 802.
Wood engravings by various French and English engravers after H. Vernet.
(Keele University. DC203–1)
Refs. : Vicaire, t. 5, 98–100; Carteret, t. 3, 375.

(29) 1840–2. *Les français peints par eux-mêmes...* Paris, L. Curmer, éditeur, 49, rue de Richelieu, au premier. MDCCCXL–MDCCCXLII.
5 tom. 270×180 mm. Tom. IV and V have the subtitle: 'Encyclopédie morale du dix-neuvième siècle.'
Wood engravings by various engravers after Lami, Gavarni, T. Johannot, Daumier, H. Monnier, Traviés, Steinheil, Gigoux, Pauquet, Meissonier and others. The large engravings ex text have been coloured.
(British Museum. 162.b.13–17)
[These five volumes represent the first part of a whole consisting of nine volumes. It concerns Paris, whereas the next three are devoted to the Provinces, and the last bears the title *Le Prisme*, encyclopédie morale du dix neuvième siècle... etc.]
Refs. : Vicaire, t. 3, 794–6; Carteret, t. 3, 245–50.

(30) 1841. *Physiologie de l'employé*, par M. de Balzac. Vignettes par M. Trimolet. Paris, Aubert et Cie, place de la Bourse; Lavigne, rue du Paon St.–André, 1.
n.d. [1841.]
134×83 mm. Pp. 128.
Wood engravings by various engravers after Trimolet.
(Dr U. Finke)
Refs. : Vicaire, t. 1, 215; Carteret, t. 3, 481.

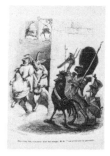

(31) 1842. *Scènes de la vie privée et publique des animaux.* Vignettes par Grandville. Études de mœurs contemporaines publiées sous la direction de M. P.–J. Stahl, avec la collaboration de Messieurs de Balzac. — L. Baude. — E. de La Bédollierre. — P. Bernard. — J. Janin. — Ed. Lemoine. — Charles Nodier. — George Sand. Paris, J. Hetzel et Paulin, éditeurs, rue de Seine-Saint-Germain, 33. 1842.
2 tom. 264×179 mm.
Wood engravings after Grandville by various French engravers in the text and on extra leaves.
(Liverpool University. L.72.23)
Refs. : Vicaire, t. 7, 405–6 ; Carteret, t. 3, 552–3.

(32) 1842. *Fables de Florian,* illustrées par J.-J. Grandville. Suivies de Tobie et de Ruth, poëmes tirés de l'Écriture Sainte, et précédées d'une notice sur la vie et les ouvrages de Florian, par P.-J. Stahl. Nouvelle édition. Paris, Garnier frères, libraires, 6, rue des Saintes-Pères et Palais-Royal, 215.
n.d. [1851.] First appeared 1842.
237×153 mm. Pp. [iv]. 308.
Wood engravings after Grandville by various French engravers both in the text and on extra leaves.
(Manchester University. 843.58-C11-Q)
Refs. : Vicaire, t. 3, 745–7 ; Carteret, t. 3, 238.

(33) 1843. *Petites misères de la vie humaine,* par Old Nick [pseud. Emile Daurand Forgues] et Grandville. Paris, H. Fournier, éditeur, rue Saint-Benoît, 7. MDCCCXLIII.
225×140 mm. Pp. [4], VIII, 391.
Wood engravings after Grandville by various French engravers in the text and on extra leaves.
(Liverpool University. H.96.96)
Refs. : Vicaire, t. 3, 756–7 ; Carteret, t. 3, 471–2.

(**34**) 1843. *Chants et chansons populaires de la France.* Notices par Du Mersan. Accompagnement de piano par H. Colet. Illustrations par MM. E. de Beaumont, Bally, Daubigny, Dubouloz, E. Giraud, Meissonnier [sic], Pascal, Staal, Steinheil, Trimolhet [and Braquemond and Courbet]. Paris, Garniers frères, libraires-éditeurs, 6, rue des Saints-Pères. 6. n.d. [1890]. First appeared 1843.
Steel plates by various engravers after the above-named artists. Both the design and the words of the song are engraved on the same plate.
(Manchester University. 398.844–D 61–Q),
Refs.: Vicaire, t. 2, 242–6 (Troisième série, 1843-édition); Carteret, t. 3, 143–53 (1843-édition).

(**35**) 1843–4. *Les Mystères de Paris* par M. Eugène Süe. Nouvelle édition, revue par l'auteur. Paris, librairie de Charles Gosselin, éditeur, 30, rue Jacob. Se vend également à la librairie Garnier frères. MDCCCXLIII–MDCCCXLIV.
4 Pt. 259×178 mm.
Wood engravings and steel engravings in the text and on extra leaves, ex text, by various engravers after Daubigny, Trimolet, Traviès, C. Nanteuil, C. Staal, Daumier and others.
(Keele University. SS.1215)
Ditto. Separate wood engraving by Lavoignat after Daumier: 'Polidori — Bradamanti'.
(British Museum. 1918. 5.11.337)
Refs.: Vicaire, t. 7, 683–5; Carteret, t. 3, 569–70.

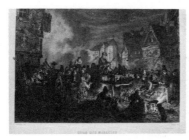

(**36**) 1844. Victor Hugo. *Notre-Dame de Paris.* Édition illustrée d'après les dessins de MM. E. de Beaumont, L. Boulanger, Daubigny, T. Johannot, de Lemud, Meissonnier [sic], C. Roqueplan, de Rudder, Steinheil, gravés par les artistes les plus distingués. Paris, Perrotin, éditeur, rue Fontaine-Molière, 41. Garnier frères, Palais Royal, péristyle Montpensier, 214. 1844.
250×164 mm. Pp.[iv], 485, [iii].
Wood engravings in the text. Wood and steel engravings ex text. Various engravers.
(Keele University. LL.281)
Refs.: Vicaire, t. 4, 260–6; Carteret, t. 3, 300–4.

(37) 1844. Arioste. *Roland Furieux,* traduction nouvelle et en prose, par M. V. Philipon de la Madelaine, traducteur de la Jérusalem délivrée, etc. Édition illustrée de 300 vignettes et de 25 magnifiques planches tirées à part sur Chine, par MM. Tony Johannot, Baron, Français et C. Nanteuil. Paris, J. Mallet et Cie, éditeurs, 9, rue de l'Abbaye. 1844.
250×165 mm. Pp. III–XXIV, 616.
Wood engravings by various French and English engravers after the above-named artists.
(Manchester University)
Specimen for five vignettes for this edition, from the Charivari, 1842.
Refs.: Vicaire, t. 1, 85; Carteret, t. 3, 36.

(38) 1845. *Le Diable à Paris.* — Paris et les Parisiens — Mœurs et coutumes, caractères et portraits des habitants de Paris, tableau complet de leur vie privée, publique, politique, artistique, littéraire, industrielle, etc., etc. Texte par MM. George Sand — P. J. Stahl — Léon Gozlan — P. Pascal — Frédéric Soulié — Charles Nodier — Eugène Briffault — S. Lavalette — De Balzac — Taxile Delord — Alphonse Karr — Méry — A. Jancetis — Gérard de Nerval — Arsène Houssaye — Albert Aubert — Théophile Gautier — Octave Feuillet — Alfred de Musset — Frédéric Bérat, précédé d'une Histoire de Paris par Théophile Lavallée. Illustrations Les Gens de Paris — série de gravures avec légendes par Gavarni. Paris comique — vignettes par Bertall. Vues, monuments, édifices particuliers, lieux célèbres et principaux aspects de Paris, par Champin, Bertrand, d'Aubigny, Français. Paris, publié par J. Hetzel, rue Richelieu, 76-rue de Ménars, 10. 1845–1846.
2 tom. 267×182 mm.
Wood engravings after the above-named artists in the text; wood engravings ex text after Gavarni.
(British Museum. 162,b.18–19)
Refs.: Vicaire, t. 3, 241–2 (Vol. I), 242–3 (Vol. II); Carteret, t. 3, 203–7.

(39) 1845. *Le Juif errant,* par Eugène Süe. Édition illustrée par Gavarni. Paris, Paulin, libraire-éditeur, rue Richelieu, 60. 1845.
4 tom. 265×181 mm.
Wood engravings after Gavarni, Karl Girardet and Pauquet by Best, Leloir, Hotelin and Régnier in the text and on extra leaves.
(Keele University. DD2113)
Refs.: Vicaire, t. 7, 687–9; Carteret, t. 3, 570–4.

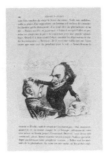

(**40**) 1846. *Jérôme Paturot à la recherche d'une position sociale*, par Louis Reybaud, auteur des Etudes sur les réformateurs ou socialistes modernes. Édition illustrée par J.-J. Grandville. Paris, J.-J. Dubochet, Le Chevalier et Cie, éditeurs, rue de Richelieu, 60. 1846.
265×185 mm. Pp. [viii], 460.
Wood engravings after Grandville by various engravers in the text and on extra leaves.
(Manchester University. 843.79-R330-47-Q)
Refs. : Vicaire, t. 6, 1100–1 ; Carteret, t. 3, 516.

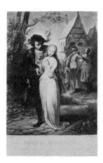

(**41**) 1847. Le *Faust* de Goethe. Traduction revue et complète, précédée d'un essai sur Goethe par M. Henri Blaze. Édition illustrée par M. Tony Johannot. Paris, Michel Lévy frères, libraires-éditeurs, rue Vivienne, 1 ; Dutertre, libraire-éditeur, passage Bourg-l'Abbé, 20. 1847.
266×174 mm. Pp. [iv], 373, [ii].
Steel portrait frontispiece by Ph. Langlois after Carl Mayer. Nine other steel plates by Ph. Langlois and G. Lévy after Johannot; a few wood engravings.
(Keele University)
Refs. : Vicaire, t. 3, 1015 ; Carteret, t. 3, 272.

(**42**) 1848–62. Gavarni. Four lithographs, being the title page and three other leaves from *Les Artistes anciens et modernes*, by H. Baron, L. Français, E. Leroux, A. Mouilleron, C. Nanteuil, Gavarni, K. Bodmere, C. Jacque. Paris, Bertauts.
(British Museum. 1880. 7.10. 46-112-126 : 1889. 6.8.397)

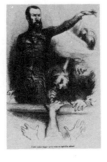

(**43**) 1849. *Jérôme Paturot à la recherche de la meilleure des Républiques*, par Louis Reybaud. Édition illustrée par Tony Johannot. Paris, Michel Lévy frères, libraires-éditeurs, rue Vivienne, 1. 1849.
265×187 mm. Pp. 584.
Wood engravings after Tony Johannot by various engravers in the text and on the extra leaves.
(Dr U. Finke)
Ref. : Vicaire, t. 6, 1102–3 ; Carteret, t. 3, 516–19.

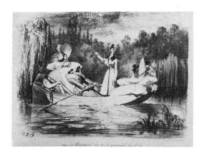

(44) 1852. *Folies gauloises depuis les romains jusqu'à nos jours.* Album de mœurs et de costumes par Gustave Doré. Paris, Au bureau du Journal Amusant, 20, rue Bergère. n.d. [1852.]
260×337 mm. Twenty lithographs and wrappers.
(British Museum. 161.b.29)
Ref. : Sander, 104, No. 235.

(45) 1854. *Histoire pittoresque, dramatique et caricaturale de la Sainte Russie* d'après les chroniqueurs et historiens Nestor, Nikan, Sylvestre, Karamsin, Ségur, etc., commentée et illustrée de 500 magnifiques gravures par Gustave Doré, gravée sur bois par toute la nouvelle école sous la direction générale de Sotain... Paris. J. Bry ainé, libraire-éditeur, 27, rue Guénégaud, 27. 1854.
284×193 mm. Pp. [iv], 207.
Wood engravings after Gustave Doré.
(British Museum. 162.c.12)
Refs. : Vicaire, t. 3, 286 ; Carteret, t. 3, 293.

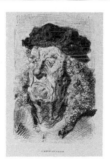

(46) 1855. *Les Contes drôlatiques* colligez cz abbayes de Touraine et mis en lumière par le sieur de Balzac pour l'esbattement des pantagruelistes et non aultres. Cinquiesme edition, illustrée de 425 dessins par Gustave Doré. Londres, John Camden Hotten, Piccadilly. MDCCCLX.
200×126 mm. Pp. xxxii, 616. Cancel title. Printed in Paris. First appeared 1855.
Wood engravings after Gustave Doré by various French engravers.
(British Museum. 162.a.12)
Refs. : Vicaire, t. 1, 190–3 ; Carteret, t. 3, 48–54

(47) 1856. Victor Hugo. Original drawing, consisting of his name worked into a townscape. Dated by Hugo 'Guernesey — 1er janvier 1856'.
131×97 mm. Pen and brush, with a piece of lace used as a stencil ; ink and sepia with red and blue watercolour. [Probably a New Year greeting.]
(Manchester University, Special Collection)

(48) 1861. *L'Enfer* de Dante Alighieri, avec les dessins de Gustave Doré. Traduction francaise de Pier-Angelo Fiorentino, accompagnée du texte italien. Paris, librairie de L. Hachette et Cie, rue Pierre-Sarrazin, 14. MDCCCLXI.
420×300 mm. Pp. [4], IV, 194, [i].
Seventy-six large wood engravings ex text, after Doré by various engravers.
(Manchester University. 851.15-C184-LF)
Refs. : Vicaire, t. 3, 12–13 ; Carteret, t.3, 184.

(49) 1862. *La Mythologie du Rhin* par X.-B. Saintine, illustrée par Gustave Doré. Paris, librairie de L. Hachette et Cie, rue Pierre-Sarrazin, No. 14. 1862.
232×153 mm. Pp. [iv], 403.
Wood engravings after Gustave Doré by various engravers.
(Manchester University. 293-B23)
Refs. : Vicaire, t. 7, 175–6 ; Carteret, t. 3, 529.

(50) 1863. *L'Ingénieux hidalgo Don Quichotte de la Manche*, Par Miguel de Cervantès Saavedra. Traduction de Louis Viardot, avec les dessins de Gustave Doré, gravés par H. Pisan. Paris, librairie de L. Hachette et Cie, boulevard Saint-Germain, No. 77. MDCCCLXIII.
2 tom. 426×311 mm.
Wood engravings after Gustave Doré both in the text and on extra leaves.
(Manchester University. 863.32-B87-LF)
Refs. : Vicaire, t. 2, 160 ; Carteret, t. 3, 138–40.

(51) 1868. Comte de Chevigné. *Les Contes rémois.* Dessins de E. Meissonier. Septième édition. Paris, Librairie de l'Académie des Bibliophiles, rue de la Bourse, 10. MDCCCLXVIII.
171×112 mm. Pp. [ii], 352. First appeared 1858.
Wood engravings by various French engravers in the text, in the first part after E. Meissonier, in the second after V. Foulquier. The steel portrait frontispiece by Buland after Debay.
(Manchester University. 236.689)
Refs. : Vicaire, t. 2, 390 ; Carteret, t. 3, 156–9.

(52) 1869. *Sonnets et eaux-fortes.*
MDCCCLXIX. Alphonse Lemerre, Éditeur,
Paris.
384×285 mm. 47 leaves.
*Forty-two etchings, including one after a
drawing by Victor Hugo, printed once in sepia
and once in black, opposite each sonnet.*
(British Museum. 162*.b.6)
Plate : p. 340, 'Le Pont des arts'. Sonnet
by Sainte-Beuve, etching by Maxime
Lalanne.
Refs. : Vicaire, t. 7, 579–81 ; Carteret, t. 3,
564.

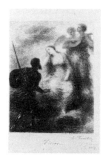

(53) 1869. Fantin-Latour (Ignace Henri
Jean Théodore). Lithograph, entitled *Weber,
Oberon, Vision.* G. Fantin, 7 janvier, 1869.
188×143 mm.
(British Museum. 1899. 4.20.227)

(54) 1874. Charles Cros. *Le Fleuve.* Eaux-
fortes d'Édouard Manet. Paris, librairie de
l'Eau-Forte, 61, rue Lafayette, 61.
n.d. [1874.]
268×224 mm. Pp. 15. No. 13 of 100
copies, signed by Cros and Manet.
Eight etchings.
(British Museum. C.70. g.8)
Refs. : Vicaire, t. 2, 1072 ('Enregistré dans
la Bibliogr. de la France du 27 Février
1875'); Carteret, t. 4, 128.

(55) 1875. *Le Corbeau,* the raven, poëme par
Edgar Poë. Traduction française de Stephane
Mallarmé avec illustrations par Edouard
Manet. Paris, Richard Lesclide, éditeur, 61,
rue de Lafayette. 1875.
536×342 mm. Ff. [12]. No. 53 of 240
copies, signed by Mallarmé and Manet.
Six lithographs.
(British Museum. 24.AP.76)
*Ditto. Separate proofs of the four large
lithographs.*
(British Museum. 1949-4-11-3330-3)
Refs. : Vicaire, t. 6, 738; Carteret, t. 4, 319.

(56) 1876. Manet (Édouard). Four wood engravings on a sheet of cream paper. For Mallarmé's *L'Après-midi d'un faune.* Paris, Alphonse Derenne [1876].
(British Museum. 1949. 4.11.2567)
Refs. : Vicaire, t. 5, 473–4 ; Carteret, t. 4, 261.

(57) 1886–93. *Les Hommes d'Aujourd'hui.* Three coloured caricatures from the fronts of numbers of *Les Hommes d'Aujourd'hui,* Librairie Vanier, 19, Quai Saint-Michel, à Paris.
(Manchester University. 840.5-H50-F)
1. *'Arthur Rimbaud' by Luque (7e volume, No. 318).*
2. *'Paul Verlaine' by Emil Cohl (5e volume, No. 244).*
3. *'Stéphane Mallarmé' by Luque (6e volume, No. 296).*

(58) 1888. Redon (Odilon). Lithograph. The wrapper for Gustave Flaubert's *Tentation de Saint-Antoine,* [Brussels] 1888. Signed by the artist.
(British Museum. 1949. 4.11.3492)
Refs. : Vicaire, t. 3, 729 ; Carteret, t. 4, 160.

(59) 1889. *À Gustave Flaubert.* Six dessins pour la Tentation de St. Antoine, par Odilon Redon. [Paris, 1889.]
509×339 mm. Seven leaves. Grey wrappers. Sixty copies.
Six lithographs. Lithograph on title.
Lithographic wrapper.
(British Museum. 161*. b.16)
Ref. : Vicaire, t. 3, 729 (1888-édition, Brussels, with ten lithographs).

(60) 1896–7. *L'image*, revue littéraire et artistique ornée de figures sur bois. Cette revue, fondée par la Corporation Française des graveurs sur bois, a été publiée sous la direction littéraire de Roger Marx et Jules Rais et sous la direction artistique de Tony Beltrand, Auguste Lepère et Léon Ruffe. Floury, éditeur, 1, Bould. des Capucines. The volume for 1896–7. 298×222 mm. (Manchester University. 840.5-131)
Plate: June 1897, p. 193, 'Le Philtre'.

(61) 1898. Redon (Odilon). Proof of a lithograph for Mallarmé's
Un Coup de dés jamais n'abolira le hasard [1898].
(British Museum. 1949. 4.11.3577)

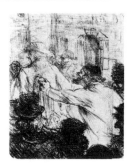

(62) 1898. Georges Clemenceau. *Au pied du Sinaï*. Illustrations de Henri de Toulouse-Lautrec. Henri Floury, 1, Boulevard des Capucines, Paris. 'Achevé d'imprimer le 20 avril 1898.'
253×192 mm. Pp. [iv], 108, [4]. No. 271 of 380 copies.
10 lithographs, each printed twice, in different tints; also tail-pieces.
(British Museum. C.123. f.6)
Ref.: Carteret, t. 4, 106.

Index